The Sociology of Art and Literature

A READER

Edited by

MILTON C. ALBRECHT
Professor Emeritus of Sociology,
State University of New York at Buffalo

JAMES H. BARNETT
Professor Emeritus of Sociology and Anthropology,
University of Connecticut

MASON GRIFF
Late Professor of Sociology,
Southeastern Massachusetts University

PRAEGER PUBLISHERS
New York

*Published in the United States of America in 1970
by Praeger Publishers, Inc., 111 Fourth Avenue
New York, N.Y. 10003*

Second printing, 1976

Library of Congress Catalog Card Number: 70-76785

Printed in the United States of Amercia

CONTENTS

v

CONTENTS

PREFACE

ALTHOUGH A CONCERN with the arts and their practical effects on society has a long history in Western civilization, sociological approaches to the arts are relatively recent, outgrowths of two major intellectual trends in the eighteenth century. One was the further differentiation of the arts from crafts and from science, which had begun during the Renaissance, and the consequent conception of the 'fine arts' or 'beaux arts,' generally assumed to refer to the five major arts—painting, sculpture, architecture, music and poetry. These arts were analyzed for their distinctive characteristics as well as for their similarities and interrelationships, and they were considered in relation to the taste of readers and the genius and originality of the artists.

The second trend occurred in conceptions of history. Earlier historians wrote chiefly of political and military events, but by the middle of the eighteenth century Montesquieu, Voltaire, Gibbon and others were searching for interrelations of political events with race, climate, population and legal and economic systems. These ideas spread throughout Europe and became part of the intellectual background out of which sociology developed as a discipline. Combined with the trend in the arts, they gave rise to the sociology of art.

The publication in 1800 of Madame de Staël's *De la littérature considérée dans ses rapports avec les institutions sociales* influenced other European writers to search for relationships between art and society. This process accounts in part for the fact that European scholars developed sociological points of view much earlier than their counterparts in America, where research in the arts was not under-

taken until the 1920's, and then in only rare instances. Whatever the reasons for the slow development of the sociology of art in America, the last thirty years have witnessed a steady increase in fruitful work by American scholars. Sorokin, Mueller, Lowenthal, Wilson, Graña and others have demonstrated not only considerable learning in the arts but also sophistication in the formulation and use of appropriate conceptual tools and methods of research, as described by James Barnett in Part VI of this volume.

These recent developments to some extent reflect the fact that sociology in the United States has been extending its interests and perspectives beyond a concern with family life, economic and industrial problems and political institutions. In 1954, just sixteen years ago, a session on the sociology of art was included for the first time in the annual meeting of the American Sociological Association. Since then, these sessions have occurred at regular intervals and now form an established part of the Association's activities. They have played an important role in encouraging sociological investigations of the arts.

Intellectual fashions have also changed. The overidentification of many social scientists with the aims and methods of the physical sciences has given rise to demands for a return to more humanistic studies, as illustrated in Robert Bierstedt's Presidential Address of 1959 to the Eastern Sociological Society. In 1968 the Sixth International Congress on Aesthetics, held in Sweden, took as its theme 'Art and Society.' Within the last few years, interdisciplinary groups have sponsored forums on 'Literature and Society' in the Netherlands and in the United States. In the summer of 1969, an international and interdisciplinary conference was held on 'Contemporary Cultural Studies' at the University of Birmingham, in England. In the political arena, it is significant that several states have created councils on the arts, and that the federal government in 1965 established a National Council for the Arts and a National Foundation on the Arts and Humanities.

Beyond the winds of intellectual fashion, the increasing sophistication in sociological studies of the arts is due in part to a broadening perspective on the field itself. Many scholars have continued to focus on the work of art, in an attempt to improve our understanding of it

from sociological points of view. However, others have become aware of other possibilities, especially the possibility that investigation of the arts may contribute to the growing body of sociological knowledge. It can add to our knowledge of professions, for example, by comparing the status and role of artists to those of entrepreneurs in business and industry. The social interactions among artists or among performing groups can illustrate or lead to modifications of sociological principles of informal group behavior. The study of audiences for the fine arts can supplement the growing information about publics for the popular arts. Studies of the relationships of critics and reviewers to audiences, and of artists to dealers and publishers, have increased our awareness of the networks of social processes that ultimately comprise a larger system within society, whose effect on its stability or change remains unknown. Parsons and his associates have begun to fit the arts and other symbolic systems into a general theory of action, while others are considering them as aspects of a general theory of communication.

These developments and possibilities suggest that the time is propitious for a stocktaking of work done in the sociology of the arts, more comprehensive than the otherwise excellent symposium presented in Robert N. Wilson's *Arts in Society*. For this reason the framework for this collection was chosen from the opening article, which emphasizes art as an institution. This framework permits the presentation of substantive findings in several important sectors of the field; it provides for an examination of essential methodological problems; and it furnishes perspectives on sociological theories. The collection as a whole offers materials for achieving a broad understanding of the present status of this field of endeavor and for projecting future research. The materials will also lend themselves to classroom work on both the graduate and the undergraduate levels and may supplement the subject matter of interrelated fields in the humanities and in philosophy, as well as in specializations such as public opinion, communication and the popular arts.

The selections are confined mainly to literature and the visual arts of painting and sculpture because much of the best sociological work to date has been done in these areas, and because the performing arts—music, opera, dance, and theater—present special

difficulties in sociological analysis. Nevertheless, where sociological principles have been applied effectively in these areas, the editors have felt justified in including them, even at the risk of accusations of inconsistency and incompleteness in representing these arts. The emphasis throughout is not on presenting all available studies in any one of the arts but, rather, on representing the diversity of sociological investigations.

Similarly, the selections are drawn mostly from Western societies because it is in these societies that the differentiation of the arts within the total cultural matrix has primarily occurred. This differentiation makes it possible to identify art groups, their life styles, their social relations, and their art products in a total system, as cannot be done in societies where the arts are closely interwoven with other aspects of the culture. But again, when an outstanding cross-cultural study exists that shows Western styles in comparison with those of simpler societies, as in the article by Alan Lomax, it has been included.

It is unlikely that our selection will please everyone who is interested in the sociology of art; each scholar will have his own favorites, reflecting his personal concerns and point of view. He may wonder why a particular article or excerpt from a book has not been included. The specialist in a particular art is least likely to find his scholarly interests satisfied. The expert on drama, for example, will probably deplore the absence of significant works on this important literary form. Scholars in literary and art criticism may find the newest trends in art and in concepts of aesthetics inadequately represented. Others may complain about the absence of materials on leisure or on the interrelations of the fine arts and popular arts. The range of interests and points of view among sociologists of art is probably as extensive as the subdivisions of art and of sociology.

We are aware of these and other limitations of this anthology. Besides the obvious constraints of time and space, the choices were restricted by the lack of sound sociological studies in areas that are theoretically part of the social institution of art: aesthetics, for example. This subject has conventionally been relegated to philosophers and is left untouched by sociologists as compared with their concern with principles of economics and science. Even more important is

the question of the functions of art in society. This volume presents
mainly the ways in which society affects the arts, largely ignoring
the counterinfluences of art on the social order. This posture does
not reflect our conviction that art is ineffectual in ordering values and
influencing social behavior, but, rather, the discovery that, although
confident assertions abound, no systematic, analytic, or experimental
studies have been made that clearly substantiate them. As yet, there
is no convincing evidence that great art, by 'purging the emotions,'
prevents antisocial behavior, or that it 'refines the sensibilities' and
'civilizes' people. Art in the West is presumed by many to support
and stabilize the social order, whereas it is regarded by others as a
harbinger and an instrument of social change because artists are
'ahead of their time.' Art is also supposed to 'integrate' people into
society, to eliminate prejudices and overcome national barriers. These
and other suppositions constitute a belief system that gives moral
support and meaning to the fine arts, but the validity of these beliefs
is still highly uncertain. Partial answers to at least some of the
hypotheses may be forthcoming in the near future.

Although these areas have by necessity been omitted, we have
provided bibliographies of worthwhile studies that will help to bridge
some of the gaps, and we have supplemented the reading selections
with introductory comments that draw attention to basic problems in
each section. Fundamentally, we believe that the fine arts can be
studied fruitfully in all their ramifications, and that the results of
these investigations will contribute significantly to our knowledge
of societies and their cultural systems.

<div style="text-align: right">

MILTON C. ALBRECHT
JAMES H. BARNETT
MASON GRIFF

</div>

BIBLIOGRAPHY OF BIBLIOGRAPHIES

Ethel M. Albert and Clyde Kluckhohn, *A Selected Bibliography on Values, Ethics, and Esthetics*, Glencoe: Free Press, 1959, pp. 137–80, on sociology.

Current Sociology: International Bibliography of Sociology, Vols. I–IX (1952–60), Paris and London: UNESCO; *International Bibliography of the Social Sciences: Sociology*, Vols. X–XVII (1960–67), Chicago: Aldine. An annual publication. See especially the sections on 'Communication through art: the dance, music, drama, literature, painting.'

Hugh D. Duncan, *Language and Literature in Society*, Chicago: University of Chicago Press, 1953, pp. 143–214. Reissued by The Bedminster Press, Totowa, N.J., 1961. A comprehensive guide to literary materials, classified mainly by content.

International Social Science Journal, Vol. XX, No. 4 (1968), 'The Arts in Society.' A selected bibliography appears on pp. 681–87, for the plastic arts, music, literature, theater, and films.

E. Louise Lucas, *Art Books: A Basic Bibliography on the Fine Arts*, Greenwich, Conn.: New York Graphic Society, 1968.

Sociological Abstracts, Inc., New York, N.Y. Annual lists, issued since the early 1950's. No. 1300 is devoted to 'Sociology of the Arts.'

Dr. E. Boekmanstichting Kunstsociologisch Studiecentrum, Keizersgracht 609, Amsterdam, Netherlands. Devoted to the sociological study of the arts, the center has a large international collection of card indexes on the sociology of art.

ORIENTATION OF THE READER:

MILTON C. ALBRECHT

Art as an Institution*

THIS ARTICLE EXAMINES art as an institution, assuming 'art' as a collective term for a wide variety of aesthetic products, including literature, the visual arts and music, as well as the combined forms of drama and opera. The aspects to be examined will include some general classifications and their implications for the place of art in the social structure, the question of the structure of art as a social institution, the problem of 'basic human need' that art serves and, finally, the question of the universality of art. These aspects represent areas of significance for considering art as an institution, but they also illustrate some major uncertainties and disagreements among sociologists, as well as other social scientists and philosophers. An attempt will be made to illustrate some of the difficulties and disagreements, which have largely gone unnoticed, and to clarify some important issues. Wherever possible, directions for achieving more satisfactory solutions will be indicated, recognizing that the suggestions will require greater support from empirical research and that this inquiry itself will need more refinement and extensive analysis before all of its aspects are described adequately.

CLASSIFICATION OF ART

Social institutions are usually regarded as one of 'the core fields of sociology.'[1] Although specialized works on institutions flourished

* Reprinted from the *American Sociological Review*, June, 1968, by permission of the author and the American Sociological Association.

mainly from the late twenties to the early forties, a few revivals occurred in the later fifties and early sixties, with Hertzler's latest effort in the field being the most complete and extensive so far produced.[2] To be sure, the subject has hardly been absent from general theory, but the course of scholarly concern has been rather erratic, revealing differences that directly affect the conception of art as a social institution, its place and importance in the social structure.

Social institutions are commonly defined by sociologists and other social scientists as the principal structures through which human activities are organized and established to serve basic human needs.[3] They are usually distinguished from 'associations' by their larger size and greater complexity; their existence is marked not by membership and specific location but by characteristic patterns of behavior in society. These patterns are structured by their specialized personnel, by special types of roles and activities and by particular groupings and organizations, and are regulated by distinct norms, values and beliefs, marked by appropriate symbols, implemented by certain types of physical equipment. Since these aspects permit considerable latitude of emphasis and interpretation, not all authors, of course, deal with all of them systematically or adequately.[4]

An initial difficulty occurs in the classification of institutions and of the place, stated or implied, that art occupies in relation to other social institutions. In general, these classifications are of two main types, the one emphasizing the degree of development of institutions and consequently their relative importance for the maintenance of society, the other their functions and importance as carriers of cultural values. The first type designates institutions as crescive or enacted, primary or secondary (or even tertiary), major or minor, mature or immature.[5] Although some authors using this type of classification list art among the major institutions, most of them find it of secondary importance. In the maintenance of society, they state or imply, art is not so 'basic' as the family or the economic and political institutions. Indeed, as Sumner and Keller were among the first to observe, in art and other forms of 'self-gratification,' 'there is no structure for [their] realization . . . corresponding to property for self-maintenance or marriage for self-perpetuation; no accretion of

mores about a core upon which taboo has been formatively at work.' Hence, they do not constitute a 'real' institution, in spite of their prevalence and persistence.[6] A number of later writers followed this distinction, especially Barnes and Panunzio, both of whom regarded the institution of art as of secondary importance for the maintenance of society.[7]

Those authors who prefer the second type of classification tend either to reverse this conclusion on art or to show considerable uncertainty. MacIver and, more recently, Feibleman, the philosopher, for example, place art in the sphere of primary values, as distinct from the realm of practical but secondary interests, the realm of 'Service.'[8] It belongs among the 'higher' institutions, according to Feibleman.[9] Although value judgments in these categories are not conspicuous, they nevertheless reflect Christian attitudes or the attitudes of idealistic philosophy in their depreciation of material values in favor of 'spiritual' ones. In a more strictly sociological view, they assume a hierarchy of importance, giving primacy to the more general, nonempirical values as compared with the more strictly instrumental ones. In these terms, art is given primary importance: for MacIver, along with religion; for Feibleman, along with religion, philosophy and the sciences.[10]

Among functionalists, Parsons shows considerable uncertainty about art, in part because of his concern with 'action.' As Hertzler points out, Parsons' early formulation of institutional types in the *Essays* includes situational, instrumental, and integrative patterns, but the conceptions lack any clear application to art.[11] In *The Social System*, however, he refines and extends his categories to include art among systems of expressive symbols, separate from belief systems. But 'pure' art for artist, coteries and other associations he regards as 'a secondary basis' that could never become 'a primary basis of institutionalization of a society.'[12] Thus Parsons agrees essentially with the first group, although he admits that 'the field of expressive symbolism is, in a theoretical sense, one of the least developed parts of the theory of action.'[13]

Briefly, then, the classifications differ primarily in their emphasis, one on the maintenance of society, the other on cultural values, and the importance of art shifts accordingly. Both points of view may be

'correct,' and they may imply certain significant characteristics for art as an institution. For one thing, if art is only of 'secondary' importance for essential services and the integration of society, it is likely to be less closely interrelated with those services, to be at least partially autonomous. This theoretical possibility is especially applicable to the fine arts,[14] and in this respect it seems to parallel science.[15] Secondly, the linking of art and religion suggests, what most sociologists do not make explicit, that these areas have values in common, confined largely to the cultural realm. Such values may include modes of belief and codifications of beliefs, as in theology and in aesthetics, which seem to exist in relative autonomy from the social system.[16] Thus both approaches seem to point in the same direction, recognizing implicitly that art is not highly integrated as an institution and that in at least some respects it leads a semi-autonomous existence in society.

INSTITUTIONAL STRUCTURE OF ART

Another fundamental difficulty arises when sociologists deal directly with the structure of art as an institution. Inevitably, perhaps, they tend to regard it as similar to, if not identical with, the structure of other social institutions, that is, as a system of social interaction. Parsons, for example, in analyzing the relation of systems of expressive symbolism to the social system, finds it 'best to start . . . with the paradigm of social interaction.'[17] When he turns to the role of the artist in relation to the public, he assumes the interaction to be directly reciprocal: 'He [the artist] supplies a want or meets a need in his public, and on the expressive level he receives "appreciation" and admiration in return.'[18]

Although writing largely in the tradition of symbolic interaction, Duncan shows a similar type of structural analysis for literature as a social institution.[19] He sets up a series of models illustrating inter-action patterns among author, critic and public. He assumes that each acts in terms of the others but in varying degrees of strength, and that their interrelationship is 'the common element in the structure of literary activity in every other society.'[20] Even though he recog-nizes that in complex societies these 'actors' may never meet, his

ideal remains 'a strong reciprocal relationship between each element in the author-critic-public triad.'[21]

Duncan assumes, obviously, that the literary work is a mode of communication between persons as if it were a language, that it acts as a means for social interaction. The form and other characteristics of the work are assumed as given, while the emphasis is placed on interaction, with its implication of social solidarity. This solidarity also implies a high degree of isomorphism among the interacting parties and the work of art.

The attempt to formulate a model for what one may call the artistic transaction is admirable. It encourages precision and an emphasis on certain essentials. It incorporates the critic in the transaction as well as author and audience—a desirable addition. The scheme is neat, persuasive. But the conditions for realizing it exist only rarely, as among certain primitive tribes in which direct critical comment may alter the character of a work,[22] or in situations today, when performers of drama or music may heighten or lower the quality of the presentation in response to audience reaction. A dramatist, similarly, may be persuaded to alter the contents of his play to meet the demands of staging effectiveness as influenced in part by audience reaction. The process is admirably demonstrated in *The See-Saw Log*.[23] But these situations represent only selected areas rather than the entire picture of art as an institution. The conception of interaction confined to the triad of author, critic and audience is limited and oversimplified, however important for some aspects of communication.

Moreover, the model tends to confuse a special type of symbolic with social interaction. If, for example, the 'actors' in the transaction never meet, then social interaction in the strict sense does not take place. Even when the performing artists and the audience are physically present at the same time, as in a theater or concert hall, the authors of the play or musical composition are usually absent; they may even be dead. Furthermore, in many situations the stimulation from performers to audience is largely one-way, not mutual.[24] At the end of the performance social interaction may take place, but then the process is obviously different in character from the previous artistic performance and audience experience. To confuse or equate the two processes is misleading.

The model, indeed, may in large part be mistaken. The fact may be that the symbolic process is not 'interactive' at all. Might the process not be more accurately described as a chain, a series of processes, beginning with the artist, whose literary product links him to publisher to critic to reader? The 'feedback,' if it occurs, may be in terms, not of aesthetic response, but only of objective indexes, such as the number of copies of a book sold. Some responses may obviously be appreciative, implying judgments of quality or expressions of good will, as in a letter from a reader to an author; but this type of response is several removes from direct social interaction and does not necessarily call for a response in kind. The model is thus deficient.

The model is also deficient, as implied above, in taking inadequate account of the work itself as an object or process of aesthetic experience with all that this implies for artist, critic and audience, including artistic traditions, social situations and broad cultural values. It tends to emphasize social aspects to the subordination if not exclusion of the cultural ones. This emphasis is not confined to symbolic interactionists, for in the past many sociologists ignored the distinction between the social and the cultural.[25] Anthropologists, of course, have concentrated largely on the cultural realm, with art usually as part of material culture, although in his classification of culture Wisler already separated art from material traits such as utensils and tools, weapons and dress.[26] Murdock's *Outline of Cultural Materials* sets up a separate category for the fine arts, reflecting Western modes of classification.[27] Among sociologists, Hiller in the 1940's was aware of the problem that art presents and stated that 'art, music, and other fields of culture content . . . though they involve communication and exchange between persons, lack norms of social relations as essential elements of their composition,' and are consequently 'nonsocial' complexes.[28] Broad recognition of the analytical distinction of the social from the cultural can be marked by the Kroeber-Parsons statement in 1958.[29] To be sure, some sociologists, Parsons among them, had recognized the distinction long before, but he was slow to take account of physical objects. As Gouldner remarked, 'Parsons' model of the social system excludes all "material" elements, including tools and machines.'[30] He could have added art. Perhaps in response to such criticisms, Parsons shows increasing awareness of 'objects.'

including art in its physical form as related to the social system. In *Theories of Society* he states that 'human action is organized through and in terms of the patterning of the "meanings" of objects and of orientations to objects in the world of human experience.'[31] Such a broad orientation may provide a sounder base for the analysis of art in society than the earlier insistence on social interaction.

Considering these limitations and suggestive possibilities, one may conclude that the structure of art as an institution is in several respects distinct from that of the family and of economic and political institutions. Art needs to be recognized as a peculiarly 'mixed' system, a type which Chapin aptly called the 'diffused-symbolic institutions.'[32] One may designate it as a 'socio-cultural' institution, though this term has become so attenuated in meaning that it may no longer be useful. Perhaps Hiller's 'nonsocial' complex points the way, so that it may be called, more simply and positively, a 'cultural' institution.

Regardless of the name, art as an institutional structure must take account of the art product as object or as process of aesthetic experience, and as an essential link in an extensive network of social and cultural relations. The entire complex cannot be spelled out here. It is suggested, however, that certain elements, when fully developed, can encompass the structure of art as an institution. These elements are not of equal importance and they will vary for specific arts, but they may be limited conveniently to a minimum of eight, briefly described as follows:

1. Technical systems, including raw materials (paint, words, junk), specialized tools, techniques and skills, inherited and invented.
2. The traditional forms of art, such as the sonnet and novel in literature, the song and symphony in music, the easel picture and mural in painting or combinations in opera and in the dance. Such forms always assume the existence of specific content and meanings changing through time.[33]
3. Artists, their socialization and training, their roles, careers, associations and modes of creativity.
4. Disposal and reward systems, including agents and patrons, museums with their personnel and characteristic activities, distributors, publishers, and dealers, with their special personnel,

equipment and organizations, governed by special norms and values.

5. Art reviewers and critics, with their typical outlets and forms of expression and their professional associations.

6. Publics and audiences, from 'live' ones in theater, concert hall or museum, to millions of television viewers or 'unknown' publics who read or listen in private.

7. Formal principles of judgment, the aesthetic and extra-aesthetic bases of judgment for artists, critics and audiences.

8. Broad cultural values sustaining art in society, such as the assumption of art's civilizing functions, its ability to refine the emotions, overcome prejudice or produce social solidarity.

From these brief descriptions it is clear that some areas are primarily cultural, others social; some involve psychological aspects, such as the personality of artists or of dealers; many of them are mixed. They involve not one simplified set of relations but distinct networks of relations and processes within and between areas, which need to be articulated in detail as part of the total operations of the institution. Some of these relations are distinctly harmonious and consistent but others, as between artists and dealers or publishers, imply conflicting aims and purposes. Some aspects, such as the selection and training of literary artists, are not yet formally organized, as compared with schools of painting and of architecture. These and other aspects need clearer description and analysis before greater certainty can be attained as to the degree of integration art in its various forms has achieved, and how art is sustained as a more or less independent institution with distinct if not unique functions in society.

INSTITUTIONAL FUNCTIONS OF ART

What, then, are the functions of art as an institution? The question inevitably calls up psychological, social and cultural explanations, but it reaches ultimately to the biological level. Social institutions are usually conceived as essential structures of society serving 'basic needs,' which are often interpreted in terms of biological survival. Hunger and sex, for example, are the 'basic needs' ultimately served by the economy and the family, which provide for bodily as well as

for social survival. Art, however, does not seem to have the same kind of physiological base. To be sure, Feibleman postulates three 'basic tissue needs,' or drives, two of them hunger and sex, the third 'inquisitiveness' or 'curiosity,' out of which the 'higher' institutions are derived, including art.[34] He admits, though, that the third is not scientifically accepted.[35] Indeed, no 'aesthetic need' has been located comparable to those of hunger and sex, and no one claims outright that art is necessary for bodily survival, despite Hertzler's statement that it is 'a stern necessity of life.'[36] It seems likely, as Stephen Pepper has shown recently, that aesthetic satisfactions, derived ultimately from the senses, are unlike the mechanisms for hunger and sex in that they do not involve consumatory activities to relieve internal tensions: they are noncyclical. They occur as 'gratuitous satisfactions' without the necessity of seeking them and without any demand for instrumental action.[37]

In a general way these suppositions had been anticipated long before. Among sociologists, Spencer in 1872 had found the source of 'aesthetic sentiments' in the senses, and as a man of his time he regarded art and play as similar in function.[38] They were distinguished precisely because they were *not* necessary for bodily survival: they occurred for their own sake. He believed that play and sports, while they simulate 'real' actions, are essentially 'useless' activities, gratifying in themselves.[39] But their close reflection of instrumental behavior places them at the lower end of a scale of gratuitous satisfactions, the higher reaches being achieved by the fine arts. This kind of satisfaction occurs principally in advanced societies, under conditions that permit prolonged rest of 'nerve-centers,' which build up energy in excess of demands for immediate instrumental activities.[40] Thus Spencer combined the prevailing play theory of art with the theory of surplus energy, ignoring many of the scientific problems of how nervous energy becomes transformed into sense perceptions, and these responses into forms of art. The emphasis was on gratifications for their own sake, functions that remain individual and psychological, that tend to isolate art from vital needs, biological and social.

This orientation influenced later sociologists, who varied Spencer's interpretations. Sumner and Keller, for example, shifted the principle of 'for its own sake' to that of 'self-gratification,' one of three basic

needs, the others being 'self-maintenance' and 'self-perpetuation.'[41]
Unfortunately, they used the term loosely, extending it also to mean
'vanity' and 'pleasure,' so that not only play but all manner of grati-
fications, from betel-chewing to a victor's trophy, were included along
with art. Such a large, elastic category could hardly become the basis
of distinguishing art as an institution.[42] Other interpretations were
made by Panunzio and Barnes, in which social implications began
to appear. Panunzio discarded Spencer's surplus-energy theory in
favor of the 'rest' hypothesis, [43] while Barnes saw no wide gulf between
art and play as activities of leisure.[44] In effect, both shifted the empha-
sis from gratifications indulged simply for their own sake to those
resulting from the activities of leisure. Thus art finds its psychological
and social function primarily as 'recreation,' one of the many forms of
'restoratives' necessary for counteracting the effects of work. Here
the familiar work-leisure dichotomy becomes clearly evident.

This interpretation was perhaps inevitable as soon as art was
separated, as in Spencer, from 'life-serving functions.' In his latest
work on social institutions, Hertzler still refers to art as a form of
recreation at the same time that he relies on Henry Murray's concept
of aesthetic need.[45] Parsons and Shils, however, suggest a somewhat
different form of the work-leisure dualism in *General Theory*, where
they deal with the content of roles in the social system. Influenced
perhaps by Weber, they wonder whether the patterns that foster
gratification of expressive interests serve, in effect, to 'balance' the
psychological strains created by instrumental roles. 'A society which
makes the institutionalization of instrument roles very widespread
must have, if it is to continue more or less stable, some compensatory
mechanisms for the gratification of need-dispositions for immediate
gratification.'[46] Indeed, they add, the contemporary mechanisms may
require exaggeration in order to balance successfully the 'one-
sidedness' of instrumental roles, and thus give rise to highly charged
emotional outlets such as 'romantic love, commercialized entertain-
ment, drinking and the literature and films of violence.'[47]

Perhaps such speculation should not be taken very seriously. If the
subject were analyzed carefully, the authors would no doubt consider
whether, for instance, other societies, less secular and with fewer
roles rationalized in instrumental areas, show fewer 'compensatory

mechanisms' of emotional violence. They would doubtless take account of the development of abstract tendencies in music, poetry and the visual arts, which can hardly be regarded as forms of violence. It appears that their concern for psychological and social stability misled them into such oversimplifications, which they admit require more extended analysis.

However, one formulation of the psychological process that Parsons and Shils present leads to another, related framework. Besides the concept of balance, they also phrase the process as one in which expressive interests 'reduce' the strains created by instrumental roles, suggesting the possiblity of a 'draining off' of tensions.[48] They do not develop this possibility, which has social as well as psychological implications, but it is precisely the mechanism which is appropriate to psychoanalytic interpretations used by Coser in *The Functions of Social Conflict*.[49] Again, it should be recognized that Coser was not writing a treatise on the functions of art; nevertheless, he uses certain art forms to illustrate psychological principles that are important for social order. His observations thus provide an example of another common interpretation used by sociologists and other social scientists whose implications for the functions of art in society deserve consideration.

Examining various means that may not only reduce social conflict but also prevent it, Coser suggests that mass culture, sports and popular entertainment are primary means of diverting aggression from original sources of institutional conflict by providing for vicarious ,'safe' release of hostile impulses.[50] Thus some of the arts, while supplying their own types of satisfaction, also become means of releasing tensions; they operate as 'safety-valve institutions' and thus prevent overt conflict. In effect, they become not an 'opiate' of the masses so much as specific means of social control which may be 'welcomed by the powers that be.'[51]

The theater, too, by presenting caricatures of stress areas of a system, may give rise to laughter, which acts as a 'displaced means' of releasing hostility, so that other social structures remain undisturbed.[52] In terms of his conflict theory, then, Coser regards some of the arts as serving to preserve the *status quo* by providing special means for releasing or displacing hostility and aggression.

Unlike Parsons and Shils, Coser does not identify the institutional sources of conflict. Nor does he imply that other fine arts besides comedy must necessarily serve the same functions. His primary concern, like theirs, is for social stability. Along with Freud, he does question whether the arts and other means of diversion are successful in avoiding conflict permanently, and whether, to the extent that such diversion is effective, it becomes dysfunctional socially in ways comparable to neurotic systems for individual personalities. It may delay, he thinks, if not prevent, desirable adjustments in the social system.[53]

All of these psychological functions of art, with their social implications, are suggestive and probably true as far as they go. They imply that the forms of art have various functions, which they do. Institutions, as Malinowski and others have pointed out, have always served multiple functions.[54] In our society, individuals may use art as recreation, as escape, as consolation, as a release of tensions or whatever, and the social consequences may include those suggested.[55] Confusion arises, however, because the basic problem is at once broader and narrower: broader if the full range of aesthetic forms is considered, narrower if the emphasis is primarily on the fine arts as an institution.

Broadly considered, aesthetic satisfactions are perhaps not so neatly separated from instrumental areas as Spencer and others assumed. In his work on purposeful behavior, the psychologist Tolman, for example, observed that aesthetic responses seldom occurred in pure, isolated form. 'They are probably always imbedded as minor moments in the going off of other appetites and aversions.'[56] In a similar vein, though in the context of 'interests,' which are obviously more culture-bound, the philosopher R. B. Perry stated that the aesthetic interest is not only common to all men, but common, at least potentially, to all interests. Any practical or cognitive interest may excite it or tempt it, and it is 'the intimate interweaving of the aesthetic with the practical and cognitive interests that accounts for its peculiar universality and eminence.'[57] Chapin, in his study of American social institutions, included 'symbolic culture traits,' usually artistic objects, as one of the four principal elements of all major social institutions.[58] Hertzler and Feibleman regard art as culture-wide, entering into all

major channels of social living.[59] In fact, aesthetic forms may be used in many social contexts: as political propaganda, as a religious icon, as a sales pitch, as commemoration of a public figure, as instruction in psychology and sociology.[60] Directly and indirectly, art may bolster the morale of groups or help create a sense of unity, of social solidarity; as used by dissident groups, it may create awareness of social issues and provide a rallying focus for action and social change. In our society it may thus be used to criticize as well as to support the social order while performing essentially the same function: that of heightening awareness of the context in which it appears and objectively symbolizing essential values of that context. Its popular forms may be institutionalized as a part of our economy, serving predominantly 'the powers that be,' as Coser suggests. It may also be institutionalized to form an independent system for the fine arts, as we have indicated.

In *The Social System* Parsons shows his awareness of the distinction between aesthetic forms that serve extra-aesthetic purposes and 'pure art,' which becomes the basis not only of the specialized role of artists but also of 'a set of artistic standards that becomes itself the primary symbol of belonging to a subcultural group.'[61] Such a group he regards as 'directly parallel to "sects" of intellectuals who share a common belief system differing from the diffuser general ideology of the society,'[62] but he indicates no over-all significance to it. In this respect Max Weber may be more suggestive. In his brief consideration of the aesthetic sphere in relation to religion, Weber, too, noted how various arts have served magical and religious purposes, but also that under the development of intellectualism and the rationalization of life 'art becomes a cosmos of more and more consciously grasped independent values which exist in their own right.'[63] Indeed, as a distinct institution, 'art takes over the function of a this-worldly salvation,' competing directly with religion and transforming 'judgments of moral intent into judgments of taste.'[64] Art thus competes with religion as another set of supreme values antithetical to those prevailing in society. These values, as Weber suggests, include 'salvation' from the routines of everyday life and from 'pressures of theoretical and practical realism,'[65] functions which Parson and Shils also noted, but Weber could have gone further.

On a more positive basis, art as an institution may be said to embody a number of specific values, having coherence and a quality of belief that often parallels the sense of absoluteness in religious beliefs. Often asserted in many forms, these values in brief include: the importance of the qualitative nature of experience as against the mechanical, quantitative character of science and technology; the sense of wholeness of 'being' as against excessive specialization and fragmentation of roles; the sense of community as against the impersonality of contract relations, of bureaucratic processes; the glorification of the intrinsic values of art as against those of wealth, of material success—all the dominant values of bourgeois society.[66] These values identify a subculture which, for Marcuse, exists as 'the Great Refusal,' the posture of defiance of those who assert their basic opposition to prevailing values of present-day society.[67] Poggioli calls *avant-garde* art a 'negative' culture, 'the radical negation of a general culture by a specific one.'[68] Perhaps it can be designated, in Yinger's terms, a 'contra–culture,'[69] one of whose extreme modes of expression among artists is Bohemianism.[70]

In more positive terms, however, art as an institution may be regarded as a minority culture that functions both for stability and for change in our complex, pluralistic society. It may contribute to stability, not only by balancing emotional against instrumental needs or by releasing tensions, but also by providing congenial occupations and interests for 'deviant' personalities. Those persons whose native tendencies and socialization are directed toward contemplation, for example, toward values of 'being' instead of 'doing,'[71] may find in art a mode of creativity expressive of their personality; others may find in related areas the means for fostering the values of art in society. The institutionalization of art activities thus becomes not only a stabilizing element in society but also an enrichment of its 'value' resources.[72]

As an alternative to religion, art as an independent system may not just 'balance' the instrumental, rationalistic aspects of society; it may become the basis for fostering social change, not merely by supporting and giving expression to the goals of a deviant social movement, but by representing its values as a distinct way of life. Once formed, every institution seeks to expand its borders and to spread acceptance

of its values, competing with other institutions for recognition and importance. Art is no exception. Its recognition has been gradual in the United States, but it is steadily increasing. Barzun, for example, believes that 'a member of the educated class nowadays need not have any direct or vivid contact with art to fall under sway of the aesthetic creed and its emotions. [He] feels about life, business, society, the Western world, what the art-inspired critics of the last eighty years have felt. . . . Indeed, the attitudes . . . have touched the wider public whose exposure to ideas is through the press, where readers find reflected not only the worship of art but also its attendant contempt of the world.'[73] The accuracy of Barzun's statements is certainly open to question, especially in the light of claims that the fine arts are doomed,[74] but the recent upsurge of interest in the arts, by the federal government as well as by the public, may be a significant index of change.[75]

Thus art meets not just one but many 'basic needs,' psychologically and socially. As an institution it has a multiplicity of functions in society, not least those of fostering social stability and enriching our culture. Most important, perhaps, is its representing a secular substitute for religion, developing and spreading values that are alternatives to prevailing ones, values that may become crucial for social change.[76]

THE UNIVERSALITY OF ART

Finally, art as an institution has certain implications for art in other cultures, especially the common notion that art is universal. Among others, anthropologists, from a somewhat older generation, such as Lowie and Boas, to more recent representatives, such as Herskovits, Beals and Hoijer, have given this idea currency. Lowie found evidence that even in the Old Stone Age craftsmen shaped their fish-hatchets gracefully, which did not improve their utility but did enhance their appearance.[77] Boas maintained that 'the very existence of song, dance, painting and sculpture among all the tribes known to us is proof of the craving to produce things that are felt as satisfying through their form, and of the capability of man to enjoy them.'[78] Beals and Hoijer are less sweeping in their inferences, but state

definitely: 'No culture is known in which some form of aesthetic expression does not occur.'[79]

It should be noted, however, that none of the authors refers to 'fine arts.' Each of them emphasizes aesthetic aspects which include crafts as well as other forms more familiar to Euro-Americans. They invariably interpret art more broadly than is common in the Western tradition, and the more recent representatives are sharply aware of the differences in cultural traditions. Such differences are entirely consistent with the formulation given earlier by Stephen Pepper, that aesthetic responses occur as 'gratuitous satisfactions,' as well as with Tolman's and Perry's observations of the close relationship of aesthetic with practical and cognitive contexts. In the dim past, one can infer, such experiences gave rise to the creation of designs and shapes, to the ordering of sounds and bodily movements which assumed meaning in one or another practical or social context and gradually became fixed in conventional forms, which varied from culture to culture.

Those most aware of these cultural differences are more inclined to emphasize cultural relativity than universality. E. R. Leach, for example, points out that 'each local group has its own aesthetic traditions which are peculiar to that group and to that group alone.'[80] Similarly, Redfield shows that 'a complex world of traditional meanings' is represented by the art of a particular culture, which has its own traditional style perpetuated and confirmed by social usage.[81] These meanings are indigenous and vital to a culture. Among Australian aborigines, as Mountford states, the 'primitive expressions of art, music and drama' are rigidly controlled by the age-old customs of the tribe, and 'they play the most vital part in aborigines' lives, for, it is by the employment of these art forms, songs and rituals that the aborigines keep alive the philosophies, the creation myths and the exploits of their totemic ancestors.'[82]

In Western tradition, also, the arts were not separated from social and cultural contexts until recently. The Greeks did not conceive of the 'fine arts' in the modern sense, but they applied the terms to activities we would call crafts or sciences. As Kristeller points out, 'Ancient writers and thinkers, though confronted with excellent works of art and quite susceptible to their charm, were neither able

nor eager to detach the aesthetic quality of these works of art from their intellectual, moral, religious and practical function or content, or to use such an aesthetic quality as a standard for grouping the fine arts together, or for making them the subject of a comprehensive philosophical interpretation.'[83] During the Middle Ages, the concept of art retained the same comprehensive meaning it had possessed in antiquity.[84] Even today in American society, as described earlier, art has continued to serve extra-aesthetic functions, as in other societies. It serves 'practical cognitive interests'; it expresses and supports religious and other general values of society. Indeed, it is in these respects that art may be regarded as universal. In every society throughout the world aesthetic expression is interrelated with social structures and cultural traits, heightening awareness of them and giving them meaning in symbolic forms. Such a conception of art as universal, however, excludes the possibility of art as an independent institution.

One of the consequences of this cultural relativity has been to encourage cultural myopia, commonly known as ethnocentrism. Forms called art today were usually not so perceived by members of different cultures. To be sure, one primitive tribe may have borrowed a design or object of ritual dance from another tribe, but the form always took on different social and cultural meanings.[85] Typically, the objects were 'not the same.' Even in the Western tradition, one era did not understand another. In the twelfth century no one looked at Greek art. 'For a Christian to see a classical statue as a statue and not as a heathen idol,' Malraux observes, 'he would have had to begin by seeing a "Virgin" statue before seeing it as the Virgin.'[86] The seventeenth century similarly disregarded medieval art. Previously, in the sixteenth century, when explorations of the New World followed those of Columbus, Cortez and his Christian representatives, such as Bishop Landa, did not perceive Mayan writings and the sacred objects in their temples as 'art' so much as 'abominations' to be exterminated.[87] In the nineteenth century, explorers and Christian missionaries to foreign lands were often offended by and hostile toward the 'idols' of unenlightened peoples. Where they could, they destroyed the sacred objects of Polynesian and other tribes, and if, as Firth points out, they brought back to Europe some of the most

important primitive art objects, the importation 'was due less to aesthetic reasons than to the fact that these things were preserved and sent home in triumph as spoils by the victors in the battle of faith.'[88]

The change came with the development of modern Euro-American conceptions of fine arts. Only then were perceptions transformed so that the artifacts, dances, songs and myths of people all over the world whose forms expressed aesthetic qualities became 'visible.' As Malraux said: 'Before the coming of modern art no one *saw* a Khmer head, still less a Polynesian sculpture, for the good reason that no one looked at them.'[89] 'No one looked at them,' of course, implies an inability to perceive those qualities expressive of aesthetic form that modern concepts emphasize.

Although many writers on aesthetics expounded the new creed, Clive Bell may be selected as representative. He regarded the essence of 'beauty' as 'significant form,' a concept that gave priority to aesthetic qualities, regardless of the content.[90] In fact, content and its related meanings, in this rather extreme view, tended to be disregarded. Thus, when Bell came to view the art of primitive peoples, he stated categorically: 'In Primitive Art you will find no accurate representation; you will find only significant form.'[91] 'Primitives,' he adds, 'produce art because they must; they have no other motive than a passionate desire to express their sense of form.'[92] Moreover, those who wish to appreciate a work of art need bring with them 'nothing from life, no knowledge of its ideas and affairs, no familiarity with its emotions ... nothing but a sense of form and color and a knowledge of three-dimensional space.'[93]

Thus interpreted, art becomes, of course, a self-sufficient entity detached from specific social and cultural meanings. It is this extreme view that Leach, Redfield and others tend to react against, and some of the more recent philosophers on aesthetics adopt much broader perspectives, while continuing to insist on aesthetic values as paramount, as they must be in order for art to become a cosmos of independent values that distinguish it as an institution.[94]

Regardless of these necessary modifications and qualifications, the idea of art as separate and distinct from all aspects of utility, apart from all social and cultural meanings, has nevertheless become widespread in the Western hemisphere among artists, critics, educated

laymen, even interested tourists. As one consequence, cultures throughout the world have been ransacked for 'art treasures.' Everywhere, portable objects have been torn out of their contexts.[95] The masks, kachinas, sculptures, totems and other cultural products of Australian aborigines, tribes of New Guinea, West Africa and elsewhere have been collected as ART and placed in our museums, hung on our walls and displayed on our mantelpieces.[96] Chac Mools and stone jaguars have been removed from ancient Mayan temples, 'gargoyles' wrenched from cathedrals. Most of the finest examples of totems and other 'art' objects native to Alaska are to be found not in Alaska but in the Soviet Union, in European museums, in Canada, New York, Portland, Seattle, Denver, and elsewhere.[97] Thus art has now become 'universal' with a meaning that is being projected round the world from the fine-art tradition of Europe and America. The process represents not a military or political invasion of the world, but an artistic one.

Perhaps it is paradoxical that a culture that raids the world of its art treasures also saves them, even though on its own terms. It should be recognized, however, that this very process tends to develop in the more specialized and enlightened social scientists, at least, an awareness of the actual or possible original meanings of art for specific societies and cultures. The process has also, of course, enriched the Western world by an enormous range of artistic forms. As Malraux remarks: 'The art resuscitated by our metamorphosis is a realm as vast and varied as was life itself in ages previous to ours.'[98] It was therefore inevitable that some of the primitive forms would become a vital source of inspiration for Western artists, as the sculptures of Africa, for example, influenced Matisse, Picasso, and others at the turn of the century.[99] Even vanished civilizations such as the Mayan may find rebirth, if not a kind of continuity, through the art of our day, in the re-creation of the Mayan figure, the Chac Mool, in the reclining sculptural forms of Henry Moore. As Kubler states: 'Through its formal vocabulary alone, the sensibility of an extinct civilization survives in works of art to shape the work of living artists in a totally unrelated civilization half a millennium later.'[100]

Thus the attempt today in our society to build up art as a cosmos separate and self-contained, existing in its own right, has ultimately

universal significance. The concept of art as embodying values that transcend cultural differences suggests the possibility, noted by Firth and others, that universal aesthetic standards may exist,[101] or that the Western concepts may spread throughout the world and thus create the first universally accepted aesthetic standards for the fine arts.

NOTES

[1] Arnold Rose, *The Institutions of Advanced Societies* (Minneapolis, Minn.: University of Minnesota Press, 1958), p. v.

[2] Charles H. Judd, *The Psychology of Social Institutions* (New York: Macmillan, 1927); J. O. Hertzler, *Social Institutions*, 1st version (Lincoln, Nebr.: University of Nebraska Press, 1929); Floyd H. Allport, *Institutional Behavior* (Chapel Hill, N.C.: University of North Carolina Press, 1933); F. Stuart Chapin, *Contemporary American Institutions* (New York: Harper & Brothers, 1935); Lloyd V. Ballard, *Social Institutions* (New York: Appleton-Century-Crofts, 1936); Constantine Panunzio, *Major Social Institutions* (New York: Macmillan, 1939); Harry Elmer Barnes, *Social Institutions* (Englewood Cliffs, N.J.: Prentice-Hall, 1942); Hertzler, *loc. cit.*, rev. version, 1946; James K. Feibleman, *The Institutions of Society* (London: George Allen & Unwin, 1956); Arnold M. Rose, *op. cit.*, 1958; Hertzler, *American Social Institutions* (Boston: Allyn and Bacon, 1961).

[3] In addition to sources noted above, see, for example, Charles Horton Cooley, *Social Organization* (New York: Charles Scribners' Sons, 1919), pp. 313–314; R. M. MacIver and Charles H. Page, *Society* (New York: Rinehart, 1949), p. 15; Bronislaw Malinowski, *A Scientific Theory of Culture* (Chapel Hill, N.C.: University of North Carolina Press, 1944), pp. 46–61; Henry A. Murray, *Explorations in Personality* (New York: Oxford University Press, 1938), p. 139: 'Institutions are congealed need patterns shared by many.'

[4] Hertzler's latest definition is the most comprehensive. See *American Social Institutions*, pp. 84–85.

[5] William G. Sumner, *Folkways* (Boston: Ginn, 1906), p. 54; Barnes, *op. cit.*, pp. 31–35; Gerard De Gré, *Science as a Social Institution* (New York: Random House, 1955), pp. 2–3; Ralph B. Perry, *Realms of Value* Cambridge Mass.: Harvard University Press, 1924), pp. 154–156; L. L. Bernard, *An Introduction to Sociology* (New York: Crowell, 1942), pp. 878–882. See general treatment in Hertzler, *American Social Institutions*, pp. 165–167.

[6] William G. Sumner and Albert G. Keller, *The Science of Society* (New Haven, Conn.: Yale University Press, 1927), III, 2061–2062.

[7] Barnes, *op. cit.*, pp. ix–xi, 31–35; Panunzio, *op. cit.*, p. 265.

⁸ MacIver, *op. cit.*, pp. 446, 498–506; Feibleman, *op. cit.*, pp. 198–214, 218–219.

⁹ *Op. cit.*, pp. 215ff. MacIver, following Alfred Weber, uses the concepts of 'Civilization' and 'Culture,' *op. cit.*, pp. 498–499. His influence is evident in Adolf S. Tomars, *Introduction to the Sociology of Art* (Mexico City, 1940).

¹⁰ MacIver, *op. cit.*, p. 499; Feibleman, *op. cit.*, pp. 215–224.

¹¹ Hertzler, *American Social Institutions*, p. 168; Talcott Parsons, *Essays in Sociological Theory* (Glencoe, Ill.: The Free Press, 1949), pp. 44–45; no essential change in these respects appears in the second edition, 1954.

¹² *The Social System* (New York: The Free Press of Glencoe, 1951), p. 412 and Chap. 10 on 'Expressive Symbols and the Social System,' pp. 384–427.

¹³ *Op. cit.*, p. 384. See similar statements in *Theories of Society* (New York: The Free Press, 1965), pp. 984, 1165.

¹⁴ This possibility is given support by Wilbert E. Moore, *Social Change* (Englewood Cliffs, N.J.: Prentice-Hall, 1963), pp. 75–76. Among many statements on art as autonomous, see, especially, Harry Levin, 'Literature as an Institution,' in Mark Schorer, *et al.*, *Criticism: The Foundations of Modern Literary Judgment* (New York: Harcourt, Brace, 1948), pp. 546–553; C. M. Bowra, 'Poetry and Tradition,' *Diogenes* No. 22 (Summer, 1958), pp. 16–26; Robert N. Wilson, *Man Made Plain* (Cleveland, Ohio: Howard Allen, 1958), p. 138; Clement Greenberg, *Art and Culture* (Boston: Beacon Press, 1961), pp. 5–6, 32–33.

¹⁵ Florian Znaniecki, *The Social Role of the Man of Knowledge* (New York: Columbia University Press, 1940), p. 158, where he sees theoretic knowledge 'a completely autonomous domain of objective intellectual culture'; Frank E. Hartung, 'Science as an Institution,' *Philosophy of Science*, 18 (January, 1951), pp. 43–45; Robert K. Merton, 'Science and the Social Order,' in Bernard Barber and Walter Hirsch (eds.), *The Sociology of Science* (New York: The Free Press of Glencoe, 1962), pp. 19–22. It should be observed, however, that all social institutions have some degree of autonomy, but that they may differ in degree. See Alvin W. Gouldner, 'Reciprocity and Autonomy in Functional Theory,' in Llewellyn Gross (ed.), *Symposium on Sociological Theory*, (Evanston, Ill.: Row, Peterson, 1959), pp. 254–259.

¹⁶ See Moore, *op. cit.*, p. 76; Greenberg, *op. cit.*, pp. 5–6.

¹⁷ *The Social System*, pp. 385–386.

¹⁸ *Ibid.*, p. 409.

¹⁹ Hugh D. Duncan, Chap. 4 in *Language and Literature in Society* (Chicago: University of Chicago Press, 1953), pp. 58–74.

²⁰ *Ibid.*, p. 67.

²¹ *Ibid.*, p. 72.

²² For a striking example among the Tiv of Central Nigeria, see Paul Bohannan, 'Artist and Critic in an African Society,' in Douglas Fraser (ed.), *The Many Faces of Primitive Art* (Englewood Cliffs, N.J.: Prentice-Hall

1966), pp. 248–249. See also James W. Fernandez, 'Principles of Opposition and Vitality in Fang Aesthetics,' *Journal of Aesthetics and Art Criticism*, XXV (Fall, 1966), 54–55.

[23] William Gibson (New York: Alfred A. Knopf, 1959).

[24] See Arnold M. Rose, *Theory and Method in the Social Sciences* (Minneapolis, Minn.: University of Minnesota Press, 1954), pp. 27–29; Colin Cherry, *On Human Communication* (New York: John Wiley, 1957), p. 17.

[25] Cf. Tomars, *op. cit.*, 28–29, where he speaks of 'artistic folkways and mores,' and of the sonnet and the fugue as 'institutions'; the writing of sonnets he regards as a 'custom of poets' and using fugues in a symphony as 'a custom of musicians.'

[26] Clark Wissler, *Man and Culture* (New York: Thomas Y. Crowell, 1923), p. 74. Herskowitz is incorrect that Wissler ignored 'such arts as music and dance' as well as literary forms, except mythology. He includes them in his classification, but it is true that he does not give them detailed consideration in his text. See p. 230 in Melville J. Herskovits, *Man and His Works* (New York: Alfred A. Knopf, 1964).

[27] George P. Murdock *et al.*, *Outline of Cultural Materials*, 3d rev. ed. (New Haven, Conn.: Human Relations Area Files, Inc., 1950), pp. 72–74. 'Fine Arts' occupy a separate category from that of 'Recreation' and of 'Entertainment.'

[28] E. T. Hiller, *Social Relations and Structures* (New York: Harper & Brothers, 1947), pp. 72, 242–243.

[29] A. L. Kroeber and Talcott Parsons, 'The Concepts of Culture and of Social System,' *American Sociological Review*, XXIII (October, 1958), 582–583. Comments by Richard Ogles and Marion J. Levy, Jr. and rejoinder by Parsons in *American Sociological Review* XXIV (April, 1959), 246–250.

[30] Alvin W. Gouldner, 'Reciprocity and Autonomy in Functional Theory,' p. 247.

[31] P. 963. Already in 1958 James H. Barnett was advocating the study of art as a process involving the artist, the work of art and the art public. See 'Research Areas in the Sociology of Art,' *Sociology and Social Research*, XLII (July–August, 1958), 401–405. Cf. his statement in Robert Merton *et al.* (eds.), *Sociology Today* (New York: Basic Books, 1959), pp. 210–211. In 1955 Stephen Pepper noted that in the history of aesthetics attention had been mainly directed upon aesthetic value or experience to the neglect of the object that produces that experience. *The Work of Art* (Bloomington, Ind.: Indiana University Press); Susan Sontag, in *Against Interpretation* (New York: Noonday Press, 1966) notes that 'the work of art is reasserting its existence as "object" . . . rather than as "individual personal expression".' (p. 297).

[32] F. Stuart Chapin, *op. cit.*, p. 13.

[33] The persistence of forms is evident in Western art and literary history, but also among primitive tribes, where borrowing of forms is usually transformed in 'content' and 'meaning.' See Ralph Linton, *The Study of*

Man (New York: Appleton-Century, 1936), pp. 405, 419; Dorothy Leadbeater, on Mayan art, in Marian W. Smith, (ed.), *The Artist in Tribal Society* (New York: The Free Press of Glencoe, 1961), p. 110. This point of view does not necessarily do violence to the concept of organic unity, in which content and form are inseparable and indistinguishable in specific works.

[34] *Op. cit.*, pp. 26–27.

[35] Cf. the concept of 'competence,' as used by R. W. White, 'Motivation Reconsidered: the Concept of Competence,' *Psychological Review*, LXVI (1959), 297–333. See discussion of this concept in Susanne K. Langer, *Mind: an Essay on Human Feeling* (Baltimore, Md.: The Johns Hopkins Press, 1967), I, 277–279. Nevertheless, the difference in levels, of bodily hunger as compared with 'interest,' must be observed and maintained.

[36] *Op. cit.*, p. 505.

[37] *The Sources of Value* (Berkeley and Los Angeles: University of California Press, 1958), pp. 53, 153–154, 158. Cf. Clyde Kluckhohn and Henry A. Murray, *Personality in Nature, Society and Culture* (New York: Alfred A. Knopf, 1953), pp. 13–16: 'The infant's mind is not acting most of the time as the instrument of some urgent animal drive . . . but is preoccupied with *gratifying itself.*'

[38] Herbert Spencer, *The Principles of Psychology* (New York: D. Appleton, 1896), II–2, 632–635. The chapter on 'Aesthetic Sentiments' was originally published in 1872 as a separate installment.

[39] *Ibid.*, pp. 630–631.

[40] *Ibid.*, pp. 629–630.

[41] Sumner and Keller, *op. cit.*, pp. 2061–2062.

[42] For extensive analysis of the limitaions of the concept of pleasure, see Stephen Pepper, *op. cit.*, pp. 196–198, 359–362, 379–385, 575–579.

[43] *Op. cit.*, p. 266.

[44] *Op. cit.*, pp. 838–839.

[45] *Op. cit.*, pp. 505, 341–345. Cf. H. A. Murray, *op. cit.*, pp. 106, 111–112, 138–139. On question, 'Are Basic Needs Ultimate?' see Dorothy Lee, *Journal of Abnormal and Social Psychology*, LXIII (1948), 391–392. Her work is used by Clyde Kluckhohn, 'Values and Value Orientations in the Theory of Action: An Exploration in Definition and Classification,' in Talcott Parsons and Edward A. Shils (eds.), *Towards a General Theory of Action* (Cambridge, Mass.: Harvard University Press, 1951), pp. 425–426.

[46] *Op. cit.*, p. 218. The necessity of 'release' functions of games, public spectacles, and aesthetic activities for individuals in societies was stated by Linton, *op. cit.*, pp. 413–414.

[47] *Op. cit.*, p. 218.

[48] *Ibid.*, p. 217.

[49] Lewis A. Coser, *The Functions of Social Conflict* (New York: The Free Press of Glencoe, 1964) (Paperback). Original edition, 1956.

[50] *Ibid.*, pp. 40–41, 45–47.

[51] *Ibid.*, p. 44.

[52] *Ibid.*, pp. 43–44.

[53] *Ibid.*, pp. 47–48.

[54] *Op. cit.*, pp. 168–169. Malinowski, however, is strongly oriented toward biological needs served by institutions. Linton is much more aware of the multiple functions of any trait complex. *Op. cit.*, pp. 418–419. See also Arnold Rose, *Sociology* (New York: Alfred A. Knopf, 1957), p. 148.

[55] See recognition of this fact by D. G. Gotshalk, *Art and the Social Order*, 2d ed. (New York: Dover, 1962), pp. 158, 167–168.

[56] Edward C. Tolman, *Purposive Behavior in Animals and Men* (New York: Century, 1932), p. 280.

[57] Ralph Barton Perry, *Realms of Value* (Cambridge, Mass.: Harvard University Press, 1954), p. 236.

[58] *Op. cit.*, pp. 15–16.

[59] Hertzler, *op. cit.*, pp. 519–522; Feibleman, *op. cit.*, p. 218.

[60] Cf. Gotshalk, *op. cit.*, pp. 163–164.

[61] *Op. cit.*, pp. 411–412.

[62] *Ibid.*, p. 412. Cf. Parsons and Shils, *Towards a General Theory of Action*, pp. 239–240.

[63] In H. H. Gerth and C. Wright Mills, *From Max Weber: Essays in Sociology* (New York: Oxford University Press, 1946), p. 342. Cf. Jacques Barzun, *The House of Intellect* (New York: Harper & Brothers, 1959), p. 17: 'For many people art, displacing religion, has become the justification of life.'

[64] *Op. cit.*, pp. 341–342.

[65] *Ibid.*, p. 342.

[66] See, for example, Clement Greenberg, *op. cit.*, pp. 5–7, 31–33; Jacques Barzun, *op. cit.*, pp. 16–19; Morse Peckham, *Man's Rage for Chaos* (Philadelphia: Chilton Books, 1965), pp. 313–315; César Graña, *Bohemianism versus Bourgeois* (New York: Basic Books, 1964), *passim*. The specific sources are almost endless.

[67] Herbert Marcuse, *One Dimensional Man* (Boston: Beacon Press, 1964), pp. 62–74.

[68] Renato Poggioli, 'The Artist in the Modern World,' *The Graduate Journal*, VI (Winter 1964), 99–100.

[69] J. Milton Yinger, 'Contraculture and Subculture,' *American Sociological Review*, XXV (October, 1960), 625–635.

[70] Graña, *op. cit.*, *passim*.

[71] See Florence Kluckhohn, *Variations in Value Orientations* (Evanston, Ill.: Row, Peterson, 1961), pp. 15–17.

[72] *Ibid.*, pp. 30–31.

[73] *Op. cit.*, pp. 18–19, 37–38.

[74] See Ortega y Gasset, *The Revolt of the Masses* (New York: New American Library, 1950); Dwight MacDonald, 'Masscult and Midcult' in *Against the American Grain* (New York: Vintage Books, 1965), pp. 3–75. See the survey by Daniel Bell, 'Modernity and Mass Society: On the Varieties of Cultural Experience,' *Studies in Public Communication*, IV (Autumn, 1962), 3–34.

[75] The National Foundation on the Arts and the Humanities, established

by the 89th Congress, September 16, 1965. See excellent summary, *Washington Report*, XIII (September 23, 1966), of the State University of New York. For general comment, see Meg Greenfield, 'The Politics of Art,' *The Reporter*, September 22, 1966, pp. 25-30. On New York's Council on the Arts, see *Saturday Review*, February 25, 1967, pp. 68-69.
[76] Florence Kluckhohn, *op. cit.*, p. 45: 'The persons who are the instigators of basic change—the innovators—are almost always the variants in the system.' Cf. H. G. Barnett, *Innovation* (New York: McGraw-Hill, 1953), p. 378ff. Also, the existence of variant values in society may be one necessary condition to internal change, along with the stresses that they inevitably produce. They may not be the 'cause' of such a change.
[77] Robert H. Lowrie, *An Introduction to Cultural Anthropology*, 2d ed. (New York: Rinehart, 1947), p. 177.
[78] Franz Boas, *Primitive Art* (New York: Dover, 1955), p. 9.
[79] Ralph L. Beals and Harry Hoijer, *An Introduction to Anthropology*, 3d ed. (New York: Macmillan, 1965), p. 643. Cf. Herskovits, *op. cit.*, p. 378: 'It will be enough to recognize that the search for beauty is a universal in human experience'; E. Adamson Hoebel, *Anthropology: The Study of Man*, 3d ed. (New York: McGraw-Hill, 1966), p. 287: 'Man could survive without art; yet man and art are inseparable.'
[80] 'Aesthetics,' in *The Institutions of Primitive Society* (Glencoe, Ill.: The Free Press, 1961), pp. 33-34.
[81] 'Art and Icon,' in Robert Redfield, *et al.*, *Aspects of Primitive Art* (New York: The Museum of Primitive Art, distrib. by University Publishers, 1959), pp. 20-21. Cf. Herskovits, *op. cit.*, p. 378: 'Toward the comparative study of art a strictly relativistic point of view must be taken....'
[82] Charles P. Mountford, 'The Artist and his Art in an Australian Aboriginal Society,' in *The Artist in Tribal Society*, p. 9.
[83] Paul Oscar Kristeller, 'The Modern System of the Arts,' Part 1 *Journal of the History of Ideas*, XII (October, 1951), 506.
[84] *Ibid.*, p. 508.
[85] See, for example, the Arapesh, who import decorative objects from neighbors, Margaret Mead, *et al.*, *Technique and Personality in Primitive Art* (New York: The Museum of Primitive Art, distrib. by New York Graphic Society, 1963), pp. 8-9. Cf. discussion of theories of diffusion by Paul Wingert, *Primitive Art: Its Traditions and Styles* (New York: Oxford University Press, 1962), pp. 10-11.
[86] André Malraux, *The Voices of Silence* (New York: Doubleday, 1953), p. 53. (This work originally entitled *The Psychology of Art*.)
[87] See Victor W. Von Hagen, *World of the Maya* (New York: New American Library, 1960), pp. 15-16.
[88] Raymond Firth, *Elements of Social Organization* (Boston: Beacon Press, 1963), pp. 158-159. See also Douglas Fraser, *Primitive Art* (New York: Doubleday, 1962), pp. 11, 35; Katherine Kuh, 'Alaska's Vanishing Art, *Saturday Review*, October 22, 1966, p. 31.
[89] *Op. cit.*, p. 608.
[90] *Art* (New York: Frederick A. Stokes, 1913), p. 25. Bell apparently

popularized in England the concept of 'the will to form' formulated in Germany by Alois Riegl and given wide circulation by Wilhelm Worringer. See the excellent brief survey of changing conceptions of primitive art in Robert Goldwater, *Primitivism in Modern Art*, rev. ed. (New York: Vintage Books, 1967), pp. 15–42.

[91] *Op. cit.*, p. 22.

[92] *Ibid.*, p. 39.

[93] *Ibid.*, pp. 25, 27.

[94] See, for example, Gotshalk, *Art and the Social Order*, pp. 218ff.; John Dewey, *Art as Experience* (New York: Capricorn Books, 1958); Eliseo Vivas, *The Artistic Transaction* (Columbus, Ohio: Ohio State University Press), 1963.

[95] Malraux, *op. cit.*, pp. 14–15. For the story of Malraux 'salvaging' Khmer temple sculptures from the Cambodian jungle, his subsequent arrest, trial and acquittal, see Clara Malraux, *Memoirs* (New York: Farrar, Straus & Giroux, 1967), pp. 245, 261ff.

[96] The ignoring of cultural backgrounds is deplored by many. See, for example, David Crownover, 'The Tribal Artist and the Modern Museum,' in *The Artist in Tribal Society*, pp. 33–35. Museum practice is illustrated in the International Fine Arts Exhibition, 'Man and His World,' at Expo '67 in presenting in one large glass case three works: A death mask from Pyramid of the Moon (metal), from Peru, 3d–8th century; a small (stone) Aztec figure, 'Ehecatl,' *c.* 1200–1500; a macehead in the shape of a fabulous demon (metal), Persia, 19th century. The general 'themes' used to assemble this excellent collection failed to 'unify' the various sections.

[97] Katherine Kuh, 'Alaska's Vanishing Art,' p. 28.

[98] *Op. cit.*, p. 627.

[99] R. H. Wilenski, *Modern French Painters* (New York: Reynal & Hitchcock, 1940), p. 197 (general statement), pp. 201, 215 (Matisse), pp. 200, 202 (Picasso), p. 205 (Derain), p. 258 (Modigliani). For extensive, detailed exploration of many influences of primitive art including African sculpture on European artists, see Robert Goldwater, *loc. cit.*

[100] George Kubler, *The Shape of Time* (New Haven, Conn.: Yale University Press, 1962), p. 108.

[101] Firth, *op. cit.*, p. 161; Gotshalk, *op. cit.*, p. 248: 'The tendency to abstraction . . . may also be read as an effort to rid the art work of the provincial and the particular, and to develop what meaning can be given at present to the world-wide and universal'; Harold Rosenberg, *The Tradition of the New* (New York: Horizon Press, 1959), p. 10: 'the rummage for generative forces has set African demon-masks in the temple of the Muses. . . . Through such dislocations of time and geography the first truly universal tradition has come to light, with world history as its past and requiring a world stage on which to flourish.'

Part I
FORMS AND STYLES

I. FORMS AND STYLES

Introduction

THE TERMS 'FORMS' and 'styles' designate specific aspects of the arts. 'Forms' usually refers to traditional types of artistic representation, such as the epic and the novel in literature, the song and the symphony in music, the easel painting and the statue in the visual arts. More generally, 'form' in the arts may be defined, as Herbert Read has done in the first article in this section, as 'the shape imparted to an artifact by human intention and action.' But 'shape' suggests style as well as form. In fact, the concepts of form and style are always closely related, as Meyer Schapiro's classic definition illustrates. 'By style,' he says, 'is meant the constant form, and sometimes the constant elements, qualities, and expression, in the art of an individual or a group.'

It is commonly believed that certain societies excel in certain forms of art: *e.g.*, Americans in the short story and in musical comedy, Italians in opera, Russians in ballet, Greeks in drama, sculpture, and architecture. But these observations are oversimplified and reflect typical Western conceptions of art. A broader and more acceptable assumption, apart from aesthetic evaluations, is that each society has unique styles of artistic expression, whatever elements it may share with other societies. This assumption is fundamental in the work of archaeologists, who use the designs and motives in art forms as indexes of a culture and its span of existence. By means of these and other clues, they can establish, within flexible limits, the origin and duration of the Mayan civilization, for example, or the rise and extinction

of Minoan culture. By similar means, but with more attention to qualities and expression in art forms, historians of art can trace in Western and other civilizations not only the characteristic styles of distinct stages of cultural development but also the growth and duration of these styles apart from specific historical events. Thus they speak of Gothic, Baroque and Romantic styles in Western society and invent other names to identify the artistic qualities of historical periods. The success of these ventures in taxonomy continues to be a subject of controversy.

So do the various theories about how specific art forms and styles arise in different societies and what psychological and social conditions foster and maintain them. Obviously, if each society develops unique modes of artistic expression, these modes and their qualities must be closely related to the nature of the society and its prevailing cultural patterns. Forms and styles of art that are meaningful to the Pygmy in the Congo are not likely to be significant to the Arunta of Australia, the Kentucky mountaineer, or the middle-class Englishman. Aside from climatic and geographical influences, the arts seem to differ according to their function in social rituals, religious ceremonies and secular situations, although the stylistic patterns in these different social contexts may be similar. One of the major tasks of the sociology of art, then, is to discover correspondences between the qualities and styles of art forms, on the one hand, and the character of social life and social structures, on the other.

In the articles that follow, both Alan Lomax and J. L. Fischer search for such correspondences in different cultures. Lomax finds significant parallels between song performance and social structure among Pygmies, Bushmen and other peoples and puts our Western patterns in a rather startling comparative framework. For example, the Pygmy-Bushman style of perfectly blended contrapuntal group singing reflects an egalitarian pattern of social integration, in sharp contrast to the Western pattern of folk singing, in which a solo singer dominates a group of silent listeners, reflecting the hierarchical pattern of interpersonal relationships characteristic of Western social structures. The variations and modifications of the patterns in these and other societies, which Lomax describes in detail, are complex and fascinating.

J. L. Fischer applies statistical methods to twenty-nine 'primitive' societies, testing hypotheses on the relationship between visual art forms and two polar types of society, the egalitarian and the hierarchical. The data show that the visual arts of egalitarian societies predominate in simple, symmetrical designs, with a large amount of empty space and no enclosed figures, whereas the visual arts of hierarchical societies tend to present complex, asymmetrical designs, with crowded spaces and enclosed figures. These are his most impressive findings. His hypotheses of certain stylistic characteristics corresponding to relations between the sexes, types of marriage, and family residence are not supported, but they are suggestive of other possible relationships between art forms and social structures.

It is noteworthy that Fischer opposes forthrightly theories that derive the styles of art primarily from the physical environment, the nature of the materials, and technical developments, and those that rely chiefly on concepts of historical diffusion. He places the emphasis rather on social conditions as determinants of artistic creativity and stylistic traits in visual arts. In a similar vein, F. van der Meer takes direct issue with scholars who assume that the form of the basilica is a product of technical development, that it 'evolved' from one or more architectural forms that existed at the beginning of the fourth century A.D. Instead, he believes that the architectural interior of the basilica was created to serve the Christian form of religious worship, based on an already fixed order of the liturgy. The design consists of a long main axis for the 'gathering of the faithful' and a platform where the bishop sits on his chair, the *cathedra*, representing the principle of authority. Together with the altar and the baptismal font, these are the essential elements, which have remained remarkably stable through the centuries, despite significant variations.

Thus the architectural form reflects and expresses the basic hierarchical structure of the Christian mode of worship, consisting of a person of authority speaking to a listening congregation, a structure that recalls Lomax's observations on the soloist in Western cultures singing to a listening audience. This arrangement is duplicated in many social situations in the West, not the least strange being that of an instructor lecturing to his class.

Among the many literary genres that originated and flourished in

Western civilization, none has attracted more scholarly attention than the novel. Some scholars, such as Diana Spearman, view the invention of the novel as a 'natural' development out of pre-existing narrative types. Others attribute it to changes in philosophic outlook in late seventeenth-century England, to the rise of the middle class in the eighteenth century, to the expansion of the book trade, and to new audiences. Subscribing to most of these social influences in his *Rise of the Novel* (1957), Ian Watt also draws attention to the rather subtle influence of the city. In the excerpt that follows, he claims that the city gives rise to new social and psychological patterns and personalities. It fosters not only people like Defoe, who relished the hurly-burly of London, but also those like Samuel Richardson, who feared and withdrew from it to the relative privacy of suburban life. This privatization of experience, Watt believes, encouraged Richardson to invent and refine new techniques in literary narrative, such as letter writing, which invest the novel with the subjective traits of private experience and personal relationships. These traits persist to the present day.

The more general aspects of style are dealt with in A. L. Kroeber's classic survey on 'Style in the Fine Arts.' After describing the elements of style and differentiating them for painting and music, Kroeber summarizes the style fluctuations occurring in relatively isolated regional and national cultures. Although he is aware that political and economic changes affect style in the arts, Kroeber observes that art also has its own dynamic, that 'art breeds art,' a process reflected in the work of individual artists as well as in historical patterns of growth and decline of styles. His perspective takes account of exceptions in cultures outside as well as within the Western traditions, and it permits him to assess realistically the possibility of the development of a universal style in the arts.

The idea of a universal style suggests that art everywhere may share the basic aspect of form. Thus we return to Herbert Read's 'The Origins of Form in the Plastic Arts,' referred to earlier, which examines some plausible explanations. This article is more speculative and philosophical than the other selections, in part because of its subject, which may not admit of scientific solutions. Nevertheless, Read in his eclectic fashion makes use of new information and old

ideas. He plays with the notion of the refinement of tools by technical mastery, a theory popularized by the anthropologist Franz Boas in *Primitive Art* (1927); he invokes the psychological principle of 'will to form,' developed in 1893 by the art historian Alois Riegl; and he adopts the concept of *logos* from the existentialist philosopher Martin Heidegger, whose works began to appear in 1927. It is not surprising that the ultimate answers elude Read, but he raises interesting questions. How, for example, does an object of utilitarian shape, such as a battleax, acquire ritualistic and symbolic significance, as it did in early China ? Few if any attempts have been made to answer this important question systematically, but partial answers may be derived from studies on symbols, rituals and the functions of art in society.

HERBERT READ

The Origins of Form in the Plastic Arts*

I

FORM IN ART is the shape imparted to an artifact by human intention and action. In English 'form' seems to have an aesthetic connotation not carried by the word 'shape,' but shape, which is cognate with the Old English *sceapan* and the German *schaffen*, better conveys the creative implications of this human activity. Form is also given to natural objects, either by the process of growth, or by crystallization of other physical changes, and there is a whole science of form in nature which we call morphology, after the Greek word for form. But there is no distinct science dealing with form in human artifacts, though these have distinctive laws or habits of perfection.

Form, as I shall discuss it, must be distinguished from composition. I shall not be concerned with the relation of parts to a whole, or to the laws of harmony and proportion that govern their interrelations. Of course, every form can be measured, and one can discuss the harmonic significance of these measurements, or their lack of harmony. But the interesting problem, and one to which practically no attention has ever been directed, is the origins of the very concept of form in art. Why, out of the shapeless chaos of sticks and stones, or out of the handy and useful objects which were the first tools of primitive man, did form progressively emerge until it surpassed the utilitarian purpose of the formed object and became a form for the sake of form, that is to say, a work of art?

I am, perhaps, already begging the question, but I will clarify it by some precise illustrations from the artifacts of prehistoric man. Man is first differentiated in the process of evolution by an ability to make tools. It has been proved by Professor Wolfgang Köhler in his famous experiments with chimpanzees that apes are capable of improvising tools, but this only

* Reprinted from *Origins of Form in Art*, 1965, by permission of Benedict Read, of the American publisher, Horizon Press, and of the United Kingdom publishers, Thames & Hudson Ltd.

happens when the animal is incited by the prospect of a *visible* reward. The ape lacks two components of thought upon which man's toolmaking depends: the power of combining mental images—in short, imagination—and the power of speech and the conceptual process that results from speech. This is perhaps not immediately obvious, but Dr. Kenneth Oakley of the British Museum of Natural History has recently reduced the considerable research on this subject to the following cautious statement:

> One may sum up by saying that apes of the present day are capable of perceiving the solution of a visible problem, and occasionally of improvising a tool to meet a given situation; but to conceive the idea of shaping a stone or a stick for use in an imagined future eventuality is beyond the mental capacity of any known apes. Possession of a great capacity for this conceptual thinking, in contrast to the mainly perceptual thinking of apes and other primates, is generally regarded by comparative psychologists as distinctive of man. Systematic making of tools implies a marked capacity for conceptual thought.[1]

The recent experiments in training chimpanzees to paint do not contradict such a conclusion. Congo, the chimpanzee in the London Zoo trained by Dr. Desmond Morris,[2] did produce amazingly effective paintings, but not only were the colors preselected by the scientist in charge of the experiments, but they were presented to the chimpanzee one by one, and the paper on which he painted was usually withdrawn to allow each color to dry separately, and so safeguard against any accidental tendency to mix the colors. The design is due to a combination of random muscular actions and automatic perceptual processes—a 'good *Gestalt*' may result, as indeed it does from various automatic painting machines that have been invented during recent years. But again, there is no capability of combining images, no shaping power of the imagination.

If we turn now to the first objects deliberately shaped by man, which are tools of various kinds, we find a chronological sequence which begins with convenient pieces of sharp stone, sharks' teeth or shells, anything with a cutting edge, and gradually (over many thousands of years) leads to objects deliberately shaped for this purpose.[3] The earliest tools are known as eoliths (dawn stones) and are indistinguishable from the accidents of nature. Such stones are still used by Australian tribes. The problem of distinguishing these eoliths from deliberately shaped tools need not concern us: we may merely note that there gradually appear various types of stone implements that are unmistakably shaped by human agency. Usually of flint, they have been produced by flaking the natural stone. The flint is sharply tapped at a

point on the surface with the result that a flake of a certain size is chipped off, and by progressive blows at the right points, the required shape is produced —the shape required by the function of the tool. The process could give two possible end results: the flake that was removed from the flint, and the core of flint from which flakes had been removed. Either might be utilized as a tool, the flake as a scraper, for example, and the core as a hand ax.

Once the process had been invented, then the way was open for a continuous refinement of skill and of the tools produced by the skill, this process of refinement going hand-in-hand with the choice of more effective materials and the invention of new methods of working. It should be realized, however, that an immense period of time stretches between the earliest appearance of the pear-shaped hand ax, the distinctive tool of the Lower Paleolithic period in Europe (*ca.* 550,000 to 250,000 years ago) and the invention of the refined tools of the Neolithic period (*ca.* 3000 to 2000 B.C.). Something like half a million years of experience in stone precedes the swift elaboration of iron and bronze. But once iron had replaced stone, and bronze had replaced (or been added to) iron, man had at his command the technical means for the establishment of an enduring civilization.

In order to get a clearer idea of the formal or morphological evolution of these artifacts, it would be best to divide them into three types: (1) piercing and cutting implements, where sharpness is the guiding motive; (2) hammering or bludgeoning implements, where concentrated mass and power is the purpose; and (3) hollow vessels to be used as containers of a food. We shall then find that although the purposes are different, the morphological evolution proceeds along parallel lines.

There can be no possible doubt that for long periods of time the drive behind such evolution was for efficiency. There can equally be no doubt that the search for efficiency led imperceptibly to forms which were not only efficient, but also, for our modern sensibility, beautiful. In any long sequence of axheads or spearheads or arrowheads there is a progressive refinement of shape due to increasing skill in flaking, then in abrading and polishing, until finally we have artifacts of such elegance that it is not reasonable to suppose they could have been intended as practical tools. Archaeologists distinguish between several Paleolithic cultures on the basis of the prevailing tools— for example, pebble-tool and hand-ax cultures, chopper-tool cultures, flake-tool and blade-tool cultures—but I do not think these need concern us, because whatever the tool, and whatever the material, the process of refinement was the same. We must not exclude, of course, the possibility of periods of degeneration.

What I would like to establish, for all these early human artifacts, is an

evolutionary sequence that passes through three stages: (1) conception of the object as a tool; (2) making and refinement of the tool to a point of maximum efficiency; (3) refinement of the tool beyond the point of maximum efficiency toward a conception of form-in-itself. The evolution from the first to the second stage is not in doubt; it is the normal cultural sequence as established by paleontologists and archaeologists. But in what manner, and for what reason, did man quite early in his cultural development, and long before historical times, pass from functional form to form-in-itself, that is to say, to aesthetic form?

There are two possible hypotheses that might lead us toward an explanation of the origins of aesthetic form. The first might be called *naturalistic* or *mimetic*, the second, perhaps *idealistic*. According to the first hypothesis, all formal deviations from efficiency would be due to the imitation, conscious or unconscious, of forms found in nature; according to the second hypothesis, form has its own significance, that is to say, corresponds to some inner psychic necessity, and is expressive of this feeling. Such feeling is not necessarily indeterminate; on the contrary, it is often a desire for reification, clarification, precision, order.

Let us now look a little more closely at some of the first human artifacts, and let us take, for the sake of contrast, a solid cutting form, such as the axhead, and a hollow containing form, such as the clay vessel.

The first stages in the formal development of the axhead were obviously pragmatic—a selection of the stone for size and compactness, for striking power consistent with handiness. Important, too, at a later stage of development, was an ovoid shape that permitted the attachment of the head to a shaft by means of thongs. But once this basic form had been standardized by a process of trial and correction, then the toolmaker began to concentrate on the cutting power of the ax, and this led to a gradual refinement of the flaking technique, and then to smoothing and polishing by various methods of abrasion. What was finally evolved, allowing for differences due to the nature of the material, was a shape essentially the same as the ax of civilized man. In all tool design there is an optimum point of functional efficiency which determines shape in the terms of the material used. In many of his artifacts—spear and arrowheads, scrapers, blades, as well as axes—man reached this optimum point in the Late or Upper Paleolithic period.

Then began the final and most significant stage of formal evolution, which does not take place before the Mesolithic period or Middle Stone Age, perhaps not before the Neolithic period: the ax was divorced from its utilitarian function, and further refined to serve as a ritual or ceremonial object. At this stage even the original material, which for a practical tool had

to be as strong as possible, was sometimes abandoned, and instead a rare and precious material, such as jadite, was substituted. Jadite and nephrite are hard stones, and were undoubtedly used for the making of tools before such tools became ritualistic or ceremonial objects; and stone or bronze tools also became ritualistic or ceremonial objects where jadite and nephrite were scarce or unknown. But scarcity leads to preciousness, to scarcity values, and for this reason we may suppose that where it was available, notably in China, jadite or nephrite was preferred for nonutilitarian objects. In any case, form, having become divorced from function, was free to develop according to new principles or laws—those laws and principles which we now call aesthetic.

Archaeologists may differ in the classification of prehistoric stone implements—there is naturally a large intermediate group which may be refined functional forms or equally free aesthetic forms, but no archaeologist will deny the general line of development. But it is not essential to find a ritualistic justification for every aesthetic form; there are arrowheads, for example, of extraordinary grace and refinement, which were certainly weapons of the chase, and in no sense ritualistic. It must be admitted that 'a purely aesthetic principle of elegance' can be combined with, and be indistinguishable from, a purely utilitarian principle of efficiency. Symmetry, for example, an aesthetic quality when man is conscious of it, was undoubtedly at first a technical necessity: an asymmetrical arrowhead would not fly straight. The problem is to determine at what point elegance ceases to be utilitarian, at what point form is divorced from function.

The ceremonial ax, which has its origins in the Late Stone Age, is highly elaborated in the Bronze Age and then persists throughout most cultures down to the Middle Ages in Europe. This artifact, in its refined stages of development, became a symbolic form. Magnificent bronze axes, which can scarcely have been real weapons, were common in ancient China. Dr. Gunnar Andersson states that the ax was one of the symbols of fertility in the Neolithic period, and compares to it the hammer which Tori laid on the knees of the bride.[4] Jade axheads of the Chou period were certainly cult objects. In the Minoan civilization the double-bladed ax (the *labyris*) was associated with whatever cult was practiced in the labyrinth (to which it gave its name). Placed within a circle (for example, between the curved horns of an ox) it becomes a mandala. In later civilizations we find the ax used as a symbol of authority in, for example, the Roman *fasces*, and its symbolic function persists in the ceremonial halberds of the Medieval and Renaissance pageants. Parallels can be found in Mexican and African cultures. But it is not the historical continuity of the form that is of immediate interest, but the nature of the form that guarantees such continuity.

A similar development with even longer continuity can be traced from the Stone Age hammer to the mace, which is still the symbol of royal and parliamentary authority in several countries. Some authorities[5] suggest that the Chinese *pi*, a jade disk varying considerably in size, generally between 10 and 20 cm. in diameter, and pierced in the center with a circular hole, was derived from the Neolithic mace—a stone mace has been found on a Neolothic site in Mongolia. The *pi* symbolizes heaven and was used in sacrificial ceremonies. It was also a token of rank and one of the emblematic objects used in burial rites.

The evolution of the hollow vessel is even more interesting and complicated. The first vessels were small pieces of rock with one surface concave enough to hold a liquid. Use must also have been made of gourds, coconut shells, fish shells, and other natural objects; and the progress of cutting the scraping tools must have made possible the hollowing of wood.

With the transition from hunting to agriculture, the possibility of working new materials was discovered, and in particular the plastic virtues of the soil which had become the source of man's basic food, grain. Max Raphael, one of the few archaeologists who has given any thought to the problem of form, in his work on prehistoric Egyptian pottery, gives this account of the origins of the clay vessel:

> Man sought unceasingly for new materials, techniques, and ideologies by which to develop his creative abilities in the face of superior natural forces. The alluviated ground, the nature of which remained a mystery to him, produced what he needed by dint of unremitting labor that entailed a number of equally mysterious and unknown changes beyond the control of man. . . .
>
> Because of this complex interaction of necessity and creative power man looked upon the products of this soil, the periodic harvests of barley and wheat that could not be increased at will, with feelings that neither the fruit gatherers nor the hunters had ever experienced—that is, with a desire to store them providentially for future security. Thus with the boom of harvests there was born the need for vessels impervious to moisture and sand, receptacles that could protect the fruits of nature and man's labor from decay.[6]

The possibility of molding clay was eventually discovered, and of baking it in the sun or embers:

> Experience taught the Neolithic Egyptian that the silt from which the grain grew was pliant and plastic, that the sun dried it and made it

serviceable as a container, and that firing made it impervious to water. The man who synthetized these separate experiences invented the clay vessel. And in thereby satisfying one of the most urgent social needs, he raised the spiritual value of the material that not only served the growth of grain but also made possible the preservation of it. Man saw that his entire existence depended upon a substance whose origin and nature he did not understand and which he could not produce himself.[7]

But the Neolithic Egyptian could give form to this mysterious substance. The first vessels were round semispherical bowls, but the nature of the material inspired variations from the beginning—bowls with low walls became platters, bowls with high walls became beakers and grain urns. Then came the desire to cover the bowl, for better containment of the liquid, for better protection from flies, and to mold its shape for better pouring or for carrying —each need calling forth an adaptation of the prototype. And again the process of refinement of the basic utilitarian shape set in, and here one must suppose that certain affinities with the shape of the human body had an unconscious influence. Symmetry was imposed by the need for balance, and for the same reason a foot or base was differentiated. The need to lift and transport the larger vessels led to the addition of lugs or handles, but always at some point in the evolution of the utilitarian shape, utility is exceeded. The form is refined for its own sake, or for the sake of a function that is no longer strictly utilitarian. The vessel may be used for libations, for holding grain or the ashes of the dead; and such ritualistic functions can justify refinements not required for normal use. What is essential to note is that at some point in this process of formal evolution the form responds, not only to a utilitarian purpose, but also to a spiritual need.

The important point to realize is that (again in Max Raphael's words) 'the fashioning of clay went beyond gratification of physical needs.' And Raphael makes the further subtle point that 'this development was favored by the fact (erroneously regarded by many writers as a limitation) that the human hand could produce the synthesis between utilitarian and spiritual purposefulness without resort to any tool.'

We must still ask by what forces, and under what guiding will, did the utilitarian shapes of the first clay vessels become the refined forms of later cultures? Max Raphael, who was a dialectical materialist by philosophical conviction, believed that the forces were economic—new needs, often imported by invading races who transformed the old conditions of life.

Max Raphael argues that when the material conditions change, man's emotional reactions change, among these his aesthetic reactions. The old

forms no longer satisfy the new feelings: they must be modified to correspond to an inner necessity, a will to form which is an emotional reaction to life as a whole—'the totality of all interacting objective conditions,' as he calls it. This seems to imply that there was an evoking consciousness of form as such.

When Neolithic man, motivated perhaps by the practical purpose of achieving greater imperviousness to liquids, combined polishing with painting and applied both to a form he had created, his consciousness of freedom was increased. The new means of representation changed the impression produced by the pot, and the man consequently gained insight regarding the difference between the actual nature and the effect of a given form. Formerly, when the prehistoric artist for the first time applied mathematics to matter, the effect was only an outward adjustment—the weight of the material, despite its smoothness, still opposed the abstraction of mathematics. Now, when polished color concealed the material from the eye, the mind began to play with the impression of gravitational pull and tried to eliminate it. This tendency was heightened by the fact that the material was actually reduced to a fairly thin layer. In the much-admired thinness of Bavarian pottery we are confronted not only with virtuosity (which surely must have had a high market value), not only with the purely aesthetic principle of elegance, but with a general ideological force that attempted to play with the opposition between matter and spirit, that is, endeavored to stress or to eliminate this opposition by dematerializing the material and materializing the immaterial.[8]

Here we have a formula for the power that transforms a utilitarian shape into a work of art—an ideological power that *plays* with the opposition between spirit and matter and endeavors to eliminate this opposition. Before we consider the adequacy of this formula, which might be illustrated even more strikingly by tracing the evolution of the bronze vessel in Neolithic China, let us glance at the origins of form in pictorial art.

We have established three stages in the development of the shape of objects of utility—namely, (1) discovery of the functional form, (2) refinement of the functional form to its maximum efficiency, and (3) refinement of the functional form in the direction of free or symbolic form. To suppose *a priori* that pictorial art, the art of representing images, underwent similar stages of development would perhaps be unwarranted. It is, of course, just possible that the first depictions of animals had a utilitarian purpose—a tally system for huntings or killings—but before the art of drawing could reach the value of a representational symbol, there must have been a long process of development, upward from aimless scratching or scribbling in sand or on the damp

clayey walls of the caves. Scribbles and the outlined silhouettes of hands have survived in various Paleolithic sites, and though there is no stratographical evidence to constitute an evolutionary development from aimless scribbling to the representational image or schema, the analogy of the similar development of pictorial representation in the drawings of children is perhaps admissible. But this is not the random activity ending in an accidental discovery of resemblances that a superficial observation might lead one to suppose it to be. Patient analysis of the scribbling activity in children, such as that conducted by Mrs. Rhoda Kellogg among infants in San Francisco, shows that there is a progressive discovery of basic forms—the circle, the cross, the square, and so on—all tending toward a synthetic form which is our old friend, the mandala—a circle divided into four sections. This mandala constitutes a basic schema from which images are developed by the process already mentioned which Professor Gombrich has called 'making and matching'[9]—that is to say, the schema is gradually modified in the direction of the retinal image, until a convincing approximation is achieved. On this hypothesis it can be maintained that 'what the artist knows' (the schema) is gradually modified by 'what the artist sees' (the illusion of reality) and that this process accounts for all variations of style in the history of representational art.

From this point of view chance rock formations or protuberances on the wall of the cave might have served as schemas for Paleolithic man, but this is a phenomenon that occurs most frequently at the peak of Franco-Cantabrian art. Paolo Graziosi, in the latest and most comprehensive survey of Paleolithic art, comes to the conclusion that 'nothing so far proves that fortuitous realism acted as a dominant creative impulse in the earliest forms of art'— on the contrary, 'it flourished especially in those who had attained a high degree of sensitivity in form and volume, and a remarkable mastery of technical skills.'[10]

It is reasonable to suppose, however, that casual scratches and scribbles may have suggested a mental schema to which the deliberate drawing was then matched—or equally probably, there may have been a gradual attempt to match the scribble to the eidetic image. But the more successful the attempt, the less interesting it becomes from a formal point of view: the reproduction of an eidetic image, however life-like, is not necessarily a work of art. It is an illustration and only becomes a work of art if there is an intention to compose or arrange the image in a significant form. The exact illustration of a reindeer or a rhinoceros corresponds to the tool of maximum efficiency. To constitute an artistic form the illustration must be carried beyond this utilitarian stage toward a conception of pure form. Or, to put

the same thought in another way: the exact representation of an animal is a reproduction of natural form; we are concerned with forms deliberately conceived by the human imagination.

It has been suggested by some archaeologists that certain of the drawings of animals at Altamira are deliberately composed in this manner: they have 'style' as well as 'exactitude.' But a categorical distinction must be made between 'style' and 'form.' Style corresponds to vitality, to kinetic qualities; form to beauty, to static qualities. Style is human, and limited to human artifacts; form is universal, and exists only when human artifacts correspond to mathematical laws. In general we may say the the Paleolithic artist achieved style but was not aware of form.

We still lack, however, a convincing explanation of why, so early in human development, the approximation of image to reality should have been achieved with such efficiency, though only in one category—the representation of animals. That explanation, it seems to me, must be sought in the social structure that conditioned the production of the images—that is to say, in the very precise requirements of the magical practices of Paleolithic man. I have suggested also that it would be legitimate to suppose at this early stage of human development, a constitutional acuteness of imagery in the human brain—that is to say, a prevailing *eidetic* imagery such as children and certain animals may possess. But if children possess such images, why do they not also produce drawings of similar realistic accuracy? I think one can say: because they have no compelling motive such as the fear and hunger that through a long period of development drove prehistoric man to the institution and elaboration of sympathetic magic.

It is obvious that between any preliminary scribbling stage in the development of prehistoric representational art and the attainment of realistic imagery there once more intervened a will, and though in this case the will did not work upon a utilitarian shape, a tool, it nevertheless took a given form—the basic scribble form—and transformed it with some deliberate intention. We must suppose that the basic form—the mandala—had been achieved by an unconscious will—we may, if we wish to remain materialistic up to this point, suppose that it is no more than a perceptual process that automatically, by reason of perceptual ease and balance, achieves the good *Gestalt*. But the modification of the basic form then proceeds by an equally perceptual process of making and matching to a point where the illusion of realism is achieved. This stage we may regard as equivalent to the elaboration of the perfectly functional tool—the realistic image is a tool required by sympathetic magic. But then, perhaps in some of the Paleolithic drawings at Altamira, but more obviously in the carved amulets of the female figure

such as the Venuses of Lespuge (France) and Dolní Vestoniče (Mikulov District of Moravia) formalization approaches abstraction. There intervenes a will to form that carries the image beyond its utilitarian function and beyond even its stylistic vitality, to constitute once again *free* or *symbolic form*. What takes place is an elaboration of the realistic or utilitarian image, and a gradual substitution, for this image, of a shape that has a power of attraction, and of satisfaction, that proceeds from the shape itself and not from its perceptual or representational function.[11]

It would seem, therefore, that in whatever direction we investigate the origins of form, we see the emergence of an independent will to form, which usually begins to manifest itself when the functional efficiency of the form has reached its optimum point of development and has then become stabilized. We still have no adequate conception of the causation of this will, nor indeed of its teleological justification. Is it merely, as some aestheticians have supposed, a playful impulse to elegant variation; or can it possess a motivation in terms of man's biological evolution? I assume that within the term 'biological evolution' we must be prepared to include the development of those faculties by means of which man achieves a mental, that is to say, a spiritual, adjustment to the mystery of his existential situation—a means of answering what Heidegger has called the fundamental question: why is there anything at all, rather than nothing; and how do we establish an apprehensible form for what *is*—how do we establish being? In other words, more appropriate to our immediate concern: why are the forms established by the artist of universal significance?

II

Form, as Heidegger has recognized, belongs to the very essence of being. Being (*Sein*) is that which achieves a limit for itself. 'That which places itself in its limit, completing itself, and so stands, has form, *morphē*. Form, as the Greeks understood it, derives its essence from an emerging placing-itself-in-the-limit.'[12]

Such is the form that we have seen emerging at the dawn of human history: such is the formative capacity that distinguishes *homo sapiens* from *homo faber*. For the forms of *homo faber*, the practical and functional tools of the first stages of human development, did not reach a limit of being (*Ständigkeit*), but merely expressed a restless busyness. It was not until form had reached the limit of efficiency or usefulness that it became form-in-itself, permanent being.

It then became the *logos*. According to Heidegger the basic meaning of

logos is gathering and togetherness, and in his words, 'gathering is never a mere driving together and heaping-up. It maintains in a common bond the conflicting and that which tends to part. It does not let them fall into haphazard dispersion. In thus maintaining a bond, the *logos* has the character of permeating power, of *physis*. It does not let what it holds in its power dissolve into an empty freedom from opposition, but by uniting the opposites maintains the full sharpness of their tension.'[13]

Heidegger derives this meaning of *logos* from Heraclitus, and interprets one of the fragments in the Diels-Kranz arrangement (the first) as an identification of *physis* and *logos*. In what I believe to be a very faithful translation of this obscure fragment, it reads: 'Although this Logos is eternally valid, yet men are unable to understand it—not only before hearing it, but even after they have heard it for the first time. That is to say, although all things come to pass in accordance with this Logos, men seem to be quite without any experience of it—at least if they are judged in the light of such words and deeds as I am here setting forth. My own method is to distinguish each thing according to its nature, and to specify how it behaves; other men, on the contrary, are as forgetful and heedless in their waking moments of what is going on around and within them as they are during sleep.'[14] In another fragment (the eighth) Heraclitus says: 'Opposites move back and forth, the one to the other; from out of themselves they gather themselves,' or, to quote another translation: 'Opposition brings concord. Out of discord comes the fairest harmony.' Heidegger interprets this fragment in the sense that the conflict of opposites is a gathering, rooted in togetherness, it is *logos*. From his identification of *logos* with *physis* Heidegger passes to beauty, for what the Greeks meant by beauty was restraint. '*Art is disclosure of the being of the essent.*' 'The being of the essent is the supreme radiance, *i.e.*, the greatest beauty, that which is most permanent in itself. . . . For us moderns, on the contrary, the beautiful is what reposes and relaxes; it is intended for enjoyment and art is a matter for pastry cooks.'[15] For the Greeks beauty was the radiance of what is complete and harmonious, of what is self-contained and original. The work of art is a disclosure of being, the establishment of a pristine relation to *physis*, to the realm of things, to nature, to being itself. But, as Heidegger makes so beautifully clear, 'the Greeks did not learn what *physis* is through natural phenomena, but the other way round: it was through a fundamental poetic and intellectual experience of being that they discovered what they had to call *physis*. It was this discovery that enabled them to gain a glimpse into nature in the restricted sense. Hence *physis* originally encompassed heaven as well as earth, the stone as well as the plant, the animal as well as the man, and it encompassed human history as a work of

men and gods; and ultimately and first of all, it meant the gods themselves as subordinated to destiny. *Physis* means the power that emerges and the enduring realm under its sway. This power of emerging and enduring includes "becoming" as well as "being" in the restricted sense of inert duration. *Physis* is the process of a-rising, of emerging from the hidden, whereby the hidden is first made to stand.'[16]

But what emerges is a form, *morphē*, and what emerges has form by virtue of its togetherness, its inner relatedness, its harmony. It is usually said that the Greeks had no word for art, and the word *technē* is substituted; but the Greeks had no word for art because they did not conceive it as separate from the apprehension of reality, the establishment of being, from physics and metaphysics. *Technē*, says Heidegger, was neither art nor technology, but a knowledge, the ability to plan and organize freely, to master institutions, and in justification he refers us to Plato's *Phaedrus*. '*Technē* is creating, building in the sense of a deliberate producing'; it is the ability to invent the efficient tool, but not the free form. But elsewhere Heidegger redefines *technē* as knowledge in the authentic sense, not as mere observation concerning previously unknown data, but as the actual doing which results in the production of objects,[17] 'the initial and persistent looking out beyond what is given at any time.' Art can then be identified with *technē* because:

> [Art] is what most immediately brings being (*i.e.*, the appearing that stands there in itself) to stand, stabilizes it into something present (the work). The work of art is not primarily a work of art because it is wrought (*gewirkt*), made (we have seen that the tool satisfies these conditions), but because it brings about (*erwirkt*) being in an essent; it brings about the phenomenon in which the emerging power, *physis*, comes to shine (*scheinen*). It is through the work of art as essent being that everything else that appears and is to be found is first confirmed and made accessible, explicable, and understandable as being or not being.[18]

Art, therefore, may be regarded as 'the ability, pure and simple, to accomplish, to put-into-the-work (*ins Werk setzen*), as *technē*. Such a manifesting realization of being is knowledge, and art is *technē* in this sense: as knowledge, not because it involves "technical" skill, tools, materials.'

This distinction of Heidegger's seems to be beautifully illustrated by the early evolution of artifacts as I have described it. *Technē* in the sense of skill will account for the form of the artifact as a tool designed for practical needs; but *technē* in the sense of making and manifesting brings about a form that stands there in itself, disassociated from its practical function, a configuration disclosing itself as the being of the essent.

In reading Heidegger's interpretation of the early Greek philosophy one is inevitably reminded of a philosophy that was contemporary with it, the Chinese, and there one finds an attempt to explain the establishment of being which can be closely related to early Greek thought. It is beyond my powers to attempt a correlation of the Greek and the Chinese cosmologies, but I can perhaps indicate some analogies. There is the same awareness of Being and Nonbeing, and of the mystery of the emergence of form from a primordial chaos. According to the *Huai-nan-Tzŭ*, a second century B.C. miscellaneous compilation of all schools of thought which summarizes earlier philosophic writings, two contrary principles, the *yin* and the *yang*, gradually emerged from a complex and universal energy, and by uniting with one another, these contrary principles constituted the first harmonious forms. To quote from Derk Bodde's translation of the *Huai-nan-Tzŭ*:

When Heaven and Earth did not yet have form, there was a state of amorphous formlessness. Therefore this is termed the Great Beginning (*t'ai shih*). This Great Beginning produced an empty extensiveness, and this empty extensiveness produced the cosmos. The cosmos produced the primal fluid (*yüan ch'i*), which had its limits. That which was clear and light collected to form Heaven. That which was heavy and turbid congealed to form Earth. The union of the clear and the light was especially easy, whereas the congealing of the heavy and the turbid was particularly difficult, so that Heaven was formed first and Earth afterward.

The essences of Heaven and Earth formed the *yin* and the *yang*, and the concentrated essences of the *yin* and the *yang* formed the four seasons. The scattered essences of the four seasons formed the myriad things. The hot force of *yang*, being accumulated for a long time, produced fire, and the essence of fire formed the sun. The cold force of *yin*, being accumulated for a long time, produced water, and the essence of water formed the moon. The refined essence of the excess fluid of the sun and moon formed the stars and planets. Heaven received unto itself the sun, moon, stars and planets, while Earth received water, rivers, soil and dust.[19]

This process of formation, of a gathering of opposites, a *logos*, remains on the cosmological level in Chinese thought, but the process does not end with water, rivers, soil and dust, but is extended by analogy to living plants and animals, and finally to the human race and its artifacts. The work of art is conceived as a symbol of cosmic units, as a reification of the concentrated essences of *yin* and *yang*.

A more significant analogy, perhaps, for our purpose is the evolution of the

trigrams used in the process of divination as practiced in the *I Ching*. According to early Chinese historians, divination was originally made by means of the tortoise shell, which was heated with fire by the diviner, who then interpreted the cracks which appeared on its surface. The eight trigrams, and the sixty-four hexagrams derived from these by combining any two into diagrams of six lines each, were intended as a formal substitute for the chaos of lines that appeared on the heated tortoise shell, and were probably introduced at about the same time that form began to emerge as a conscious entity in the artifacts of the Chinese—the period of the Five Emperors,[20] or the Yang-Shao period as it is now usually called after the site of one of the Neolithic villages of about 3000 to 2500 B.C., discovered by Dr. J. Gunnar Andersson.[21] I am not suggesting that the parallel between the discovery of pure form in such artifacts as the axhead or the adz and the invention of the trigrams is an exact one, but we may discount the legend that the trigrams were actually invented by Fu Hsi (according to another legend he found them on the back of a dragon-horse that suddenly rose from the waters of the Yellow River). It is more probable that the legends were invented to explain the gradual evolution of formal shapes from the intricate cracks on the heated tortoise shells.

It should be observed that the form of each trigram has a sign value, or symbolic significance. The signs consist of the eight possible combinations of broken and unbroken lines in threes, and it is said that the unbroken line represents the male principle, the broken line the female principle (equally they may represent 'the hot force of *yang*' and 'the cold force of *yin*'). Richard Wilhelm, in his edition of the *I Ching*,[22] classifies the various attributes, images and family relationships that the eight trigrams symbolize: the details are not significant for our present purpose, but only the fact that a formal arrangement, a *Gestalt*, has become endowed with a sign value, or with symbolical significance. The symbols may seem fairly obvious (and should therefore more correctly be called signs)—a combination of three unbroken lines signifies the creative, the strong, heaven and father; whereas a combination of three broken lines signifies the receptive, the yielding, earth and mother, but the symbolism becomes less obvious in the more intricate combinations, and very obscure when the eight trigrams are combined with one another to make sixty-four symbols.

Why should form have symbolic significance?—that is the question to which we must finally address ourselves, for we may assume that pure or artistic form would never have been separated from the utilitarian shape unless the mind of man had suddenly perceived a nonutilitarian significance in the shape, a manifesting realization of being. There are three possibilities:

1. That a symbolic function developed from the utilitarian function—*e.g.*, the ax used in sacrifices acquired by association a ritual significance in addition to its utilitarian purpose, and its form was on that account gradually refined.
2. That a symbolic value was attached to a form because it resembled a natural object—*e.g.*, the unbroken line is the creative male organ, the broken line the receptive female organ.
3. That the form itself became significant because it acquired harmonic proportions. We must on this supposition ask further why harmony should be significant.

I think we can dismiss the second of these possibilities for the semantic reason already given: a form that has significance because it resembles another object is not a symbol, but a sign. A symbol is only a symbol insofar as it signifies an unknown, or not otherwise expressible, perception or feeling.

We are therefore left with two values that may be symbolized in a created form: one of perception and sensation, the other of intuition and feeling. What is evident to perception and sensation is the radiance of being; what is evident to intuition and feeling is the gathering-together-in-itself, the formal restraint.

Consciousness itself is formal: not so much form-giving as form-receiving. That is to say, we understand experience insofar as it is presented to consciousness as form. 'From the very first, so to speak, consciousness is a symbolizing activity. Hence one never finds in it anything barely "given" without meaning and reference beyond itself. There is no content that is not construed according to some form.'[23] That was the great affirmation that Kant made in his *Critique of Pure Reason*, and it has never been convincingly disproved. On the contrary, it has been developed in our time into an all-embracing philosophy of form by the genius of Ernst Cassirer, on whom I shall rely for my concluding observations.

There was form before there was human consciousness of form: the universe itself, the *yin* and the *yang* that emerged out of primal chaos and formed concentrated essences. Human consciousness began with the forms of perception, and human intelligence and spirituality with the representation of form. Man's freedom and his culture begins with a *will* to form. Language, the sustaining medium of his imagination, is a formal creation. Art itself is a will to form, and not merely an involuntary or instinctive reaction. 'The moment of *purposiveness* is necessary for linguistic and artistic expression. In every act of speech and in every artistic creation we find a definite teleological function.'[24] Or, as Cassirer says in another place: 'The artistic eye is not a passive eye that receives and registers the impression

of things. It is a constructive eye, and it is only by constructive acts that we discover the beauty of natural things. The sense of beauty is the susceptibility to the dynamic life of forms, and this life cannot be apprehended except by a corresponding dynamic process in ourselves.'[25]

Applying this observation to the first human artifacts that revealed artistic form, we must still ask: how did that susceptibility to the dynamic life of forms come into being?

We can only grope for an answer to this question. We know that the concept of abstract space, for example, was not discovered before the time of Democritus (460 to 360 B.C.)—it was one of the distinctive achievements of Greek thought. We cannot assume that the human beings who first discovered beauty in the Neolithic age had any abstract conceptions of space, or proportion, or harmony. Theirs was an unreflective, sensational experience. If therefore form became significant for Neolithic man, it was an act of perception and not of intelligence. Insofar as Neolithic man was purposive in giving an artistic form to his artifacts, the purpose must have been a progressive approximation toward a sense of form derived from his general experience. That is to say, man must have gradually acquired from his material environment a conditioned response to those physical properties of symmetry and harmonic proportion which his senses received from the observed form of his own body, the forms of animals and plants, the rhythm of day and night, and so on. Since form is prior to human experience, we can legitimately assume that the consciousness of form was received from the natural environment of man, and then spontaneously matched in his artifacts. But it was the form that was matched, not the appearance, and it was the form that was symbolic.

The purpose of such symbolic forms, we may assume with Heidegger and Cassirer, was to disclose meaning, to create the tools of discourse. Cassirer observes:

Since every particular content of consciousness is situated in a network of diverse relations, by virtue of which its simple existence and self-representation contain *reference* to other and still other contents, there can and must be certain formations of consciousness in which the pure form of reference is, as it were, sensuously embodied. From this follows the characteristic twofold nature of these formations: their bond with sensibility, which however contains within it a freedom from sensibility. In every linguistic 'sign,' in every mythical or artistic 'image', a spiritual content, which intrinsically points beyond the whole sensory sphere, is translated into the form of the sensuous, into something visible, audible,

or tangible. An independent mode of configuration appears, a specific activity of consciousness, which is differentiated from any datum of immediate sensation or perception, but makes use of these data as vehicles, as means of expression.[26]

That passage from Cassirer's great work contains, it seems to me, in concentrated essence the answer to our question. The transition from a refined but still utilitarian form, produced under necessity, is effected at the crossroads of consciousness, where forms meet and mingle; and at this encounter forms first acquire at once their freedom and their expressive function. At this moment 'consciousness *creates* definite concrete sensory contents as an expression for definite complexes of meaning. And because these contents which consciousness creates are entirely in its power, it can, through them, freely "evoke" all those meanings at any time.' In other words, language and art acquire their symbolic functions: a symbolic discourse, divorced from material necessity, then becomes possible.

We cannot reconstruct or even imagine that 'moment' in prehistory when form first disclosed being, when man for the first time stabilized being into the concreteness of a work of art. One might as well ask at what 'moment' was consciousness born in the human race. But my object in this chapter has been to show that the origins of form in art are also the origins of *logos*, of knowledge of being, of reality. Art, insofar as it has retained its primary function and not become 'a matter for pastry cooks,' has throughout history always been such a mode of revelation, of establishment, of naming. This was all said succinctly, in one line of verse,[27] by Hölderlin:

Was bleibet aber, stiften die Dichter.

What endures is established by poets; that is to say, man achieves being and identity by virtue of his creative activity, his will to form.

NOTES

[1] Kenneth P. Oakley, *Man the Tool-Maker* (London: British Museum, 1958), pp. 2–3.
[2] The pioneer among chimpanzee painters was a female called Alpha, at the Yerkes Laboratory in the United States. An analytical study of her drawings was published by *The Journal of Comparative and Physiological Psychology*, XLIV (1951), 110–111. For Dr. Morris' analysis of Congo's painting, see *The New Scientist*, August 14, 1958.

³ For a clear account of this technical development see Sir Francis H. S. Knowles, *Stone-Worker's Progress, a Study of Stone Implements in the Pitt Rivers Museum* (New York: Oxford University Press, 1953).

⁴ J. Gunnar Andersson, *Children of the Yellow Earth* (London: Routledge & Kegan Paul, 1934), pp. 293, 318.

⁵ Carl Hentze, 'Les jades archaïques en Chine,' *Artibus Asiae*, No. 4 (1929). Cf. also Soame Jenyns, *Chinese Archaic Jades in the British Museum* (London: British Museum, 1951).

⁶ Max Raphael, *Prehistoric Pottery and Civilization in Egypt* (New York: Pantheon Books, 1947), pp. 24–25.

⁷ *Ibid.*, p. 25.

⁸ *Ibid.*, p. 55.

⁹ E. H. Gombrich, *Art and Illusion* (New York and London: Pantheon Books, 1960).

¹⁰ Paolo Graziosi, *Palaeolithic Art* (London: Faber & Faber, 1960), pp. 24–25.

¹¹ This process of the formalization of the female figure is illustrated still more clearly in the Cycladic representations in marble of the female figure; these date from the third millennium B.C.

¹² Martin Heidegger, *An Introduction to Metaphysics*, trans. by Ralph Manheim (New Haven, Conn.: Yale University Press, 1959), p. 60.

¹³ *Ibid.*, p. 134.

¹⁴ Philip Wheelwright, *Heraclitus* (Princeton, N.J.: Princeton University Press, 1959), p. 19.

¹⁵ Heidegger, *op. cit.*, p. 131.

¹⁶ *Ibid.*, pp. 14–15.

¹⁷ Cf. Thomas Langan, *The Meaning of Heidegger* (London: Routledge & Kegan Paul, 1959), p. 193.

¹⁸ *Ibid.*, p. 159. It is better to avoid, in the present discussion, the distinction between *physis* and *idea*. *Idea*, according to Heidegger, 'is a determination of the stable insofar and only insofar as it encounters vision. But *physis* as emerging power is by the same token an appearing. Except that the appearing is ambiguous. Appearing means first: that which gathers itself, which brings-itself-to-stand in its togetherness and so stands. But second it means: that which, already standing-there, presents a front, a surface, offers an appearance to be looked at.' (Heidegger, *op. cit.*, p. 180). The Greek word for what is offered in appearance, what confronts us, is *eidos*.

¹⁹ Fung Yu-Lan, *Chinese Philosophy*, trans. by Derk Bodde (Peking and London: Kelly & Walsh, 1937), I, 396–397.

²⁰ Wang Pi (A.D. 226–249), the famous *I Ching* commentator, attributes their invention to the first of these mythical emperors, Fu Hsi.

²¹ Cf. Andersson, *op. cit.*, Chaps. 10, 12, 13, 21.

²² *The I Ching or Book of Changes*. The Richard Wilhelm translation rendered into English by Cary F. Baynes, 2 vols. (London and New York: Pantheon Books, 1951).

²³ Charles W. Hendel, in the introduction to Ernst Cassirer's *The*

Philosophy of Symbolic Forms (New Haven, Conn.: Yale University Press, 1953), I, 57.

[24] Ernst Cassirer, *Essay on Man* (New York: Oxford University Press, 1953), p. 182.

[25] *Ibid.*, p. 193.

[26] Cassirer, *Philosophy of Symbolic Forms*, I, 106.

[27] 'But what is lasting, the poets provide.' Last line of Friedrich Hölderlin's poem 'Anderken' ('Remembrance').

ALAN LOMAX

*Song Structure and Social Structure**

ᵉMUSIC-MAKING IS one of the most strictly patterned forms of human behavior. Its modes of communication are so limited that even a casual listener can quickly distinguish the best performers and identify the pieces in an idiom with whose technique and content he has little acquaintance. For many centuries and in many cultures, musical adepts have had at their disposal elaborate systems of notation and theory. The musicologists of our time have inherited this treasure of knowledge and have refined greatly their analytic tools. Thousands of volumes of accurately notated music exist, alongside of carefully wrought critical studies. Yet, it seems, none of us is much closer to understanding what music is and what it says than are the singers of primitive cultures. As one of America's leading musicologists once remarked to me, ... 'No one knows anything about melody.' If melody, a possession of all human beings everywhere and at every stage of development, is a mystery, what of rhythm, harmony, and the superstructures erected with these three magic tools?

It is suggested here that ethnomusicology should turn aside, for a time, from the study of music in purely musical terms to a study of music in context, as a form of human behavior. In the first stages of such a study it is not necessary that all that is known and notable about music be accounted for. It

* The substance of this paper was read at the annual meeting of the Society of Ethnomusicology in Philadelphia, November 15, 1961. The research was sponsored by Columbia University and supported by the Rockefeller Foundation. Many of the ideas developed in the paper grew out of informal discussions with Professor Conrad Arensberg, under whose general direction the research was carried out. The present version was adapted by the author from an article in *Ethnology*, October, 1962, and printed by permission of the author and George P. Murdock, editor of *Ethnology*.

would be a positive step forward to delineate the varying shapes of musical behavior and to begin to frame this behavior in its precise cultural setting. It should then be possible to discern the bonds between patterns of musical behavior and the socio-psychological traits worked out by the other humanistic disciplines.

As a working hypothesis, I propose the common-sense notion that music somehow expresses the culture from which it comes; therefore, when a distinctive and consistent musical style lives in a culture or runs through several cultures, one can posit the existence of a distinctive set of cultural patterns or drives that are somehow symbolized or evoked by this music. If such a musical style occurs with only a limited pattern of variation in a similar cultural setting and over a long period of time, one may assume that a stable expressive pattern has existed in group A in area B through time T. Thus we might look forward to a scientific musicology that could speak with some precision about formative attitudes pervading cultures and operating through history. In this first stage of investigation we need not be concerned about the way musical symbolism works, but only with a method that would locate sets of musical phenomena cross-culturally.

Until recently, the musical habits of mankind were not well enough known to make such a cross-cultural study possible. In the past twenty-five years, however, excellent field recordings from a wide sample of primitive and folk cultures have been published. We need no longer depend upon written notations of music from exotic sources. Unlike the musicologists of the past, we need no longer evaluate the varied music of the world from the perspective of Western Europe, for we now have recordings of the living sounds from the whole planet which we can examine and compare at leisure and on their own terms.

The method of comparison used by the author is described in some detail in a version of this article published in *Ethnology*, but it was felt that its inclusion here would simply get in the way of the ordinary reader. However, a brief discussion of the technique is pertinent to the presentation of the findings on song-style areas.[1] This method, called *cantometrics*, is a system for rating recorded song performances in a series of qualitative judgments. The parameters of measurement or judgment in the system are those discovered in a study of a sample from the whole range of world folk song, to vary in an orderly way from one culture region to another. In other words, these traits were found, upon actual inspection of the data, to be the most dependable markers of the differences between the main world musical styles. The list of thirty-seven traits included in the cantometric system includes the features that Western European musical notation describes—melody, rhythm,

harmony and dynamics—along with others essential to a holistic description of the musical event. These factors include: the size and social structure of the singing group, the relation of the leader or soloist to the group, the qualities of the singing voice, the degree and kind of embellishment employed, the level of cohesiveness in the chorus and orchestra. All judgments in the system can be made by ear and do not depend upon an analysis of the musical texture or structure perceived. Indeed, it has been found that nonmusicians can be trained, by attentive listening to exemplary recordings, to produce the same results as the 'expert coders.' Thus, the whole system rests, for its validity, upon the agreement it has produced among judges.

To facilitate the rating process, the traits are listed in a series of thirty-seven rating scales on a standard data sheet, each scale containing from three to thirteen points, and each point being the locus of a proximate judgment in relation to other points on the same line. The relative judgment for each trait is then recorded on a symbolic map located on the right side of the coding sheet. For example, the line for the organization of a vocal group ('Vocal Gp.') can be rated first in terms of the degree of group dominance and integration. If the performance consists of a solo by a leader with a passive audience, this fact will then be recorded by the symbol $\frac{L}{N}$ (leader over audience). Other shorthand symbols indicate other types and degrees of group organization. After some practice, a listener can observe and rate rapidly on the coding sheet the thirty-seven traits of the performing group. When completed, the ratings and their symbolic representations form a profile, which can be repeated, compared and then averaged with material from the same culture. Within a short time, a master profile in numerical or linear form is ready for cross-cultural comparison.

On the basis of extensive experience and experimentation, the method has proved to produce consistent profiles of musical performance over large culture areas that both anthropology and musicology tell us share a common culture history. In fact, it displays sharply the effects of musical acculturation. It shows the way in which Negro singers, for example, on coming to the New World, added the European strophic form to their own system, which otherwise remained more or less intact. Furthermore, the profiles reveal that most folk and primitive cultures erect their song structures on one or two, or at most three, models, whatever the function of the song, which is often characterized as a work song, funeral lament, ballad, love song, religious song or the like. So style in song performance is apparently superordinate over function. Indeed, the cantometric diagrams of song style, which represent the song-producing models in a culture, may stand for formative and emotional patterns that underlie whole sets of human institutions. Thus, the

cantometric system looks at a level of musical activity that is highly patterned, resistant to change, and superordinate over function. The remainder of this paper will relate certain levels of song-performance structure to social structure.

PYGMY–BUSHMAN VERSUS
WESTERN EUROPEAN SONG STYLE

One of the universals of song performance seldom remarked upon by musicologists is the working organization of the musical group. There is a difference in kind between the main performance structure of Western European folk song, where a lone voice dominates a group of passive listeners, and the situation in which every member of a group participates, not only in the rhythm and the counterpoint of a performance, but in re-creating the melody, as in the Pygmy hocketing style. A comparison of the structure of interpersonal relationships and of role-taking in the two societies shows the same order of contrast, strongly hinting that musical structure mirrors social structure, or that, perhaps, both structures are a reflection of deeper patterning motives of which we are only dimly aware.

The general shape of Pygmy music must first be summarized. Colin Turnbull, who has done field work among the forest-dwelling Pygmies, discovered that they had concealed the very existence of their musical system from surrounding tribes for centuries.[2] Solo song does not exist among the Mbuti Pygmies except in the form of lullabies. Their choral songs may be begun by anyone, no matter what his talent. Leadership, during the course of a song performance, shifts from an accomplished to a less accomplished singer with no apparent lessening of support from the whole group. The chief delight of the singers is to listen to the effect of group-produced counterpoint as it echoes through the dark cathedral of the jungle. These little black hunter-gatherers sing with yodeling tone, which, in the estimation of laryngologists, is produced by the voice in its most relaxed state. When a singer yodels, all of the vocal dimensions, from the chords through the resonating chambers, are at their widest and largest. This extraordinary degree of vocal relaxation, which occurs rarely in the world as an over-all vocal style, seems to be a psycho-physiological set, which symbolizes openness, nonrepressiveness, and an unconstricted approach to the communication of emotion.

Our coding studies show that a high degree of choral integration is always linked with a relaxed and open vocal delivery. This connection is strikingly dramatized by the Pygmy-Bushman style. These stone-age hunters normally

express themselves in a complex, blended, contrapuntal singing at a level of integration that a Western choir can achieve only after extensive rehearsal. Indeed, the Pygmy-Bushman profile represents the most extreme case of total focus on choral integration in our world sample, and in this sense it is unique among folk cultures.

The vocal empathy of the Pygmies seems to be matched by the cooperative style of their culture. All that Turnbull has told us about the Pygmies confirms this point. Normally the group never goes hungry. Their environment furnishes what they need for food and shelter. The men hunt in groups, and the women gather in groups. A precise system of dividing food assures every individual of his share. There are no specific penalties for even the greatest crimes, such as incest, murder, or theft, nor do judges or law enforcement exist. The community expresses its vociferous dislike of the criminal, and he may be belabored and driven out of the group for a time, but soon he will be pitied and welcomed back among his people.

A Pygmy baby lives, literally, on his mother's body, his head positioned so that he can always take her breast, her voice constantly soothing him with a liquid-voiced lullaby. Children grow up in their own play community relatively unhampered by their parents. When a girl begins to menstruate, the whole tribe joins in rejoicing that a new potential mother is among them. Her joyful maturation ceremony concludes with marriage. Pygmy men do not impose on their sons a painful puberty ceremony; in Pygmy terms, a boy becomes a man simply when he kills his first game. The Mbuti sometimes permit the Negro tribesmen with whom they live in symbiosis to put Pygmy adolescents through a rite of passage, but this is only one of many ways in which the Pygmies tactfully pretend to conform to the desires of their Negro neighbors in order to live at peace with them and to conceal the existence of their own forest culture. When the Negroes have gone back to their village, the Pygmy children are given the bull-roarer and the fetishes to play with, and the little hunters laugh together over the childish superstitions of their black masters. During the initiation ceremonies there is ritual whipping of the boys by the Negroes, but when this takes on a sadistic character the Pygmy fathers intervene.

The forest Pygmies do not share the magical beliefs of their Negro neighbors; indeed, the Pygmies look down on the Negroes because of their superstitious fears and their focus on evil. They have no myths and little formalized religious belief. Their only religious ceremonies occur in times of crisis, when they sing to wake the beneficent forest and to remind it to give them its usual protection. When the tribe gathers after the hunt, joy-filled dances and songs knit the group into a cohesive and fully expressive whole.

In our code the Pygmy musical form emerges as a static expression of community joy sung in liquid, open-throated style.

I have dwelt upon this extreme, rare, and somehow utopian situation because it so strongly contrasts with the life styles and the song styles of all other cultures and thus illuminates the rest of human musical activity in an extraordinary way. It points to the close bonds between forms of social and musical integration. The choruses of these hunting-gathering peoples sit in a circle, bodies touching, changing leaders, strongly group-dependent. Even their melodies are shared pleasures, just as are all tasks, all property, and all social responsibilities. The only parallel in our coding system is found at the peak of Western European contrapuntal writing, where again all the separate interests of a variegated musical community are subordinated to a desire to sing together with a united voice about universal human values.

Thus far we have assumed an identity between Bushman and Pygmy musical styles, and, indeed, this is what our profiles indicate. Perhaps no two peoples so far separated in space (3,000 miles), living in such different environments (desert and jungle), and belonging to different racial and linguistic groups share so many stylistic traits. Even after pointing out numerous musical idiosyncrasies, this cross-cultural mystery still disturbs the two researchers who have most closely examined it, Yvette Grimaud and Gilbert Rouget. Rouget speculates upon the possible influence of a common cultural heritage or similar environmental adaptation, then leaves the problem.[3] It seems to me that he has neglected one important piece of evidence.

Solo songs are common among the Bushmen and rare, except in lullaby form, among the Pygmies. Otherwise, as far as cantometric analysis is concerned, the styles are, indeed, identical. Bushman males sing plaintive solo songs to the accompaniment of the mouth bow, which, like our blues, dwell upon loneliness and isolation. This sense of personal deprivation grows out of a special Bushman situation that does not exist among the Pygmies. Their harsh desert existence, beset by thirst and hunger, results in a scarcity of women. Thus, in order to have a mate, Bushman men often betroth themselves to infant girls. The result is long years of waiting for marriage and consummation, then a union with a capricious little girl who may be anxious to postpone her connubial duties. Meanwhile the Bushman men, battling for their group's existence in a barren waste, suffer the deprivations common to lonely males everywhere, and they voice this emotion in their solo plaints.[4]

In all other important respects, Pygmy and Bushman social and musical structures are extremely close. Both groups share all wealth, all goods. Their

acephalous bands lack any form of superstructure or enforced law. The people dwell together only because they enjoy one another. Their hocketing, polyphonic, polyrhythmic, maximally blended style seems to mirror this system of closely integrated relationships. The Bushman solo 'blues,' the only major deviation from this pattern, thus suggests the influence of environment on an otherwise consistent social and musical structure. It does not matter whether this Bushman solo song style has been borrowed from a neighboring group. A musical structure stands for a social adjustment, for the fulfillment of a commonly felt emotional need, whether borrowed or not. There is no better proof of this hypothesis than this one divergence of Pygmy and Bushman musical structures.

For further evidence of the link between song structure and social structure we may look at the other extreme of the coding system—a leader dominating a passive audience—the principal pattern of Western Europe folk song. This profile shows only slight variation for most folk songs from Norway, Holland, the British Isles (apart from old Celtic areas of Wales, Cornwall, and the Hebrides), Western France, Central Spain, and colonial United States. Text is dominant and rhythm simple and regular in this style, whose melodies generally conform to the model of three or phrase strophes, wrought from diatonic scales within an octave range and with little ornamentation. The usual solo ballad singer pitches his voice between mid-range and falsetto range, enunciates his consonants precisely, employs a moderate, 'speaking' vocal delivery and uses plenty of vocal harshness and nasality to add force to his delivery. In fact, this rather noisy vocal style is responsible for the poor blend of most untrained European choruses. Rotarians at lunch, soldiers on the march, football crowds, cockneys in pubs—all sing in rough unison, for each of these situations brings together a crowd of extreme individualists, each one of whom holds to his own way of singing and pronouncing words. This uncompromising vocal independence—or, better, intransigence—results in a diffuse, poorly blended choral sound.

By far the most common singing style in Great Britain and backwoods America is solo without accompaniment. The British or Kentucky ballad singer sits quietly, his hands passive in his lap, his eyes closed or gazing unseeingly out over the heads of an attentive but equally passive and silent audience. He sing-tells his ballads in simple strophes that permit a concentrated narrative pace and that unobtrusively carry the story along. His listeners must keep silent and remain physically passive, for activity on their part threatens a dramatic relation that depends upon the single voice of one lone actor. Often, when one singer has finished his budget of tales, another will take his place and continue in a similar style.

Each ballad singer commands and dominates his listeners during his performance. His association with his audience is, in sociological terms, one of exclusive authority, a principal interaction model in Western European culture.[5] When a doctor or a lawyer takes over a case, his authority is absolute for the duration of the relationship. The same unspoken pact joins boss and worker, priest and penitent, officer and soldier, parent and child. Dominance-subordination, accompanied by a deep sense of moral obligation, is the fundamental form of role-taking in the Protestant West. Our cooperative enterprises are organized in terms of assemblages of experts, each one temporarily subordinating his separate, specialized and exclusive function to an agreed-upon goal. Workers on beltlines cooperate in this way to produce automobiles for Ford or bombers for Lockheed, just as instrumentalists combine to make the big symphonic sounds. Ultimately, this leader-follower pattern is rooted in the past, *e.g.*, in the European concept of lifelong fealty to the king or the lord. Ignatius Loyola inculcated the same principle in his teaching of the Jesuits: 'In the hands of my superior I must be a soft wax, a thing . . . a corpse which has neither intelligence nor will.'

This degree of compliance is precisely what the contemporary symphonic conductor demands and gets from his orchestra—and from his audience as well. In its role relationship the symphonic audience, quietly listening to a work of one of the masters spun out under the baton of the conductor (whose back is to his admirers), differs from the ballad audience only in its size. Even the most group-oriented and fully integrated Western music is produced by a collectivity, organized in a manner fundamentally different from that of the acephalous Pygmy chorus, where all parts are equal, where subordination does not exist, as it scarcely exists in the society itself.

A Western table of organization or a beltline or a symphony depends upon a series of clear and explicit commands, arranged in a clear pattern agreed upon in advance. Our Western European folk songs are arranged in the same fashion—a series of compact, clearly outlined strophes and stanzas, each of which bids the listener to view such-and-such an aspect of a sung tale in such-and-such an explicit fashion. While this series of explicit and well-constructed packages of fantasy or fact are being delivered to the listeners, the leader-singer must not be interrupted. If he is, he will very likely refuse to sing any further. 'If you know so much, sing it yourself,' he will tell his rude listeners, much as a doctor might tell an anxious patient, 'If you don't like my medical procedure, get another man.'

According to Turnbull, a long Pygmy performance may, as a maximum, contain only enough text to make a normal four-line stanza. The rest of the

phonating consists of hooted vocables or variations on one phrase of text. Tiring of this material, another singer is free to introduce another bit of text, which in its turn is torn apart into syllables and played with for a while in somewhat the manner of a child or a musing adult in our culture. Here language loses its cutting edge and becomes a toy in a delightful game with sounds. . . .

THE BARDIC STYLE OF THE ORIENT

Having now described two styles that lie at the extremes of the cantometric system—one solo-unaccompanied and the other contrapuntal-hocketing—let us now consider three master types that lie between these extremes and that show again how musical structures rise out of, or reveal, the general shape of their social contexts. First, there is the area that I call 'bardic.' Here solo performance is again dominant, but various levels of accompaniment support and reinforce the authority of the soloist-leader. Linking together several large subareas, this bardic style shapes most of the music of Southern Europe and Moslem Africa, of the Near and Middle East, of the Far East, and, indeed, of most of Asia aside from certain tribal cultures.

A searching portrait of the societies that gave rise to the bardic tradition can be found in the analysis of the system of Oriental despotism by Karl Wittfogel.[6] Wittfogel argues that, wherever an agricultural system depends upon the construction and maintenance of a complex of great canals and dams, a despotic control of labor, land, political structure, justice, religion, and family life arises. All the great hydraulic empires—of Peru, of Mexico, of China, of Indonesia, of India, of Mesopotamia, of Egypt, of the Moslem world—conformed to the same over-all pattern. The center owned and controlled every person and all the means of production and power. Complete and blind obedience was the rule. The way to approach the throne was on the knees or on the belly. Deviation was immediately and ruthlessly handled by capital punishment, imprisonment, confiscation, or torture. The ancient rulers of Mesopotamia asserted that they received their power from the god Enlil, who symbolized power and force. The ministry of justice in ancient China was known as the Ministry of Punishment. The Egyptian peasant who failed to deliver his quota of grain was beaten and thrown into a ditch. A court favorite could be executed or deprived of his perquisites at the whim of the emperor.

Wittfogel points out that this system results in a state of total alienation for the rulers at the top as well as the slaves and serfs at the bottom of the society.

The peasant or small official knew that no one would dare protect him if he rebelled; the king or the pharaoh knew that he could trust no one with his confidence or, for that matter, with his life—neither his closest advisor nor the members of his family, and especially not his sons and heirs.

Depersonalized conformity to authoritarian tradition is the norm for such a society. Everywhere in the hydraulic world, song styles show an analogous set of traits. The singer learns to use his voice in a formalized way and then masters a complex set of rules for starting and improvising a theme, and he displays his talent by showing how far he can develop this theme without breaking the rules that apply. The growth of systems of modes, with the elaborate set of beliefs and customs surrounding them, reminds one strongly of a society split into strict divisions where rules of conduct govern the development and growth of each individual from birth to death. Above all, there is one voice, expressive of doom and pain and anger, which speaks the varied moods of the center of power. It is a testimony to the noble spirit of the poets and musicians of the past that within this structure they created universes of plastic and plangent beauty.

The Oriental bard is a highly idiosyncratic solo singer, a master of subtly designed verse and of complex, shifting, and sometimes meterless rhythm. He performs highly complex strophes composed of many long phrases, with maximal ornamentation, vocal rubato, melisma, and tremolo, in a voice that is usually high or falsetto, narrow and squeezed—with maximal nasality, raspy, and often characterized by forcefully precise articulation. In places where a primitive type of feudalism still prevails, as in Mauritania and Afghanistan, bards are generally attached to a big or powerful chief, and their duty is to celebrate the magnificence of their lords before their world. The bardic voice quality is generally tense, high, thin, feminine, and placatory. Sometimes it is harsh, guttural, and forceful, symbolizing ruthless power and unchecked anger. Its marked nasality, tremolo, and throbbing glottal shake and its quivering melodic ornaments speak of tears, of fear, of trembling submission. These vocal mannerisms are employed by Eastern mystics, muezzins and cantors—the bards of God—as well as by the epic singers and the composers of praise songs for the king.

King David, like the great singers of early high culture, probably sang in the bardic manner. This inference is strong, since the style still survives in the whole Orient today, reaching its apogee in the court music of Japan, Java, India, and Ethiopia. A profusion of musical flowers, representing a sort of conspicuous consumption of music, is everywhere pleasing to the ears of kings, and thus to the almighty, whatever his name or names. In the same way, the lover in the bardic area abases himself before his mistress,

showering her with flowery compliments, telling her with trembling voice and lavishly ornamented melody that he is utterly her slave.

Thus the Oriental bard was a specialist and virtuoso of a high order. He was the product of long and rigorous training. He conformed to rigid and explicitly stated aesthetic theories. In fact, it was in the bardic world that the fine arts of music and poetry arose, alongside of highly developed metrical and melodic systems. Here, too, instruments were refined and developed and complex orchestras established.

In his paeans of praise of the king or of God, the bard spoke for or about the all-powerful center, and it was important that these praise songs be as grand and impressive as possible. He extended this manner to all his productions. Normally he sang at length—in long phrases, long and complex strophes, often in through-composed style, characteristically in song or verse forms that lasted for hours and ran to thousands of lines. He also used his voice in a depersonalized manner, appropriate to the voice of the king, of the god, or of one of his ministers or supplicants. Generally the bard was unsupported by other voices; in an absolutely despotic situation, only one voice should be heard—the voice of the despot or his surrogate.

Thus group singing in the bardic area is at a minimum. Normally, when it occurs, it is unison with poor rhythmic or tonal blend, or it is heterophonic. One thinks here of the choirs of Ethiopia or Korea or the heterophonic style of the Watusi or the enforced unison of the royal choirs of Dahomey. Yet the bard, like the king, needs support. He finds it in an elaborate accompanying style. The court orchestras of the Orient are generally large and play together heterophonically; that is, each instrument speaks the same melody but in its own variant, with many voices independently following the same line. Usually, however, a high-pitched nasalized singer or an instrument with a similar timbre leads and dominates the orchestra.

AN AMERINDIAN PATTERN

When Europeans first encountered Amerindian tribes, they could not understand how Indian society worked at all, for there were apparently no permanent authoritarian leaders. Walter Miller[7] shows that American Indian and feudal European societies conformed to two opposed concepts of authority. Europeans swore allegiance for life and carried out the commands of the representative of their king. Indians took orders from no one and bore allegiance to no one except on a temporary basis of personal choice. An Indian war party might be organized by a war chief if he were persuasive enough,

but the braves who set out with him would desert if the enterprise encountered difficulties. A sizable percentage of such enterprises ended in failure, and the participants straggled back to the village with no loss of face.

Among the Fox Indians, whom Miller particularly studied, each person had his own supernatural protector, whom he venerated when fortune smiled upon him but reviled in periods of bad luck. The permanent village chiefs had no direct authority; indeed, they were not much more than permanent presiding officers at a village council of equals. Individuals were trained from childhood to venture self-reliantly into the wilderness. Collective activity was at a minimum, and, when it occurred, it was unforced, each individual participating, not upon command, but because he knew from tradition what he should do and how and when he should do it. Just as the individual Indian might ask for and obtain power directly from a supernatural source, so he might acquire a medicine song from the spirit world that would give him the power to heal or to lead a war party.

The shape of the American Indian musical group conforms to the pattern of role-taking briefly sketched above. The solo singer uses a chesty voice, wide rather than narrow, yet with strong characterizers of nasal resonance and throaty burr and with forceful accent—a voice which is expressive of a full-blown and unrepressed masculinity. The major manner of Indian song performance, however, is that which we code as N/L—group superordinate over leader. The leader initiates the song but then is submerged in a chorus performing the same musical material in unison. This chorus links their bassy, resonant voices with moderate tonal blending (varying to well-integrated blend among the Iroquois and some Pueblo groups), but in precise rhythmic concert. Individual voices in these choruses can still be heard, and the effect is of a loosely knit but well-coordinated group of individuals cooperating in relation to a common goal. Here, as with the Pygmies and in contrast with the West and the Orient, the importance of text is often minimized. Indian songs normally consist of a few phrases padded out by repetitions and vocal segregates to form long strophes of complex structure, which the whole group knows how to perform.

Many Indian melodies may be described as through-composed—that is, basically open-ended, leaving the decision for extension and termination to a collective impulse. The strongest element in this situation is a dominant one-beat rhythm that unites the group in a simple, highly physical re-enactment of their adventures on the hunt, on the warpath, and in the supernatural world. Hardly anywhere in this system, except at this nonstratified rhythmic level, is the individual asked to conform either vocally or musically.

The very style of conformity in group performances exhibits the principle of individualism.

The profile of Amerindian song remains remarkably constant throughout most of North America and many parts of South America. This consistency of style explains why Amerindian music has been so remarkably resistant to change and how it is possible for Indians to swap songs, as they frequently do, across linguistic and cultural barriers. Indeed, the solidity of this framework confirms a common-sense impression that there is an Amerindian music, distinct from other world musical systems and congruent with an over-all Amerindian culture pattern.

THE NEGRO AFRICAN PATTERN

We have designated the working structure of West African song style as L/N. African music might be called interlocked antiphony. A leader initiates and a group responds, litany phrase by litany phrase, but the group does more than respond and overlap with the leader's part, and the leader usually does more than overlap with the chorus. Very frequently both L and N support and comment on the other part with murmurs, bits of chords, or snatches of musical laughter and with a complex pattern of counterrhythms from hands, feet, and orchestra, not to mention kinesic comment from the dancers. In the solo line itself, a playful lead voice shifts from open, ringing tones to strong nasalization to powerful rasp, from falsetto coo to bass grunt. Indeed, without such exhibitions of vocal display, an African song leader is soon replaced by another.

Yet, despite the shifting vocal timbre of the African singer, the choruses blend their voices in striking tonal effects. Visible speech analysis shows how this is possible. Although rasp and nasalization are present in the harmonic pattern of the solo voice, they are controlled and precisely placed instead of being pervasive characteristics, as is the case with the vocal characterizers that Western European bardic and Amerindian voices handle. Also, the harmonics are well and widely distributed—signs of the well-tuned voice.

A leader and a chorus part are normally implied in Negro African song, whether or not the performance is solo, for both elements are essential to African song structure. The song leader never performs for long without complex counterbalancing comment by the instrumental or vocal chorus. Furthermore, our research indicates that the length of the leader's part varies roughly with the importance of tribal chiefs over against the tribal

council. In more or less acephalous African tribes, song leaders usually perform against a constant background of choral singing. Where chieftainship is paramount, vocal solos are longer and more prominent.

This hypothesis is strengthened by our coding of the ceremonial music of the Kingdom of Dahomey and the court songs of the Watusi of Ruanda-Urundi. In Dahomey, long solos are again important; no polyphony is permitted, and highly embellished chromatic passages, rare in Negro Africa but common in Oriental song, become prominent. Among the royal Watusi, highly embellished heterophonic singing, meterless rhythm, long bardic performances, and other traits link Watusi style with that of the hydraulic empires. It would be improper not to observe that, in both these cases, song functions as a support to a powerful ruling hierarchy rather than playing the role normal in most African societies. Along the southern border of the Sahara, among peoples strongly influenced by the culture of Islam, and in many tribes where powerful kingship systems dominate large nations, solo bardic singing of the type described previously is common. It is my conviction, however, based on examination of a number of cases, that bardic singing of a strongly Oriental type is not of significant importance except in those African societies where institutional patterns akin to despotic Oriental societies shape the whole social system.

This brief sketch of African song performance structure matches in a remarkable way the gross structure of most African Negro societies.[8] An African normally belongs to several interlocked groups—to a tribe, then perhaps to a series of segmentary patrilineal kin groups, to one or more cult groups, to a work organization, to an age group, to a political faction, and so on. Each of these groups may have a different head, and in each of them an individual may achieve a varying degree of prominence in accordance with his talents and his status. Although the society is stratified, it is quite possible for a witty man with a highly developed sense of political maneuver to rise to the top of one or several of the organizations of which he is a member. If he is an hysteric, he may become a religious leader and prophet. This provides an exact analogy to the emergence of a talented individual in the African musical group. African music is full of spaces. The loose structure of this musical situation gives the individual dancer, drummer, or singer the leeway to exhibit his personality in a moment of virtuosic display. He will then be replaced, but later on he may pre-empt longer and more elaborate solo passages, thus establishing himself as a recognized and talented musical leader.

Since music is keyed to group integration in a wide variety of African activities, a musical virtuoso may be or become a religious or political leader.

Yet the very structure of African melodies stands in the way of the L/N dominance pattern, for African melody is litany and responsorial, made up of more or less equal contributions from solo and chorus, with the chorus part dominant more often than not. Thus, in Negro Africa, musical performance structure and social structure mirror one another, reinforce one another, and establish the special quality of both African music and African society—whether in Africa or in African enclaves in the New World.

The strong rhythmic bias of African music also represents this many-goaled, many-headed, group-oriented culture. African rhythm is usually anchored in a strongly accented two- or four-beat rhythm, but around and through this positive, thrusting rhythmic unity plays a variety of contrasting counterrhythms on numbers of instruments that give voice to the diverse groups and personalities bound together in tribal unity. At any moment, one of these tangential rhythms can seize the imagination of the group and become dominant, just as in a West African cult ceremony an individual may be mounted by his cult deity and rise from obscurity to total group dominance for a period.

Nor does the Negro group discourage women from taking leading roles in singing, as do many primitive peoples. Here Negro society reflects the comparative importance and independence of women, recognized in other spheres by their ownership of land, their control of marketing activities, and their part in religious ritual.

Perhaps, too, the prominence of polygyny in Negro Africa[9] finds its expression in African musical structure. African education and custom place great emphasis on sexual matters—on fertility, on potency, and on erotic skill. This focus of interest supports the system of polygynous marriage, where a man must be able to satisfy several wives and a woman must compete for the favor of her husband with a number of co-wives. African dance prepares and trains both sexes for strenuous lovemaking, and the swinging, offbeat, rhythmically climactic rhythms of Africa motivate and support this frankly erotic dance style. Yet not all African dancing is a dramatization of courtship and lovemaking, just as not all group rhythmic activity in Africa is dancing in the strict sense. Collective rhythmic activity runs like a bright thread through the web of African life and is, indeed, one of its organizing principles. Work is done, journeys are made, law cases are argued, myths and legends are told, social comment is made, religious rites are conducted to rhythms that can be danced and sung by leader and chorus in accordance with the main structures of African music. The result is that the whole of African culture is infused with the pleasurably erotic, community-based pattern of African song and dance style. The attractiveness of African music for all the world

today may, indeed, lie in the fact that it is so practical, that it operates successfully in more of life's activities than any other musical system.

It is my hope that the preceding thumbnail sketches have indicated the usefulness of the cantometric approach for both ethnomusicology and anthropology. Several viable concepts seem to be indicated by the research at this stage. First, as long as music is considered cross-culturally and as a whole and in behavioral terms, it is possible to locate structure comparable to known culture-patterns. Second, these aesthetic structures remain relatively stable through time and space. Third, these stable structures correspond to and represent patterns of interpersonal relationship that are fundamental in the various forms of social organization. Fourth, analysis of cantometric structures may provide a precise and illuminating way of looking at the cultural process itself. Fifth, since the cantometric coding system deals with expressive material which all societies provide spontaneously and unselfconsciously, it may become a tool for characterizing and, in some sense, measuring group emotional patterns. Finally, the way may be open for us to make the all-important distinction, first discussed by Sapir[10]—the intangible yet grave distinction that all human beings respond to—between spurious and genuine culture.

NOTES

[1] The simplified presentation of cantometrics has been approved by the author. A full statement of the coding method and its results in correlations with social traits appears in *Folk Song Style and Culture*, published in 1968 by the American Association for the Advancement of Science, Washington, D.C.

[2] Colin M. Turnbull, 'Initiation Among the Bambuti Pygmies of the Central Ituri,' *Journal of the Royal Anthropological Institute*, LXXXVII (1957), 191–216; 'Legends of the Bambuti,' *Journal of the Royal Anthropological Institute*, LXXXIX (1959), 45–60; 'Field Work Among the Bambuti Pygmies,' *Man*, LX (1960), 36–40; 'Some Recent Developments in the Sociology of the Bambuti Pygmies,' *Transactions of the New York Academy of Sciences*, Ser. 2, XXII (1960), 267–274; *The Forest People* (New York: Simon & Schuster, 1961).

[3] Gilbert Rouget, *Music of the Bushmen Compared to That of the Babinga Pygmies* (Paris and Cambridge, 1956).

[4] Elizabeth Marshall, *The Harmless People* (New York: Alfred. A. Knopf, 1959).

[5] Talcott Parsons, *Essays in Sociological Theory* (Glencoe, Ill.: The Free Press, 1949).

[6] Karl A. Wittfogel, *Oriental Despotism* (New Haven, Conn.: Yale University Press, 1957).

[7] Walter B. Miller, 'Two Concepts of Authority,' *American Anthropologist*, LVII (1955), 271–289.

[8] George P. Murdock, *Africa: Its Peoples and Their Culture History* (New York: McGraw Hill, 1959).

[9] *Ibid.*

[10] E. Sapir, 'Culture, Genuine and Spurious,' *American Journal of Sociology*, XXIX (1922), 410–430.

J. L. FISCHER*

Art Styles as Cultural Cognitive Maps†

STUDENTS OF THE history of the visual arts have long postulated connections between art forms and sociocultural conditions. Such a connection is often obvious in respect to overt content: e.g., the religious art of the Middle Ages. But connections between social conditions and general features of style have also been postulated: romanticism versus classicism, for instance, [has] been explained as related to the positions of the individual in society and to the rapidity of social change. While these explanations of style are often convincing and appear profound, from an anthropological point of view they suffer from being limited, for the most part, to artistic data from various branches of European civilization, or in some cases certain other extremely complex societies such as the Oriental civilizations. The study of art in a widely distributed sample of primitive, relatively homogeneous societies would seem to offer valuable evidence for testing theories of the relationship of art style to social conditions. This paper is intended as a modest contribution in this direction, making use of objective statistical tests.[1]

Two sets of variables are used in the tests reported below. The judgments on the art styles were made by the psychologist Herbert Barry III and formed the basis originally of his undergraduate honors thesis at Harvard, carried out under the direction of John Whiting. Barry later published some

* I wish to thank the following persons for offering helpful suggestions and criticisms: Herbert Barry III, Irvin L. Child, Clyde Kluckhohn, George P. Murdock, David Riesman, and John Whiting. This chapter is a revision of a paper presented at the annual meetings of the American Anthropological Association in Mexico City, December, 1959. I also wish to thank a number of people who made verbal comments at that time, some of which I hope I have heeded, even while lacking adequate notes to give them credit. Barry deserves special thanks for making his findings available to me.

†Reproduced from the *American Anthropologist*, Vol. 63 (1961), pp. 79–93, by permission of the American Anthropological Association and of the author.

of his findings in a paper on 'Relationships Between Child Training and the Pictorial Arts.'[2] Judgments on the social variables are from Murdock's 'World Ethnographic Sample.'[3] Since both sets of judgments were made independently, without, moreover, any intent to test the specific hypotheses to be discussed below, it can be fairly stated that the positive results are not to be explained by bias of the judges in favor of the hypotheses.

The sample of primitive societies used below is determined by the overlap of Barry's and Murdock's sample. Thanks to the large size of Murdock's sample all except one of Barry's societies are also represented in Murdock. Barry's sample itself consists of those societies with sufficient art data from the larger cross-cultural sample of Whiting and Child.[4] It is somewhat biased geographically in favor of well-covered parts of the world—North America and the Pacific—but I personally doubt that this seriously affects the validity of the conclusions, since for many of the art variables both extremes of values can be found in the same continental area. A total of 29 societies are available for testing, although for stratification Murdock makes no rating of the Thonga for lack of specific data.

The general theoretical position behind this chapter is that in expressive aspects of culture, such as visual and other arts, a very important determinant of the art form is social fantasy; that is, the artist's fantasies about social situations which will give him security or pleasure. I assume that, regardless of the overt content of visual art, whether a landscape, a natural object, or merely a geometrical pattern, there is always or nearly always at the same time the expression of some fantasied social situation which will bear a definite relation to the real and desired social situations of the artist and his society. Incidentally, while this point of view, that man projects his society into his visual art, will not seem especially revolutionary to many anthropologists or to psychoanalysts, it is one that is by no means universally accepted among art critics, who often emphasize historical relationships, the stimulus of forms in the natural environment, or the limitations of the material worked with. I would not discount these other influences entirely but would point out that almost any society has a variety of materials to exploit and cultural and natural forms to serve as models. It may be more important to ask, not 'What is in the environment?' but 'Why do these people notice items A and B and ignore items C and D in their environments?'; to ask, not 'What materials do they have to work with in their environments?' but 'Why have they chosen to work with wood and ignore clay, even though both are available?'

In a sense, the hypotheses tested below may be said to deal with latent content of art as opposed to the overt ('representational') content. I do not

assume that the artists themselves are necessarily or usually fully aware of the significance of their art as representative of fantasied social situations. There is, on the contrary, reason to believe that this awareness is usually repressed. On the other hand, if some sort of fairly regular connection between some artistic feature and some social situation can be shown, this would constitute plausible evidence for a repressed significance to a work of art which the artist might deny if questioned directly, although one would assume that further and better confirmation of the repressed meaning could be obtained by psychiatric interviews, life histories, projective tests, etc., from individual artists and their public.

A word about the assumed relation of the artist to his society is in order here. It is assumed that the artist is in some sense keenly aware of the social structure and modal personality of his culture, although of course he cannot necessarily or usually put his awareness into social science jargon or even common-sense words. It is not assumed that the artist's personality is a simple duplicate of modal personality for the group; in fact in many societies artists appear to have rather unusual personalities. However, I do assume that all sane people inevitably participate to a considerable extent in the modal personality of the group, and that the successful artist has a greater than average ability to express the modal personality of his public in his particular art medium. Perhaps under special circumstances he would also have the ability to express his private personality too, but in most societies there are fairly strict social and traditional controls on art production; personal isolation of the artist and encouragement of individual expressiveness to the degree typical of modern Western society are not found to my knowledge in any of the societies in Barry's sample.

I assume that the latent social meaning of visual art refers primarily to people, especially to characteristic physical configurations and to characteristic gestures and motor patterns. Conceivably socially important objects may be also involved to some extent, although because of the variety of artifacts and possessions in most cultures it would probably be hard to pick out general Gestalten from material objects which could influence art styles.

Two examples will be given of the ways social conditions may be reflected in art. The first and statistically more striking involves the reflection of the development of social hierarchy. We may postulate two ideal types of societies with respect to the development of social hierarchy.[5] In the authoritarian type, social hierarchy is positively valued. Society is seen as differentiated into groups of people lower than ego, who will serve ego and whom in turn ego must protect and help, and others higher than ego, whom ego must serve but who also in return will help and protect ego and glorify him by their

association with him. These groups of higher and lower people, of course, are further differentiated internally along the same lines: there are those in both the lower and the higher group with whom ego has direct and regular contact; there are others too low or too high with whom contact is most often through intermediaries. The comfortable, secure situation in such a society is one where the relative rank of each individual is known and is distinct from the rank of each other individual.

The opposite ideal type of society is the egalitarian society. In this type of society, hierarchy as a principle of organization is rejected. While differences of prestige between individuals inevitably exist, it is bad taste to call attention to them. Work involving two or more people is organized as cooperation between equal partners rather than as service upwards or help downwards. A 'bossy' individual is seen as a threat to security rather than as a strong and wise leader.

If we assume that pictorial elements in design are, on one psychological level, abstract, mainly unconscious representations of persons in the society, we may deduce a number of hypothetical polar contrasts in art style. These are listed below, briefly discussed, and the results of statistical tests of them given in Table I [p. 77]:

1. Design repetitive of a number of rather simple elements should characterize the egalitarian societies; design integrating a number of unlike elements should be characteristic of the hierarchical societies.
2. Design with a large amount of empty or irrelevant space should characterize the egalitarian societies; design with little irrelevant (empty) space should characterize the hierarchical societies.
3. Symmetrical design (a special case of repetition) should characterize the egalitarian societies; asymmetrical design should characterize the hierarchical societies.
4. Figures without enclosures should characterize the egalitarian societies; enclosed figures should characterize the hierarchical societies.

The reasoning behind the first hypothesis, an association between visual repetition and egalitarian societies, is perhaps obvious. Security in egalitarian societies depends on the number of equal comrades ego possesses. By multiplying design elements one symbolically multiplies comrades. That the repeated design elements themselves will tend to be simple rather than complex also follows from the basic assumption that design elements are symbolic of members of the society, since, first, it is easier to maximize repetition with simple elements than with complex elements, and second, with the need to de-emphasize actual interpersonal differences in the society,

typical persons would be conceived of as relatively simple, with emphasis on their relatively few near-uniform features, and will be symbolized in art accordingly.[6] Conversely, in the hierarchical society, security depends on relationships with people in a number of differentiated positions in a hierarchy. In art these can be symbolized by a design integrating a variety of distinct elements. Moreover, the more complex the elements in the design representing members of the society, the greater the possible differences between elements of the design, and the greater, therefore, the symbolic emphasis on personal differentiation. Note that even if one does not accept the human symbolism of the design elements but regards them instead as symbolic of valued objects or artifacts the argument leads to the same results: in the egalitarian society group harmony is promoted by an abundant supply of the same property for everyone—plenty of the same shelters, clothes, etc.; in the hierarchial society group harmony is promoted by every member keeping his place and having his own distinctive paraphernalia.

The second hypothesis, the association of empty space with egalitarian societies, assumes that for members of such societies other people are either comrades or nothing at all. If they are not comrades one tries to avoid contact with them. This implies a shrinking away from members of other groups, from foreigners. There are several reasons why one would be led to postulate that egalitarian societies tend to be more fearful of strangers. For one thing, such societies are necessarily small, and hence it is more likely that external aggression can totally disrupt them. Also, small societies are on the whole economically independent with respect to subsistence and therefore have less positive attraction to foreigners to counteract their fear. From a sociopsychological viewpoint, in small, close-knit, cooperative societies with intense face-to-face contact with limited number of people, one would expect the generation of a considerable amount of in-group aggression which could not be directly expressed, and would in consequence be projected (in the technical psychoanalytic sense) onto foreigners and supernaturals—anyone outside the in-group—with resultant fear of the supposedly hostile out-group. The ideal situation for security is then one in which one's own group is numerous but well isolated from other groups. This isolation presumably can be symbolized by an empty space around the design.[7] In the hierarchical societies, on the other hand, security is produced by incorporating strangers into the hierarchy, through dominance or submission as the relative power indicates. Isolation of one's group implies that there may be other groups whose relative position is unclear. In fantasy the hierarchical society seeks to encompass the universe.[8]

The third hypothesis, an association of symmetry with egalitarian societies,

is posited on grounds similar to the first, symmetry being a special case of repetition. However, since symmetry tends to put a limit on the number of repetitions, one might expect that the association would not be as strong. Note also the bilateral symmetry can be said to involve an 'original' image and a mirror image which is the opposite or negative of the first. This could suggest an egalitarian society perhaps but with an emphasis on competition between ostensible equals, *i.e.*, some interest in establishing a hierarchy, but without success in stabilizing it.

The fourth hypothesis, association of enclosed figures and hierarchical society, assumes that in the hierarchial society boundaries between individuals of different ranks are important. Higher are protected from lower and vice versa by figurative boundaries of etiquette and prescriptions of time, place, and nature of association, and also often by physical obstacles such as walls and fences, doors, moats, etc.

Table 1. Relation of Social Stratification (Murdock Col. 14)
to Variables of Art Style (Barry)
Stratification of Peers

Art Style	Low (A,O)	High (W,C,H)	
Simple design	13	1	p is less than ·005
Complex design	6	8	

Note: Since there are in fact more societies with low stratification than high in the sample, one would expect more with simple art styles. If one increases the number of societies with simple styles by moving the point of dichotomy up the scale of complexity, the distribution is as follows:

	Low	High	
Simple design	16	1	p then becomes
Complex design	3	8	·000045
	Low	High	
Space empty	12	2	p is less than ·05
Space crowded	7	7	
	Low	High	
Design symmetrical	12	2	p is less than ·05
Design asymmetrical	7	7	
	Low	High	
Enclosed figures	7	7	p is less than ·05
No enclosed figures	12	2	

Fisher-Yates test used for probabilities.

As is shown in Table 1, all four of these hypotheses are supported as statistically significant levels, especially the first.[9]

A second variable of social structure of considerable psychological importance is the relative prestige or security of the sexes. As a measure of this, types of residence as categorized by Murdock may be used. These may be dichotomized into those which favor male solidarity in residence strongly and those which do not. The former are patrilocal and avunculocal, while the latter are all others occurring in our sample.[10] The hypotheses below assume that individuals of both sexes find it advantageous to live with their own blood relatives if possible. Even where, as is usually true, the younger relatives must serve and obey the older, the younger have their own old age to look forward to, when they will be honored and cared for. In general, the spouse living with blood relatives has an advantage over the in-marrying spouse in obtaining support from other members of the household or family, so the side of the family chosen by married couples to reside with would seem to be a sensitive index of the relative security of the sexes. This choice is also a measure of the prestige of the sexes, in so far as one measure of prestige is deference to the wishes of the person with higher prestige by persons of lower prestige. There are often sound economic reasons, of course, which influence residence choice, as well as other rational and irrational considerations, but even where these exist I believe that there will *also* be an interpersonal prestige significance of considerable weight to the decision. From this reasoning two hypotheses were made, as follows: (1) Straight lines, representing the male form, as opposed to curved, should be associated with societies which strongly favor male solidarity in residence. (2) Complex, nonrepetitive design, representing a hierarchical society, should be associated with societies which strongly favor male solidarity in residence.

Reasoning behind the first hypothesis was that if the society gave high prestige to males and favored close association of males, a fantasy suggesting numerous males should produce security.

The reasoning behind the second hypothesis involved an association between male dominated and hierarchical societies. In man and the primates generally, dominance hierarchies are most developed among males. Also, it seems more likely that the man-wife relationship will be regarded as hierarchical in societies with male solidarity in residence. The data on complexity of design cited above already suggested that hierarchical societies are associated with complex design.

Testing of these two hypotheses yielded the results shown in Table 2. As will be seen, the first hypothesis is strikingly *dis*confirmed and the

opposite association supported. The second hypothesis is confirmed at a more modest statistical level.

Table 2. Relation of Marital Residence (Murdock Col. 8)
to Variables of Art Style (Barry)
Male Solidarity in Residence

Art Style	Low (M,X,B,N,Z,U)	High (A,P)	
Straight lines	14	1	p is less than ·005
Curved lines	6	8	
	Low	High	
Simple	13	2	p is less than ·05
Complex	7	7	

Fisher-Yates test used for probabilities.

An ex post facto explanation of the association between curved lines and male solidarity on residence is slightly more complicated but, I believe, more plausible. We may assume that when an adult individual is psychologically secure he will be extroverted and look for pleasure by seeking out members of the opposite sex. In fantasy a man will be creating woman and vice versa. When, on the other hand, one sex is relatively insecure psychologically, members will be introverted and more concerned in fantasy with improving their own body image and seeking successful models of their own sex to imitate. Thus, to take polar extremes, in societies favoring male solidarity (and sociopsychological security) the men are looking for women as love objects and the women are looking for women as models for self-improvement, while in the societies favoring female solidarity in residence both sexes are looking for men. In visual art, I assume, this concern manifests itself as a relatively greater concern with curved and straight lines respectively.

The reader may have noted that I have grouped with matrilocal residence here some forms of residence, such as bilocal and uxoripatrilocal, which are logically intermediate between matrilocal and patrilocal residence. In the initial test I regarded these as intermediate but on examination found that they grouped with matrilocal rather than patrilocal residence, and amended the hypothesis to its present form. I believe that this finding suggests that the presence or absence of peer support may be more important for adult men than for adult women. If the woman is in an equal position with her husband as far as support of adult relatives goes, as would be the case in bilocal

residence, for instance, she is still in a favorable position in the family because of the support of the children. In the family, it would seem, the wife tends to have the children more strongly on her side, the Oedipus situation being generally more severe for males, because of the strength of early ties to the mother of children of either sex.

On reading an earlier draft of this chapter, Irvin Child, Professor of Psychology at Yale, called my attention to two psychological reports bearing on sex difference in preference for shapes. One of these[11] reports a study of Scottish school children in which it was found that significantly more boys than girls preferred designs with rounded shape and more girls preferred designs with straight, angular shapes; also that the difference between the sexes in preference became significantly more marked after puberty. The other[12] dealt only with college girls but included a questionnaire designed to get at attitudes toward sex roles as well as asking for preference of paired similar pictures differing only in respect to abstract sex symbols in the design. In this the investigator found that those girls who were more accepting of their own sex role significantly preferred more of the 'male' pictures. The findings of both of these studies would fit in with the point of view reached above that sexual instincts affect preference for visual forms differently for the two sexes, but that these preferences can be reduced or even perhaps reversed by socially induced sexual conflict.

As an extension and further test of the above theory it later occurred to me to investigate the relationship between form of marriage (monogamy, polygamy, etc.) and art style. One might assume that in societies where one man may marry two or more women the heterosexual drive of the men is more freely expressed and the men more secure than in those where a man may marry only one woman at a time;[13] that therefore there would be more curved designs in polygynous societies and more straight-line designs in monogamous societies; likewise in the polygynous societies there should be more complex design as a consequence of male hierarchical dominance. Both of these hypotheses are in fact supported by the Barry and Murdock ratings at a statistically significant level, as shown in Table 3.

There is, however, one important qualification. This is that societies with sororal polygyny are distinct from other polygynous societies. In their preference for curvature of line sororal polygynous societies are roughly intermediate between the extremes, and they go with monogamous societies rather than other polygynous societies as far as simplicity of design is concerned. Sororal polygyny is different from ordinary polygyny in that the wives tend to form a united front against the husband in case of conflict. The husband can not so easily play one off against the other, and is not in

such a secure position as other polygynous husbands. Sororal polygyny can be regarded as a compromise between the man's desire for heterosexual relationships and the woman's desire for congenial comrades and coworkers of her own generation. The intermediate position of societies with sororal polygyny in respect to curvature of line seems therefore reasonable.

However, evidently sororal polygyny can work well only in relatively simple egalitarian societies, with at most age-grading as the main legitimate manifestation of the hierarchical principle. In hierarchical societies competition between siblings tends to be too severe to permit sororal polygyny to function: a wife would get along better with an entirely new rival than with her sister, an old rival from childhood. This, I believe, is why the societies with sororal polygyny nearly all have relatively simple art styles, as do the monogamous ones in this sample.

Table 3. Relation of Form of Marriage (Murdock Col. 9)
to Variables of Art Style (Barry)
Form of Marriage

Art Style	Nonsororal polygyny (GNL)	Sororal polygyny (ST) Polyandry (Y)	Monogamy (M)
Simple design	2	7	6
Complex	10	4	–
Straight lines	3	5	6
Curved lines	9	6	–

Using the extremes and omitting the middle colomn p is less than ·005 for both hypotheses using the Fisher-Yates test.

Incidentally, it is not necessary to assume that most men in a polygynous society have more than one wife in order to affect the sociopsychological security of the sex roles. As long as it is understood by a married couple that the husband may legitimately take a second wife, or probably even a mistress, if his first wife is not agreeable enough, this gives even the men in monogamous marriages a considerable psychological advantage. Relatively speaking, in a society in which polygyny is common, a second wife is usually available sooner or later to a man who wants one badly enough, regardless of the lack of a demographic surplus of women. This is so because there is usually a marked difference in marriage age between the sexes, women marrying earlier. In a manner of speaking, young men pay by prolonged

bachelorhood for the polygyny of middle-aged men. The characteristic age difference between spouses where polygyny is common gives the man another psychological advantage.

Moreover, in the relatively complex societies which have nonsororal polygyny the best art is generally produced for the upper class and must be adapted to their taste. If upper class people have polygyny while lower do not, it will probably be the upper class polygynous art which gets collected for museums and reported in ethnographies on the whole. In such societies one would expect distinct class differences in art consistent with the findings about cross-cultural differences described here. Fieldwork directed at this question in a series of appropriate societies would provide a useful further test of these hypotheses.

My colleague, Henry Orenstein, has noted that it would be desirable to have information on the sex of the artists in testing cross-cultural hypotheses about sex symbolism in art. I can only agree that this would be highly desirable, but plead that the ratings were not available in advance. In addition to the considerable work involved, if I made them now myself I would be in danger of biasing ratings in favor of the hypotheses or overcorrecting for impartiality. I would, however, expect systematic differences to show in the use of curved and straight lines by the sexes in most cultures. Incidentally, I might report a casual observation that at a recent exhibit of contemporary American artists at the Newcomb College Art Department (Tulane University) I found myself able to predict fairly well from a distance without reading the labels whether the artist was male or female by noting the relative predominance of curved or straight lines. The men seemed to have more straight lines and the women more curved. One might conclude from this that both sexes in modern American society are insecure in their sex roles. One could also guess that the form of marital residence favored solidarity of relatives for neither sex, as is of course the case.

The question arises as to the relationship between Barry's published findings on art style[14] and the findings reported here. As his title implies, his original study was concerned with predicting aspects of art style from socialization data. Barry concluded that, in his sample of societies, complexity of art style was positively related to general severity of socialization as rated by Whiting and Child,[15] and notes that this measure of severity of socialization applies especially to severe pressure on the child toward independence rather than toward obedience.

This is consonant with the interpretation offered here of the relationship between art complexity and social stratification. In the cooperative, egalitarian society there is a fear of the independent, self-reliant person as well as

of the 'bossy' person. Strength and success are achieved by unity of approximate equals, who must be regarded as powerless alone, for if someone felt competent working by himself he might not cooperate with others when needed. Moreover, since directions for work are given on the whole as subtle suggestions rather than as firm commands, a strong trait of obedience and responsiveness to the wishes of others is highly valued and useful. In the hierarchical societies on the other hand, at least those in which there is substantial practical opportunity to improve one's place in life, obedience and responsiveness to others does not have to be so strongly ingrained, since there are public and explicit means which can ensure compliance. Commands can be stated clearly, with their punishments and rewards. The proper working of the hierarchical society depends on the presence of interested and efficient people in a variety of different independent statuses. This means that each person must be trained to be self-reliant within his own special sphere of competence, and widespread personal ambition is useful in ensuring that the key positions are filled with competent people.

It is interesting to note that Barry conceived of a sort of relationship between social complexity and the complexity of art, on the grounds that technical artistic development might accompany general sociocultural development. To test this he examined the relationship of his art complexity ratings to thirty variables of Murdock's 'World Ethnographic Sample,' at the time in a preliminary unpublished draft. Barry observed that the relationships of art complexity to social stratification and also to nonsororal polygyny (as well as to two other variables, discussed below) appeared to be significant at the 5 per cent level. He did not, however, pursue the significance of these relationships, I gather because the results of many of the variables were poor and because statistically more satisfying results were obtained by choosing socialization severity in advance as an independent variable. One of the statistically significant results he obtained by this wholesale testing, an association of complex art with root rather than grain crops, seems on the face implausible to me and I assume it is a sampling accident. The other result, an association of complex art with sedentary rather than monadic residence, fits in with the social stratification hypothesis in an obvious way.

Barry may have also felt that if socioeconomic variables were relevant to art style, they exercised their effect through their influence on child training and personality, not directly. He and his colleagues have since pursued the question of the relationship of child training to subsistence economy with notable success.[16]

The general point of view of art styles exemplified there, and in Barry's

work from which this is derived, gives high emphasis to social conditions of various sorts as determinants of artistic fantasy or creativity. As such it is in opposition to those views of art which see the development of art style as primarily a matter of technical evolution, or of historical diffusion, or of the influence of the physical environment as model or source of materials. If art style is determined primarily by current social factors this does not invalidate the study of relatively trivial technical details as evidence for historical connection between cultures, and I would not deny the great usefulness of such evidence for some purposes. It does, however, cast strong suspicion on the use of general features of art style to establish historical connections, or on the use of known historical connections alone to explain the similarities of art styles of two distinct cultures. Practically all cultures are evidently exposed to a variety of art styles among their neighbors, and also possess within their own tradition a variety of models which could be developed in various directions. If a neighboring art style at a certain period of history proves congenial no doubt the society will adopt it by importation and imitation, but we must still explain why culture A rather than culture B provides the model, and why the diffusion of style did not proceed in the reverse direction. It is here, I suggest, that similarity of social conditions, and relative order of development of these, plays a major role.

These findings suggest that we may regard a work of art as a sort of map of the society in which the artist—and his public—live.[17] To be sure, unlike a geographic map, a wide, though not unlimited, variety of concrete works of art may represent the same social structure. Also, even in a fairly abstract sense, the works of art are not always isomorphic with aspects of social structure. One would not conclude, for instance, that a preoccupation with rounded female forms indicated a numerical preponderance of women in the society; one would simply conclude that the social structure encouraged the artist's interest in women. We might then speak of a work of art as a selective cognitive map of the society with predictable distortions.

The question may be raised whether the artist should not be said to be depicting a wish rather than social reality. I would concede that the wish-fulfillment aspect of art is in some sense primary, but would at the same time urge that wish-fulfillment and reality are closely related, even in fantasy. For art to be effective as wish-fulfillment it must attain a certain degree of plausibility by at least making a rather close compromise with reality. If the artist in a simple egalitarian society finds pleasure in repeating the same simple design over and over again, it is because he can in reality find whatever security and pleasure he knows in a repetitive, undifferentiated social structure. If the artist in a polygynous society becomes preoccupied with

curved female forms it may be because he knows he has in the long run a good chance of obtaining security and pleasure from relationships with women. Of course, the questions of relating to peers in an egalitarian society and obtaining women in a polygynous society are also frequent sources of frustration. Problems as well as sources of pleasure are involved, but there are also culturally prescribed solutions which, if not infallible, are usually seen as the best possible.

For an anthropologist, one of the most exciting possibilities that the study of art styles and social conditions opens up is the application to extinct cultures known only through archeology. If we can learn enough of the pan-human implications of art styles for social structure and the resulting psychological processes, we should eventually be able to add a major new dimension to our reconstruction of the life of extinct peoples known only from their material remains.

APPENDIX: BARRY RATINGS OF PICTORIAL ART VARIABLES USED IN THIS PAPER

Note: For a description of the manner in which the ratings were made see Barry.[18] In the following lists the order of the societies corresponds to their rank with respect to the art variables, the most extreme being at the beginning and end of the lists. The ratings deal only with graphic art, not with three-dimensional sculpture. For ratings on the social structure variables consult Murdock.[19] The Kwakiutl, while rated by Barry and listed below, are not included by Murdock.

Simple	Empty	Symmetrical	No Enclosed Figures	Lines Straight
Andamans	W. Apache	Yakut	Andamans	Navaho
Chenchu	Chenchu	Teton	Ashanti	Ashanti
Masai	Chiricahua	Omaha	Chenchu	Teton
Yagua	Comanche	Ainu	Yagua	Thonga
Paiute	Omaha	Paiute	Zuni	Yagua
Papago	Ainu	Comanche	Murngin	Paiute
Thonga	Paiute	Navaho	Navaho	Marshalls
Navaho	Thonga	Zuni	Comanche	Hopi
Murngin	Yakut	Hopi	Thonga	Ifugao
Marshalls	Teton	Arapesh	Hopi	Chenchu
Hopi	Hopi	Andamans	Maori	Maori
Zuni	Marshalls	Thonga	Masai	Zuni

Comanche	Masai	Marshalls	Paiute	Omaha
Omaha	Zuni	Yagua	Papago	Andamans
Ifugao	Ifugao	Chenchu	Omaha	Samoa
Ainu	Navaho	Kwakiutl	Teton	Ainu
W. Apache	Papago	Samoa	Alor	Marquesas
Chiricahua	Dahomey	Maori	Trobriands	W. Apache
Ashanti	Andamans	Marquesas	Marshalls	Masai
Teton	Ashanti	Murngin	Ainu	Comanche
Arapesh	Murngin	Papago	Ifugao	Murngin
Maori	Arapesh	W. Apache	Marquesas	Papago
Trobriands	Kwakiutl	Chiricahua	Dahomey	Yakut
Kwakiutl	Yagua	Ifugao	Kwakiutl	Chiricahua
Alor	Alor	Trobriands	Arapesh	Alor
Dahomey	Samoa	Ashanti	W. Apache	Arapesh
Samoa	Trobriands	Masai	Bali	Kwakiutl
Bali	Maori	Bali	Yakut	Bali
Yakut	Bali	Dahomey	Samoa	Dahomey
Marquesas	Marquesas	Alor	Chiricahua	Trobriands
Complex	*Crowded*	*Asymmetrical*	*Enclosed Figures*	*Lines Curved*

NOTES

[1] For useful discussion of the methodological problems involved in investigation of this type, see George M. Murdock, *Social Structure* (New York: Macmillan, 1949); J. W. M. Whiting and I. L. Child, *Child Training and Personality* (New Haven, Conn.: Yale University Press, 1953); and J. W. M. Whiting, 'The Cross-Cultural Method,' in G. Lindzey (ed.), *Handbook of Social Psychology* (Cambridge, Mass.: Addison-Wesley, 1954). For further information on the statistical methods used, see Sidney Siegel, *Nonparametric Statistics for the Behavioral Sciences* (New York: McGraw-Hill, 1956).

[2] *Journal of Abnormal and Social Psychology*, LIV (1957), 380–383.

[3] George P. Murdock, 'World Ethnographic Sample,' *American Anthropologist*, LIX (1957), 664–687.

4 J. W. M. Whiting and I. L. Child, *op. cit.*

5 These ideal types are set up for the purpose of simplifying the exposition and derivation of hypotheses. There is no intent of course to claim that any real human society can be categorized as purely hierarchical or egalitarian. On the contrary, all real societies fall at various intermediate points along a continuum between the two poles. On an impressionistic basis I would guess that if there is any tendency of societies to cluster it is near the center of the continuum—a balance between the two structural principles—rather than near either or both extremes. Even in this central group, however, any two societies can be compared as to their relative nearness to the two poles, and their art styles can then be investigated to see whether they differ in the predicted direction. The statistical summaries given herein do this on a group basis.

6 Although of course important individual personality variation due to differences in inherited constitution and life history is to be found in all societies, this simplistic conception of people postulated here, I believe, has a definite effect in actually reducing personality variation among members of egalitarian societies. Therefore, even though simplicity in art design is far from a complete representation of the personality of its producers and consumers, I believe that the relationship between simplicity of art design on the one hand and personality and social structure on the other should be, as the data cited suggest, positive (the more A, the more B), not negative or antithetical (the more A, the less B).

7 One might be tempted to argue that enclosed figures should characterize the art of egalitarian societies as a means of symbolizing the isolation desired and often achieved relatively well. However, one must consider that the isolation desired by these people is isolation of the whole in-group, while within the in-group close contact is desired with other individuals. At most this might lead one to hypothesize a tendency to frame the entire design in an enclosure but not to enclose separate figures within the design, I believe. For reasons too lengthy to discuss here I am doubtful about hypothesizing even the framing tendency.

8 Clyde Kluckhohn has pointed out that empty space is characteristic of at least some Japanese pictorial art and asked how this may be reconciled with the interpretation given here. One question which arises is whether Japanese art is really characterized by empty space in terms of Barry's scale. As it happens, Barry did include Japan in his initial ratings but later dropped it because he felt that the country was too diverse and there was no guarantee that the art works rated were characteristic of the particular segments of the society from which the Whiting and Child socialization data came. Barry put Japan on the 'crowded' side of the dichotomy, about intermediate between median and extreme. This suggests that while Japanese graphic art has much empty space by Western standards, it is still relatively crowded compared to the art of many primitive societies.

Another problem which arises is that Barry's sample was limited almost entirely to simple and middle-level societies. The only literate society

included was Bali (also, incidentally, on the crowded side of the dichotomy). Perhaps in stable, large-scale, literate societies relationship to a social hierarchy is taken for granted more than in middle-level hierarchical societies. If so, the artist might safely engage in compensatory fantasies of temporary withdrawal from the hierarchy, the withdrawal being represented artistically by the empty space. But one would not expect this withdrawal to be extreme. The withdrawal of the simple primitive from foreigners should be more drastic psychologically than the withdrawal of man in civilized society from his obligations and restrictions. If this reasoning is correct the emptiest art should be found in simple societies, the most crowded in middle-level societies, and somewhat emptier art again in complex, stable societies.

9 If one tests a large enough number of hypotheses it is to be expected by chance alone that one will receive confirmation of some of them at 'significant' statistical levels. Statements of probability levels of confirmation of hypotheses are therefore questionable unless accompanied by a statement as to the total number of tests from which the reported significant tests were selected. For this paper the total number of hypotheses from which the 6 tests reported in Tables 1 and 2 were selected was 20. None of the other fourteen hypotheses was supported or contradicted at a statistically significant level.

10 Murdock, *op. cit.*, Column 8: P, A vs. V, Z, N, B, X, M.

11 W. A. McElroy, 'A Sex Difference in Preference for Shapes,' *British Journal of Psychology*, XLV (1954), 209–216.

12 Kate Franck, 'Preferences for Sex Symbols and their Personality Correlates,' *Genetic Psychology Monographs*, XXXIII (1946), 73–123.

13 There are grounds for questioning this assumption also. Some might argue that polygyny is comparable to what the psychoanalysts have described as Don Juanism; that it is a sort of overcompensation for feelings of sexual inadequacy. This is a complex question, but I would simply suggest here in reply that there may be a considerable difference between a Don Juan who conquers many women only to spurn them and a polygynous husband who has lasting responsible ties with two or three wives.

14 *Op. cit.*

15 *Op. cit.*

16 Herbert Barry III, I. L. Child, and M. K. Bacon, 'Relation of Child Training to Subsistence Economy,' *American Anthropologist*, LXI (1959), 51–63.

17 I do not intend to claim that the social factors identified here as relevant to various factors considered in art design are the sole relevant factors. Art is a complex enough phenomenon so that I would not expect to be able to comprehend thoroughly and explain even a fairly limited aspect of it within the scope of a study of this size. The evidence cited suggests, however, that I have a plausible explanation for a good part of the variance for specific factors studied. Of course, as in all statistical studies of phenomena with complex causes, decisions as to the validity of a

hypothesis are unaffected by limited numbers of contradictory cases, and such cases can be expected to occur unless the factor one is studying is unusually strong. Also, it is generally true that a statistical relationship can be interpreted as evidence for more than one set of theoretical explanations, although by no means for just any set. If the reader can propose another set of assumptions which is congruent with the findings reported, further investigation will be required to determine which set is the more powerful.

[18] *Op. cit.*, pp. 390–383.
[19] *Op. cit.*, pp. 664–687.

F. VAN DER MEER

The Basilica*

ALL CHURCHES IN Christendom, from the greatest cathedrals to insignificant chapels in the Greek Islands with domes like nutshells, are heirs of that compact and unassuming building of the fourth century, which contains them all in essence—the building called a 'basilica.' Century after century, the forms of the buildings based on the basilica have changed, every imposing variant giving way to a successor: the massive Romanesque abbey church, the Gothic cathedral, the Duomo of the Renaissance, the festive halls of the Baroque, and the cold spaciousness of a Classical church interior; today, every one of these belongs to the past; but the elements that are essential to a basilica reappear over and over again (provided that bad workmanship does not mask them, they appear in even the most modern of modern churches).

The situation is the same in the case of the Orthodox churches of the East. When viewed from the outside, it may seem that few buildings could show slighter kinship with Early Christian basilicas than Greek or Russian churches, with their five domes; yet the ground plan, the arrangement of the interior, indeed, the layout of the entire building, are very similar to those of the earliest basilicas.

The churches of the faith have remained as constant and unchanging as the faith itself. Builders have tried their hands at many styles, sometimes striking an alien note, sometimes producing a work of almost visionary beauty. Yet always the basilica motif underlies the planning.

It is natural to assume that the oldest churches would not only be the simplest but would also express in the most unambiguous way the very nature of a church: what is taken from near the source we would expect to

*Reprinted from *Early Christian Art*, 1967, by permission of the author and the publishers, Faber and Faber Ltd. and The University of Chicago Press. Translated by Peter and Friedl Brown.

be crystal clear. But whether or not the oldest churches of all unequivocally display an architectural form valid for all time, is a different question; and the answer to it is, No. The decisive elements that were there from the beginning, and which will last until the end of Christianity—for the believer until the end of the world and the coming again of his Lord—are not so much architectural features as elements bound up with the nature of the Church and its liturgy. The first Christians 'went to church' in houses. From the third century, these might be very great buildings, but nonetheless they still always bore the same name of *domus ecclesiae*—'house of assembly' —or, since *ecclesia* (assembly) is the same as our 'church'—'church-house.' For a long time, these 'churches' must have been purely makeshift or occasional. We do not know when the first attempt was made to build a church as such, because in 304 all churches in private houses in the Roman Empire were pulled down by order of the Emperor Diocletian; and if some did survive here and there, they have not been preserved, and we do not know what they looked like.

On the other hand, it is obvious that when the Christian Church became a recognized institution of the Empire in 313, Christians everywhere had to set about erecting new churches, intended for public worship: they immediately sought a type of building that could meet the unique requirements of the *domus ecclesiae*—requirements which in those days would have been regarded by an outsider as extraordinary innovations.

The remarkable thing is that as often as not the first attempt at a design was the one that remained valid. We know from the documents that immediately after the Edict of Toleration of 313, the Emperor took in hand the building of gigantic Christian shrines, financed by government funds. From the surviving monuments, which we know well, we can gather that these first buildings were not basically different from the innumerable churches that followed in the course of the next two centuries, throughout all the provinces of the Roman world. This is not to say that no single church was built that deviated from the usual type. This deviation may well have been intentional: we know of some such exceptions, for instance the Great Church of Antioch, built on an octagonal ground plan; or in Rome itself, four great cemetery-basilicas, surrounded by ambulatories. (These four, the basilicas of the Apostles [now San Sebastiano], of St. Agnes, of St. Lawrence, and of SS. Peter and Marcellinus—the three last known only from their remains and excavations—were foundations of the Constantinian dynasty.) The original Basilica Salvatoris (St. John Lateran) had no transept, and a staggered western end, with a projecting apse. But it remains true that the overwhelming majority of all churches built after 313 are of the same type—not

three-quarters of them, but ninety-nine per cent. Overnight this type, the 'basilica,' seems to have become the standard form for a church. We are forced to conclude either that this type of building already existed, in essence, at the time of the persecutions (before 313) or, failing this, that we are dealing with one of those simple and latent creations of genius that suddenly come into being and then determine the history of architecture for an incalculable stretch of time.

I personally believe, that this last suggestion is the correct one: at least for the layout of the building. This form did not 'evolve': things created by the human mind are not subject to 'growth' in the biological sense. They arrive, once and for all, through the creative power of an individual—in this case, of an architect (or a succession of architects) who risked this decisive step, only to be proved right. It is possible that there were many of them, that they learnt from each other through what they created, that they had borrowed certain elements: but this is not necessarily so. At one point of time, the decisive stage was reached, at which a particular individual found his way to a synthesis, that carried conviction and set the tone for the whole future of ecclesiastical building. A parallel to this is the sudden flowering of the Baroque church interior. This interior design is not the result of a gradual evolution: instead, we owe it to the completely unexpected, unheralded sketch of Vignola for *Il Gesu*. Or consider the beginnings of classical French Gothic: the really new idea of making the side walls soar and then covering them with tapestries of glass, belongs to the architect of Chartres, who drew up the first design in 1194; it is his idea and no one else's. We do not know who made the regal ground plan of the first basilica proper, in 313 or some years later (possibly even, for all I know, earlier, although this is less probable); but it is a thoroughly satisfying solution to a complex problem. Perhaps it was the master of the 'Basilica of the Saviour' (modern St. John Lateran) which, as the principal church of the first bishop in the Roman world, is still called 'Mother and Head of all the churches of the City and the World'—*Urbis et Orbis*. Both in origin and in status this church stands first in the succession of the earliest great basilicas, though its primacy is not strictly provable.

It is improbable that the basilica existed as an architectural form before 313; certainly, I myself find it difficult to accept the view that it did. But what had existed, and for a long time, was the element that explains the origin of the basilica and the basic lines of its interior—that is, a *liturgy* that had already assumed a fixed form. Before the beginning of the fourth century, this word 'liturgy' stood for the assembly of Christians as such, as well as for the order in which its worship was conducted. There was no

basilica at that time; but the basic elements that would distinguish the basilica from similar buildings were already there. These were determined by the structure of the Christian community and by the nature of its worship, neither of which changed markedly in 313, nor at any later date, and which are today essentially the same wherever Christendom abides by its most ancient traditions.

The action of the unknown creator of the first monumental basilica was simply this: in 313, he provided a convincing architectural form for what were already traditional elements in a Christian place of assembly—a form which was then taken over as the only possible one by the whole of Christendom, with amazing unanimity and speed. For the one surprising thing about the many hundreds of monuments known to us from the period after 313 is this mystifying uniformity. In textbooks, we always find that the local variations are stressed: we are always told how one variant is typical of Africa, another of Illyricum; that in Syria we can see how the basilica built after 313 stems directly from the 'house-church,' because the doors are at the side and we enter the church by passing through an inner courtyard, lying to the south of the main building, as is the case with a private house . . . and so on. What is more important, however, than these local individual quirks, is the way in which these hundreds of basilicas, even in Syria, present the same architectural type; and even two and a half centuries later, this same type remained as the basis of the domed basilica, when the domed church came to predominate in the East.

So far as the Christians of the time were concerned, they were so accustomed to having basilicas everywhere that they took this fact for granted. Occasionally, in a distant country, the magnificence of a particular shrine would impress them, or the splendid position of a great church. But the church itself, and its general plan, was so familiar, that they hardly noticed it. It was the same with the liturgy: with the liturgy, as with the church, they 'felt at home.' Everywhere they found the same faith, and they had lost the habit of being surprised by this: only the church, and not any single sect, could claim the name *catholica*. The only difference that struck them was the difference in the liturgical language. If they were Latins, they noted that the service was sung in Greek, or that the lesson was read in Syriac: in cities of international importance, they would find interpreters who would give a rendering in Latin of the Scripture readings. But the church and the service were the same everywhere. The famous pilgrim, Egeria, a nun of distinguished birth from Northern Spain, visited Jerusalem in 416, during Passion Week and Easter. She describes all the ceremonies that were performed at the Holy Places—ceremonies that no one could have seen else-

where, in an environment where everything testified, in the most insistent manner, to the Passion and Death of the Lord: but what does she have to say of the usual Sunday liturgy that was celebrated in the great basilica on Mount Calvary?—that it began at such and such a time, and that it was just the same as at home! As for the church, she only mentions it, because it is particularly large and magnificent, and because she happens to know that the Emperor Constantine and his mother had founded it.

Wherever they lived, Christians of the fourth, fifth and sixth centuries, 'went to church' in one and the same kind of building—the basilica: and, once inside, they found the same arrangement and the same incomparable atmosphere.

What, then, are the decisive elements of a basilica? These elements are not essentially, or not primarily, specific architectural features that the basilica had in common with the secular public buildings of the time. The basilica, as much as any other building of its age, is a 'late antique' building. We never hear, not even from hostile pagan writers, that the basilicas impaired the beauty of a city's architecture. I think myself that they would not have been very conspicuous; for it was their interiors that counted.

Some time ago it was fashionable to make the basilica 'originate' or 'evolve' from one of the many forms of late antique buildings: from the distinguished upper-class mansion, from the market hall, from certain palace rooms, or from a combination of these forms. It is a harmless game, based on the unconscious acceptance of Darwin's principles of evolution; but it has created a flood of worthless erudition, and it has not brought the question of the origin of the basilica one step nearer to a solution.

It is, of course, obvious that particular elements in a basilica can be found elsewhere: one would have to be blind not to see this. The colonnades of the basilica may, in some cases, be on a larger scale, but they are no different from the rows of pillars of other contemporary interiors in the ancient style. The archivolts (the little arches that hold together the head blocks of the capitals, and so mark the transition between the column and the wall) were once hailed triumphantly as a Christian peculiarity; but even these have also been found in the Palace of the Emperor Diocletian in Split, and, a hundred years earlier, in the city of Septimus Severus, at Leptis Magna in Tripolitania. The great niche that stands at the focal point of the axis of the church as you look lengthways, and so rounds off the interior, and which is called an *apsis* or *absida*, may usually be less spacious in secular buildings; but it is a feature of almost every building, in which a public body had to take seats on a platform—in courts, in the Senate, in Imperial audience chambers. As for the throne of the presiding figure, placed in the center of a row of bench-seats

that run in a concentric semicircle along the sides of this apsidal niche: this existed everywhere, even in schools, and to judge from the mosaics, in literary clubs: the staging of a public meeting in any other way just could not be imagined. The rows of windows placed at a height were already a feature of secular interiors. Soon after 300, round windows appeared. The only impressive innovation was in the structure of the walls, where a clerestory was placed on top of the colonnade. The monumental bronze doors, framed by handsome marble posts, were no different from ornate secular entrances. The veils hung between the pillars were exactly the same as those in the colonnades of palaces. The galleries around the forecourt, the *atrium*, were such as could be seen in rich men's houses, and even—though more as open arcades and more closely connected with the adjacent colonnaded streets— on public squares, in front of great monuments. The fountain in the middle of the *atrium* doubtless took on a symbolic meaning for the Christians, as they washed their hands in its waters before entering the basilica: but this kind of fountain was part of the usual decoration of any of the larger inner-courts in the ancient world. The perforated balustrades of marble, between short square posts or columns topped with fir-cones, that surrounded the altar, and the latticework gates of stone and metal that shut off the apsidal platform of the bishop, could be seen on the forum, in palaces, and in secular meeting-halls: only here and there would the use of a Christian symbol in the carving make it clear that these barriers, the *cancelli*, were intended for a Christian basilica . . . and so on. Although the basilica did not 'evolve,' there was enough that was borrowed, indeed, almost everything; everything, that is, excepting the one thing that was decisive.

For all this is no more than the architectural trappings of the time: we might just as well have added to our list the bricks, the mortar and the blocks of marble. And these external appearances of the basilica will not vanish entirely: it was impossible to abandon all the ancient forms, although a transformation would be brought about by a new feeling for style, that no longer belongs to the ancient world. The one unchanging element, even in the Middle Ages, was the way in which a single building was created to meet certain basic needs which, as we have seen, derived from the structure of the Christian community and the particular nature of their religious gatherings. Such elements were few in number: it will be worth our while to enumerate and emphasize them.

Everyone can see at a glance that the basilica's interior as a place of assembly takes precedence over all other features. As is the case with so many such buildings used for meetings in the ancient world, the basilica has no arresting contours; indeed, it is hardly possible to recognize a careful plan

from the exterior. The outside is merely incidental; it is subservient to the needs of the interior. Furthermore, the basilica was but seldom a spectacular public monument, of the type of the earlier 'peripteros' temple, that stood alone on a high façade of columns; and if it became one at all, it would be only in the predominantly Christian East. On the contrary, it was generally built in between blocks of houses or in cemeteries, hemmed in by rows of tombs. Nobody conceived of the idea of erecting a mighty building to dominate the scene high above the roof-tops, as in a medieval town, where the cathedral rises like a citadel of heaven above the tangle of tiny houses: for that matter, the ancient world had given no thought to endowing their buildings with a marked vertical line; they knew nothing of steeples, nor of the high-pitched dome (their domes were flat, as in the Pantheon). What the early Christians wanted was to build an interior capable of holding many people, and, if possible, to cut it off from the noise of the street and the profanity of life in the city, by a larger forecourt and a thick wall. We must not forget that the Christian community was essentially urban: the church began with small gatherings in houses, always in the towns, always cut off from the bustle of life; Christian propaganda was directed to the individual, and so the Christian assembly was no mass meeting, but rather a silent forgathering of initiates behind locked doors.

The interior was arranged for the 'gathering of the faithful.' This gathering took place with a strict sense of order: the principle of authority was dominant. The attention of the gathering and its rites were always focused on the throne of the presiding member, that is, of the bishop (*episkopos*, 'overseer'; *proestos*, 'leader'), surrounded by the benches of the presbyters (our 'priests,' from *presbyteroi*, 'the elders'). For this reason, the interior had to have a long main axis: all those present stood facing the platform, where the bishop sat on his chair—the *cathedra*. If the bishop was not there, then only a priest who was empowered to do so could lead the gathering; but he never sat on the seat reserved for the bishop. The bishop was the community. The *cathedra* of the bishop was also the symbol of his authority, and, when he expounded the Scriptures, he did so seated: he spoke from his chair— *ex cathedra*—facing his community. Right up to the time of Augustine, in the West, the priests had no right to address the congregation during the service.

But the bishop does not himself speak words of his own devising; he only gives his exposition of the Word of God. For this purpose, each place of assembly has a reading-desk, from which the books of the Scriptures would be read in an order laid down according to the feasts of the ecclesiastical year. This desk is called an *ambo* (from *anabainein*, 'to mount'), because of the steps leading up to where the reader stood. The reader was a well-schooled

young man, with a clear voice, who could read the handwritten codices and declaim them with ease, so he was called a '*lector*.' The bishop did not himself read the Scriptures aloud, as such reading was very tiring; and as he was often an old man, he could not compete with the *lector* in strength of voice and eyesight. (It is no easy business to read fluently from a codex of the fourth century.) The *lector* also faced the congregation when reading.

The elements we have mentioned so far: the room for the gathering of the faithful, the *cathedra* of the bishop on his dais, and the reading-desk for the lessons, were all connected with the visible structure of the community and with what we now call 'preaching the Word.' These gatherings could be attended by anyone interested by catechumens, Jews and pagans. During the 'service of the Word of God' the doors stood open, and anyone who wished, could step inside and listen. But after the lesson and the homily of the bishop (the sermon), the unbaptized were sent out. When they had all gone, the doors were closed. Meanwhile, the candelabra in the nave were lit; the bishop, his priests and deacons would 'step down from the apse and make their way to the Place of Prayer,' in the main nave of the church.

This place was the altar, a small stone table covered with white cloth, that was separated from the crowd of the faithful (now only the baptized) by a low balustrade—the *cancelli* we have already mentioned. The altar stood in the central axis of the building, between the nave and the raised platform with the *cathedra*. But this was the place of prayer: at the altar, the bishop no longer faced the faithful but, standing between the people and the altar, he and his priests and the congregation assembled outside the *cancelli*, turned toward the East, and the bishop 'raised his hands,' the attitude of prayer in the ancient world. The deacons placed the dishes with the bread, and the cup with the wine, on the altar. Then the bishop began the age-old prayer that had already assumed a fixed form in the fourth century, and so today is still called *kanon*—that is, 'the fixed rule.' After the remembrance of the Passion, Death and Resurrection of the Lord, he would bring to a close this prayer of thanks (the *eucharistia*), which included a prayer for the living and the dead, with solemn praise of God the Three in One, which the congregation would affirm, and as it were 'sign for,' by a roar of 'Amen!' Then he would say the Lord's prayer, break the bread, and distribute it to the faithful who had come up to the entrance of the *cancelli*. The faithful, men first, then the women, took the consecrated bread with their right hand, 'so that they could use their left hand as a support for their right,' and swallowed it, then they drank a sip of the consecrated wine from the cup, which the deacon offered them. After a short prayer of thanks, they would disband; the doors would open, and the basilica would empty.

The 'initiates' were those who had 'put on Christ' in baptism. Because of this, a special building stood beside the main basilica of every town, called simply *Fons*, the 'Fountain,' representing the 'Fountain of Life.' There the 'living' water poured from the usual harts' or lions' mouths, into a basin (the *piscina*), that was reached by stepping down three steps. Veiled from spectators, those who had been sufficiently prepared would be baptized, on Easter Eve—on the night of the Resurrection; they too would rise again to a new life, and from then on would be among those who had been 'enlightened,' who carried upon them the seal of the Spirit of Christ.

The two elements which we have just mentioned—the altar and the baptismal font—came into being to enable proper performance of the sacraments of the church; together with the *cathedra* and the *ambo* and the nave that contained the congregation of the faithful, they made up the interior of a Christian church. Everything else is of secondary importance.

When we turn from these essential elements to consider the basilica as an architectural ensemble, we cannot fail to be struck by the simplicity and the certainty of touch with which the basilica builders carried out these basic ideas. For the basilica is a building completely dominated by the purpose for which it is used. Anyone who had crossed the silent forecourt, stepped inside through the curtain and the open bronze main door, and could see before him the body of the church, roomy, untouched by the heat of the sun, lit by windows from above, would understand at a glance; here the community of Christ assembled, under the eyes of God. What baffled the pagans and the police in the house-churches of around 304, was the strange fact that, although they had found a meeting-place, they could not discover a single image of a god; what they confiscated in the end, was 'only books,' which were then burnt on government instructions. Their impression was the right one: there was no place for images in the basilica, but only for thoughts of the Invisible God; and the most precious things it seemed to possess, were books that contained the Word of God. The most priceless treasures of all, however, were known neither to the police, nor to pagan well-wishers: these were the 'mysteries,' of which the altar, standing empty and hidden beneath a cloth, betrayed nothing to the eyes of the uninitiated. Even indifferent and tepid half-Christians, who may have gone to church and heard the lessons and sermons, but could not screw up the courage to be baptized until on their death-bed, did not know these holy secrets.

This message, simple and clear, was perfectly expressed in the spacious interior of a basilica. The well-informed visitor, who let his gaze wander throughout the massive, silent building, would instantly have noticed in the great niche which formed the blank end of the building, its semicircle of wall

covered with incrusted marble-plaques, the high throne of the bishop sur-
rounded by the raised benches of his clergy: nothing could have conjured up
more plainly the idea of authority and of the Apostolic Succession. The small,
empty altar table, always covered up, made inaccessible for the mass of
believers by the *cancelli* that fenced it in, and placed beyond eye and thought
by the silence that surrounded the mysteries associated with it, spoke to the
initiated more plainly than did any book, of the simplicity, the sublime nature
and the power of the 'Food of Life,' as it was called, the 'Medicine of
Immortality.' Even the uninitiated could not avoid the impression of a
worship 'in spirit and in truth,' that would be worthy of an invisible Ruler
and King of the World.

The whole interior must have seemed to contemporaries a powerful,
irrefutable contradiction of what they had been used to seeing in the temples.
The temples had no spacious interior: they were the houses of a God, not of a
community. Their solemn rites would have been performed in broad day-
light, fully open to the public view. The altars would have smoked, as the
flute players blew and the sun shone through the heavy wreaths of vapor
in front of a crowd already impatient for the stage-shows that would, by
custom, follow the ceremonies.

By contrast, a solemn emptiness reigned in the basilicas. Not a single
statue: except for the leaf-patterns of the capitals and a slender cornice, not
a single sculptured motif that stood out in high relief. Towards the end of the
fourth century, the Christians had begun to decorate the high walls of the
clerestory with Biblical scenes in mosaic, and to cover with mosaics the great
niche of the apse and the blank end wall that surrounded it, from the top
down to the upper beading of the marble facing. Here, at the point at which
the spaces of the main building converged, was placed (as a rule) the Re-
deemer in His splendor. This was done with restraint and with an artist's
certainty of touch: the arched surfaces of the conch of the apse, that formed
a quarter-sphere, for instance, would be given shape by road moldings and
strips of frieze, so that the general composition remained a united whole,
easy to understand, and the figures within the actual scene, though they stood
in a stylized landscape, would not have seemed distorted. Figures on too
large a scale—the mistake that so many modern artists make in decorating
interiors—were always avoided in the art of the Early Christians.

In Rome, Christ was usually seen as the Lawgiver of the New Covenant:
He stands on the New Mount of Paradise with its four rivers that flowed
together into the spiritual Jordan, the prefiguration of baptism; flocks of
white lambs, trotting out from the sheep-pens of the Circumcision and of the
Gentiles, drink from this river: while the Lord hands over the Law of the

Gospel to the new Moses, to Peter, easily recognized by his characteristic head and by the cross of his martyrdom. On the other side of the mountain stands Paul; and above a landscape, dotted with the palm trees of the heavenly paradise, in which can be seen the Phoenix-bird, the symbol of immortality, drift the fire-tinged clouds of the ethereal regions, warning the beholder of Him who would one day come again 'in the clouds of Heaven.' This famous composition, in which the two Apostles, who had died and were buried in Rome, appeared in the company of the Lord, could in all likelihood have been seen in the apse of the old church of St. Peter, which has vanished today: and, over many centuries, it was imitated in many other churches. Another mosaic showed the Lord holding sway in the city of the Heavenly Jerusalem, between Apostles seated on thrones, Peter and Paul on each side, and behind Him the sign of the Cross, surrounded by the Four Beasts of the Revelation of St. John: this can still be seen in the little church of Santa Pudenziana—the 'Church-house of Pudens,' as it was called in ancient times that date back to the time of the persecutions.

The great blank wall around the apse was either divided up into several parts like a frieze, one above the other (as in Santa Maria Maggiore), or it would have contained only one great composition—often of the twenty-four elders praying to the Lamb, from the book of Revelation: there are examples of this in San Paolo Fuori Le Mure, in SS. Cosmas and Damian on the Forum, and in many other later basilicas. The walls of the nave were decorated with scenes from the Story of Salvation in mosaic or fresco, often arranged in such a way that the scenes from the Old Testament, on the left, echoed the scenes from the New Testament, on the right; an example is in the main church dedicated to St. Peter and St. Paul (though the picture cycle has disappeared). This marks the beginning of the famous 'typological' juxtaposition of the two Testaments, that was such an important feature of the decoration of churches far into the Middle Ages: it is the origin of that great cycle of Biblical pictures, which we find century after century, in mosaics as well as in fresco, on the walls of every church in East and West.

From a technical point of view, the basilica was an uncomplicated building. The middle nave was as broad as the beams of the roof-support would allow: the dividing of the church into three or five naves, quite apart from the natural structure of the building, was necessary to gain sufficient freedom of movement. The entrance-hall, the adjoining buildings, the forecourt with its four galleries (*quadriporticus*) and the fountain for washing one's hands—all these were joined to the main building as simply as possible, in rectangular blocks, as in a modern ground plan. So the building as a whole impresses modern man as being unpretentious and matter-of-fact: it was not a mean

building however, for even small churches of out-of-the-way townships were furnished with great care.

What is more, the basilica, as a building, had no ulterior 'meaning.' It may have been described as 'a mother's womb,' that 'takes all inside it,' as 'the royal throne-room for our King,' as 'the house of all men,' in inscriptions and in the verses of some poets, such as Paulinus and Prudentius; but the form of a basilica as such, was not dictated by concepts of this kind. The Gothic royal cathedrals of the Ile de France may have been consciously contrived by all means calculated to impress the senses, above all by their stained glass, to evoke the Heavenly Jerusalem, built with precious stones, to which a basilica was compared in the liturgy of its consecration; but the basilica was not built to 'symbolize' anything. We do not know the rites for the consecration of the earliest basilica; but the thesis that the basilica of the fourth and fifth centuries, with its 'street of colonnades,' was a visual image of the City of Heaven, seems to me to lack foundation.

The basilica then is not a symbolic building; it is austere and matter of fact. But the historian is impressed by the fact that the very greatest and most magnificently furnished Roman basilicas—in Rome, or in Constantine's city on the Bosphorus, in Jerusalem or Ephesus—were built as broad halls of columns, roofed over with rich, gilt, coffered ceilings. Except for the conch of the apse, the basilica was never vaulted. It is plain that vaulting was consciously avoided in these mighty buildings. It is inconceivable that men who could build secular meeting-halls, such as the Basilica of Maxentius and Constantine on the north side of the Roman Forum, resting on a solid block of walls, in which the barrel vaults of the supporting side-naves covered a span of twenty-three meters (some of them are still standing today), were no longer capable of doing the same for a building of similar dimensions intended for Christian worship. It was a matter of not wanting to use vaulting; vaulting was common for public baths (some of which we can still see in Rome: those of Diocletian—now part of Santa Maria degli Angeli—and the ruins of the Baths of Caracalla); for some smaller buildings—cellars, store-rooms, blocks of dwellings, mausoleums; also for underpinning on a large scale, as in an amphitheater. Plainly in planning a basilica, vaulting was deliberately renounced. Why was this? Perhaps because it was not thought suitable for sacred purposes. The dim glow of a gigantic coffered ceiling would have been the admiration of all contemporaries; it was a continuation in the Christian basilica of the traditional rich coffered ceiling of pagan temples. (Theodor Klauser has also pointed out to me the way in which this flat ceiling would contribute to the total effect of the interior; in order to stress the crucial significance of the semicircular lines of the vaulted niche of the

apse, the remaining parts of the interior are given a pure, cubic form; the flat floor, the flat ceiling and the severely vertical, straight walls on either side, converging by an effect of perspective, and leading the eye inevitably up to the apse with its altar and the *cathedra* of the presiding bishop.) Not until Baroque times did builders transform the remains of the Roman baths into vaulted churches.

The early Christian builders rejected the vaulted roof and chose the solemn hall with its rich ceiling. This appears to us to be a transitory form, but in practice it would last very well; and in the eyes of the early Christian, it was an appropriate setting for sacred art. Two centuries later, the builders of the eastern half of the Empire would combine the motif of a dome, rising from a central position with its four sides open, like the domed covering above an altar, with the layout of the ancient basilica; and in this way they introduced the general use of vaulting in Christian ecclesiastical architecture. Their example was not followed in Rome. The first church here to be fully vaulted was built at the end of the thirteenth century by foreigners, who had come from Southern France: the Dominicans' Santa Maria Sopra Minerva, which has remained the only Gothic church in Rome. Only with the Renaissance was the distinctive Italian form of vaulting introduced into Roman churches.

But this 'utilitarian' air in the classical basilica did not imply that the founders and the faithful were grudging in their endowments. The Emperor himself set the tone in endowing the most important shrines: and at a time when so much wealth still existed, as in the first decades of the fourth century, the furnishings of a church would have been of an overpowering magnificence. We happen to possess, in the *Liber Pontificalis*, that invaluable chronicle of the popes, the authentic lists of the endowments that Constantine had made to certain famous basilicas, among which were the Lateran Basilica, St. Peter's on the Vatican Hill, St. Paul on the road to Ostia, San Lorenzo Fuori Le Mure, and some others. Not only do these endowments include many estates from the Imperial demesnes, whose revenues were devoted to the maintenance of the basilicas, of their ministers, and, not least, of their thousands of oil lamps, but they also included an immense number of golden and silver consecrated vessels, bowls, cups, jugs, candelabra, and ornaments to stand and hang in the church, ornamental columns, veils, metal railings and precious draperies. In the smaller basilicas, even in those founded in poorer times, the interior was furnished with a certain splendor. Candelabra with their innumerable oil lamps and veils hanging between the columns were never lacking. On Easter Eve and on other feasts, any basilica, great or small, in whatever out-of-the-way corner of the world would have

given the impression of being a murmurous festive hall: the crowd streamed in under the red glow of candles, beneath colored hangings with bright embroideries. Over their heads, far away in the depths of the apse, the mosaics reflected the light, and the whole building was immersed in the scent of herbs carelessly trodden under thousands of feet, of marjoram, laurel, myrtle and box.

All this has completely vanished; and only by reading the occasional text can we conjure it up in our imagination. It is not only the Goths and Lombards who have stolen the gold and silver ornaments: time itself has annihilated what remained. The only thing that has usually survived is the mosaic floor. Some are still intact. The oldest and the largest of these can be seen in the medieval Cathedral of Aquileia, once an important city, now a village. This floor, of around 310–20, lay under two layers of later flooring, and has now been uncovered between the early Gothic columns of the nave. Mosaic floors of a later time, especially of the sixth century, can be found everywhere. Right beside Aquileia, in Grado, there is a floor—again within the present-day cathedral—which was endowed in the sixth century, partly by the congregation of the faithful, and partly by their clergy: the inscriptions with the names of the benefactors of each piece can still be read. At that time, anyone who wanted to do something for the church would present a piece of mosaic flooring, or a ritual vessel, or a curtain: only the most distinguished would found a *memoria* (that is, a chapel of remembrance in honor of the relics of a saint) or a mausoleum for himself and his family; while only princes and bishops would have had the means to found, and largely meet the cost of, a basilica.

The magnificence of southern lands, always dignified and somehow subdued, that characterizes the early basilica, was a matter of course for the Christians of the fourth and fifth centuries. Poverty, in their opinion, ill-suited the 'house of the family of God.' Even the significant name that they used for their church—*basilica*—pointed to this: for this name meant 'a monumental public building.' Before 313, in the time of the persecutions, they called what were often handsome churches in private houses, 'the house of the community,' or the 'house of prayer.' After Constantine, however, along with the accustomed word *ecclesia*, *basilica* suddenly becomes current, especially in the Latin West; the new term may well have some connection with the unexpected monumental quality of the more prominent new churches. After the dissolution of the old religion under Theodosius the Great, when house-churches everywhere, humble and large, were replaced by spacious, and often monumental, colonnaded halls surrounded by court-yards and annexes, both names remained in use. But *ecclesia* was the original

name, and was the more popular, as is shown by the survival of the word in nearly all Romance languages. With a fine instinct, the faithful preferred to keep, instead of the empty and secular name *basilica*, the older, richer and more striking word *ecclesia*. By the nineteenth century, *basilica* became a purely technical term of art history: it stood for a very definite type of building, dating from Christian late antiquity: but for many centuries the basilica had been the keystone of European architecture, an inexhaustible theme on which the Romanesque abbey-churches, the Gothic cathedrals, the cupola halls of the Renaissance, even St. Peter's and the Baroque interiors, are but brilliant variations.

IAN WATT

*Private Experience and the Novel**

AARON HILL WAS perhaps the most ebullient member of the vociferous Richardson claque, but when he announced that 'a force that can tear the heartstrings' had appeared 'to gild the horror of our literary midnight'[1] he was only slightly exaggerating the emotional enthusiasm with which *Pamela* and *Clarissa* were received by most of his contemporaries both in England and abroad.[2] . . . One reason for this enthusiasm was the way that Richardson's subject matter endeared him to feminine readers; but the men, on the whole, seem to have been almost equally excited, and so we must seek for further explanations.

One fairly common view has been that Richardson's novels gratified the sentimental tendencies of his age. 'Sentimentalism' in its eighteenth-century sense denoted an un-Hobbesian belief in the innate benevolence of man, a credo which had the literary corollary that the depiction of such benevolence engaged in philanthropic action or generous tears was a laudable aim. There are undoubtedly features in Richardson's work which are 'sentimental' in this as well as in the current sense, but the term is nevertheless somewhat misleading when applied either to his own outlook or to the characteristic literary quality of his novels. For, as we have seen, Richardson's moral theory was opposed to the cult of love and emotional release in general, while in his practice as a novelist he presented a much wider range of feelings than those to which the sentimentalists proper usually restricted themselves. What is distinctive about Richardson's novels is not the kind or even the amount of emotion, but rather the authenticity of its presentation: many writers of the period talked about 'sympathetic tears'; even more deplorably

* Reprinted from *The Rise of the Novel*, 1957, by permission of the author, the British publisher, Chatto & Windus Ltd., and The Regents of the University of California.

Richardson talked about 'pellucid fugitives,'[3] but he made them flow as no one else and as never before.

How Richardson made them flow, how he involved his readers so deeply in the sentiments of his characters, is well described by Francis Jeffrey in the *Edinburgh Review* (1804):

> Other writers avoid all details that are not necessary or impressive. . . . The consequence is, that we are only acquainted with their characters' in their dress of ceremony, and that, as we never see them except in those critical circumstances, and those moments of strong emotion, which are but of rare occurrence in real life, we are never deceived into any belief of their reality, and contemplate the whole as an exaggerated and dazzling illusion. With such authors we make a visit by appointment, and see and hear only what we know has been prepared for our reception. With Richardson, we slip, invisible, into the domestic privacy of his characters, and hear and see every thing that is said and done among them, whether it be interesting or otherwise, and whether it gratify our curiosity or disappoint it. We sympathise with the former, therefore, only as we sympathise with the monarchs and statesmen of history, of whose condition as individuals we have but a very imperfect conception. We feel for the latter, as for our private friends and acquaintance, with whose whole situation we are familiar. . . . In this art Richardson is undoubtedly without an equal, and, if we except DeFoe, without a competitor, we believe, in the whole history of literature.[4]

[Among] the constituents of the narrative method described by Jeffrey [are] the more minutely discriminated time-scale and the much less selective attitude to what should be told the reader, which are characteristic of Richardson's formal realism. But this unselective amplitude of presentation does not alone explain how Richardson enables us to 'slip . . . into the domestic privacy of [the] characters': we must take account of the direction as well as of the scale of his narrative. This direction, of course, is toward the delineation of the domestic life and the private experience of the characters who belong to it: the two go together—we get inside their minds as well as inside their houses.

It is primarily this reorientation of the narrative perspective which gives Richardson his place in the tradition of the novel. It distinguishes him from Defoe, for example: since although both writers were, as Mrs. Barbauld wrote, 'accurate describers, minute and circumstantial, . . . the minuteness of Defoe was more employed about things, and that of Richardson about persons and sentiments.'[5] In combination with his fullness of presentation

it also distinguishes him from the rival French claimants to the paternity of the modern novel. When George Saintsbury, for example, concludes that *Pamela* is indeed the first novel, he does so because the only answer he can give to the question 'Where are we to find a probable human being, worked out to the same degree, before?' is—'Nowhere'.[6] There are many equally probable and perhaps more interesting characters in literature before Pamela, but there are none whose daily thoughts and feelings we know so intimately.

What forces influenced Richardson in giving fiction this subjective and inward direction? One of them is suggested by the formal basis of his narrative—the letter. The familiar letter, of course, can be an opportunity for a much fuller and more unreserved expression of the writer's own private feelings than oral converse usually affords, and the cult of such correspondence was one which had largely arisen during Richardson's own lifetime, and which he himself both followed and fostered.

In itself it involved a very significant departure from the classical literary perspective; as Madame de Staël wrote, 'the ancients would never have thought of giving their fiction such a form' because the epistolary method 'always presupposes more sentiment than action.'[7] Richardson's narrative mode, therefore, may also be regarded as a reflection of a much larger change in outlook—the transition from the objective, social and public orientation of the classical world to the subjective, individualist and private orientation of the life and literature of the last two hundred years.

The contrast is a fairly familiar one. It is implied in Hegel's comparison between ancient and modern tragedy, or in Goethe's and Matthew Arnold's yearning for the impersonality and objectivity of Greek and Roman art, as opposed to the feverish subjectivity of their own romantic literature; and its most important aspect from our point of view is expressed by Walter Pater in *Marius the Epicurean*, when he comments on how the ancients were 'jealous for the most part of affording us a glimpse of that interior self, which in many cases would have actually doubled the interest of their objective informations.'[8]

Some of the most important causes of the very different modern emphasis have already been mentioned. Christianity in general, for example, was essentially an inward, individualist and self-conscious kind of religion, and its effects were strongest in Puritanism, with its stress on the inner light; while the indispensable Madame de Staël drew attention to the influence of the changed philosophical outlook of the seventeenth century on the novel's subjective and analytic approach to character: '*ce n'est même que depuis deux siècles que la philosophie s'est assez introduite en nous-mêmes pour que l'analyse de ce qu'on éprouve tienne une si grande place dans les*

livres.'[9] The secularization of thought which accompanied the new philosophy tended in the same direction: it produced an essentially man-centered world, and one in which the individual was responsible for his own scale of moral and social values.

Finally, the rise of individualism is of great importance. By weakening communal and traditional relationships, it fostered not only the kind of private and egocentric mental life we find in Defoe's heroes, but also the later stress on the importance of personal relationships which is so characteristic both of modern society and of the novel—such relationships may be seen as offering the individual a more conscious and selective pattern of social life to replace the more diffuse, and as it were involuntary, social cohesions which individualism had undermined. Individualism also contributed to Richardson's emphasis on private experience in at least two other respects: it provided an audience deeply enough interested in all the processes that occur in the individual consciousness to find *Pamela* absorbing, and its economic and social development eventually led to the development of the urban way of life, a fundamental formative influence on modern society which seems to be connected in many ways with the private and subjective tendency both of Richardson personally and of the novel form in general.

Eighteenth-century London had an importance in the national life of the time that was unequaled elsewhere. Throughout the period it was over ten times as large as any other town in England,[10] and, perhaps even more important, it was there that such social changes as the rise of economic individualism, the increase in the division of labor, and the development of the conjugal family were most advanced; while, as we have seen, it also contained a very large proportion of the reading public—from 1700 to 1760 over half of the booksellers of England were established there.[11]

The continual increase of the size of London was noted by many observers. They were especially struck by the proliferation of buildings beyond the ancient limits of the twin cities of London and Westminster, which became particularly evident after the Great Fire of 1666.[12] Fashion moved westward and northward, while to the east settlements arose which were almost exclusively inhabited by the laboring poor. This increasing segregation of classes was commented on by many writers. Addison's remarks in the *Spectator* are particularly significant:

When I consider this great city in its several quarters and divisions, I look upon it as an aggregate of several nations, distinguished from each other by their respective customs, manners and interests. . . . In short, the inhabitants of St. James's, notwithstanding they live under the same laws,

and speak the same language, are a distinct people from those of Cheapside, who are likewise removed from those of the Temple on the one side, and those of Smithfield on the other.[13]

This process—the growth of London and its accompanying social and occupational differentiation—has been seen as 'perhaps the most important single feature of the social history of the late Stuart period.'[14] It is at least the plainest of many indications that something approaching the modern urban pattern was gradually imposing itself on the more cohesive community that Shakespeare knew, and we should therefore expect to find that some of the distinctive psychological features of modern urbanization began to manifest themselves at the same time.[15]

The growth of the population of London in the last decades of the seventeenth century from about 450,000 in 1660 to 675,000 in 1700,[16] combined with the increasing residential segregation of its inhabitants, and the extension of the metropolitan area, was certainly on a large enough scale to make the contrast between the rural and urban ways of life much deeper and more complete than it had been previously. Instead of the countryman's unchanging landscape, dominated by the regular alternation of the seasons, and the established hierarchy of social and moral order symbolized by the manor house, the parish church and the village green, the citizen of eighteenth-century London had a horizon that was in many ways like that of modern urban man. The streets and places of resort in the various quarters of the town presented an infinite variety of ways of life, ways of life that anyone could observe, and yet for the most part utterly alien to any one individual's personal experience.

This combination of physical proximity and vast social distance is a typical feature of urbanization, and one of its results is to give a particular emphasis to external and material values in the city-dweller's attitude to life: the most conspicuous values—those which are common to the visual experience of everyone—are economic; in eighteenth-century London, for example, it was the coaches, fine houses and expensive clothes which pervaded the outlook of Moll Flanders. There was no real metropolitan equivalent to the expression of the community values available to all represented by the parish church in the country. In many of the new centers of population there was no church at all, and, consequently, according to Swift, 'five parts in six of the people of London [were] absolutely hindered from hearing divine service';[17] and in any case the atmosphere of what was fast becoming 'a mart of infidelity'[18] tended to discourage church-going. Bishop Secker said that 'people of fashion' often attended 'Divine worship in the country . . .

to avoid scandal,' but that they 'seldom or never [did so] in the town.'[19] This decline of religious values in the town made way for the supremacy of material values, a supremacy that was symbolized in the way that London was rebuilt after the Great Fire: under the new plan it was the Royal Exchange and not St. Paul's which became the architectural focus of the City.[20]

An environment so large and various that only a little of it can be experienced by any one individual, and a system of values that is mainly economic—these have combined to provide the novel in general with two of its most characteristic themes: the individual seeking his fortune in the big city and perhaps only achieving tragic failure, so often described by the French and American Realists; and, frequently in association with this, the milieu studies of such writers as Balzac, Zola and Dreiser, where we are taken behind the scenes, and shown what actually happens in the places we know only by passing them in the street or reading about them in the newspapers. Both these subjects also feature prominently in eighteenth-century literature, where the novel supplemented the work of journalists and pamphleteers[21] and revealed all the secrets of the town: both Defoe and Richardson appeal to this interest, and it is even more marked in such works as Fielding's *Amelia* and Smollett's *Humphrey Clinker*. At the same time London figured in much of the drama and fiction of the time as the symbol of wealth, luxury, excitement and perhaps a rich husband: for Steele's novel-reading girl Biddy Tipkins, and for Eliza Haywood's Betsy Thoughtless it is the milieu where everything happens, where people really live; triumph in the big city has become the Holy Grail in the individual's secular pilgrimage.

Few participated in the glories and miseries of London life more intensely than Defoe. London born and bred, he ran the gamut of court and jail, and finally, like the Complete Tradesman he wanted to be and in a sense was, finished life with coach and country house. He was intensely interested in all London's problems, as is evident in such studies as *Augusta Triumphans* (1728), an interesting essay in urban reform, as well as in many of his other works; and he planned to profit directly from London's growth by establishing his ill-fated manufacture of bricks and tiles at Tilbury.

Defoe's novels embody many of the positive aspects of urbanization. His heroes and heroines make their way through the competitive and immoral metropolitan jungle in the pursuit of fortune, and as we accompany them we are given a very complete picture of many of the London milieus, from the Customs House to Newgate Prison, from the poor tenements of Ratcliff to the fashionable parks and houses of the West End. Yet although the picture has its selfish and sordid aspects, it has one very significant

difference from that presented by the modern city. Defoe's London is still a community, a community composed by now of almost infinite variety of parts, but at least of parts which still recognize their kinship; it is large, but somehow remains local, and Defoe and his characters are a part of it, understanding and understood.

There are probably many reasons for Defoe's buoyant and secure tone. He had some memory of the days before the Great Fire, and the London he had grown up in was still an entity, much of it enclosed by the City Wall. But the major reason is surely that although Defoe had since seen enormous changes, he himself had participated in them actively and enthusiastically; he lived in the hurly-burly where the foundations of the new way of life were being laid: and he was at one with it.

Richardson's picture of London is totally different. His works express, not the life of the whole community, but a deep personal distrust and even fear of the urban environment. Especially in *Clarissa*: its heroine, like Pamela, is not one of the 'town-women' whose 'confident' mien Richardson so disliked, but a pure country girl; and her fall is caused by the fact that, as she later tells Belford, 'I knew nothing of the town and its ways.' It is this which prevents Clarissa from realizing that Mrs. Sinclair is 'a very vile creature'; and although she notices that the tea which is being used to drug her 'has an odd taste' she is easily put off with the explanation that it contains 'London milk.' When she attempts to escape from her enemies she is equally at a disadvantage, never knowing what duplicities are hidden in the behavior of the people she meets, or what horrors are being perpetrated behind the walls of its houses. Eventually she must die, because the pure heart cannot survive the immoral brutality of the 'great wicked town,'[22] but not until she has dragged herself through all her Stations of the Cross, from St. Albans to the brothel off fashionable Dover Street, from the shady resorts of Hampstead to the sponging-house in High Holborn, to find peace only when she returns to her native countryside for burial.

It is interesting to note that one at least of Richardson's contemporaries, the anonymous author of the 1754 *Critical Remarks on Sir Charles Grandison, Clarissa and Pamela*, saw the agents of Clarissa's downfall as typical products of urbanization. He wrote that 'such characters as Lovelace and his associates, or mother Sinclair and her nymphs' could only subsist 'in a city like London, the overgrown metropolis of a powerful empire, and an extensive commerce,' and added: 'all these corruptions are the necessary and unavoidable consequence of such a constitution of things.'[23]

There can be little doubt that some of the differences between the attitudes of Defoe and Richardson to urban life are due to the considerable changes

that occurred in the middle decades of the century. This period witnessed many innovations such as the replacement of signs by house numbers, the demolition of the city wall, the creation of central authorities for paving and lighting the streets, water and sewerage, the reform of the police system by Fielding; they are not particularly important in themselves, but they show that conditions demanded quite different methods from those which had formerly sufficed:[24] changes of scale had reached a point which made changes of social organization imperative. Nevertheless, the great contrast between Defoe and Richardson as Londoners cannot be explained only, or even mainly, as the result of the effects of increasing urbanization: the two men were, after all, only a generation apart—Defoe was born in 1660, Richardson in 1689. The major reason for their very different portrayal of urban life is undoubtedly that they were poles apart in physical and psychological constitution.

Even here, however, their differences have a certain representative quality. Defoe had all the vigor of the textile tradesmen pictured by Deloney over a century earlier; like them he was in part a countryman, knowledgeable about crops and cattle, as much at home riding up and down the country as in shop or the counting-house; even in London the 'Change, the coffeehouse and the streets supply him with the equivalent of the watching countryside of saga: and wherever he goes he is at home. But if Defoe harks back to the days of the heroic independence of the citizenry, Richardson offers us a glimpse of the middle-class tradesman to come, bounded by the horizons of the office in the city and the gentility of the suburban home.

London itself certainly provides no way of life in which he can participate. On the one hand, he is deeply aware of the social difference between the tradesmen of the City and the people of quality who inhabit Westminster, and this awareness is not qualified by Defoe's confident preference for his own class. 'There is a bar between us,' Richardson wrote to Mrs. Delany in 1753 concerning a mutual acquaintance, 'Temple-Bar. Ladies who live near Hill Street, and Berkeley and Grosvenor Squares, love not to pass this bar. They speak of it, as if it were a day's journey.' On the other hand, Richardson participated very little in the life of his own environment. He was 'not able to bear a crowd,' and stopped going to church on that account; while even in his own printing-shop he preferred to supervise his own workmen by looking through 'a spy window.'[25] As for the pleasures of the town, they were the road to damnation of such abandoned females as Sally Martin in *Clarissa*, and made him long for 'the last age, when there were no Vauxhalls, Ranelaghs Marybones, and such-like places of diversion, to dress out for and gad after.'[26] Even the life of the streets was rapidly becoming something which only the

poor shared. Certainly not Richardson if we can judge from the description
he gave Lady Bradshaigh of how he walked abroad:

> One hand generally in his bosom, the other a cane in it, which he leans
> upon under the skirts of his coat usually, that it may imperceptibly serve
> him as a support, when attacked by sudden tremors or startings, and
> dizziness, which too frequently attack him. . . . Looking directly foreright,
> as passers by would imagine, but observing all that stirs on either hand of
> him without moving his short neck; hardly ever turning back . . . a regular
> even pace, stealing away ground, rather than seeming to rid it.[27]

There is something about Richardson's gait and posture which is dis-
tinctively urban; indeed even his ailments have this quality, being, as his
friend Dr. George Cheyne told him, the ills typical of 'those obliged to follow
a sedentary occupation.' Cheyne suggested that Richardson, whose nerves
did not allow him to ride horseback, should at least get a 'chamber-horse,' a
'liver-shaking device,' as B. W. Downs has described it,[28] much used at this
time. But exercise could not allay the fever of his nerves, and here Cheyne
diagnosed the 'English Malady' or 'nervous hyp,' which was no more, he
confessed, than 'a short expression for any kind of nervous disorder,'[29] and
which may be regarded as the eighteenth-century version of anxiety neurosis,
the typical derangement of the urban Psyche.

Richardson, then, is an example of many of the less salutary effects of
urbanization, and here the contrast with his great contemporary Fielding is
as great as that with Defoe. It also had equally marked literary conse-
quences, as was pointed out by Richardson's acquaintance Mrs. Donnellan,
who linked his poor health with his characteristic sensibility as a writer, in
an attempt to console Richardson for his perpetual ill health:

> . . . the misfortune is, those who are fit to write delicately, must think so;
> those who can form a distress must be able to feel it; and as the mind and
> the body are so united as to influence one another, the delicacy is com-
> municated, and one too often finds softness and tenderness of mind in a
> body equally remarkable for those qualities. Tom Jones could get drunk,
> and do all sorts of bad things in the height of his joy for his uncle's recovery.
> I dare say Fielding is a robust, strong man.[30]

Fielding has indeed much of the countryman's robustness, and the dis-
parity between the two novelists and their works may therefore stand as a
representative example of a fundamental parting of the ways in the history
of English civilization, a parting in which it is the urban Richardson who
reflects the way that was to triumph. D. H. Lawrence was keenly aware of

the moral and literary effects of this revolution, and he recapitulated many of them in *Apropos of Lady Chatterley's Lover*, his defense of a novel whose treatment of sex may be said to bring the trend initiated by *Pamela* full circle. Briefly he suggests that economic changes and Protestantism combined to destroy man's sense of harmony with the natural life and with his fellows, and as a result created 'the feeling of individualism and personality, which is existence in isolation.' This harmony had existed 'in the old England' until the middle of the eighteenth century: 'we feel it,' Lawrence wrote, 'in Defoe or Fielding. And then, in the mean Jane Austen, it is gone. Already this old maid typifies "personality" instead of character, the sharp knowing in apartness.'[31]

Lawrence, of course, was a refugee from 'personality' and personal relationships, from a world of 'nothing but people.'[32] By being so, he was, perhaps a refugee from the novel. For the world of the novel is essentially the world of the modern city; both present a picture of life in which the individual is immersed in private and personal relationships because a larger communion with nature or society is no longer available; and it is surely Richardson, rather than his successor Jane Austen, who is the first novelist in whom all the tendencies which make for a 'sharp knowing in apartness' are apparent.

The connection between urbanization and the novel's concentration on personal relationships is stated in E. M. Forster's *Howard's End*. Its heroine, Margaret Schlegel, comes to feel that 'London was but a foretaste of this nomadic civilisation which is altering human nature so profoundly, and throws upon personal relations a stress greater than they have ever borne before.'[33] The ultimate reason for the connection would seem to be one of the most universal and characteristic features of the city-dweller's experience: the fact that he belongs to many social groups—work, worship, home, leisure—but no single person knows him in all his roles, and nor does he know anyone else in all theirs. The daily round, in fact, does not provide any permanent and dependable network of social ties, and since there is at the same time no other over-riding sense of community or common standards there arises a great need for a kind of emotional security and understanding which only the shared intimacies of personal relationships can supply.

In Defoe there is little suggestion of this need; the personal contacts of Moll Flanders are transient and shallow, but she seems to revel in the multiplicity of her roles and the only kind of security she seeks is economic. By the middle of the century, however, there are signs that a different attitude was coming into being. London, for example, is the milieu where, as the sub-title of her novel *David Simple* (1744) announces, Sarah Fielding's hero travels cheerlessly 'Through London and Westminster in Search of a

Real Friend,' lonely and anonymous in an anarchic environment where personal contacts are mercenary, fleeting and faithless.

Richardson's recoil from this environment would seem to have been very similar. Fortunately, however, there was a way out: urbanization provided its own antidote, the suburb, which offered an escape from the thronged streets, and whose very different mode of life symbolized the difference between the multifarious but casual relationships depicted in Defoe's novels and the fewer but more intense and introverted ones which Richardson portrayed.

Defoe had spent his last years at Stoke Newington, but the pattern of living in the suburbs even before retirement was still relatively new, as was pointed out in the introduction of the 1839 edition of the *Complete English Tradesman*, which comments disdainfully that from Defoe's 'insisting so much on the wives of tradesmen acquainting themselves with their husbands' business, and his scarcely making any allusion to out-of-town houses for the families of tradesmen ... we readily see that a simple state of things then existed in London, such as is now perhaps found only in fourth-rate towns.'[34] Very soon, however, the movement of the prosperous into the suburb became very marked and indeed caused a decline of the population within the city limits.[35] This was one urban trend in which Richardson could unreservedly participate; on weekends and holidays he was happy to leave his place of business in Salisbury Court off the Strand to luxuriate in the peace of his handsome retreats first at 'agreeable suburbane North End,' and after 1754 at Parson's Green. Both were in Fulham which, in 1748, according to Kalm, was a 'pretty town' with all the houses of brick, set in a countryside that 'is everywhere nothing but a pleasaunce.'[36] Here Richardson established his little court, where, according to Miss Talbot, 'his very poultry [were] made happy by fifty little neat contrivances.'[37]

The suburb is perhaps the most significant aspect of the segregation of classes in the new urban pattern. Both the very rich and the very poor are excluded, and so the middle-class pattern can develop unmolested, safe both from the glittering immorality of the fashionable end of town and from the equally affronting misery and shiftlessness of the poor—the word 'mob' is a significant late seventeenth-century coinage which reflects a growing distaste for and at times even fear of the urban masses.

The contrast between the old urban way of life and the new social pattern which replaced it is perhaps best suggested by the different implications of the words 'urbane' and 'suburban': the one is a Renaissance idea, the other typically Victorian. 'Urbanity' denotes the qualities of politeness and under-standing which are the product of the wider social experience which city

life makes possible; with it goes the spirit of comedy which, in Italian, French or English comedy of the sixteenth and seventeenth centuries, centers on the gay life of the streets and the squares where the walls of houses afford a purely nominal privacy. 'Suburban,' on the other hand, denotes the sheltered complacence and provinciality of the sheltered middle-class home: as Mumford has said, the suburb is a 'collective attempt to live a private life';[38] it offers a peculiar combination of the solace of society with the safety of personal privacy; it is dedicated to an essentially feminine ideal of quiet domesticity and selective personal relationships which could only be portrayed in the novel, and which found its first full literary expression in the works of Richardson.

The privacy of the suburb is essentially feminine because it reflects the increasing tendency already discussed to regard the modesty of womanhood as highly vulnerable and therefore in need of a defensive seclusion; and the seclusion of the suburb was increased by two other developments of the period—the greater privacy afforded by Georgian housing, and the new pattern of personal relationships made possible by familiar letter-writing, a pattern which, of course, involves a private and personal relationship rather than a social one, and which could be carried on without leaving the safety of the home.

In the medieval period nearly all the life of the household went on in the common hall. Then gradually the private bedroom and separate dining quarters for masters and servants became current; by the eighteenth century the final refinements of domestic privacy had fully established themselves. There was much more emphasis than before on separate sleeping quarters for every member of the family, and even for the household servants; a separate fireplace in all the main rooms, so that everyone could be alone whenever they wished, became one of the details which the up-to-date housewife noted with approbation; and locks on doors—still a great rarity in the sixteenth century—became one of the modernizations on which the genteel insisted, as Pamela does when she and Mr. B. are preparing a house for her parents.[39] Pamela, of course, has good reason to pay attention to this matter: during her ordeals being able to lock the door of her various sleeping places was a matter of life or a fate worse than death.

Another characteristic feature of the Georgian house is the closet, or small private apartment usually adjoining the bedroom. Typically, it stores not china and preserves but books, a writing desk and a standish; it is an early version of the room of one's own which Virginia Woolf saw as the prime requisite of woman's emancipation; and it was much more characteristically the locus of women's liberty and even licence than its French equivalent, the

boudoir, for it was used, not to conceal gallants but to lock them out while Pamela writes her 'saucy journal' and Clarissa keeps Anna Howe abreast of the news.

Richardson was something of a propagandist for this new forcing-house of the feminine sensibility; in a letter to Miss Westcomb, for example, he contrasts the 'goose-like gabble' of social conversation with the delights of epistolary intercourse for the lady who makes 'her closet her paradise.'[40] His heroines do not and cannot share the life of the street, the highways and the places of public resort with Defoe's Moll Flanders and even Fielding's Miss Western, whom Richardson described with characteristically outraged horror as 'inn-frequenting Sophia';[41] they inhabit substantial houses that are quiet and secluded but where each room has its feverish and complicated inner life. Their drama unrolls in a flow of letters from one lonely closet to another, letters written by an occupant who pauses only to listen with wild surmise to footsteps in some other part of the house, and who communicates the intolerable sense of strain which arises when an opening door threatens some new violation of a cherished privacy.

In their devotion to familiar letter-writing Richardson's heroines reflect a cult which is one of the most distinctive features of eighteenth-century literary history. The basis of the cult was the great increase in the leisure and literacy of middle-class women; and it was materially assisted by a very great improvement of postal facilities. A penny post was established in London in 1680, and by the twenties of the next century it gave a service whose cheapness, speed and efficiency were, according to Defoe at least, unrivaled throughout Europe; while the ensuing decades also witnessed a great improvement in the postal system of the rest of the country.[42]

With the increase in the writing of letters went a significant change in their nature. In the sixteenth century and earlier most regular correspondences were of a public nature, concerned with commercial, political or diplomatic affairs. Letters were of course written about other matters, about literature, family concerns and indeed love: but they seem to have been fairly rare and confined to a relatively restricted social circle. There is certainly little indication of the existence of the 'scribbling treaties,' as Lady Mary Wortley Montagu called them,[43] that were so common in the eighteenth century— correspondences in which people of very varying social classes habitually exchanged news and opinions about their ordinary lives. A fairly recent parallel to the kind of change that seems to have occurred is afforded by the telephone: long reserved for important transactions, usually of a business nature, its use, as facilities improved and cheapened, was gradually extended, especially

under feminine influence perhaps, to the purposes of ordinary sociability and even intimate converse.

At all events, by 1740 it was apparently not wholly implausible that a servant girl such as Pamela should keep regularly in touch with her parents; and it was, of course, the wide diffusion of the letter-writing habit which provided Richardson with the initial impetus to write her adventures, since it led two of his bookselling associates to suggest that he prepare a volume of 'Familiar Letters' 'in a common style, on such subjects as might be of use to those Country Readers, who were unable to indite for themselves.'[44]

Pamela's epistolary expertness, however, suggests a somewhat higher-class position than the one which she is supposed to have—she patently needs no help in inditing! She is, in fact, a heroine after the pattern of those innumerable eighteenth-century gentlewomen who took Richardson's own advice as to the employment of their leisure: 'The pen is almost as pretty an implement in a woman's fingers, as a needle.'[45]

We are now in a position to see more clearly the main links between urbanization and Richardson's emphasis on private experience. The same causes which brought about Richardson's rejection of city life and his preference for the suburb, made him find his supreme satisfaction in familiar letter-writing, the form of personal intercourse most suited to the way of life which the suburb represents. Only in such a relationship could Richardson circumvent the deep inhibitions which made him silent and ill at ease in company, and caused him to prefer to communicate with his workmen in the printing-house, and even with his own family, by means of 'little notes.'[46] All these inhibitions could be forgotten when he was engaged in real or fictitious correspondences: it was a necessity of his being so deep that his friends said that 'whenever Mr. Richardson thought himself sick, it was because he had not a pen in his hand.'[47]

The pen alone offered him the possibility of satisfying his two deepest psychological needs, needs which were otherwise mutually exclusive: withdrawal from society, and emotional release.

NOTES

[1] Letter to Richardson, March 8, 1749 (Forster MSS. XII, ii, f. 110).
[2] See A. D. McKillop, *Samuel Richardson: Printer and Novelist* (Chapel Hill, N.C., 1936), pp. 43–106.
[3] *Clarissa*, Everyman Edition, III, 29.
[4] *Contributions to the Edinburgh Review* (London, 1844), I, 321–322.

[5] 'Life,' prefixed to *Correspondence of Samuel Richardson* (1804), I, xx.

[6] *The English Novel* (London, 1913), pp. 86–87.

[7] *De l'Allemagne*, in *Œuvres complètes*, XI, 86–87.

[8] London, 1939, p. 313.

[9] *De l'Allemagne*, p. 87.

[10] See O. H. K. Spate, 'The Growth of London, A.D. 1660–1800,' in N. Darby (ed.), *Historical Geography of England* (Cambridge, 1936), pp. 529–547.

[11] Marjorie Plant, *English Book Trade* (London, 1939), p. 86.

[12] See, for example, T. F. Reddaway, *The Rebuilding of London after the Great Fire* (London, 1951), pp. 300–308.

[13] No. 403 (1712); see also Fielding, *Covent Garden Journal*, No. 37 (1752).

[14] Max Beloff, *Public Order and Public Disturbances*, 1660–1714 (London, 1938), p. 28.

[15] I base the ensuing generalizations mainly upon the area of agreement indicated in Louis Wirth's sociological analysis in 'Urbanism as a Way of Life,' *American Journal of Sociology*, XLIV (1938), I, 24, and Lewis Mumford's imaginative and historical treatment in *The Culture of Cities* (New York, 1938). I should perhaps make clear that no comparative evaluation of the urban as opposed to the rural way of life is intended here: the stability of the latter, for example, may well be a euphemism for what Marx and Engels once so impoliticly characterized as 'the idiocy of rural life.'

[16] Spate, *op. cit.*, p. 538.

[17] 'A Project for the Advancement of Religion and the Reformation of Manners,' 1709, *Prose Works*, ed. by Davis (Oxford, 1939), II, 61.

[18] Bishop Sherlock's phrase, 1750; see E. Carpenter, *Thomas Sherlock* (London, 1936), p. 284.

[19] Cited in W. E. Lecky, *History of England in the Eighteenth Century* (New York, 1878), II, 580.

[20] Reddaway, *op. cit.*, p. 294.

[21] For example, John Gay, *Trivia*, 1716; Richard Burridge, *A New Review of London*, 1722; James Ralph, *The Taste of the Town: or A Guide to all Public Diversions*, 1731; and see also Paul B. Anderson, 'Thomas Gordon and John Mottley,' *A Trip through London*, 1728, *PQ*, XIX (1940), 244–260.

[22] *Clarissa*, I, 353, III, 505, 368, I, 422; see also III, 68, 428.

[23] p. 54

[24] See Ambrose Heal, 'The Numbering of Houses in London Streets, *Notes & Queries*, CLXXXIII (1942), 100–101; Sir Walter Besant *London in the Eighteenth Century* (London, 1925), pp. 84–85, 88–101 125–132; Mary D. George, *London Life in the 18th Century* (London 1926), pp. 99–103.

[25] Anna L. Barbauld, *Correspondence of Samuel Richardson* (1804), I, clxxix, III, 225, IV, 79–80.

[26] *Clarissa*, IV, 538.

[27] Barbauld, *op. cit.*, IV, 290–291.
[28] *Richardson* (London, 1928), p. 27.
[29] *Letters of Doctor George Chyne to Richardson*, 1733–1743, ed. by Mullett (Columbia, Mo., 1943), pp. 34, 59, 61, 108, 109.
[30] Barbauld, *op. cit.*, IV, 30.
[31] London, 1930, pp. 57–58.
[32] *Letters of D. H. Lawrence*, ed. by Huxley (London, 1932), p. 614.
[33] See Chapter 31.
[34] Edinburgh, p. 3.
[35] George, *op. cit.*, p. 329.
[36] *Account*, p. 36.
[37] Cited by McKillop, *op. cit.*, p. 202.
[38] *Culture of Cities* (London, 1945), p. 215.
[39] *Pamela*, Everyman Edition, Part 2, p. 2.
[40] Barbauld, *op. cit.*, III, 252–253.
[41] Letter to Miss G[rainger], Jan. 22, 1750, in *Notes & Queries*, 4th ser., III (1869), 276.
[42] Howard Robinson, *The British Post Office: A History* (Princeton, N.J., 1948), pp. 70–103.
[43] *Letters and Works*, ed. by Thomas (London, 1861), I, 24.
[44] Barbauld, *op. cit.*, I, liii.
[45] *Ibid.*, VI, 120.
[46] *Ibid.*, I, clxxxi.
[47] Cited in Clara L. Thomson, *Samuel Richardson* (London, 1900), p. 110.

A. L. KROEBER

*Style in the Fine Arts**

THERE REMAIN A good many intriguing problems, not too clearly solved, in the matter of content and form in art. For instance, the difference between the madonnas of Leonardo, Perugino, Raphael, Titian—does that lie wholly in the sphere of creative form? Is each painter's distinctive visualization only that? Or is he also painting a different person? And how about the different feeling tone evoked by each?

In any event, there is in all works of representative art a third element, a certain technique or skill—brush strokes, choices of words, and such— through which the artist expresses what I have so far called creative 'form,' but which as technique can be distinguished from such form. It is the means of executing or achieving the form; it is part of a technical mastery or professional efficiency; and it is usually the last quality perceived by the spectator or layman, even when he may be emotionally aware of a quality of form.

We have then three ingredients of style in the representational fine arts. First is the gross or objective subject matter dealt with: whether it be a deity or a man that is shown, a figure in action or at rest, an animal or a view of nature, in the case of a picture; a sentiment, a happening, a clash or a recollected image, in a poem.

Second is the 'concept' of the subject, along with its emotional aura and its value toning. This is the factor that differentiates one portrait of a person from another painter's portrait of him, one poet's love longing or regret of death from another poet's. This is still, in one sense content, subject matter, but it is subjective content, as felt by the artist; and in another sense it is form, the product achieved by the artist and the style.

* Reprinted from *Style and Civilizations*. © 1957 by Cornell University. Used by permission of Cornell University Press.

And third is the specific, technical form given the work of art by the artist in his execution of it—his diction, rhythm, or brush stroke. With this ingredient we have fully entered into the realm of creativity, of aesthetic achievement. This is the distinctive sphere of the artist himself. It is followed, *after the act*, by the critic, the connoisseur, the cultivated reader or viewer. They too react articulately to the creation; but secondarily or analytically. The untrained layman may experience interest, stir, admiration; he may actually know what he likes; but he mostly cannot 'say' why he likes, not even particularize what it is that attracts him. His feeling may be strong as that of the smitten lover, but emotion makes him also dumb.

It would be possible to press farther, to go on from the brush stroke to the medium in which it is executed: whether the pigment is borne in water or tempera or oil, or frozen in glass, or abandoned in favor of the black and white of the engraver's point. To the artist, these considerations are all-important. They undoubtedly relate to his creativity. But they relate to it technically and technologically, as part of his virtuosity in both the good and the bad sense; and they bring us back in many cases to physical materials and their objective qualities, whether these materials be human vocal cords or the resonance of wood or the properties of marble as against clay, or of brush as against knife. Such considerations are important, but they are also highly special; and having recognized their existence, we must leave them in order to pursue our general interest in style.

For the nonrepresentational arts, such as music, the case is somewhat different, and seemingly simpler, because representation and the element of subject matter are to all intents lacking. On the other hand, the situation is also more complicated. For a creation in music to reach its maximum ultimate public, two creative artists are usually necessary: the composer and the performer. In principle, these apparently differ rather drastically; for while most notable composers have also been excellent performers or masters of performance, the reverse holds much less. The reason may be that, as such, the performer is reproducing, not originating. However, our purpose being not to differentiate the several fine arts from one another but to define the qualities of style as the arts possess these in common, we must leave this interesting bypath untrodden.

If the formation of a style is due to a series of creative acts, it is our third ingredient—execution, I have provisionally called it, for want of a better term—that is cardinal. This fact can hardly be emphasized sufficiently. Especially must a corollary or implication of it be kept always in mind. Aesthetic execution is a specialized and coordinated selection from among a variety of possible expressions; and the expressions of the artists living in

one region and period—in the same tradition, in short—are highly inter-related and coordinated, even if they may also be highly individuated. In fact, this interrelation of their modes of expression (or executions) is what makes a style, in the social sense of the word. A historical style can be defined as the coordinated pattern of interrelations of individual expressions or executions in the same medium of art.

This interdependence obviously is one-way because it occurs in the flow of time, and only predecessors or contemporaries can influence successors. To this must be added a fact that is less patent and that has again and again been overlooked, namely, that predecessors *must* influence successors. Even when their effect is negative, it serves as a stimulant. The take-off for a variation in execution is always the already traversed course of the style, or some part or facet of it; it is never actually a 'return to nature,' never a wholly fresh observing of the objective world by the uncontaminated mind of individual genius, as enthusiasm so often proclaims it to be. The testimony of artists on this point is not always credible. They may focus with such keen intensity on how they differ from their predecessors that they see only the difference, and may talk as if they had invented their differentiation out of nothing. But a judicial analysis of the course of development of any art belies such a belief. Beyond this, fine arts are among the flowerings of cultures, all of which are social growths in the channels of traditions.

André Malraux in his *Voices of Silence* has reemphasized this point. The artist has been conditioned from the start of his career by the paintings or statues he has seen. He has seen them differently from other men: that is why he is an artist, and they are not. They see nature, and nothing comes of it, beyond perhaps moods; he sees nature as previous artists have remodeled it in their executions. It is these predecessors' *expression* of nature—their art—that triggers him into imitating them, and, if he happens to possess the energy, imagination, and skill, to transcend them. It is not nature that breeds art but art that breeds art. Nature is merely the inexhaustible reservoir into which the artist dips, to take out what the state of tradition of his art, plus his individual personality in the ban of that tradition, tell him to select and use.

Malraux says that 'it is never the sheep that inspire a Giotto, but rather his first sight of paintings' of them. He points out that no painter progresses 'directly from his drawings as a child to the work of his maturity. Artists do not stem from their childhood, but from their conflict with the achievements of their predecessors.' They struggle with the forms which other artists have 'imposed on life.' All painters and sculptors begin by imitating others. They begin not with a sudden uprush of emotion taking form in a void, but with sensing the form-expressed emotion of another artist.

If this holds in painting, sculpture, and literature which operate through representations of life and nature, it is evidently true also of essentially nonrepresentational arts like music, dance, architecture.

All the foregoing we can infer as fact from unprejudiced scrutiny of the biographies of artists. But it greatly invigorates the concept of traditional arts as being fundamentally social growths—cultural processes resulting in cultural products. And let us note, in this connection, how difficult it is to name great artists in any art who stand historically isolated, who had no contemporary artists, no near predecessors in their homelands. Goya, perhaps? or François Villon? But Goya worked long in Italy; and Villon wrote in verse forms centuries old.

Any art rising from obscurity to its first modest achievements has to make certain choices and therewith commitments; and as its condition develops farther, momentum increases, and it is usually more profitable to improve, refine, extend these commitments than to start all over again with contrary or unrelated choices. If poetry has begun, as in Greece, with measuring lengths of syllables in lines, additional variants of quantitative syllable patterns of line and stanza are likely to be developed. Therewith there tends to be increasingly inhibited any rise of mere syllable counting as in the Romance languages, or patterning of stress accents as in English, or rhyming as it was first devised in China. Here we are right in the crucial aesthetic ingredient of the execution or technique of achieving form; but subject matter, medium, and the emotional value sought for may also be highly selective.

Similarly, a musical style may start with melody, rhythm, and timbre differentiation, but never attain to harmony. It may commit itself to a scale of fairly wide and even-spaced notes, such as we call pentatonic; or again, to one in which the intervals vary between quite wide and very narrow ones— of semitone or less. Whatever the scale commenced with, it becomes increasingly difficult to abandon as the art progresses. The frame helps strongly to channel the course of development.

Many art styles accordingly follow a course not unlike the trajectory of a missile—with a definite rise and fall, and persisting at least more or less in one general direction. This is particularly true of arts that have grown up in national or regional isolation—as most styles in past known history have grown: their trajectories have had few influences from outside to disturb their course.

From this again flows the comparability of stages of growth evident in so many unconnected art styles. There is crude stiffness or ineptitude at the emergence; an archaic phase with form developing into definiteness but

still rigid; then the freeing from archaism, followed by a rapid culmination of the style with full achievement of the potentialities for plasticity inherent in it; after which there may come a straining for effect, overexpressionism, or again ultrarealism, or a flamboyant rococo or overornamentation; if indeed repetitive atrophy of form—a veritable death of feeling in the style— has not preceded these latter. Most of the terms descriptive of these successive phases—archaic, flamboyant, rococo—are taken from the history of European sculpture and architecture, but are applicable in India or China, in Egypt or aboriginal Mexico also; and in part they fit recognizable phases in styles of painting, music, and literature.

It is an old saying that while civilization as a whole progresses with time, the great arts soon wither away and have to begin all over again. There is considerable truth in this view. Practically useful knowledge is not likely to be forgotten, especially once writing exists to hand it along. Inventions are rarely lost altogether, even if their use may be abandoned through lack of resources in times of economic disaster. That whole part of civilization which is concerned with survival and subsistence and welfare must in its nature face reality. Means once achieved are accordingly likely to be retained and added to. So the general course of this practical component of civilization is cumulative. But the fine arts face values, not reality, and do not grow cumulatively; or at least they have not generally grown cumulatively through their recorded history. So they come in intermittent spurts instead of going on continuously. It is not too clear what determines where their development stops, except that it seems to be the point at which the values—or ideals, if one likes—that are shaped as the art grows have been attained by the artists' execution, and therewith are exhausted. Unless the goals can now be set farther ahead or widened, and the style be reconstituted on a new basis, there is nothing left for its practitioners but maintenance of the status reached; which is in its nature—by implied definition, as it were—incompatible with the play of creative activity. In other words, styles are produced by forces that are inherently dynamic. It is difficult for styles to become static without deteriorating or disintegrating. The developmental flow of style is one of its most characteristic qualities.

What happens to a style after it has reached its realization or exhaustion point—realization of its ideals, exhaustion of its potentialities—what happens to it from then on is quite variable in detail. The style deteriorates, but the ways of deterioration are multiple.

Where the style is relatively simple but highly defined, consistent but limited in its goals, and content with its goals, and forbidden by religion or a strong conserving cast of the civilization to attempt enlargement of these

goals, as in ancient Egyptian sculpture and painting, then a simple freezing of manner and quality of performance is possible. But let the conditions of life in the society slip downward, with weakening of political administration, economic worsening or other insecurity, and the art promptly shows deterioration. It becomes slovenly, hasty, inaccurate or inelegant in line, uses baser material, and applies laxer technique to it, and poor finish. But let political and economic functioning regain effectiveness, and the art reacquires its pristine qualities, and returns almost identically to its former canons. Three times did Egyptian art return essentially to the style and quality of its original culmination in the fourth and fifth dynasties of the Old Kingdom: in the twelfth, the eighteenth, and the twenty-sixth dynasties—the Middle Kingdom, the New Empire, and the Late Renaissance. To be sure, the style of these several periods scattered through two thousands years is not absolutely identical. But it is essentially identical: even a novice can identify all the phases as Egyptian and never confound any of them with any non-Egyptian style. The expert, familiar with differential minutiae, can tell the periods apart, but even he is likely to note first the divergences in content, in subject matter represented, such as changes in the dress worn, or that when horses are depicted we are in the New or the Late Empires, the Old and Middle Kingdoms having known only the native ass.

In fact the totality of ancient Egyptian civilization underwent much more change in these two thousand years than did its art. Wheels, iron, new domestic animals were introduced from abroad along with new materials and new inventions, and other inventions were made at home. The consequence was that from 2600 to 600 B.C. the totality of life and culture altered at hundreds of points, while Egyptian art stood almost still. Here was a figurative and symbolic art which, contrary to the rule that styles flow, froze contentedly and repeatedly back to its first culmination, whereas in the actual and practical business of carrying on his life the Egyptian slowly admitted innumerable innovations. It is evident that when they so wish, people can hold their ideal outlook, their art and religion, as the most nearly constant part of their universe.

It is of interest that Egyptian art showed one single inclination from within to alter its course, as contrasted with the declines to which it was subject from politico-economic causes. This happened under the famous heretic king, the monotheist Akhnaton, toward the close of the most successful of all dynasties, the eighteenth, when power, wealth, and art were all in culmination. Militarily and abroad, a decline had indeed just begun, though it can hardly have yet been much felt in Egypt itself. The attempt to change was thus seemingly prompted rather by a surplus of energy, a surfeit of

success, an exploratory and expansive national mood. Or let us say, a royal mood, the mood of a royal entourage, with national resources adequate to sustain considerable innovation. At bottom, the monotheistic episode may stem, as alleged, from an endeavor by the dominant court faction to limit the power of a hampering or encroaching priesthood. At any rate, whether the first motivation was factional or intellectual, it was corporate religion that was attacked, and a new philosophy and worship were endorsed and pro-claimed by the divine king. This monotheistic reform failed with the king's early death; but with it went a movement, which remained largely successful, to modernize writing and perhaps style of literature, and another to make formal art more naturalistic. To us today the gain in attempted truthfulness of art representation appears rather small. We see a slightly different con-ventional canon substituted for the old one, with possibly a naturalistic touch or two introduced as a compliment to royal physique. In any event, the new philosophy and art alike collapsed with Akhnaton's death, and left no apparent trace of influence on the subsequent course of philosophy, ritual or art. It is in accord with what we know of the comportment of Egyptian art elsewhere through its history, that this attempted innovation of the style did not arise primarily within the art, among the sculptors and painters, so far as we can tell, but was imposed upon them by power above; though some of the artists may have been willing or eager to meet the change.

At any rate, the over-all course of art in ancient Egypt, though its rise seems to have been rapid and a true flow, once it had reached its goal, was used by the masters of the civilization, secular and religious, as an instru-ment for conservation of the culture as it was. Religion has apparently been utilized far more often and more successfully in history than art as such a conserving tool.

Let us consider the declines of some other art styles.

Greek sculpture, of which on account of its partial preservation we have much fuller knowledge than of Greek painting, culminated between Pericles and Alexander. It continued for several centuries at a less eminent level, though still an effective art, influential westward through Roman dominion and eastward to India. Perhaps the first phase after Praxiteles was one of expressionism—expression of emotion and effort, dynamic and strained, sometimes contorted. A comparison with the baroque sculpture of Bernini after Donatello and Michelangelo is pertinent, and the time interval was about the same as from Praxiteles to the friezes of Pergamum. The Laocoön and Niobe are other examples. An overlapping phase was naturalism, associated with genre subjects and with a more realistic portraiture than was attempted in the great period. This realism became a speciality of Roman

sculpture, with a subculmination of its own early in the second century of the
Empire. A third tendency faced away from these two, back to the great
golden past, and was therefore avowedly academic and derivative, sometimes
deliberately archaizing—Neo-Attic. In fine, Hellenic sculpture, which
became Graeco-Roman, was split into several currents, plus transitions, and
much eclecticism. The appropriate metaphor is that of a great river entering
its delta.

The third and fourth centuries of our era, when Graeco-Roman art
rapidly declined into coarseness, especially in the West, were also the period
of the spread and success of Christianity. The new religion had new themes
to be portrayed, but having no stock of visual expressions of its own, of
necessity took over the established classical forms. Between the worsening
of technique that was already in progress, the stripping off of pagan elements,
and the greater interest of the converts in their new beliefs than in the form
in which these were expressed—because of these combining influences, the
old style which had begun as Hellenic art now sank to levels of crudity it had
not dipped to in a thousand years. At the same time this early Christian art,
with its new orientation, was laying the foundations of what was to become
'Western' or 'European' sculpture and painting. Its very amorphousness
made possible a development in new directions, which could hardly have
occurred had the old Classical Mediterranean style maintained more of its
hold, strength and skill. This is shown by what happened in the Eastern or
Byzantine half of the realm where Greek language, culture, and art were more
deeply rooted and the empire was preserved. The art here also of course
became Christian, and with an ascetic, monastic, and severe cast, but with
far more preservation of a sense of the old aesthetic forms and standards
than in the broken, tumultuous, ungoverned and barbarized West. Byzantine
art may truly be said to have mainly atrophied and fossilized repetitively,
whereas Western Roman art disintegrated. Yet the very barbarization of
Western art enabled it gradually to evolve new patterns of style—Roman-
esque, Gothic, Renaissance—and to achieve a great culmination of its own
after a thousand years, when petrified Greek art had crumbled away with the
Byzantine empire.[1]

Like the realm and culture centered at Constantinople, Byzantine art
remained bound in the fetters of its past. The West, having lost most of the
civilization it once had, floundered and moiled for centuries but gradually
forged for itself a new future.

Political revolutions are often fought for ideals, but always involve also
overturning of power and wealth to new hands. Such transfers are hardly
possible in aesthetic revolutions, although ego assertions can play a part. In

the main, however, revolutions in style, whether successful or unsuccessful, seem to arise when there is a sense that the existing style has exhausted its possibilities; that most of what can be done with its forms and techniques has been done; and that the future of present executants is therefore being cramped by the hold of the past: genuinely creative impulses are frustrated when their outlets are mainly reduced to repetition. There may still remain certain new themes and new mannerisms to be discovered conformable to the existing style, or extending it. But when these have been found and established, original imagination faces a dead end. Unwilling to accept resignation, imagination may fight.

If there is still room for some change within the style, a battle for dominance may take place, as when toward 1830 the romantics revolted in French art and literature, and won, only to be superseded in their turn within a few decades by naturalism and impressionism. When the smoke had cleared from the romantic battle, and still more in further retrospect, the freedoms gained seemed somewhat trivial as against the heat with which the revolution had been staged. There was a change, but the courses of both literature and art visibly have remained continuous in France: there was no sudden break at any point, not even a sharp angle in the road traveled.[2]

In time, however, the romantic movement and its heirs were subjected to attacks by genuinely revolutionistic programs—indeed, anarchistic ones, which set out to abolish all rules of style. Verse was to be 'free'—that is, formless—and representative arts nonrepresentative: cubist, abstractionist, nonobjective. Nor were the arts to be allowed refuge in mere decoration, which normally moves with balance, symmetry, and repetition. In fact, there was to be abolition of all previous aesthetic order. There is no doubt that these movements aimed at an outright disruption of the basic patterns of European art styles as they had evolved over many centuries.

It is perhaps extreme to attribute these events wholly to exhaustion of existent style patterns. Politico-economic unsettlements may have furnished both stimulus and example. And a vastly larger public, for the first time touched somewhat by higher education and art, but still with unschooled taste, may have contributed. But the effects of the movements, if successful, would certainly have been the total leveling of all the aesthetic styles of our civilization. And inasmuch as the origination and leadership of the anarchic movements was throughout by writers, painters, sculptors and musicians and not by politicians or Marxists, we are driven to conclude that the dominant causation was presumably internal to the arts. Whether this means that the potentialities of the styles had actually been exhausted; or whether personalities arose that felt the opportunities left them were insufficiently

great; or how far the frustrated were ready for any overturn (and there were leaders eager for any following)—these are alternative possibilities that should be considered.

It is also pertinent that all the assaults contained as an essential element some innovating mode of technique of execution of works of art—the meter of poems, the brush strokes of paintings, the scale or system of consonance of music—in addition to the new themes proclaimed as mandatory. In painting, this had begun to happen well before the frontal efforts to disintegrate style: already with the impressionists nearly a century ago. Outline was to be broken up; not the object was to be painted, but its lighting or impression; not its surface, but the atmosphere between it and the beholder; from which it was only a step to suppress representation of things in favor of representations of space. These impressionist efforts of the later nineteenth century were not yet attempts to wreck the style as a whole; rather were they efforts to alter the style by emphasizing possibilities that had until then been neglected. But as the emphasis on the novelties grew heavier, older elements tended to recede and fade out, with the result that as the manner became more extreme and one-sided, more and more of the previous style had *de facto* been eliminated. This perhaps in some minds cultivated tolerance toward the idea of total elimination, of a complete doing away with all the past of the art. At any rate, it is clear that the effective alterations were made by artists within the art, in fulfillment of their personalities, not at behest of outside theorists. Also, the innovators were not incompetents unable to achieve in the established tradition—though their imitators might often be inept and merely mannered. The innovators indeed might have had a more immediately comfortable success if they had conformed to tradition; but their ultimate rating and fame would in that case presumably have been lower. It is also interesting that when the coherent force of the impressionist group movement was spent, and its members rutted farther and farther into their personal channels, and the neoimpressionists took over, it was again matters of technique that were in the forefront—the myriad dots of pointillist Seurat, the vehement swirls of raised pigment by Van Gogh.

In literature the career of Joyce is equally illustrative of the general principles we are considering. He started conventionally enough with some adequate but undistinguished poetry, and with *Dubliners*, a collection of stories, of which the last attained to a climax of extraordinary poignancy. One such passage however hardly justified much expectation of a really outstanding career by mere perseverance, and Joyce turned off to exile, to his *Portrait of the Artist as a Young Man*, to *Ulysses*, and to *Finnegans Wake*, to poverty, obscurity, and obloquy from much of the world for his remaining

years, though he was also the great champion of a growing following, perhaps most numerous after his death. By the time his manner was fully developed, it had dispensed with objective events, with grammar and sentences, often with meaning in terms of English, and had substituted introspection, a coined vocabulary, and an infinite play of free-associational punning. There are those who hold this a supreme achievement, the founding of a new literature, and others who see in it only stubbornly perverse egotism carried to a simulation of psychopathology. What can perhaps be agreed to by nearly all is that Joyce's final style is an ultrapersonal one, dispensing both with narrative manner and with English, in favor of samples of the working of his own inner mind and of a language designed by and for himself. I am not in the least questioning Joyce's ability in what he chose to do. But he was substituting for the tradition of English prose narrative style as it had been developed over the centuries, the private style of James Joyce, as personal as he could make it in both preoccupation and expression. It was in short an attack upon all the past of his art. In this endeavor to destroy a great style, to substitute himself for a national and cultural tradition, lies the historic significance of James Joyce.

There is this to be said for the attempt: that a higher structure requires a wider base; and that there come times when in order to build greatly it may be more advisable to raze entirely and erect afresh. Thus the collapse of Minoan civilization left some centuries of Dark Age in Greece, but made possible the development of a broader and richer Greek civilization. Most of us also feel that Western culture is a greater construct than was the Hellenic or Graeco-Roman one; and it may be that this larger construct could not have been made had there not been a new religion and new barbarian forces and internal convulsions to topple the old. Perhaps five hundred years of Dark Age confusion and barbarism were needed to make possible the replacement of Greek art, science, and philosophy and Roman Empire and law by their broader Western counterparts. Not of course that Joyce singlehanded can do what it took Christianity, Goths, Vandals, and Franks several centuries to accomplish. But if he prove a precursor or symptom of similar destructive currents, precedent suggests that the ultimate outcome may be a larger reconstruction.

Much as there ensues confusion when the period of supreme strength of an empire has ended, be it that of Alexander, of Rome, of Charlemagne, we have seen that there is confusion when an important and coherent style has passed its zenith. There ensues a pulling in different directions—some groups plunging on ahead, some pulling back uphill, others trying to stand still or to edge sideways. Sometimes the divergent impulses may be active

in a single personality. At any rate we have a contemporary case in perhaps our greatest living painter: Pablo Picasso. A somewhat similar case of un-reconciled impulses in literature might be made for Goethe; but on the whole his phases were more successive. He passed on from one stage to another, where lesser men only deepened one characteristic execution. Picasso, however, has vibrated between his blue and circus manners, his neoclassic, the cubistic, the wholly abstract, the supersymbolic of Guernica and Mino-tauromachy, and with essentially equal intensity and success in each. It is true that there has been some drift with age toward greater leaning to the symbolic, but it has been accompanied by return to the other manners, and experimenting in new ones. We have here the unusual phenomenon of a great talent extremely sensitive to the first stirrings of new substyles, and able to switch his several powers into their full development, splitting himself aesthetically into alternant multiple personalities.

There is another feature of art styles that is characteristic of contemporary days, in fact is peculiar to them. Heretofore, no style—and no civilization—has ever prevailed over more than a minor fraction of this planet's surface. Many styles, great and small, were always flourishing simultaneously. Mostly the artists following them did not even know of the existence of most of the other styles. Here and there there might be interinfluences, but they were not too common or too deep, and most styles in most arts through most of history have grown up autonomously and in essential insulation. If foreign influences had a hand in the formation of a style, this was soon forgotten, and by the time it approached maturity, its practitioners no longer knew or were interested in the former alien impingements. It is doubtful whether Phidias knew enough of the history of incipient Greek sculpture to be aware of its absorptions from Crete and Egypt and Asia.

Now, however, two factors have changed this normal condition under which hitherto the arts have been practiced by the human species. The first is the shrinkage of our planet by the mushrooming growth of intercommuni-cations. The second is the fact that at least the visual arts of the whole world, including many past arts, have been gathered in museums, spread by photography and reproduction, and are available to, nay, knocking at the doors of, our ateliers and living rooms. This second factor is preconditioned by the first, that of greater intercommunication; but its specific ingredient is the fact that our aesthetic lives are now lived as it were in the illumination of a world museum instead of the candlelighting, as heretofore, of a national or uniregional art. No visual art can henceforth wholly escape being in-fluenced by the totality of the arts of mankind. Malraux has made this fact clear again in his *Voices of Silence*. In the presence of this unheard-of degree

of impingement, there is already greater receptivity, and this is bound to grow. True, there will also no doubt be efforts at stylistic isolationism, and some of these will be locally and temporarily successful. But in proportion as they are successful, they will reaffect style in the larger open world, and thereby a new interrelation will be established which will feed back the influences from the larger styles to the regional ones. All this means that there is genuine prospect of the visual arts of the human race henceforth entering into a condition of unresolved coexistence, of eddies and currents within one larger stream, of an uneasy schizoidness foreshadowed by Picasso's multiple stylistic personality.

There surely are elements of danger in such a condition. But we need not yield wholly to fears. Resoluteness in meeting the situation may reveal unexpected new potentialities. Eclecticism has in the past normally been a symptom of flagging of positive originality in the artist, or in the stage of the style of which he formed part; its products run much risk of being an elegant but characterless mishmash. But the point is that we shall no longer be able to infer the future from the past to the degree that has been valid heretofore: from now on, the whole history of styles promises to contain new factors that will produce new courses of events. No one can accuse Picasso of being indecisive in execution, of weakness; he is highly original, and he is supremely skilled, even if his art is split stylistically. If his single personality can contain several styles without mishmashing them—as Goethe already successfully expressed ultraromanticism and Hellenic classicism side by side—surely a world art should be able to contain them. The weaker practitioners will blend and fudge and eclecticize; but they will have less influence and be soon forgotten. The stronger ones will not only be able to manage multiple manners, but the essence of their creativity is likely to lie in the contrast they feel and can achieve between these manners. We shall have, in that event, something new in the world: a style that is comparative instead of exclusive, and conscious instead of ignorant of universal art history. There will be great risks, but exciting possibilities.

Let me pour this much oil on the troublous waters of this envisioning. Great changes do not happen overnight. If this one does happen, it will take time and come gradually. Also, there is no reason to believe that every artist will be driven to eclecticize or learn to juggle. The majority will quite likely continue successfully to cultivate one manner in which they were born or educated, or which they have chosen as the one most compatible to their personal skill and likings, leaving the comparison and wider contrastive activity to the art as a whole, or to those personalities in it that are irresistibly attracted by the severalty of its sides.

Another qualification is that this prospect of merging of all regional and national styles into one universal but multiple style may not offhand be assumed to hold equally for all the arts. The prospect is certainly much the strongest for the visual arts which produce material objects, objects which can and sometimes do withstand the centuries, and can be further preserved in museums. We know that the surviving Greek and Roman sculpture had something of such an influence in Europe at occasional spots even during the Middle Ages, more in the Renaissance, and again after the rediscovery of Pompeii and before the rise of neoclassicism. They exercised another such influence in the early Christian centuries through Buddhist Gandhara that extended as far as China and Japan. But we cannot trace anything comparable for Greek and Roman music. Melodies are intangible; archaeology cannot recover them; and all indications are that no outright flow of music comparable to that of Greek sculpture ever did take place westward and eastward. If we are to have a universal style in music, it will not be through any digging up and assembling, but through movements of people, contacts, hearing, and learning from music performances—all of which would at best yield a somewhat different situation from that I have projected for the visual arts.

For literature, we have still another set of conditions. Writing does preserve extinct literatures. Translation spreads them—almost without loss so far as they consist of prose, inadequately for form of verse, but substantially for theme. And languages can be and are learned. Yet there are contrary factors which would tend to impede universalization: above all languages are numerous, and poetic forms must fit the properties of their languages. The quantitative prosody of Greek could be transferred to Latin which also distinguished long vowels from short, and could arise in Arabic for the same reason. It cannot be used in Chinese nor in modern English, in both of which length is not present phonemically—the so-called long and short syllables of English really differing only qualitatively. And the quantitative meters repeatedly 'introduced' by English—and French—poets are essentially self-delusions under the influence of the way these speakers of languages mispronounced Latin. Similarly it will be evident that it would be impossible to transfer to phonemically nontonal languages, as most European ones are, the tone-arrangement patterns which characterize much of post-T'ang Chinese verse.

True, some features of language, though not many, are universal. One could presumably count syllables in all languages, also find rhyming words. However, even here there are differences, sometimes between closely related languages. Two-syllable rhymes are prevalent in Italian, because the language 'gives' them—the normal stress falls on the second syllable from the

end. French calls them feminine rhymes and alternates them with masculine one-syllable rhymes, which is easy because all the many French words ending in a 'mute-*e*' syllable are natural feminine rhymes. German also has a mute or weak-stressed *e* frequent in final position, so natural feminine rhymes abound, and they are used almost as often as in French. English, however, has lost the pronunciation of these unstressed final syllables—Chaucer still pronounced them, and that is what makes it hard for us to scan him—so that the number of naturally given feminine rhymes is quite small in modern English. They often have to be made up of two words, and in general are somewhat contrived and tours de force. These differences are thus inherent in the languages, and will remain effective in them until the languages change. They are in no sense due to the 'soul' of English and of French poesy wanting different expressions: the 'soul' rather is afforded or denied certain mechanisms of expression by the language; but, once habituated, the soul— if there is one—flatters itself that it has sought and found its perfect vehicle.

All this will suggest some notion of why a world-wide style in literature will encounter greater difficulties than in the visual arts. The nearest approach to something universal is by a happening that has occurred several times in history on a subcontinental scale and that now seems conceivable on a supercontinental and global basis. Chinese, Sanskrit, Arabic, Greek, Latin have all at one time become the dominant language of a large international civilization—through conquest or through sheer cultural supremacy or both. Underneath these great and widespread languages of culture, particular nations retained their national idiom for familiar and native use. They spoke it as a vernacular, perhaps also wrote it; but greater matters were written, and formally spoken, in the language of higher culture. All this has taken place before, and may take place again, but on a world-wide basis. It seems a more likely event than the establishment of any artificial or synthetic universal language, or than the gradual assimilation of all existing languages to a point where their literatures will be freely transferable.

Such are some of the generic properties of aesthetic styles, and some of the problems arising from them.

NOTES

[1] A dash of Byzantine influence entered early Renaissance art, and was followed by the effect of discoveries of ancient monuments in Italy, but the great Renaissance culmination was of course mainly autonomous and original, not a reawakening or return.

[2] In German literature, where romanticism came both earlier and with more uncalculated vehemence, its effects were perhaps equally blurry, but this was so because the existing style that was reacted against was much more recently and less firmly established. There was in fact a protoromanticism nearly half a century earlier—labeled 'Storm and Stress'—whose chief stylistic quality was a heightened tension of expression.

SUPPLEMENTARY READINGS

Franz Boas, *Primitive Art*, Cambridge: Harvard University Press, 1927; Dover Books, 1955. Analyses of American Indian art of the Northwest, influenced in theory by Semper's conception of technological determinants of style, but emphasizing motor habits and mastery of techniques.

C. M. Bowra, *Primitive Song*, New York: Mentor Books, 1962. An excellent survey of the songs of 'modern' primitive peoples. Includes descriptions of social structures and beliefs and extensive treatment of techniques and styles as well as content and types of song.

Abbé H. Breuil, *Four Hundred Centuries of Cave Art*, trans. by Mory E. Boyle, Paris: Presses of Sapho, 1952. A detailed account of cave art, based on many years of observation and research.

Ernst Cassirer, *The Philosophy of Symbolic Forms*, 3 vols., New Haven: Yale University Press, 1953, 1955, 1957. An extensive investigation into the phenomenology of linguistic forms, mythical thought, and knowledge.

Hershel B. Chipps, 'Formal and Symbolic Facts in Art Styles of Primitive Cultures,' *Journal of Aesthetics and Art Criticism*, Vol. 19 (1960), pp. 164 *ff.*

Hugh D. Duncan, 'The Search for a Social Theory of Communication,' in Frank E. X. Dance, ed., *Human Communication Theory*, New York: Holt, Rinehart and Winston, 1967. A brief survey of the historical development of communication theory, extensively examined in Duncan's earlier *Communication and Social Order* (Bedminster Press, 1962), and an attempt at sociological synthesis. Includes valuable annotated bibliography.

Raymond Firth, *Elements of Social Organization*, London: Watts & Company, 1951; Boston: Beacon Press, 1963. Chapter V, 'The Social Framework of Primitive Art,' presents some reasons for the lack of understanding of primitive arts in the West, and states Firth's belief in aesthetic sensibilities as universal; also deals with changes in art as related to social changes.

E. H. Gombrich, *Art and Illusion*, New York: Pantheon, 2d. ed., 1965. An attempt to develop a psychology of art, strongly emphasizing the force of art tradition on the development of art forms.

D. W. Gotshalk, *Art and the Social Order*, New York: Dover Publications, 2d. ed., 1962. Chapter IV, 'The Materials of the Work of Art,' is an excellent summary, emphasizing the perceptual and aesthetic characteristics as well as instrumental and 'terminal' values involved in the dimensions of 'form, expression, and function.'

Ernest Grosse, *The Beginnings of Art*, New York: Appleton Company, 1914. A materialist interpretation: art reflects the stage of economic organization of a society. Discusses the changing functions of art since early times.

Arnold Hauser, *The Social History of Art*, 2 vols., New York: Alfred A. Knopf, 1951. Marxian in orientation, this book presents a number of explanations for the origins of styles and art forms, from Palaeolithic cave paintings to abstract expressionism. Reprinted in 4 vols. by Vintage Books, 1957, 1959.

Alfred A. Kroeber, *Configurations of Culture Growth*, Berkeley: University of California Press, 1944. After Sorokin's *Social and Cultural Dynamics*, the most

extensive examination of fluctuations in art forms and styles in Western civilization.

——, *Style and Civilizations*, Ithaca, N.Y.: Cornell University Press, 1957. An inquiry into civilization: its characteristics, its essential nature, its features in the past, its future prospects. See especially Chapter I, 'Kinds and Properties of Styles.'

Suzanne Langer, *Feeling and Form: A Theory of Art*, New York: Charles Scribner's Sons, 1953. Emphasizes 'the creation of forms symbolic of human feelings.'

Marshall McLuhan, *The Gutenberg Galaxy*, Toronto: University of Toronto Press, 1962. A discursive survey of the consequences of the inventions of the alphabet and of printing for Western culture.

Louis Menashe, 'Historians Define the Baroque: Notes on a Problem of Art and Social History,' *Comparative Studies in Society and History*, Vol. 7 (1964–65), pp. 333–42. A critical analysis of conflicting definitions of the baroque, which throw into question the validity of 'period' styles in general.

Desmond Morris, *The Biology of Art*, New York: Alfred A. Knopf, 1962. A survey of American, European, and Russian experiments in painting by primates, compared with the work of children, analyzed by Rhoda Kellogg on the basis of 200,000 drawings.

Lewis Mumford, *The Myth of the Machine*, New York: Harcourt, Brace & World, 1966, 1967. Reinterpreting Mumford's earlier *Technics and Civilization* (1934), this work emphasizes the priority of symbolic systems and social organizations over tools and techniques in the development of man.

Thomas Munro, 'Style in the Arts: A Method of Stylistic Analysis,' *Journal of Aesthetics and Art Criticism*, Vol. 5 (1946), pp. 128–58.

Stephen Pepper, *The Work of Art*, Bloomington: Indiana University Press, 1955. A reconsideration of the work of art as an 'object.'

Meyer Schapiro, 'Style,' in *Anthropology Today*, A. L. Kroeber, ed. Chicago.: University of Chicago Press, 1953, pp. 278–302. After defining style and its components, Schapiro surveys various explanations of style and style changes in Western civilization by art historians, psychologists and other social scientists.

Pitirim A. Sorokin, *Social and Cultural Dynamics*, 4 vols., New York: American Book Company, 1937. Vol. I, 'Fluctuations of Forms in Art,' describes the shifts from Ideational to Idealistic and Sensate styles as well as to mixed types. The one-volume edition (1957) omits some of the detailed statistical data on which Sorokin's generalizations are based.

Diana Spearman, *The Novel and Society*, London: Routledge and Kegan Paul, 1966. An attack on extreme, mechanistic interpretations of the origins of the novel and a reassertion of the historical continuity of literary traditions.

Peter J. Ucko and Andrée Rosenfeld, *Palaeolithic Cave Art*, New York: McGraw Hill, 1967. A critical examination of the theories of Abbé Breuil and others, based on recent discoveries.

Max Weber, *The Rational and Social Foundations of Music*, trans. and ed. by Don Martindale, Johannes Riedel, and Gertrude Neuwirth, Carbondale: Southern Illinois University Press, 1958. A technical description of the 'rationalization' of Western music, with brief suggestions of social factors in the development of musical instruments.

Part II
ARTISTS

A. SOCIALIZATION AND CAREERS

Introduction

CAREERS, AS THE term is used here, are a series of objective and subjective stages through which members of an occupation or a profession move as they strive for the ultimate goals and rewards offered in that pursuit. The concept of career was introduced into sociology to suggest the dynamic aspect of work and, in the larger sense, to recognize (and to permit study of) the problems of social change. A number of corollary concepts pertaining to careers have been derived from studies of work by Becker and Strauss and by Everett C. Hughes. Several of these concepts, such as colleague groups, career contingencies, recruitment and turning points, are used implicitly or explicitly in this group of readings.

Approaching the sociology of art with concepts developed in the sociology of work has at least two immediate merits. First, focusing on the artist as a 'worker' cuts through the ideologies of art that we have inherited from Romanticism, which tended to "spiritualize' the artist and the creative process to the point where it seemed blasphemous to recognize that art is subject to profane influences no less than any other form of 'work.' Secondly, such concepts as colleague groups, turning points and the like allow the investigator to specify the way in which social influences upon the artist and his work are mediated. Without these concepts one must fall back on much clumsier attempts to establish relationships between art and society.

The article by Mason Griff applies sociological concepts and methods to data derived from interviews with a controlled sample of art students and commercial artists. The study, concerned with

the beginnings of a career, suggests clues to questions frequently directed to the artist. What factors in society are responsible for an early interest in art? What is the influence of the family, teachers, schools, significant others and peer groups in choosing a career? Although the sociologically relevant factors are the primary focus of this article, these questions and processes would also clarify many of the concerns of aestheticians, philosophers, humanitarians and art historians.

The study by Anselm Strauss describes the formal and informal aspects of the art school. Usually an art school is thought of as an institution where skills and techniques are taught. Strauss, however, emphasizes the social-psychological aspects: What are students searching for in terms of self-conception, identity and self-discovery? What are the processes whereby the student tests himself to see whether he is worthy of being an artist? These questions are related to other more general questions: Why are some artists drawn to the comic and others to the tragic? What effect do the school and the peer group of students have on the development of the imagination, the sensitivity and the prophetic abilities commonly associated with the role of the artist? And what apposite social factors in the formal educational process provide for the possibilities of achieving the noblest and highest accomplishments of mankind?

Ben Shahn's article clarifies some of these issues from the point of view of a mature, recognized painter. The selection describes the many elements, personal, philosophical and social, that Shahn drew upon in composing a specific painting. It bridges the gap between the purely sociological factors illustrated in the articles by Griff and Strauss and a personal introspective statement. Furthermore, it has a double significance: Shahn focuses on the art product rather than the artist, while suggesting the various social influences that, distilled through the painter's mind, result in the particular style and subject matter of a painting. In addition, the article describes a general problem faced by every artist: How does one master the necessary rudiments of an art while emancipating oneself from the authority of the educational and other socialization processes? Shahn describes his personal experiences in these matters by speaking of his gradual recognition of two internal selves: one the producer-imaginer

self, the other, slower to mature, a sort of artistic censor or superego. In the internal dialogue between these hostile forces, Shahn says he discovered that the art he had been producing was spurious and servile. This experience became a turning point in Shahn's career, and as a consequence he moved toward the creation of a personal style.

It has often been noted that the artist-creator is a figure of loneliness, attributed to the nature of his vocation and to the individuality of artistic endeavors. No one can dispute the ultimate solitariness of the artist when he faces a canvas or stone or piece of blank paper. On the other hand, his individuality has limits; man is not an isolate and cannot exist as one. As a child he is dependent upon individuals for his existence, and he interacts with and is influenced by others as he matures. It is this point, the influence of the group upon the artist, that is illustrated in the article by Maria Rogers. Through the imaginative use of historical documentation, she has reconstructed the informal group structure of the Impressionists, the patterns of and changes in leadership, the entrances and exits of various artists, the effect of this activity on the structure of the group, and the influence each group member had on the others in perfecting a specific style, while retaining a unique approach to that style.

Our knowledge of the ballet is derived chiefly from biographies of well-known choreographers. The article by Forsyth and Kolenda applies sociological theories of Parsons and of Homans to the study of how competition and cooperation in a ballet company function to maintain the delicate, synchronized equilibrium necessary for optimal performance. These authors show, not only why competition is inherent in the ballet, but also how it is socially controlled by the ballet-master so that the company reaches its maximum potential. They also present data on recruitment, roles and careers, and the nature of primary-group functions within the company. They describe the obstacles and sanctions imposed on the formation of primary-group relations, comparing the ballet company to a military organization, which similarly demands loyalty to the over-all group at the expense of the primary group.

The crucial factor in the career of the composer is the performance of his music. But without the consent of such persons and groups as

audiences, boards of trustees, conductors and critics, the composer cannot have his music performed. And without hearing his music, he cannot judge its merits or determine where modifications may be necessary. Dennison Nash suggests that the composer tries to deal with this dependent situation by acquiring *role versatility*. This means that he learns as part of his career a number of functional roles pertinent to the musical complex—instrumentalist, critic-writer, conductor, teacher. After he has acquired the knowledge and has experienced these roles, he is able to converse with others in the musical world. Communication leads to social interaction, which may produce cooperation and understanding and may ultimately create opportunities for the performance of the composer's music.

Nash's study raises several questions that are important for studies of other performing arts and for career analysis in general. What relation exists between career contingencies and performances? For example, is it easier to advance one's career if one has studied at certain schools and/or with certain luminaries? Is role versatility applicable to other perfoming arts and to certain work situations in general?

In the last article in this section, Malcolm Cowley discusses the influence of the social backgrounds of writers on their writings. This study uses many of the same variables—ethnic background, social class, family—as the one by Griff. But where Griff emphasizes social interaction between artists and significant social others and describes the various social-psychological processes in connection with role-conflict resolution and self-conceptions, Cowley describes the effect of these variables on the subject matter, roles and central concerns in the *stories* themselves.

Cowley suggests that there is a sequence in the central themes of novels that correlates with the stage of assimilation into American society of writers of particular ethnic origin. Trying to account for the dominant position of Southern novelists at mid-century, he stresses the continued existence and viability of the extended family in the South. It would be valuable for our knowledge of the arts if we could gather data like Cowley's for the other arts, as well as for the new arts of the film and mixed media.

MASON GRIFF

The Recruitment and Socialization
of Artists*

'RECRUITMENT' IS A term used to refer to the underlying processes for bringing new members into a group. Sociologists are especially interested in understanding those social forces that encourage individuals to join, or repel them from joining, an occupational or professional group and to embark on a particular career within that group.

In many occupations the process of recruitment can be readily understood. For example, consider the military, from whom the word 'recruitment' was originally borrowed. We know in clear terms the subjective and objective meaning of the professional soldier. We are aware of the symbols, such as money, glory, social advancement, travel, and adventure, which attract persons to become soldiers. We are equally aware of the symbols that distract, discourage, and repel the individual from this profession—fear, lack of sympathy with the cause, discipline, death, separation from loved ones and from one's community.

By contrast, there is a great vagueness concerning the recruitment of the artist. It is very difficult, first of all, to define the term 'artist'; any attempt at an essential, or even an operational, definition of the artist—an attempt in which many generations of aesthetes have failed—is bound to founder.[1] The reasons for this become apparent as soon as several crucial questions are asked. For example, who is an artist, and why is he one? Does it depend on the amount of time spent working as an artist? Then how does one include

* Reprinted with permission of the Publisher from David L. Sills, ed., *International Encyclopedia of the Social Sciences*, V, 447–454. Copyright © 1968 by Crowell-Collier and Macmillan, Inc.

individuals like Charles Ives, an American composer whose entire working career was spent in an insurance company?

Does working as an artist qualify one to be included in this category? Then we must exclude individuals of high artistic potential whose creative urge is latent or shows itself in activities other than art. Can we rely on contemporary recognition by institutions within the art world, such as galleries, museums, or private collectors? But to do this would exclude practically all the impressionist painters, not to mention Rembrandt at the time that he created some of his most important masterpieces. In view of these difficulties, we must rely on connotative and denotative examples in order to define our term 'professional artist,' while keeping in mind the shortcomings of this method.

When speaking of a professional artist, I think of Pablo Picasso, Marc Chagall, Alberto Giacometti, Ernest Hemingway, William Faulkner, Anton Webern, and Arnold Schönberg, to name a few outstanding figures from the first half of the twentieth century. Such men devote their time and psychic energy to creative endeavors or would do so if circumstances permitted. In other words, their primary work is or would be directed toward exploring the 'fundamental categories' of human existence, the attempt to exalt or denigrate authority, 'to explore or explain the universe, to understand the meaning of events, to enter into contact with the sacred or to commit sacrilege, to affirm the principles of morality and justice and to deny them, to encounter the unknown . . . to stir the senses by the control of and response to words, sounds, shapes, and colors.'[2]

Control of the arts. In some countries and during some eras there has been fairly tight control of the arts, both in the number of recruits and in the course of their careers. For example, during the guild era in Europe no disciple could change masters unless his first teacher agreed to break his contract, and all disciples had to remain with the master for three years.[3] Furthermore, there was an attempt to establish mastership as a hereditary privilege.[4] Willetts writes that during the existence of the Sung Academy in China (twelfth century) 'its appointments seem to have been sinecures with promotions through four ranks.' The French Académie Royale de Peinture et de Sculpture had a similar elaborate hierarchy. In both academies 'admission and promotion were by competitive examination. In both, the candidate was required to submit his personal version of a set theme, after gaining official approval of his proposed treatment by means of a preliminary sketch.'[5]

In twentieth-century Europe and the United States the arts are characterized by a relative absence of centralized occupational control, as compared,

for example, with the academies mentioned above or with the medical profession in the United States, with its institutional self-awareness, its standards of competence and discipline, and its relatively stabilized recruitment. Moreover, in these countries the demand for the visual arts—and for other arts as well—is rapidly and vastly expanding. This combination of an expanding market and an absence of tight controls suggests that the world of art—fine and commercial—must recruit in a rather generous, if not excessive, fashion. Unlike certain occupations, the world of art need not underrecruit for the purpose of controlling a valuable skill, with its accompanying monetary rewards, prestige, and honor.

Much of the rather 'open' recruitment in art is reflected in various gentle practices and policies of many art schools in the United States. Probably few applicants are refused admittance. Students occasionally drop out of school of their own volition but are rarely expelled as from medical or engineering schools. There are few or no crucial tests or other hurdles that a student must pass to remain in school. Grades seem mainly to yield encouragement or prestige and seem not to be utilized to restrict enrollment or to force the repeating of courses. Anyone who has the time and money can go to any number of commericial and fine-arts schools.[6]

EARLY SOCIALIZATION OF THE ARTIST

Because recruitment into the art world is neither tightly limited nor carefully controlled, we should not be led to assume that artists somehow drift into art. There exists a whole social paraphernalia for getting persons committed to their artistic identities; and the fact that the machinery is not usually visible to the person himself does not, of course, make it any less real.

The chief mechanism for pumping a flow of talent into art today is the public-school system—aided by the art schools and often abetted unknowingly and unwillingly by the student's family. This is true, among other reasons, because nowadays artists do not appear to come from very high or very low social classes. An artistic career is not generally initiated by an education at prep school or an elite college, nor do persons of low economic standing usually become artists by emulating models found in their communities (they are far more likely to emulate athletes). Parents in various strata introduce their offspring to art, stressing humanist, hobbyist, and other values; but not many parents consider the visual arts a propitious locale on which to fight the battle for class and occupational success. As a consequence, few parents directly influence their children to enter the field of art. Moreover, attendance at galleries and museums, with or without parents, plays no

discernible part in recruitment; it is, in fact, a rare art student who reports having any art 'in his background.' Nor do students entering art school usually know artists of any kind except their public-school teachers; nor are they especially acquainted with art history or with the biographies of famous artists.

Public-school experiences. The public-school art teachers begin to exert their influence quite early in the career of the artist, generally in grammar school. Impoverished or misguided though their teaching may be, they may introduce the youngster to the satisfactions and delights of drawing and painting. These teachers serve to keep interest in art alive throughout the school years by bestowing approval upon the child, singling him out for special honors, placing his work in public view, or assigning him honorific tasks, such as decorating the blackboards. Some students mention that as early as kindergarten, teachers singled them out for praise and isolated them from their classmates so that they could concentrate on their art.

In high school the child who has been recognized for his artistic virtuosity continues to take art courses and often has the opportunity to major in art. Art teachers may begin to suggest that he go on to art school—a step that otherwise might not occur to some—and may procure information and even scholarships for their protégés. The high-school milieu affords additional prestige, for the child may win a school prize, or even a national one, or receive acclaim for decorating a stage set, drawing for the school paper, and other such activities.

Saturday morning art classes. Complementing the role of the high school in the recruitment process are the typical Saturday morning classes sponsored by the community art museum. These special classes, which are to be found in Europe as well as in the United States, play a crucial role in encouraging an art career. For school children whose art instruction is limited (especially in the private or parochial schools, where art instruction may be absent), they provide the first exposure to advanced courses and qualified teachers. The Saturday classes provide students not only with material facilities, such as oils, brushes, and models, but also with professional instruction and the encouragement offered by the milieu of a museum. Also, for both children and adolescents, this may be their first (and perhaps only) opportunity to come into contact with peers having similar dispositions toward art.

Another important effect of the Saturday morning classes is that they single out the artistic person: that is, they signify to those in his social milieu, as well as to himself, that he has been socially recognized as having an unusual ability, absent in others, which has certain rewards. In addition,

these classes stimulate the nascent attributes of independence and freedom from external restraint that are associated with artists, because they separate the individual from his social milieu perhaps for the first time in his life. This *may* accelerate for these children the normal personality development from unilateral to autonomous thinking, studied by Piaget.[7] Finally, the experience of the Saturday classes may reinforce a sense of security for some children; in the childhood and adolescent world of comparisons, they can brag about their painting ability, which may, indeed, be the only outstanding skill they have.

PARENTAL ATTITUDES

The portrait that emerges from a study of the childhood and adolescent social experiences of the individual who possesses artistic skills reveals the congruence of encouragement and reward, of aspiration and fulfillment. He learns that his contribution is socially meaningful and constructive, and at the same time he is encouraged to exercise freely that which he most basically feels is himself. Except for the normal tensions of childhood and adolescence all the factors favoring the retention and nourishment of an artist's career are present.

Discontinuities in this pattern become apparent when the person declares publicly that he wishes to prepare for a career in art. The parents of the would-be artist make two very strenuous objections to his desire. The first is that the painter cannot hope to support himself solely from the sale of his paintings and that this will make it impossible for him to attain many of the symbols of success that families cherish. The second objection is directed at the bohemian stereotype of the artist, which the family wishes to avoid because it violates the professed mores of our culture. (The fact that artists often seem to become bohemians is, of course, closely related to their financial problems.)

When the student's intention to become an artist is discovered, there is a reversal in the attitude of his parents toward him. Thus, a crisis is engendered, which becomes aggravated during the period beginning with the announcement of his intentions and ending with the termination of his formal education. The entire family makes a determined effort to dissuade him. They remove his paintings from the walls where they were prominently displayed. Artistic achievements and the large remunerations for paintings received by artists become topics to be avoided.

It is at this point that the germ of self-estrangement (commonly referred to as alienation) is first implanted. Going contrary to the wishes of one's

parents causes one's conscience to suffer. It suffers because of the strong affective relationship between parents and child, because of intensive cultural imperatives emanating from the mores and reinforced by religious institutions—particularly the dogma concerning filial duties—and because of the acute sensitivity and imagination characteristic of the artist qua artist. While the exertion of the individual toward independence is normal during this period, this breaking away may have added significance for the career of the artist. Rank, for example, in discussing the creation of individuality said:

> The gradual freeing of the individual from dependence by a self-creative development of personality replaces the one-sided . . . dependence on the mother. . . . The person in the third and highest level of development, the creative type, such as the artist or the philosopher, creates a world for himself which he can accept without wanting to force it on others; and he accepts himself. Such a person creates his own inner ideals, which he affirms as his own commandments. At the same time he can live in the world without falling into continual conflict with it.[8]

There appears to be an inconsistency in parental attitudes toward the child who chooses the artistic career. It has been stated that the young artist is encouraged and rewarded and that his early success in art is a source of gratification for his parents as well as for him. However, the parents' later disapproval of his career choice becomes understandable if the difference between school success and occupational success is considered. School success is confined largely to the yardstick of the report card ('My daughter gets all A's in art'), and there is also recognition in the form of prizes, articles in the local newspaper, or acknowledgment on graduation programs. However, when a child graduates from high school new standards and criteria of judgment are applied, which are associated with symbols of financial success and social prestige. Art is not an avenue leading to the attainment of these symbols, and parents know this. Moreover, these reactions reflect some significant attitudes toward the fine artist and toward art in contemporary culture.

Cultural variations. Contemporary industrial culture stresses conformity, respectability, rationality, practicality, and security. These are a few of the essential values incorporated in the cultural complex that Max Weber called 'rational bourgeois capitalism.' Art and the life of the artist are antinomies of this. Fine art is nonutilitarian. Moreover, the artist tends to be nonconformist and to violate many of the behavioral patterns prescribed by society. His choice of career opposes the success theme so strongly emphasized and so

pervasive in contemporary culture. The parents of artists may themselves have failed to achieve success, and they, with all good intentions of loving parents, want their children to avoid the disappointments that they have experienced. Also, to parents who value success for their children as an affirmation and confirmation of their worthiness as parents, there is little comfort in the notion that the young artist may achieve recognition posthumously. Yet, this is frequently all the young artist can offer as justification for the sacrifices he proposes.

Parental opposition to a career in art is neither recent nor geographically confined; nor, for that matter, is parental encouragement. The way in which a son is forced to struggle against his parents because he suffers from an internal ebullition of artistic desire, which they try to suppress, has become a classic ritual.[9] Yet, instances of the encouragement of artistic careers have also been notable.[10] The experience of the contemporary composer Gian-Carlo Menotti provides an example:

> How well I remember as a child watching the profound sorrow of all Milan as the funeral of Puccini passed through the streets. It was a loss for each of us as well as for our country. No wonder that a young Italian boy's wanting to be a composer could only be a source of satisfaction and pride to his family and friends. But the family's regard for music was only a reflection of the general public's esteem in which the composer was held in Italy.[11]

The explanation for this variation in attitudes is open to debate and awaits further research. Two hypotheses, however, immediately come to mind. One is suggested by Menotti:

> It is my contention that the average American has little or no respect for the creative artist and is apt to consider him as an almost useless member of the community. The average American father still views with dismay the fact that one of his sons may choose to become a composer, writer, or painter. He will consider any such pursuit a sign of 'softness,' an unmanly and, I venture to say, un-American choice.
>
> I must add in all frankness that this hostility toward the arts is not uncommon in Europe within a certain class of society. But it exists only in a very small percentage of the population, mostly among the *nouveaux riches* and the very orthodox members of the aristocracy who still feel that it is more noble to patronize than to create. Moreover, even in this latter small moribund class, artistic activity is at least looked upon as an essential element of gracious living rather than the adornment of uneventful Sunday afternoons.[12]

An alternative hypothesis is suggested by an artist turned popular writer: 'Art needs a proper climate. The average Frenchman is no more artistic than the average American. . . . But the French climate is good for art, because in France an artist isn't expected to earn as much as a stockbroker. He is justified in his existence even if he is just a *little* artist. He doesn't have to be a Picasso. He counts as a necessary human factor although he hasn't reached the very top.'[13]

PREPARATION FOR A CAREER IN ART

After graduating from high school the neophyte artist enrolls in an art school or art institute, where he takes a basic course in the fundamentals of drawing, painting, and illustration. There he is thrown together with a large group of individuals having a variety of talents and backgrounds. For many, the first year is a joy. They work and learn (perhaps for the first time) in a milieu that is permeated with art. The school may be in a museum, or at least very near one, and the students are socially united by their common interest in art.

Specialization ensues during the subsequent years. In the second year, the students are divided into fine arts, commercial or applied arts, and art education sections. Further specialization takes place during the third and fourth years, but the most important specialty, in terms of the recruitment process, is fine arts.

The fine-arts student searches for a teacher compatible to his temperament both as an artist and as an individual. Some seek and readily accept technical instruction; others expect to get instruction only upon request; still others are hostile to any instruction, asseverating that it is a violation of artistic mores for an instructor even to touch their canvases.

Competition for grades is discouraged because of the inherent difficulty in judging art; both talented and untalented students, as well as instructors, mention this. Usually, the only institutionally fostered competition that is meaningful is the rivalry for the traveling fellowships, which takes place during the senior year. Both students and instructors have suggested that some students deliberately alter their natural style during the fellowship competition in order to cater to the known tastes of the judges. However, in general, we can say that the art school does not constitute a disruptive force, in terms of the unity of the self, as other types of schools frequently do. In other words, the intensive competition that tempts or forces students to engage in subterfuge or parroting their mentors in order to receive passing or superior grades is not present in the art school. What emerges in the art school is a consistency between self and fulfillment. Thus, the

self-estrangement that for the average person begins with formal schooling and continues indefinitely does not, for the most part, affect the art student.

Vocational choices. As the student nears the end of his academic training he becomes anxious over what he will do when he graduates. Some may succumb to the prodding of their parents (or fiancées or wives) and take a few commercial-art courses before they graduate. For the same reasons, others may take courses in art education or may return for a year after they graduate to take courses in art education. Still others pass through four years of training and delay their decisions until they graduate. A very few will win traveling fellowships lasting for a year or two and thereby postpone their decisions temporarily. A few, both those who have completed their fellowships and those who did not win one, will find galleries that will give them small subsidies. Eventually, however, each must find a source of steady income. Some will find work in the post office or in stores and will paint in the evenings or on weekends. A prolonged siege of this work is disheartening, especially when the individual realizes that he may have to do this for many years—that is, until he is recognized—or that he may have to work at whatever he is doing for the rest of his life. In the end, most return to art in secondary ways—some as art educators and many as commercial artists.

Whichever alternative is chosen, it will be a secondary choice and one that implies taking a job which the person feels is not his basic calling. It is at this point in the recruitment process of the artist that the state commonly referred to as alienation begins to be seriously experienced. As mentioned above, the first signs of alienation appear in connection with the students' conflict with their parents, as they finish high school, but in art school this parental opposition is usually overcome or disregarded. However, there is this important difference between finishing formal art school and finishing high school. While parents will strenuously object to their child's going to art school, they will, in most cases, continue to support their child because the mores demand it. After graduation, however, there are no moral imperatives necessitating continued support and certainly none that would obligate the parents to support the child indefinitely. It must also be pointed out that it is at this point in the student's life that the philosophies to which he has been exposed in his intellectual quest as artist—no matter how ingenuous they may appear —begin to fructify.

These circumstances raise a number of important questions concerning the artist. One of the most important of these is, What happens to one's artistic identity when one enters various types of employment? Griff[14] has

sought the answer to this question in a study of commercial (*i.e.*, advertising) artists. Commercial artists were selected for study because it was believed that these people had chosen the extreme alternative among the possibilities available to the artist. It was felt that the role of the commercial artist differs in so many fundamental ways from that of the fine artist that a study of it could serve as a paradigm for what happens in the case of less extreme vocational choices.

ART AND ADVERTISING

There are few institutions whose basic values are more opposed to one another in all fundamental respects than are those of art and advertising— their vocabularies, their traditions, their standards and rules, beliefs and symbols, criteria for the selection of subject matter and problems, modes of presentation, canons for the assessment of excellence—are all antithetical.

The traditions of art seem by their very nature to entail a measure of tension with the traditions of advertising and its close allies, commerce and industry. The very intensity and concentration of commitment to these value orientations reflect the distance that separates the two. Art, like genuine religion, continues to be vitally concerned with the sacred or the ultimate ground of thought and experience and the aspiration to enter into intimate contact with it. Thus, art involves the search for truth, for the principles embedded in events and actions, or for the establishment of a relationship between the self and the essential, whether the relationship be cognitive, appreciative, or expressive.[15]

In contrast, the traditions of advertising emphasize the selection of the mundane as subject matter; its presentation in terms of immediate perception as well as by the use of standardization, classification, and clichés; the necessity for certainty of cognition and direction; the deliberate attempts to manipulate through the use of visual stimuli based upon emulation, fear, and sex; and the assessment of excellence in terms of attention value, consumption, and fidelity (called brand loyalty) to the product of one's client.

In addition, there are innumerable technical differences between advertising and the fine arts, based upon the problems of graphic reproduction. The commercial artist must consider the different qualities of papers and printing inks and the effect these will have on the final version of his work. He must consider that the painting as seen in the original and then on the printed page will be different, because the flat surface of the paper eliminates the third dimension together with the brush strokes and canvas pores. Since it is necessary to make the product and accompanying message stand

out (known technically as highlighting), a sharp linear style is used; a firm principle of advertising art is recognition through a silhouette.

The differences in compositional techniques are also readily apparent. For example, in many automobile ads there is an illusion of deep space, but upon careful analysis it can be seen that the eye does not move from the front plane to deep space; compare this to a painting by a Dutch master, where the eye moves into the interior from the front of the room and then into the distance through an open door or window. In the advertisement the automobile covers the horizon, extends along most of the composition, and blocks the eye from easy recession into the background. Even the space in the background is indeterminate and has the function of forcing the nearer objects toward the eye, thus forcing the viewer to concentrate on the advertised product.[16]

Role identification and artistic values. Commercial artists range in type from those who remain symbolically attached to the role of the fine artist to those who reject this role completely. Between these two extremes lies a third group that identifies with both roles.[17]

The traditional role. Some artists work as commercial artists, but subjectively identify themselves as fine artists 'temporarily' engaged in the commercial field. In other words, they identify with what they regard as the artist's *traditional role*; their rationalization for working in the commercial field is that the normative standards of contemporary society preclude any economically feasible alternative. Underlying this assumption is the belief that society will give lip service to, but in reality will not support, the artist's primary identity—that of the fine artist as he emerged at the end of the nineteenth century. In supporting their premise they cite numerous examples, both past and present, of other individuals who have tried, without success, to live exclusively from their paintings. In addition, there is the actual attempt by many of them to live from the sale of their paintings. Finding this to be an impossibility, they may have turned to commercial art. Also, there is the further realization that other aspects of the reward system of society are absent (*i.e.*, prestige, praise, or admiration of others for their dedication to their ideals). Instead, in many cases, negative sanctions have been applied against them in the form of derision and questions concerning the practicality of their labors, as well as their 'sanity.'

The commercial role. Artists who assume the 'commercial role' see art (both fine and commercial) as a utilitarian product, and they conceive of themselves as instruments for the transformation of verbal symbols (dictated by a client) into visual ones. Consequently, their ideological orientation is directed

toward pleasing and satisfying their clients. Conceiving their roles in this manner the commercial-role artists refrain from interjecting or altering in any way the intent of their clients unless specifically directed to do so. Thus, they accept a norm that is not only upheld by their occupational group but also sanctioned by the larger society: The customer is always right. In carrying out this belief, they define their roles as having been successfully fulfilled when the requirements of their clients have been met as parsimoniously as possible. This means the creation of illustrations in the quickest and cheapest fashion.

In contrast to the attitudes held by the traditional-role artists, the commercial-role artists reject the notion that they are artists working in the commercial field because of extenuating circumstances. On the contrary, they believe that the traditional role is a nineteenth-century anachronism and therefore should be discarded by the contemporary artist.

The compromise role. The 'compromise role' is a mixture of both the traditional and the commercial roles. Like the commercial-role artists, those who assume the compromise role believe that they are instruments of the clients; however, they conceive of themselves as active, rather than as passive, agents. In carrying out this conception of themselves, they translate the demands of the client but at the same time attempt to persuade him to accept innovations, specifically the interjection of fine-arts symbols into their illustrations. Thus, many feel that they are involved in a crusade for better art. They believe that by raising the standards of their clients' art, they are at the same time raising the level of taste of the public.

The resemblance between the compromise role and the traditional role lies in the fact that both are concerned with fine arts. However, the artists who choose the compromise role do not consider the commercial field onerous or harmful to fine arts or believe that their status should be independent of the secular realm. They believe, as do the commercial-role artists, that their legitimate position in society lies in the commercial field. They reflect to a great extent the Bauhaus definition of the artist. This definition stresses the importance of the artist's working in a society rather than being isolated from it. The definition also stresses that the artist, while working in a society, should exert all his technical, moral and aesthetic skills to influence the products of mass production.[18]

The study of the recruitment of the artist is part of a broader field called the sociology of art. This field is still in its infancy, and much fundamental work must be done before its outlines, contributions and limitations will be known and understood. Griff's study[19] of art students in Chicago is a step in that direction; further research will confirm, invalidate or suggest revisions

of it. Meanwhile, what is needed now are similar data from the other fine arts and from those areas that are emerging as new fine arts, such as photography, the film, television and multi-mixed media. In this connection, important research could be accomplished by studying how an area emerges as a fine art. Other important questions and areas of needed research are: What are the career patterns of successful and unsuccessful artists? What are the social conditions responsible for the fame of an artist, the capriciousness of fame, and immortality; the social conditions hindering or encouraging creative endeavors; the relationship between contemporary patrons and styles of art; the social and psychological conditions impeding artists or aiding them to break with traditional and acceptable styles of art, thus innovating new styles; and the social roles of critics and patrons? Once research on these questions has been undertaken, it will be possible to clarify the more significant and elusive questions, such as whether the artist is a reflection of his society, or whether art is a reflection of the age.

NOTES

[1] See Dennis Gabor, *Inventing The Future* (New York: Alfred A. Knopf, 1963), p. 148, who makes the same point for the definition of 'art.'

[2] Edward Shils, 'Mass Society and Its Culture,' *Daedalus*, LXXXIX (1960), 290.

[3] Wallace J. Tomasini, 'The Social and Economic Position of the Florentine Artist in the 15th Century' (Ph.D. dissertation, University of Michigan, 1953), pp. 135, 140.

[4] Maurice Dobb, *Studies in the Development of Capitalism*, rev. ed. (New York: International Publishers, 1949), pp. 116–117.

[5] William Willetts, *Chinese Art*, 2 vols. in 1 (New York: George Braziller, 1958), p. 518.

[6] These data on art schools, as well as the following section on the students' family background and public-school experience, are based on Anselm Strauss, 'The Art School and Its Students: A Study and Interpretation' (unpublished manuscript, 1955). See also Mason Griff, 'The Commercial Artist: A Study in Changing and Consistent Identities,' in Maurice Stein, A. Vidich and D. White (eds.), *Identity and Anxiety* (Glencoe, Ill.: The Free Press, 1960), pp. 219–241; 'The Recruitment of the Artist,' in Robert N. Wilson (ed.), *The Arts in Society* (Englewood Cliffs, N.J.: Prentice-Hall, 1964), pp. 61–94; 'Conflicts of the Artist in Mass Society,' *Diogenes*, XLVI (1964), 54–68.

[7] Jean Piaget, *The Language and Thought of the Child*, 3d ed., rev. (New York: Humanities Press, 1959).

[8] Otto Rank, as quoted in Patrick Mullahy, *Oedipus: Myth and Complex* (New York: Hermitage, 1948), pp. 177, 183–184.

⁹ Roger Fry, *Cezanne: A Study of His Development* (New York: Noonday Press, 1958), p. 6.

¹⁰ Francis Haskell, *Patrons and Painters: A Study in the Relations Between Italian Art and Society in the Age of the Baroque* (New York: Alfred A. Knopf; London: Chatto & Windus, 1963), pp. 20–21. See also Tomasini, 'The Social and Economic Position of the Florentine Artist in the 15th Century.'

¹¹ Gian-Carlo Menotti, 'A Plea for the Creative Artist,' in Fernando Puma (ed.), *The 7 Arts* (Garden City, N.Y.: Doubleday, 1953), pp. 42–43.

¹² *Ibid.*, pp. 39–40.

¹³ Alexander King, *Mine Enemy Grows Older* (New York: Simon & Schuster, 1958), p. 8.

¹⁴ Griff, 'The Commercial Artist.' See also Griff, 'Conflicts of the Artist in Mass Society.'

¹⁵ Edward Shils, 'The Traditions of Intellectuals,' in George B. de Huszar (ed.), *The Intellectuals* (Glencoe, Ill.: The Free Press, 1960), pp. 55–61.

¹⁶ Paul Parker, 'The Analysis of the Style of Advertising Art' (Master's thesis, University of Chicago, Department of Art, 1937), pp. 119–122.

¹⁷ See Griff, 'The Commercial Artist,' pp. 219–241, for an extended account of the three roles mentioned here.

¹⁸ Laszlo Moholy-Nagy, *The New Vision* (New York: Wittenborn, 1946).

¹⁹ Griff, 'The Recruitment and Socialization of Artists.'

ANSELM STRAUSS*

The Art School and Its Students:
A Study and an Interpretation†

THIS PAPER IS a report on art students attending the school of the Art Institute of Chicago. It will attempt to answer questions about the differential experiences and school careers of students majoring in commercial art, fine art, and art education. Most, if not all, who teach in art schools have speculated and have good impressionistic knowledge about the very questions which will be discussed. The chief virtue of this paper is perhaps twofold: it is based upon fairly extensive two- and three-hour interviews with about seventy art students and recent graduates, and the interpretation of these interviews is that of a sociologist familiar with similar studies of other professions and occupations, where the problems are both parallel and different from those of the visual arts. The results and interpretations are based upon a study of a single art school (to whose staff and students I owe thanks); and the extent to which generalization is legitimate, and to what kinds of art schools, cannot be known except by additional and careful investigation. It is my hope that the profession will wish to pursue further these and related questions about itself and its practitioners.

I

The characteristics, experiences and careers of art students are inextricably tied up with the fact that art schools, unlike engineering and medical schools, do not prepare students for a single occupation but for a very loosely

* I am indebted to Mason Griff and Leonard Schatzman, who did most of the interviewing of art students for this study.
† Printed here for the first time, by permission of the author.

related family of occupations and specialties. In addition, schools of art are functioning parts of a 'world of art' which partakes of characteristics not wholly nor merely occupational. In a certain sense anyone can belong to an artistic world, whether or not he has had extensive training: as consumer, producer, hobbyist, critic, museum worker, owner of a gallery, or whatnot. The boundaries of participation in the visual arts—and in similar worlds like those of drama and music—are highly permeable and persons drift in and out as they discover or disavow the virtues and values of art. Within an artistic world there is of course organization—involving jobs and duties with differential prestige—but there are also allegiances to wider artistic ideals and standards. Art schools function to instill standards and artistic values, to teach techniques and skills. But they graduate not merely personnel who will sell in a market or produce creatively without selling: they graduate some of the future collectors of art, the museum-goers, the hobbyists, the teachers, the popularizers of art, and the personnel for museums.

Some schools, of course, focus more upon some types of human products than others: for instance, some commercial-art schools chiefly recruit and train personnel for businesslike and specific kinds of art jobs, often jobs with little artistic prestige or merit. On the other hand, schools as broad-gauged as that associated with the Art Institute of Chicago train, wittingly or unwittingly, their students for the whole rainbow of the art world, including the occasional collector, art-appreciator, and visitor to museums.[1] When students who end up along such diverse career routes are taught under one roof and in the same studios and classrooms, something of the stresses and tensions of the wider art world are bound to find their way into their experiences. One might thus hazard a guess that those commercial artists who display a hankering for fine art and exhibition painting, and yet feel often that they cannot afford the requisite time and effort to pursue them, are products of art schools that service a fairly wide spectrum of artistic ends. Schools which stress fine art also turn out students who are later forced into the commercial market and these artists undoubtedly suffer some of the more poignant kinds of guilt and remorse which accompany betrayal to what was earlier felt to be an enemy. When students attend 'straight commercial-art' schools, or dabble in art at colleges without thought of making a vocation of art, then experiences are bound to be different, and membership in an art world is likewise of a different sort.

II

In the interplay of student, school and art world, the student himself is

certainly an important factor. It assuredly makes some difference if the bulk of art students are drawn from one social class or another; if they follow in their fathers' footsteps or are in violent reaction against parental restraint and control; if they come to art schools with stars in their eyes or because they cannot think of anything better to do. The art school must make what it can of the persons who are attracted to it; and what goes on in the school necessarily must be heavily conditioned by its student body—whether or not the teachers approve of this state of affairs.

In a preceding paper, recruitment into visual arts was discussed, and it will be useful here to review this material briefly as background to further discussion. As we have previously noted, art students are recruited mainly through the public-school system, via teacher and student approbation of the child's artistic skill. Teachers do not serve as occupational models to be emulated but, during the latter half of the high-school years, direct the students' attention to the existence and possibilities of art schools and art careers. The youngster may not actually possess rich artistic abilities, but insofar as he has been confirmed in his belief that he is 'good in art,' he may think of turning his ability into vocational channels. However, many never make the transition from conceiving art as 'fun' to conceiving it as potentially providing a living. Still others are diverted away from artistic careers by strong alternative vocational paths. College, with its social life, beckons the economically well-to-do. Professions and occupations of various kinds carry more promise of security and prestige. For some of the poorer adolescents, family finances do not permit further schooling, and the youngsters may have already worked at jobs that appear to have a future. In the choice of paths, the family is crucial. If the parents have definite and strong notions about occupation or career, generally they seem to discourage art as a vocation; and this discouragement and pressure is potent, for family restraints are still strong at the ages (18–22) at which most students enter art school. On the positive side, parents exert little influence in inducing entry into art; pressure in this direction is virtually nonexistent. But when parents have few or weak alternative courses to suggest or impose, then the way into visual arts is less blocked for the children; and the parents may be educated to the vocational opportunities by their children. The part-time and summer jobs of the high-school student are also relevant to later matriculation at art school, for these jobs may demonstrate to the future artist either that he cares less for business than his art, or that the office and factory is meaningless or dull or hateful. Thus job and career alternatives very different from those to which the students actually have been exposed are sealed off. Some commercial-art majors begin their careers with part-time commercial-art work while at high

school and this eventually brings them to the art school. Generally speaking, the decision to enter art hardly calls for much soul-searching or anxious weighing of occupational alternatives, and it is easy to see why. Neither does the decision necessarily rest on anything more than the recognition that art can be turned to some serious purpose. Dedication to artistic ideals is something that must be developed at art school, if it is to occur at all, for few students at entrance know anything about the great art traditions and not many have had 'any art' in the home. When they enter art school, expectations of earning a living at art are, on the whole, fairly vague. Even those who have done some commercial art work may be uncertain as to what kind of specialty they should pursue. Some anticipate eventually becoming art teachers; some assume they will discover a specialty during their training and welcome the further schooling as a moratorium on immediate occupational decision; and some, particularly girls, seem relatively unconcerned with specific occupational decisions at all. So the terms of committing self to continuing in art are vague or general—job, security, career, and liking art best. The art school, then, has the task of taking this kind of human material and making of it the personnel for the various kinds of artistic tasks: it must develop dedication in some, mainly technical facility in others; it must allow still others to dally along so that they can become collectors and consumers of art; and it must also help to reconcile others—who really do not have too much artistic talent or the requisite drive to persist over obstacles but who yet love art—to less strenuous, or at least less individualistic, goals.

III

At the school of the Art Institute, about 200 students enter at the beginning of each school year, and they are placed for that year into eight or nine sections, irrespective of declared art major. All then take basic art courses: figure drawing, history of art, design, and the like. During the second year the commercial-art majors (or industrial-art, as the field is termed at the Art Institute) may, if they wish, take classes designed primarily to prepare them for commercial positions. Those who decide to work for a degree in art education usually must declare that intention and begin taking education courses—along with many of the fine-arts courses—at the beginning of the second or third year. In addition, the school offers an M.A. degree in education to students who wish to return after four years of work, irrespective of previous degree. According to information given me by the school's administration, when students enter, many do not know what they will specialize in, and a great many put down 'commercial art' on their admission

blanks, although presumably they do not yet know what branch of commercial art they will choose.

The design of our study called for interviewing approximately twenty students from each of the three majors (commercial art, art education, fine arts) and at all grade levels. We also interviewed ten recent graduates (mainly fine artists), and three students who had dropped out of the school. It became apparent through the interviewing that fairly substantial differences in experience were associated with choice of major. But it also became clear that different types of careers were being pursued by persons who chose the same major, and we have attempted to pin down these types and to clarify what kinds of gratifications and strains are associated with each type.

First, let us look at the general picture, although in certain ways it is less interesting and less important than the delineation of different careers within each area. One difference that stands out is the kind of art course the student had in high school. The education major is more likely to have had a fine-arts course; the commercial-art major is more likely to have had a course oriented toward commercial art; and the fine-arts major has had either fine art or a combination of fine- and commercial-art work, but not solely the commercial course. The commercial-art major is a little more likely to have worked part-time in a commercial studio, and this, as we shall see later, forms the beginning of his career—for he takes the work seriously and likes it. Later, while students at the art school, approximately a third of the fine- and commercial-art students work at paying commercial jobs, but virtually none of the education students are thus plunged into the occupational art world. Among the students of each field, a certain number (four in each field) come to the school as a partial reaction against doing badly in, or not liking, college or commercial-art school. Turning now to the point at which the student decides to major in one field or another: all the fine-arts students made their decisions in high school or by the end of the first year of art school; the education students' decisions scatter from high school through until the end of the third year of art school. It is thus apparent that fine-arts students are 'caught early' but that education students gradually sift into that specialty. We shall discuss this point at greater length later. Industrial-art students tend to declare their field by at least the end of the first year and to find a specialty by the end of the second year.

The grades which are assigned for course work function somewhat differently for the students of each field. For the fine-arts majors, excellent or good marks provide confirmation of ability and spur interest and confidence. The picture is quite different for education students. It became

apparent to a number of the latter that they were not cut out to be genuine professional artists, that they did not quite have what it takes or did not have the persistence to carry through to first-rate marks. For two of the students, excellent marks in fine-arts courses drew them into that field, but considerations of security and parental pressures drew them back into education— with accompanying inner conflict. Three students who entered the school with teaching firmly in mind did not receive such exceptional grades as to be led to consider fine arts as an alternative. The bulk of the commercial-art students either had chosen a branch or specialty of that major before entering, and marks confirmed this choice, or they had found a specialty during the second or third year by dint of interest and doing well in the associated courses. Three girls who belong to what will later be discussed as 'the moratorium student' had entertained notions of becoming fine artists but their marks helped to dissuade them and shift them over into vague pursuit of commercial-art goals. Three commercial students discovered that they had considerable fine-art talent and that they enjoyed using it, and were having some conflict of purpose thereby. In short, marks are not just marks, but function quite differently for different kinds of careers.

The same can assuredly be said for teachers. Terms that are spontaneously used to describe or talk about teachers bring out something of the differential meanings that teachers have for students in the three different areas. Industrial-art students typically use a vocabulary that emphasizes the teacher's role in getting across techniques, helping to solve problems, suggesting which of one's efforts are likely to sell and which will not, and showing one the difference between good commercial art (in the fine-arts sense) and bad. The education student appears to conceive of teachers mainly as furthering his search for artistic broadening and development. Teachers do not pressure one, they allow one to work at one's own pace and help one to master techniques, but are also criticized for being too permissive and not directing the student enough; there is no talk whatever of the utilitarian variety so characteristic of commercial-students' comments. The terminology of the fine-arts students reveals the more psychologically sensitive relationship existing between teachers and students, with some of the latter resenting their student status, some identifying with teachers rather than merely viewing them as purveyors of knowledge, and others finding themselves in the position of having to choose among diverse drawing and painting styles of their teachers. They speak of apprenticeship relations, of teachers as friends, as reacting against teachers' styles, as having the opportunity or the problem of choosing among many viewpoints, of being set upon the right artistic course, of teachers who can help the student because they are older (but not

potentially better artists than the student). But also the teachers are criticized for pushing their own styles too vigorously, and praised for being permissive and allowing students to go their own way. A few commercially minded fine-arts students stress approvingly that they are taught techniques and correct interpretations of art.

There are parallel differences in the meanings of their own art work. The industrial students speak of their work as instrumental in their getting good jobs and as the means toward occupational mobility. Although they take some personal pride in their work, the key term is the product's potential or actual salability. The education student refers to his work as pleasurable and as proof of personal development or progress. The most frequently used term, by far, is 'fun.' The fine-arts major talks of expressing himself, of the contribution his work makes to his self-respect, as expressing his way of life, as being a creative product: in general, he indicates great pride and a very possessive attitude toward his work. The commercially minded fine-arts student, like the industrial major, talks of learning techniques and indicates that his work is an index of his progress toward future occupational success.

Friendship patterns are likewise different for the different groups. Fine-arts students mainly mix with each other, although a few have friends among the commercial artists and a few have friends among both commercial and education students. The future teachers mingle with each other and with fine artists, but rarely have friends only among art-education people, and never solely with commercial artists. This indicates both the degree to which they are influenced by fine artists and the lesser degree of isolation than that which is attained, or suffered, by the fine artists. The commercial students mix, as might be expected, mainly among themselves, but a very considerable number have friends also among the fine artists; none reports real contact with education majors. The higher degree of contact with fine artists than perhaps might be anticipated is due partly to the impact of fine arts upon certain of the commercial-art students, but partly it stems from the presence of types of students probably not frequently found in 'straight commercial-art' schools.

Although the parents of the students are notably passive in the occupational direction which they offer, nevertheless some do exert pressure in various forms, seeking assurance from their children that jobs lie ahead; attempting to get commitment to something definite, like teaching; and in extreme cases forcing withdrawal from the school or from particular friendship cliques. Parents of fine-arts students are understandably much more concerned about the futures of their children than those whose children

are more visibly headed toward paying jobs. Considerable familial pressure and strain is reported by many, especially male, students. Very little such extreme pressure is brought to bear upon the non-fine-arts students (except for two middle-class, male, commercial students who had disappointed higher occupational expectations of parents, and three education students who had tendencies to abandon education for fine arts). Two men (one commercial art, one fine art) partially coped with parental opposition by living away from home, but this method is surprisingly little used, even by the older students.

<div align="center">IV</div>

The general picture of differences among the three student groups probably runs about as one might anticipate from working with and teaching the students. But the picture, by its very generality, obscures some of the more detailed differences and similarities which mark the initiation of artistic careers. In Table 1 there is a classification of art students in accordance with certain characteristic psychological aspects of the 'careers' they are pursuing. We have interviewed only a very few students of each type (and this is why the table is not filled in), but feel certain that in any school of good size the students will fall into similar—and we believe useful—categories. We shall give a typical profile of each type, but it should be understood that these profiles represent only general, or more-or-less typical, pictures, for every student by no means conforms exactly at each point.'[2]

CAREER ARTIST

The career artist is found in each of the three art fields. Since the occupational and artistic requirements of each career are rather different, however, the experiences and early training associated with each are correspondingly dissimilar. So are the strains and gratifications.

Table 1.

	Commercial Art	Education Art	Fine Arts
Career Artist			
Art as a Haven			
Moratorium Types			
Vocation & Avocation			
General Way of Life			

Commercial Art. All such students turn out, in our sample, to be males (seven). They have had art courses of a commercial type in high school, and no fine art, and all did well in these courses. Three had already begun their careers, while in high school, by working in commercial studios. When they enter art school, they are thinking of jobs, of 'getting ahead,' and the school is supposed to provide the necessary techniques and knowledge. Parents go along with and encourage their education—except for the two middle-class parents mentioned previously. The students work in commercial studios pretty much throughout their school lives. Thus they are inducted into the occupation early and intensively, and gain fairly clear ideas of paths to jobs and sometimes to success. Understandably, their post-school plans are fairly clear and unambiguous. Grades confirm their abilities or lead them to a specialty during the second year. The first year, consisting of basic art, is generally liked, particularly because it gives basic and useful techniques. Teachers are perceived typically as transmitting techniques, and occasionally as making clear the difference between good and trashy commercial art. One boy phrased nicely what is surely a common view of some who work outside while attending school: he said that the school gave him theory while the studio gave him practical details and sales know-how. The work which the students produce in class is similarly conceived in instrumental terms, and their friends are other commercial students who share these goals and conceptions. In summary, we might say that the psychological strains of pursuing an art education are not great because an occupational identity forms easily and early.

Art Education. There are three such students in our sample: all girls. Their parents are in the professions (teaching and nursing). None had commercial courses in high school. They made their occupational decision under the very direct guidance of parents and/or teachers while still attending high school. Hence their lives while at art school are relatively serene, since they are not particularly tempted to go into fine arts. They conceive of their art work as 'fun' and as developmental. Instructors are approved of for informality and permissiveness. Their friends are in education, but they know a few fine-art students fairly well—not the most 'serious.' Since post-school plans are so definite—all they have to do is 'keep going'—their occupational selves and personal selves are mutually supportive, pretty much as with the commercial-art careerists. The school gives them the wherewithal—techniques and degree—with which to teach; meanwhile the occupational world is far removed (until practice teaching the fourth year), and the immediate student art world is close and enjoyable.

Fine Arts. The essential thing about these students, both men (two) and women (two) is that they have enjoyed art in public school, have decided that 'this is for me,' and art school allows both the continuance of artistic activity and the solidification of an artistic identity. None had only a commercial-art course in high school; only one had worked part-time in a studio, and he had disliked it. At the Art Institute, their grades, prizes, exhibitions, and a general approval of their work by teachers and peers (all fine-arts students), confirm their earlier conception of talent. They tend to think of instructors as helpful critics. A fourth-year boy during his last two years at school conceived of himself as an apprentice to his favorite teacher (and this may be usual among the more advanced students). The terminology with which they refer to their own work expresses pride in achievement, or concern when they feel they are not doing as well as they might. While there is some *stürm* and *dräng*, the dramatic and often painful intensity of identification of work with self-expression, as it appears in certain other fine-arts students, does not show up.

The first year at art school comes neither as a jolt nor as a great transforming experience, for the new activities seem not so very different from those of high school, merely more advanced and intensive. However, one girl, who had never encountered the concept of painting as deeply self-expressive, struggled for most of the year both with her inability to grasp the concept and with her associated deflation of self-esteem; but she did not yield her intention of becoming a painter. The very firmness of goal appears to prevent or short circuit much parental pressure that might otherwise be put upon the students. (One boy had his teacher home to dinner as a quiet tactic in convincing his parents of his future.) The chief strains are neither familial nor deeply psychological; they arise over questions of painting style and from competition engendered by post-graduate travel fellowships awarded near the end of the fourth year. Possibly the most severe stresses arising from this kind of career appear only after graduation. This is suggested by two interview documents: one with a student who unexpectedly did not receive a travel fellowship, and another with a student who returned after his fellowship to face a problem he had never looked at closely—how now to support himself. The Art Institute school undoubtedly helps some artists over this rough early part of their professional career by utilizing their teaching skills. Probably also many painters, no longer students, must face difficult decisions when they see that their work is not selling or is not being taken up by galleries or receiving due recognition by the public—and that this is not merely a temporary state of affairs.

ART AS A HAVEN

Some students enter art school with a sense of desperation, after previously drifting or failing at something else. At the Art Institute they discover some talent in themselves, however slight, around which to form some firmer self-esteem. Pursuit of an artistic career thus becomes an intensely personal and deep-set matter. The school acts to give initial direction to such lives, initially so badly in need of this kind of compass. Whether or not these people become creative or vocationally successful we do not know, although there is no special reason to suppose they do not.

Commercial Art. Two boys, having had only fine-arts courses in high school and having done only fairly good work, went on to college according to parental expectations. They fared so badly there that they and their parents eventually bethought themselves of the modest degree of art talent the boys previously displayed while attending public school. They then decided to go to art school to learn—and this is somewhat vaguely conceived—enough art to make a living at it in advertising or illustration. Early in art school these boys found something they could do fairly well and structured their thinking quite narrowly about doing just this—although they now avoid going out into the world of work and their occupational plans are quite hazy. Naturally their parents encourage rather than pressure them; and the chief psychological strain experienced during the school years is the proving of self to self—probably a fairly continual process. One gets the feeling that these students have found a lifeline and are hanging on for dear life.

Art Education. Two males, who had had fine-arts courses in high school but had not done well enough to be tempted into an art school, first tried college and had done badly; they then turned to art as an alternative. Their notion, at that time, was to get into some sort of commercial-art work. Parents encouraged them. During the first year at the Art Institute they decided they had not sufficient talent to become artists, and during the second year they turned with relief and appreciation to education. This vocational path now gives them both a future and a stake in art—which they enjoy. As one student put it, 'I have a feeling for art, but not the ability.' For this type of student, success at practice teaching—usually done initially during the fourth year—is confirmatory of occupational choice. But major stresses are over and done with when the initial choice is made, with the first year causing or being associated with a fair amount of anguish and prolongation of the sense of failure. The stability of choice and of personal

identity is perhaps greater than in the comparable commercial-art student, since the occupational route to education is more direct and perhaps less competitive than those routes in the commercial fields.

Fine Arts. Two female students and one male student were interviewed. The women had not done particularly well in high-school fine arts, and the man had had no such classes, and his own amateurish drawing was not highly regarded by anyone. All three came to the Art Institute as a possible refuge or 'out,' after some type of failure—either at college or at commercial-art school. Their first year was food and drink. 'It was the happiest year of my life.' 'Art is like religion. I feel secure in it.' 'It was like coming home. It opened my world. It was the first time I was ever on an equal basis with anyone. I wasn't different any longer.' Since their work is an extension of self in the most profound sense, they regard it with extreme possession—not with the quieter technical and personal pride of the career fine artist. 'It's part of myself—I show it only to those who appreciate art. You shouldn't sell it to people who don't appreciate your work—it's too personal. You give part of yourself away.' 'It's a way of tying things together. A religion. Art ties into all of life.' 'You shouldn't sell—it's too highly personal. It's precious to you. It's your creation.' Their attitudes toward teachers are not particularly uniform: 'They encourage you'; 'They leave you blessedly on your own'; 'They provide you with negative models of what not to become' (*i.e.*, stereotyped, not self-expressive). But grades function to give great support, since they confirm the students' discovery of their talent. Their parents understandably do not urge them to abandon art school for other occupations—although if we had interviewed more males of this type, such a generalization might well turn out to be incorrect. One fellow, after his second year, left the school to go into business with a relative, having found self-respect through his artistic abilities and activities. (He is married to a girl of this type.) The vocational plans of the three students are very hazy: their main focus of attention is upon continuing this activity which has made them reasonably, and unexpectedly, happy.

MORATORIUM TYPES

At the opposite pole from those who find a firm vocation or dedication at the school are those who utilize the school years pretty much as an escape and a delaying of definite occupational commitment. This is a serious matter, for they are not merely 'stalling' but are betraying an inability to come to grips with their destinies. Their problem is not so much that they face

parental or other external criticism, but that they are restless and adrift in a world without clear guideposts or meaningful paths.

Commercial Art and Fine Arts. Five female students and three male students were interviewed. These students are much alike. They are the daughters of businessmen or professionals. They enter art school from high school or college with no great purpose—in one instance after vainly looking for it throughout college—and leave art school without much more purpose. They enjoy being in the world of art, since they have nothing much better to do. Grades neither confirm their choice of major nor specify special talents to be pursued. The parents of the fine artists, however, enjoin their daughters to 'do something with art,' and this imposes an additional burden. Some of the commercial artists are fond of fine arts and dabble in these along with their supposed major, trying hard not to specialize or turning restlessly from one commercial specialty to another. All view their work exclusively in terms of having progressed—*i.e.*, they cannot take this for granted and enjoy it. Such evidence as we have suggests that there is an increase during the last two years in the strain of not yet finding a vocation, and this, of course, is not helped by mounting parental impatience and expectation.

Art Education. Five male students and one female student were interviewed. This is a fairly heterogeneous group of students: they come from the entire range of unskilled to professional parents; they have had commercial, fine, or no art in high school; some have worked in commercial studios, some have not; some come directly to art school, one worked for many years before entry, one became dissatisfied with commercial art because he worked with college (middle-class) persons and so conceived of going to art school for a college education, and another became dissatisfied with commercial art because he worked with scientists on a project. For each, the art school permits a delay in decision—even though two of the men are in their late twenties and one is even older. But the moratorium afforded by attendance at school is not comforting: there is much restlessness even during the first year. Decision to go into education may be made as early as the time of entrance or as late as the third year—but even in the latter case the students may be truly indecisive, whatever their public declaration. Grades do not function decisively except to rule out incipient, but not strong, tendencies to move into fine arts. The art work itself is pleasurable and broadening, but quite obviously is not satisfying merely in itself. Plans are hazy and ambiguous, despite the clarity of the usual educational paths, and this is a reflection of the students' incapacity to indicate to themselves where they are going and what they really want from life and from themselves.

VOCATION AND AVOCATION

The classic picture of the dedicated artist has him supporting himself and
his family at nonartistic jobs, or at jobs of little artistic merit, so that he can
devote himself to his real vocation. This split between a paying avocation and
art-as-vocation starts during the first year of art school for some students.

Commercial Art and Art Education. Four male students and one female
student were interviewed. The commercial students entered art school from
high school. One had worked in a studio for three years and was solidly
entrenched there. During the initial year they discovered fine art! Although
they now continue to major in commercial art, and even do commercial work
outside, their deeper allegiance is to painting and drawing. Around these
latter, a sense of profound identity forms, supported by the approval of
teachers and fine-arts friends. Yet they cannot abandon their commercial
major, either because of strong parental expectations or because they them-
selves require the money which a commercial career will give them. The
strains of such a split career are immediately apparent. Parents have to be
kept at arms' distance. One should be concentrating on improving commercial
techniques but is not. One vacillates between going into the fine arts and not
daring to. Ways of juggling the requirements of two different kinds of careers
are sought. One boy, successful at commercial work since high school,
plans to do just as little commercial work as he can while doing as much
painting as he can (he has recently won a substantial prize in a contemporary
painting show). Another fellow, several years out of school, is still trying to
get a firm leg up on the commercial ladder, while entering painting exhibi-
tions. It is important for his self-respect to convince himself and other
painters that he is not merely a businessman. Presumably it is the fate of
many students after graduation to get into commercial studios and to suffer—
at least in the initial years—from dual career requirements. The conflict is
made all the more severe by an ideology which prevails among many fine-
arts students that commercial art is essentially noncreative and restricting.

Two art-education students are in something of the same boat. They
entered school with vague notions of career, became converted to drawing
and painting during the first year, now view their work with passion, have
friends almost wholly among the fine artists, and experience parental pres-
sure to make their art pay. One, whose immigrant parents viewed with
pride his continuing with advanced education, was additionally advised by
his favorite first-year teacher—himself of immigrant parentage—to go into
education. He reacted against the advice but later capitulated. The key

terminology of this kind of education major was expressed as, 'You just have to; you just can't earn any money by painting.' But the retreat is made with bitterness.

Fine Arts. Four male students and one female student were interviewed. These students perhaps should not be classed with those discussed immediately above, for if they experience any conflict between commercial and fine-arts interests, it is mild or potential. Their orientation toward art is essentially a commercial or security-seeking one, while their interest in fine arts is peripheral or secondary. Yet they major in fine arts rather than in the industrial field. One possible reason is that their high-school courses had been in drawing and painting, and they had done very well. One had held a job in commercial photography and was advised by his boss to attend art school to learn good color work. Their parents now assume, or are led to believe, that art will not become a final *cul-de-sac*. The students' attitudes toward their work are varied, but have pretty much of a commercial cast; the work will be a means of assuring economic security and even success. An extreme view expressed by one boy was that at school one can learn how to make one's art appealing and that teachers ought to tell one how to sell and make contacts: he hardly makes any distinction between what he calls commercial art and fine art. Another fellow, although a very competent painter, engages extensively in school politics and socializing, and has an eye open for the possibilities of using art as a means to success in the art world—in museum work, perhaps. These people appear capable of very fluid career strategies, although their vocational plans are far from definite.

ART AS A GENERAL WAY OF LIFE

There are two remaining types of students (in education and fine arts) who appeared in our interviewing, each having something in common, though otherwise quite different from each other. Their hallmark is that primary devotion is not to the art career itself so much as to the art world *qua* world.

Art Education. Three female students were interviewed. Two of these students came directly to the Art Institute; the third entered after doing badly in a commercial-art school. They find the atmosphere of the art school thrilling and exciting, and may even go mildly bohemian at first. They never actually sign up for a fine-arts major, although they continue to be interested in it after they declare for education. They conceive of their work as fun, and teachers are to help one, or are nice because they don't criticize or

pressure one overmuch. The attendant strains of this career are mild, such as having to take too many courses in art education, which interferes with painting. The plans of these women embody combinations of teaching and painting 'on the side,' with marriage as a substitute for teaching or added to it. We might hazard (especially since their friends are almost all in education) that their own productive work will be slight after graduation, while their attendance at museum and gallery shows will be quite considerable, symbolizing, as it does, their membership in the world of art.

Fine Art. Five male students were interviewed. Unlike the education girls, for whom the first year of school is a kind of continuation of high-school activity, these men find the basic arts course during the first year an eye-opener. They have entered with the vaguely formulated notion of becoming commercial artists, and then undergo a conversion experience into fine arts. (One was converted during his last year of high school by his teacher, a former graduate of the Art Institute.) They develop negative attitudes toward commercial work and learn that art is something more than techniques and a job. 'Art is a twenty-four-hour matter.' 'My teacher has taught me that painting is as much seeing as painting.' Acquaintanceship with other students fills in the meaning of art as *weltanschaung*, with hot discussions and sometimes the discovery of associated art forms, such as ballet and drama. Toward their work they display a tremendous involvement, but different from the 'At last I can do something' kind. A vast world has been opened for them and their own work signifies to them that they are taking their place within it. Hence their dedication to art has a much less taken-for-granted quality than that of the 'career artist.' They have their troubles with parents, since they are breaking informal agreements to enter commercial art—one boy's father cut off his allowance in an effort to bring him to heel, but the boy moved away and got a job to support himself. These students have other strains also arising out of the conversion experience: proving self to self; questioning whether they can really be great; fighting the attempts of instructors to teach techniques which appear mundane compared with problems of self-expression; breaking with former industrial-art friends; facing the future with no skills to fall back upon for economic support. For these students the school has opened a rich world and has at the same time allowed them to take initial steps in finding a place within it. Whether or not they become successful or creditable artists, they are deeply committed to their artistic identities. We interviewed one graduate, three or four years out of school, who no longer paints much, pleading tiredness from his regular job, but who surrounds himself with art objects and mingles

constantly with his former—and more active—colleagues. He pays a price, of course, for his failure. Another graduate, with a husband and child, is impaled upon a dilemma consisting of her avowed failure as a great artist ('I have the talent but don't know what to do with it'), and her joy at having had the world of art opened for her. These people who abandon or slack off in their production of art are also among the steadiest consumers of art.

<p style="text-align:center">V</p>

From the viewpoint of the art student, the school is a place where one can pick and choose courses, majors, teachers, friends, techniques, and so on. But from the perspective of the wider world of art, the school can be conceived of as functioning as a huge sorting device, whereby recruits are made available for the multitudinous art jobs that have to be done and the large numbers of different artistic roles that have to be enacted. The school takes the human material which comes to it from the public-school system, and sorts and trains it—sometimes in curiously subtle and indirect ways. Something of this surely may be gleaned or sensed from our description of student types.

The sorting may be seen even more clearly if one glances at Table 2. The small number of students interviewed in our study means that this table must be read with caution, but the patterning is quite suggestive. Here may be seen, for instance, how art education at the school probably recruits its members, when, and from where. The stability and movement of types is also seen to be patterned.

Of course, the processes of switching fields do not cease upon graduation; as in other occupations, personnel end up in strange berths. But these later switches, in turn, certainly are not fortuitous and could with profit be studied. Not only are such changes of field important events in the lives of those who make the changes, but they also bring persons of different training and psychology into close professional contact. Thus they set the backdrop against which is enacted the drama of professional cooperation and antagonism.

NOTES

¹ In reviewing the services rendered to the world and business of art by any school of art, it is assuredly pertinent to ask just what becomes of its students *after* graduation, and this cannot be known for certain unless follow-up studies of graduates are made. It is sometimes said, for instance, that college art departments do not produce many first-rate artists, but I have heard various speculations concerning just what does happen to the graduates.
² The total number is less than fifty-three because data from first-year students are not used here.

BEN SHAHN

The Biography of a Painting*

IN 1948, WHILE Henry McBride was still writing for the New York *Sun*, I exhibited a painting to which I had given the somewhat cryptic title 'Allegory.' The central image of the painting was one which I had been developing across a span of months—a huge Chimera-like beast, its head wreathed in flames, its body arched across the figures of four recumbent children. These latter were dressed in very commonplace clothes, perhaps not entirely contemporary, but rather as I could draw them and their details from my own memory.

I had always counted Henry McBride as a friend and an admirer of my pictures, about which he had written many kind words. Even of this one, he wrote glowingly at first. Then he launched into a strange and angry analysis of the work, attributing to it political motives, suggesting some symbolism of Red Moscow, drawing parallels which I cannot recall accurately, but only their tone of violence, completing his essay by recommending that I, along with the Red Dean of Canterbury, be deported.

Mr. McBride's review was not the first astonishing piece of analysis of my work that I have read, nor was it the last. Perhaps, coming as it did from a critic whom I had looked upon as a friend, it was one of the most disconcerting. In any case, it caused me to undertake a review of this painting, 'Allegory,' to try to assess just for my own enlightenment what really was in it, what sort of things go to make up a painting. Of the immediate sources I was fully aware, but I wondered to what extent I could trace the deeper origins, and the less conscious motivations.

* Reprinted by permission of the publishers from Ben Shahn, *The Shape of Content* (Cambridge, Mass.: Harvard University Press), Copyright 1957 by the President and Fellows of Harvard College.

I had an additional reason for undertaking such an exploration besides the pique which Mr. McBride's review had engendered. I had long carried in my mind that famous critical credo of Clive Bell's, a credo which might well have been erased by time, but which instead has grown to almost tidal proportions and which still constitutes the Procrustean bed into which all art must be either stretched or shrunk. The credo runs as follows: 'The representative element in a work of art may or may not be harmful, but it is always irrelevant. For to appreciate a work of art, we must bring with us nothing from life, no knowledge of its affairs and ideas, no familiarity with its emotions.'

Once proffered as an isolated opinion, that view of art has now become a very dominant one, is taught in the schools, and is laboriously explained in the magazines. Thus, in reconsidering the elements which I feel have formed the painting 'Allegory,' I have had in mind both critical views, the one which presumes a symbolism beyond or aside from the intention of a painting, and the other, that which voids the work of art of any meaning, any emotion or any intention.

The immediate source of the painting of the red beast was a Chicago fire in which a colored man had lost his four children. John Bartlow Martin had written a concise reportorial account of the event—one of those stories which, told in detail, without any emotionalism being present in the writing itself, manages to produce a far greater emotional impact than would a highly colored account.

I was asked to make drawings for the story and, after several discussions with the writer, felt that I had gained enough of the feel of the situation to proceed. I examined a great deal of factual visual material, and then I discarded all of it. It seemed to me that the implications of this event transcended the immediate story; there was a universality about man's dread of fire, and his sufferings from fire. There was a universality in the pity which such a disaster invokes. Even racial injustice, which had played its part in this event, had its overtones. And the relentless poverty which had pursued this man, and which dominated the story, had its own kind of universality.

I now began to devise symbols of an almost abstract nature, to work in terms of such symbols. Then I rejected that approach too. For in the abstracting of an idea one may lose the very intimate humanity of it, and this deep and common tragedy was above all things human. I returned then to the small family contacts, to the familiar experiences of all of us, to the furniture, the clothes, the look of ordinary people, and on that level made my bid for universality and for the compassion that I hoped and believed the narrative would arouse.

Of all the symbols which I had begun or sought to develop, I retained only one in my illustrations—a highly formalized wreath of flames with which I crowned the plain shape of the house which had burned.

Sometimes, if one is particularly satisfied with a piece of work which he has completed, he may say to himself, 'well done,' and go on to something else. Not in this instance, however. I found that I could not dismiss the event about which I had made drawings—the so-called 'Hickman Story.' In the first place, there were the half-realized, the only intimated drawings in a symbolic direction which were lying around my studio; I would develop some of them a little further to see what might come of them. In the second place there was the fire itself; I had some curious sense of responsibility about it, a sort of personal involvement. I had still not fully expressed my sense of the enormity of the Hickman fire; I had not formulated it in its full proportions; perhaps it was that I felt that I owed something more to the victim himself.

One cannot, I think, crowd into drawings a really towering content of feeling. Drawings may be small intimate revelations; they may be witty or biting, they may be fragmentary glimpses of great feeling or awesome situation, but I feel that the immense idea asks for a full orchestration of color, depth, texture, and form.

The narrative of the fire had aroused in me a chain of personal memories. There were two great fires in my own childhood, one only colorful, the other disastrous and unforgettable. Of the first, I remember only that the little Russian village in which my grandfather lived burned, and I was there. I remember the excitement, the flames breaking out everywhere, the lines of men passing buckets to and from the river which ran through the town, the madwoman who had escaped from someone's house during the confusion, and whose face I saw, dead-white in all the reflected color.

The other fire left its mark upon me and all my family, and left its scars on my father's hands and face, for he had clambered up a drainpipe and had taken each of my brothers and sisters and me out of the house one by one, burning himself painfully in the process. Meanwhile our house and all our belongings were consumed, and my parents stricken beyond their power to recover.

Among my discarded symbols pertaining to the Hickman story there were a number of heads and bodies of beasts, besides several Harpies, Furies, and other symbolic, semi-classic shapes and figures. Of one of these, a lion-like head, but still not a lion, I made many drawings, each drawing approaching more nearly some inner figure of primitive terror which I was seeking to

capture. I was beginning to become most familiar with this beast-head. It was, you might say, under control.

Of the other symbols I developed into paintings a good menagerie of Harpies, of birds with human heads, of curious and indecipherable beasts all of which I enjoyed immensely, and each of which held just enough human association for me to be great fun, and held just enough classical allusion to add a touch of elegance, which I also enjoyed. (And this group of paintings in turn led off into a series of paintings of more or less classical allusion, some only pleasant, but some which like the 'City of Dreadful Night' or 'Homeric Struggle' were major paintings to me, each having, beside its classical allusion, a great deal of additional motivation.)

When I at last turned the lion-like beast into a painting, I felt able to imbue it with everything that I had ever felt about a fire. I incorporated the highly formalized flames from the Hickman story as a terrible wreath about its head, and under its body I placed the four child figures which, to me, hold the sense of all the helpless and the innocent.

The image that I sought to create was not one of a disaster; that somehow doesn't interest me. I wanted instead to create the emotional tone that surrounds disaster; you might call it the inner disaster.

In the beast as I worked upon it I recognized a number of creatures; there was something of the stare of an abnormal cat that we once owned that had devoured its own young. And then, there was the wolf.

To me, the wolf is perhaps the most paralyzingly dreadful of beasts, whether symbolic or real. Is my fear some instinctive strain out of my Russian background? I don't know. Is it merely the product of some of my mother's colorful tales about being pursued by wolves when she was with a wedding party, or again when she went alone from her village to another one nearby? Does it come from reading Gogol? Whatever its source, my sense of panic concerning the wolf is real. I sought to implant, or, better, I recognized something of that sense within my allegorical beast.

Then, to go on with the wolf image: I had always found disconcerting the familiar sculpture of Romulus and Remus being suckled by the She-Wolf. It had irritated me immensely, and was a symbol that I abhorred. Now I found that, whether by coincidence or not I am unable to say, the stance of my imaginary beast was just that of the great Roman wolf, and that the children under its belly might almost be a realization of my vague fears that, instead of suckling the children, the wolf would most certainly destroy them. But the children, in their play-clothes of 1908, are not Roman, nor are they the children of the Hickman fire; they resemble much more closely my own brothers and sisters.

Such are a few of the traceable sources of imagery, and of the feeling of a single painting—mine, only because I can know what these sources are, because I am able to follow them backward at least to that point at which they disappear into the limbo of the subconscious, or the unconscious, or the instinctive, or the merely biological.

But there are many additional components present within a painting, many other factors that modify, impel, restrain, and in unison shape the images which finally emerge.

The restraining factors alone wield a powerful, albeit only negative, invisible hand. An artist at work upon a painting must be two people, not one. He must function and act as two people all the time and in several ways. On the one hand, the artist is the imaginer and the producer. But he is also the critic, and here is a critic of such inexorable standards as to have made McBride seem liberal even in his most illiberal moment.

When a painting is merely in the visionary stage, the inner critic has already begun stamping upon it. The artist is enthusiastic about some idea that he has. 'You cannot,' says the inner critic, 'superimpose upon visual material that which is not essentially visual. Your idea is underdeveloped. You must find an image in which the feeling itself is embedded. An image of a fire? Not at all! A fire is a cheerful affair. It is full of bright colors and moving shapes; it makes everybody happy. It is not your purpose to tell about a fire, not to describe a fire. Not at all; what you want to formulate is the terror, the heart-shaking fear. Now, find that image!'

So the inward critic has stopped the painting before it has even been begun. Then, when the artist strips his idea down to emotional images alone and begins slowly, falteringly, moving toward some realization, that critic is constantly objecting, constantly chiding, holding the hand back to the image alone, so that the painting remains only that, so that it does not split into two things, one, the image, and another, the meaning.

I have never met a literary critic of painting who, whatever his sentiments toward the artist, would actually destroy an existing painting. He would regard such an act as vandalism and would never consider it. But the critic within the artist is a ruthless destroyer. He continually rejects the contradictory elements within a painting, the colors that do not act upon other colors and would thus constitute dead places within his work; he rejects insufficient drawing; he rejects forms and colors incompatible with the intention or mood of the piece; he rejects intention itself and mood itself often as banal or derivative. He mightily applauds the good piece of work; he cheers the successful passage; but then if the painting does not come up to his standards he casts aside everything and obliterates the whole.

The critic within the artist is prompted by taste, highly personal, experienced and exacting. He will not tolerate within a painting any element which strays very far from that taste.

During the early French-influenced part of my artistic career, I painted landscapes in a Post-Impressionist vein, pleasantly peopled with bathers, or I painted nudes, or studies of my friends. The work had a nice professional look about it, and it rested, I think, on a fairly solid academic training. It was during those years that the inner critic first began to play hara-kiri with my insides. With such ironic words as 'It has a nice, professional look about it' my inward demon was prone to ridicule or tear down my work in just those terms in which I was wont to admire it.

The questions 'Is that enough? Is that all?' began to plague me. Or, 'This may be art, but is it my own art?' And then I began to realize that however professional my work might appear, even however original it might be, it still did not contain the central person which, for good or ill, was myself. The whole stream of events and of thinking and changing thinking; the childhood influences that were still strong in me; my rigorous training as a lithographer with its emphasis upon craft; my several college years with the strong intention to become a biologist; summers at Woods Hole, the probing of the wonders of marine forms; all my views and notions on life and politics, all this material and much more which must constitute the substance of whatever person I was, lay outside the scope of my own painting. Yes, it was art that I was producing, perfectly competent, but foreign to me, and the inner critic was rising up against it.

It was thus under the pressure of such inner rejection that I first began to ask myself what sort of person I really was, and what kind of art could truly coincide with that person. And to bring into this question the matter of taste I felt—or the inner critic felt—that it was both tawdry and trivial to wear the airs and the artistic dress of a society to which I did not belong.

I feel, I even know, that this first step in rejection is a presence within the fire-image painting of which I have undertaken to speak. The moving toward one's inner self is a long pilgrimage for a painter. It offers many temporary successes and high points, but there is always the residuum of incomplete realization which impels him on toward the more adequate image.

Thus there began for me the long artistic tug of war between idea and image.

At first, the danger of such a separation did not appear. For my first disquisition in paint was only semi-serious. My friend Walker Evans and I had decided to set up an exhibition in the barn of a Portuguese family on

Cape Cod. He would exhibit a series of superb photographs which he had made of the family there; I would exhibit a few water colors, most of them not yet in existence.

At just that time I was absorbed in a small book which I had picked up in France, a history of the Dreyfus case. I would do some exposition of the affair in pictures. So I set to work and presented the leading malefactors of the case, the defenders, and of course Dreyfus himself. Under each portrait I lettered in my best lithographic script a long or short legend setting forth the role which the original of the portrait had played in the celebrated affair.

What had been undertaken lightly became very significant in my eyes. Within the Dreyfus pictures I could see a new avenue of expression opening up before me, a means by which I could unfold a great deal of my most personal thinking and feeling without loss of simplicity. I felt that the very directness of statement of these pictures was a great virtue in itself. And I further felt, and perhaps hoped a little, that such simplicity would prove irritating to that artistic elite who had already—even at the end of the twenties—begun to hold forth 'disengagement' as the first law of creation. As artists of a decade or so earlier had delighted to *épater le bourgeois*, so I found it pleasant, to borrow a line from Leonard Baskin, *to épater l'avantgarde*.

Having returned only recently from France, where the Sacco-Vanzetti case was a national fever, I now turned to that noted drama for the theme of a new group of paintings, and set about revealing the acts and the persons involved with as rigorous a simplicity as I could command. I was not unmindful of Giotto, and of the simplicity with which he had been able to treat of connected events—each complete in itself, yet all recreating the religious drama, so living a thing to him.

The ensuing series of pictures was highly rewarding to me. First, I felt that my own work was now becoming identified with my person. Then there was the kind of response which met the pictures; not only did the customary art public receive the work kindly, but there was also an entirely new kind of public, a great influx of people who do not ordinarily visit galleries—journalists and Italian immigrants and many other sorts of sympathizers. And then there was the book about the case which Benchley sent to me, inscribed, 'to Ben Shahn without whom this crime could never have been committed.'

I continued to work in terms of pictures which related to a central theme, the inner critic being somewhat appeased and exercising only a certain technical stringency. A new series of questions now arose for me, and with them the inevitable consequent rejections. I began to question the

degree of my belief in the views which I held. It became uncomfortably apparent to me that whatever one thinks as well as whatever one paints must be constantly re-examined, torn apart, if that seems to be indicated, and reassembled in the light of new attitudes or new discovery. If one has set for himself the position that his painting shall not misconstrue his personal mode of thinking, then he must be rather unusually alert to just what he does think.

I was impelled to question the social view of man to which I had adhered for a number of years without actually doubting that it might be either a right view or a natural one to me. Now it dawned upon me that I had always been at war with this idea. Generalities and abstractions and vital statistics had always bored me. Whether in people or in art it was the individual peculiarities that were interesting. One has sympathy with a hurt person, not because he is a generality, but precisely because he is not. Only the individual can imagine, invent, or create. The whole audience of art is an audience of individuals. Each of them comes to the painting or sculpture because there he can be told that he, the individual, transcends all classes and flouts all predictions. In the work of art he finds his uniqueness affirmed.

Yes, one rankles at broad injustices, and one ardently hopes for and works toward mass improvements; but that is only because whatever mass there may be is made up of individuals, and each of them is able to feel and have hopes and dreams.

Nor would such a view invalidate a belief which I had held about the unifying power of art. I have always believed that the character of a society is largely shaped and unified by its great creative works, that a society is molded upon its epics, and that it imagines in terms of its created things—its cathedrals, its works of art, its musical treasures, its literary and philosophic works. One might say that a public may be so unified because the highly personal experience is held in common by the many individual members of the public. The great moment at which Oedipus in his remorse tears out his eyes is a private moment—one of deepest inward emotion. And yet that emotion, produced by art, and many other such private and profound emotions, experiences, and images bound together the Greek people into a great civilization, and bound others all over the earth to them for all time to come.

So I had crossed the terrain of the 'social view,' and I would not return. At the same time, I feel that all such artistic terrain which one has crossed must to some extent affect or modify his later work. Whatever one has rejected is in itself a tangible shaping force. That all such work improves the skill of the hand or the discernment of the eye is only a minor consideration. Even of one's thinking, however much his views may change, one retains a

great deal, rejecting only that which seems foreign to him or irrelevant. Or, one may wholly reject the social view of man and at the same time cherish its underlying sympathies and its sense of altruism.

Such a process of acceptance and rejection—the artist plus the inner critic—or you might just say, the informed creator—is present in the most fragmentary piece which an artist produces. A small sketch of Picasso's, a drawing by Rouault, or Manet or Modigliani, is not to be dismissed as negligible, for any such piece contains inevitably the long evolutionary process of taste, deftness, and personal view. It is, if brief, still dictated by the same broad experience and personal understanding which molds the larger work.

I was not the only artist who had been entranced by the social dream, and who could no longer reconcile that view with the private and inner objectives of art. As during the thirties art had been swept by mass ideas, so during the forties there took place a mass movement toward abstraction. Not only was the social dream rejected, but any dream at all. Many of those names that, during the thirties, had been affixed to paintings of hypothetical tyrannies and theoretical cures were now affixed to cubes and cones and threads and swirls of paint. Part of that work was—and is—beautiful and meaningful; part of it does indeed constitute private experience. A great part of it also represents only the rejection, only the absence of self-commitment.

The change in art, mine included, was accomplished during World War II. For me, it had begun during the late thirties when I worked in the Resettlement Administration. I had then crossed and recrossed many sections of the country, and had come to know well so many people of all kinds of belief and temperament, which they maintained with a transcendent indifference to their lot in life. Theories had melted before such experience. My own painting then had turned from what is called 'social realism' into a sort of personal realism. I found the qualities of people a constant pleasure; there was the coal miner, a cellist, who organized a quartet for me—the quartet having three musicians. There was the muralist who painted the entire end of his barn with scenes of war and then of plenty, the whole painting entitled 'Uncle Sam Did It All.' There were the five Musgrove brothers who played five harmonicas—the wonderful names of people, Plato Jordan and Jasper Lancaster, and of towns, Pity Me, and Tail Holt, and Bird-in-Hand. There were the poor who were rich in spirit, and the rich who were also sometimes rich in spirit. There was the South and its story-telling art, stories of snakes and storms and haunted houses, enchanting; and yet such talent thriving in the same human shell with hopeless prejudices, bigotry, and ignorance.

Personal realism, personal observation of the way of people, the mood of life and places; all that is a great pleasure, but I felt some larger potentiality in art.

During the war I worked in the Office of War Information. We were supplied with a constant stream of material, photographic and other kinds of documentation of the decimation within enemy territory. There were the secret confidential horrible facts of the cartloads of dead; Greece, India, Poland. There were the blurred pictures of bombed-out places, so many of which I knew well and cherished. There were the churches destroyed, the villages, the monasteries—Monte Cassino and Ravenna. At that time I painted only one theme, 'Europa,' you might call it. Particularly I painted Italy as I lamented it, or feared that it might have become.

It had been my principle in painting, during all the changes that I had undertaken, that outer objects or people must be observed with an acute eye for detail, but that all such observation must be molded from an inner view. I had felt consistently, also, that any such content must be painted in a way wholly subject to the kind of medium, whether oil, tempera, fresco, or whatever.

But now I saw art turning abstract, courting material alone. It seemed to me that such a direction promised only a *cul-de-sac* for the painter. I wanted to avoid that direction, and at the same time I wanted to find some deeper source of meaning in art, a constant spring that would not run dry with the next change in political weather.

Out of the battery of acceptances and rejections that mold the style of a painter, there rises as a force not only his own growing and changing work, but that of other work, both contemporary and past. He must observe all these directions and perhaps continue those which appear to be fruitful, while shunning those which appear to be limited and of short duration. Thus a degree of sophistication is essential to the painter.

While I felt a growing conviction as to the validity of the inner view, I wanted not to retread the ground which had been so admirably illuminated by Surrealism. Indeed, the subconscious, the unconscious, the dream-world do offer a rich, almost limitless panorama for the explorations of art; but in that approach, I think we may call it the psychological approach, one may discern beyond the rich imagery certain limits and inevitable pitfalls.

The limitation which circumscribed Surrealist art arose from its efforts to reveal the subconscious. For in that effort control and intention were increasingly relinquished. Surrealism and the psychological approach led into that quagmire of the so-called automatic practices of art—the biomorphic, the fecal, the natal, and the other absurdities.

The subconscious may greatly shape one's art; undoubtedly it does so. But the subconscious cannot create art. The very act of making a painting is an intending one; thus to intend and at the same time relinquish intention is a hopeless contradiction, albeit one that is exhibited on every hand.

But the great failure of all such art, at least in my own view, lies in the fact that man's most able self is his conscious self—his intending self. The psychological view can at best, even assuming that it were accurate, tell us what man is in spite of himself. It may perhaps discover those animal motives which are said to lurk beneath the human ones. It may unmask selfish purposes lying within altruism. It may even be able to reveal primitive psychological states underneath the claims and achievements of philosophy—the brute beneath the intellect. But the values of man, if he has any at all, reside in his intentions, in the degree to which he has moved away from the brute, in his intellect at its peak and in his humanity at its peak.

I do not conceive it to be the role of art to retrogress either into the pre-natal or into the pre-human state. So while I accept the vast inner landscape that extends off the boundaries of consciousness to be almost infinitely fruitful of images and symbols, I know that such images mean one thing to the psychologist and quite another to the artist.

One might return to Oedipus. For, to the psychologist, Oedipus is a symbol of aberration only—a medical symbol. But to the artist Oedipus is a symbol of moral anguish, and even more than that, of transcendent spiritual power.

Or, consider Van Gogh; to the psychologist it is the periodic insanity of Van Gogh that is pre-eminent, and the psychologist deduces much from that. But to the artist it is clear that it was the great love of things and of people and the incredible suffering of Van Gogh that made his art possible and his insanity inevitable.

I know that there must be an ingredient of complete belief in any work of art—belief in what one is doing. I do not doubt that those artists who work only for pure form believe in form alone as the ultimate possible expression in art. Those who look upon their art as therapy probably believe with equal fervor in what they are doing. And I am sure that the artists who only manipulate materials believe firmly in that method. But here again one must be impelled by rejection. Such art can contain nothing of experience either inward or outward. It is only a painted curtain resting midway between the subjective and the objective, closing either off from the other.

To me both subjective and objective are of paramount importance, another aspect of the problem of image and idea. The challenge is not to abolish

both from art, but rather to unite them into a single impression, an image of which meaning is an inalienable part.

I had once believed that the incidental, the individual, and the topical were enough; that in such instances of life all of life could be implied.

But then I came to feel that that was not enough. I wanted to reach farther, to tap some sort of universal experience, to create symbols that would have some such universal quality.

I made a series of paintings during the war which, in my own view—and what other view has an artist?—began to realize this more difficult objective. I shall discuss the pictures themselves, but again it is necessary to emphasize the conflict which arises in any such change of view, and the painful necessity to be aware of what one really thinks and wants in art.

I have already mentioned my personal dislike of generalities. Now, one must ask, is not the universal merely another term for the generality? How can one actually achieve a universality in painting without becoming merely more generalized and abstract? I feel that this question is one which greatly concerns artists. Its resolution will greatly affect the kind of an artist one is to be.

My own approach can only be to ask myself just why it is that I so dislike all statistics and most generalities. The answer that I find is simply that I dislike such material because it is impersonal. In being average to all things, it is particular to none. If we were to attempt to construct an 'average American' we would necessarily put together an effigy which would have the common qualities of all Americans, but would have the eccentricities, peculiarities, and unique qualities of no American. It would, like the sociologist's statistical high-school student, approximate everyone and resemble no one.

But let us say that the universal is that unique thing which affirms the unique qualities of all things. The universal experience is that private experience which illuminates the private and personal world in which each of us lives the major part of his life. Thus, in art, the symbol which has vast universality may be some figure drawn from the most remote and inward recesses of consciousness; for it is here that we are unique and sovereign and most wholly aware. I think of Masaccio's 'Expulsion from the Garden,' so intensely personal that it leaves no person untouched. I think of a de Chirico figure, lonely in a lonely street haunted by shadows; its loneliness speaks to all human loneliness. As an experience, neither painting has anything of the average; both come from extreme limits of feeling and both paintings have a great universality.

The paintings which I made toward the close of the war—the 'Liberation'

picture, 'The Red Staircase,' 'Pacific Landscape,' 'Cherubs and Children,' 'Italian Landscape,' and quite a number of others did not perhaps depart sharply in style or appearance from any earlier work, but they had become more private and more inward-looking. A symbolism which I might once have considered cryptic now became the only means by which I could formulate the sense of emptiness and waste that the war gave me, and the sense of the littleness of people trying to live on through the enormity of war. I think that at that time I was very little concerned with communication as a conscious objective. Formulation itself was enough of a problem—to formulate into images, into painted surfaces, feelings, which, if obscure, were at least strongly felt.

But in my own view these paintings were successful. I found in them a way to go, actually a liberation of sorts for myself. I became most conscious then that the emotional image is not necessarily of that event in the outside world which prompts our feeling; the emotional image is rather made up of the inner vestiges of many events. It is of that company of phantoms which we all own and which have no other sense than the fear sense, or that of the ludicrous, or of the terribly beautiful; images that have the nostalgia of childhood with possibly none of the facts of our childhood; images which may be drawn only from the recollection of paint upon a surface, and yet that have given one great exaltation—such are the images to be sensed and formulated.

I became increasingly preoccupied with the sense and the look, indeed, with the power of this newly emerging order of image. It was, as I have indicated, a product of active intentions plus the constant demands and rejections of the inward critic; even perhaps of a certain striving to measure my own work critically with some basic truth in art. At the same time I read and do read comments about my work by outer critics, some referring to the work as 'social realism,' some lamenting its degree of content, holding that to be irrelevant to any art, but most employing certain labels which, however friendly they may be in intention, have so little relation to the context of a painting. I believe that if it were left to artists to choose their own labels most would choose none. For most artists have expended a great deal of energy in scrambling out of classes and categories and pigeonholes, aspiring toward some state of perfect freedom which unfortunately neither human limitations nor the law allows—not to mention the critics.

I don't just think, I know, that this long historical process which I have just described is present within the one painting of the fire animal which is called 'Allegory.' There is considerable content which extends through one's work, appearing, disappearing, changing, growing; there is the shaping power of rejection which I have discussed, and the constant activity of

revising one's ideas—of thinking what one wants to think. All these elements are present to a greater or less degree in the work of any painter who is deeply occupied in trying to impress his personality upon inert matter.

But allowing all this procedure and material, I must now say that it is, in another sense, only background. It is formulative of taste; it is the stuff and make-up of the inner critic; it is the underground stream of ideas. But idea itself must always bow to the needs and demands of the material in which it is to be cast. The painter who stands before an empty canvas must think in terms of paint. If he is just beginning in the use of paint, the way may be extremely difficult for him because he may not yet have established a complete rapport with his medium. He does not yet know what it can do, and what it cannot do. He has not yet discovered that paint has a power by itself and in itself—or where that power lies, or how it relates to him. For with the practiced painter it is that relationship which counts; his inner images are paint images, as those of the poet are no doubt metrical word images and those of the musician tonal images.

From the moment at which a painter begins to strike figures of color upon a surface he must become acutely sensitive to the feel, the textures, the light, the relationships which arise before him. At one point he will mold the material according to an intention. At another he may yield intention—perhaps his whole concept—to emerging forms, to new implications within the painted surface. Idea itself—ideas, many ideas move back and forth across his mind as a constant traffic, dominated perhaps by larger currents and directions, by what he wants to think. Thus idea rises to the surface, grows, changes as a painting grows and develops. So one must say that painting is both creative and responsive. It is an intimately communicative affair between the painter and his painting, a conversation back and forth, the painting telling the painter even as it receives its shape and form.

Here too, the inward critic is ever at hand, perpetually advising and casting doubt. Here the work is overstated; there it is thin; in another place, muddiness is threatened; somewhere else it has lost connection with the whole; here it looks like an exercise in paint alone; there, an area should be preserved; thus the critic, sometimes staying the hand of the painter, sometimes demanding a fresh approach, sometimes demanding that a whole work be abandoned—and sometimes not succeeding, for the will may be stubborn enough to override such good advice.

I have spoken of the tug of war between idea and image which at an earlier time in my painting had plagued me so greatly. I could not reconcile that conflict by simply abandoning idea, as so many artists had done. Such an approach may indeed simplify painting, but it also removes it from the arena

of challenging, adult, fully intellectual and mature practice. For me, there would be little reason for painting if idea were not to emerge from the work. I cannot look upon myself or upon man generally as a merely behaving species. If there is value it rests upon the human ability to have idea, and indeed upon the stature of the idea itself.

The painting of the Red Beast, 'Allegory,' is an idea painting. It is also a highly emotional painting, and I hope that it is still primarily an image, a paint image. I began the painting, as I have said, with no established idea, only with the sense of a debt to be paid and with a clamoring of images, many of them. But as to the fire itself, and as to fires, I had many ideas, a whole subcontinent of ideas, none of which would be executed to measure, but any one of which might rise to become the dominating force in the painting. So it was with the series of paintings which I made during and after the time of the fire animal. There was the painting 'Brothers.' Paint, yes, but also reunion, reconciliation, end of war, pain of strong feeling, family, brothers. There was the painting called 'City of Dreadful Night'—a forest of television aerials—lines in paint—splashes of light or heads of ancient demons tangled in the antennae—a somber building with moldering Greek heads. All of these images arose out of paint, yes, but they also arose out of the somewhat ominous implications of television for the mind, for the culture. Out of a chain of connective ideas, responding to paint and color, rises the image, the painted idea. Thus the work may turn in an amusing direction, in a satirical direction. Or sometimes images are found—image ideas which are capable of great amplification, which can be built up to a high point of expressive power, at least for my purposes.

I cannot question that such a two-way communication has always constituted the painting process, sometimes with greater insistence of idea, sometimes with less, or none. Personal style, be it that of Michelangelo, or that of Tintoretto, or of Titian or of Giotto, has always been that peculiar personal rapport which has developed between an artist and his medium.

So I feel that painting is by no means a limited medium, neither limited to idea alone, nor to paint alone. I feel that painting is able to contain whatever one thinks and all that he is. The images which may be drawn out of colored materials may have depth and luminosity measured by the artist's own power to recognize and respond to such qualities, and to develop them. Painting may reflect, even brilliantly, the very limitations of an artist, the innocence of eye of a Rousseau, of a Bombois, of a John Kane. Painting can contain the whole of scholarship, and it has at various times. Painting can contain the politician in a Daumier, the insurgent in a Goya, the sup-

pliant in a Masaccio. It is not a spoken idea alone, nor a legend, nor a simple use or intention that forms what I have called the biography of a painting. It is rather the wholeness of thinking and feeling within an individual; it is partly his time and place; it is partly his childhood or even his adult fears and pleasures, and it is very greatly his thinking what he wants to think.

MARIA ROGERS

The Batignolles Group:
Creators of Impressionism*

ONE OF THE outstanding attainments of Western culture in the latter part of the nineteenth century was Impressionist painting, the first style to receive universal critical acclaim since the Renaissance painters were crowned by all Europe as undisputed masters. This achievement, remarkable in art history, was due, not to the genius of any one individual nor of several individuals working more or less alone, but to a small peer-group of painters closely related by ties of friendship, whose group purpose was support of one another's efforts to solve new problems and to invent new methods to give plastic form to a unique aesthetic vision and novel ideas of beauty held in common.† Initiators of a creative revolution, their achievement was not stylistic only: they jointly made important discoveries regarding color and light which transformed their palettes and compositions and were later confirmed by the studies of scientists.

The dedicated core of the group, the painters to whom life itself and their bold new approach to painting were almost synonymous, never numbered more than a dozen at any one time. This number and the nature of the ties which united them entitle them to be called a group in the sense in which we use the word in this publication.[1] Their united intransigent nonconformity

* Reprinted with permission of the author and the publishers from *Autonomous Groups*, Vol. XIV, Nos. 3 and 4, Spring and Summer, 1959.
† The studio organizations of Renaissance sculptors and painters were different in kind, being master-pupil groups. The architect-designer group in Victorian England led by William Morris was more like the Batignolles group, but it is of minor importance in the history of art.

to the then official norms of French art makes them eligible, in any reasonable use of the term, to the designation 'autonomous group.'

Their dazzling—but for the most part posthumous—success[2] has resulted in the collection of exhaustive information about them individually and collectively. This material offers an invaluable opportunity to investigate the dynamics of the birth, maturation and disintegration of their group as type of social configuration which makes a contribution to culture. The fact that their contribution is no longer disputed enhances the significance of the material and sociological analysis of it.

As Teilhard de Chardin wrote, 'Nothing is so delicate and fugitive, by its very nature, as the beginning of anything.' Fortunately, the data in our possession cover the first stages of this group's existence and are, moreover, ample enough to provide answers to two questions: one, the extent to which group activity or organization facilitates the development of individual talents and makes way for acceptance of their work; two, to what extent the contributions of these painters to world culture (for they are accepted as great even in the Orient) were actually a group achievement or only that of a number of individuals whose interrelations were not significant factors in the achievement. Examination of this material should help toward our understanding of the nature of 'group contributions to culture.'

Since the beginning of the era of individualism, historians and biographers have tended to credit all accomplishments solely to *individuals*. Popular opinion, following suit, has made an axiom of the hypothesis. But there is much reason to question this folklore; documentary evidence is ample to support the postulate that highly important innovations and achievements have resulted from the fortunate conjunction of a congenial group of friends and a problem which spurred them to joint exploration of a field of study or experiment.[3]

In presenting the evidence regarding the group which created Impressionist painting,[4] we have kept in mind the analytical scheme advanced by Homans in *The Human Group*,[5] but rely on the reader to identify his four interdependent variables, for which we have often preferred synonyms, in the interest of making the reading of the report somewhat more lively than it would be if we confined ourselves to the scientific terminology.

THE EXTERNAL SYSTEM[6]

In the France of 1850, art was a career strictly governed by rules laid down by the State which the student had to follow meticulously in order to win fame, wealth, social prestige and influence. The first rung on the ladder was

enrollment in one of the studios of the *Ecole des Beaux-Arts*. There poorly
understood traditions, represented as 'classic,' were forced on the students.
A character in a recent novel describes the period as one which approved
only gods and goddesses, historical subjects, landscapes painted in stuffy
studios, mythology, allegories, sentimental peasants.[7] Contemporary scenes
were anathema; subjects for contemporary portraits had to be draped in
Roman togas or medieval costumes. Moreover, only the colors used by
Renaissance masters were permitted. A brushstroke was barbaric; paintings
must look as if breathed on the canvas.

The second step upward was acceptance by the jury of one or more of a
student's paintings for display at the annual or biennial State exhibitions,
called 'Salons.' Honorable mentions and medals awarded there were followed
by the *Prix de Rome* which entitled the student to study in Italy at State
expense. Next came purchases of his paintings by the State, then government
commissions for paintings and murals for State buildings. Finally, with
election to the Academy of Fine Arts or acquisition of the ribbon of the
Légion d'Honneur, the artist reached the pinnacle of success.

The Academy of Fine Arts was the top echelon of the bureaucracy which
despotically governed the whole art world. Only its members could teach
at the *Beaux-Arts*. It controlled the juries of admission and of awards at the
successive Salons, hence could insure exclusion of every student whose work
did not conform to the personal taste of his teacher. Moreover, its influence
was paramount with the Director of Fine Arts, who purchased paintings
for State Museums and the personal collection of the ruling monarch (soon
to be Napoleon III) as well as awarding the commissions for murals in
State buildings. As a consequence, he bought the paintings of, and awarded
commissions to, the 'teachers' pets' admitted to the Salons.

The deleterious effects of this tight State control of the art of painting
were exacerbated by the political upheavals experienced by France during
the first half of the nineteenth century, which had particularly affected the
nobles, traditional patrons of the arts. To make up for the loss of this market,
artists were turning to the new bourgeoisie, which was quite willing to buy
paintings but lacked training in taste. Only through the Salons could this
public be educated to appreciate new works of artistic merit and thus enable
young artists to achieve a reputation and persuade this growing, prosperous
class to invest in their paintings. But that public regarded honors, medals and
prizes won at the Salons as proofs of an artist's merit and so it bought only
the works of the docile pupils. A mere handful of collectors had the courage
to buy paintings rejected by Salon juries. Such rejections were, there-
fore, tantamount to failure at the outset of a young painter's career. Dealers

would refuse to handle their works or offer derisory prices for them.

Fortunately for freedom of expression in art and speech, beside the official hierarchy, and mostly hostile to it, flourished a powerful *informal organization*, widely ramified, for which that native French institution—the café—served as headquarters. In the era of gaslight, artists stopped work at dusk and usually spent the remainder of the afternoon and much of the evening with their friends in one of the various cafés, each of which was patronized by a different group. There the officially honored painters were rarely discussed with admiration. Praise was given, instead, to Delacroix, Courbet, Corot, and their disciples, who had broken away from the rigid 'classical' tradition, and dared to paint landscapes out-of-doors, to record contemporary subjects and scenes, to depict the people around them as they were, not dressed in antique costumes nor undressed as mythological personages.

In the cafés, idols were created with eloquent phrases or demolished with stinging witticisms. No eminence was sacred. Logic and vehemence, comprehension and enthusiasm, flourished. Here was life united to a tremendous will to conquer. The heritage of the past was regarded as a positive barrier to original work. The more forcefully the Academy proclaimed the sacredness of tradition, the more suspect were traditions in the cafés.

But the cafés offered more than conversation. Students eager to grasp, absorb and apply new ideas found leaders and stimulating companionship; innumerable friendships were formed around the beer-laden tables. Later in his career, many an artist's struggle for success was lightened when some critic, met at a café, published favorable criticisms about his work.

Within the informal organization were the few art-dealers who responded to pressures of friendship and personal preferences as often as to those of profits from sales. Journalists and critics were very powerful members because they were often able to influence the policies of their papers on behalf of their friends.[8]

THE INTERNAL SYSTEM

The four friends: the nucleus. Next to be considered are the painters, their interrelations, cooperative activities, conflicts, sentiments and norms. We are basically concerned with: Claude Monet, Auguste Renoir, Alfred Sisley, Frédéric Bazille (and his successor, Gustave Caillebotte), Camille Pissarro, Paul Cézanne, Berthe Morisot, Edgar Degas and Edouard Manet. Today these names are world-famous but in 1862, when our story starts, only Manet had a slight reputation in Paris, as a result of success at the Salon of 1861. He, Degas and Pissarro were older than the others, who were all in their early twenties.

Monet, Renoir, Sisley and Bazille met as students in the studio of Gleyre,
were immediately mutually attracted despite varied backgrounds and tem-
peraments, and quickly formed a group of 'chums' who kept somewhat
apart from the other students. Monet, the son of a grocer, was a year older
than his friends, had had much more experience in the art world and took
the lead over them at once.

He had come from Le Havre, where the painter Boudin, who had loose
affiliations with the famous Barbizon School of open-air painting, had taken
him sketching in the fields when he was only seventeen, and had imparted
to him two principles Monet was never to forget: one, 'Everything that is
painted directly on the spot has always a strength, a power, a vividness of
touch that one doesn't find again in the studio'; two, 'One never arrives alone,
unless with very powerful propensities, and one doesn't invent an art all
by one's self.'

In 1859, at the age of nineteen, Monet had arrived in Paris to study art,
had frequented the cafés and made the acquaintance of well-known painters.
He had not enrolled at the *Beaux-Arts*, but at the *Académie Suisse*, where for
a small fee, painters could draw from the living model. Here he met
Pissarro, who like many other landscape painters, came there to study human
anatomy or merely to meet friends.

Pissarro had arrived in Paris several years before from the Virgin Islands,
where his father kept a general store. He had worked in many different
studios and had a wide acquaintance both among mature painters and
students. Like Monet, he believed in painting out-of-doors.

Shortly thereafter Monet had served his two years in the Army, follow-
ing which his father sent him back to Paris on condition that he follow the
State-controlled path to success. This led to his enrollment in Gleyre's
studio in 1862, and to his meeting with the friends with whom he was to work
and live for many years.

Renoir, whose father was a tailor from Limoges, had supported himself
from the age of sixteen by painting china, fans, screens and other objects,
saving every sou to enter the *Beaux-Arts* at twenty-one. Sisley, the son of
prosperous English parents, had been brought up in France. Bazille came
from a wealthy Montpellier family. All three had entered Gleyre's eagerly,
to learn to do as others did. Monet, however, was from the first day a rebel.
He told his friends of his work with Boudin, of the discussions of revolu-
tionary new movements and ideas to which he had listened in the cafés in
his first years in Paris, of what Boudin had told him of Courbet and Pissarro
of Corot.

In the Spring of 1863, he persuaded them all to go with him to Chailly

in the Forest of Fontainebleau, where the Barbizon painters had been working for twenty years. His friends naturally followed his example of painting entirely in the open, as Boudin had taught him. In chance encounters in the woods they met the Barbizon masters and received advice from the older men. Their intimacy grew and when in the fall they returned to Paris, Bazille and Monet shared a studio together, to which Pissarro came to see his old acquaintance, bringing with him another painter, Paul Cézanne. The meeting was to be highly significant in the lives of all of them.

Cézanne came from Aix-en-Provence. His father was a banker with whom he had had to struggle for three years before gaining permission at the age of twenty-one to study in Paris. There he had eagerly joined his school friend Zola in 1861, but his adolescent provincial dreams of success having failed to materialize immediately, he had returned to Aix. He had been unable to resist returning to Paris in 1863, this time in a dogged and embittered spirit. He had revolted from official art and all its regulations. Unlike the four friends and Pissarro, however, he was quite indifferent to the study of nature and greatly admired the more flamboyant Spanish masters. Aside from Pissarro, who on meeting him had been instantly convinced of his outstanding talent despite his awkward drawings, slovenly appearance and rough manners, his only other friend was Armand Guillaumin, a fellow-artist.

That winter the four friends, accompanied occasionally by Pissarro and Cézanne, frequented concerts and even penetrated some of the Paris salons through Bazille's connections. They were a strange coterie. Monet was bold; Renoir was gentle and gay; Bazille was shy; Sisley was dreamy and conservative; Pissarro was a passionate socialist with anarchistic leanings and a convinced atheist.

In the Spring of 1864, both Monet and Renoir sent paintings to the Salon which were accepted and praised. Both felt they were well on the way to success. Next summer they were back in the Forest of Fontainebleau and were often joined by Pissarro and Cézanne.

The jury for the next Salon, in 1866, accepted both Monet's and Sisley's paintings, but rejected Renoir's and Cézanne's, and accepted only one of Bazille's and Pissarro's. Monet enjoyed an outstanding success, far greater than did his friends. All looked forward to 1867, when the Salon was to coincide with a World's Fair in Paris. They were certain that the Fair would draw many collectors to Paris, who, seeing their works at the Salon, would look them up in their studios and buy their paintings. They were doomed to abject disappointment. All were rejected.

First steps in the formation of the Batignolles Group. In despair and resentment,

the four friends and Pissarro resolved to organize exhibitions on their own from that time forward. The idea was probably Monet's. Their older painter-friends, Courbet, Diaz, Daubigny and Corot approved of the plan. They discussed it with younger painters who shared their sentiments of opposition to the official bureaucracy and its rigid adherence to tradition. Thirteen of them met to consider the project. They were: the four friends; Pissarro and Cézanne; Fantin-LaTour, a friend of Renoir's,[9] much admired in the informal organization; two friends of Fantin's—Berthe Morisot, the only woman, and Edouard Manet, who was regarded as a leader by younger painters; Manet's intimate and eccentric old friend, Edgar Degas; Bracquemond, the engraver, a friend of Degas; Armand Guillaumin and Antoine Guillemet, both friends of Cézanne, the former also a friend of Degas and the latter of Manet.

After pooling all their resources, they found them too meager to make possible an independent exhibition. They did not abandon the idea, however, having convinced themselves that this was the best way to show their works, to win public approval and thus to earn a livelihood by painting.

Failure though it was, the project for an independent exhibition con-stituted the point of crystallization for a new grouping of painters. During the meetings and discussions the project entailed, those interested in it, despite diverse gifts, conceptions and tendencies, began to feel themselves drawn together and members of a little group. The four friends were the nucleus. They had developed norms in common, had interacted together in work and living for five years, and were bound by sentiments arising from a thousand shared insights and experiences, as well as by ties of mutual friend-ship. Closest to them in these respects were, of course, Pissarro and Cézanne, who had often joined in their activities and had participated in the many discussions and experiments from which their standards of judgment had emerged.

Fantin, Guillaumin, Guillemet and Bracquemond played rather minor roles in the group. Berthe Morisot, Degas and Manet, however, are in a different category and require some characterization. The three of them, like Bazille, were cultivated and wealthy bourgeois. All four were generous and as time went on and their association grew more intimate, they helped their needy colleagues as much as their means permitted, buying their paintings and loaning or giving them money as their road in life became rougher and success eluded them.

Berthe Morisot was a serious painter whose temperamental affinity with Corot had led her to espouse open-air painting. Manet was brilliant, worldly and inordinately ambitious, with his heart set on the *Légion d'Honneur*, for which he was prepared to make every sacrifice—except that of tampering

with his painting to please official taste. In this Degas was his exact opposite, having a fanatical disdain for official or popular success. He was incomparably witty, highly intelligent, solitary by nature and always something of an outsider in the group even when working closely with it. Neither he nor Manet were interested in painting out-of-doors. Manet had no sympathy with the ambition of those of the group who were searching for a new style wholly outside the Museum tradition, but Degas' natural inclination was for the unorthodox. No conventions could influence his gift for observation and his meticulous craftsmanship. He had not yet turned for subjects to the life around him, except for his studies of racehorses, and preferred the human figure to landscapes. Manet and Degas were unaffectedly independent in judgment and behavior, but whereas the first, although proud, was generous in social relations, the other was haughty and intolerant to all but erratically selected favorites.

The members of the group shared several passionate convictions: first, each had resolved to find 'his own way' of expressing his aesthetic vision, regardless of contemporary taste, official or lay; second, all held the State art hierarchy and its log-rolling judgments in contempt; third, all were determined to oppose both, as forcefully and effectively as possible; finally, all but Degas (so much the egoist that he felt no need for it) and Berthe Morisot were obstinately resolved to win acclaim in every quarter against all odds. Such were their emotional and ideological bonds (or sentiments). The interrelationship of sentiments and norms is exemplified by the first three items on this list. Any behavior which violated these sentiments would, in their opinion, also violate corresponding norms to which they were committed by their sentiments.

Rejection of their work by the Salon of 1867 had a devastating effect on the financial prospects of Renoir and Monet, who needed sales in order to live. Monet's family lost confidence in his future and cut off his small allowance, so he no longer had anything to share with Renoir. Sisley's father having just lost his whole fortune in a speculation, he was little better off. Bazille did everything he could to help the three, even pawning his watch. That summer, Renoir went to live with his parents on the banks of the Seine and Monet found a tiny house nearby. They worked together persistently. Renoir later remembered gratefully that Monet had inspired him with fresh courage whenever he had fits of despair. He wrote to Bazille: 'We don't eat every day. Yet I am happy in spite of it, because, as far as painting is concerned, Monet is good company.'

The two friends frequented La Grenouilliére, a bathing resort on the Seine. There the study of reflections in water led to the first of the

revolutionary Impressionist discoveries: that the color of an object is a blend or synthesis of its own color with the colors reflected by surrounding objects, modified by atmospheric conditions.

Their style was affected by these studies. In their attempt to fix on canvas the glittering atmosphere, the vibrations of light and water and the broken reflections of objects, they began to experiment with rapid strokes, dots and commas of colors, composing the surfaces of their paintings entirely by juxtaposing small bits of pigments of different shades. By means of this technical invention, they captured their subjects as *wholes* spontaneously perceived, without regard to their separate details. The result was a liberation from classic rigidity they had never before achieved.

During that summer the two friends built a working partnership. Each studied the same flowers in the same vase and put up easels in front of the same subjects. In this communion of work, they developed a style of expression which brought them closer to one another than to the two others of the quartet. This rare congeniality was reinforced by mutual attachment between Renoir and Monet's wife, Camille. In October, Renoir returned to Paris to live with Bazille in a new studio in the Batignolles quarter, not far from the Café Guerbois.

Maturation of the Group. In that quiet café, the painters attracted by the exhibition project casually began little by little to meet. By 1869, it had become their headquarters. Manet was the intellectual leader. Monet, the leader of his little group of four, was content to listen rather than contribute to the discussions. Of all the group, Degas was closest to Manet; but they had violent quarrels, for Manet brooked no contradiction of his views and Degas as well as the others was unwilling to be muzzled. Bazille had the education and the taste to engage in verbal battles with Manet and Degas; but Renoir, having left school early, was like Monet, inhibited by his lack of education and also by reluctance to raise his voice in noisy debates. He had ardently studied both books and the paintings in the Louvre and had formed firm opinions which did not need the confirmation of others.

Cézanne did not frequent the café regularly; he did not care for discussions and theories. He seldom spoke, but then with vehemence and conviction. Pissarro, who was living in Louvenciennes with his wife and children, came frequently to Paris and always appeared. Every one of the painters felt deep esteem and genuine affection for his generous and pure spirit, which was nevertheless indomitably belligerent. Even the two most mistrustful and undependable members of the group—Cézanne and Degas—felt real friendship for him.

One of Degas' favorite topics was the unsuitability of making art available to the lower classes and selling reproductions of paintings for 13 sous, views which must have aroused the opposition of Pissarro and possibly of Monet. But Degas' most irritating propensity was that of taking seriously the works of artists in whom the others could discern no merit whatever—a tendency that was to have decisive and tragic consequences in the future.

The novelist Zola, Cézanne's old friend, attached himself to the group and became its mouthpiece in the press and its zealous defender everywhere. Himself searching for new forms of expression in literature, he had become an advocate of 'naturalism,' a term coined by Castagnary, a critic, to denote the work of these painters. He defined it as 'truth balanced by science,' claiming that in art it expressed a synthesis of philosophical rationalism, sociological preoccupations, and social as well as political equalitarianism! The painters themselves rejected this formula and Zola's blind conviction that they were as attached to it as he was bore bitter fruit in later years.

Although he and Pissarro occasionally brought up political questions, discussions at the café centered on theoretical and technical problems of painting. Many hours were spent on the subject of shadows, which had become one of the painters' main problems. The landscapists who worked out-of-doors had gradually been learning from observation that—contrary to all that had been taught for centuries—areas in shadow are not dark, but rich in color, complementaries and blue being dominant. Monet, Sisley and Pissarro, in order to study the problem further, began to devote themselves to winter landscapes. They made another revolutionary discovery: that the areas exposed to the sun determine the colors of adjacent areas in shadow. So the group gave up the established method of indicating shadows by using more and more somber colors the farther the shadowed objects were removed from the source of light.[10]

They had many a practical discussion about their difficulties in making a living by their art. Opinions concerning the Salon were not unanimous. Renoir and Manet were convinced that it was the real field in the battle for success, the place where the painter's measure was taken, to which Zola agreed. Cézanne was determined to be admitted to the Salons, but he did not believe in compromise with official taste and advocated sending to the juries the painter's most advanced canvases, rather than—as was the custom —the most nearly traditional. It was a practical matter rather than one of principle for the others. Rejections by the juries blocked their way to sales and kept the public from learning about their discoveries.

In their meetings at the Café Guerbois, the painters expressed themselves freely, gained understanding of one another's aims, ideas, theories, and

techniques, formulated criteria for judging their contemporaries, and jointly explored new influences—for example, Oriental art, brought to Paris by the World's Fair of 1867. Even more important, despite their many disagreements, they reassured one another and found in this companionship solace for their hard and difficult lives of unremitting struggle to perfect their art and hold fast to their original vision. 'Nothing could be more interesting,' Monet later recalled, 'than those *causeries* with their perpetual clashes of opinions. They kept our wits sharpened, they encouraged us with stores of enthusiasm that for weeks kept us up, until the final shaping of the idea was accomplished. From them we emerged tempered more highly, with a firmer will, with our thoughts clearer and more distinct.'[11]

Although united by their common contempt for official art and their determination to find their own ways without following traditional methods, almost every one of the painters was experimenting in a different direction; they could not, therefore, be called a 'school.' By 1869–70, their contemporaries were referring to them as 'the Batignolles group,' public recognition that the friends constituted a 'movement' and were bound together by distinctive affinities, but had not as yet preempted a specific field for common effort.

In July, 1870, France went to war with Prussia. Cézanne eluded the draft and went to the Mediterranean coast to work. There he began to adopt the small brushstrokes of his friends and their brighter palettes. Sisley, Monet and Pissarro fled to England. The other seven members enlisted in the armed forces.

In November, Bazille was killed in battle.

In London, Pissarro and Monet met by chance and immediately began to work together. Pissarro later wrote: 'Monet and I were very enthusiastic over the London landscapes. Monet worked in the parks, whilst I studied the effect of fog, snow and springtime. . . . We also visited the museums. . . . We were struck chiefly by the landscape painters, who shared . . . our aim with regard to "pleinair," light, and fugitive effects.'

The war and the terrors of the Commune over, in the autumn of 1871 the painters were back in Paris and meeting again at the Guerbois. The working partnership between Renoir and Monet was immediately resumed, this time in Argenteuil. For both, nature had become the direct source of pure sensation, to be reproduced by dots and comma-like brushstrokes even smaller than those they had used at La Grenouilliére. This technique improved their ability to record every nuance they perceived, and to retain the richness, the color and the liveliness of their spontaneous impressions. Sisley, after finding, through association with his friends, a new approach

to nature, began to make personal discoveries along the lines they had stimulated him to explore. Pissarro settled in Pontoise, where at his urging Cézanne joined him. The two worked side by side. 'We were always together,' Pissarro later recalled, 'but . . . each of us retained the one thing that counted, his own unique sensation.' Cézanne willingly recognized that Pissarro had played a decisive part in his development during this period. But as Pissarro considered it absurd to think that artists are the sole inventors of their styles, he insisted that Cézanne had influenced him at the same time. All the friends admired and strove to acquire the humility of Pissarro's approach to nature, but Cézanne now came closest to it. He abandoned his fiery, emotional execution, and adopted a new approach based on Pissarro's experiments, purified his palette after Pissarro's example, even appropriated completely both his technique of small brushstrokes and his method of modeling with modulations of color-tones, which Pissarro had picked up from Manet in their work together.

After the war, Salon juries showed themselves as hostile as ever to works by most of the friends, so in 1873 Monet suggested that the group boycott the Salons and hold, as proposed in 1867, a group exhibition to be financed by the artists themselves. Renoir, Sisley, Pissarro, Berthe Morisot and Degas agreed. The friends had slowly acquired a nucleus of collectors interested in their art and this seemed a sound reason for embarking on this project.

Manet,[12] Fantin and Guillemet had become convinced that group shows were not a practical means of gaining recognition and they refused to participate. They did not allow this policy to separate them from the group, however, and even assisted the others in every way possible, although Manet voiced many protests.

The enthusiastic friends expected a public demonstration of their independence to bring them more prestige than participation in the Salon. Their own exhibition furthermore had the additional advantage of enabling them to show many more canvases than the three allowed by the Salon. But difficulties began immediately. Each painter had his own ideas about how the exhibition should be organized and promoted.

Pissarro advocated formation of a cooperative association, offering as a model the charter of a bakers' cooperative in Pontoise, a suggestion Renoir rejected in horror. It was finally agreed that each painter should simply turn over one-tenth of the proceeds from any sales. Pissarro's suggestion that lots be drawn to decide the hanging of the paintings was a brilliant solution for a problem that has sometimes split similar groups. An admirable gallery was found in the heart of Paris. There was a struggle over the title, Renoir and Degas insisting that it should have no precise signification; all

feared being bracketed together as a new 'school.' So the exhibition was announced simply as that of 'The Society of Artists, Painters, Sculptors and Etchers.'

Degas was determined to invite artists who were to show at the Salon, so as not to give the enterprise a revolutionary character. In this Renoir, always against 'playing the martyr,' supported him. The others, however, wished the exhibition to be limited to the members of their group, so as to present a comprehensive panorama of their accomplishments. They suspected Degas, not in full sympathy with their studies of nature, of fearing to be alone in their midst. His proposal finally prevailed for the very practical reason that a greater number of participants would reduce the financial burden on each contributor. The disagreement was not serious at the time but resentment at Degas' indifference to their determination to show contempt for the Salon rankled, as did his lukewarm attitude toward the special preoccupations of the landscapists. These resentments were to play their part in future dissensions.

Each organizer then undertook to recruit as many other exhibitors as possible. Pissarro wanted Cézanne, but Monet and Degas were reluctant to admit him, fearing to outrage public opinion[13] and thus defeat their objective of demonstrating the stupidity of Salon rejections. Opposition to Guillaumin was voiced on the same grounds, but eventually both were admitted. Boudin participated at Monet's request. Bracquemond came in at the last minute. One hundred and sixty-five works were shown, the nine members of the Batignolles group contributing fifty-one.

The opening took place on April 15, 1874. Today this is a landmark in art history—the first group exhibition of painters later to become the fabulous 'Impressionists.' But it excited only derision in the Paris public which attended in laughing crowds. The critics were hostile or ignored the show altogether. Nothing but ridicule for their devoted and painstaking efforts! Pissarro later wrote: 'What I suffered is beyond words, much more than when young, full of enthusiasm and ardor.'

Suffer cruelly from this fiasco the painters did, but it taught them an important fact—not before completely realized because they lived in a somewhat closed world—that their new approach to painting, the new palette and the new techniques which they had together created, were accomplishments critics and public were unwilling to try to understand or accept. Having tested their methods individually and together, the painters knew that they had made a great stride forward in the representation of nature since the days of their masters, Corot, Courbet, Boudin and their predecessors. Public hostility did not shake their convictions. After the exhibition,

without hesitation, they continued their daily efforts toward creation, 'like a company of actors performing night after night for an empty theatre.'[14]

After the closing of the exhibition, Cézanne left for Aix and Sisley for England. Monet went to Argenteuil to a house Manet had procured for him where, apparently unaffected by their failure, he painted more energetically than ever, Renoir frequently at his side. Manet also spent several weeks in Argenteuil working with him. It was at this time, watching Monet paint, that Manet was finally won over to work done out-of-doors.[15] He began to study people in the open, attempting to achieve the unity of figures and natural surroundings which had intrigued Bazille, Monet, Renoir and Berthe Morisot.

Notwithstanding his reservations, Degas, like Manet, had been much influenced by his contacts with these painters. He had been induced to study Courbet's work carefully and—highly important for his future reputation—to concentrate on contemporary life. To be sure, it was a gas-lit life, for he spent hours in the rooms at the Opera where the ballet-master trained young girls in their exacting art, and he frequented music halls, café concerts and circuses, attracted by the sight of skillful performers subjecting their bodies to a merciless routine. His friends' preoccupation with their immediate sensations, their insistence on studying their subject while working on it, made them, in his opinion, slaves to chance circumstances of weather and light. He espoused the principle of observing first and painting afterwards and urged his friends to seek for discoveries along the lines of draftmanship instead of exploring light and color. 'But,' he later told the English painter Sickert, 'they wouldn't listen to me and have gone their own way.'

The painters' financial situation had become so desperate that Renoir persuaded Monet and Sisley to organize an auction sale of paintings at the Hotel Drouot in 1875. They were joined by Berthe Morisot, who did not need the money but wished to support her colleagues. Durand-Ruel, the Paris art-dealer who had promoted the Barbizon painters in France and England (and was to do the same for the Impressionists later in America), gladly officiated as expert. The auction was a disgraceful scene. The public howled down every bid. The police had to be called in. The works went for almost nothing. Again the painters had to endure public contumely. But they received one important benefit: a new buyer—a collector with trained and developed taste—Victor Choquet, a supervisor in the customs administration.

Immediately after the sale Choquet asked Renoir to paint a portrait of his wife. A close friendship soon developed, Renoir being much attracted by the enthusiasm, sincerity and taste of Choquet. As each of the friends always

tried to let the others benefit from new acquaintances—even advising as to the prices they might charge—Renoir immediately took Choquet to Père Tanguy's to acquaint him with Cézanne's work,[16] knowing that nothing would be more helpful to Cézanne at this painful time than acquisition of a new admirer. Choquet immediately bought a Cézanne and later met the painter. In turn, Cézanne took Choquet to Monet's.[17]

A new personality rather suddenly entered the nuclear group at this time: an Argenteuil neighbor of Monet's, Gustave Caillebotte, who painted in his spare time. Their common enthusiasm for painting and yachting soon created between Monet and his neighbor a strong bond of friendship which the latter immediately extended to Renoir. Not unlike Bazille in character and social position, Caillebotte began to fill his vacant place of comrade and patron. He bought their works, concentrating on those particularly unsalable.[18]

In April, 1876, the friends held a second group exhibition. Cézanne refused to participate,[19] as he planned to send a painting to the Salon; neither did Bracquemond. Guillaumin was unable to do so. Boudin did not again support Monet's efforts. Fifteen non-Impressionist painters declined to appear again in that derided company. Caillebotte was a new recruit. Visitors and sales were few; the press was savage; the exhibition did not change their position.

Their difficulties were exacerbated by publication of a monograph entitled: *The New Painting: About the Group of Artists Who Exhibit in the Durand-Ruel Galleries.* Written by the critic Edmond Duranty, a friend of Degas, it began by granting that the artists had made genuine discoveries: 'From the point of view of delicacy of eye, of subtle penetration of the art of color, it is an utterly extraordinary result.' Derogatory remarks followed, however, about the eccentricities of some of the personalities in the group, intimations that their performance was extremely uneven, and warnings that there was reason to doubt they would ever create works of substantial merit. The resentment of the artists was extreme. They did not blame Duranty so much as Degas, who shared the author's limited approval and cautious reservations. The little cloud of dissension, 'no larger than a man's hand' was growing in volume. The failure of the second exhibition shook the confidence of some of the painters in the wisdom of the course they were pursuing; especially as Manet, who had much influence among them, despite rejection by the Salon in 1876, did not reconsider his policy regarding group exhibitions. Instead, he showed the rejected canvases in his own studio!

That summer and autumn Renoir and Monet continued their experiments.

But this time each worked much alone. In a garden on the heights of Montmartre, Renoir set himself the problem of studying the play of shadows and broken shafts of sunlight on the faces, dresses and nude bodies of friends placed under trees. His human subjects were reduced to mere objects which reflected the dancing light which, from moment to moment, changed their forms, endowed them with new contours and enhanced their brilliance. At times Monet joined him in studying these effects but he was branching off in another direction.

In the winter he tried something not before attempted by any of the painters: an industrial scene, the Gare St. Lazare. Inspired by Degas' principle of painting a single subject from various angles, he depicted from different points of vantage the great enclosure of the railway station, with its contrast between the pale, calm sky and the stacks of locomotives belching huge clouds of heavy smoke toward the domed glass roof, the movement of hurrying crowds, of incoming and outgoing trains. For the eyes of beholders not yet aware of its kind of beauty, he made a conquest of one of 'the most typical scenes of modern life,' which the critic Duranty had challenged the painters to attempt. But as the paintings showed not a trace of 'social consciousness,' he refused to accept them for what they were.

The group was now generally referred to as 'the Impressionists.' The term had been coined in derision, but they accepted it and gave it meaning by publicly proclaiming their belief in 'treating the subject in terms of tone,' emphasizing that their efforts were wholly directed toward putting on canvas their first spontaneous impressions, uninhibited by conventional interpretations of the subject or by previous experience with it.

Dissension in the Group. Due solely to the initiative and enthusiasm of Caillebotte, a third group exhibition was organized in 1877. Over Degas' violent opposition, it was announced as *Exposition des Impressionists.* Cézanne and Guillaumin rejoined, bringing the participating members of the group to nine. Eighteen painters in all took part; newcomers included young friends of Renoir and Pissarro. More than 230 works were shown, each of the Impressionists contributing more examples than before. But public response was little more encouraging than in previous years and the press continued venomous. Choquet spent all his time in the gallery relentlessly and vainly endeavoring to change hostility and derision into appreciation. A second auction was organized after the closing, with results little different from the first; but at least the police were not called in!

Both exhibition and auction created a furor in Paris. Impressionism became notorious overnight. Caricatures of the artists appeared in the

newspapers; they were the butt of jokes on the stage; everyone gossiped about them. But the most impressive exhibition they had yet put on brought them neither public acclaim nor money. Almost all of them became deeply depressed.

Monet, heretofore the staunchest spirit of them all, began to doubt their ultimate victory. Renoir was equally dispirited. Pisarro wrote: 'I am going through a frightful crisis and I don't see any way to get out of it.' He appears not to have been tempted to abandon the group's cardinal rule of boycott of the Salons, but that summer, while again working side by side with Pisarro and Guillaumin, Cézanne's determination to seek success through the Salons became fixed and he announced his refusal to participate in any more group exhibitions. Then the timid and shy Sisley took the same course. He wrote: 'I am tired of vegetating. . . . Our exhibitions have served to make us known and in this have been very useful to me, but . . . We are still far from [being] able to do without the prestige attached to official exhibitions.' Renoir—who never enjoyed 'making up his mind'—in his despair allied himself with Sisley. Notwithstanding the defection of his old comrades and best friends, Monet could not bring himself to break with the group and remained undecided, although the loss of their support intensified his suffering.

At this very time, the group gained two brilliant young recruits: Mary Cassatt and Paul Gauguin. The former came through Degas, the latter through Pissarro. Daughter of a Pittsburgh banker and devoted to the work of Degas, Manet and Courbet, Miss Cassatt's own work had been both accepted and rejected by Salon juries and she held their standards in contempt. So when a mutual friend brought Degas to her studio and he, after seeing her work, invited her to join the group and to exhibit with it, she 'accepted with delight' this release from the necessity to conform to official prejudices. Subsequently, she herself bought Impressionist paintings and for many years persevered in urging her rich American friends, the Potter Palmers, the Havemeyers and others to do likewise. To her taste and initiative the Art Institute of Chicago and the Metropolitan Museum of New York owe their choice collections of early Impressionist works. Almost immediately after her acceptance by the group, she joined Degas, Pissarro and Bracquemond in their joint venture to publish portfolios of prints by the members of the group and continued doing etchings with them for several years.

Gauguin was a well-do-do stockbroker who painted in his spare time. Attracted to the works of the Batignolles group, he began to buy them soon after his arrival in Paris in 1871. Feeling the need for professional advice, he consulted Pissarro, who agreed to become his teacher. He tried to develop

Gauguin's gifts through close contact with nature. Mary Cassatt once said of Pissarro: 'He was so much a teacher that he could have taught stones to draw correctly.' But it was Cézanne's work that Gauguin most admired.

Withdrawal by Renoir and Sisley from the group shows appears to have exacerbated resentments and irritations which various members of the group had been feeling for a year or two. That a change was taking place in the relationships between the members was symbolized by a gradual shift of headquarters. About 1878, Manet and Degas began to frequent the Nouvelle-Athens and to appear less often at the Guerbois. Renoir, Pissarro and Gauguin followed them there, but Monet, Cézanne and Sisley rarely joined them. At the same time, Pissarro, Renoir, Sisley, Guillaumin, Père Tanguy and a few others began to meet regularly for dinner at the flourishing restaurant of Eugene Mürer, a friend of Guillaumin, who had become a patron of the artists.

Despite the abstention of Sisley and Renoir, Caillebotte went ahead in 1879 with a fourth exhibition. He was obliged to take care of everything: borrow paintings, look after frames and inspire the fifteen exhibitors, of whom only six were group members,[20] with optimism. Visitors were satisfactorily numerous and sales encouraging, but the press did not change.

Meanwhile both Cézanne and Sisley had been rejected by the Salon. But Renoir's large portrait of Mme. Charpentier and her two small daughters became the 'hit' of the show with press and public alike. The success owed little to the painter's genius. M. Charpentier was an important publisher, his wife a figure in the intellectual world of Paris. She had freely used her journalistic influence and her powerful contacts in official circles to insure this result.

Renoir had made the acquaintance of the Charpentiers in 1877 through Zola, one of Charpentier's authors, and the commission had been offered to him almost immediately. This was a great piece of luck for him; but his triumph, although it rejoiced his friends, precipitated further dissension in the group.

Monet was profoundly disturbed. His opposition to the Salon had become an article of faith; to repudiate it was to confess having for years been blind and foolish. However, without confidence in the future, it was undoubtedly stupid to persist in a course of action which had so far brought no reward at all when, as Renoir had just demonstrated, the Salons offered at least the possibility of attaining status and prestige. After the exhibition, he therefore announced that he also would submit paintings to the Salon of 1880. This decision met with Degas' profound contempt. He refused to have anything

further to do with Monet, who complained that others in the Batignolles group also treated him as a 'renegade.'

Interaction in the meetings of the Batignolles group was marked now by bitterness, acrimony and violent quarrels, gleefully watched and reported by their enemies. Such a radical change from their hitherto good-natured and stimulating disputes demands explanation.

Like all autonomous groups, this one was oblivious of its own processes, so explanations must be inferred from such evidence as is available. From this data, it seems safe to assume that a number of factors were at work. These will be listed, but not in any order of importance, for which evidence is lacking.

1. The painters were no longer in their first youth. The youngest were facing forty years of age in 1879; Manet and Pissarro were on the verge of fifty.

2. They were all discouraged with their work, not alone because it sold poorly but predominantly because they seemed to be making no progress in the directions they had chosen and faithfully pursued for many years.

3. The experience of the members between 1874 and 1879 had made some of them aware that the group was not satisfying, and could not be expected to satisfy, expectations which, consciously or unconsciously, they had entertained. Maturity necessarily brings disenchantment with the ardor of youthful faith in the future; only the greatest spirits or the unimaginative and insensitive escape this experience. These painters (with the possible exception of Pissarro) were neither. Everything we know about them points irrefutably to the conclusion that except for Degas and Morisot they were avid for public as well as critical recognition and equally desirous of prestige, status and financial rewards.

The *manifest* purposes of the group had been stated clearly and often: (1) to encourage members to 'go their own way' without following traditional methods; (2) to demonstrate contempt for official art institutions. The first had been fulfilled with brilliant—and as history has since shown—with enduring success. Together the members had created a distinctly new form of art. Its effects were beginning to be felt even in official circles.[21]

During the twelve years (1867–79) they had interacted almost continuously, each of them had matured artistically. Their sense of their own unique qualities had become increasingly sure, a result it is safe to attribute to the encouragement they derived from membership in a group devoted to continuous experimentation with new problems and new methods. Time had been requisite for these constructive developments. Simultaneously, however, it had brought them to the period in life when scrutiny of one's strategy for attaining prestige and status must be harsh and realistic.

The second manifest purpose they had pursued consistently, but they had gained little thereby. In their innocence, they had apparently believed until 1878 that their defiance of the Salons by means of independent group exhibitions would redound to their credit and constitute a short-cut to success. It is clear that unconsciously some of the members—including Monet—had endowed the group with a *latent* purpose: *to win through joint action (i.e.,* their defiant independent exhibitions) *the prestige and status they ardently desired.* Their disappointment on this score, coupled with the pressures from time and maturity, forced them to face squarely the fact that they had deceived themselves.

Manet, Fantin and Guillemet had foreseen this result from the beginning.[3] Having chosen the Salons as their path to success, they refused to show with the group. Next, Cézanne had become aware of the futility of group exhibitions as a means to success. His participation in the 1874 show had been due in part to his congenital sympathy with a defiant gesture and in part to his devotion to Pissarro. He had wavered only once, in 1877, possibly again persuaded by Pissarro. But after he began to feel complete confidence in his own abilities, he opted for the Salon as the only certain road. He continued his close association with the group, however, and readily acknowledged its value to his development.

The others, having chosen to express their contempt for the Salons by showing with the group, had loyally stood together. Then Renoir and Sisley broke away. They appear to have accepted disillusionment with fair equanimity, but Monet could not do so without a severe internal struggle. He had been a leader of the group, had been the strongest advocate of the policy of group action and had for long received loyal support from his sympathetic colleagues. Now he had to decide whether or not to 'go it alone' in search of success. To do so involved public repudiation of the policy he had tenaciously fought for and wholeheartedly pursued. It also required desertion of the group members who still remained loyal to that policy. Not to do so would enable him to remain with them and to adhere to a policy which from the days of his youth with Boudin had seemed the only right and self-respecting one. The conflict assumed the moral dimension of acting on behalf of his own self-aggrandizement or of remaining loyal to his old ideals of cooperative action and to the comrades-in-arms with whom for years he had shared so much of himself. He took a year longer than his friends to make his decision in favor of the Salons and when he made it was more bitter than they. He publicly proclaimed his ill-feeling in June, 1880, at the opening of his one-man show at a commercial gallery. Asked by a newspaper reporter whether he was still an Impressionist he

answered: 'I am still and always intend to be an Impressionist . . . but I see only very rarely the men and women who are my colleagues. The little clique has become a great club which opens its doors to the first-come dauber.'

It is interesting that once Monet had made his decisión, the Batignolles group was split exactly in half, with Bracquemond having a foot in each camp. Manet, Guillemet, Fantin, Cézanne, Renoir, Sisley and Monet were for the Salons; Degas, Pissarro, Berthe Morisot, Mary Cassatt, Guillaumin, Caillebotte and Gauguin continued to have faith in group exhibitions.

The fact that the issue of Salon-versus-group exhibition so decisively affected the Batignolles group makes it practically certain that for some members the latent purpose was at least as powerful as the manifest purposes in holding the group together for twelve years.[22] One might be tempted to go further and to suggest that, granted the ambition of the painters, the group would not have persisted so long without the latent, unexpressed purpose. But in fact the manifest purpose of mutual support of each member's endeavors to 'find his own way' was at least equally potent as a binding force. An ironical corollary follows recognition of this fact: Neither the latent nor the manifest purposes of the group foreshadowed its eventual historical significance. The manifest purpose of supporting the endeavors of members to 'find their own way' was conceived in strictly limited terms o: satisfying each individual's own drive toward unique personal expression. Yet the by-product, or consequence, of *joint* action to facilitate this wholly individualistic drive was an invaluable *group* contribution to art and culture!

Undeterred even by Monet's defection, in 1880 Caillebotte, strongly supported by Pissarro, went ahead with a fifth group show. As Pissarro': living depended on sales, and there were few of them, his unswerving loyalty to the group's boycott of the Salon was truly heroic. The exhibition on Degas' insistence, included works by a large number of indifferen painters who were friends of his and had not the slightest interest in Impres sionism. The group members included Degas, Berthe Morisot, Guillaumin Caillebotte, Mary Cassatt and Gauguin. Degas insisted that the word 'Impressionist' be dropped from the posters and 'Independent Painter: was substituted. Despite this victory, he showed a lack of zeal—which dea: the enterprise a heavy blow—by failing to send many of the works he ha. promised. Visitors were few. But at last there was a change in the press. . few critics instantly discerned the wide differences between the common approach and techniques of the Impressionists and those of Degas' friends. For the first time, several influential reviews evinced genuine critical under- standing of the group's aims and accomplishments.

Sisley and Cézanne again gained nothing by deserting the group; their paintings were rejected by the Salon jury. Monet's important landscape was refused in favor of a canvas inferior to it. Both of Renoir's paintings were accepted, but they and the Monet were so badly hung as to be seen only with difficulty. The friends tried to enlist the support of Zola, now a powerful journalist, to protest against this flagrant injustice. But they could not arouse Zola's professional indignation in a matter of major importance to them—for Zola, too, was drifting away from the group. He now trumpeted his conviction that as Cézanne and Renoir, Sisley and Monet, had returned to the Salons, the group no longer existed and Impressionism as a movement was dead.

Pissarro and Caillebotte ignored the dissensions in the group and began to discuss a sixth exhibition for 1881, only to find themselves in violent disagreement about—Degas!

Caillebotte was indignant against him for his summary repudiation of Monet and Renoir and for other reasons, but Pissarro could not leave 'friends in the lurch' and defended Degas, remembering the many times he had helped him in extremity. Caillebotte thereupon refused to help with the show and to exhibit by himself.

In the end a sixth exhibition was held. No one quite knows how it was organized. In all probability, Pissarro and Degas pulled it off together. Two distinctly different types of painting were represented: on the one hand, the group members—Pissarro, Berthe Morisot, Guillaumin, Gauguin, Degas and Mary Cassatt—on the other, six conventional painters who were friends of Degas. By this time, the critics' eyes had been educated to appreciate the superior aesthetic vision and unexampled execution of the Impressionists. The absence of their acknowledged leaders, however, together with the deplorable lack of cohesion in the show, seemed to signalize dissolution of the group.

But human relationships of many years' growth do not dissolve so rapidly; they are like a fire which goes out slowly only as fuel is withheld. What the group apparently needed at this point was new leadership. When Monet separated himself from it, neither Pissarro nor Caillebotte succeeded in filling his place. Degas could not do so, having for long played an obstructive role. Durand-Ruel, now the exclusive Parisian dealer in Impressionist paintings, who was motivated more by a sincere appreciation of their art than by commercial considerations, assumed the leadership after both Caillebotte and Pissarro had failed.

In 1882, he induced the painters to cooperate in staging a seventh group exhibition. First he had to obtain the consent of Monet and Renoir. Both

answered his letters in the same vein: they refused to be associated with any but artists who belonged to the real Impressionist group; each insisted on his freedom to continue sending pictures to the Salon;[23] each made his acceptance contingent on the participation of the other; both were willing to accept Degas but not his protégés. Renoir had been increasingly irritated by Pissarro's political and revolutionary tendencies and protested against any show of so-called Independents, adding: 'exhibiting at the Salon . . . is not for pleasure but . . . it will dispel the revolutionary taint which frightens me.'

Eventually, all the old group were included except Cézanne. Degas paid his dues and remained a member as Manet had done, but refused to exhibit without his protégés. Mary Cassatt abstained out of loyalty to him.

Thus, after fifteen years of association, the Batignolles group presented to a largely unappreciative Paris its most resplendent and most representative exhibition. This brilliant public appearance was a triumphant demonstration of the successful issue of the group's joint researches for new avenues of aesthetic expression.

The Group disintegrates. The exhibition brought no rewards in money. The financial distress of many of the painters was accompanied by deepening discouragement with their work.

For a time, Pissarro, Cézanne and Gauguin continued to paint side by side. But Pissarro felt himself tame and lusterless beside Renoir's glittering color effects. Renoir was assailed by equally disturbing doubts. He began to fear, after a trip to Italy to study Raphael, that he had neglected drawing too completely while working in the open and concentrating on color and light; a positive hatred of Impressionism assailed him. Sisley and Monet were equally dissatisfied for different reasons. In December, Renoir and Monet left together for the Côte d'Azur, where they met Cézanne for a brief period. But their working partnership had ceased. Monet made this explicit in a letter to Durand-Ruel, in which he said: 'Nice as it has been to make a pleasure-trip with Renoir, just so would it be upsetting for me to travel with him to work.'

Eventually, even the team of Pissarro, Gauguin and Cézanne broke up. Yielding to his long-felt urge to isolate himself, 'to make out of impressionism something solid and durable like the art of museums,' Cézanne settled permanently in Aix. Gauguin, after deserting Pissarro as his master and turning to Degas, who rejected him as a pupil although he both admired and bought his work, left for his first trip to the South Seas. Pissarro floundered until 1885, when he attached himself to the young 'pointillist'

painters, Seurat and Signac, and began to work in a way which alienated all his old comrades, to whom he now slightingly referred as 'romantic Impressionists.'

At this very time, when even the ever-loyal and patient Pissarro had found new associates, Zola publicly dealt the group a crushing blow. In 1886, he published a novel, *L'Oeuvre*, the hero of which is a painter, presumably Manet or Cézanne. The Batignolles group is portrayed as an object for pity because its members had failed to achieve worldly success and thus live up to what Zola had expected when he joined them. He scornfully castigated his former friends for their obstinate insistence on fighting for their 'own way.' Cézanne's letter, thanking him for his presentation copy of the book, was one of farewell and the school friends never met again. Monet, Renoir and Pissarro publicly condemned Zola's crude judgment and avoided him until his stand on the Dreyfus case aroused their admiration, but Cézanne did not relent.

During the eighties, possibly as a symbolic reflection of each painter's independent search for a new direction for his work, several of them moved away from Paris while others traveled extensively, thus making contacts difficult. That the physical separation did express a psychological situation was demonstrated in 1886, when Berthe Morisot, Pissarro and Guillaumin took the initiative in organizing a new group exhibition. Only Degas, Mary Cassatt and Gauguin joined them. After 1886, not even an attempt was made to rally the group for a new show. The organization had ceased to exist. Not one of them seemed to regret its passing; the group had served its purpose.

But the ties of old friendships and the sentiments formed through years of struggle and intimacy persisted. In time, even the sharpest estrangements were healed. Between 1890 and 1894, 'Impressionist dinners' were held monthly at the Café Riche, attended by Monet, Pissarro, Renoir, Sisley and Caillebotte, where they joined old friends among the journalists and critics and new admirers of their work, which had at last attained, in the informal organization, the prestige accorded a generation before to Delacroix, Courbet and Corot.

Degas elected to stand apart from these gatherings. Manet had died in 1882 and of his old associates, he saw only Pissarro until 1897. In that year the Dreyfus case agitated all France and he broke off the friendship of thirty years' standing because of Pissarro's Jewish origin. Renoir, who became extremely fond of Berthe Morisot, saw her frequently, as both lived in Paris. Cézanne, anchored in Aix, was visited often by his former colleagues and spoke of them with affection to the disciples who gathered around him, referring particularly to Pissarro, Monet and Renoir. Sisley, when asked

whom among contemporary painters he most admired, named none of his
former comrades. Yet in 1899, when suffering from cancer of the throat and
feeling his end was near, he sent for Monet, who hastened to his bedside.

'Perfection is a collective work,' Boudin once wrote. The words are
particularly true when applied to the Batignolles Group. For nearly twenty
years its members helped, supported and encouraged one another in their
joint and individual pursuit of a new conception of art and nature, of color
and light, achieving in the end a style and conception of beauty peculiarly
their own and creating the Impressionist movement, which survived them,
growing in power as new generations of painters studied the works of the
members of the group and so long as they lived turned for advice to indivi-
duals who had belonged to it, as they when young had sought the advice of
the Barbizon painters.

NOTES

1 Dorothy Blitsten, 'Forms of Social Organization,' *Autonomous Groups*,
Vol. XI, No. 1.
2 Recent announcements in the daily papers of the prices at which works
of these painters are selling today—as high as, and in some cases higher
than, those for famous works by Old Masters—as much as $100,000 to
$300,000—indicate that their achievement is definitely a contemporary
fact.
3 For example, Philip Wiener, 'The Metaphysical Club,' *Autonomous
Groups*, Vol. X, No. 1; and *Evolution and the Founders of Pragmatism*
(Cambridge, Mass.: Harvard University Press, 1949). Also, *The Journal
of the History of Ideas* (College of the City of New York). This publication
with its interest in the cultural milieu within which ideas and conceptions
proliferate, and the antecedents from which they derive, has, since 1940,
published a wealth of scholarly papers which point, in sum, in the
direction opposed to the individualistic bias. These papers have shown
almost all cultural achievements to be, basically, products of a number of
individuals all influencing one another, but often without being aware of
it. This, however, is not quite the same as the thesis suggested in this
paper. Our thesis involves not only mutual influences but *also an organiza-
tion* (however informal) *of some of the individuals who influence one another,
plus common consciousness of a joint goal, of which the organization is the
carrier*.
4 In *The History of Impressionism*, 2d ed. (New York: Museum of Modern
Art, 1946), John Rewald assembled the evidence from innumerable
sources—the artists' works, their letters, reported conversations in
memoirs, numerous accounts of contemporary witnesses, contemporary
criticisms, etc. His researches convinced Mr. Rewald that the association

of the Impressionist painters had been a determining factor in their development and achievement. His documentation supports this conclusion. We have drawn heavily on his book and gratefully acknowledge our great indebtedness to it.

[5] (Harcourt, Brace, 1950.) Dr. Homans postulates four interdependent variables as the constituents of the internal social system of any group: interactions, sentiments, activities and norms. He also emphasizes the need for studying the external social system (the relevant human environment) within which the internal system (or group) grows and develops.

[6] It is never possible to analyze this system in its entirety, as it integrates particular cultural elements, specific legal and political arrangements characteristic of the period under review, as well as fashions in taste, fads, and many intangible factors to which the members of the group might themselves be unconscious of responding. The best one can do is try to single out from the records the factors to which they were *conscious* of responding.

[7] Susan Ertz, *The Charmed Circle* (London: Collins, 1956).

[8] The behavior of dealers, journalists and critics toward the Impressionists and their effect upon the development of the movement is part of such a subtle balance of pressures that it is not possible at this time to describe and evaluate them with any assurance of accuracy. But they played a very important role, of which only a few instances can be noted here.

[9] Renoir had met Fantin while at Gleyre's and had been taken by him to copy paintings in the Louvre. The two had done this together for years.

[10] Rewald, *The History of Impressionism*, p. 178.

[11] How much this companionship must have meant to most of them is indicated by an observation by Elie Fauré regarding Cézanne: 'When he returned [to Aix], he was alone. . . . Around him was indifference, slander, folly, prejudice, and a total lack of comprehension of what he was, of what he desired, and of the torturing sensibility which drove him to take refuge in himself. . . . No one took him seriously.' *History of Art* (New York: Harpers, 1924), V, 417.

[12] Manet's obduracy was due as much to sad experience as to theory. In his youth he had participated in the famous Salon des Réfusés in 1863 and other private protest exhibitions, all unproductive of prestige.

[13] His paintings had been mobbed when shown shortly before in Marseilles.

[14] Rewald, *op. cit.*, p. 273.

[15] For the influence of Monet on Manet, see Elie Fauré, *History of Art*, 1924 V, 371–398.

[16] In 1873, when Cézanne's father had halved his allowance, Pissarro had introduced him to the color-grinder Père Tanguy, who agreed to take canvases in exchange for painting supplies. Tanguy became enamored of Cézanne's paintings and until 1895, when Vollard—at Pissarro's instigation—gave Cézanne a one-man show, Tanguy's shop was the only place in Paris where students could go to study his work or buyers procure his paintings.

[17] During his long friendship with the painters, Choquet acquired a considerable number of Cézannes and paintings by the other Impressionists, especially Monet and Renoir.

[18] In November, 1876, he wrote his will, leaving to the State his collection of his friends' paintings, on condition that it be hung as a whole in the Louvre. He made Renoir executor. By the time of his death in 1893, the Impressionists not as yet having won their fight for public favor, only part of the collection was accepted by the officials. This became the foundation for the present State collection of Impressionist art which now comprises hundreds of paintings willed by other friends of the painters, such as Gachet, Guillaumin, etc. As announced in *Connaissance des Arts*, February, 1959, the Orangerie Museum has begun construction of a second story for the sole purpose of housing these once despised and rejected works. Notwithstanding the hostility of the State officials, thanks to the gifts of the friends of the painters, the museums of France now boast of their possession of Impressionist paintings! A good commentary on the contribution of informal organizations to culture.

[19] In bluntly announcing this decision to Pissarro, Cézanne offered to reserve his best canvases for the group's exhibition in return for freedom to submit to the Salons, which was, of course, contrary to their agreement.

[20] Pissarro, Monet, Degas, Caillebotte, Bracquemond and Cassatt were the six. Berthe Morisot refrained because she was pregnant. Guillaumin was apparently again handicapped by having no works ready for exhibition and Gauguin was in a similar position, being as yet only a part-time painter.

[21] An example of their effect on students is the riot and strike staged a year before by pupils of Lehmann at the *Beaux-Arts*, because he would not permit them to utilize in their classwork what they had learned by visiting the group exhibitions; failing to force relaxation of the curriculum, they left his studio in a body and went to study with Renoir and other Impressionists.

[22] This observation is not meant to imply acceptance of the theory that *interests* alone bind the members of a group. On the contrary, it is abundantly evident from the information available that interpersonal ties of mutual attraction, liking or congeniality were the real links which drew members of the Batignolles group together and held them together after dissolution of the group as a social unit, as Dr. Blitsten points out in her comments.

[23] But Monet never sent a painting after 1880.

SONDRA FORSYTH (ENOS) AND
PAULINE M. KOLENDA

Competition, Cooperation, and Group Cohesion in the Ballet Company*

IN THIS PAPER we shall attempt to present a description of the preprofessional and semiprofessional ballet troupe. Besides the description of the ballet company as a unique social system, we are concerned with a more general theoretical problem that emerged early in the discussions between the two authors—that of the interrelationship between cooperation and competition in the ballet company.

Let us explain the problem. The ballet dancer (whom we shall refer to in the feminine gender, since our information is chiefly about women, although much of it probably applies also to men) is both personally committed and spurred on by the critical regard of others to improve her technical and artistic qualifications as a dancer. Each class, rehearsal, and performance can be viewed as a competition between the dancers for praise and recognition by the teacher and other dancers, and each performance as a competition for praise and recognition by critics and audience. Classes, rehearsals, and performances, as competitions, function also to establish rankings within the company hierarchy. Generally, competition tends to disrupt harmonious interpersonal relations. Competitors are likely to feel at least restraint and strain in interaction with each other, and conflict may develop. In some social systems conflict is guarded against by the separation of competitors—in some instances they meet only for formal competitions. In the ballet companies considered here, however, the dancers are not physically separated.

* Reprinted with some abridgment by permission of the authors and the editors from *Psychiatry: Journal for the Study of Inter-Personal Processes*, XXIX, No. 2, May, 1966, 123–145.

All women dancers usually share the same dressing room, and they are constantly together in the classroom, in the rehearsal room and on stage.

The strain of competition seems to be exacerbated by the demand for cooperation, for a ballet is a group production requiring closely timed coordination of the performances of many dancers.[1] This double strain must be endured for long periods—several hours a day, possibly for a number of years, for unlike a football team, a ballet company may retain largely the same membership over a long period. Again, unlike a football team in which the specialization of functions tends to limit the number of competitors to those playing the same position, in a ballet company there is rather little functional specialization other than by sex, age (really only children versus adults), and excellence. Thus one female dancer in her prime is potentially substitutable for almost any other. When there are little differentiation of roles and many contenders for scarce rewards, competition is likely to be especially intense.

Dancers tend to be young—most of them under thirty, many in their teens; the company cannot depend upon the wisdom of the mature for interpersonal harmony and individual effort. One may, therefore, suppose that it is the social structure of the company that achieves the socialization and sanctioning of its members, so that they strive for individual excellence, company cooperation and company harmony. If a ballet company fails in motivating its members to bring off this juggling act, the consequences can be serious—poor performances and the eventual breakup of the company.

In a ballet company, competitors must be together, and they must cooperate and compete for the good of the company, as well as for their own good as individual artists. The alternatives open to other kinds of groups are not available to them. They cannot subvert the competition as did the men in the well-known Bank Wiring Observation Room, who refused to compete with each other or to spur each other on, as their superiors hoped they would, in response to a piece-rate pay plan.[2] There are some indications of sanctioning of 'rate-busting' and 'chiseling' in the ballet company's dressing room, but these are not the dominant note in the informal group life of the ballet company. Nor can the dancer limit herself to interacting informally only with noncompetitors (those who do different work, or work for a different supervisor) as did workers studied by Gross in a mail-order company's main office.[3] The ballet dancer does not have many noncompetitors to choose from; in informal situations such as the dressing room she cannot avoid her competitors; and, of course, all the dancers are under the surveillance of the same superior, the teacher or head.

How do dancers interact with each other so that group harmony, cooperation and competition are maintained? How is the strikingly acute competition within the troupe managed so as to interfere least and contribute most to the success of the troupe as a whole? In the course of our description of the ballet company we shall be particularly concerned with the specification of the mechanisms by which individual competition is combined with collaboration.[4]

METHOD AND CONCEPTUAL FRAMEWORK

Mention must be made of the nature of the division of labor between the authors of this paper. The data of the study are provided by Sondra Forsyth [Enos], who was trained and has performed as a ballet dancer, and who wrote two lengthy papers and tape-recorded additional information, using Homans' social-system scheme as a frame of reference,[5] while she was a sociology student in a course taught by Pauline Kolenda. All of the data presented in this paper in indented blocks are verbatim quotations from Sondra Forsyth [Enos], and all descriptions of and comments on the ballet which are not specifically attributed to others are drawn from her experience. While dependence upon a single informant is not ordinarily countenanced in a sociological study, we felt that the uniqueness of the data, covering many years of experience and provided by a participant observer with some training in social-system analysis, seemed to warrant at least a preliminary report. The view of the ballet presented here is biased by the first author's own personality and possibly by the degree to which she succeeded in ballet; the student who attains professional status may idealize ballet more than one who does not. The anecdotal nature of the account, along with a synchronic frame of reference, may give the impression of a static social system; we leave it to others to study changes in a company over time.

The conceptual analysis is the work of Pauline Kolenda, who has found it useful to cast the problem of this paper—how close collaboration is maintained in a social system that requires individual competition for rank and critical acclaim—in the terms of Talcott Parsons and his co-workers, as a question of the relationship between various subsystems or phases of a social system.

The phases or subsystems that are considered here are parts of the microphasic movement—that is, they are the subsystems which may come into play in the course of a day or hour, as the dancers move from home to the dressing room, to the classroom, to the rehearsal hall, to the stage. There will be some references, however, to the macrophasic movement—the

larger course of the company and its dancers as the company rehearses, holds a public performance, receives, if it is successful, the rewards of audience response and critical attention, enjoys an afterglow which may include delightful parties and then may rest after a performance, or may begin rehearsal immediately for the next performance.[6]

The first phase that we shall consider is *latency*—which occurs when those making up the group are dispersed and are not interacting. The problem of this phase is the maintenance of patterns of behavior that are necessary for the activities, goals and survival of the group. In microphasic terms, it includes all those times when the dancers are away from the studio or their attention is claimed by other matters. The second phase is the *adaptive-instrumental* one—which refers to the hard competitive work, along with intricate coordination of dance parts, by which the ballet company increases the accomplishments of its performers and works toward the goal of public performance. The third phase is that of *goal-gratification*, which refers to the rewards which the dancer receives, in rank, desirable assignments and creative satisfaction. The fourth phase in the *integrative* phase, in which the solidarity of the group is developed and maintained.[7] Connected with each of these subsystems or phases are combinations of pattern-variables— that is, attitudes usually encased in implicit or explicit social norms applying to the actors' roles, which we shall discuss shortly.

The problem of the paper may now be restated as follows: How does the ballet company maintain the dominance of the adaptive-instrumental phase and yet retain a sufficiently high level of integration?

We shall refer, in the course of our description, to the *external* system and the *internal* system, using Homans' terms.[8] The external system is concerned with the explicit goal, work, and purpose of the group. The internal system includes the interactions, activities and sentiments of the informal or friendship groups that develop while people are 'on the job' in the external system. For the ballet dancers, the dressing room is the primary physical environment of the internal system, while the class and rehearsal rooms are the main physical environments of the external system.

The relationship between physical settings and phases of the social system is not perfect. For instance, interaction in the dressing room is related largely to the integrative phase of activities; yet the girls prepare themselves for dancing, an activity of the instrumental phase. Similarly, there are rewards allocated in the dressing room within the internal system or friendship group that represent subgoal gratifications. The daily classes consist in the main of the adaptive-instrumental phase of activity, yet there is some interaction between dancers, and between teachers and dancers,

that is also integrative. There are also times in class when rewards and punishments are allocated by the teacher or by high-ranking dancers, which may be regarded as subgoal gratifications. Rehearsals are steps in the development of a performance—the achievement of the company, which refers to goal-gratification—while at the same time they are adaptive-instrumental in contributing to the accomplishments of the individual dancer and the company.[9]

ROLE INVENTORY

We shall limit ourselves to the minimal role inventory in a ballet troupe, the roles of teacher and dancers. Among the dancers we shall be concerned with the differentiation of roles within the explicit ranking system, and, to some extent, with the differentiation based on age and sex differences, but we shall ignore the complications in structure due to the presence of a director or impresario, choreographers, assistant teachers, and assistant choreographers. We shall also not concern ourselves with the roles of accompanist, costume mistress, lighting engineer, designer, stage crew, conductor, orchestra, business manager and publicity manager, in addition to a head teacher and dancers.

A company of the sort under consideration may have twenty-five female and ten male members. The teacher is usually called 'Madame' or 'Maestro.' A typical ranking would include one male and one female lead, two male and two female second dancers and four or five male and four or five female soloists. In addition, there is a corps ranked as front-line and back-line dancers. The titles for these ranks, partly Italian and partly French, are, among females from highest to lowest, *prima ballerina assoluta*, *prima ballerina*, *ballerina*, *solo danseuse* and *danseuse du corps de ballet*, and, among males, *premier danseur noble*, *premier danseur*, *solo danseur* and *danseur du corps du ballet*.

A troupe holds regular daily classes of an hour to an hour and a half and rehearsals of two or more hours in length. Both are directed by the Madame or Maestro; in a larger company an assistant may direct the class, and a choreographer may direct the rehearsal.

Like most roles in the occupational system of the United States, the roles of both dancer and teacher within the semiprofessional or preprofessional ballet company are, in terms of Parsons' pattern-variables, *affectively neutral*, for the demands of ballet discipline require the postponement of most immediate gratifications except those derived from dancing itself; they are *functionally specific*, since the responsibilities and interest of each actor in

relation to the others are limited to those required by the ballet; they are *achievement-* or *performance-oriented* because the teacher evaluates the dancers, and the dancer evaluates herself, other dancers and ultimately the teacher as well, in terms of dancing, teaching, and choreographic performances rather than in terms of some ascribed qualities; and they are *universalistic*, for judgment of others is in terms of shared standards of excellence with respect to ballet dancing, not in terms of personal relationships.[10]

Like the free professions, but unlike business occupations, in the cross-systems exchange—between the company and the audience—the roles are collectively-oriented, not self-oriented.[11] The dancers seek to give the audience an experience that is aesthetically gratifying; only secondarily do they seek monetary gain. All organizational roles within the company are also collectivity-oriented; the good of the company must always take precedence over personal gratification.[12]

Although all of these characteristics are important, the collectivity-orientation is probably the basic value orientation upon which the others depend, for the most important possession of a ballet company is a corporate one, its reputation, the accumulated reward for past performances, bestowed by ballet critics and audiences. With each public performance, this reputation may be maintained, enhanced, or diminished, and connected with its quality is the monetary support from the audience which provides the remuneration and facilities necessary for the continued work and existence of the troupe.[13]

In the name of the performance and the collective reputation, the dancer is required by her teacher and fellow-dancers to endure long, rigorous physical discipline and considerable self-restraint and to give priority to her dancer role over all other roles and interests.

THE LATENCY PHASE

The latency phase includes those times and circumstances in which the wholehearted absorption of the troupe member in activities of the dance is attenuated—when she is away from the studio, for instance. During this phase, the actors do not interact, so the social system does not move toward its goal or accomplishments or enjoy goal-gratification. During this phase, however, the motivation of individual actors must be maintained and renewed; each dancer must continue to consider her dancing role as her most important social role. This section presents illustrations of how this personal commitment is maintained, and how any tendency to develop other

commitments is severely discouraged by sanctions from the teacher and others at the studio.[14]

Relevant here are the surplus of aspiring dancers and the shortage of companies, factors which are basic to the ballet social system. An implicit sanction on the dancer in the company is the assumption that there are many other envious dancers pressing to be admitted.[15] One does not decide lightly to withdraw from a company; there may be no alternative company in the locality, or only a very few, and there is no assurance of welcome by them.

The ballet company makes few allowances for other social roles than that of dancer, including the young dancer's role as a member of her family. Nijinsky reported that in the old Russian imperial school of dancing, 'The moment a child was admitted, the parents virtually relinquished all rights, and the child was formally "adopted" by the Tsar.'[16] Today in serious ballet schools and companies in the United States the child's obligations to his parents are partly ignored. The dancer's family is expected not to intrude upon or interfere with the activities of the company in any way, but to co-operate in keeping the dancer in good health, keeping her interested in dance, and providing her with dance costumes and shoes, money for lessons, and transportation. Parents of young dancers must regularly wait long hours during rehearsals to pick up their children. The following quotation indicates something of the position of the parents in relation to the school:

> Don't call the studio. That's one thing parents of all aspiring young dancers must learn. If the telephone rings everyone cringes for fear it might be their parents. If it is, you get a horrible bawling out. You get no attention paid to you for a while. That is really serious punishment. You don't ask, 'When will rehearsal be over?' ever. Little ones, new ones that start in, say, 'My Mommy wants to pick me up at five o'clock.' You just don't say things like that. 'Mommy will pick you up at five o'clock if I (the teacher) say she picks you up at five o'clock; otherwise, no.' Usually, if you did that, you'd be kept until six, even if you were going to get out at five.

In the cross-systems exchange between the company and the young dancer's family, what the family requires is that the teacher provide the child with good training. The costs to a girl and her family may be high, but both look forward to the possible rewards. About her great success in *Oklahoma*, Agnes de Mille has said: 'Those performances had cost my mother a very great deal, twenty years' work in fact, and all her savings. She was being repaid now.'[17]

While concessions must be made to the demands of attendance at public schools, they may not be made for school activities that are not absolutely obligatory.

Margaret was a senior in high school, and her school was going to hold graduation exercises on the night of an important rehearsal for a forthcoming performance in which she had a role. Timidly she approached Madame and asked for an excuse for that evening. The answer was simply, 'Use your own judgment.' Meg chose to graduate. When she returned the following evening to the studio, she found herself completely ignored throughout class. At the rehearsal following class, Meg made a wrong entrance, having failed to ask beforehand if any changes had been made the night before. The Madame rapped the rehearsal to a stop. 'Apparently,' she said, 'the Mademoiselle has been having too much of a good time on her nights off. Step up, Louise, let us see how Gerald would like a new partner.' Louise had fortunately been careful to learn all the roles, as everyone is expected to. She danced it passably that night, showing potential, and on the evening of the performance, Meg found herself in Louise's place in the corps, while Louise danced a brilliant *pas de deux*.

It is even more difficult for a dancer to attend college, where the demands are still greater and even fewer concessions may be made by the company.

Most dancers, including professional ones, who are no longer attending school must work, for few dancers in the United States can support themselves solely by their earnings from dancing. Since dancers seldom have extensive training in anything except dancing, they are usually employed in rather routine clerical or secretarial jobs, which do not compete in interest with dance and do not threaten the dancer's commitment.

Many dancers spend what leisure time they have absorbed in the dance world—attending ballets, reading magazines on dance and reviews of ballets and keeping up with news of the great stars and outstanding companies. Because of lack of free time, they have little opportunity for social activities with others of their age or for recreation, and any such activities are discouraged.

The dancer must be constantly preoccupied, in her time away from the studio, with her health, her body and her clothes.

... a dancer takes care of her body with an almost fanatic devotion. A slight turn of the ankle, a common cold, even a toenail inadvertently trimmed too short, are near disasters. Consequently, diets are well-planned, sufficient sleep and rest are seldom foregone and the most minor of ailments

is attended to immediately. How many times does a dancer want to explain, 'It's not that I'm a hypochondriac. If I were a regular person . . . '

Since a dancer must not have an ounce of extra fat, not only for ease of movement, but because one tends to appear as much as ten pounds heavier on the stage, those who tend to gain are constantly watching their weight. If you are not particularly heavy, say, five or six pounds overweight, and you're a great dancer, and you know that by the time you get this role you would be thin enough for it, they won't give it to you until they see that you can lose weight. Maybe you won't. How do they know? It's good to be trim because it shows you've got self-discipline. Sometimes you stay thinner than you would have to, just to prove that you have the discipline to do it. Some companies even make their dancers weigh in once a month. I remember how we laughed the day a salesman came to the studio door and innocently asked if we were interested in having a candy machine installed.

Along with all the other demands of her role, the dancer is under a special pressure of time. Agnes de Mille tells of consoling Diana Adams when her solo dance was dropped from *One Touch of Venus*: 'Behind her disappointment lay eight years of daily practicing, no games after school, and history and English learned under hanging practice clothes in a dressing room that smelled of sweat and old malted milk, and a young back, weary every night when it went to bed with a weariness like old age. Behind it lay the fear that if she didn't justify herself quickly, the family could not continue the expenses of her career. Behind it lay the fear that if she didn't hurry, she'd never make the grade: a ballerina must be well on her way by twenty.'[18]

Dancers, particularly when they are away from the studio, are conscious of their special role-commitment as compared with other girls, and no doubt sometimes wonder whether ballet has been the right choice. Agnes de Mille has suggested that many dancers are motivated by a desire to reject and escape from the woman's normal roles as wife and mother. She says, 'Dancing can become, more frequently than not, a substitute for physical sex, and it has all too often been chosen as a vocation because woman's sexual life in our civilization has become unsatisfactory, uncertain and expensive to the individual personality.'[19] In a parallel vein, Ryser suggests that student dancers are motivated in part by a rejection of teen-age social life, and more generally a rejection of the middle-class style of life.[20]

The dancer's ideal total commitment to her role is illustrated finally by a note written by the first author's aged Maestro to her dormitory head to explain that she was late for meals because of long rehearsals. The note

ended, 'And please remember, dancers are not people, and allowances have to be made.'

THE ADAPTIVE-INSTRUMENTAL PHASE

Within the adaptive-instrumental phase the ballet company works toward the goal of a public performance and increases the accomplishments of its dancers and its overall 'system-capacity.' The teacher, who occupies a technical-executive role, is responsible for the technical and artistic training of the dancers and for encouraging them to improve. She recruits members, allocates roles, assigns facilities such as dressing rooms, arranges for the performances of the company, choreographs the dances and directs the rehearsals.[21] She is essential to a dancer, who must not only have a company with which to perform, but a teacher to help her improve her dancing technique. The teacher transmits a complicated and esoteric body of knowledge. 'It's sort of like a dictatorship. The whole thing is a dictatorship. The Madame's word is law, although she is very human and she wants the good of the company; she does not want things for the good of herself.'

While the teacher's direction may be 'like a dictatorship,' it seems to be one to which dancers willingly submit, and to be necessitated and legitimized by the complex coordination required to produce a ballet. The teacher does not tolerate rebellion and disobedience, but the dancers' cooperation is ultimately voluntary; they can withdraw from the situation if they so desire.

The teacher's standards for judging dancers' performances are probably, on the whole, shared by the dancers; they are performance-oriented and universalistically-oriented. Her decisions are collectively-oriented, affectively neutral and functionally specific. The dancer obeys ultimately because the teacher has in the past produced good dancers and successful ballets; she also is performance-oriented and universalistically-oriented, affectively neutral, functionally specific and collectivity-oriented.

To some extent, dancers of high rank and older dancers have leadership roles in the adaptive subsystem. One of them takes the front position at the *barre* in class to act as a model in performing steps. She may take the teacher's place if the latter is called away in the middle of a class. She often is asked to teach steps to less experienced dancers, and may voluntarily give advice and instruction to others, or be asked for it.

In contrast to the teacher-executive, the dancer is, on the whole, a technical specialist, required to endure long physical exertion in the effort to improve. The dominance of the adaptive-instrumental dimension or phase in ballet is indicated by the fact that dancers themselves refer to their bodies as

'instruments.' The discipline of the dancer not only requires the effective neutrality of foregoing various alternative gratifications—spending her time in some other way—but also that of subservience to the teacher, requiring considerable self-restraint.

Dancers usually arrive for class a half to a full hour in advance to dress and warm up. Absences are almost unforgivable and seldom occur.[22]

> No teacher permits her classes to be disrupted. I sometimes wonder if even a fire in the building would convince her to let her pupils out before she thought they were ready for final *grands battements*. Also once a class or rehearsal has begun, not an irrelevant word is spoken, and the few pertinent ones that may be necessary are said as softly and quickly as possible. If a student feels she must put a question to the teacher, she speaks clearly in a respectful voice of normal volume. No sign of desiring recognition need be given prior to speaking, since raising the hand or nodding the head might distort whatever position or step the dancer might be performing. If the teacher puts a question to the class, or to a specific student, response is immediate and respectful, even if it is only 'I don't know,' or 'May I think a moment, please?' The norms are undoubtedly due to the fact that if someone were late for a performance, talked on stage, lost a shoe, or upset the delicate coordination and co-operation of her fellows by asserting unwarranted individualism, a whole production might be ruined.

Subgoal Gratifications in the Adaptive-Instrumental Phase. The teacher praises and scolds dancers in class and in rehearsal. Since each dancer works toward a goal of becoming an excellent dancer, these experiences of sanctioning, from the dancer's point of view, represent positive or negative subgoal gratification within the adaptive-instrumental phase. The following quotation describes the sanctioning by the teacher.

> The Madame can hit anybody she pleases. I have come from lessons with black and blue spots. Because you've got to obey her for your own good, for your own training. It's so hard to make your muscles work. Sometimes you think, 'I just can't do it. I just cannot move my leg up one more time!' But you have to. Because what if it were in the middle of a performance? So supposing that you stop—forbid the thought—in the middle of an exercise, she has a little stick. Wop! You keep moving. It doesn't matter what has happened. Straighten your knee. Blop, right across the patella. She never does anything that would hurt your instrument. But she hits hard. Especially some. Miss X was a great one for that. Miss Y didn't do

it as much because she didn't feel it was as effective as other things. She shamed people. Sometimes they get so mad—they have what you'd call the artistic temperament. Sounds like an affectation, but it isn't. It's important that they do.

On the other hand, the teacher's praise is an important reward.

The teacher's praise is unbelievably scarce, being doled out with such rarity that one can almost recall not only all the occasions when she herself received some, but those when her colleagues were honored as well. A classmate of mine was a delicate and exquisite dancer with definitely enviable technique. She could do pirouettes, a turn on one leg, with considerable ease, never going less than three times around before stopping. Most of us considered going twice around to be quite an accomplishment. Class after class, when we practiced the turns, Madame called out only, 'Straighten your knees! Spin lightly! Come, girls, you do not work hard enough.' And she never made special mention of Alicia's lovely triples. One day, as each of us was taking a turn at doing pirouettes solo, for close scrutiny, Alicia turned five times around and landed as gently and perfectly as could be desired. Madame said, 'Well! So, lazy girl, you are finally improving yourself. Now if you can learn to smile and to use your hands decently, you might be worth a little something. Next, please!' The visitors' gallery gasped. We smiled. Alicia fairly glowed.

A dancer is appreciative of any kind of attention from the teacher, even blows and scoldings; a more severe negative sanction by the teacher is to ignore the dancer. However, the collectivity-orientation of the teacher requires that, on balance, her methods of discipline encourage the dancer, and do not discourage her.

Although corps members need absolutely to lose their individuality, it must not be forgotten that every company member is a potential soloist and must be urged and guided toward this goal, else she lose ambition and become static. In lessons, even the most insignificant dancer will be cared for and criticized if she shows earnest interest and effort.

In one instance a young dancer, criticized for being out of line, burst into tears:

It was all too much for her, and Maureen burst into heaving sobs. After a moment, the Madame's soft voice said almost tenderly, 'Come, all of you, do not have such tragic faces. You all know that one must shed at least a bucket of tears before she is a dancer. This little one has barely

begun.' Then the Madame herself fetched a handkerchief, and when Maureen was a bit more settled, the Madame said, 'In line, all of you. Do you think you can stand about all day and get your muscles cold and your brains dull? Not in my studio. Begin!'

Counternorms are not allowed to develop. Any sign of rebellion against the teacher or the system is severely punished; ostracism of the incipient rebel is not unusual.

During the class Miss X used to throw wicker chairs and books and pencils at dancers [who were making mistakes]. She'd get so mad. She'd say, 'You get out of line once more!' and wham—she'd throw a chair at you. You'd skitter out of the way, and then you'd have to pick it up, walk back over, curtsy before her humbly, and say 'I'm sorry.' You had to humble yourself. Whether you thought you were right or not—it didn't matter— you had to take it back to her, curtsy and apologize, and then try to do what she said. . . . Once Alice got so mad that she wouldn't bring the chair back and apologize, and she walked out of the room and slammed the door. This resulted in her being thrown out of the company. It took her a long time to get back in.

The norms relating to dance are thoroughly internalized by many of the dancers. In the following instance, a dancer ostracized herself for breaking such an essential norm as attaching ribbons to shoes in such a way that they cannot break. In a performance in which she took a lead role, the ribbons on both slippers broke during her solo.

She managed to keep the show going. That's vital. Nothing is to stop the show. She kept dancing. It was such a horrible thing to do that no one spoke about it. We avoided the topic. It was a horror. Next summer she had nothing whatsoever to do with dance [but worked nearby]. She'd cut her hair the week after that happened, and she had put on a little weight. She was completely away from the dance, although she often came over to watch classes. It was too much for her.

The discipline that the dancer endures may be viewed as oriented to three major norms: *Obey the teacher, strive to excel as a dancer* and *do not do anything to disrupt or spoil a class, rehearsal, or performance.*

The Integrative Aspects of the Adaptive-Instrumental Phase. Dancing together and undergoing common experiences in class, rehearsal, and performances build up feelings of belonging and liking between dancers, and

between dancers and teachers. The development of such feelings of solidarity represents an integrative aspect of the adaptive-instrumental phase.

There are rather few opportunities for expressing sentiments in the classroom, somewhat more in the rehearsal hall. The teacher does not temper her training methods with attempts to be liked, although she must be just, and there are institutionalized modes of indicating her functionally specific concern for each dancer. Success and failure in ballet are much more clearcut than in many organizations; the teacher's methods of training are ultimately legitimized not by any statements of liking by the pupils, but by the success of the dancers in the performances.

THE GOAL-GRATIFICATION PHASE

We have discussed, in connection with the adaptive-instrumental phase, goal-gratifications which occur within that phase. Here we shall be concerned with goal-gratification in terms of the allocation of the rewards of leads, solos, and high-ranking positions, as well as the inner satisfaction felt by the dancer.

The ballet company is held together by the belief in dance as a meaningful and worthwhile art and activity, and by a set of standards for evaluating the excellence of both the individual and company performance. Dancers in a company are rigidly and openly ranked by means of these standards of excellence from lead and second-lead dancers at the top of the hierarchy, to solo dancers, first-line dancers, and second-line dancers in the corps. These positions are allocated through competition, a process going on all the time through the continual evaluation of the dancers in class and rehearsals by the teacher and by each other. Higher rank in the hierarchy becomes a goal for each dancer. For the system, this competition results in role differentiation, the allotment of leads and solos in a performance. The following quotations describe the rights of rank and the process of promotion and demotion.

> ... the girls entered in very close to rank order, although A tried to hang back with B [a girl of lower rank], and C [a low-ranking girl] often pushed ahead. They went to the resin box, lead girl first, then lead boys, and so on, alternating until the last girls got only 'jewel dust.' As they left the box, they arranged themselves at the *barres*. They were theoretically free to choose any empty space, but they were guided by certain customs or norms: the boys should stand together, the leads should have the best view in the mirror and the most space, especially alert people should stand at

the ends of the *barres* for the sake of those slower to catch on to combinations, people with high extensions should stand together so as not to embarrass stiffer people. Thus, a rather regular order was established. Should a corps girl situate herself in the wrong place, the sanction of either a cool glance or actual crowding would send her humbled and skittering to her proper place. . . . *Barre* work finished, the class was called to the center. They formed lines quickly, each an arm's length from anyone else, lined up in terms of rank. Should someone be in line for advancement, a girl in the line ahead of her might say softly, 'Move up here where there's more room.' Likewise, if someone had pushed herself up too far she would be told either, 'Could you move back, where there's more room?' or 'There's room back here by me if you feel crowded up there.'

After center work, they usually worked on the diagonal, the order of pairs again by rank. If a change was in order, a higher girl would whisper, 'Want to be my partner?' or 'You could be a triangle with us if you like.'

Since it is so important that rank and roles be allocated fairly, there are various devices to insure that the teacher gives all dancers equal attention. Thus, in class, lines of dancers rotate in front, middle, and back positions with every combination or step done, so that even the back-line corps dancers have an equal turn directly in front of the teacher's critical eyes.

In the dressing room as in the class there were established places. [The higher-ranking girls] used the large full-length mirror and left their cases near it. The lower-ranking girls shared the small face mirror.

When a new ballet is to be cast, there may be tryouts, or leads and solo roles may be assigned to those in the upper ranks of the hierarchy. Following is a description of a tryout.

Suppose a soloist becomes ill, and her choice role in a forthcoming production is left vacant. Girls of a rank equal or nearly so to hers know that they are eligible. Girls of a lower rank are almost sure of not getting the role. Yet if they have improved lately, they might be in line for advancement, and are not to be completely discounted. . . . Naturally, everyone begins to calculate and tries to decide who will be the lucky girl, but no one wonders out loud. Talk might display favoritism or an attempt to rebel. The choreographer will decide, at any rate, and he will decide 'correctly.' In order to make that decision, the teacher [as choreographer] may call for auditions. . . . Should he invite the whole troupe, the whole troupe had better attend. Admitting a lack of desire to either improve oneself, in the case of a lower-ranking dancer, or of improving the

production, in the case of a higher-ranking dancer, is unacceptable. . . . No one tries to anticipate the teacher's decision. Yet when his decision is made, it is rarely upsetting. In the first place, he does not want it to be, and, in the second place, the ranking system is usually so efficient that upsets can rarely occur.

The Integrative Aspect of the Allotment of Rewards. The preceding quotation has indicated the norms against open speculation about casting, or complaints about it afterward. The competition for roles is less disruptive to the integration of the company, in terms of either group harmony or group survival, than it would appear to be potentially, because the teacher or choreographer makes the 'right decision'—that is, she chooses dancers whom other dancers consider the best for the roles involved. This implies high agreement among dancers and teacher about the relative excellence of the dancers. Agreement is achieved partly by the fact that competition goes on daily and openly in class and rehearsal, in full view of all members, rather than privately in a periodic examination in which one's performance might be uncharacteristically good or poor. Competition leads to less antagonism and disruption within a group if the rewards of winning appear to be deserved.

Occasionally a surprising assignment is made. In one case, a girl from the corps was given a lead role, which forced a lead to take her place in the corps. In this instance the corps girl's acting ability and physical type made her appropriate for the role.

> The teacher knew there would be a lot of antagonism, so she was very careful not to give her [the girl who won the role] too much attention in class.

In general, shared standards and open competition enable the teacher to make awards that will be regarded as just by the dancers. However, there are two somewhat related sources of 'distributive' injustice in the ballet competition—to use Homans' word.[23] First, excellence in dance is not entirely a result of hard work over a long period of time. There are features of natural endowment that make one a better or worse dancer.

> Ideally, a dancer should be of medium height for his or her sex, neither extremely tall nor short, and of moderate bone structure carrying no excess weight. The torso, legs, arms, and neck should be in good proportion, none being too long or too short for the others. Feet should be well-arched, and toes should be, especially for females who dance on *pointes*, nearly square across. A nice bonus is legs which will naturally turn out, or

assume the heels-together, toes-to-the-sides position which has been found to be both the most efficient one for dancing and most attractive visually. However, most people have rotary muscles of the hip and leg ball-and-socket joint which will respond to correct and constant limbering. Some handicaps, however, are almost insurmountable.

Thus physical endowment gives some dancers a head start in the competition, and it is easy for other dancers to envy and resent the girl who is a 'natural'— that is, who has naturally the turned-out toe position. Insurmountable handicaps include knock-knees, bowlegs, too long or too short a torso, flat feet or feet with unusually high arches.

In addition to these differences in physical endowment, there are differences in other natural endowments such as intelligence and possibly 'talent,' and perhaps also in the quality of effort, so that the length of time spent working in ballet is not perfectly correlated with degree of excellence.[24] Long years of hard work represent a great investment to a dancer, and there are also costs to her family in time, money, and interest. In order to be just in the eyes of its members, the reward system of a ballet company must take these investments and costs into consideration.

Besides those mentioned, one other factor colors the ranking system, and that is one's seniority with a specific group. It is important to a group's cohesion and complacency, and perhaps even to an individual's sanity, that long faithful years of hard work do not count for nothing. No newcomer, even be she supremely talented and trained, leads a class her first day or even week in a company. On the contrary, she is expected to step quite to the rear, and to advance only at the invitation of the teacher, or, in some cases, of her classmates. Naturally, a good dancer would work up more quickly than a poorer one, but no one attains high rank with rapidity.

Children, who have little investment of time in dance, have their own separate ranking system and do not compete with the dancers in their prime. The 'small fry' or 'rats', as they are called, are not given solos or leads even when they are, in fact, equal to or better than the adult dancers chosen.

Downward mobility occurs, of course, as back-row girls strive to displace front-row girls, who strive to displace soloists, who strive to displace leads. However, a high-ranking dancer who is well-established does not lose rank as she becomes older. Her high rank becomes a permanent status.

If loss of technique that once made her a high-ranking member is not a dancer's own fault, she does not experience downward mobility. Necessarily, she loses roles, but she retains the respect and admiration from the

other members which were due to her as a high-ranking dancer. . . .
Dancers do not slip back down in rank to end their careers dancing the
same corps parts with which they began. Far from it! Until the end of her
days, a once good dancer is respected, her advice desired, her youthful
photographs admired and set as examples. She relinquishes her roles, but
it is she who teaches them to the younger dancer, who is thus considered
to be a highly honored pupil. In class it is not likely that the aging dancer
will lose her front-line position until she chooses to stop attending. Old
dancers become wonderful legends, to be remembered for their inhuman
grace and suppleness, their unmatched interpretation of roles, their cur-
tain calls and roses.

It is important to understand, however, that the aging dancer does not
perform; her high rank is recognized in class and dressing room, not in
performances. The aging dancer, although she is not scoffed at for her
decreasing technical capability, and is thus apparently resting on her laurels,
is no longer really a member of active dance society. She is a memory even
as she lives.

In addition to technique, the ability to be expressive in dance—that is,
acting ability—affects status. Sometimes a lead or solo dancer is less accom-
plished technically than some dancers of lower rank, but she is better able
to 'project,' to act. Feelings about recognition for this reason are probably
ambivalent. The dancer who gains recognition in this way often feels
apologetic toward her fellow dancers, and they may shrug off her high rank
as something of a fraud. Yet it is recognized that the successful performance
is one by which the audience is moved emotionally.

> . . . having a good body and a good mind is not enough. We must remem-
> ber that dancers are not machines, not even just people, but artists. They
> must be sensitive and poetic souls, capable of profound and worthwhile
> emotion, able and willing to express through their instruments the most
> delicate and intimate pieces of themselves to the foreboding and thrilling
> entity, 'the audience.' If they cannot do so, they are simply excellent
> technicians doing difficult feats, masters of their muscles and nothing
> more.

There are other kinds of performances that lead to high, although not the
highest, status. These include reliability—always being on time, being regular
in attendance, maintaining personal appearance, and having a good memory
for choreography and steps. A dancer who is a 'catalogue of repertoire' is
very valuable to a company and often is given the front-line-center position

in the corps where she can be seen and followed by other dancers, even though her technique is not as good as her position might suggest.

Informal sanctioning against self-orientation, glorying in one's personal success, probably takes place frequently. Thus, on an occasion when the first author of this paper had performed unusually well in a solo performance, her arrival backstage was greeted by some of the other dancers with recollections of another of her performances, one in a dress rehearsal when the top of her costume had come off. 'Remember the undress rehearsal?' they chuckled.

In considering the reward system in dance, we cannot ignore the reward which the dancer herself feels when she is dancing well. The following passage indicates the gratifying quality of dance itself, as well as the thorough internationalization of norms by many dancers:

> Performing isn't really the end—it's the ultimate end. I suppose, because we are theater people, but the very dancing itself becomes a sort of life in itself, and everyday class is just as vital as the performance. I suppose you could say that somewhere in the beginning it started that the Madame or Master insisted that it was so, because if his students were not neat and well-prepared and working hard each day, how would they expect to be so on the day of the performance? But it has become—it's not because the Maestro demands it—it's because we want to. Some artists say that they could even dance for the walls and be happy. But most others feel that it is an art, so it is necessary to have someone there to communicate to.

Agnes de Mille says of the motivation of the dancer: 'Dancing has always been fruitful in its effects of direct fulfillment and satisfaction, and today the appeal is, as before, spellbinding through the body. It is not the concomitants of theatrical success that draw young girls so much as the vision of becoming generically DANCER in the permitted dress, exposed legs, free and floating arms, aerial skirt. . . . Dancing inflames and exercises the sense of the viewer (hence its long connection with prostitution) and of the performer (hence its long connection with religion). It is a physical release as no other performing art can be, because it is practiced on the whole body; the body is the instrument, the medium itself, and the exposure is total and voluptuous.'[25]

The dancer Martha Graham comments on the vocation of the dancer: 'People have asked me why I chose to be a dancer. I did not choose to be a dancer. I was chosen to be a dancer, and with that you live all your life. When any young student asks me, "Do you think I should be a dancer?" I always say, "If you can ask me that question, no! Only if there is just one

way to make life vivid for yourself and for others should you embark upon such a career." '26

There are perhaps few occupations whose practitioners are motivated, as dancers are, by sheer love of the activity involved, and by the feeling of fulfillment which it provides. A dancer may even feel herself to be almost religiously impelled to dance—and, if possible, to dance well—as toward an ultimate value. It is difficult to account for such a quasi-religious commitment to an art.27 The joy of creative expression seems to be sufficient in itself to account for the pursuer's determination to achieve it.

Such commitment to the art of ballet is probably essential to its survival as a performing art. The high costs of time and energy and the low monetary rewards for the dancer probably have the result that most of the insufficiently committed drop out of a company, and out of ballet, voluntarily. The committed willingly conform to the norms of dress, obedience to the teacher, and single-minded devotion to dance.

The especially gratifying nature of the rewards in ballet is due to their very scarcity and their attainment after high costs of negative sanctions and rigorous discipline.

That little girl's mother was certainly not the first to discover with amazement that behind the stage full of lovely girls in pink tutus and pink satin *pointe* slippers, and handsome princes in velvet tunics, all floating and flying about to wonderful music, lies a world of dedicated and difficult work, regimentation, obedience, corporal punishment, sweat, and tears. It is only lamentable that she could not perceive that it is not a cruel and foolish world, but a supremely sensible and joy-filled one; dancers earn their joy, but that could be what makes it so true and sweet.

THE INTEGRATIVE PHASE

The integrative phase refers to situations in the social life of the group in which positive and negative sentiments of the actors toward each other and toward the collectivity as a whole are developed. Minimally, there must be sufficient positive sentiments for actors to cooperate in the instrumental activities of the organization; even this minimum is usually renewed not only in the instrumental phase, but in other interactions among the actors.

In the ballet company, it is important that friendships not undermine the competition for excellence. Friends may not wish to compete with each other, for when they do, as they must, the bitterness may be especially intense for the one outranked. So in the ballet, norms against friendship

may be explicit, as in one company whose head laid down the law 'Do not be friends.' Various devices are used to discourage friendships. Talking is not permitted in class, except when it is absolutely necessary to facilitate the group practice. The teacher may nip budding friendships by separating the would-be friends in their positions in the class and dressing rooms. In one instance the teacher, before the whole company in class, scolded two girls because they had been carrying on a telephone friendship outside the studio. The teacher may even accept information from dancers about other dancers' budding friendships, although she never recognizes her sources of information openly. The usual dressing-room atmosphere is described as follows:

> Dancers of one's own sex may be polite, even warm, acquaintances, but they are essentially competitive, threatening and jealous. Too close a friendship might soften the necessary spirit of egotistical aloofness and ruin a potential soloist. On the other hand, antagonism is forbidden, absolutely not allowed, since it would impair the precious concert of the group as a whole. Thus, members of the same sex carry on smiling, carefully-guarded conversations about shoes, diets, music, muscles, hair, last Saturday's class, Fonteyn, slippery floors, the Graham school, last week's performance, and New York. They know less by far about one another's affairs of life than they do about their styles of dancing and special abilities in dance.

Although there may be norms against the formation of friendships and cliques, they do develop.

> ... you're not supposed to have friends. But the truth of the matter is you do. ... The group as a whole is what it is. If a company is to dance well, it has to be a coordinated whole. And, therefore, there can be absolutely no antagonism between its members. And if there's no antagonism there has to be positive sentiment. And positive sentiment, if you interact with people a lot, develops into friendships. I think the way it works is if you absolutely forbid something in the strongest form, then it will at least have less chance of becoming a powerful force, although it probably will develop to a certain extent.

But on the whole, in preprofessional and semiprofessional companies, dancers do not become intimate friends. Pairs or groups of dancers may go to the nearby coffee shop or bus stop together, but the restrained conversation of the dressing room is likely to continue there. They do not develop group activities irrelevant to the ballet production. They do not spend

leisure time together away from the studio, going to the movies, visiting each other's homes, or becoming confidantes.

The discouragement of cliques and friendships, the norms against gossip and complaint about role or rank assignments, the explicit emphasis on 'the good of the company,' the long interaction between members of a company, and the shared fate of performances all tend to build up a strong group solidarity. This includes a group history with tales of glory and horror, which, in turn, reinforces the value-orientations toward dancing.[28] An instance of group solidarity is described as follows:

> At Miss X's studio everybody was friends. It was the closest-knit little group—it was just a delight to be with them. We were all children, up to our early teens. And it wasn't so extremely vital that we be great, although we hoped we would be. We were surprisingly good dancers for our age, because Miss X was such a good teacher, and because she had such willing people at the time. A lot of them are still very close friends of mine.

The internal system of the ballet company—that is, the informal or friendship groups—generally reinforces the external system, sharing the same norms and dedicated to the same goal. However, the internal system has its own strength and its own sanctions. For example, a new member entering the company must be humble toward the older members.

> You don't speak to anybody and say, 'Hello, my name is so-and-so.' You just walk in sheepishly and sneak over in a corner. If someone is friendly, she might say, 'Ah, hello, I'm so-and-so. What's your name? Why don't you hang your coat up here next to mine?' Then it's OK to hang your coat there. If they say, 'Are you going to study here?' you're a little less likely to be offered a hanger. If you're a guest, well, there's no danger, you may get a hanger. If you come early or no one speaks to you, you put your coat and clothes and things in your bag, or stuff them in some unobtrusive place. You let the others use the mirror. You just try to keep to yourself. You must be shy and retiring. Then someone is likely to say, 'Ah, we usually go into the small room to warm up first,' or 'We usually warm up in the dressing room because there's a class in the small room.' They'll give you some hint about where to go or what to do. Or they'll say, 'Have you met Miss Y?' 'No, I haven't.' 'Well, you'll meet her in the small room. She'll come in there.' They'll try to help you in that way. They don't want to force you to break any rules or to get you in trouble with the Madame, but they are very formal, and they carry on their own conversation as if you didn't exist.

If you have a black leotard on and pink tights, and you have your hair in a neat chignon, if you have the right amount of makeup on, if you stand there in a turn-out (which most people do—if you work long enough, eventually it gets so that's the way you walk), if you look, in other words, as if you are seasoned, it'll be introductions all around. 'Where are you from?,' and so on. If you look like you don't know what's going on, you're ignored. You get a few introductions and a few hurried instructions, and don't get introduced to everybody.

If you are a very seasoned dancer and you have been using a towel, taking a towel into class may be all right.[29] In some cases, it would be better to show that you do know that you should do it if you're a good dancer. But if you feel that perhaps these people are much better than you are and perhaps you're really going to have to work hard to catch up with them, it might be a better idea not to take the towel in. It'd look kind of pushy.

So then you go in. . . . You know where the others are going to stand— at the end of the *barre* and where they can see the mirrors. So you hedge toward a place in the back, or if you seem to be fumbling and can't find a place, someone might say, 'It would be a good idea if you stood here.' If the girls want you in the company and see that you're a fairly good dancer from your warm-up, they will try to put you next to people with extensions about your height. But if they see that you're sloppy they won't even pay attention to you.

You'd usually wait till last for the resin box. When Madame calls 'center' you take the back line, on the end. The end is a bad spot because you usually kick the wall. So you stand in the back, but you'll get attention. The Madame is the critical eye. It is very nerve-racking.

If, as in the Y company, your first lesson is your audition, it is even worse. The teacher is watching. The girls are all watching and asking, 'Is she good or isn't she?' 'Is she a natural?' 'Let's see what kind of an arch does she have?' 'Can she do turns?' 'Is she good on jumps?' 'Is she lyric?' It's just awful, the most torturous experience. The only thing to do is to lose yourself in it and keep telling yourself, 'I am a good dancer. I can keep up with them.' And lose yourself in the art, so you enjoy it. If you enjoy it, you can forget about the fact that you are on trial.

But if the newcomer acts properly, hostility is not permanent. . . . Eventually the fear passes, and the old members cease looking upon the newcomer as a threat. Finally, they accept her as normal competition. Antagonism never lasts long in ballet since it colors performances, and everyone knows that.

In many organizations, norms develop in the internal system that are counter to the norms and goals of the external system. Despite the general reinforcement which the ballet company's internal system offers the external system, there is some evidence of the development of counternorms. Thus the internal system may repair felt injustices in the external system, rewarding, for example, dancers with long seniority but rather low rank in the hierarchy of excellence.

> Carolyn had been with the company ever since childhood, but she just could never make it, and she worked hard. In the internal system she was quite accepted. Her closest associate was the second lead. And if we wanted something done like talking to the Madame—'Say, do you think maybe we could get off for Fourth of July?'—Carolyn would do it. We gave her these little honors, because she was to be respected for her seniority.

High status in the internal system is a very important aspect of the continuing rewards given to the good established dancer who is declining.

> Elaine was in her mid-twenties, approaching thirty, I bet, and she had been with the company a long time. She had at one time had lead roles, and she was as dependable as you could get. If you wanted somebody to remember a ballet of three years ago, she could do it. She was just like a catalogue of the repertoire. She was magnificent. She never was a really great dancer in a lot of ways. She had low extensions. She had good turns. She was never what you'd call spectacular. If you wanted somebody to do a role right, though, she could do it. But she was getting old. She was losing some of her roles. They never put her down. They never get roles lower than what they had had, but they obviously have to lose some. What happens is that in the internal system she gets the greatest respect, greater than the current lead. For one reason, she's no threat anymore. The current lead gets to use the resin box first. If she wants to, she can step back for the other [the older dancer]. And it's nice to have one [an older dancer] like that around. It's a nice thing. It eases tension. There's somebody you can respect that you don't have to worry about. It is also a very good thing for the wise lead dancer, because the wise lead dancer can pass on some little things of respect to her which she would have to accept herself if she were the only one in high command. She will give Elaine a good place. She will ask Elaine's advice. Asking her advice is good: 'What would you do in this?' If the lead does this, she makes herself more acceptable to the other girls, and it makes her more human in their eyes. It's good to have someone like that around. It's more comfortable.

Another kind of injustice that may be repaired in the internal system is the allotment of a solo or lead to a person who did not, in terms of the ranking system, deserve it.

Let us suppose that a newcomer has received a solo after a few weeks with a company. The older members tend to react by forming a more active internal system from which the newcomer is excluded. Dressing-room chatter becomes more voluble, and it is always about 'our last tour' or 'Remember when Louise dropped her *pointe* shoes out of the train window, and that boy tried to throw them back?' followed by gales of laughter and nods of recollection. In-group solidarity is strengthened, and clique lines soften. The lead dancers suddenly warrant more respect even than usual, another member whispering to the newcomer as the *prima* rehearses her solo, a challenging, 'Isn't she wonderful?'

In one company a girl who had been with it only two years was given the lead role. There were two other girls who had been there for seven years who were good dancers who got the second leads below her. Needless to say, although Sally had the greatest honor in the external system, she was immediately dropped from the internal system. The other two controlled the internal system, because they had been there for so long, so Sally had to start a clique of her own. As the lead dancer, she had to have supporters. Sally was not an unlikable person. It was just the fact that it was so unusual, they could hardly stand for it, but eventually it worked out all right. Because Sally had the lead, they eventually dissolved their little business [their exclusion of her] and joined up.[30]

The internal system may also give high rank to a girl who, because of excellence in technique, would ordinarily have high rank in the external system, but who because of lack of seniority does not. Thus, in one company a new member, Joyce, had formerly danced with a world-famous ballet troupe. She had to take a back-line corps position to begin with, as all new members do, but in the informal dressing-room group, she was the equal of the leads and soloists.

In addition to the repair of injustices, there are some other indications of the development of counternorms to those of the external system. Thus while the norm of the external system, 'Be on time,' is accepted, it may also come to mean, in the internal system, 'Don't be too much ahead of time.' In the Y company a tacit competition developed to see who could come earliest, but those outstripped eventually put a stop to it through sarcastic remarks.

On the whole, however, the internal system reinforces the external system. For example, cliques in one company were divided almost exactly along rank lines. The 'big-mirror clique' was made up of the leads and Joyce, who had transferred from the famous company; the 'small-mirror clique' was made up of corps girls plus one soloist who was a childhood friend of Carolyn, the girl with long seniority. One girl belonged to both cliques, and two girls, Bea and Lucille, were excluded from both. Bea broke too many of the norms.

She talked loudly and constantly, pushed herself ahead in class, carried the hand towel traditionally reserved only for those who really worked hard enough to need it, and she wasn't an especially good dancer.

Leadership functions in the internal system may be filled by the leads in the ranking system of the external system. It is likely to be one of the leads who gives directions to new or guest dancers. If there are shoes to be passed out, money to be collected for gifts, or decisions to be reached, the lead dancer is likely to do it. One other person likely to perform such functions is the dancer of medium height and versatile talents who has at one time or another danced with almost every other member. She, if likable, is likely to be the most popular person in the group. The girl who belonged to both cliques in the company described above was of medium height.

The socio-emotional roles in the ballet company—the roles of those who give and receive affection and support, rather than instruction and command, are usually occupied by older, declining dancers and children.

The teacher's role in the internal system is a delicate one. She must above all be fair in rewarding dancers in the external system, so she is under pressure not to play favorites—not to develop particularistic, affective or functionally diffuse relationships with her dancers. However, teachers are considered to have special perferences for dancers who have been with them from childhood, and a teacher is likely to be possessive about 'my girls.' Some teachers develop affection and feelings of responsibility for their lead dancers; others maintain the aloof, functionally specific role at all times.

There are some teachers who like to have a social relationship with their pupils. This is usually with a student who has been with her for a long time, or who is the *prima* in a company. Then they use endearment terms and treat them as their children. Or they are close to them and send them birthday cards; they're like foster parents. This happened in the old Russian school—Nijinsky's old teacher did this with him. On the other hand, there are teachers who believe that breaking down authority will

ruin class, so they retain what they ask you to retain in the company, a cool but pleasant relationship. Even outside of class they maintain this attitude. If she's working on developing a very good company, then she probably won't get very close to people. She can't help some closeness, especially with the lead dancers. When she works with them for hours and hours on one step, they can't help but have things they share and giggle over. But they try to keep aloof. Then there are others who are close. I don't know which works better, because actually they don't lose their authority.

The dancers' confidence in their teacher is a crucial integrating attitude, but this is dependent on more than her having an authoritative manner. Confidence in the teacher is dependent ultimately upon whether the performances of the company are successful. This attitude of confidence is an accomplishment, an addition to the 'system capacity' of the company, and while based on performances in other phases, it is particularly important to the integration of the company. Even large and famous ballet companies seem to be integrated largely by their head teachers; some companies are named for the teacher, but in any case the ballet company, like a symphony orchestra, is closely identified with its leader. Successful performances are also essential to the solidarity of the group; they not only represent the reward for long effort, but also renew the dancer's loyalty to the company as the means to achieving more rewarding performances.

The presence of dancers with long seniority contributes to the integration of the company, since their presence is a testimonial to their confidence in the teacher, which helps to reinforce the confidence of newer members. In the Y company, four of the six solo or lead dancers had been with the company since childhood, another had been with it for many years, and one had been with it for three years. Three of the six girls in the corps had been with the company since childhood; the other three had transferred from other companies within the past two years.[31]

Nijinsky mentioned the fact that the imperial Russian ballet was modeled in its organization upon the military.[32] A ballet teacher and pupil may be likened to the officer and enlisted man in the army, and, less seriously, the ballet performance to a battle. In his paper on the primary group in the American Army in World War II, Shils reported that enlisted men's liking for their officers increased in the early stages of combat, and that they often showed admiration and devotion toward the officer who had led them successfully through battle.[33] In the same way, dancers develop confidence in and admiration for the teacher who guides them safely through performances.

Her abrupt and even severe methods of training are legitimized as necessary for the training required for the battle ahead.

Furthermore, the dancers themselves learn what is necessary for excellence in ballet; the standards are explicit, clear, and relatively unchanging, and they are also shared and relevant to the goal of the group. If the teacher sanctions dancers in encouraging them to fulfill these norms, her activity is legitimate in their eyes.[34]

CONCLUSION

Our answer to the question of how a ballet company reconciles cooperation and competition is a kind of 'complex-adequate hypothesis'[35] that lists factors of three kinds: Those that seem important in stimulating competition, those that appear to prevent the arousal or expression of resentment and jealousy and the outbreak of conflict, and those that contribute positively to the development of group solidarity or integration.

There are various ways in which a dancer's motivation to compete and to strive to improve is sustained. Especially important are the high standards maintained by the teacher—her prompt, explicit and even severe sanctioning of mistakes in dance, in costume and in behavior, her squelching of any distraction by other interests, and her overruling of any challenge to her authority. She banishes the malcontent and rebel, potential initiators of counternorms, and demotes the lazy. The dancer is also stimulated to compete by the rewards of high rank and critical acclaim, and she is inspired by dressing-room gossip and information about famous dancers and companies, by the saga of the past achievements of her own company or of the Madame, as well as by the example of the current leads. The norms against friendships among dancers help to prevent the undermining of competition. Group *esprit de corps* is desirable, but special friendships may dampen the desire to compete.

But how is the competition kept from becoming disruptive? There are a number of factors that seem to mitigate it. First of all, there is an explicit collectivity value-orientation. The 'good of the company' and 'the good of the performance' are repeatedly cited to justify conformity and self-restraint and to sanction the expression of self-interest. There are also the fairness and openness-to-view of the competition as it goes on continuously in class, rehearsal and performance. It is fair in the sense that the standards for judging are shared by teacher and dancers, and the teacher is seldom guided by irrelevant factors in distributing rewards and punishments. While she gives some consideration to factors other than excellence of technique—

such as seniority, a good memory for dance combinations, and reliability—these are relevant to the ballet production. Her recognition of these other characteristics probably gives hope and satisfaction to dancers, especially those who are technically not of the highest rank, and this may mitigate the intensity of the competition for technical excellence. There are also conventional procedures that contribute to the fairness of competition; thus in class all dancers rotate through the front position directly before the teacher.

The ranking system also acts as a limitation on the disruptiveness of competition. Although rank is a result of past competition, and high rank represents part of the goal of each dancer, ranking also limits the competition for roles for each dancer to those of the same or slightly higher or lower status; she is not, at least in the short run, competing directly with all other dancers. Although the ranking is the result of the teacher's judgments and assignments of roles, the dancers themselves help to maintain it—for instance, by pressure on each other to take their appropriate places at the *barre*. The ranking, once established, is not easily upset, and the fact that even a superb dancer, if she is new to a company, takes the lowest rank until her excellence has been demonstrated and accepted, softens the shock of her introduction to the rest of the company. The ranking system also tends to make the outcome of the competition for new roles predictable, and presumably less anxiety-provoking and disruptive to personal relations.

The scarcity of praise from the teacher may mean that envy is not often aroused, and her more frequent negative criticism may arouse feelings of sympathy and solidarity among the dancers, who are all at the mercy of her little stick or sharp tongue. The fact that formulae of etiquette call for such gestures of recognition of the Madame's authority as applauding her at the end of a class, or recognition of those who have excelled in the competition by observance of rank at the resin box and in *barre* positions, may mean that the individual does not have to strain to innovate indications of her willing subordination.

Furthermore, the internal system, though it cannot allow any extensive development of norms counter to those of the ballet production, or strong sentiments of personal friendship, may, in rather subtle ways, relieve the strain of competition by repairing felt injustices in the external system. Thus in the dressing room the dancer undeservingly awarded a high rank may be quietly snubbed, and the deserving or aging dancer who has been passed over may receive gentle indications of affection and respect. In the internal system there is also some sanctioning of 'unfair' competition. The overconformer, such as the dancer who comes much earlier than anyone else to warm up before class, may be met with sarcastic remarks, and the dancer

who openly indicates ambition for herself is met with sour words calculated to silence her.

There is also restraint in the interpersonal relations between competitors, with norms against antagonism between members of the company and norms against gossip. Relations between dancers are pleasant, but not intimate. The teacher is also not usually intimate with her dancers; she usually does not invite them to her home or associate with them away from the studio, nor is she part of the dressing-room group. The noncompetitors, such as child-dancers and retired dancers, may give support and encouragement to the dancers in their prime, as well as serving as objects of affection. Interacting with them may serve as a relief from the competition.

Lastly, there is the judgment passed on teacher, leads, solos, dancers, and the company as a whole by the outside world. The competition among dancers is for a purpose—that the best dancers may play the lead roles in ballets performed for the public. A dancer cannot criticize the teacher openly, but the audience which views the ballet may criticize her for the performance of the company, for she, above all, will be held responsible for its quality. If the ranking system is unjust, if she has been wrong in her judgments, the critics may point this out. A dancer must subordinate herself to teacher, ranking system and 'the good of the company,' but all of these are subordinate to the judgment of the critics, the balletomanes and the general audience.

Especially important in insuring harmony is this interdependence of fate; the company as a whole has to perform publicly, and the reputation of the company will reflect upon each member. The company will collapse unless it is continually renewed by successes. In the performance, self-orientation and collectivity-orientation coincide; the individual's self-interest is furthered by the success of the company.

Several general propositions are suggested by this study. First, if participants in a group enterprise are strongly, even religiously, committed to the value of the activity itself, or if the prizes for the individual involved are great, severe negative sanctioning of deviant behavior may be institutionalized and willingly accepted by the participants. Second, the arousal of resentment and jealousy between competitors and the outbreak of conflict between them may be minimized when the norms of the competition are well-defined and conformed with; the standards of judgment are well-defined, shared by competitors and judges, and conformed with by judges; the competition is open to the observation of all competitors; each competitor has only a few rivals; the outcome is predictable; and the awards are made by a noncompeting expert.

Third, the development of an internal system of friendship groups with

activities, interactions and sentiments beyond those required by the goals of the organization may be minimized when the activities and goals of the external system are highly valued by the participants. When there is such commitment, the internal system may function almost entirely to reinforce the values and activities of the external system. Fourth, commitment to such goals as beauty and excellence distract attention from interpersonal relationships, whether rivalries or friendships. And, fifth, when attention is directed toward the good of the collectivity, attention is distracted from self-interest.

NOTES

[1] Various definitions of 'cooperation' and competition' are available, but Homans' seem useful here: 'Cooperation occurs when, by emitting activities to one another, or by emitting activities in concert to the environment, at least two men achieve a greater total reward than either could have achieved by working alone.' Competition occurs when each actor 'emits activity that, so far as it is rewarded, tends by that fact to deny reward to the other.' See George C. Homans, *Social Behavior: Its Elementary Forms* (New York: Harcourt, Brace & World, 1961), p. 131.

[2] Fritz J. Roethlisberger and William J. Dickson, *Management and the Worker* (Cambridge, Mass.: Harvard University Press, 1947). See Part IV, especially Chaps. 18, 21, and 22.

[3] Edward Gross, 'Social Integration and the Control of Competition,' *American Journal of Sociology*, LXVII (1961), 270–277.

[4] We owe thanks to Stewart E. Perry for his help in clarification of the outline of this study and for other suggestions for its improvement.

[5] George C. Homans, *The Human Group* (New York: Harcourt, Brace, 1950).

[6] The definitions of 'macrophasic' and microphasic' movements appear in Talcott Parsons, Robert Bales, and Edward A. Shils, *Working Papers in the Theory of Action* (Glencoe, Ill.: The Free Press, 1953), p. 178.

[7] Parsons, Bales, and Shils define these four phase movements in a social system as follows: 'Successful adaptation involves (a) an accommodation of the system to inflexible "reality demands," and (b) an active tranformation of the situation external to the system. . . . Goal attainment involves intrinsically gratifying activity. It is the culminating phase of a sequence of preparatory activities. . . . Successful integration involves a determinate set of relations among the member units of the system such that it retains and reinforces its boundary-maintaining character as a single entity. . . . During periods of suspension of interaction (latency), there exists the imperative, if the system is to be renewed, for the motivational and cultural patterns to be maintained.'

One dimension or phase tends to be dominant at one time, although

social movement may simultaneously take place along all four dimensions. Typically, a social system moves from adaptation to goal-gratification to integration to latency. See Footnote 6, pp. 183-189.

[8] See Homans, *The Human Group*, in Footnote 5, pp. 90-94 and 109-110.

[9] Here it is important to introduce Parsons' distinction between accomplishment and achievement. 'Achievement' refers to goal-attainment —giving the performance and enjoying the rewards for it. 'Accomplishment' refers to changes in the social system itself through sequences of phases over time. In the ballet company its 'system capacity' is continually being renewed and perhaps increased through the individual dancer's increasing excellence in dance technique and expression, and the development of group solidarity. See Footnote 6, pp. 169-170.

[10] Parsons and Shils hold that the actor always has certain dilemmas of choice in any situation. He has two attitudinal choices: First, shall he gratify need-dispositions in this situation, or must he postpone gratifications? These two choices are labeled affectivity and affective neutrality. Second, is his orientation to an object, either social or nonsocial, to be a full or narrow obligation or interest? These choices are called functional diffuseness and functional specificity. Further, he has two choices in evaluating the modalities—that is, the properties of an object, either social or nonsocial. Shall he see it as a member of a class of objects or as a unique object related to himself? This choice is labeled universalistic versus particularistic. Second, shall he view the object in terms of its performance capacity or manifestations, or in terms of its ascribed qualities? This choice is called the dilemma of achievement-orientation or performance-orientation versus ascription-orientation or quality-orientation. Lastly, in the exchange with another person or collectivity, shall he be altruistic or not? If the good of the other takes precedence, he is collectivity-oriented; if not, he is self-oriented. These dilemmas may be internalized in the personality, and may be institutionalized in social roles and cultural value-orientations. For comments on occupational roles, see 'The Professions and Social Structure,' in Talcott Parsons, *Essays in Sociological Theory Pure and Applied* (Glencoe, Ill.: The Free Press, 1949), and Talcott Parsons, *The Social System* (Glencoe, Ill.: The Free Press, 1951), p. 434. See also Footnote 6, p. 255.

[11] See 'The Professionals and Social Structure,' in Footnote 10, and *The Social System*, in Footnote 10, p. 434. Ryser suggests that dancers may not care whether the audience enjoys a performance which is aesthetically gratifying to the dancers themselves. However, the social structure of the ballet company is founded on the requirement of public performances, and its continued survival requires some minimum positive appreciation by audience and critics. See Carol Pierson Ryser, 'The Student Dancer,' in Robert N. Wilson (ed.), *The Arts in Society* (Englewood Cliffs, N.J.: Prentice-Hall, 1964), pp. 95-121.

[12] 'Internal roles in organizations are always collectivity-oriented, they presume loyalty to the organization within the defined limits, and the alternative of cooperation or resignation.' See Footnote 6, p. 261.

[13] While in the United States ballet companies depend upon box-office remuneration, even for those companies in other countries—such as the U.S.S.R. and England—that receive financial support from the state, their reputations are all-important.

[14] In later works, Parsons has used the term 'pattern-maintenance' instead of latency. See Talcott Parsons and Robert Bales, *Family: Socialization, Interaction Process* (Glencoe, Ill.: The Free Press, 1955), pp. 160–161; and Talcott Parsons, *Structure and Process in Modern Societies* (Glencoe, Ill.: The Free Press, 1960), p. 164.

[15] Since there seems to be, at least in the United States, a shortage of male dancers, this sanction may be less applicable to them, and they may receive more concessions from the teacher than do female dancers.

[16] Romola Nijinsky, *Nijinsky* (New York: Simon & Schuster, 1934), p. 31.

[17] Agnes de Mille, *And Promenade Home* (Boston: Little, Brown, 1958), p. 37.

[18] See Footnote 17, p. 84.

[19] See Footnote 17, pp. 221–222.

[20] See Ryser, in Footnote 11, pp. 109–111.

[21] Parsons, Shils, and Olds say, 'In the executive role is centered the responsibility for the specification of roles to be performed, the recruitment of personnel to perform the roles, the organization and regulation of the collaborative relations among the roles, the renumeration of the incumbents for their performances, the provision of facilities for performance of the roles, and the disposal of the product. The organization of an instrumental complex into a corporate body which exists in a context of other individual actors and corporate bodies involves also the management of "foreign relations." ' In contrast, the technical role is 'confined to a technical instrumental content.' See Talcott Parsons and Edward A. Shils, with the assistance of James Olds, 'Values, Motives and Systems of Action,' in Talcott Parsons and Edward A. Shils (eds.), *Toward a General Theory of Action* (Cambridge, Mass.: Harvard University Press, 1951), pp. 211–212.

[22] Female dancers continue strenuous physical exercise during their monthly periods. Agnes de Mille remarks, 'Certain great soloists have been lacking in even primary sexual functions and are known to have menstruated rarely.' See Footnote 17, p. 224.

[23] Distributive justice is felt to exist, Homans suggests, when rewards, costs and investments are 'in line' with one another, and when a man's contribution in one aspect of a group's life is about equal to his rewards in another aspect of the group's life. See Footnote 1, pp. 234, 241.

[24] The sex of the dancer also affects competition. Since the number of men competing for roles is small as compared with women, a man has a much greater likelihood of dancing a solo or lead role.

[25] See Footnote 17, p. 221.

[26] Martha Graham, 'How I Became A Dancer,' *Saturday Review*, August 28, 1965, p. 54.

[27] Max Weber wrote of a similar passionate commitment on the part of a

scientist to his vocation in 'Science as a Vocation,' in *From Max Weber*,
trans. and ed. by H. H. Gerth and C. Wright Mills (New York: Oxford
University Press, 1946), pp. 135–137.

[28] Yonina Talmon discusses the way in which the peer group in the
kibbutz encourages group solidarity, but discourages friendships and love
affairs within it. See 'Mate Selection in Collective Settlements,' *American
Sociological Review*, XXIX (1964) 491–508, especially 501–502.

[29] The towel seems to be a status symbol of a very hardworking dancer
of considerable accomplishment.

[30] The internal system may, of course, be unjust. Thus, Romola Nijinsky
says about Nijinsky's early days in the Russian imperial school of dancing,
'He did not mix with the other frolicking pupils unless expressly called by
them, as by this time he had become used to being ignored by his class-
mates who were jealous of him.' See Footnote 16, p. 37.

[31] Mary Clarke in *The Sadler's Wells Ballet: A History and Appreciation*
(New York: Macmillan, 1955), p. 4, speaks of the many dancers who
gave ten, twenty-five, or even, as in the case of Margot Fonteyn and
Robert Helpmann, their entire dancing careers to the Sadler's Wells
Ballet Company.

[32] See Footnote 16, p. 30.

[33] Edward A. Shils, 'Primary Groups in the American Army,' pp. 31–34,
in Robert K. Merton and Paul F. Lazarsfeld (eds.), *Continuities in
Social Research: Studies in the Scope and Method of 'The American
Soldier'* (Glencoe, Ill.: The Free Press, 1950).

[34] We would like to comment here on the relevance of some of Sigmund
Freud's concepts in 'Group Psychology and the Analysis of the Ego,'
Standard Edition of the Complete Psychological Works (London: Hogarth,
1955), XVIII, 65–143. Freud emphasizes the strong feelings of love felt
by the members of a group for its leader and the members' love for each
other, love stemming from their common love-object, the leader. In
following their leader, the members allow individual ego, including
initiative and critical capacities, to subside. Presumably, the leader may or
may not actually love all, or even any, of the members of the group, but it
is important that the illusion that he loves all equally be maintained if the
group is to survive in any voluntary way. Freud also suggests that the
members of the group do not feel aversion for each other, having repressed
the inevitable negative side of ambivalence.

We know little about the real feelings of the ballet teacher, and we
have only limited information about the feelings of the dancers, but the
norms of the company can be said to reflect Freud's analysis of the group
and its leader. That is, the norms imply that the teacher 'loves'—or at
least cares about—each and every dancer, and that the dancers feel respect
and admiration for her which might be equated with, or might develop
into, 'love' for her, and that in following her they allow individual ego to
subside. There are, again, norms against expression of 'aversion' by
members against each other, and there is an emphasis on their getting
along together and maintaining harmony. Only in passing, however, does

Freud suggest the importance of values and goals for the integration of the group, and this seems to us, in the case of the ballet company, to be crucial.

[35] A complex-adequate hypothesis is a 'hypothesis which selects several weighty factors and combines them in a statement of maximum likelihood.' See Robin M. Williams, Jr., 'Continuity and Change in Sociological Study,' *American Sociological Review*, XXIII (1958), 624.

DENNISON NASH

Challenge and Response in the American Composer's Career*

ARTISTIC BEHAVIOR HAS received scant recognition by behavioral science. Whatever the reason for such neglect, it is evident that the present-day researcher tends to choose his problems in nonartistic areas. The scientific approach to art, therefore, may sound slightly foreign in a gathering of this kind.

But it need not sound so, especially if we consider art as one variety of behavior to be investigated and charted. Further, we will be better able to fit artistic behavior into our developing research framework if we put aside for the moment romantic conceptions—one of which pictures the artist seated in his favorite bistro, struck by a bolt of superhuman origin, dashing off to his garret and creating his masterpiece.

Art in our society may be a life's work; an artist follows a trade as does any tradesman, even though he may be more emotionally involved than others. In consequence, there seems to be no valid reason why production in a given artistic medium cannot be included in the rapidly developing sociology and psychology of the vocations. Undoubtedly, some artists would writhe at this conception, but these, according to my evidence, would constitute a minority. And, when artists begin to look upon their work as a trade we are far removed from the bistro indeed.

The data for this paper have been provided by a social-psychological study of living, American-born composers of serious music. I prefer to

* Presented at the meetings of The Eastern Sociological Society at Harvard University, March 28 and 29, 1953. Reprinted by permission of the author and the publisher for the *Journal of Aesthetics and Art Criticism*, xiv [Sept., 1955], pp. 116-122.

think of this investigation as research in the social-psychology of vocational adjustment. The art medium involved is the one which revolves around the aural sense. The serious composer has been operationally defined as one who produces music, predominantly, for certain media of musical expression, *e.g.*, the symphony orchestra, the ballet and modern dance, motion pictures, etc.

The major problems of the study are:

1. To describe the role and subrole social situations of serious composition in America[1]
2. To describe the personalities which have achieved the role and sub-roles[2]
3. To describe the situational history of these personalities
4. To describe role-perception and role behavior as a product of personality and social situation.

The method employed in this exploratory study is the case history. In this, the techniques of interviews, schedule, and Rorschach's Test have been employed. Informants, written documents, and participant observation provided additional evidence. The fieldwork was carried on out of four principal field locations, and lasted approximately six months.

Table 1.

Noncompositional Roles Ever Played in the Musical Process
by 23 American Composers*

Vocational Role	Frequency
Teacher-lecturer	22
Instrumentalist	16
Critic-writer	9
Conductor	7
Business-manager	5†
Other artist	1
Total	60

* On a professional level.
† Three teaching administrators are included here.

An aggregate of twenty-three American-born composers of serious music (hereafter called American composers), who were among the sixty-two living composers ranked by a jury of experts as the most successful in the United States, participated. The term 'success,' as employed by the jury, refers, apparently, to social acceptance, as indicated by a direct relationship between rank and direct and indirect measures of quantity of performance.[3]

Twenty-five advanced students of composition also participated in the study. They were interviewed and tested in the same field locations, but constitute a separate report to be presented elsewhere. Approximately eight hours were spent with each participant.

The data from the aggregate of twenty-three composers are now being assembled, but only preliminary conclusions are ready for public presentation. In particular, generalizations by my Rorschach interpreter are lacking at this time. However, I do have his report of the significant inability of the Rorschach to predict 'success' in this role; *i.e.*, there are few central tendencies in the twenty-three personalities as revealed by the Rorschach. This supports Roe's conclusions in regard to painters, and urges upon us as sociologists the added consideration of the situational factors behind, and in, the compositional role.[4]

SITUATIONAL ANALYSIS OF THE MUSICAL PROCESS

The diagram depicts the network of roles which constitutes the process of serious music in our society. It assumes that all music has a social function, and that the function of the composing role at any time or place is to produce music for performance to perceivers, *i.e.*, an audience. Such performance involves the tonal expression by musical instrumentalists of the graphic-symbolic notation of the composer.

The diagram accepts as given a framework provided by a mass society with an emphasis upon competition in its culture. The cooperative and competitive organization of the role system embraces the production, distribution and consumption of serious music, *i.e.*, the musical process, in our society; to be performed, the composer must cooperate, to a greater or lesser degree, with personalities playing the other roles depicted here. At the same time, he must compete with his colleagues, living and dead, the latter of whom constitute his most formidable rivals for audience attention.

In the musical process the composer produces music to be performed. My data reveal that performance is very important to a composer, and the lack of it provides him with his outstanding musical 'gripe.' Present-day American

composers have been trained under the shadow and influence of a generation of foreign-born composers active in the revolution against nineteenth-century music, and leaders in the subsequent period of experimentation. Stravinsky, Schoenberg, Bartok and Hindemith are important names in this movement. At present, there are several major trends in American compositional style,

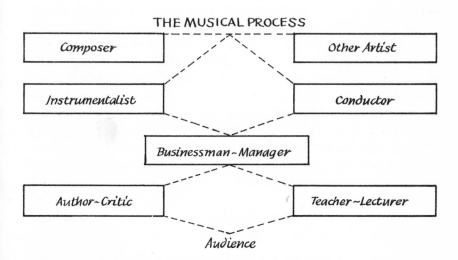

THE MUSICAL PROCESS

e.g., Neo-classicism, Twelve-tone Row Technique (with a basis in expressionism), and experimentalism, but the gist of the present trends is probably indicated by one composer's remark. 'Anyone,' he said, 'who writes like Brahms now is a slob.'[5] The lush, self-expressive sounds of nineteenth-century romanticism are old or dead to the majority of American composers in the present era. However, originality and inventiveness continue to be highly valued. Each work by a composer is an intensely personal document.

The audience perceives, aurally, performed music. In the present-day U.S. the taste trend for this aggregate runs strongly in favor of so-called popular music, as exemplified by the juke-box song. Radio, which seeks to meet audience taste, devotes more than 80 per cent of its musical time to popular music. Record companies approximate this percentage in their repertoire.[6] The music of our society, to the anthropologist, would be popular music—a near *universal*, to borrow one of Linton's terms. In the same classificatory scheme, serious musical behavior in our society might be called a *specialty*.[7]

Of that audience which listens considerably to serious music, the taste

is clearly in favor of music written prior to the twentieth century, particularly nineteenth-century romantic music. Evidences from Mueller, Nash and the National Music Council indicate that the serious audience prefers such music, and gets it.[8] The gap between the taste of the American composer and the audience for serious music is enormous.

Now, since the musical process, to a great extent, is organized around the taste of the audience, the American composer becomes a relatively dispensable man. Probably, the musical process could function quite adequately without the product of *any* American composers. This condition renders the vocation of composing an uncertain and insecure one at best. In the aggregate of composers, for the year 1951, income from composition ranges from zero to 95 per cent of total income, with a mean of 27 per cent. Some composers react to this comparatively outcast financial state by donning the cloak of a martyr. Others seek to express themselves in the more popular (and financially lucrative) media such as the movies and radio and television. The latter rationalize their 'functional' pursuits in a variety of ways, most of which involve the mention of Johann Sebastian Bach, a notably 'functional' composer.

This brings us to the realization that the gap between the tastes of audience and composer was not always so great. As Mueller says:

> During the pre-Napoleonic era, composers were craftsmen who composed to order, and who, like the architect, the portrait painter, and the cook, expected their work to be appreciated forthwith. It would not have occurred to Bach, Mozart, Haydn and the other *Kappellmeister* of the day to ignore the interest of the current generation by writing *Zukunftmusik*, nor could they have the temerity to expect their socially superior patrons to sit through repeated hearings of a symphony on the chance that they or their descendents might possibly enjoy it at some future time.[9]

The relationships of the American composer's role with all other roles, save one, in the diagram are variations on the dependency theme previously mentioned. As Nash has demonstrated, conductors are caught between the taste grindstone of the musical businessman, boards of directors, and audience.[10] What is more, most of the big conductors of American orchestras are of a foreign-born older generation, and have tastes which favor pre-twentieth-century music. Conductors are stars in their own right who add to their own recognition by numerous first performances and interpretations, not always in keeping with the composer's intention. The frustration of a composer at a conductor's inadequate interpretation of the composer's work is a terrible thing to see. Should the composer object and take the chance of

losing the performance, or should he permit the distortion of his original intent? The conductor can continue to function fairly adequately without performing new works. A one-sided dependence, unfavorable to the composer, is therefore evident in this cooperative relationship.

The culture of the instrumentalist is similar to that of conductors. There are a few big stars who maintain their popularity by scintillating and idiosyncratic renditions of audience favorites. Should a solo instrumentalist deviate too far into the 'modern' category he may be ordered to get back in line by his management. Though he cooperates with the American composer, his need for the latter's works is not great.

The long fingers of the businessman extend into all of the roles by direct and indirect relationship. He is a native to the economic jungle which pervades the musical process, and must continually point out its facts of life to the other participants, *e.g.*, he is in business to make money, primarily, not to satisfy some aesthetic craving. Music publishers, record, radio and television executives, concert managers and movie executives are the major kinds of businessmen who play this role. Some of these men, the data reveal, are aware of a distinction between 'good' music and salable music, but the latter always takes precedence here, a fact which establishes the composer as dependent once again.

The pressure of business expediency is particularly powerful in writing for such media as the motion pictures and radio and television. The primarily commercial orientation of these media places a minimum value on 'ivory tower self-expression.' Composers in these media usually write on contract within subordinated and prescribed limits. A preliminary impression from personality data is that this role attracts a significantly different personality type than that subrole in which the composer writes primarily from his 'inner urge.'

The function of the critic and author is to facilitate the perception of the audience. However, the extent of their influence on this perception is not known. It is my impression that though criticism is very important in its effect on the career of conductor and instrumentalist, it has only a slight effect on the career of the composer. However, a critic (and any other important musical personality) may function as a go-between in the relationship between composer and conductor or instrumentalist, upon whom they can exert pressure. Since, in a mass society, the problem of contact is a serious one, this renders the composer a considerable service. The various conditions of friendship, of course, determine who will act as go-between.

The teacher and lecturer control, to a greater or lesser extent, the learning

process. In our society, the teacher can carry out this function quite success-
fully without reference to *any* contemporary music. Carpenter believes that
contemporary works receive extended attention only in the professional
school.[11] To the extent of the teacher's influence on his potential audience,
therefore, the composer is dependent in this rather vague and indirect
relationship.

There is one role relationship in the whole musical process which seems
to be a mutually rewarding and dependent situation. This is the composer's
cooperation with another artist, *e.g.*, the choreographer, librettist and scene
designer. The reasons for this fact are three: (1) All artists, with the possible
exception of the dramatist and novelist, appear to be pretty much in the
same boat as far as societal rewards are concerned. (2) The process of
creating a work of art, according to data provided by Hutchinson, Nash,
Roe and Wilson, does not appear to be significantly different for the various
art media.[12] (3) Should the American composer choose to cooperate with a
dead artist, he obviously is dominant in the relationship.

Now, since the composer's role is dominated by all other roles (except that
of other artists) in the musical process to the degree that they exercise
a greater control over the performance of a work, we might expect, in a
competitive society, the development of attitudes and techniques to gain
greater control. This last is evident in the formation of such associations, by
composers and their allies, as the League of Composers, the International
Society for Contemporary Music, the Society for the Publication of American
Music, the American Composers' Alliance, the Koussevitzky Foundation,
Inc., and the National Association of American Conductors and Composers,
all of which seek to put the composer's music before the public. This means
a tipping of the competitive axis to the cooperative. Confronted by a hostile
out-group, composers and their allies manifest certain *in-group* tendencies
along personality lines. Such *in-grouping* promotes a common cause, *i.e.*,
increased performance.

It has been mentioned previously how the very nature of the medium of
music decreases the control of the creator over the destiny of his own work,
i.e., performance. To the composer, there is nothing more important than
performance which is congruent with his original intention. In interactional
terms then, any behavior which will facilitate and balance cooperation will
increase the composer's control. In the aggregate, this seems to have been
accomplished by a phenomenon which I call *role versatility*.

If we consider our diagrammed role system as a small society in which
socialization takes place through 'taking the role of the other,' we can
hypothesize, following Mead, that how well the composer comes to adjust

or cooperate depends on his role-taking ability, a major factor in which is actual experience in other roles.[13] If he plays, and has played, many roles, communication (and therefore interaction) would be facilitated, and control increased.

By listing the other vocational roles in the musical process which composers in the aggregate have played on a professional level, we find that the composer is a remarkably socialized and versatile individual. As many as three roles have been played simultaneously by composers in the aggregate, not to mention other roles not included in the musical process.

The functions of such role versatility all would appear to improve the composer's control over the destiny of his work: (1) It increases the composer's financial income, and therefore decreases his dependence upon the other roles in the process. (2) It increases his prestige, *i.e.*, the composer who is ranked rather low on prestige scales as a composer ranks higher as a teacher, even though he considers his life's work to be composing.[14] This facilitates interaction by rendering him more socially acceptable, and presumably, increases his bargaining power. (3) It increases control over performance when he actually plays additional roles in the distribution of his own music. (4) Through previous role-playing, empathy with the other roles in the musical process is increased and interaction facilitated.

The case of the sidewalk painter may help us to understand what the composer actually achieves through *role versatility*. The painter produces, exhibits and sells his own work in a self-contained operation. Unlike him, the composer depends upon others to cooperate with him in producing, exhibiting and selling his composition. It is by his *role versatility* that he expands his self in social interaction toward the self-contained artistic process of the sidewalk painter—thus increasing his power in the cooperative activity of the musical process.

CONCLUSION

This situational analysis has sought to depict the central tendencies in the organization of roles which comprise the musical process in our society. For the composer, the situation is a contradiction. First, the prevailing values of the composing and aesthetic culture sanction originality and the pursuit of a constantly developing individual style. On the other hand, the 'facts' of the musical process conflict directly with such 'ivory tower self-expression.' Only a very special kind of individual, it seems, could choose to live such a vast contradiction. *Role versatility* appears to be one device with

which the American composer deals with this problem. Now, we are led to ask:

1. What are the personality resources which enable the composer to become a master of many trades?
2. What is the 'cost' of this, musically speaking?

These and other personality questions I hope to be able to answer at a later date.

NOTES

[1] The term *'social situation'* is used here as defined by Thomas, *i.e.*, the interaction of personalities.
See W. I. Thomas and D. Thomas, *The Child in America* (New York, 1928), p. 506.
[2] 'Personality' is defined here as the psycho-social organization of the functions of the human organism which evolves through the socialization process and which is common to all the social roles it (synchronically) plays.
[3] The twenty-three composers were ranked in three classes according to the degree of agreement in listing them as 'most successful' by the jury. One measure of quantity of performance is membership in ASCAP and ACA, performance right associations which restrict their membership to composers with the most 'active repertoire.' A consistent decrease, from class I to class III, in the percentage of composers who were members of these two associations was evident.
Mueller has ranked composers according to quantity of performance by symphony orchestras for the period 1945–50. A consistent decrease, from class I to class III, in the percentage of composers from zero to twelve on his scale is evident.
See J. H. Mueller, *The American Symphony Orchestra* (Bloomington, Ind., 1951), p. 277.
[4] Anne Roe, 'Painting and Personality,' *Rorschach Research Exchange*, X, No. 3 (October, 1946), 86–100.
[5] Quoted from an interview with a composer and critic.
[6] P. Carpenter, *Music: An Art and a Business* (Norman, Okla., 1950), p. 25; Ross, Parmenter, 'Economics of Records,' *New York Times*, March 9, 1952.
[7] R. Linton, *The Study of Man* (New York, 1936), p. 272.
[8] J. H. Mueller and K. Hevner, *Trends in Musical Taste* (Bloomington, Ind., 1942); D. Nash, *The Construction of the Repertoire of a Symphony Orchestra: A Study in Social Interaction* (Master's thesis, Washington

University, 1950); *National Music Council Bulletin*, VII (September 1, 1952), 1–2.

[9] Mueller, *The American Symphony Orchestra*, p. 289.

[10] Nash, *op. cit.*, pp. 50–66.

[11] Carpenter, *op. cit.*, pp. 154–183.

[12] E. D. Hutchinson, *How To Think Creatively* (Nashville, Tenn., 1944); Nash, *op. cit.*; Roe, *op. cit.*; R. Wilson, *The American Poet: A Role Investigation* (Unpublished Ph.D. dissertation, Harvard University, 1952).

[13] G. H. Mead, *Mind, Self, and Society* (Chicago, 1934).

[14] The composer does not attain a pre-eminent prestige rank on scales so far utilized. See K. Evans, V. Hughes, L. Wilson, 'A Comparison of Occupational Attitudes,' *Sociology and Social Research*, XXI (1936), 134–148; Mueller, *The American Symphony Orchestra*, p. 283; L. Terman, *Genetic Studies of Genius* (Stanford, 1925), 1, 66f. Evidence is also presented for my interview and schedule data, not yet available for formal presentation.

MALCOLM COWLEY

*Where Writers Come From**

THE REPUBLIC OF letters is in some ways desperately snobbish, but nobody is excluded from it because of his family background; in that respect it is a true democracy. By the middle of the twentieth century American writers might come from any economic level and any section of the country, if they weren't born abroad. They might come from any college or university, or none, and from almost any of the racial stocks and cultural groups that compose this nation of peoples. They were, however, more likely to come from certain backgrounds; as sociologists would say, the incidence of authorship was higher in some groups than it was in others. It was very high among the children of professional families, of many racial origins, living in the Northeastern states, especially if the children were educated in Eastern preparatory schools and at any of the Ivy League colleges. The lowest rate for the native-born was among Indians and Spanish-Americans living in the Mountain states; it came close to being no rate at all. On the other hand, there was a high incidence of authorship among Mormons born in the same region.

I don't know that sociologists have ever studied what they would call the racial provenience of American writers, although it would make an interesting subject for a doctoral dissertation. Our nineteenth-century authors were mostly of English stock, with an admixture of Dutch blood in New York; Melville and Whitman were both half Dutch. Elsewhere there were some Pennsylvania Germans, French Huguenots, and Scotch-Irish (though not many of these), with a thin sprinkling of O'Briens and O'Reillys. Bret Harte

* From *The Literary Situation* by Malcolm Cowley. Copyright 1954 by Malcolm Cowley. Reprinted by permission of The Viking Press, Inc., and the author.

was our first famous author of Jewish descent. After 1890 the newer racial stocks began to come forward one at a time, as if to mark, in each case, the integration of a new group into American culture. First the still foreign-sounding names had appeared as those of boxers, then as those of politicians in the working-class wards down by the river; then came the businessmen, the college football players (in the second generation), and finally one of the names would be signed to a best-selling novel. There had been another pattern in literature. First we read about members of the new group as apparently stupid but really shrewd and lovable persons who made funny remarks in broken English (like Hashimura Togo, the Japanese Schoolboy). Other members of the group would then be presented in angry books, as tragic or pathetic spokesmen for their people. Still later their children would be presented simply as human beings to be valued for themselves.

The literary pattern is clearest in the case of the Irish, because of their group consciousness and their long experience as an oppressed minority. The first Irish-American author who won, and deserved to win, a national reputation was Finley Peter Dunne, in the 1890s. His Mr. Dooley was a saloon-keeper who discussed national politics with a mixture of innocence and wisdom and whose eyes filled with tears—though we don't read the sadder dialogues today—when he discussed the sorrows of Irish immigrants. If we except Donn Byrne, that romantic Orangeman, Scott Fitzgerald was the next really famous Irish-American author. Like Dunne he had been accepted into the ruling Protestant group, and unlike Dunne he wrote about that group, so that his Irishness was a little disguised, but it remained an under-tone in all his stories; it gave him a sense of standing apart that sharpened his observation of social differences. He liked to give his heroes Irish names or, at the very least, an Irish lilt to their voices. James T. Farrell, beginning in the 1930s, wrote about the Irish on the South Side of Chicago, not far from the saloon where Mr. Dooley used to hold forth, but there wasn't much humor in Farrell's stories, nor was there any attempt to please the ruling group. Most of his characters were pathetic creatures, oppressed by conditions, and his underlying mood was indignation at their being denied a chance for a better life.

By the 1950s there were distinguished Irish writers in all branches of American literature, including the criticism of abstract art (James Johnson Sweeney) and the translation of Greek tragedies (Robert Fitzgerald). *The Trouble of One House*, by Brendan Gill, is good enough in itself to stand for much of the newer Irish-American fiction. Gill tells the story of a cultivated and prosperous family that happens to be Catholic and of Irish descent, but whose troubles are those of human beings everywhere in modern life.

Although his novel is more skillfully written than anything by Farrell, or even by Scott Fitzgerald, it lacks the emotional power of those earlier books conceived at a time when the American Irish were still in some ways an oppressed group. That loss of power belongs to the pattern too, for the sorrows of a novelist—including his racial sorrows—are part of his emotional stock in trade.

The Irish were literary pioneers and were followed by dozens of other racial and cultural groups. After 1900 there appeared in succession—though not in quite this order—the South German Catholics (Dreiser), the North German Protestants (H. L. Mencken, Ruth Suckow), the prosperous and highly cultivated German Jews (Gertrude Stein, Paul Rosenfeld), and the Scandinavians (among them O. E. Rolvaag, who lived in Minnesota, wrote in Norwegian, and translated his own novels into English). Soon there were also scores of writers among the newly arrived Polish and Russian Jews, perhaps beginning with Mary Antin and Abraham Cahan. Negro writers had been published for many years, but after 1930 they spoke with more authority and appeared in greater number. Richard Wright was the most distinguished, and Frank Yerby the most cynical and successful; he published romantic novels about white Southern planters and was the first American Negro to earn a million dollars by his writing. The Armenians appeared in 1934, with William Saroyan, and the Italians in 1939, with Pietro Di Donato's *Christ in Concrete*. I am thinking of writers who learned their trade in this country, not of adult immigrants or refugees who had learned it in Europe. Had I included those others, I might have mentioned precursors in several groups, going back as far as Lorenzo da Ponte, who died more than a hundred years ago, after teaching New Yorkers to like Italian opera.

By 1950 there were professional writers who represented many newer and sometimes rather localized groups, including the Greeks (A. I. Bezzerides and Kimon Friar), the Croatians (with the late Louis Adamic), the Sicilians (Jerre Mangione), the Dutch in Michigan (David Cornel DeJong), the Icelanders of the Dakotas (Holger Cahill), the Frisian Islanders (Feike Feikema), the Nisei (S. I. Hayakawa), and even the Koreans (Younghill Kang). A few of the larger racial groups were still seriously underrepresented in American literature; they included the Poles (Marya Zaturenska), the French Canadians (John Kerouac), and the Hungarians (represented chiefly by refugees). These groups were still at the stage of producing businessmen and football heroes. Others, like the Mexicans and the Puerto Ricans, were such recent arrivals and were so handicapped educationally that they had no writers to speak for them in English; their admired representatives were still

boxers or baseball players. Their time in literature will come. Every group has something of its own to contribute, a special experience or sense of life, and all of them will someday do their part to enrich American writing.

Economically the provenience of American writers—or one might better say their background and class loyalty—has changed more than once during the last sixty years. In the 1890s writing was regarded as a leisure-class occupation. Few of the writers themselves had leisure-class incomes; more of them than today were starving in garrets, but they wrote for a privileged audience, and their fictional heroes regarded themselves as gentlemen born. Successful writers were entertained by Andrew Carnegie and might even be supported by William C. Whitney, who gave more than a million dollars, in the course of years, to his friend Finley Peter Dunne. It was a time when Lorenzo de' Medici was a pattern for millionaires. The National Institute of Arts and Letters, founded at the turn of the century, was subsidized by Archer M. Huntington, as the National Arts Club was subsidized by Spencer Trask. Later Trask's widow endowed their mansion, Yaddo, near Saratoga Springs, as a summer retreat for writers and artists. She hoped that they would regard themselves as well-bred guests of the family.

All this munificence encouraged writers to accept the leisure-class standards, and the standards were also enforced by the truly great magazines of the 1890s: *Harper's*, the *Century*, and *Scribner's*. When Edith Wharton, then a young society matron, first ventured into literature by writing three poems she thought might be published, she sent one poem to each of the magazines, with her calling card. All three were accepted, and possibly would have been accepted if they had come from Kokomo, being fairly distinguished poems, but the calling cards helped the editors to make up their minds. Theodore Dreiser, the poor German boy from Indiana, felt that the magazines and their contributors existed on a happier planet. 'These writers,' he said in *Newspaper Days*, 'seemed far above the world of which I was a part. Indeed I began to picture them as creatures of the greatest luxury and culture, gentlemen and ladies all, comfortably housed, masters of servants, possessing estates, or at least bachelor quarters, having horses and carriages, and received here, there and everywhere with nods of recognition and smiles of approval.'

Dreiser would write about his own class of small-town boys and girls making their way, or failing to make it, in Chicago and New York. His early work, which had fervent admirers in literary circles, may have had something to do with the change in economic loyalties after 1910, though I suspect that the change would have taken place if Dreiser had never written.

Many of the younger writers were professing radical sentiments and joining the Socialist party. Millionaires were withdrawing their support from literature, and, on the other hand, a broader, well-educated middle-class public was being formed that was willing to buy sophisticated novels. After 1910 writing came to be regarded as one of the middle-class professions, open to young men and women who were highly trained for the work. Writers talked less about being gentlemen or ladies and took to presenting middle-class heroes, but they tried not to follow a middle-class pattern in their personal lives. Even if they earned comfortable incomes, as many of them did after 1920, they spent the incomes for travel and services and entertainment, rather than houses or motor cars, and lived in the style of prosperous gypsies.

Once again I am offering a few general remarks on what might well be a subject for sociological researches. I can picture the postgraduate students setting out with questionnaires and coming back with charts. 'Where were you living in 1930?' they would ask a number of writers in succession. 'Did you own your own house? How did you support yourself during the Depression? What was your income in 1930 and what was it ten years later?' Putting together the answers to questions like these, our students would find that there was, after 1930, still another change in literary loyalties. Instead of being leisure-class or bohemian, the younger writers of the time began to picture themselves as genuine proletarians. More of them than before came from working-class families. For others the role of oppressed worker was easy to assume, since they were living on very small stipends from the Federal Writers' Project, but their behavior was not without an element of inverted snobbery. Young men from good Eastern universities disguised themselves in dirty cotton-flannel shirts while they tried to write proletarian novels like those admired in Russia. Most of the novels were merely stylish, for the time, and were based on secondhand feeling, but some of them revealed a serious effort to broaden the horizons of American fiction. We began to read stories about coal miners, turret-lathe operators, filling-station attendants, production-line workers, oil drillers, lumber-mill hands in the Northwest, Southern sharecroppers; and fruit pickers in California—employed, unemployed, or on strike. All sorts of backgrounds and occupations, or the lack of them, appeared in literature for the first time, as if to remind us that earlier novelists had failed to present many broad levels of American society.

The horizons of fiction narrowed again after World War II, except in stories about fighting men overseas; most of the new stateside novels had college-bred heroes and heroines. The novelists themselves, with a few

exceptions, had stopped acting like bohemians or proletarians, and it was getting hard to tell a writer from anybody else. Many of the younger ones lived on residential streets, owned their homes—or were trying to buy them—and were active members of the Parent-Teacher Association. Unlike most writers of the 1920s, they worried about public opinion outside their own group and were letting themselves be absorbed into the new white-collar classes. In some respects, however, there was a curious reversion to the leisure-class standards of the 1890s. The institution of literary patronage had been revived and extended, although it had ceased to involve many personal contacts between writers and millionaires; now the money was given to foundations, which disbursed it in the form of fellowships. The genteel tradition of the 1890s had also been revived in fiction, and many of the new novels had an air of decorum that would have pleased William Dean Howells in his later years. It is never genteel to talk about money, and the novelists didn't talk about it much, but one could see that their characters hadn't many financial worries. My friend George Ollendorf, who reads the novels attentively, has been impressed by the financial progress of characters in American fiction since the days when novelists wrote about the unemployed. 'To make a rough estimate,' he says, 'the annual incomes of heroes and heroines have increased in the last twenty years by at least five hundred per cent.'

I mentioned the question of college background. At the beginning of this century young writers went to Harvard if their parents could afford to send them; any other university was a second choice. 'I went to Harvard,' says Van Wyck Brooks in his memoirs, 'just as students in the twelfth century went to Paris, because, for me also, Abelard was there; for I knew I was a writer born—I seemed always to have known this—and I supposed that Harvard was the college for writers.' Harvard retained that reputation for many years after Brooks was graduated in 1907, and partly retains it today. The most famous literary class was 1910, with T. S. Eliot, Jack Reed, Walter Lippmann, Heywood Broun, and others who then seemed of equal promise. After 1915, however, active literary groups appeared at other universities: first at Princeton, with Edmund Wilson, John Peale Bishop, and Scott Fitzgerald; then almost simultaneously at Yale, Columbia, Pennsylvania, Ohio State, and Chicago; then came the young poets at Vanderbilt who published the *Fugitive*. In those days it seemed that writers usually came forward by college groups, but Hemingway, Hart Crane, and a few others had never been to college. Faulkner had briefly attended the University of Mississippi.

The situation is a little more complicated today, though Harvard still has a higher incidence of authorship than any other American university. In the last few years it has been producing novelists and poets, and more than its share of future publishers. Princeton, which probably ranks second, has been producing novelists, poets, and new critics, most of whom have studied under Richard Blackmur. Yale is more public-minded and seems to specialize in reporters, including many of those who have made reporting a twentieth-century art form, but it also trains a good many critics and maintains a famous school of the drama. Kenyon College, in Ohio, has attracted young poets and critics, largely because John Crowe Ransom teaches there. On the Pacific Coast the universities popular with young writers are Stanford and California; in the South they might be Alabama and Tulane. Often the attraction of a university has been a single famous teacher, like Hudson Strode at Alabama. Iowa has a school of creative writing with a group of able teachers, and enrolls postgraduate students when they appear—as they do today—from colleges anywhere in the country. It would seem unlikely that any university will ever again establish the sort of undisputed literary prestige that Harvard enjoyed at the beginning of the century.

The sectional background of American writers becomes an interesting topic, not when we ask where they were born (the answer being almost anywhere), but when we ask what the sections were to which they have felt an emotional loyalty. For half a century after 1830 the section was likely to be New England. It was so much the center of the literary life that several authors born west of the Alleghenies became New Englanders by adoption, like William Dean Howells of Ohio and George Washington Cable of Louisiana. Even Mark Twain, who didn't get along with the Bostonians, spent much of his life in Connecticut. At the end of the 1880s, however, the center shifted to New York City, which was a section in itself and exercised a magnetic force, stronger than that of New England had been, on authors born in other sections. The most fashionable New York writers of the years after 1900 were Richard Harding Davis, of Philadelphia, and the playwright Clyde Fitch, who had grown up in Schenectady. The most loyal New Yorker was O. Henry, who was born in North Carolina and trained as a newspaperman in Texas. Except for Henry James and Edith Wharton, who lived in Europe, hardly any of the prominent authors had been born in New York, but nevertheless it was the seat and shire of the writing clan. Although its central position was threatened twice by Chicago—in the middle 1890s and after 1915—and once by Paris, in the 1920s, New York always retained the

publishing houses, the magazines, the theatrical producers, the literary agents, and so the writers couldn't stay away.

It was in the Depression years that one first began to notice a geographical diffusion. Young writers were still coming to New York, but there were not so many as before, because the city had ceased to glitter with opportunities. The glitter was in Hollywood, if the young men wanted to earn a great deal of money. If they simply wanted to keep alive while writing, they tried to join the Federal Writers' Project, and it was always easier to be certified to the Project if they stayed at home in Missouri or Idaho than if they moved to New York. There was no Writers' Project after World War II, but by then the magnetic attraction of the big city had weakened. Young writers were studying or teaching in universities all over the country. Many established writers had moved to Connecticut, just beyond the New York suburbs, but others had continued to live in California or Mississippi; perhaps they felt that airmail and the long-distance telephone brought them close enough to the publishing industry. As always, that industry was centered in New York—it was now almost confined to New York—but in some branches of serious writing, especially fiction, the prestige of leadership had passed to the South.

I have often wondered about the reasons for this dominant position of Southern novelists at the mid-century. Like everything else in literature, it can partly be explained in terms of personality: one novelist—in this case, William Faulkner—had found a path that many others could follow. But Faulkner had several distinguished and quite independent contemporaries; one might mention Katherine Anne Porter, Caroline Gordon, Robert Penn Warren, and Eudora Welty in what is now the older group of novelists, as well as poets-and-critics (the term should be hyphenated) like Ransom and Allen Tate. Faulkner has also had many able successors—so many, in fact, that the new position of Southern writing seems to call for additional explanations in social terms.

One explanation among others is that Southern writers belong to what is really a national minority with its own tradition, which they feel to be endangered and which they are bent on reaffirming in literature. Another explanation is that the rural South hasn't many commercial amusements, with the result that its people have been forced to amuse one another, largely by telling stories about local characters. Southerners have a good deal of practice in story-telling even before they begin to write. Still another explanation applies to Southern fiction, though not to criticism or poetry. It depends on the definition of novels as *long stories that deal with changing relationships*; these relationships are easiest to study when they exist among

members of the same family. Many novels, of course, deal with relationships of other types, from narrow ones like those between lover and mistress to the broad relationships among members of any social group (for example, an army platoon, a business office, or a college faculty). The family, however, makes an ideal subject for a novel and thereby simplifies the task of Southern writers—for the family is more important in the South than anywhere else in modern America (except among some cultural minorities, notably the Jews and the Italians, who have also been producing many young novelists). The South alone has preserved what sociologists call the extended family, or clan—that is, a group which includes aunts, uncles, and even distant cousins, as well as parents and children. The Southern family, at least in the smaller towns, is also likely to include persons of many different callings and levels of income; often there are rich and poor farmers, storekeepers, filling-station attendants, a doctor, a banker, and even a novelist in the same family group. From earliest childhood the novelist has been acquainted with a great diversity of characters, and he finds it easy to present them in action. Northerners travel more, but know fewer persons intimately. Most of their friends are likely to be on their own economic level, even in their own profession, with the result that their novels may be lacking in variety and color.

The South, of course, is not the only section with interesting writers. Today they are appearing in many regions, and often their work bears a sort of regional imprint. Publishers' readers learn what to expect; sometimes they look at the return address on a manuscript and wager what kind of story it will be. 'It comes from Maine,' I heard a reader say. 'I'll give you odds that it's a historical novel about the great days of the shipbuilders.' Novels from the Pacific Northwest and from Utah are also likely to be historical; in one case they might deal with covered wagons and in the other with Mormon pioneers and their plural wives. Novels from Hollywood are often slick jobs about a topic of current interest. Novels from Chicago are usually naturalistic; Chicago is the homeland of American naturalism. About novels from Connecticut one can never be sure; the writers who live there come from many states, and most of them haven't yet acquired the regional color of their new home.

B. SOCIAL POSITION AND ROLES

Introduction

MAN'S CONCERN WITH his own social standing as well as that of his group is probably as old as his existence. It was also one of the first ideas used by sociologists and anthropologists to analyze both the internal structure and the interrelationships of groups.

In contemporary usage, social ranking has become equated with social status and such corollary concepts as ascribed and achieved, high and low status. These concepts have helped us to focus on a number of major questions concerning group behavior: How does one attain, maintain or lose social position, and what are the power claims and prestige associated with each position?

The virtue of the concept of social ranking is that it permits structural analysis. Its major shortcoming, however, is that it does not account for the changes in and ongoing aspects of group behavior. The concept of social role has emerged to fill this need, and it has now become central in the study and analysis of group life. The idea of role has also provided a crucial and logical link between sociology and other disciplines. This concept has proved so valuable that the corollaries and hypotheses surrounding it now occupy what scientists call the 'strategic research site.' According to Robert Merton, in his Introduction to *The Crowd*, by Gustave Le Bon, the 'strategic research site is the . . . object(s) which enable one to investigate a scientific problem to particularly good advantage . . . [and which] exhibit the interplay of variables of broader meaning than the cases under study.'

The article by Jean Gimpel illustrates this point. Gimpel describes the historical evolution of the role and social position of the sculptor and offers, in addition, important documentation concerning the beginning, form and social importance of art associations; the elusive subject of the 'spirit' of the age; the social basis of aesthetics and the linguistic basis of our contemporary approach to this subject; the interrelations among artist, patron and architects; and the suggestion that changes in the living expression of an art foreshadow the end of an era.

The main contribution of Gimpel's article is a description of the changing status of the sculptor during the medieval period. He also describes the change in the meaning of the word *art* since the Middle Ages, when it meant an object to be admired as an entity in itself, needing no commentary. Contemporary usage implies commentary by critics as well as a series of social relations and institutions different in degree and kind from those of the Middle Ages.

The last part of 'Freemasons and Sculptors' contributes to our understanding of the so-called spirit of the age. Rather than refer to this 'spirit' as some mysterious afflatus, as is so frequently done, Gimpel traces the historic stages in the decline of the Cathedral Crusade (which was the living expression of the era) and the termination of the art associated with it. He implies that the most important variable explaining this decline was the weakening of religious faith.

It would be useful to replicate this study for contemporary society to see what can be discovered concerning the viability, persistence and continuity of today's secular faith in the art of our era, particularly the newer art forms: film, television, photography and mixed media. Such studies, if Gimpel's hypothesis is correct, could provide clues concerning whether or not Western culture in its present form is at the crossroads of what Karl Jaspers has called 'the Axial Age' in mankind's history. The last sentence of this article intimates that the decline in the work of the sculptor as a living force was just such an adumbration, a significant signal presaging the end of the Middle Ages and the beginning of the Renaissance.

Frederick Antal's article describes the efforts made by Florentine painters to improve their status within the guilds by disaffiliating

themselves from craftsmen who were members of the same guild—
e.g., color-grinders, drapers, etc. The guilds' primary concerns were
with working conditions: contracts, fees, control over entrance into
the profession. Their social objectives, involving maneuverings,
pressures, and counter pressures, internal and external, were to
enhance the social standing and independence of artists and sculptors.

Like the article by Gimpel described above, Neil Harris' article
contains more than information on the artist's status and role in
America. It provides a wealth of documented evidence on such
topics as art associations, attitudes of the artist's parents toward a
career in art, and why one community becomes a center of art while
others of equal or greater wealth, population and social standing
fail to develop.

The articles by Gimpel and Harris complement each other in their
concern with the social position and role of the artist, but whereas
Gimpel deals with the rise of the artist as a process of evolving
folkways, mores and traditions, Harris focuses on artists who took
these phenomena for granted. He particularizes the appeals to the
judiciary and their ruling that artists have a different legal claim to
their product than the ordinary claims of a producer in an industrial,
capitalistic economy: *e.g.*, the right to preserve and prevent destruc-
tion of works of art. In exerting these rights and claims, the artist was
not only establishing precedents for himself but foreshadowing a
problem concerning the rights to the creative process in industrial
and mass societies. It has become characteristic for industrial
corporations to stipulate in their employment contracts that their
claims to the creative processes and products of their workers and
scientists are paramount over the rights of the individual.

Marvin Elkoff's article examines the informal institutional complex
of contemporary art in its recognized center, New York. Although
written in journalistic style, the article nevertheless examines several
questions of importance for the sociologist, the art historian and the
aesthetician. Is success in art based on objective, consensually
validated aesthetic criteria, or on informal personal channels or
economic speculation and exploitation? Will fame continue to be
capricious as in the past with respect to painters successful in their
day who are subsequently relegated to mediocrity? And will the

touchstone of time discover another unrecognized genius who is being overlooked by contemporary cultural arbiters?

The article by J. W. Fernandez supplements and goes beyond the earlier articles in two ways: it examines art in a non-Western culture, and its conclusions are supported by data from a number of informants. In addition, Fernandez describes objectively and conclusively the role and (low) status of the artist in the preliterate Fang society. If preliterate society is imbued with the sacred, and art is an essential element of the sacred, what accounts for this low status? Can comparisons be drawn with the societies of the Middle Ages and early Renaissance, when artists occupied a comparable position?

The article by Nelson Graburn is a study of a form of art imposed and controlled by an external, superior force—in this case, the Canadian government, which imposes upon the Eskimo artist a style of art which it has labeled indigenous. Control is so effectively imposed, and the Eskimos are in so subordinate a position, that when they do create a genuine piece of art, it is either willfully destroyed, not purchased or declared illegitimate art.

Graburn describes the remarkable revival of a tribal art tradition in a new medium—soapstone rather than ivory carving—and the shift of art from a tribal function to one controlled by an open market system. He also raises some important questions pertaining to 'acculturated' or 'transitional' art. Rather than peremptorily referring to this art pejoratively and sequestering it from the realm of legitimate art, he suggests that acculturated art should be judged on its own merits.

In a condensed treatment of the relationship between art and society, Graburn asks why Eskimos excel at carving. His answer, documented by others, is that Eskimos possess exceptionally well-developed mental and linguistic concepts of space and form. These are necessities for visualizing and communicating the location and shape of objects in the relatively featureless landscape of the Eskimos. Since space and form are the essence of carving, these developed senses of visualization are major factors determining their unusual abilities in this technique.

JEAN GIMPEL

*Freemasons and Sculptors**

WHEN WALTER OF Hereford sent laborers to the quarry at Vale Royal, he had his carpenters build one lodge of fourteen hundred boards to accommodate the stonecutters. The following year he built a smaller lodge of one thousand boards. Whether the stonecutters were paid by the piece or by the week, their lives centered in or around the lodge. In the morning they went to get their tools, they had lunch there, and in very hot weather they took siestas there. There were always one or more lodges at the workshop, and they can be seen located at the foot of buildings under construction in manuscript illuminations.

The lodges not only gave workers a place in which to eat and rest, but they provided a place in which stonecutters could work in bad weather. For this reason these lodges were very important during the winter months. Stonecutters stayed in the lodges then and, sheltered from the elements, prepared work for the masons, who would return to the shop only with the coming of good weather. Yet nights were not spent in the lodges. In the cathedral cities, workers were housed in inns or in private homes. Due to the isolation of abbeys, wood dormitories were erected for workers engaged in monastic construction programs.

The lodge became, in addition to being a place for work and rest, a place in which problems of interest to all could be discussed. In a way it was a club, and this was the early beginning of masonic lodges in the modern sense. The discussions carried on there could become very heated. A text preserved in the Cartulary of Notre-Dame de Paris cites an incident that happened in

* From *The Cathedral Builders* by Jean Gimpel (New York: Grove Press, Inc., 1961). Reprinted with permission of the author and *Éditions du Seuil*, Paris.

that cathedral's lodge on Assumption Eve. It must have been rather serious since reference to it was made in 1283 concerning a battle for control between the chapter and the bishop of Paris. And the chapter must have used armed intervention to control the situation. Little by little, chapters came to control lodge life, the earliest known rule being that handed down by the chapter of York in 1352.

Masons and stonecutters were part of an essentially floating working force, with many factors contributing to their migration from workshop to workshop and from country to country. Younger masons aspired to new horizons, to learn new customs and different techniques. Awed by their times, they wanted to see the incredibly audacious edifices that were springing up nearly everywhere in the Christian world. In a year's time they could expect to be hired successively at Mont-Saint-Michel, Mans, Paris, Reims and Strasbourg. There were no borders and no passports in those days, and masons could cross the Rhine to the east to work at Cologne or over the Channel to the west to work at Canterbury. What pride and pleasure a laborer must have had in returning to his home town to describe the wonders he had seen! The villagers would recall that he had left home still almost a child to work in the nearby quarry. Inspired by faith, some masons accompanied the crusaders into Asia where they built the famous Krac of the knights and other strong forts to protect holy places. Still others went along with famous architects summoned to countries far across the sea, for example, the stonecutters who went with Étienne de Bonneuil when he sailed to Sweden to build the cathedral at Upsala. Bachelors were of course more attracted by the call to travel than married men. The latter were very careful not to go too far from their homes, in order to return at regular intervals.

Those who chose a wandering life did not all do so solely for the thrill of travel. Some quit one workshop to find another where the pay was higher. Often, too, workers took to the road to find new work not of their own free will but because the shop was closing, because the foreman, dissatisfied with their work, fired them without notice or pay, or because funds were exhausted and the shop closed while work was temporarily suspended.

On the other hand, conscription threw men onto the roads against their will and effected a major mobility among the builders, particularly in England where the king had the power to order county sheriffs to recruit twenty-five to forty men and send them to a castle workshop sometimes hundreds of miles away. French conscription did not cause such a migration of workers because no lord, not even the king, had the authority necessary to requisition laborers from such a great distance.

The life of these builders contrasted sharply with that of other laborers in the Middle Ages, who were for the most part sedentary workers living in the same place the year round. They traveled only exceptionally, and then not for business reasons. In the public interest and for the commercial prosperity of their cities, municipal councils in the thirteenth century became concerned about these stationary workers and succeeded in establishing, with the approval of the city's more important businessmen, charters to organize the trades and to form what would someday become associations. Until the cities intervened, there was rarely any organization by laborers other than into charitable groups which have survived today as mutual aid societies.

Turning to the situation in England, where fortunately numerous charters such as those at York and Coventry are preserved, one notices the absence of documents concerning masons and stonecutters. This is explained by their predominantly migratory character, which allowed them to escape municipal control. Moreover, these men worked for the Church or noblemen, who had no interest in organizing guilds on their projects. The Church lacked interest because organized workers could band together disputing methods of employment and wages. Lords opposed organization because eventually workers would oppose the convenient conscription system.

The first English city to make an exception was London, where in the late fourteenth century traces of a professional organization of stonecutters and masons appeared. But London was then a city of fifty thousand people, five to ten times more populous than York or Coventry. There were necessarily more builders there than in a less important city, and they were consequently in a better position to organize themselves and to defend their right to do so. The very size of London assured its builders of constant employment and made them less dependent on their two traditional patrons, the Church and the nobility. There was a law concerning 'masons, stonecutters, plasterers, and cementers' in Étienne Boileau's book for this same reason: Paris was a city of nearly two hundred thousand inhabitants, while Chartres and Amiens had only five or ten thousand. It was Boileau's forty-eighth entry that bore the royal seal, and the king appointed his own master mason, Guillaume de Saint-Patu, to mastership over the guild in Paris. This of course facilitated finding workers for royal works.

The Latin terms that designated workers who cut stone in the Middle Ages do not generally permit a distinction to be made between those who simply quarried the stone and those who cut the vault stones, window tracery and monumental portal sculpture. The sculptors were lost among the general mass of stonecutters. This is really rather extraordinary to us, because an

enormous difference seems to exist between those who perform a seemingly mechanical task, such as cutting blocks of stone, and those who sculpt, *with their very soul*, the magnificent statues in the cathedrals. The truth is that for the great majority of men in the Middle Ages there was between a good *work* and a *masterpiece* only a difference of degree, not a difference of kind. The idea that there is an unbridgeable gulf between a worker and an artist (in the modern sense of the word) did not really occur until the Renaissance, when it was expressed by intellectuals who judged, classified, and evaluated manual labor which was very foreign to them.

It was the Renaissance writers who, for the first time in history, extolled the personal merits of painters and sculptors, resulting in an excessive deification of both, the consequences of which are still felt. The Renaissance fabricated the notion of 'the artist.' The medieval thinker hardly ever expressed himself in his writings on actual questions of aesthetics, and when he did concern himself with what we call 'art,' it was in terms of theology or philosophy. Why? Did he more or less consciously hold manual labor in disdain and relegate both sculptor and mason to the same ill-favored category? Was he insensitive to the beauty of forms? Or was it because he intuitively perceived that a beautiful statue or a beautiful window were complete works in themselves, sufficient in themselves and thus requiring no comment? (In this connection it should be noted that the glorification of the 'artist' since the Renaissance, even though it would seem to be a promotion, has been nothing more than a placement of art under the guardianship of literature. Art henceforth was always to await its justification from literature.)

To avoid this problem of terminology, the word 'artist' is deliberately not used here, since it adds nothing to the greatness of the cathedral builders and because its current meaning is essentially foreign to the spirit of the Middle Ages. Only in the dictionary of the French Academy of 1762 was 'artist' mentioned in the sense that we now understand it.

In England, however, the terms that designated stonecutters permit a certain distinction to be made between laborers who did the heavy work and those who executed the more refined work. This distinction is based on the characteristics of the stone worked. For example, those who worked the particularly hard stone found in Kent were known as 'hard hewers.' They were distinguished from 'freestone masons' who worked the beautiful calcareous stone found in great abundance from Dorset to the Yorkshire coast and which was perfect for the delicate work of sculpture-carving. 'Freestone masons' were also distinguished from 'rough masons,' who simply rough-hewed the stone.

The expression 'freestone mason' was replaced after a while by the sim-
plified 'freemason,' a word which evidently had to do with the quality of
stone and not with any franchise which would have benefited builders. When
honorary freemasonry was introduced into France from England about 1725,
it was naturally translated as *franc-maçonnerie*, an expression unknown in the
Middle Ages. On the other hand, it is known that in London in 1351 a
maître maçon de franche peer was more or less the Anglo-French equivalent
of two Latin expressions: *sculptores lapidum liberorum* (London, 1212) and
magister lathomus liberarum petrarum (Oxford, 1391). The modern English
and French translations of this second term would be: *a master mason of
freestone* and *un maître tailleur de franche pierre*.

Application of the words *franc* or *franche* ('free') to stone in France has
survived uninterruptedly to the present. The beautiful building-stone found
in the region about Paris has long been spoken of as 'free liais,' a term which
is still applied to veins of excellent quality. When I visited the underground
quarries of Paris, an engineer in charge of supervising the subterranean part
of the capital showed me the inner side of a tunnel and told me, much to my
surprise, that to designate veins of stone of the very best quality one would
say 'free veins.'

Stone used for sculpture did not often have the same grain as that used for
building the walls to which the statues were attached. A rapid glance at the
Portail Royal at Chartres is sufficient to show that the stone of these famous
statue-columns was not taken from the quarry at Berchères. And at Vézelay
the capitals are not of the same stone used in building the rest of the church.

The frequent trips made by stonecutters from shop to shop gave them the
opportunity to examine stone from many quarries. It was made possible for
some of them to work with the stone best suited to their capabilities, and
others were able to have stone ordered from a specific quarry for a specific
difficult job. The sculptors had a true love for material of high quality.
Knowing the high cost of transportation at this time, one can only admire the
intelligent understanding of those who bore the additional expense of these
costly shipments of stone.

Studying the sculptor's position in medieval life and his role in the
complex problem of the iconography of the time makes it clear that his
position was constantly changing from the beginning of the eleventh century
until well into the fourteenth. Any concern with the problem of creativity
naturally raises the question of the sculptor's part in the choice and execution
of these masterpieces. Due to the lack of texts, one is frequently reduced to
more or less accurate hypotheses on the subject. But, so far as possible, we
must abstain from our modern way of thinking. The danger of using the

word 'artist' to describe or recall these creators of the past has already been pointed out.

One way of arriving at a better understanding of the creators of a given period is to relocate them in the framework of the history of oral, literary or visual techniques of expression according to their historical situation. In this case it is the visual. Paleolithic man expressed himself by shaping bone objects or by means of wall paintings such as those at Lascaux; the Greeks of the fifth century B.C. by painting of terra-cotta vases or marble sculpture such as that of the Parthenon; the Byzantines by ivory work or great mosaics such as those at the Hagia Sophia; the Italian Renaissance by bronze sculpture or easel-painting; the United States by movies or television. These techniques of expression provide a partial insight into the religious thought and ethics of the society. But techniques of expression are in a state of perpetual evolution, one in connection with the others, susceptible to transformations of thought and material changes in the communities where they appear. Some for a time reach a level which we consider a great means of expression, whereas others lose their privileged status to become secondary or forgotten means of expression.

Theologians expressed the medieval thought of the tenth and eleventh centuries in frescoes, gold work and miniatures, which were the primary means of expression at that time, but not in sculpture. In the course of the eleventh century when stonecutters, thanks to a better understanding of their material, began to carve little representational scenes, they doubtless did so freely and without ecclesiastical supervision. Their timid, gauche attempts received little attention, but their ceaseless efforts and progress finally attracted monastic attention by the end of the eleventh century to this new technique, in the Western Christian world. Monks made personal contracts with these sculptors and gave them themes to execute. Thus was born in southwest France and Burgundy the monumental sculpture that first appeared in the Cluniac priories of Moissac, Toulouse, Autun and Vézelay. Society was then bathed in a religious atmosphere: from his youth on the stonecutter was in daily contact, at home as well as in the Church, with the scenes that served as subjects for his creations. There was something of a universally common inspiration which explains how a given subject retained its identity almost perfectly in regions far distant from one another.

Monumental sculpture rapidly developed and became a major means of expression from the twelfth century on. From the middle of the century stained glass in its turn gained considerable importance at the expense of frescoes, as window areas increased and wall surfaces diminished. In the thirteenth century fresco-painting became a lost means of expression.

Within what limits did the sculptor's freedom evolve? In the first place, it must be made clear that in an 'ascendant' period there can be no creators who are misunderstood or in opposition to those who commission work. There can be only divergent opinions on details. It is certainly wrong to think that the Lascaux painters made their point of view prevail over that of the magicians who were the theologians of the time. The sculptors of the Parthenon were able to discuss form with the priests within certain limits, but no more. This submission of creator to the directives of magician or priest is natural to creation. It was a principle or a tradition so self-evident that only rarely have societies had occasion to state it in writing. A famous exception to this rule was that document compiled by the Church Fathers at the Second Council of Nicaea in 787. They were faced with the necessity of clarifying what, until the extraordinarily bitter iconoclastic controversy broke out, had long been clear to the Catholic Church. It was stated that 'the composition of religious images is not left to the inspiration of artists; it exemplifies those principles established by the Catholic Church and religious tradition. Art pertains only to paintings, its composition to the Fathers.'

It would be impossible to be more explicit. In removing the *Christ* from the choir of the famous church of Assy in Haute-Savoie, the Church was only complying with the principles established at the Council of Nicaea twelve centuries earlier. One might ask if the Nicene text should not be placed in capital letters at the entrance to exhibitions of sacred art, and if everyone desiring to work for the Church should not be required to memorize it.

Becoming a sculptor, the stonecutter rose to the world of the spirit. He was closer to the theologians and learned more through this contact; he had the wonderful opportunity to thumb through precious manuscripts in abbeys; he learned to look, observe, think. His intellectual horizon was expanding, which permitted him to participate spiritually as well as physically in his creations. Thanks to the manuscript miniatures leafed through and admired in various abbeys, the sculptor could humbly suggest slight variations in the subjects proposed by the Fathers. Since the sculptor and the theologian worked toward the same goal, the sculptor could consider himself free, for in this association he did not submit to any constraint. In this sense it could be said that the difference between the artist of today and the medieval sculptor is that the latter was not an individualist since he did not claim the rights of personal inspiration. However, a legitimate pride did overcome the spirit of these workers with humble backgrounds, and sculptors did not hesitate, especially in the twelfth century, to sign their works. Gislebert signed the famous tympanum of Autun: '*Gislebertus fecit hoc opus.*' Giraud

signed the portal of Saint-Ursin in Bourges; Umbert, a capital of the porch at Saint-Benoît-sur-Loire; Rettibitus, a capital of Notre-Dame du Port in Clermont.

Sculptors were not the only workers who signed their creations. The mason Durandus signed one of the vault keystones at Rouen Cathedral about 1233 with '*Durandus me fecit*.' And in the same cathedral, the glassmaker Clément de Chartres signed his window. This Latin term *me fecit* must be used carefully, remembering that it could concern the person who ordered or paid for the work as well as its actual creator. Yet it is obviously incorrect to insist on the absolute anonymity of the cathedral builders. Not all medieval sculpture is signed, but then neither is all that at Versailles, and no one has ever considered the sculptors of the seventeenth century anonymous.

The sculptor often worked on a block of stone already in place in the building. This was true, for example, with the capitals at Vézelay. The sculpture executed on the façade of Saint-Ferdinand des Termes in Paris's 17th Arrondissement in 1957 was worked like many twelfth-century pieces, right on the wall. The sculpture thus becomes an integral part of the building. Statue-columns of the twelfth century, such as those of the *Portail Royal* at Chartres, show this close collaboration between sculptor and architect, a magnificent harmony that unhappily lasted only a short time. The sculptor, perhaps having lost a little of his former humility, wanted to make his work independent, so he detached his sculpture from the column. From that time forth he worked his block of stone in the lodge, away from the church. He is seen working in this way in the thirteenth century in a stained-glass window that he, together with the other stonecutters, offered to Our Lady of Chartres.

Intoxicated by his freedom and his extraordinary success in the spiritual and physical order of things, he dreamed only of putting sculpture everywhere. He wanted literally to cover churches with his creations and he suffocated them. Compositions became confused. Some of the twelve hundred sculptures at Notre-Dame de Paris were misplaced on the building. At Reims it was necessary to number the cathedral's three thousand sculptures in much the same way that prefabricated parts are numbered today. At Tournai sculptors established themselves and produced works to order. In 1272 the abbot of Cambron bargained over prices with two sculptors to cut and ship cut-to-specification window mullions to Brussels.

Having broken with the architect, the sculptor next dissociated himself from the theologian. Did he already consider himself better than the mortals around him? Was this the dawn of the Renaissance? He constantly had to be brought back into line. The period of Christian expansion was over. In 1306

the sculptor Tideman executed a Christ for a London church which did not conform to the accepted conventions. The bishop actively intervened, had the Christ removed and ordered Tideman to return his fee.

Such freedom for the sculptor from all tradition, something that would have been impossible a century earlier, coincided with a general weakening of the Faith. The powerful and rich who previously had given their riches to the cathedral now devoted their fortunes to increasing their own comfort and satisfying their taste for life. They built private chapels and city houses. Activity in the great workshops ground to a halt as the better sculptors and builders were hired away and hired to build and ornament the mansions and chapels of the nobility. The situation was similar to that in Athens in the fifth and fourth centuries B.C.: the progressive era for Athens ended with the Peloponnesian Wars. Throughout the fifth century sculptors worked on such projects as the Parthenon, but Athens was ruined in the fourth century and rich individuals hired sculptors—Praxiteles, for example—to appease their egotistic appetite for beauty.

But the French sculptor of the fourteenth century for a long time could not profit from working for private individuals because the Hundred Years' War, beginning in 1337, disrupted both his life and tranquillity. It ended prosperity and travel for the sculptor. National revenue fell sharply. Misery and poverty were felt everywhere, and plagues, famine, and battle all but decimated the population. Rare indeed were the privileged who could still engage sculptors. Life was of and for the war, a situation in which sculpture was only a luxury. Workshops either closed or slowed down, most sculptors were impressed into military service and then forced to build military structures such as prisons and fortified castles. Needless to say, delicate skill was not a primary concern. Local stone was used since it was impossible to haul better stone from great distances during the war. With the impossibility of travel, new generations of workers forgot where the famous quarries which had provided stone for monumental sculpture were located. It is difficult to recognize in these sculptors—compelled as they were to carve stone cannonballs—the descendants of those who built Chartres and Mont-Saint-Michel.

When the Hundred Years' War ended in the mid-fifteenth century, and stonecutters once again began to sculpt, they could not return to the great tradition of the cathedral crusade regardless of their efforts. The world had changed, and in its turn stone sculpture had ceased to be a living means of expression.

FREDERICK ANTAL

Social Position of the Artists: Contemporary Views on Art*

IN THE FOURTEENTH CENTURY art was still regarded simply as one of the manual crafts. The profession of artist had not yet obtained any special nimbus, and it was not regarded as in any way extraordinary among the poorer classes if, usually for some practical reason, a son should become a painter. In fact, almost all the fourteenth-century Florentine artists came from craftsman, petty bourgeois or peasant circles. Thus, from the start, the artists stood on an incomparably lower social level than their patrons. Neither well-to-do upper-middle-class citizens nor nobles would have become artists, since the profession would still have been rather degrading for them.

As with all other professions, the artists were naturally compelled to join a guild. Painters, sculptors and architects were all organized in separate guilds; in the Middle Ages, the artists were united in guilds with those professions with whom they had some sort of craft connection. The painters, who had originally formed an independent organization resembling a guild, were joined at the beginning of the fourteenth century[1]—as were also the color-merchants—to the greater guild of the doctors and apothecaries (*Medici e Speciali*).[2] Not only were doctors members of this guild, but also, among others, the dealers who supplied various wares not only to the doctors and painters, but also to other professions; for example drugs, chemicals (to the doctors), wax (for the churches), dyes, pigments (to the painters, and also to the wool and silk industry), groceries, herbs, spices, etc. Besides

* Reprinted from *Florentine Painting and Its Social Background*, London, 1948, by permission of Kegan, Paul, Trench, Tribner & Co. Ltd., and Boston Book & Art Publishers, Boston, Mass.

these, the guild also contained members of numerous crafts connected with these articles.[3] It was thanks to this association with the doctors and apothecaries, and especially with the merchants who imported the valuable Oriental wares, that the painters found themselves organized in a greater guild [4] The goldsmiths belonged to the silk guild, while the sculptors and architects were members of the lesser guild of the bricklayers and carpenters. But the painters did not benefit very much from their registration with one of the greater guilds, because—and this is of fundamental significance—they were not fully privileged, active members of the guild like the doctors, apothecaries and retail traders, but were classed merely as *sottoposti dell'Arte*. Within the *Medici e Speciali* there was a special organization—the painters, to which the house-painters and the color-grinders belonged as well, all being designated merely as *sottoposti*. As was also the case with the saddlers, this group, in contrast to the artisans, who had no rights at all in the guild, obtained in the first decades of the fourteenth century a certain very limited administrative and judicial autonomy.

Supported by the general democratic movement of these years, the painters, whose economic and social standing was steadily improving, were able in 1339 or 1349[5] to achieve a further degree of emancipation. They joined themselves to the Compagnia (or Fraternità) di S. Luca, where they had their own leadership and could hold meetings independently of the main guild. Freedom of assembly was the most coveted and fiercely contested prize in the struggles of the various professional groups. But the Compagnia di S. Luca, like all other companies, was not an economic organization. As to the professional duties of the painters, these were included in the Statutes of the *Medici e Speciali* guild (1316–49). On the other hand the Compagnia was, significantly enough, an ethico-religious corporation of a comradely character. It was under the protection of St. Luke (the painter of the Virgin). Its meetings took place in a church, S. Maria Nuova; it celebrated the feast days, especially that of its patron; it took part in processions; daily prayers were enjoined upon its members, they were compelled to confess and to communicate on joining, and at least once a year afterward. The founders and most of the members were painters, though there were also a few wax-modelers, glass-workers, etc., and women, too, were admitted, in principle, presumably if they worked as painters. We can therefore define the Compagnia di S. Luca as simply one of the numerous religious fraternities of laymen, springing up especially after the plague year of 1348, which gave the middle and petty bourgeoisie an opportunity for 'public' activities under the official control of the Church. The Church was very skillful—we saw this reflected in art itself—in keeping the democratic movements of these strata in her own hands,

and even using them for her own ends. Nevertheless, the fact that this fraternity could be formed[6] shows that the painters had a certain democratic consciousness and as a group were inclined to be more independent than the sculptors or architects belonging to lesser, craft guilds. This is also evident from the demands advanced by the painters within the guild soon after the *ciompi* revolt: late in 1378 they attempted to enforce full equality of status for themselves with the three ruling groups (doctors, apothecaries, retail traders) and to have their name (*dipintori*) added to the title of the guild. In the actual year of the revolt the name of a painter figures for the first time among the list of the consuls of the guild. But this only occurs up to 1382, and furthermore the aforesaid decision was, in practice, successfully sabotaged by the guild authorities.[7] All the same, the struggle must have had a certain intensity, for the painter Starnina, who was implicated in the *ciompi* revolt, had to escape to Spain when the oligarchic reaction began about 1390.[8]

The painters, when executing frescoes, had to travel from place to place, and thus became better known; those painting panels, especially for use as domestic devotional pictures, came into even closer contact with their patrons.[9] Hence it was that the painters were economically the strongest, and socially the most mobile group among the artists, and were thus generally able to emancipate themselves earlier than the representatives of the other arts.[10] They stood out sooner[11] as individual personalities and figured—this was especially true of Giotto,[12] but also applies, for instance, to Buffalmacco, the well-known witty painter[13]—as the heroes of artists' tales and anecdotes (*e.g.*, Boccaccio, Sacchetti). They gradually assumed a bourgeois class-consciousness;[14] this again applies to no one more than to Giotto, who was already spoken of with appreciation by Giovanni Villani—the first mention of an individual artist in any Florentine chronicle.

The Florentine architects and sculptors as a rule continued to work collectively as members of a masons' lodge[15] up to about 1400. Thus in the municipal builders' corporation engaged on the Loggia dei Lanzi—the same which worked on the Cathedral—real collective work continued right down to the end of the fourteenth century; for example, on the reliefs of the Virtues of the Loggia three or four artists were engaged simultaneously or successively in many cases.[16]

The painters' guild, like all others, naturally had its craft rules.[17] The training of the painter followed the customary course of medieval craft customs. He was apprenticed to a recognized master of the guild, who had full disciplinary power over him.[18] The apprentice had to learn his *métier* from the bottom upwards. He had to begin with grinding the colors and with

the preliminary treatment of the surface; he had to acquire all the necessary technical knowledge, learn all the tricks of the trade and go through a period of many years as an apprentice and journeyman, before he was able to paint in the same way as his master.[19] This must be understood in a literal sense, for the copying of acknowledged masterpieces, especially those by the master himself, was a principal part of the last stage of an apprentice's training.[20] It is only in the light of this training that we can understand the tenacious preservation of the traditional heritage in fourteenth-century painting. The guild also prescribed which materials and colors could be used and which were prohibited (*e.g.*, the use of German blue instead of real ultramarine was forbidden). But on the whole the discipline of the guild in Florence was far milder than that, for instance, in the economically and socially far more backward German towns, and this discipline was relaxed more and more as time went on. Thus, although the conditions of entry into the guild would make financial concessions to relatives of existing members wishing to enter the workshop, and would favor members of this particular guild as against members of other guilds, and also Florentines as against foreigners, yet they had no really rigid regulations or very definite prohibitions in this respect, as was so often the case in the Northern countries. Although in Florence too father and son, or several brothers, would often run a workshop together, yet the Florentine artist-workshops rarely became—as did those in the North—the privileged preserves of a few guild-protected families, into which it was necessary to marry in order to follow the profession. Side by side with the very substantial advantages of family connections with one of the existing workshops, it is certain that individual talent also counted for a great deal in Florence. In fact, numerous painters who had come from other towns were at work there in the fourteenth century.

The artists—including of course the painters—had to satisfy every possible requirement of their clients. For there was, as we have seen, no dividing line between the arts and the crafts in the fourteenth century.[21] Thus the painters did not merely paint frescoes and altarpieces, and complete the works left unfinished by their predecessors, but they also produced church banners, military banners, heraldic shields (even Giotto is alleged to have done this), made designs for embroideries, painted curtains, applied emblems to horse-cloths,[22] and sold painters' goods, inlays, etc.[23] The sculptors in their turn made wax effigies, belt-clasps, goldsmiths' settings and similar objects. The goldsmiths' trade—which was especially flourishing in Florence—with its typical craft organization, was a lucrative source for many painters and sculptors. The versatility of the artists, which continued beyond this period, arose originally as a result of the many-sided activity of the medieval

workshop; it was a usual practice for a single man to be painter, sculptor, and even architect, and to be conversant with numerous technical processes.

The painter with his apprentices and journeymen formed the workshop organization. According to the social status of the clientele, and the type of work commissioned in the workshops, either collective work or the individual achievements of the master predominated; collective work was much the more frequent,[24] and the more individual type of work was much less common, but up to a certain point it did not really stand in very sharp contrast to the former. It frequently happened that the collective work would be done by a number of painters forming an association, or, as also often happened, by an *ad hoc* grouping of two or three artists to execute a particular order. The more eminent the social position of the patron and the more the kind of work commissioned necessitated personal contact between patron and artist, the more highly would the personal achievement of the artist be valued, and his own social standing, and his professional consciousness increase.[25] In monastic workshops the individual personalities of the various miniaturists were still entirely submerged. On the other hand, it may occasionally have been stipulated in the case of frescoes, altarpieces and domestic altarpiece commissions that the principal parts of the work should be executed by the master himself. This seems sometimes to have been the practice when it was a question of such famous artists as Giotto, who left to his pupils only the execution of subordinate tasks in his Paduan frescoes. Yet in his old age he worked almost entirely as an artistic entrepreneur,[26] and, in the Lower Church at Assisi he left everything to his pupils.[27] This was more or less the case also with Gerini and Agnolo Gaddi at the end of the century.

In all external matters the artists were very precisely bound by their contracts, the amount and terms of payment and the terms of delivery being, of course, most strictly defined.[28] In settling the price, the measurements of the picture and the size and number of the figures portrayed were generally the deciding factors, while the expenses to be borne by the artist himself also played a large part—a natural outcome of the whole artisan-like process of work. As a general rule the artist had to pay the wages of his journeymen, while arrangements varied with regard to the cost of materials, especially in the case of the most expensive pigments (*e.g.*, ultramarine and gold), which were considered essential for the picture (also by Cennini). Usually, these contracts tended to deprive the artists of all rights; they had to accept the conditions laid down by the patron, the latter alone being left with any rights or means of redress.[29] It was the same openly one-sided and dependent relationship as that of the ordinary worker, craftsman or any subordinate in

every other branch of production.[30] The painters really derived no help in this matter from their rights of assembly in their semi-ecclesiastical Compagnia, which left out of consideration the economic aspects of their profession. Nor were the consuls of the guild of the *Medici e Speciali* of much use, for owing to their inferior position painters could never obtain election to these offices, and moreover the arbitration courts could apparently do little for them owing to the severe nature of their contracts.[31]

Like those of all other professions, the painters naturally wished to make good money. Cennini—in a typical middle-class fashion—openly admits this.[32] Nevertheless very few of them could ever manage to acquire a house or landed property; the great majority lived with their families in a state of permanent financial stringency. The fees paid to the artists were in general low; often, especially in the case of monastic commissions, the payment was even made in kind. Moreover, the artists, with the exception of the most celebrated, remained unemployed for too long periods to make it possible for them to become in any degree affluent. Giotto—we mention him in particular simply because of his quite exceptional position—was one of the few able to do well for himself, as he worked with many assistants and was a unique celebrity. For example, in payment for the mosaic of the Navicella in the porch of St. Peter's, he received the enormous sum of 2,200 florins, for the altarpiece of St. Peter 800 florins and for certain frescoes in the choir 500 florins; King Robert of Naples paid him an annuity of ten ounces of gold. Moreover, from 1334 onward he earned extra fees as city architect, and he was able to amass a good deal of wealth by lending out money and looms.[33] He also possessed considerable landed property. Thus Giotto actually lived like a wealthy citizen, and by no means as a simple craftsman.

All the major works of the artists would be executed in pursuance of a definite order, and all their principal pictures would be painted for a definite place, and with a carefully specified subject. Small unimportant domestic altarpieces, repetitions of well-known and favorite examples, were, however, increasingly produced by the Florentine workshops for stock in the fourteenth century, and in the same way small routine pictures were produced (for example in the workshop of Jacopo del Casentino) for mass export, for sale at foreign fairs (especially in Champagne), for Avignon and for the remoter parts of Italy itself; later valuable cassoni were also occasionally produced for the same purpose.[34] But in general it is true to say that pictures of quality created by an artist merely following his own inclination and intended for future sale were never produced at all at this time.

The freedom of the artist, which, of course, did not exist in the modern

sense, was confined within the framework of his rigidly prescribed com-
mission. In general it was the rule that the painter was regarded as a crafts-
man and therefore should have no more freedom with his work than the
latter would. Whatever artistic liberty there was, was certainly most pro-
nounced during the dominant phases of the progressive upper bourgeoisie,
when certain of the artists were able to regard themselves too as members of
the middle class. This was the case in Giotto's lifetime, after the final victory
of the upper middle class. Giotto's artistic freedom, though perhaps not
evident in his choice of subjects, is felt to some extent in their arrangement,
and very forcibly in their treatment. In monastic commissions, on the other
hand, the artists had very little liberty, and this was especially the case, for
reasons already examined, with the Dominicans; thus Andrea da Firenze
certainly had to adhere strictly to the complicated scheme worked out for
his frescoes in the Spanish chapel. In general, the patrons stated in the
contract their demands as to certain thematic motives and often issued fresh
instructions, to the artist when the work was already in progress. Neverthe-
less, in cases where they had to deal with less-educated clients, such as priors
of provincial monasteries, the artists tried to retain the widest freedom
possible over details, and often played pranks on these patrons—as is
related in many artists' anecdotes. It would probably only have been after
the end of the fourteenth century, since the democratic movements, that the
role of the artist in the elaboration of the subjects came to have wider latitude;
it is noteworthy that the artists just then attained some equality of status in
their guild. Differences of opinion between artist and patron as to the style
of a painting were probably rare. The patron would almost invariably have
selected artists whom he could expect to work to his satisfaction.[35]

NOTES

[1] R. Ciasca (*L'Arte dei Medici e Speciali*, Florence, 1927) claims that this
fusion took place after 1295. According to R. Graves Mather ('Nuove
Informazioni relative alle Matricole di Giotto, etc., nell'Arte dei Medici e
Speciali,' *L'Arte*, Vol. XXXIX [1936] the first artists—including Giotto,
T. Gaddi, and Daddi—were not accepted into the guild until 1327.
Giotto's entry was previously thought to have taken place about 1312.
[2] This guild was established some time after the middle of the thirteenth
century, as one of the last of the greater guilds.
[3] See Ciasca (*op. cit.*) for a description of the enormous variety of profes-
sions within the guild, though they all had some common economic bond.
In Bologna the painters were organized in a guild together with the
papermakers. In Perugia they formed a guild of their own, but a lesser one.

[4] The doctors' and apothecaries' guild was given supervision over the church of S. Barnabà, and consequently the painters were given the task of decorating it; this church was erected in honor of the apostle Barnabas because it was on his feast day in 1289 that the Florentine Guelphs had won a victory over the Ghibellines of Arezzo.

[5] It is not certain which is the correct date. L. Manzoni (*Statuti e Matricoli delle Arti dei Pittori delle città di Firenze, Perugia, Siena*, Rome, 1903) believes the earlier date to be the more likely, Ciasca (*op. cit.*) the later one.

[6] Similar corporations of painters were also established in Rome and Siena.

[7] C. Fiorilli, 'I dipin tori a Firenze nell'Arte dei medici, speciali e merciai' (*Archivio Storico Italiano*, Vol. LXXVIII [1920]).

[8] In 1393, after the *coup d'état* carried out by the oligarchic upper middle class against the lesser guilds, the goldsmith Giovanni di Piero was beheaded for having participated in a revolt on the side of the latter and having shouted, 'Viva il popolo e gli Arti.'

[9] How far panel-painting contributed to the social rise of the painter is shown by a passage of Cennini, where he says, 'And let me tell you that doing a panel is really a gentleman's (*gientile huomo*) job, for you may do anything you want to with velvet on your back.'

[10] But much later than the poets and writers, who came from a higher social stratum. It was actually Dante in the *Divina Commedia* who—apart from official documents—was the first to mention painters: Cimabue and Giotto. It is true that artists such as Arnolfo and Giotto received honorable mention in municipal documents, but mainly because of their position as city architects and because, in this capacity, they had helped to beautify Florence. Nevertheless even this honor was possible only at the climax of upper-middle-class self-assurance.

[11] This earlier emancipation of the painters was observed equally in every country, but owing to the earlier development of the Italian towns it took place sooner in Italy than elsewhere.

[12] Giotto's sharp mother-wit, however, contributed a good deal toward his popularity.

[13] It has not yet been possible to establish his artistic identity. Perhaps he is none other than the Master of St. Cecilia.

[14] In one of Sacchetti's tales Giotto amuses himself at the expense of a craftsman who came into his workshop to order a coat-of-arms to be painted on his shield, 'as if he were a Bardi.' Thus a few artists and writers who already felt themselves to be part of the upper middle class claimed the right to jeer at those craftsmen who evinced a similar desire to rise in the social scale.

[15] In many towns these bodies formed the organizations of the artists before they joined the guilds. In the fourteenth century, these corporations in general still paid no regard to special individual talent among the sculptors; they all had to execute the same impersonal, routine stone-masons' work. See G. Swarzenski's review of A. Venturi's *Trecento Sculpture* (*Kunstgesch. Anzeigen*, 1906) and K. Rathe, *Der figurale Schmuck der alten Domfassade von Florenz* (Vienna, 1910). Thus there

was far less opportunity here for the formation of individual personalities among the sculptors, than was the case in the painters' workshops. On the other hand, the individuality of the principal architects made itself felt much more in the secular corporations of builders in Florence than in the monastic ones of the north. See Paatz, *op. cit.*

[16] There is documentary evidence of the collaboration of two painters (Agnolo Gaddi designed it, Lorenzo di Bicci painted it over) and of three sculptors in the work of the *Caritas* relief.

[17] But apparently numerous conditions were settled in the individual contracts themselves as a result of free agreement between master and apprentice.

[18] A number of contracts for the employment of painter apprentices are published in Davidsohn, *op. cit.*, and V. Ottokar, 'Pittori e contratti d'apprendimento presso pittori a Firenze alla fine del dugento' (*Rivista d'Arte*, Vol. XIX [1937]). There was generally an apprenticeship of four years during which the master usually had no financial obligations.

[19] An indication of the very close relationship that often existed between master and pupil is seen in the case of Taddeo Gaddi, who was Giotto's godson, and apparently was engaged in his workshop for twenty-four years.

[20] On the whole question of the training of painters see Cennini's treatise. He specifically emphasizes the close dependence of the pupil on the master. Cennini had in mind the organization of Agnolo Gaddi's shop, where he worked for thirteen years.

[21] The frame was regarded as just as valuable as the painting itself. For example, Don Michele da Pisa, Abbot of the Olivetan monastery of S. Maria Nuova near Rome, paid 50 florins in 1385 for the frame of an altarpiece, 100 florins for the gilding, and 100 florins for the execution—only this latter sum going to the painter of the panel, Spinello Aretino. When an altarpiece was to be put up in the church of S. Felicità, the frame was first commissioned in 1395 from the wood-carvers for 80 florins, and the painting itself—which of course had to be made to fit the frame—was ordered only four years later from Spinello Aretino, Niccolo di Pietro Gerini and Lorenzo di Niccolo for 100 florins.

[22] In the 1350's, the statutes of the guild indicate the beginnings of a certain differentiation between the painters proper and those who concentrate on purely decorative work.

[23] Our information about these various occupations of the painter comes principally from Cennini, who, among others, also undertook women's make-up.

[24] This was so often the case that it is impossible to base a history of fourteenth-century Florentine painting on individual artists' personalities, as is still usually done in the literature of art history. But naturally the various workshops had each its own particular, if not always entirely unified, artistic character from which we can draw certain conclusions as to the master himself.

[25] Tradition has it—it is mentioned by Ghiberti; —that in the huge

Tabernacle of the Virgin in Orsanmichele, the figure of one of the apostles in the relief of the Death of the Virgin is a self-portrait of Orcagna. In fact this particular head is given an individual twist unlike the typical expressions of the others. This is probably the earliest artist's self-portrait in Florentine art, and was a sign of the increasing professional consciousness of the artists.

[26] Davidsohn, *op. cit.*

[27] Weigelt, *op. cit.*

[28] Nevertheless there was often a great deal of friction over the payments (cf. Piattoli, *op. cit.*).

[29] In 1341 Ridolfo de' Bardi obtained a distraint on the painter Maso, as a result of demands which probably arose out of the painting of the frescoes of the legend of St. Sylvester in S. Croce. Not only were all the paintings in Maso's workshop confiscated, but even his colors and his painting instruments were removed. (G. Poggi, 'Nuovi documenti su Maso di Bianco,' *Rivista d'Arte*, Vol. VII [1910)]. In 1361 the Seta, with the permission of the city, authorized the sale of all the belongings, both movable and fixed, of Bencio di Cione, the head of the masons' lodge of Orsanmichele, because they thought that he was too careless. The money obtained from the sale was used toward the building of Orsanmichele. (See La Sorsa, *La Compagnia d'Orsanmichele*, Trani, 1902.)

[30] A. Doren, 'Das Aktenbuch für Ghiberti's Matthäus-Statue an Or S. Michele zu Florenz' (*Italienische Forschungen*, published by the *Deutsches Kunsthist. Institut in Florenz*, 1906).

[31] Piattoli (*op. cit.*) gives a few examples.

[32] Very characteristically he combines this solid-middle-class attitude with a homily on the subject of fame; steady work brings fame, fame brings higher payment.

[33] Agnolo Gaddi, who like Giotto conducted a big workshop, also occupied himself, according to Vasari, with mercantile activities, and is alleged to have left 50,000 florins.

[34] Documentary evidence of the export of pictures from Florence is given in the business files of the merchant Datini (1335–1410), which have been published. See also Piattoli, *op. cit.*

[35] This is shown by an entry in the records of the authorities of S. Giovanni Fuorcivitas in Pistoia (*c.* 1347–50) regarding their search for a suitable painter to execute the high altarpiece of their church. The first name on the list—typical of a provincial town—was that of Taddeo Gaddi, who had already received wide recognition, and really belonged to an older generation. The second choice fell on the two brothers Andrea Orcagna and Nardo di Cione, who were just beginning to make their name at this time. It was Gaddi who actually obtained the commission (C. Fabriczy, 'Ein interessantes Dokument zur Künstlergeschichte des Trecento,' *Repert. für Kunstwiss.*, Vol. XXIII [1900]).

NEIL HARRIS

The Pattern of Artistic Community*

IN THE TWO decades before the Civil War, as professional self-consciousness and energetic leadership realized many of the hopes of an earlier generation, the artistic community grew clearly articulate. Generous patrons made this era the brightest and most hopeful moment in the history of American art, and the nation's artistic capital became centralized in New York. But with new privileges came new problems: material success brought unexpected perils and factionalism followed prestigious advancements.

The explosion of interest created journals like *The Crayon*, the *Cosmopolitan Art Journal* and the bulletins of various art unions; general periodicals gave increasing space to the activities of American artists, also. *The Christian Examiner*, *The Atlantic Monthly* and *The North American Review* featured a stream of commentary.[1] Under the supervision of a painter, Thomas Addison Richards, *The Knickerbocker* became an illustrated journal for the first time, and *The Independent* broadcast the comments of a well-known critic, Brownlee Brown. The *Home Journal*, edited by Nathaniel Parker Willis, and *Putnam's Monthly* further directed the public's attention to native creators.

The development of an art market and a dramatic rise in sales held even more interest for professionals. In 1850 the United States imported less than forty thousand dollars' worth of art from Europe; twenty years later the figures had passed the half-million mark, and America had begun to re-export art from its Eastern ports to England, France, Canada and the British West Indies.[2] Art auctions also jumped, more than quadrupling in three

* Reprinted by permission of the author and publisher from *The Artist in American Society* (New York: George Braziller, Inc., 1966), pp. 254–267. Copyright © 1966 by Neil Harris.

decades.[3] The collecting fever that had begun in the 1840's formed the basis
for further auctions in the 1870's and 1880's. Firms sprang up to handle art
sales, the most prominent of which was Henry H. Leeds of New York.[4]
Leeds sold a number of famous collections, including the holdings of Charles
M. Leupp of New York. The ten thousand dollars this sale achieved indi-
cated the high value attached to the work of native painters. Particularly in
the late 1850's, Henry Leeds confided, prices rose steadily; it took four
evenings for him to complete his domestic art sales and even European
buyers competed for the treasures.[5]

Artist journals sought to persuade businessmen that paintings and statuary
were 'the most profitable personal securities a merchant can hold,' reliable
physical assets in this world and valuable spiritual holdings in 'the books of
the world to come.'[6] Auctioneers were so effective that *The Crayon* urged
artists to rely on them for sales instead of their own studios. Thomas
Rossiter auctioned off his canvases in 1859 for almost six thousand dollars,
and three years later Jasper F. Cropsey, a Hudson River landscapist, made
even more money.[7] Many artists used the money made at auctions to finance
trips to Europe.

New art associations and academies also testified eloquently to this growth
of interest. In 1856 collectors and painters helped form the Washington Art
Association, one year after the artists of Maryland had organized their own
society.[8] The Artistic and Literary Society of St. Louis first met in 1856,
while almost seven thousand people paid twenty-five cents apiece to see a
great exhibition in New Haven two years later.[9] Similar activities took place
in Brooklyn, Albany, Pittsburgh and Charleston.

Educational opportunities for professionals and laymen also expanded.
In 1851, New York's Stuyvesant Institute ran a six-part lecture series,
featuring Henry James, Sr., on 'The Universality of Art,' and George
William Curtis on 'Contemporary Art.'[10] The School of Design for Women
sponsored talks by ministers on the value of art.[11] Schools and institutes of
design were founded all over the East in the 1850's as states and munici-
palities began to require drawing classes in the public schools. The Penn-
sylvania Institute of Design held its first annual exhibition in 1857, seven
years after the establishment of the city's School of Design for Women.[12]
Industrialists grew increasingly interested in the commercial value of
trained artists, spurred on by the South Kensington Museum and its schools
in London.[13] Even the nude could now be studied without too much pro-
test; the Graham Art School of the Brooklyn Institute, organized in 1858,
had this as one of its major functions.[14]

Artists themselves began to demonstrate a new sense of mutual

responsibility, and a more successful emphasis on professional dignity. The Artists' Fund Societies multiplied and changed characteristically. The 1835 charter of the Philadelphia Society extended relief to its membership in times of sickness or adversity. But the Artists' Fund Society of New York, founded twenty years later, felt a broadened sense of obligation; two treasuries were set up, one for Society members and the other for any artists whose families might be in difficulties.[15] New York's leading painters contributed their works for the benefit of the profession as a whole, members or nonmembers.

A series of court cases further aided artistic independence. One involved Thomas Sully and the Society of the Sons of St. George.[16] The points at issue concerned the artist's right to exhibit a commissioned picture before delivering it to his client, and his power to sell or exhibit copies afterward. A board of adjudication maintained the artist's absolute right to reproduce his pictures or make use of any preliminary studies. A picture was not like any other chattel, the property of the purchaser when ordered and partly paid for. The idea belonged to the creative mind which had originated it and could never be wholly transferred.

Professional artists benefited further from an 1862 case in which the purchaser of a store argued that a valuable oil painting was a business 'sign' and hence a fixture. The court denied his claim; an artistic achievement could not be considered a commercial fixture.[17] Architects also began to protect their status, turning to the courts for aid. Richard Morris Hunt's 1856 suit for a commission fee established the principle that architects, as professionals, were entitled to proper remuneration for their work.[18] *The Crayon* reported gleefully that legal action forced a picture manufacturer who copied a W. J. Hays painting without leave to pay costs and damages. Artists were reminded that they could copyright paintings by depositing photographs in the clerk's office of any United States district court.[19]

Even politics became an artistic concern. When the Pennsylvania Academy of Fine Arts was threatened with a state tax law from which it had been exempted for fifty years, its artists turned to New York for legal advice.[20] In March, 1858, the first national Artists' Convention met in Washington, forming itself into a permanent association with annual meetings.[21] Some artists disparaged the new institution as a waste of energy, but Congress was quickly bombarded by petitions for duties on foreign art and for increased public commissions.[22] Major art organizations quickly appointed delegates to the Convention and in 1859 President Buchanan commissioned three professional artists to superintend the decoration of the Capitol.[23]

Artists no longer brooked professional injuries. When Edward L. Carey of Philadelphia asked Thomas Cole to take back a landscape he disliked,

Cole refused. Portraits were returnable, he explained, but not works of the imagination. 'When you gave me the commission you were acquainted with my pictures,' he wrote Carey, who had left the subject to the artist. 'I fulfilled my commission conscientiously and considered myself to be entitled to the remuneration. I cannot take the picture back and give another in place of it, for that would be establishing a serious precedent.'[24] Cole offered to paint another picture for a nominal price, but the artist's dignity and creative freedom were too important to be bartered away. A Philadelphia merchant complained that artists were 'an irritable race' who 'think their dignity is wounded' when they were not given control of association funds; but it was just this irritability and quickness to take offense which was responsible for their self-government.[25]

Artists, therefore, received much better treatment from their clients. Asher B. Durand's correspondence files reveal the extraordinary respect he inspired in his admirers. Letters requesting paintings were couched in the humblest terms. A rural attorney wrote that he had begged a friend 'to intercede with you on my behalf in regard to a small picture.'[26] He promised to prize any painting Durand offered as more than mere 'furniture.' Another suppliant insisted that he and his wife considered their Durand painting 'the central point of all our possessions.'[27] Writers addressed him as the greatest landscapist in the country, and pledged to begin collecting only if he would start them off.[28] Transplanted Easterners wished to revive 'the glorious scenery' of their childhood, while others predicted that a Durand painting would be 'the only well-executed picture of any size in our new city of some 40,000 people.'[29] Newly formed art associations scraped funds together to make their first purchase, and patrons from Baltimore, Philadelphia, Boston and St. Louis wrote in after seeing one of his canvases.[30] Young artists sought instruction and older ones paid compliments. Some merely wanted to add his autograph to their collections.[31]

Along with increased respect came a higher social status. Henry James, Sr., contrasted pure and applied artists in an 1851 lecture; men paid tailors and masons to work for them, though they did not seek their society. 'But it is the reverse with the Artist. He has been from the beginning always a very suspicious individual in the moral regard. . . . Yet, whether he be naughty or virtuous, we seek him and honor him . . . for what he represents, and never dream that money can pay for his pictures.'[32] In 1865 William Cullen Bryant recalled the time when men 'would almost as soon have thought of asking a hod-carrier to their entertainments as a painter.' Things had changed so much ('artists' studios are frequented by distinguished men and elegant women') that Bryant warned young artists not to be spoiled by attention.[33]

Even a crusty Philadelphian like Sidney George Fisher found time to accept a party invitation by Thomas Sully, though he was not entirely happy about it.[34]

Successful artists were not only men of distinction but occasionally men of wealth as well. Those on top raised their prices with the season. Frederic Church increased his fees from one winter to another until he demanded $1,200 for a four- by six-foot painting.[35] Thomas Sully produced more than 2,500 pictures in his long career, for which he received a quarter of a million dollars; he averaged more than $3,500 a year.[36] Henry Inman was getting $500 for half-length portraits, and $1,000 for full-lengths.[37] Durand, Kensett, Cole, Hicks and Huntington also reached this level, though artists rarely attempted to compose such large works without specific commissions.[38] Even lesser-known artists were able to charge $300 or more for medium-sized studies. In 1860 European paintings still took the highest prices, but native artists could attain comfortable incomes.

Despite these status improvements, some families continued to grumble at discovering in their midst a youngster with artistic ambitions. George Inness was put into a grocery store by his merchant father, who finally allowed him to study drawing after a series of commercial disasters indicated that the boy would never be a businessman.[39] W. R. Barbee, a Virginia-born sculptor, was punished by his parents for slipping off to carve blocks of soapstone; following the pattern of other Southern artists, Barbee studied law to get enough money for a European trip.[40] And William J. Stillman, landscapist and editor of *The Crayon*, sadly recalled his father's insistence that he attend Union College. This deferred his artistic training during 'precisely those years when facility of hand is most completely acquired and enthusiasm against difficulties is strongest.'[41] Other parents tried to divert artistic talent into more remunerative channels. Attempting to 'strike a bargain with imperious nature' the fathers of Elihu Vedder and Albert K. Bellows placed their boys under architects.[42]

Such discouragement was not universal. Bellows' biography was used by one writer in urging parents to gratify a child's natural bent. Everywhere, he wrote in 1859, we see fine artists who are poor lawyers, and poor artists who could be good lawyers, men *'misplaced . . .* in all professions and occupations, chiefly owing to the fact that the tastes and wishes of the child are not consulted in the determination of the life-calling.'[43] Parents grew more permissive about art training and occasionally actually nourished it. Mayor Flagg of New Haven encouraged the artistic ambitions of his three sons. The fact that the Flagg family was related to Washington Allston helped quite a lot. Frederic E. Church, also Connecticut-born, was taught drawing

and coloring as a youth with his father's good wishes; a friend intervened to make sure he was instructed by Thomas Cole.[44] David E. Cronin remembered his mother's arguments for art, promising fame and love 'long after I had crumbled into dust—the most seductive prospect that my imagination could then hold—to be numbered among those individuals ... who live after they are dead.'[45]

The growth of interest in art was recognized by entrepreneurs, native and foreign. By the 1850's Bostonians had the opportunity to buy paintings and prints from more than half a dozen establishments.[46] Dealers, who had by now grown apart from art suppliers, continued to sell picture frames and looking-glasses, but courted retail art sales by increasing their exhibition space. Some, like Williams and Everett, handled painters on a regular basis, guaranteeing an income in return for exclusive market rights.[47] To emphasize its art commitments further, this firm ran the only free gallery in the city, and sent agents to examine the output of studios in Europe and America. As a commercial institution it influenced Boston's art development sharply; artists no longer needed to rely on the Athenaeum for publicity. But picture dealers were soon drawing the ire of American artists who condemned them for making European art fashionable and degrading the lot of native painters.[48]

Like Boston, Philadelphia had a number of retail art dealers by 1860, though none with a gallery of any size.[49] James Earle and Alexander Robinson were able to lend lavishly to the Pennsylvania Academy exhibitions. Art-lovers could stroll through the Free Gallery of the Art Union of Philadelphia, organized in 1844 and dissolved a decade later. Until this gallery was established, wrote George W. Dewey in 1851, 'there were no galleries or stores, in the city of Philadelphia, for the exclusive purposes of the exhibition and sale of American works of art.'[50] Carvers, gilders and looking-glass salesmen dominated the shops (which usually lacked good light) where artists deposited pictures for sale. The Free Gallery, however, stimulated the looking-glass stores to further exertions, and four of them improved their exhibition arrangements.

Both Philadelphia and Boston paled into insignificance as art markets when compared with New York City; here the strongest exertions were made to stimulate sales.[51] Of the half million dollars' worth of art imported from Europe in 1858, New York's share was almost four hundred thousand dollars. Philadelphians and Bostonians may well have bought some of the art New York imported, but they probably bought it in or through that city.

New York did more than offer numerous exhibitions and opportunities for sales. It established innovations which spread rapidly to other cities, and

knit the artist community closer together. One of these novelties was the Artists' Reception, a combination exhibition, concert and *soirée* which united social and artistic ambitions. In 1858 *The Crayon* announced quietly a series of 'Art Conversazioni' after the European model.[52] The first such reception at Dodsworth's Building on Broadway, the home of several studios, was so successful that three more followed. New York's most famous artists produced pieces, and the guests included judges, city officials and clergymen. 'We do not know how Art can be better amalgamated with our social system,' *The Crayon* exclaimed, terming the receptions 'the most serviceable institutional effort' in behalf of art for the last ten years.[53] In 1859 receptions continued at Dodsworth's and spread to the Studio Building on Tenth Street.

Bostonians held the first of their receptions in January, 1859; soon hundreds of people were attending, with music supplied by the Mendelssohn Club. Even the staid National Academy discontinued its annual exhibition supper that same year and held a reception in its place, introducing full evening dress.[54] Worthington Whittredge recollected that the Academy's receptions were so popular during the Civil War that it was difficult to get a ticket, so many 'fine people' wished to attend. 'They were the great occasions for the artists to show their works and meet nearly all the lovers of art in the City.'[55] Less than ten years after Thomas Cummings tried to discourage an exhibitor from dressing his ushers in white cravats and kid gloves, guests at art exhibitions appeared in white tie.[56]

Not everyone was happy. Ever alert to Bohemian affectations the *Cosmopolitan Art Journal* warned young artists to beware of 'Reception reputations' and charged that artists gave receptions 'purposely to hear themselves praised by pretty women and long-bearded men.' True artists, it concluded, 'are not in want of such nurseries of conceit.'[57] Nonetheless, the receptions expanded immeasurably artists' social contacts, and gave moral support to their cause. The excitement of formal dress and concert music reinforced the glamour of the studio. Even ordinary exhibitions grew more dramatic; Frederic Church, with his flair for the theatrical, placed his 'Heart of the Andes' in a spectacularly lit setting, daringly showing it at night.

The excitement of New York's art life did not spread to every major city; Philadelphia artists were unable to organize many receptions before the Civil War, though not for want of trying. Joseph Harrison, an engineer and art patron, held a reception at his home in 1859 to honor Thomas Sully and Rembrandt Peale, the city's chief artistic lions.[58] More than two hundred artists and amateurs were brought together. One other reception was held, that same month, but that was all. In July, 1859, rumors appeared that

Philadelphia would soon have a club for artists and their friends, something like The Century in New York. Reports continued that a studio building would be constructed 'to induce artists to remain . . . instead of emigrating as many of them would otherwise do.'[59] But six months later a sad announcement dispelled these hopes. *The Crayon* explained that the projected studio building and the club 'where Art was to have been occasionally talked about' had been abandoned. 'The artists of Philadelphia are in consequence deserting. . . . The younger men are hastening to New York.'[60]

Philadelphia's art life was far more depressed than its numerical inferiority to the New York community indicated. The corporate unity which had led Philadelphians to form America's first Artists' Fund Society was not strong enough to prevent the city's art world from fragmenting, and not influential enough to create a favorable climate for artists. Again and again John Sartain sounded a note of alarm in the 1850's. The management of the Pennsylvania Academy of Fine Arts, he insisted, did little to promote the profession's interest, and the same applied to the Boston Athenaeum. 'The artists of New York happily rid themselves from this thralldom of insolent corporate patronage more than twenty years ago, and now occupy an enviable and commanding position' with the only real art academy 'in the western hemisphere.'[61] Philadelphia artists apparently lacked the *esprit de corps* necessary to found their own. Local artists had to send their work out of the city to get good prices, Sartain claimed, and only operations in '*foreign* art stocks' flourished.[62] He was disillusioned with the institutional guarantees which earlier generations had prophesied would create a living art. Any city can call itself an Athens, wrote Sartain, but the possession of 'the finest Academy of Art' would not by itself encourage living artists. 'When a city is without artists of merit, it is only because the citizens are unworthy of them.'[63]

New Yorkers, by contrast, crowed delightedly about the prospects for art in their city. James Jarves observed in the 1860's that New York had become 'the representative city of America in art,' much as Paris dominated the French art world.[64] Lavish patronage and excellent professional facilities ensured its predominance. A British correspondent wrote more than a decade earlier that 'the most eminent artists in the United States reside in New York, and by far the greater number of them are natives of this state.'[65] New York's art associations, its schools and academies, its community enterprises like the receptions, gave 'early position and recognition to the truly deserving,' wrote the *Cosmopolitan Art Journal*. 'These offer a potent excuse for centralization; and it is almost imperative that a painter should come hither ere he can seal his fame.'[66] As much as other Americans disliked such

centralization, metropolitan endorsement would eventually prevail. If the '*lazzaroni* of Naples' validated every great European singer, why should not New Yorkers 'give position to every singer, and painter, and poet, and actor in America'?[67]

New York's self-confidence was justified; by 1860 Philadelphia and Boston had ceased to be real alternatives to artistic residence in New York. With a few exceptions these cities contained local artists lacking national reputations, and those who did achieve fame remained because they were born or brought up there.[68] Decisions which artists agonized about in the 1830's and early 1840's were no longer necessary; either they stayed in their native community or they moved to New York. For the art world, municipal pluralism had disappeared.

NOTES

[1] See *The Crayon*, VI (November, 1859), 356.

[2] These statistics are taken from the annual *Report of the Secretary of the Treasury, Transmitting a Report from the Registry of the Treasury of the Commerce and Navigation of the United States, 1840–1865*. Until the 1850's art imports were low, though steadily increasing. The government's shifting categories make these figures difficult to evaluate; in some years art was lumped together with books; in the 1850's painting and sculpture were divided, and an additional category, American Art, presumably the work of natives abroad, was added.

[3] The source here is Harold Lancour, *American Art Auction Catalogues, 1785–1942* (New York, 1944).

[4] Other leading auctioneers were Leonard & Company of Boston, M. Thomas & Sons of Philadelphia and two New York houses: E. H. Ludlow and George A. Leavitt.

[5] Thomas S. Cummings, *Historic Annals of the National Academy of Design* (Philadelphia, 1865), pp. 291–292. For a list of Leupp's holdings see 'Our Private Collections,' *The Crayon*, III (June, 1856), 186.

[6] *The Crayon*, IV (December, 1857), 377.

[7] *The Crayon*, III (May, 1856), 158. Auctions were beginning to standardize art values. See Theodore Allen to Asher B. Durand, New York, March 2, 1844, Durand Papers, box 4, NYPL, for a discussion of the effect of sale prices on the incomes of working painters. For Cropsey and Rossiter see Cummings, *Annals of the National Academy*, p. 277; and *The Crayon*, III (May, 1856), 158.

[8] *The Crayon*, III (July, 1856), 218; and Leila Mechlin, 'Art Life in Washington,' *Records of the Columbia Historical Society*, XXIV (1922), 66. Washington had no art club until 1877.

[9] *The Crayon*, III (October, 1856), 320; *The New Englander*, XVI

(November, 1858), 807–808; *Catalogue of the Works of Art Exhibited in the Alumni Building, Yale College, 1858* (New Haven, 1858).

[10] *The Literary World*, Vol. VIII (February, March, 1851), summarized the talks each week.

[11] *The Crayon*, III (December, 1856), 376.

[12] *Catalogue of the First Annual Exhibition of the Pennsylvania Institute · of Design, 1857* (Philadelphia, 1857). The institute had been founded two years earlier.

[13] For more on the industrial design movement see Neil Harris, 'The Gilded Age Revisited: Boston and the Museum Movement,' *American Quarterly*, XIV (Winter, 1962), 547–566.

[14] *The Crayon*, VI (January, 1859), 26.

[15] See *Artists' Fund Society Catalogue, Fifth Annual Exhibition, 1864* (New York, 1864), for their constitution.

[16] The case is discussed in Henry Budd, 'Thomas Sully,' *Pennsylvania Magazine of History and Biography*, XLII (April, 1918), 97–126.

[17] Cummings, *op. cit.*, p. 306.

[18] Russell Lynes, *The Tastemakers* (New York, 1949), pp. 135–136. The defendant, Eleazar Parmlee, was an eccentric art patron trying to save some money.

[19] *The Crayon*, VI (March, 1859), 92.

[20] James R. Lambdin to Asher B. Durand, Philadelphia, January 30, 1854, Durand Papers, box 4, NYPL.

[21] *The Crayon*, Vol. V (1858) and Vol. VI (1859), *passim*, gives details.

[22] For Durand's hostility to the Washington convention and its organizer, a physician named Horatio Stone, see a letter of his son, John Durand, New York, March 12, 1858, Miscellaneous File and Art Boxes, NYPL. The National Academy of Design refused to send a representative. See Cummings, *op. cit.*, p. 254, for a memorial to Congress asking for an art tariff.

[23] They were the sculptor, Henry Kirke Brown, and two painters, J. R. Lambdin and J. F. Kensett.

[24] Thomas Cole to Edward L. Carey, Catskill, August 30, 1842, Gratz Collection, box 39, Historical Society of Pennsylvania.

[25] Entry for October 9, 1841, The Diary of Joseph Sill, microfilms in Archives of American Art.

[26] Irving Browne to Asher B. Durand, Troy, February 23, 1861, Durand Papers, box 5, NYPL.

[27] Henry Kirke Brown to Durand, Newburgh, February 1, 1864, Durand Papers, box 5, NYPL.

[28] Mark Skinner to Durand, Chicago, January 10, 1855, Durand Papers, box 4, NYPL.

[29] William B. Ogden to Durand, Chicago, May 31, 1852, Durand Papers, box 4, NYPL.

[30] See James S. Walter to Durand, Baltimore, April 28, 1851, Durand Papers, box 4; and Cephas G. Childs to Durand, Philadelphia, March 3, 1844, Durand Papers, box 3, NYPL.

31 The Gratz Collection of Artists' Autographs and the Dreer Collection, both in the Pennsylvania Historical Society, are monuments to this era. So is the Chamberlain Collection in the Boston Public Library, and other collections in New York, and the Archives of American Art in Detroit.

32 Quoted in *The Literary World*, VIII (February 1, 1851), 94.

33 *Prose Writings of William Cullen Bryant*, ed. by Parke Godwin (New York, 1884), II, 234. These remarks were made at the opening of the National Academy's new building.

34 'The Diaries of Sidney George Fisher,' *Pennsylvania Magazine of History and Biography*, LXXXVII (April, 1953), 210. 'A crowd of men there, for the most part vulgar and common-place. . . . There seems now no such thing as *gentlemen's society*.' But he considered Sully to be 'intelligent and pleasant.'

35 Frederic Church to E. P. Mitchell, New York, December 14, 1857, Gratz Collection, box 39, Historical Society of Pennsylvania.

36 Charles Henry Hart, 'Thomas Sully's Register of Portraits, 1801–1871,' *Pennsylvania Magazine of History and Biography*, XXXII (October, 1908), 385–432.

37 Theodore Bolton, 'Henry Inman. An Account of his Life and Work,' *Art Quarterly*, III (Autumn, 1940), 353–375.

38 For such prices see 'The Dollars and Cents of Art,' *Cosmopolitan Art Journal*, IV (March, 1860), 30. For European prices see *Cosmopolitan Art Journal*, IV (June, 1860), 82. Everard M. Upjohn, 'A Minor Poet Meets Hiram Powers,' *Art Bulletin*, XLII (March, 1960), 63–66, also contains good information on art incomes.

39 George Inness, Jr., *The Life, Art and Letters of George Inness* (New York, 1917), pp. 11–12.

40 *Cosmopolitan Art Journal*, IV (June, 1860), 70.

41 William J. Stillman, *The Autobiography of a Journalist* (London, 1901), I, 52.

42 Elihu Vedder, *The Digressions of V.* (Boston, 1910), p. 81; and H. W. French, *Art and Artists in Connecticut* (Boston, 1879), p. 138. A number of artists still lived like businessmen-entrepreneurs. See 'Some Letters of William S. Jewett, California Artist,' ed. by Elliott Evans, *California Historical Society Quarterly*, XXIII (June, September, 1944), 149–177, 227–246; and 'Letters of George Caleb Bingham to James S. Rollins,' ed. by C. B. Rollins, *Missouri Historical Review*, XXII (1937–38), 3–34, 165–202, 340–377, 484–522.

43 *Cosmopolitan Art Journal*, III (June, 1859), 123. See also *Cosmopolitan Art Journal*, III (December, 1858), 27.

44 French, *op. cit.*, pp. 81–82, 127–134. Church's father retained some reservations, however. See David C. Huntington, *The Landscapes of Frederic Edwin Church. Visions of an American Era* (New York, 1966), 21–22.

45 Seth Eyland (pseud. for David E. Cronin), *The Evolution of a Life* (New York, 1884), p. 16.

46 Material concerning Boston's art community has been gathered from

many sources. I have found particularly helpful the *Boston Directory*, various years; *King's Dictionary of Boston*, various years; *Sketches and Business Directory of Boston . . . for 1860 and 1861* (Boston, 1860); [Mrs. Ednah Dow Cheney] *Memoirs of Seth W. Cheney, Artist* (Boston, 1881); Martha A. S. Shannon, *Boston Days of William Morris Hunt* (Boston, 1923); E. Durand-Gréville, 'L'Art aux États-Unis,' *Gazette des Beaux Arts*, XXIV (September, 1886), 255–264; William Howe Downes, 'Boston Painters and Paintings.' *Atlantic Monthly*, Vol. LXXII (July–December, 1888); and various exhibition catalogues and brochures, Fogg Library, Harvard University.

[47] Other dealerships included A. A. Childs & Company, and Alden and Vose. Williams and Everett had been started, under a different name, in 1810. At an early date for such practices, they guaranteed the income of George Inness in exchange for his franchise. See Inness, *op. cit.*, p. 34.

[48] For an early comment see Thomas Doughty to Asher B. Durand, Boston, May 6, 1833, History of Art Manuscripts, Vol. I, Archives of American Art. See also the comment of John G. Brown, quoted in G. W. Sheldon, *American Painters: With Eighty-three Examples of Their Work Engraved on Wood* (New York, 1879), pp. 142–143.

[49] For Philadelphia the following were helpful: *Cohen's Philadelphia City Directory*, various years; *Philadelphia as It Is in 1852* (Philadelphia, 1852); J. T. Scharf and Thompson Westcott, *History of Philadelphia, 1609–1884* (Philadelphia, 1884), II; E. P. Oberholtzer, *Philadelphia, A History of the City and Its People* (Philadelphia, 1922), 4 vols.; E. Digby Baltzell, *Philadelphia Gentlemen, The Making of a National Upper Class* (Glencoe, Ill., 1958); *Boyd's Philadelphia City Business Directory*, various years; *M'Elroy's Philadelphia City Directory*, various years; Nathaniel Burt, *The Perennial Philadelphians, The Anatomy of an American Aristocracy* (Boston, Toronto, 1963); Thompson Westcott, *The Official Guide Book to Philadelphia* (Philadelphia, 1875); Anna Wells Rutledge (ed.), *The Pennsylvania Academy of the Fine Arts, 1807–1870. Cumulative Record of Exhibition Catalogues* (Philadelphia, 1955); exhibition catalogues of the Artsits' Fund Society; the Graff Collection; the Gratz Collection; the Claude W. Unger Collection; The Artists' Fund Society Minute Books, all in the Historical Society of Pennsylvania.

[50] George W. Dewey, 'The Art-Union of Philadelphia,' *Sartain's Union Magazine*, IX (August, 1851), 157.

[51] For New York the following were of value: *Pictorial Dictionary of Broadway* (New York, 1849); *The Crayon*; *The Cosmopolitan Art Journal*; *The Literary World*; *New York City Mercantile and Manufacturing Directory* (New York, 1853); Mary Bartlett Cowdrey (ed.), *National Academy of Design, Exhibition Record, 1826–1860* (New York, 1943), 2 vols.; James Grant Wilson (ed.), *The Memorial History of the City of New York* (New York, 1893), 4 vols.; Mount Papers, New York Historical Society. Durand Papers, NYPL; American Art-Union Collection, New York Historical Society.

[52] *The Crayon*, V (February, 1858), 59.

[53] *The Crayon*, V (April, 1858), 115.

[54] Cummings, *op. cit.*, p. 270.

[55] 'The Autobiography of Worthington Whittredge,' ed. by John I. H. Baur, *Brooklyn Museum Journal*, I (1942), 43.

[56] Cummings, *op. cit.*, p. 225.

[57] *Cosmopolitan Art Journal*, IV (March, 1860), 34.

[58] *The Crayon*, VI (May, 1859), 161.

[59] *The Crayon*, VI (July, 1859), 221.

[60] *The Crayon*, VI (November, 1859), 349. See also *The Crayon*, VI (December, 1859), 381.

[61] 'Art Notices,' *Sartain's Union Magazine*, VII (August, 1850), 120.

[62] *Sartain's Union Magazine*, VII (July, 1850), 58.

[63] *Sartain's Union Magazine*, V (December, 1849), 387. Sartain did serve as an Academy officer for a number of years, however.

[64] James Jackson Jarves, *The Art-Idea*, ed. by Benjamin Rowland, Jr. (Cambridge, Mass., 1960), p. 181.

[65] *The Literary World*, I (July 3, 1847), 517.

[66] *Cosmopolitan Art Journal*, III (March, 1859), 85.

[67] *Cosmopolitan Art Journal*, II (December, 1857), 30. For the failure of a single American city to dominate literature see Lewis P. Simpson, 'The City and the Symbolism of Literary Community in the United States,' *Texas Quarterly*, III (Autumn, 1960), 97–112. See also 'The Representative Art,' *Atlantic Monthly*, V (June, 1860), 608.

[68] William E. Winner, the Lambdins, William Trost Richards and the Peales were practically all native Philadelphians; John Sartain emigrated from England at an earlier date.

MARVIN ELKOFF

*The American Painter as a Blue Chip**

THE LONGVIEW FOUNDATION some years ago set up a grant for painters who had made significant contributions and were in need of cash. A gentleman on the committee selecting the recipients reports that the Foundation used up most of its money at the same time as it ran out of eligible painters.

To many of us, the idea that there are no longer any painters both reputable and short of funds comes as a shock. It is hard to adjust to the rapidity of change in the United States. We are bred for one life and lead another. And so we are prepared to look at the world of *avant-garde* art with memories of Modigliani selling his drawings in cafés and dying of consumption at thirty-five, of Soutine starving in his vermin-and-stench-ridden garret, of Van Gogh's madness, of irascible Cézanne's private labors and lack of public recognition.

The idea of a genius going unrecognized and unrewarded in his lifetime has always been part myth, but the myth has been more of a reality here in America than it ever was in Europe. Yet even the vivid example of Soutine is softened by the realization that Dr. Albert Barnes started buying him in quantity when the painter was thirty.

Today the myth serves a purpose. It is a selling weapon for the dealer, a justification for the uncertain collector. It is, in any event, one of the results of our history-conscious period: *Be the first on your block to recognize a genius,* says the dealer. *Don't let the critics make fun of you in thirty years,* says the collector to himself.

Nevertheless, we *have* been trained to see the art world through these

* Reprinted by permission of the author and *Esquire Magazine,* © 1960 by Esquire, Inc.

mythic glasses, and what we find today is something different, radically different.

Up until the end of World War II, great modern art was always assumed to be School of Paris. American artists themselves were Francophiles, and the collectors more so. Adolph Gottlieb, one of the four or five leaders of the Abstract Expressionist generation that has dominated American art until recently, remembers that up until the end of the war he assumed that this situation would go on forever. And suddenly it began to dawn on people, first on the painters, that Americans were doing the best and most original art in the world. Soon the French were the ones doing the imitation. The process has already begun with Pop art, which now has imitators in almost every country.

Though painting power, along with so much other power, came to America in the Forties, there was still no money. But a painter like Willem de Kooning, America's most famous and most highly rewarded *avant-garde* painter, looks back regretfully to that period. He appreciates his great current success and his money, but he felt more reality then, more security, more exuberance. 'First there was this underground reputation we had in the late Thirties and during the war, you know, one painter for another, by ourselves, to hell with the rest,' he says, with a Dutch accent that you almost forget because of his hip, loose style. 'Whoever figured on a big success? That sounded crazy. Then after the war the reputation was above ground, you know, the critics, a few dealers like Egan. Still no money. But excitement.'

Today, at sixty, de Kooning's paintings sell for anywhere from $3,000 to $35,000, according to size. He is involved in the seemingly endless task of building a studio-house in East Hampton (costing over $100,000).

De Kooning speaks of the huge house as if it were a piece of reality he could mine from a fantasy of wealth and success that never seems too firm or credible, even to an artist of his stature. He is nervous about his reputation, which is under attack, nervous about his next show. He works slowly, and few people have seen his recent work. He seems intent on conveying that he really does not make all that much money, after taxes. On the other hand, he insists that he does not want to seem ungrateful to the American government by complaining about the taxes.

These proper statements seemed odd coming from a man who feels himself in the romantic tradition of Van Gogh, but only if you read them without hearing the odd combination of irony and innocence that hovers under the words.

The big money did not come into art until the middle Fifties, as late as

'58 and '59 for most of them. 'Poor Jackson [Pollock, who died in an accident in 1956] started it all and he died before the money came,' says de Kooning. Only eight or nine years ago, though his world fame was second only to Pollock's, de Kooning still had little money. Sidney Janis, whose gallery handled his work, had turned down a group of his paintings about women. Around Christmastime, when de Kooning needed money to pay his mother's hospital bills, he offered these for sale from his studio. (He was then sharing a house in Bridgehampton, Long Island, with Ludwig Sander and the late Franz Kline.) Martha Jackson bought a number, which accounted for a fine show she had the next year. It was as late as 1959 that Janis held the historic de Kooning show, when all his paintings were sold the first day for a total of $150,000. De Kooning says it was so unnerving he wished he were back on the W.P.A. project.

De Kooning displays a childlike surprise, almost entirely sincere, at his fame, especially when it comes in the form of governmental recognition. ('Me! Who expected it? I came here as a stowaway, a kid of twenty.') One night the government traced him to a dinner at the sculptor Ibram Lassaw's in East Hampton. A man named Goodman left a message that President Johnson wanted to give de Kooning the Presidential Medal of Freedom and would he please call back. His first impulse was to figure out who was playing the practical joke. He was finally persuaded to make the call, and then had to be persuaded to go to Washington. It would have seemed like reverse snobbery, he said, *not* to go when such famous people as Leonard Bernstein would be there. As so often with celebrities, he was most impressed with the other celebrities.

Gottlieb's success came about the same time as de Kooning's—Gottlieb at sixty-one is a year older—but his life is very different. De Kooning would prefer to be left alone out in East Hampton; he lives there all year, and goes along with the business side of art only insofar as he is pulled into it or persuaded it is necessary. A sturdy, direct and businesslike man, Gottlieb is always Gottlieb and one feels he does simply that which he has to do to maintain his success. It was only eight years ago that he moved from Brooklyn to Manhattan, only four years ago that he bought a handsome $75,000 summer house on 'Millionaire's Row' in East Hampton, formerly owned by Jacqueline Kennedy's aunts. In the late Thirties he spent his summers in Gloucester, Massachusetts, for $25 a month. In the early Fifties in Provincetown he still spent no more than $300 for the summer. Now, once each summer in East Hampton, Gottlieb throws a huge and stylish cocktail party for perhaps two hundred people—artists, gallery owners, collectors and the local rich, who are often the collectors. This year there

were several maids, several bartenders and a local policeman to keep traffic moving. Everyone but the painters seemed to enjoy the party. To them it was clearly a business occasion; the strain on their faces showed it.

The rise of these older painters—Kline, Mark Rothko, Barnett Newman and others, in addition to Pollock, de Kooning and Gottlieb, who though various in style are known as the first generation of Abstract Expressionists—was very slow and modest until the late Fifties. Most of them either had wives with jobs or worked themselves. The wives of both Newman and Gottlieb, for example, were teachers.

In 1946–47 Gottlieb sold all his paintings to the Kootz Gallery for $3,000. In 1960 a single painting sold for twice that. Today, especially after winning the recent Grand Prize at the São Paulo Bienal, a large Gottlieb will go for $10,000 to $15,000.

In 1957, after leaving a teaching job at Brooklyn College, Mark Rothko had difficulty raising enough money to make a trip to New Orleans—a matter of $600 or $700. When he came back he found he had made sales worth $10,000. Today, because of taxes, he refuses to sell more than four or five paintings a year, and there is a long, long waiting list. Each of his paintings, since he paints large, sells for $15,000 to $25,000. Last year he rejected a sale to The Four Seasons because he did not like the idea of his paintings being hung in a restaurant. 'I did them a favor,' he says. 'My paintings might have been bad for the digestion of their patrons.'

In 1955 Newman was selling nothing at all. And now, according to collectors, it is an ordeal to get one at $15,000. Newman has been known to inquire where the collector will hang it, what paintings it will be near and how sincere he really is in his desire for the painting. In other words, does the collector love him for his investment possibilities or does he really love his work.

In 1957 Janis Gallery had a hard time selling large Franz Kline paintings for $1,200; today they go for $25,000.

A Pollock bought for $8,000 in 1954 is now worth more than $100,000. Whereas prices had been rising steadily, it was his death in 1956 that triggered the beginning of the rise to a new plateau. Then, about three years later, prices of Pollocks jumped enormously and drew other prices up with them.

To one collector, these masters of the first generation have now become a 'bunch of accountants. They're guarded, wary, suspicious.'

Another collector sympathizes with them, sees them as Depression-bred, and as suspicious and quirky because of the country's rejection of their work until they were on to fifty.

Both the first and second generations of Abstract Expressionism have been characterized as rougher, more drunken, brawling and womanizing, angrier and less given to the amenities than the generation that followed. Henry Geldzahler, Associate Curator of American Paintings and Sculpture at the Metropolitan Museum, who is very friendly and involved with the younger painters, threw a large party last year where some of the older artists met the young generation of Pop and hard-edge people (to deal in at last two categories). To Robert Motherwell, younger than the first generation but considered part of it, there was a whole difference in style of life as well as style of painting. The younger painters were, he says, so much more polite and sweet, so much less angry and brawly.

Certainly the biggest reason is that painters, far from being rejected by society, are in fact drawn into a too passionate, if not too pure, embrace. To be outside society had been a twisting and frustrating experience. But it also protected the artist from distortions of success, from all the familiar vices that beset the other entertainment worlds. The painting world is closest of all to that of fashion and the theater. Unlike the movies, or even publishing, where a product is thrown out into the world of millions who then either take it or reject it, paintings are thrown to a limited audience, a more homogeneously rich audience, almost in a face-to-face situation. It thereby takes less to make a trend, and to break it.

This audience is restless for the new, needs the *new* as a distinguishing accoutrement. It uses painting as a sign of rising social status in a world where minks, swimming pools, foreign travel and huge homes no longer carry enough distinction or have the same personal appeal—for most collectors *do* like painting: it is not just a flip of the coin between racehorses and painting. Since painting becomes a way of identifying oneself, there is a tendency to pick up some new trend in painting—to become among the first collectors to buy a certain kind of far-out work.

Investment in painting becomes uncertain in this atmosphere, especially among the second line of collectors. The sudden rise of Pop art almost paralyzed the art business for a while. Art sales were seriously hurt in 1963 because no one knew what effect Pop's success would have on art prices, or how long Pop would last. In Los Angeles, said one gallery owner who had returned from there in the Summer of 1963, sales were at a standstill and galleries were on the verge of closing.

The Pop revolution was a perfect example of the fact that the small, compact world of modern painting is moved more quickly and easily than other culture worlds. Observers say that Pop took off—as opposed to developing slowly, which it would have done anyway—because of the

support of three collectors: Mr. and Mrs. Robert C. Scull, Mr. and Mrs. Burton G. Tremaine, Jr., and Mr. and Mrs. Albert A. List.

What happens in situations like this, where changes are sudden, fads steadily changing, is that painters have their eyes cocked on their market as well as on their paintings. They suffer the anxiety of a Marc Bohan or an Yves St. Laurent preparing for a spring showing. That goes for everyone, but most intensely for the young, who are bred to making it, *anticipate* making it. A noted collector pointed out a double rub: That fathers still don't want their sons to be stupid enough to be painters; and if they don't make it in this success world, they appear doubly stupid. Young painters ask in effect: 'What's the secret . . . how do you make it . . . how do you become a successful painter?' Since they now believe it can be done, they want to know how to do it.

When a young painter says this, he usually does not have in mind calculatedly painting for a certain market—opportunism is more complex and interesting than that, more intertwined with self-delusion. He usually has in mind that his paintings are just as good or as bad as another's; he feels all he lacks is the special selling mystique.

It is a too easy cynicism to consider a change of style an opportunistic change, for there are two histories to art, an internal stylistic history, and an external one of markets and collectors. Styles dry up, just as markets do.

Many people feel that both histories are operating in the case of the second-generation Abstract Expressionists—such painters as Al Leslie, Michael Goldberg, Grace Hartigan and Joan Mitchell. In the middle Fifties, these painters (who are all around forty now) were successful, quickly successful by the standards of the times. But in the recent crush of new fads and styles in the art world, they have become a frightening object lesson to other painters. Pressed between the masters of the first generation and the new men of Pop and hard-edge, their fame and prices rose and fell with alarming speed. They have been squeezed out by the new.

Whether they can come back is a familiar topic in the art world. Michael Goldberg is a good example that change *can* be successfully managed. Goldberg's first success started in 1956 when Walter Chrysler came down to his cold-water loft on East Tenth Street and bought sixteen paintings for a total of $10,000, which he was to pay in four $2,500 installments. Until then, Goldberg had worked as a moving man. His painting brought him a materials stipend of $650 a year from the Poindexter Gallery.

Shortly thereafter, Martha Jackson gave him a $10,000-a-year contract and he was on his way—for a while, until the younger generation pressed up under him. Last year he had gathered together a quantity of new paintings

in a very different Pop-influenced style. Goldberg candidly states that Martha Jackson did not want to show him; she had no confidence that his paintings would sell. They seemed too radical a change and there is a half-articulated, rather silly notion in the art world that a change has to be slow and visible, one stage related to another, thus betokening integrity. But she was persuaded to do so and the show sold out.

Not all changes work with such financial felicity. Al Leslie tried and so far has not succeeded. After an unsuccessful showing of Pop paintings in Los Angeles last year, he is now reported working in a realistic tradition. And there is the case of an older painter, Michael Loew, a serious and reputable artist who, during all the years of Abstract Expressionism's reign, painted in the then unfashionably pure geometrical style. Friends kept suggesting that he loosen up, get more Action, get more surface brushwork. He refused for years, then gradually changed. Now that he paints in the looser, more painterly style of Abstract Expressionism, he is once again on the outs with fashion.

Galleries, too, get squeezed by the new when they commit themselves to the 'wrong' school at the wrong time. The handsome, well-financed Howard Wise Gallery on Fifty-seventh Street supported the cause of the first- and second-generation Abstract Expressionism for several years, to ever-diminishing returns. It is relieving itself of some of these painters, taking on the now popular geometrical and optical painters.

So far as the middle generation of Abstract Expressionism is concerned, Mark Rothko sees the problem as a possible release from a style that dominated them. 'My generation,' he says, 'never thought we had anything to lose or anything to gain; we just painted. Maybe now they will too.'

To the steadily successful, nonschool Larry Rivers—an example that in this world of fashion it is probably safer *not* to be part of a school—there is no turning back. The glare of success, the pull of money and fame is *there*, a reality, and he can't pretend it isn't. Nor would he wish to. He can conceive of the 'lights going out'—but if they did he frankly concedes it would be unbearable to him. Right now he is a successful painter. This winter he will have a retrospective—he is only forty-one!—at the Marlborough-Gerson Gallery, the affiliated international giant that recently invaded the New York art world. (Another recent move—Sotheby's purchase of the controlling interest in Parke-Bernet—marks the final shift of power to the United States, because it means that New York will become the auction, or price-setting, capital of the world.) Whatever paintings are on sale will probably go for prices up to $20,000. Rivers' success is marked not only by a nonschool style, but by an especially seductive and charming character

to his work and to his personality; in fact, it is probably true to say that if you're not part of a school, you had better have personality, whatever the caliber of your painting. In the face-to-face world of painting, that is important.

Rivers came out of the jazz world. In 1947, when he first started painting, he was the first Beat character this writer had met; every fourth word was 'like.' He speaks that way no longer, indeed is highly articulate, though no less restless and distracted.

It is probably this uniqueness of painting and personality that accounts for the fact that his success came at about the same time, if not earlier, than the first generation of men twenty years his senior. He started to sell in 1951, and a few years later was able to live completely if modestly on his paintings. In 1955 he sold the well-known painting of George Washington Crossing the Delaware for $2,500, quite a large sum in those days. (The buyer donated it to The Museum of Modern Art.) He remembers vividly receiving a call from John Bernard Meyers of the Tibor de Nagy Gallery telling him of the sale; he fell flat on the floor in a mixture of amazement, disbelief and joy. Five years later, the Seagram Building bought a very large painting for $15,000. This message also came over the phone; Rivers received it coolly, and his first thought was to wonder if he could have gotten $20,000. (About this story, Jasper Johns murmured, 'Well, one can't go on indefinitely falling on the floor, can one?')

Rivers is more subtle and perceptive about the results of fame than other painters. He points out how striking it is to see one of your paintings hanging at the Museum on the same spot that a great Picasso had hung. According to your personality, he says, it either makes you think more of yourself or less of Picasso. Above all, he feels, it says *yes* to your impulses, makes you feel that whatever you do will somehow be right for you.

More than most painters, he moves easily in the celebrity world. Last year he had a show in Los Angeles, which received a substantial play in the press. Hollywood producer Walter Mirisch—a distant relative—called Rivers when he saw the story and wondered how come Larry hadn't called him. They had met, but until then Mirisch had paid no particular attention to him. However, now there was a special situation. Billy Wilder, an admirer of Rivers, was at that time directing *Irma La Douce* for Mirisch—and fighting with him. It seemed there might be a blowup. Mirisch learned that the one painting Wilder wanted to buy was the one painting Rivers was not selling. Rivers realized that Mirisch hoped to use his family connection to get the painting, present it as a gift to Wilder and thereby heal the wounds. Rivers would not sell. Mirisch sought to woo him. He took him to dinner and then to a party

at his house with Peter Sellers, Tony Curtis, writer George Axelrod, Phil Silvers and several other celebrities. Beguiled by the fact that both he and Curtis came from the Bronx, Rivers got the nerve to tell Curtis how much he had always admired him. Mr. Curtis thereby got the courage to tell Rivers how much *he* had always admired Rivers' paintings, how he had always wanted to tell him, as one Bronx boy to another. Then they all watched a performance of *The Birds* in Mr. Mirisch's living room, where a wall of paintings swivels around to expose a projector. The next day Mirisch, Axelrod and Curtis bought paintings. Mirisch took four, thus earning the right to buy the fifth—the one that Wilder coveted. ('And why,' wondered Rivers, 'didn't Peter Sellers buy a painting?')

Rivers' rapidity of success, the youth at which it was achieved, has become the standard in the new world of Pop.

One of the most recent and stunning successes has been thirty-two-year-old James Rosenquist, who rose from obscurity to fame within two years, whose prices rose from $600 to $4,000 in the same space of time, literally between two shows.

He was discovered less than three years ago by Richard Bellamy of the Green Gallery, who arranged a visit for collector Robert C. Scull, a specialist in Sunday-morning strolls to the studios of unknown artists. Scull saw Rosenquist's work and, after an initial confusion, decided he liked it. It showed some men sliding off the edge of the canvas; Scull asked for an explanation. 'Well,' said Rosenquist, 'they're 1949 men, they're on their way out.'

'I like it. I want to buy it. How much is it?' Scull says he enjoys this moment, which has become familiar to him, when he says he wants to buy a painting. There is a pause, a glazed expression, great suspicion. 'It is a marvelous moment when they become a pro,' says Scull. There was perhaps more suspicion than usual in Rosenquist, who has been described variously as a shrewd farmer or a hick inventor, leery of city slickers. Rosenquist said he didn't know how much to charge since he had never sold a painting. Scull offered to leave in order to give Rosenquist time to figure out a price. Rosenquist hurriedly dissuaded him, then, as the story goes, called to his wife, 'Mary Lou, Mr. Scull wants to buy a painting. How much should I charge him? How about $200?' They agreed on that price. It was the first piece of Pop art Scull had bought.

Rosenquist had his first show at the Green Gallery in 1962, and quickly moved on to the powerful Castelli Gallery and the $4,000 price level.

He is reportedly already changing his style—putting sculptural objects in front of his paintings. This makes quite interesting a statement he gave

to an art magazine recently. 'If things are accepted very fast, they will be rejected very fast. This is inherent in the technology of the time. There is a new kind of paint that dries in a few minutes. It will displace other paints. Now it is practical to tear down a building and replace it every fifteen years. People constantly demand better things.' (This does not sound like a hick.)

Jasper Johns—who, with Rauschenberg and Rivers, is more a bridge to Pop than part of the current deluge—began to live off his paintings at twenty-nine; he is now thirty-four and his works have sold for as high as $30,000. A wry, intelligent young man, Johns finds his success disconcerting. No matter how seriously one takes oneself, $30,000 *is* a lot of money for a young man's painting.

According to friends, he spends money wildly, in a classic throwing-away-the-easy-evil pattern, and is not a prolific painter. 'What can Jasper do next,' asked a friend, 'after his international fame, his financial success, his critical success, . . . become a Zen master or something?'

This last question was prompted by Johns's extended sojourn in Japan where his fame was a little eerie, according to the painter. 'I had never had a show there, nobody had ever seen my paintings on exhibition. Yet everybody in the art world knew me, knew my work, discussed my ideas. I was famous, and yet the only things they had seen were one or two illustrations in magazines.'

Handsomely bearded and bald-domed Jim Dine, another early success in Pop art, tells of coming to New York from Ohio six years ago at twenty-three. Although Johns and Rauschenberg were already famous in the hinterlands, Dine came upon their work by chance at the Castelli Gallery. Now Dine has acquired international repute; last year he was in twenty European shows. He has lived off his paintings since he was twenty-six.

Dine found his early fame too much to handle. A few years ago *Life* printed the photos of a hundred young comers in various fields, and Dine was the only one from the painting world. He was asked to go on radio and TV, and suddenly: 'I felt like a Hollywood star, I felt like a commodity, because nobody really knew or cared about my work.' For that matter, Dine apparently was asked to join the large and successful Janis Gallery at a time when Sidney Janis had seen little or none of his work. Or without Dine's doing anything about it. One day he received a call from Adolph Gottlieb, who was then with the Janis Gallery, saying that Janis would be in East Hampton the next day and wanted to talk to Dine about joining the Gallery. (And on the beach the next week a tipster came up and whispered to a collector: 'Buy Dine, he's going with Janis.' Which was an indication that his fame and prices would be going up, Janis having a reputation as a man

who takes on artists that have been promoted by others, just before they suddenly take off.)

The more the art world operates as a Bourse, the more the painter becomes a commodity, a measurable amount of concretized fame. ('I don't collect Jasper Johns's paintings,' said a collector, 'I collect Jasper Johns'.)

Dine talks of the need of insulating oneself against it and reports that too many painters do it with drinking. Unreality is at work here, too; there is too great a gap between what one is and does and has learned to expect, and what one gets from the world. It is all too like the problem reported by a psychoanalyst: Dr. Charles Socarides said that he had found increasing problems among executives, who were unable to justify the huge salaries they were making.

As fame moves fast, as fads move quickly, as reputations move and perhaps can be moved up and down quickly, it becomes necessary to rationalize production as businessmen do in other industries. Thus a new kind of professionalism emerges in the dealer world—symbolized by Leo Castelli. It is a professionalism marked by efficiency and the more streamlined public-relations methods of the modern business.

This new professionalism shows itself in the smallest ways, according to an art reviewer If you need a photograph or biographical and bibliographical information from the Castelli Gallery, you get it at once, and most courteously. On the other hand, an equally large but less modern gallery is often without the photograph, or the information, and, if they have the photograph, testily demand a dollar for it. Castelli sees himself merely as a man trying to promote the art he loves, of promoting a life he loves. To him, the newer kinds of painting are part of a general new spirit of the arts to which he feels committed—Nouvelle Vague in movies, Absurd Theater, a certain fashion exuberance of Paris. He is delighted when a Terry Southern wants to have his picture taken at the Castelli Gallery during a Pop show, when Antonioni in Rome contacts him to tell of a movie he wants to make about Pop painters. He is trying to recreate the Surrealist milieu he enjoyed in prewar Paris.

But others give him credit for more businesslike motives. They feel he watches the market like a research analyst, attempting to rationalize his market and anticipate trends. His talent for this draws nothing but admiration from collectors and competitors alike. The Green Gallery's Bellamy admits his own innocence in the face of Castelli's wisdom. He tells how Castelli wanted to make sure the Green Gallery held its first Rosenquist Show at the same time as Castelli held his show of Roy Lichtenstein—best-known for his comic-strip paintings—thereby creating a sense of movement

to build up the enthusiasm of collectors, museums and the press. For the same reason, Castelli himself says, he urged Andy Warhol to go to the Stable Gallery, Dine to Janis, rather than his own gallery. (This year Warhol has come to him after all.)

Though committed to Pop, he also has Action painters in his gallery. There was a time, say close observers of the Castelli phenomenon, when he seemed to be hedging by diversification. But these same observers say that Castelli now foresees a long and rich life for Pop and that is why he is taking on Pop artists that originally he shunted off to other galleries.

Castelli denies that he is such a trend-watcher. But if he isn't, he should be. For if it took only three collectors—or four or five—to accelerate (so astonishingly) the growth of Pop in the tight little world of art, how many will it take next time, and when will it happen?

J. W. FERNANDEZ

The Exposition and Imposition of Order: Artistic Expression in Fang Culture*

THE FANG RELIQUARY figures (*mwan bian, eyima bieri*) constitute a well-known and often praised style of African plastic art. In contrast to the very high valuation set upon them in Europe and America,[1] the Fang only learned to value them over the years, probably in response to voracious European collecting. Tessmann[2] testifies to the ease with which they were acquired at the turn of the century, in contrast to the very high inviolability of the ancestral skulls over which they posed. Due to the pressures of missionary administration, the reliquaries were either broken up or dismantled, whole craniums or portions of them falling thereby into individual hands. As a consequence of the disintegration of the ancestor cult, a proportionately greater number of figures were elaborated by the Fang to accompany the now dispersed relics of the ancestors. Frequently, possibly stimulated by a custom of the Loango, pieces of bones were actually worked into the trunks of the figures, thereby greatly increasing their value in the eyes of the Fang. In recent decades these figures, therefore, have been much more difficult to acquire than formerly. In the last decade production for any religious purpose had virtually ceased, even in Rio Muni, where, however, in contrast to Gabon, these figures, usually somewhat modernized, are still produced for interested colonials and other collectors.

I propose now to briefly discuss the situation in which these figures were

* Section I of a paper presented at the Conference on the Traditional Artist in African Society, Lake Tahoe, California, May 28–30, 1965. Reprinted by permission of the author. The complete article appears in *The Arts in African Societies*, ed. by W. L. d'Azevedo (Indiana University, 1969).

produced, the qualitative experiences associated with them in the eyes of the Fang, and the position and role of the sculptors themselves.

The economy of the Fang was never well articulated. Though intervillage and long-distance trade was present, it operated on a sporadic basis, and there were no fixed markets. Ironworking was the closest approximation to a specialized trade, and even ironworkers maintained fields and kept an eye to family subsistence. On the other hand, practically all mature men whiled away the long periods of debate and discussion in the men's council house (*aba*) in some craft or another . . . basketmaking, fish-trap construction, the carving of spoons or other utensils, the carving and polishing of canes and pipes, the polishing and incising of brass ornaments. For the individual involved there was artistic satisfaction in having produced implements of quality, insofar as he achieved quality, and for his peers there was aesthetic satisfaction in the contemplation and use of his product.[3]

Over a period of time, in any village and among various villages, preferences and particular skills sorted out artisans, inclining them toward specialization. There were those who spent most of their time in tying baskets, others in making spoons. Still, it was rarely the case that a man would conceive of his main business in the council house as that of tying baskets or making spoons. These activities remained secondary occupations. Moreover, whatever skills a man had or developed were usually regarded as particularly his own, and very little attempt was made to pass them on to the younger generation in his own line. His younger relatives might tend to take up the same skills by very proximity and example but there was no institutionalized attempt to assure this, except in the case of ironworkers. But even here inheritance of the necessary knowledge and skills was never so tightly controlled as to establish particular clan rights to the trade, as occurred elsewhere in Africa. Finally, although a man might become associated with a particular craft, not infrequently it would become tiresome to him and he would shift his hand to another.

Those who carved reliquary figures (*mbobeyima*—carvers) worked in this context. Their product was in general more highly regarded than the crafts we have mentioned, but customarily they would work on their carving in the same casual and secondary way as any of the other craftsmen. Their subsistence preoccupations were the same as those of their fellow villagers. They were not impelled by any family tradition, and I have no record of any father making attempts to teach this craft to his son. Most frequently it was a classificatory uncle—one of mother's brother's brothers—who was credited with the stimulus that first set a man's hand to wood.[4] The record shows, moreover, that a man might carve two or three statues over a year's time,

then turn to something else, not to return to carving for a number of years. The output of recognized carvers was surprisingly low. I have estimated, though it is difficult to get valid information on this point, that the average lifetime output for traditional carvers who had not commercialized their skills under colonial blandishments was not above ten figures and probably lower. This is explained not only by the relatively casual manner in which this carving was undertaken but also by a tendency of men who had broken their extended family away from their village to fabricate their own figures for the new reliquary.[5] The nature of Fang culture was such that men might feel a passing competence in almost all of its aspects. The great range of styles and relative crudity of the majority of reliquary figures pictured in the field collections of Tessmann, Grebert,[6] and others testify to the degree to which the carving of most of these figures was undertaken by relatively inexperienced men. In the face of the utilitarian need to have a figure to 'defend' (*aba'ale nsuk*) the reliquary—for that was their principal purpose—any figure would do. Aesthetic considerations were secondary. Any statue can function atop the reliquary, though some statues are to be preferred.

While, therefore, in the face of need aesthetic considerations may have been secondary, they were still present, and accomplished carvers were known and remarked widely. They might, because of their skills, be requested to carve statues for the reliquaries of other lineages and other clans. But they were never overwhelmed with requests, not only for the reasons detailed above but also because of the feeling—not a requirement—that the family reliquary ought really to be guarded and decorated by the hand of some kinsman either consanguinal or affinal.

Fang dance masks and standing drums, which have received very little attention from European and American authorities,[7] give us a better example of artistic work driving out the crude and the commonplace in the aesthetic marketplace. Frequently but not always, the men who worked in figures would also work in masks, and vice versa. But every carver preferred his genre. In respect to these latter art objects, demand might be brisk enough to push a man toward specialization if he would capitalize upon it. Few ever did and none, to my knowledge, to the extent of giving up their subsistence and other village responsibilities. This is true even in the late colonial period, when extended communications, the cash nexus, and European collectors exerted added pressures. Those who did undertake to devote disproportionate time to their art did so in the face of the custom that carving, like the other crafts to which it relates, should be a casual and secondary occupation. Men should define themselves principally as family heads, living representatives of the perpetuating lineage, debaters, warriors, hunters, trappers and

agriculturalists. Their skills with wood or reed, vine leaf or metal, are the necessary supplemental skills and not the essentials of Fang personality.

Nevertheless, there were men who, by reasons of character and talent and because of the satisfactions involved, devoted disproportionate time to carving, developing thereby inordinate skill. The Fang, on their part, recognized that such skills were not equitably distributed, and they were not strangers to the qualities of fine carving.

My own collecting[8] brought me into close contact with four such men, all well enough known in their districts as carvers . . . for the skill and time they spent in this occupation. Only one of them, Clemente Ndutuma, Clan Efak of the Demarcacion of Akurnam in Spanish Guinea, was, however, actively engaged in carving when I first visited him. One Mabale Oye, Clan Essangi, Village Nkolabona, District of Oyem, northern Gabon, had not carved anything of consequence in a decade. The two others, Eye Mengeh, Clan Mbun (Mobun), Village Antom, District Oyem, and Mvole Mo Ze, Clan Mkojen, Village Endum, District Oyem, yearly turned out several masks and figures, the former concentrating on masks and the latter on figures. Only the first man, to some extent commercialized by the Spanish, worked rapidly, finishing a figure in several weeks' time. All the others customarily took a minimum of several months, working sporadically on a figure or a mask, then putting it away entirely for several weeks or a month in favor of other business, whether plantation work or long trips to visit relatives. None of these men nor any other Fang carver I met could be hurried. Both Mvole Mo Ze and Mabale Oye claimed that a figure or a mask only took shape gradually, as the spirit moved the carver, and it could be rushed only at the sacrifice of its quality. By this I understood them to mean that there were many other things for a carver to do besides carve. Carvers, it may be remarked, were considerably less responsive to the European's requests than the majority of their compatriots.

Of these four men only Eye Mengeh had a position of importance in village affairs.[9] He was both *ntolomot* and *mienlam*, most active elder and economically most powerful person in the village. Eye Mengeh's business acumen and leadership qualities are the exception which proves the rule that Fang carvers are peripheral and not highly respected members of their kin groups. The rule applied without exception to all other carvers encountered. It applies to the other three men discussed here. Clemente lived with his wife and two sons in isolation from his kin and village. Mabale and Mvole Mo were both elderly men who had never accumulated much in the way of wives or renown for qualities of leadership and economic acumen. They rarely participated in debates in the council house, though they occasionally

contributed caustic commentary and ribald impieties from the peripheries. These contributions were appreciated, but carvers were not infrequently referred to as *okukut*—good-for-nothings.

I am unable to reach any satisfactory generalizations about the character of Fang carvers from my knowledge of these four men. Mvole Mo was retiring, caustic and dour. He was his father's eldest son but had been replaced in village affairs by younger brothers. He only smiled when his work was being admired and then perfunctorily. Mabale was ribald, bouncy and socially oriented, a source of absurdities and impieties. Heavily preoccupied with sex and his own failing sexual powers, he did not fail to exaggerate the sexual organs of his figures, with obvious satisfaction. He was his mother's only son. Eye was formal and dignified, the soul of graceful hospitality. When I did not compensate him quickly enough for his kindnesses to me in his village he appropriated our brass teapot, which was reproduced when our transactions were satisfactorily concluded. He had an exaggerated notion of what I should pay for his work and I was never able to establish a satisfactory clientship with him. Parenthetically and in reflection, I may say that I do not find him in the wrong. He was a middle son who had supplanted his elder brothers through death and superior competence. Clemente was preoccupied with family resentments and with the evil intentions of his brothers, who had tried to bewitch him. He had isolated himself from village affairs and could spend more time, therefore, in carving. Encouraged by the Spanish, he was rapidly becoming commercialized. The rather exaggerated respect demanded of the African in Rio Muni carried over to me, and I never learned much about him. I did learn that if I was not at his door the day a figure was finished it would be sold to another. He carved to sell and not with specific clients in mind, as was the case with other carvers who were in this respect closer to the traditional situation of special commissions.

Informants frequently argued that the *beyima* were never sold but were fabricated for the blessing, *abora*, to be obtained by making something to adorn the reliquary. Since this blessing could hardly apply to someone without the kin group, this statement is a testimony to the degree to which the figures were made within each village and not commissioned from without. But sometimes, as we have said, they *were* commissioned from without. When this occurred the leader—*ngomalan*—of the ancestor cult in question made a visit to the carver and commissioned the statue in person. He made several gifts to begin with so that the carver would see him well—*a yen nye mbung*—and be properly animated (I was brought very rapidly to understand the utility of this practice). Later the carver would deliver the figure in person and receive final compensation in the form of a modest amount of

trade goods and hospitality. (The compensation for carving has always been low.) The statue had to be ceremoniously presented to the reliquary—rubbed with the oil of the raffia palm, *djwing*, and accompanied by a meat offering to the craniums—whether it was carved locally or by a stranger. No additional ceremony seemed to be required in the latter case.

The area in which the qualitative experience of the carver as an artist and his audience as the aesthetically moved could be best observed was the council house, where a great deal of the carving took place. The thesis that there is such a thing as art criticism in nonliterate society is easily supported here. One might almost ask if art lies so much in the act of creation as it does in the relationship between creation and criticism—the artist and his critics. A lively spirit of art criticism flows around the carver as he is in the process of turning out his statue in the men's council house, and it influences his work. The carver has the prerogatives of his creation but he must still reach some accommodation with his critics, who not infrequently consider themselves the final cause of the work.[10] What this accommodation may be depends upon the personalities involved. Mvole Mo Ze retreated from the council house to the solitude of the banana plantation behind the village. But the carver cannot expect to escape his critics when the statue is completed. He cannot for lack of status impose aesthetic acquiescence upon his clients, even though his work is almost always accepted.

The criticism and aesthetic appreciation expressed in the council house most often referred to the way in which the statue was emerging from the block of wood from which it was carved as well as the priority and arrangement which the sculptor had given to the various bodily parts. When the figure first begins to become evident and issue forth from the wood—*a yen do ete*—admiration is usually expressed. For this is the crucial moment of the artist's skill and is the miracle, *akyenge*, which he accomplishes. From this point on criticism and reaction are most often taken in respect to the way the various body parts are carved and the balance established among them.[11]

Though Fang statues, in their style, characteristically exaggerate and suppress the natural, they are nevertheless, as African art goes, on the naturalistic end of the continuum. The Fang often argue that these figures and masks constitute traditional photographs. Part of the qualitative reaction of the observer is then based upon the degree to which the carver has been able to reproduce the human form ... working within those expectations set by stylistic criteria; very short and flexed limbs, long thin torso, and large head. ... The four carvers we have mentioned all claim that a good carver must study the human form and be able to reproduce it. That what is reproduced is very far from a reproduction of the human form is quite

clear to a European. What we have in this argument about 'our photography' is an indication of the degree to which culture can persuade the senses if not impose upon them: an indication, if one wills, of the degree to which artistic conventions come to have a reality of their own, symbolizing greater truths than are iconically represented.

It is clear that there are limits on the extent to which men can be persuaded of the real relevance of artistic conventions, and this is true of the Fang. Moreover, they will suspend disbelief in conventional directions but not in others. Mabale elaborated a very exaggerated male organ on one of his statues and evoked a spirited reaction ... mostly protest. He had clearly violated that collective representation which is the Fang notion of a reliquary figure. He was inspired to tell one woman who gazed on it with disapprobation not to be afraid. The member, he said, couldn't even pass water.[12]

I have elsewhere[13] indicated that though the Fang argue that their figures and masks represent living persons as the Europeans represent them in photographs, they rarely argue that these statues represent particular living persons but only living persons in general. They are not portraits. One is led to believe, since in extended discussion the Fang recognize well enough that the proportions of the statues are not the proportions of living man, that what the statue represents is not necessarily the truth, physically speaking, of a human body, but a vital truth about human beings symbolically stated. This symbolic intelligence seems to arise from the way the statue holds opposites in balance—old age and infancy; somber, passive inscrutability of visage and muscular tension of torso and legs; etc. What is expressed in these statues, then, is the essence of maturity. For the mature man, *nvamoro*, is he who holds opposites in balance.[14] The statues express the most fundamental principle of maturity and vitality (whose secret is the complementary interplay of opposites) and hence they lay claim to the most profound reality, despite their stylistic exaggerations.

Be this interpretation as it may—it is an inference developed from, but not directly contained in, informants' remarks—it relates to explicit commentary from the Fang on their figures and their relation to the reliquary. In response to the question as to which ancestor the figure represented, I have the following response from Essona Ekwaga, corroborated by Obunu Ndutuma, Clan Bukwe, Village Sougoudzap, District Oyem:

The figure represents no ancestor. There are many skulls in the reliquary. Who should we choose to represent? And who would be satisfied with the choice if his own grandfather should be ignored? The figures were made to warn others that this was 'the box of skulls' and they were made to

represent all the ancestors within. What causes us satisfaction in seeing the *eyima* atop the *bieri* is that there we see disclosed our ancestors. Their faces are strong, quiet, and reflective. They are thinking about our problems and how to help us. We see that they see.

What is implied here and in the informant's later remarks is that the statues convey to the Fang the benevolent disposition of the unseen world (*engang*), conceived by them as the world of the dead spirits. The religious figures, in short, in their peculiar tension, their inscrutability atop the collection of craniums, help convey to the Fang ancestor-worshiper what he so devoutly desires to know—that all is in order in the unseen world. Part of his aesthetic satisfaction in respect to these statues is bound up in a conviction conveyed by them; a conviction that the moral order which is the universe of the unseen is favorably disposed toward him.

Our conclusion at this point is altogether implied in what we have said. It is the carver in his art who enables the order of the unseen to be exposed. Though any statue, regardless of aesthetic quality, may serve to 'defend' the *nsuk*, not all attain that quality of balance and inscrutability which conveys as it exposes some kind of overriding order in the universe. The power of the carver's art to help convey this order is esteemed but by and large it is not, as we have shown, very highly respected.[15]

NOTES

[1] A very substantial price, in the tens of thousands of dollars, was given for a famous Fang reliquary head from the collection of Sir Jacob Epstein. This head is now one of the prize items in the collection of the Museum of Primitive Art, New York.

[2] Gunter Tessmann, *Die Pangwe. Volkerkundiche Monographie eines Westafrikanischen Negerstammes* (Berlin: Wasmuth, 1913).

[3] The term for exceptional skill or talent—*akeng* (in the Ntumu dialect, *akunge*)—is, in substantive form, applied to the skillful or talented person —*nkengbe*. The term *akeng* is sometimes translated secondarily as 'art' and *nkengbe* as 'artist' (Samuel Galley, *Dictionaire Français-Fang, Fang-Français* [Neuchâtel: n.d.]), though it is clear that the creativity component of skill and talent, so essential to the Western use of the term and its distinction between the artist and the artisan, is not implied. In my own experience, it is true, the term *akeng* was often used with a connotation of awesomeness, as if the skill in question was as much lodged in the supernatural as in the natural course of events.

The distinction between the good and the beautiful arises in relation to

these materials. The three generic terms of appreciation in Fang—*mbung, mve, mba* (or *mbamba*)—are all translated as meaning both good and beautiful (*bon et beau*) by Galley and others, though they tend to have their appropriate semantic space. *Mbung*, for example, is particularly applicable to feminine qualities and *mve* to the masculine. *Mve* and *mba* are extended more often to beneficial social actions. A person who conducts himself skillfully in social relations so as to promote harmony would be more likely appreciated as *mba* or *mve* than *mbung*. Thus, in reference to our discussion here, *mbung* is the term of appreciation more often employed in respect to ancestor figures, *mve* or *mba* to the actions of those imposing social order. In any case, the debate as to the distinction between the good and the beautiful could hardly, for linguistic reasons, be easily posed or satisfactorily carried out by the Fang.

[4] Of a total of fifteen carvers of masks and figures encountered in the field, only one took up the art from his father. Half were taught by classificatory fathers, *i.e.*, by patrilineal relatives in their own village. The rest picked up the impetus in the villages of relatives, usually on the mother's side. But this teaching process is not sharply defined and often consists simply in the opportunity to help cut away excess wood before the figure emerges and to help polish it when it is completed. Since practically all children sculpt animals and figures out of the very soft and spongy wood of the raffia tree, *dzam*, they obtain some practice in the art without any formal kind of apprenticeship.

[5] Village fission was frequent, usually taking place through the cleavage of two extended families (*ndebot*) who were no longer able to live together as one *mvogabot*—'village of people.' When the reliquary was itself divided in this cleavage a new figure was needed. Because of the greater stability of villages in the early days, there was less demand for figures than was characteristic of the intense fission of the colonial period. Even in cases of village fission, however, there was not inevitably a need for a new figure as two extended families may have been celebrating the ancestor cult together but maintaining separate reliquaries. Tessmann pictures such a situation (*Die Pangwe*, II, 125). In short, the demand for reliquary figures was not very great in traditional times.

[6] Tessmann, *Die Pangwe*, II, 118–120; F. Grebert, *Au Gabon* (Paris, 1921), p. 79. In 1957 an anti-witchcraft and purification movement swept northern Gabon in which a great number of reliquary figures were confiscated. The vast majority of these were by any standards very crude objects.

[7] William Fagg and Eliot Elisofon, *The Sculpture of Africa* (London and New York, 1958), p. 160. Fagg remarks how little is known of these interesting masks. Both helmet and half-face masks were made. The Lowie Museum, at the University of California, contains some of the best examples of each to be found in European or American collections.

[8] Made for the Lowie Museum at the University of California, Berkeley.

[9] Importance is a function of wealth, calculated by reference to the number of wives, and of effective authority exerted in the council house.

[10] This tendency to consider the carver as only the efficient cause of

aesthetic satisfaction is corroborated by the degree to which many Fang, not themselves carvers, have definite formal criteria in mind to which the statue ought to conform. The following criteria of Ayang Ndong, Clan Essisis, Village Etsam, District Medouman, are not untypical: 'A statue has six cutting points: (1) forehead to chin, (2) chin to knee, (3) back of head to buttocks, (4) buttocks to tip of calf, (5) tip of feet to knees, (6) tip of calf to ankles. All of these cutting points in any good statue should be in a line.'

[11] Both arms and both legs, for example, should be carved with identical proportions so that the figure is balanced. This applies to eyes, ears, feet, etc. Mabale Oye, the oldest man who carved for me, was failing in sight as well as in concentrated muscular control. His figures therefore showed some imbalance. Though more interesting to me for that reason, they were criticized by the Fang.

[12] The presence of women at the carving seems inconsistent with the function of the figure, to 'defend' the reliquary against the uninitiated: women and children. The custom of keeping children and women out of the council house, however, is nowadays much relaxed. But in any case it was not the figure in the process of carving that had awesome power. It only developed this power through its ritual associations with the reliquary itself.

[13] James W. Fernandez, 'Principles of Opposition and Vitality in Fang Aesthetics,' *Journal of Aesthetics and Art Criticism*, Fall, 1966, pp. 53–64.

[14] He is, for example, able to balance off conflicting opinions in debates in the men's council house. But more fundamentally he most successfully combines the contradictory inheritance of female blood (*maki me mininga*) and male sperm (*meyom*), each of which provides him with a different set of qualities—reflection and will, etc.

[15] It should be reiterated that it is more than the carver's art, it is also the ritual association with the craniums, which gives the statue its power. Since the carver himself does not usually participate in the ritual process by which the statue is incorporated into the ancestral cult and located atop the reliquary, very little charisma attaches to him.

NELSON GRABURN

The Eskimos and Commercial Art*

THE MOTION PICTURE and the mobile are considerably more ancient art forms than Eskimo soapstone carving. Only in the last two decades have the Eskimos of the Eastern Canadian Arctic been producing these carvings, although they have already become commonplace in museums, arts-and-crafts stores and the homes of middle-class North America. The short history of these carvings suggests certain worldwide acculturative processes and poses new problems about the relationship between art and culture.

Until very recently, these Eskimos produced little that we would call art. Occasionally, for the amusement of themselves and their children, they carved small models—usually in ivory but sometimes in soapstone—which are called *pinguak*. Literally, the word means 'imitation of a thing,' but it is usually translated as 'toy' because that is how these models, an inch or two long, were used. There were amulets or charms made of lightly carved whale or bear teeth; shamans wore these in quantity, but most people wore one or two. Also, everyday utensils of wood, bone or ivory were sometimes etched or scratched for decorative reasons. The Eskimos had no over-all concepts of art or aesthetics, but, of course, they knew what they liked. The word *takuminaktuk* means 'it is good to look at, or beautiful,' but it could be applied to a sledge or the northern lights or any other natural or manufactured phenomenon, and not just to the *objets d'art* I have mentioned.

The arrival of the white man in the North meant a demand for souvenirs. During the first two centuries of regular contact, this demand was satisfied

* Reprinted with permission of the author and publisher from 'The Eskimos and "Airport Art",' by Nelson H. H. Graburn, *Trans-action* (St. Louis, Mo., October, 1967), pp. 28–33, copyright © 1967 by *Trans-action* magazine.

through trading in the normal manufacture of the Eskimos—parkas, har-
poons, utensils and so forth. Few carvings were offered, but as long ago as
the 1880's, anthropologists noted that such carvings were distinctly souve-
nirs. In return, the Eskimos received the manufactured objects of the white
man—guns, nets and steel harpoon tips, for instance—and generally thought
they were getting a bargain. They could always make more of what they had
offered in exchange.

CREATING AN ART FORM

It was not until 1949 that any concerted attempt was made to sell these
objects other than by direct exchange. The year before, James Houston, a
Canadian artist, visited Port Harrison, Quebec, on the east coast of Hudson
Bay. Houston collected a small number of ivory and soapstone figurines,
which he took to a Montreal art exhibition where they were admired and
sold. The next year he returned to encourage the Eskimos of Port Harrison
and the nearby settlement of Povungnituk to produce more carvings for
sale 'down south.'

Ivory from the fast-disappearing walrus was rare. Whatever was available
was already being used. Soapstone is abundant. It is called 'lamp material'
(qullisak) because it was widely used in making ordinary utensils such as
lamps and dishes. The rarity of ivory also meant that the people of the area
were less accustomed to and less skillful in working it.

The old Canadian Department of Northern Affairs and other agencies
responsible for the welfare of the Eskimos were quick to see the chance to
increase the cash income of the Eskimos through expansion of this venture.
Since World War II, their economic position had been weak because of the
poor prices paid for skins. Houston was prevailed upon to return north to
encourage the production of figurines and spread the idea to other settle-
ments. It is said that he even trained some carvers and persuaded the govern-
ment to produce a do-it-yourself manual for others. In the summer of 1950
he brought back $3,000 worth of carvings. Sugluk and Cape Dorset on the
Hudson Strait about 450 miles north of Port Harrison became important
carving centers, and later other smaller settlements took it up. By the end
of the 1950's the annual production was being measured in hundreds of
thousands of dollars. A system of marketing was established with the
Hudson's Bay Company and the Canadian Handicrafts Guild.

In Povungnituk an enterprising missionary started a Sculptors' Associa-
tion. This unique organization was a guild in which the better carvers were
to produce, price and sell carvings of supposedly higher quality. It became

a prestige group to which other carvers might aspire. Admission to the group was extended by the members on the basis of quality. The Hudson's Bay Company store continued to buy carvings from the rest of the population. This competition meant higher prices for all the carvers.

The carving boom was a response to the economic position of the Eskimos. They were caught between a rising total population and constant or declining natural resources. Wage employment was for the very few. Port Harrison, Povungnituk, Sugluk and Cape Dorset greatly increased their production. By 1952, 20,000 carvings had been sold; by 1954, 30,000. The total income of Sugluk from all sources in 1956 was $66,000. Carving alone accounted for half of it. Nearly all adults carved, and some were almost full-time specialists.

In 1957 the Hudson's Bay Company surveyed the market and its inventory and suddenly, without warning, stopped buying carvings at a few settlements. The Eskimos were distraught and often destitute. One man recalled: 'We were so poor that it was like the old days; we could not even afford to have a cup of tea before going hunting in the morning!' The demand for welfare rose sharply, and the government began buying carvings. Later, when the demand picked up, the Company started buying again, although more selectively than before. Competition was the result, and carving has continued to be a major economic support, although never to the extent of the first years.

In the 1960's, the Sculptors' Association of Povungnituk began operating a full-blown cooperative store in competition with the Hudson's Bay Company. Similar arts-and-crafts cooperatives have been started with government support in most of the major settlements.

In 1959 the industrious James Houston introduced another 'Eskimo' art form; Eskimo prints using soapstone lithography or sealskin stencils were made under his direction at Cape Dorset. Under the auspices of white agents, this technique has spread.

SOAPSTONE AND SUBJECT MATTER

Soapstone is found throughout the Eastern Arctic area in large veins, often near the coast. It is mined in the summer by Eskimos of the nearby settlements, who use axes and sometimes large saws. The blocks of stone are shared among the men of a family or camp, and each man usually has a supply in his household so that he may carve whenever there is little else to do. The blocks are roughly shaped with small metal axes and the carvings are then perfected using chisels, awls and drills, all of which are purchased

at the settlement store. The final polishing may be done with sandpaper, and some carvings are then oiled to produce a particularly dark, shiny surface.

The commercial carvings of the modern era are incomparably larger than the traditional *pinguak* toys and may weigh 100 pounds. They are produced for an entirely different consumer and occupy a far greater place in the life of these Eskimos than any previous nonutilitarian manufacture. However, carving shares many characteristics with the 'art' of a growing number of other contemporary 'primitive' peoples.

The subject matter of the Eskimo works is usually confined to human and natural phenomena with which the carvers are familiar, such as animals, people, hunting and camping. In Povungnituk and Cape Dorset the Eskimos have been encouraged to add scenes and figures relating to their traditional mythology. The Eskimos themselves, however, have been devout Anglicans for many decades. From the great range of phenomena with which the Eskimos are now familiar—including much of the industrial culture of North America—there is considerable selection in favor of what is felt to be traditional.

Very little study has been given to the influence of the market on the content, much less the style, of these carvings. I do know that many carvings have proved relatively unsalable because the white man's market could not identify them as 'Eskimo' or 'primitive.' One of the best carvers at Great Whale River was unable to sell an excellent sculpture of a human figure that had been inspired by the Steve Reeves movie *Atlas*. Edmund Carpenter reports that Eskimo inmates of a government tuberculosis sanatorium in Ontario did carvings of Edsels and kangaroos. These were destroyed by officials on the grounds that they were not authentic.

Still, many of the carvings reflect an Eskimo life that is not truly traditional—for instance, scenes of hunting with guns or fishing with nets. In some cases, most Eskimos and all whites are unaware that the subject matter is not traditional, as in carvings that show the parka with a peak.

In spite of the obvious pressures on them, the Eskimos do not seem to be bothered by these limitations on their subject matter. In fact, most seem to prefer to carve objects which they believe to be 'Eskimo' and enjoy the identification with the past and the fact that the white man could hardly attempt to do the same.

One important consideration is that there is no special class of artists in this medium. (This is not true of the printmakers.) Soapstone carving tends to override even the traditional division of labor by age and sex. Young children have been encouraged by their parents in the hope of

increasing the family income. Not only do most adults attempt carving, but they are usually successful—that is, the carvings sell.

While most carvings cannot be classified as great art, the vast majority are by no means mediocre. From our point of view, most Eskimos have a superior ability to carve in soapstone. Two factors seem to explain this: familiarity with the tools, materials and subject matter; and an extremely well-developed series of mental and linguistic conceptions of space and form. The latter is probably related to the necessity of visualizing and communicating location and shape in a relatively featureless landscape. Carpenter gives a striking example of this skill:

> Of course, what appeared to me as a monotonous land was, to the Aivilik [an Eskimo group], varied, filled with meaningful reference points. When I travel by car I can, with relative ease, pass through a complex and chaotic city, Detroit for example, by simply following a handful of highway markers. I begin with the assumption that the streets are laid out in a grid and the knowledge that certain signs mark my route. Apparently the Aivilik have similar, though natural, reference points. By and large, these are not actual objects or points, but relationships: relationships between, say, contour, type of snow, wind, salt air, ice crack.

One observer claimed that the Eskimos were completely unable to make good judgments about the quality of their own carvings and that the Sculptors' Association was thus not pricing the pieces correctly. In the vast majority of the settlements, the white man is responsible for the pricing. To the Eskimos the rewards of carving are financial rather than aesthetic. Most works are produced when there is nothing else to do—in bad weather, for instance. Carving is also done when money is needed and there is no other means of obtaining it, which may be most of the time in some areas.

Once I was returning from a whale hunt in the Hudson Strait when we spotted a ship far off. One young Eskimo quickly took a piece of soapstone from a quantity that we had mined and carved a seal by the time we reached the ship. We went on board, and he immediately sold the carving for $2.50.

The rate of return on most carving, however, is about fifteen to fifty cents an hour, though this has risen recently. When the opportunity arises for some more pleasurable occupation, a carving may be left on the floor, whatever its state. Many are broken or lost before they can be finished. I interviewed nearly all of the ninety adults of one settlement, and all but one said he disliked carving although it was necessary to earn a living. In another

settlement, a long-time white resident fluent in Eskimo thought that only one carver really enjoyed his work or took pains to 'get things right' for his own satisfaction.

It is often asserted by the retailers that no Eskimo ever carves two pieces alike or copies another's carvings. This is said to prove that all Eskimos are artists. This is not true. An individual 'down south' rarely sees more than a small proportion of the output of any one man. I asked one old man in Ivujivik why he always produced 'Man sitting on a walrus head.' He replied that he did the carving well and it was a good seller. The Canadian government propaganda has made much of the great range of subject matter in order to help the market, but the government has recently admitted the repetitions, and now one may even order carvings by number of the artist.

There is a great deal of variety, however. Not all soapstone is of the same color or consistency. Often the type of stone identifies a certain settlement's production. Furthermore, each settlement seems to develop its own style. Although the reasons for this have not been investigated, I can suggest that the nature of the stone available and conscious or unconscious copying of the more successful carvers may affect local styles.

ACCULTURATION AND ART

The place of carving in the economic side of acculturation is most clear. Carving is an occupation which the dominant white man rewards well because he could produce the result himself only with great difficulty. Few white men have ever been known to carve soapstone successfully. During the boom in the 1950's, 'Eskimo soapstone carvings' were produced in the Orient, but they were obvious fakes to the trained eye. The Canadian government put an end to the practice by registering a trademark for the genuine article. I do know of one Japanese-Canadian anthropologist who passed as an Eskimo and sold his carving for $7 to the crew of a ship visiting a northern settlement.

Carving has fallen into place as a natural occupation alongside fox-trapping and seal-hunting. If carving had not developed, the Canadian government would have been saddled with an even greater welfare burden because of the lack of a sound economic base. This is typical as a stage in worldwide acculturative processes where the original special economic relationship—for the Eskimos, fox-trapping—is no longer adequately beneficial to either side. The controlling authorities find themselves in a situation where they no longer need the large indigenous population and yet do not know what to do with it. The subordinate group is not ready for

assimilation even if the larger population would allow it. Yet total neglect is impossible.

From the aesthetic point of view both the white buyers and the Eskimo sellers admit the pleasing quality of the carvings. To the majority of buyers the works are simply Eskimo or even 'primitive' art. The Eskimos themselves still have no conception of art; they call the carvings *qullisangmik sanasi-mayanga*, 'things made out of lamp material.' A few talented individuals have an 'artistic' approach to their work, but these are not necessarily those whose works sell best. An examination of both form and content cannot reveal whether the creator was trying to meet his own requirements or to make money, or both. In our own society we depend on the special class of artists and art critics to tell us what is art and what is good art. This difficult task is rendered more difficult when the artists are in one culture and the critics in another.

If we are to judge the carvings on technical merit—control of material and technique—we must conclude that nearly all Eskimos are artists. We would probably come to the same conclusion about the Australian aborigines of Arnhem Land at Yirrkalla and Milingimbi, though their bark paintings are in a traditional technique. Carpenter asserts, however, that soapstone carving is 'a new, delightful non-Eskimo art that has brought financial assistance to needy Eskimos and joy to many Western art connoisseurs.' He bases this on the grounds that the idea and the market are the white man's and that the form resembles white efforts more than it does the traditional Eskimo *pinguak*. However true this may be, the assertion that the carvings are non-Eskimo is untenable because only Eskimos can produce them. Carpenter could answer, of course, that the producers are not 'real Eskimos.' Still, Charles A. Martijn, in his very fine summary on the subject (*Anthropos* 59, 1964), is much nearer the point when he says: 'carving is an Eskimo art, but one of directed acculturation.'

There are a number of parallel cases of acculturation art, or 'airport art,' as it is sometimes called, such as that of Navajo silversmiths, Arnhem Land bark painters and Kamba wood-carvers of East Africa. Airport art has been little studied as such, however. In all cases there has been considerable modification of style and even introduction of new materials in order to satisfy a market. The culturally embedded meanings of the productions have become tenuous, and in many cases 'mass production' has been introduced as well. Eskimo prints are a particularly striking example. These phenomena are characteristic of the structural position of the small-scale peoples with respect to the world's dominant socio-economic systems.

Acculturation art may also tell us much about social changes among its

producers. In Great Whale River, for example, the Naskapi Indians living alongside the Eskimos abandoned their traditional wood carving in favor of soapstone. No doubt they hoped to cash in on the demand. But their first efforts in soapstone, while technically proficient and aesthetically pleasing, still looked more like Naskapi wood carvings than Eskimo soapstone works. They have recently been forbidden to carve stone for fear of the buying public confusing them with Eskimo carvings.

Now, however, the difference between the two carving styles is disappearing. Indian and Eskimo pieces have begun to look very much the same. What is significant here for the relation between art and culture is the fact that this assimilation of art styles has been closely paralleled by assimilation of another sort: the fast-developing coalescence of Eskimos and Indians into an undifferentiated 'native lower caste.'

The Canadian Eskimos are producing an art form which is a good example of that long-neglected category of 'transitional' or 'acculturation' art. For a century or more Western man has been excited by the exotic, and collections of 'primitive' art are numerous. However, even today, when so little truly traditional art is being produced, many still consider it somehow impure to take a serious interest in the artistic production of those many peoples who have come in contact with civilization. Such an approach ignores artistic values. Just as people do not stop being people just because they are becoming assimilated, neither does their art cease to be art just because it is no longer traditional. The Eskimos have developed a new art form in response to demands from the outside, and they have successfully incorporated traditional themes into a style much admired by the market. They are using new (metal) tools with great skill on a material—soapstone—with which they were already familiar. Far from 'degenerating' with the increasing influence of civilization, their present art, in many opinions, surpasses anything they have produced previously.

If we are seriously interested in art, rather than in the titillations of the exotic, the Eskimos should be considered artists first and members of an exotic culture second. The Canadian government has taken a lead in encouraging the artistic abilities of its indigenous citizens, and this example might well be followed in many other countries where the potential of native groups is still untapped.

SUPPLEMENTARY READINGS

A. SOCIALIZATION AND CAREERS

Howard S. Becker and Anselm L. Strauss, 'Careers, Personality, and Adult Socialization,' *American Journal of Sociology*, LXII (1956), pp. 253–63.

Kenneth Clark, *The Nude: A Study in Ideal Form*, New York: Pantheon, 1956. Primarily a study in art history and aesthetics but contains many insights into the relationship between art and society.

Ananda K. Coomaraswamy, *The Religious Basis of the Forms of Indian Society*, New York: Orientalia, 1946. An analysis of Indian art from various points of view, including the social-psychological.

Louise Cowan, *The Fugitive Group: A Literary History*, Baton Rouge: Louisiana State University Press, 1959. An excellent study of the effect of face-to-face interaction upon the emergence of an original poetic style.

Adrian A. Gerdrands, *Wow-Ipits: Eight Asmat Woodcarvers of New Guinea*, The Hague: Mouton & Company, 1967. A detailed description of the individual procedures and styles of the wood carvers, which corrects the view that primitive artists mechanically reproduce the traditional art style of their culture.

E. H. Gombrich, *Meditations on a Hobby-Horse*, London and New York: Phaidon, 1963. A collection of articles on various facets of art. See especially the critical article on Arnold Hauser's *Social History of Art*, pp. 86–94.

——, *The Story of Art*, 11th ed., London and New York: Phaidon, 1963. An introduction to the history of art, with many social references.

Mason Griff, 'The Commercial Artist: A Study in Changing and Consistent Identities,' in Maurice Stein, A. Vidich, and D. White, eds., *Identity and Anxiety*, Glencoe, Ill.: Free Press, 1960, pp. 219–41. A study of the careers and dilemmas faced by art students and artists.

——, 'Conflicts of the Artist in Mass Society,' *Diogenes*, 46: 54–68 (1964), pp. 61–94. A report based on a social-psychological study of the artist who, unable to earn a living by painting, becomes a commercial artist.

Thomas Hardy, *Jude the Obscure*, New York: The Modern Library, n.d. A novel depicting the development of the acute sensitivity to life commonly associated with the role of the artist.

Everett Cherrington Hughes, *Men and Their Work*, Glencoe, Ill.: The Free Press, 1958.

Janheinz Jahn, *Muntu: The New African Culture*, London: Faber & Faber, 1961. The social, psychological, and philosophical factors of African art.

Alfred Lord, *The Singer of Tales*, Cambridge, Mass.: Harvard University Press, 1964. An empirical study of the training and creative processes among oral epic artists. The object of the study was to answer several enigmatic questions concerning the origins and development of the Homeric poems. The more relevant sociological materials are in the introduction and first chapters.

Herbert Marcuse, *One-Dimensional Man*, New York and London: Routledge &

Kegan Paul Ltd., 1964. Concerns the effect of mass society on the role and product of the artist. See especially pp. 247ff.

Gian-Carlo Menotti, 'A Plea for the Creative Artist,' in Fernando Puma, ed., *The Seven Arts*, Garden City, New York: Doubleday, 1953. A comparison of European and American attitudes toward composers.

Patrick Mullahy, *Oedipus: Myth and Complex*, New York: Hermitage, 1948. See pages 162–207 for a discussion of 'The Theories of Otto Rank' regarding the differences in personality development between the artist and the non-artist.

George Orwell, *Keep the Aspidistra Flying*, New York: Harcourt, Brace & World, Inc., n.d. A novel about a poet who attempts to make a living from his art but fails. Illustrates a major problem faced by artists in contemporary society.

Herbert Read, *Art and Alienation*, New York: Horizon Press, 1967. Most of these articles emphasize the social basis of modern art. However, 'Rational Society and Irrational Art' is a well-balanced critique of Marcuse's 'one-dimensional society,' specifically, the theory that the developing technology tends to invalidate not only certain styles of art but also the very substance of art.

L. Stern, 'George Lukacs: An Intellectual Portrait,' *Dissent*, Vol. 5, 162–173. A concise statement of Lukacs' background and life. Includes a short discussion of Lukacs' theories concerning art and mass society.

B. SOCIAL POSITION AND ROLES

Ulli Beier, *Art in Nigeria*, London: Cambridge University Press, 1960. Details the effect of acculturation on the role of the artist and his art. Excellent photographs.

Louis Dudek, *Literature and the Press*, Toronto, Canada: Ryerson, 1960. Contains a wealth of material on the effects of mass society on the creative product of writers.

James W. Fernandez, 'Principles of Opposition and Vitality in Fang Culture,' *Journal of Aesthetics and Art Criticism* (Fall, 1966), 53–64. An empirical study which supplements the selection by the same author in this book. It shows a remarkable similarity between the aesthetic evaluation of Fang culture and Heidegger's metaphysical statement concerning beauty. See Herbert Read's article, 'The Origins of Form in the Plastic Arts,' pp. 35–54, above.

Sigmund, Freud. *On Creativity and the Unconscious*, New York: Harper & Brothers, 1958. A famous study which attempts to reconstruct the social, psychological, and humanistic factors in the creative processes that result in the production of a masterpiece. See especially 'The Moses of Michelangelo,' pp. 11–41.

Jean Gimpel, *The Cathedral Builders*, New York: Grove Press, 1961. A model of scholarship, first published in French. Gives technical, historical, and sociological accounts of the building of cathedrals in Europe from 1050–1350, one of the greatest manifestations of man's creative genius. Illustrations are sensitive and superb.

Jane E. Harrison, *Ancient Art and Ritual*, London: Butterworth, 1927. An important sociological study of dramatic art. See especially pp. 119–69, on 'The Transition from Ritual to Art.'

Francis Haskell, 'Art and Society,' *International Encyclopedia of the Social*

Sciences, pp. 439–47. A concise statement of the role and status of the artist in Europe over time. Selected bibliography at the end of the article.

———, *Patrons and Painters: A Study in the Relations between Italian Art and Society in the Age of the Baroque*, New York: Knopf; London: Chatto and Windus, 1963. A scholarly work of paramount importance. It suggests a number of further research possibilities along the same theme but for other eras, including the contemporary. Draws mainly on primary sources.

Karl Jaspers, 'The Axial Age of Human History,' in Stein, Vidich, and White, eds., *op. cit.*, pp. 597–605.

Robert K. Merton, 'Introduction' to *The Crowd*, by Gustave Le Bon, New York. Viking Press, Inc., 1960.

Geraldine Pelles, *Art, Artists, and Society: Origins of a Modern Dilemma*, Englewood Cliffs, N.J.: Prentice-Hall, 1963. A survey of French and English painters, 1750–1850, describing their shifting positions and accompanying dilemmas.

Marian W. Smith, ed., *The Artist in Tribal Society*, New York: The Free Press of Glencoe, 1961. Papers presented at a symposium by Charles P. Mountford, Edmund Leach, Paul Bohannan, and others, with comments by Herbert Read and other participants. The papers describe the position of the artist in various tribal communities and discuss the role of the artist and his art in society.

Wallace J. Tomasini, 'The Social and Economic Position of the Florentine Artist in the Fifteenth Century,' Ph.D. dissertation, University of Michigan, 1953.

Harrison White and Cynthia White, *Canvases and Careers: Institutional Change in the French Painting World*, New York: John Wiley, 1965. A study of the Impressionist painters, their role, status and interrelationships with dealers, critics, and other significant persons in the art world.

William Willetts, *Chinese Art*, New York: Braziller, 1958, pp. 501–652. See especially the section on 'Status of the Artist.'

Florian Znaniecki, *The Social Role of the Man of Knowledge*, New York: Harper & Row, 1968. While primarily a work in the sociology of knowledge, this book offers many suggestions for the use of the same framework in other areas of the sociology of art.

Part III

DISTRIBUTION AND REWARD SYSTEMS

III. DISTRIBUTION AND REWARD SYSTEMS

Introduction

THE SOCIAL POSITIONS and roles of painters, sculptors and writers exist within a larger social complex of relations and structures termed 'reward systems.' These systems are the apparatus for rewarding creative artists with money, prestige, and honors. Thus they enable at least some artists to earn a livelihood and to obtain other types of recognition for their artistic efforts. In Western Europe these rewards were traditionally provided by patronage systems from the Middle Ages until some time during the nineteenth century, when radical changes occurred.

Under the traditional system, wealthy and powerful persons either provided regular financial support for artists at work or could be depended upon to buy completed works of art that were done according to their taste. This arrangement gave the artist some degree of financial security, but he often had to sacrifice his own artistic predilections to the wishes of his patrons. If these were men of developed taste and exacting standards, the artist was fortunate; if not, he had to please the patron even at the expense of his artistic integrity. In these circumstances, patrons had considerable influence on the work of the artist, although how and to what degree this influence operated are still matters for debate.

This issue is the subject of Henning's article, which makes the point that most discussions of social influences on art are unable to account for stylistic diversity in a given society at a particular time. Henning argues that patrons have always had the power to require

that artists provide specific kinds of art as a condition of purchase. He concludes, therefore, that stylistic diversity among artists living at the same time *can* occur when there are two or more patronage groups with different aesthetic needs and approximately equal power to select works of art that satisfy their needs.

Henning admits that this sociological explanation has severe limitations when applied to the art of the contemporary Western world because patrons today are less powerful and seldom in direct contact with artists. Today, the dealer intervenes between the artist and the potential patron, and most dealers are guided chiefly by motives of financial gain. This leads to great stylistic diversity in a market that emphasizes novelty in art. For this and other reasons, patronage in the traditional sense no longer influences painting as it did before the nineteenth century.

Pevsner's comparison of the systems of monetary and prestige rewards that prevailed in France and Holland during the seventeenth century also illustrates how social factors condition art. In France, the king and the nobility were the recognized patrons of art and demanded the distinctive types of art—whether in painting, textiles, sculpture or literature—that they considered appropriate to their traditions, taste, and style of life. In Holland in the same period, the art patrons were mostly successful merchants and tradespeople. They had smaller resources than the French aristocracy and did not demand costly art. Nor were their standards of artistic excellence so high.

In France, the artist had little freedom of choice; he had first and foremost to please his patrons. In Holland, on the other hand, the artist had great freedom to create as he wished—so long as he paid his guild taxes—but he had to take his chances on finding buyers in the open market. Many of those who bought art in Holland during this century had little artistic discrimination. As a result, even so great an artist as Rembrandt was popular only so long as he painted simple, easily understood pictures.

French artists who were designated 'Painters of the King' were required to attend the Royal Academy of Painting and Sculpture. This ensured that they would be trained only by those who followed traditional forms and that any nonconventional style of painting would be discouraged or suppressed. The lack of a monied middle

class in seventeenth-century France prevented the development of an alternative outlet for the work of artists and gave to French art of this period a highly developed but monolithic character. In Holland there was no comparable training for artists, but established artists frequently took private pupils. If they lost their popularity, they also lost commissions and pupils. This arrangement encouraged a variety of talents and styles and allowed unrestricted training of pupils at the hands of successful painters. Each system had advantages, and both produced great artists and great works of art.

The continental system of patronage, controlled by monarchs, aristocrats, and churchmen, underwent massive changes in France toward the end of the eighteenth century and in the early decades of the nineteenth. Daniel Fox discusses this shift by tracing the rise of state patronage following the French Revolution and as a consequence of the destruction of the power of the Academy. The establishment of a Commune of the Arts in 1790 marked an entirely new conception of art patronage and was the forerunner of ideas and practices that found expression in the WPA Arts Project in the United States and in similar ideas and practices in England, Germany, Italy, and Russia. Fox discusses the effects of state patronage on the character and quality of the artist's work, concluding that not all stylistic changes can be attributed to external social and economic factors. He argues that twentieth-century forms of patronage have evolved largely from nineteenth-century foundations and reflect an altered role for the artist in the modern social order.

Harold Rosenberg has explored certain aspects of art patronage in contemporary America in terms of what he sardonically calls 'The Art Establishment'—a conjectural structure of individual patrons, museum officers, dealers, collectors, and publicity agents, plus a large number of persons whose chief involvement in art is gossip about the private lives of artists and their associates. Except for this last group, members of the Art Establishment are united by their shared interest in the enjoyment, exhibition, purchase, and sale of works of art. Rosenberg fixes the center of the Art Establishment in New York City, with influence radiating to other urban centers throughout the United States and to other parts of the world. He faults the Establishment for its lack of firm standards, its relentless search for novelty and

its overconcern with the financial aspects of art, which he believes cause the reputations of artists to fluctuate far too rapidly by subjecting their work to the vagaries of fashion, the market and the manipulations of publicity. Rosenberg's article highlights the instability of the reward systems, both informal and formal, that dominate the visual artist's world today.

The writer confronts a different set of circumstances than the visual artist: Paintings or sculptures are created in single units that may be bought by individual patrons, dealers, collectors, museums, art galleries; the reward will be determined by some kind of market system or by prices set by commission agreements; a painter's works will be few, and each one unique in some respects. On the other hand, Escarpit points out, the writer's rewards depend on how and by whom his works are printed and distributed. Publication is essential if the writer is to be rewarded for his efforts. The nature of his compensation is determined by the publication system that selects, prints, and distributes literary creations.

Historically the trend of publication is one of increasing specialization of functions: from printer to printer-bookseller to the modern publisher, who coordinates the activity of the printer and the bookseller, deals with the author, handles publicity and advertising—all in the interest of profit-making. This has been the general pattern since the eighteenth century. Printer-publishers and bookseller-publishers still exist, but the pattern of specialization is well established. The publisher is the crucial figure in the distribution of an author's work, and his enterprise, resources, and generosity affect the size of rewards for all concerned. Authors frequently move from one publisher to another in an attempt to maximize their income or to find more congenial working relations, but, ultimately, writers are entirely dependent upon *some* publisher unless they are able to pay for publication of their work.

In the contemporary world the distribution of literary works and the rewards accorded their authors are influenced by the mass-media technology and economic organization. Lacy points out that authors of successful books currently have audiences numbering in the millions, and that an occasional author receives as much as a million dollars for a single book—including regular royalties, book-club, motion-picture

and reprint rights. However, to receive such compensation and distribution the book must suit the needs of the mass media rather than satisfy the creative wishes of the author or even please an audience. The media tend to serve their own ends, which are to make profits from publicity and advertising, and they direct the efforts of writers and other artists in a manner reminiscent of the Renaissance patrons discussed by Henning.

Although book publishing is a growing industry, it has retained in its economic organization certain characteristics that free it, in some respects, from mass-media influence. The publisher is essentially an entrepreneur whose function is to bring the book into physical existence by risking the costs of manufacture and distribution. This business is highly speculative. However, the entrepreneurial role of the publisher does not require a large capital investment relative to other pursuits. This fact has made possible the publication of many books by small firms that cannot take advantage of the economies of mass production and advertising. In addition, many small firms are willing and even eager to take chances on publishing books in the hope that a fortunate selection will appeal to the public or to the mass media so that both author and publisher will enjoy large returns. The other factor that encourages publishers to risk issuing works from which small profits can be expected is the stability and steady growth of the textbook market, which constitutes the largest sector of the book industry.

The selections in this section describe and analyze the institutional arrangements used at various times to reward the painter, sculptor, or writer and to distribute his works. These selections deal only with the visual arts and literature. It is likely that different patterns operate in the performing arts, such as symphony orchestras, dance groups, operatic groups and the theater. For example, the article 'Competition, Cooperation, and Group Cohesion in the Ballet Company,' by Sondra Forsyth and Pauline M. Kolenda, in Part II A, *Socialization and Careers*, provides some clues to the reward system of dance groups. Apparently the greatest rewards of dancers are not monetary but rather recognition for technical and professional excellence as established by the achievement of prominent roles within the company. These dance roles, such as leads, solos and high-ranking

positions within the company, are clear signs of social esteem and furnish personal satisfaction to the dancer as well. Recognition by the public is important to the dancer but subordinate to the judgment of professional peers. The ballet performance is presented by a group, not by a single individual, and the reward system reflects this fact.

EDWARD B. HENNING

Patronage and Style in the Arts: A Suggestion Concerning Their Relations*

I. SOME PROBLEMS AND SOME ATTITUDES CONCERNING STYLE

ALTHOUGH MOST HISTORIANS agree today that art styles are determined to some degree by the social context which gives them birth, there is still great disagreement concerning the extent of influence and the way in which it operates.[1]

The economic determinists from Plekhanov to Antal and Hauser have done valuable spadework describing the economic and social structures of historical periods and the artist's position within them. They have suggested that art styles can be ascribed to a complex of class reactions within a social and economic situation.[2] This is valuable so far as it goes, but it fails to give a clear account of the process by which class reactions are translated into actual works of art of a particular kind. A serious weakness of this school of thought, however, is its tendency toward a mechanistic system which fails to take into account the psychology of the individual, especially the creative artist.

The need for synthesis of the social and the psychological methods of study is obvious and was proposed by Walter Abell in an article in the *Journal of Aesthetics and Art Criticism* in 1953.[3] Abell proposed that the mechanism which transforms the cultural potentials of social conditions into actual works of art of a particular kind is 'immediately centered in the creative impulse of the philosopher or artist' and 'can in its general nature be only one thing, and that is the human psyche with all its flexible interplay of perception

* Reprinted from *Journal of Aesthetics and Art Criticism*, (April, 1960), XVIII, 464–471 by permission of the author and the publisher.

and thought, impulse, intuition, and emotion.' He then went on to suggest that 'the participation of many individual artists in a common collective unconscious could go far toward explaining such cultural phenomena as the unity of period styles.' It would make things much easier of course, but as Abell recognized in a later book[4] it is not likely that Jungian psychology can cut this Gordian Knot with one stroke. A few tough threads remain. The problem of stylistic diversity within a period, for example, is not so easily answered.

Hippolyte Taine, almost a hundred years ago, proposed a method for studying these problems which was naturalistic, empirical and rationalistic in its approach.[5] His words often seem naive today in the light of subsequent studies in psychology and the social sciences, but his method, which is primarily a structure of relations, might still be used as a framework for more accurate studies of the relations of the arts with their social background.

'A work of art is determined by an aggregate which is the general state of the mind and surrounding circumstances' wrote Taine as he developed his three-part formula of *La Race, Le Milieu, et Le Moment.* Any attempt to investigate the arts by means of scientific method, however, was doomed to fail until a body of social and psychological knowledge came into existence. Taine's seemingly naive oversimplifications and analogies have not been taken seriously since, and aesthetics itself has often been described as dealing with such elusive phenomena that it is peculiarly unsuited to systematic study.

In an essay on 'La Fontaine', Taine concisely stated his views on the interaction of *la race, le milieu, et le moment*:

A race is found which has received its character from the climate, the soil, the elements, and the great events which it underwent at its origin. This character has adapted it and reduced it to the cultivation of a certain spirit as well as to the conception of a certain beauty. This is the *national soil,* very good for certain plants, but very bad for others, unable to bring to maturity the seeds of the neighboring country, but capable of giving its own exquisite sap and perfect efflorescence when the course of the centuries brings about the temperature which they need. Thus was born La Fontaine in France in the seventeenth century, Shakespeare in England during the Renaissance, Goethe in the Germany of our day. For genius is nothing but a power developed and no power can develop completely, except in the country where it finds itself naturally and completely at home. Where education nourishes it, where examples make it strong, where character sustains it, where the public challenges it.[6]

This three-part formula, which is the basis of Taine's theorizing about the arts, obviously oversimplifies complex psychological and social relations. It should be remembered, however, that psychology and sociology had at that time no standing as sciences and had produced no body of verifiable data. Moreover, this formula was advanced by Taine as an 'abbreviation of a set of problems' and not as a closed system and final solution. At any rate, it is certainly true that art and culture in general result from the interactions of creative artists (with their particular physiological and cultural heritage) and the environment (geographical and social), which varies constantly.

Since Taine, the idea that art is a reflection of the social conditions under which it is found has become commonplace in art history. However, the baldness of this assumption is pointed out by Richard Wollheim, who asserts that there is no justification for assuming a causal relationship between events simply because they happen simultaneously.[7] In the 'Introduction' to his book on *Florentine Painting and Its Social Background*, Frederick Antal cites two paintings, one by Masaccio, the other by Gentile de Fabriano, which were done within a year of one another in Florence but which are stylistically quite different. He asks how two such widely differing pictures could have been painted in the same town and at the same time. After disposing of several traditional answers to the question, he points out that there were several different social groups existing in Florence and patronizing the arts at this time. 'We can understand the origins of co-existent styles only if we study the various sections of society, reconstruct their philosophies and thence penetrate to their art.'[8] Wollheim, however, asks, 'What justifies us in talking not just of Giotto's painting and a prosperous upper-middle-class rule but of Giotto's painting because of a prosperous upper-middle-class rule?'[9] The word 'because' cannot be used until a clear and direct relationship between social groups of patrons and works of art is established. Exactly how do patron groups influence the individualistic tendencies of artists and so affect the development of styles of particular kinds in art?

II. THE INFLUENCE OF PATRON GROUPS ON STYLE: HOW IT OPERATES

Before investigating this question, however, it is necessary to consider how such groups are themselves unified in their aesthetic needs and desires. The human mind, it is generally recognized, is erected on a basic structure of hungers and drives common to all animal life. It is distinctly human because of its ability to work by means of visual images, symbols, ideas and values, and this ability depends in turn upon language. Thus, through the processes

of education, knowledge and tradition are transmitted from generation to generation. However, society is in reality made up of many, often antagonistic, groups and the transmitted traditions and knowledge often vary from one group to another. The education of the medieval lord, for example, was hardly the same as that of his serf, nor was it the same, a little later on, as that of the merchant or craftsman or banker. Furthermore, the relations of these groups to the economic and political facts of life are usually quite different from one another. A condition which is pleasant and seems just to one group is often unpleasant and seems unjust to another. Stories or caricatures which satirize, ridicule, or vituperate a particular race or nation are never enjoyed by their subject as they are by others. As Thomas Munro remarks, 'The arts of the urban elite, of the church and of classical scholarship, never fully expressed the minds and folklore of the lower classes, of the peasant and urban worker, of the child, the neurotic.'[10]

The varying relations of social groups to the environment leads, therefore, to differences in their psychological states and thus in their aesthetic needs and desires. Unfortunately for simplicity, however, artists usually belong to a different social group than the patrons of art and so do not often share the same psychic state or aesthetic needs.

Here the question of how the psychic states of patron groups affect the creative act and so the stylistic traits of particular works of art comes up again. The answer proposed here is that artists, and through them works of art, can be influenced by patronage in at least three ways: by stipulation, by attraction and by selection.

Stipulation includes any actual order which must be carried out by the artist. It is weak today in the arts of easel painting, novel writing and most musical composition. It is still operative in commercial art, portrait painting, architecture and the composition of music for films or television. In ancient Egypt, medieval Europe and Nazi Germany, stipulation in painting and literature was strong, as it is yet in the Communist countries, and included subject and general style as well as specific traits.

Attraction suggests the ability of a group to attract artists to its own point of view by a sympathetic moral or intellectual climate as well as by economic support. During the deeply religious eleventh and twelfth centuries in Europe, for example, attraction played an important role. It is often influential during periods of social change or revolution, such as the late eighteenth and early nineteenth centuries when artists such as David and his followers were attracted by the aims, ideals, and beliefs of the revolutionary group and were then caught up in the enthusiasm for Napoleon and the Empire. It also is a factor after works of art in a certain style have been

'selected' and are successful socially and economically and thus influence or 'attract' artists to follow the same stylistic path.

Selection involves the choosing of works of art. People on all levels choose art of some kind but it has usually been only those at the top economic levels who could afford to become patrons or collectors of the 'major arts.' Those making up such a group will have, as has been suggested, some psychological needs and desires and thus tastes in common, so forming a group taste which leads to the selection of works which are satisfying. Other artists, working for applause and economic reward, are *attracted* to follow the lead of the successful works of art and so a style is established. Attraction and selection are, therefore, interactive and inseparable in practice.

III. PLURALISM AND CONFLICT: SOCIAL AND IN THE ARTS

Stylistic pluralism and conflict within a period frequently occur during periods of conflict between two patron groups with different psychological and aesthetic needs. One of the first recorded instances of this kind of conflict occurred during the reign of the monotheistic Egyptian king, Akhnaton, between 1375 and 1358 B.C. when the court faction tried to limit the massive power of the priesthood. *Coincident* with this conflict was a change in the traditional stiff, formal, sculptural style to a freer, more elegant, curvilinear, courtly style. The traditional mode persisted, however, and after the early death of Akhnaton its final victory was assured. Again in Florence in the late thirteenth and early fourteenth centuries, the middle-class merchants and bankers organized in guilds and, controlling great wealth, ousted the old landed aristocracy from political power. This struggle between the aristocratic Ghibellines and the bourgeois Guelph party *coincided* in time and place with a conflict between the medieval Byzantine style and a new more realistic style stressing light and shade and sculptural figures arranged in suggested limited space. A similar change took place in the late eighteenth century in France when the final seizing of political power by the upper middle class *coincided* with the rise of the Neo-Classical style in art and then the abrupt end of the sensuous Rococo style.

A brief stylistic conflict often results when a change in the conditions of existence of a patron group causes new aesthetic needs or desires which are incompatible with a traditional style. The transition from the robust Baroque style of the seventeenth century to the lighter and more frivolous Rococo of the eighteenth, *coincided* with a change in the political position of the aristocratic patron group. The once powerful nobility had been stripped of much of its administrative and judiciary power by Louis XIV and his minister

Colbert. Civil administrators and judges were appointed by the King to take over these jobs in the lords' domains. Thus the power of the King and his middle-class allies was strengthened and the nobles were frequently reduced to the role of courtiers. Such paintings as Watteau's *Departure for the Island of Cythera* and later erotic paintings by Boucher, Fragonard and others seem to mirror the frivolous existence and provide an escapist dream for a nobility which only shortly before had found expression in the power of the Baroque style.[11] The history of art contains so many examples of just such *coincidental* conflicts in the social and artistic fields that they cannot be assumed to have no connection.[12]

However, political and economic conflicts between classes are not always reflected in a clash of art styles. In times of social conflict art is often regarded as a weapon for influencing the beliefs and opinions of people, and very often both sides adopt the same stylistic weapons—as they do armaments—those which prove most effective. The Counter-Reformation, for example, produced the dramatic and emotional art of Caravaggio, El Greco and Rubens, while the Protestant, bourgeois North produced the equally dramatic, expressive art of Rembrandt, van Honthorst and Terbrugghen. In our time the similarities between the propagandist realistic art of Nazism and its arch-enemy Communism are obvious.

Stylistic diversity and conflict seem to occur, therefore, when there are two or more patron groups with *different* aesthetic needs and approximately equal power to stipulate, attract and select works of art which satisfy those needs. However, political or religious conflicts sometimes produce similar aesthetic needs in the conflicting groups and thus result in similar styles in art.

IV. THE DESCENT OF STYLES IN ART

In a recent book A. L. Kroeber wrote:

> Any art rising from obscurity to its first modest achievements has to make certain choices and therefore commitments; and as its condition develops farther, momentum increases, and it is usually more profitable to improve, refine, extend these commitments than to start all over again with contrary or unrelated choices. . . . The frame helps strongly to channel the course of development.[13]

The channel sometimes changes its course, however, for no pupil produces work exactly like that of his master or teacher and no artist produces two works exactly alike. Normally such variations are slight and remain within the

over-all configurations of the channel of the period style. Occasionally, however, more radical changes appear, as ror example, in the work of Giotto or Beethoven, which survive and affect the future course of style in that art.

The analogy with biological evolution is obvious. Physiological variations, however, are more random than cultural variations, because the mechanism for cultural variation is located in the individual human personality and involves the freedom to *choose* traits which seem most likely to succeed. The mechanism of biological adaptation is natural selection while cultural adaptation, operating through the intellect of human beings, involves stipulation and attraction, as well as selection. The idea of cultural selection is very simple, although its operation may be highly complex. Works of art are constantly selected by art consumers. The works of Giotto and Masaccio, of Beethoven, and of Shakespeare were, in a sense, chosen or 'selected' by those who found them psychologically satisfying. Artists whose works are 'selected' tend to have more students, apprentices, followers and imitators than those who fail and their stylistic traits will thus be more frequent in the new generation. The works which have the most followers and imitators are those which are best integrated with their environment and most successful in it, that is, those which best satisfy the aesthetic and psychological requirements of important patron groups. It should always be remembered, however, that the aesthetic needs of patron groups are normally determined in part by already existing art works. There is thus a back-and-forth flow of influence from works of art to patron, to works of art.

V. THE SPECIAL CHARACTER AND CONDITIONS OF THE MODERN PERIOD

The complex character of contemporary art defies explanation on the basis of the system of relations just described. Even allowing for the fact that the trees obscure the forest, stylistic diversity exists to an unprecedented extent, and the styles cannot be clearly traced to the causes outlined above.

Several nineteenth-century developments contributed to the diverse character of the artistic scene. Among them were: (1) the political triumph of the bourgeoisie and the consequent 'moral climate' of the industrialist and the shopkeeper which many artists found unfavorable for artistic creativity; (2) the romantic spirit of revolt, freedom and individualism which was in the air; (3) the tendency for a relativistic point of view to replace absolutism as a result of the decline of the prestige of tradition which accompanied the overthrow of the old regime, the separation of church and state, and experiments and new discoveries in many different fields.

Artists were encouraged by these developments to seek actively outside the relatively narrow channel of the classical Western tradition for inspiration. They turned to medieval, Oriental and African sources as well as to the art of children. In harmony with the times, they experimented freely and raised self-expression to the highest level of importance.

Art for art's sake and esoteric trends, however, are short-lived in the absence of a harmonious relationship between the artist and his environment. Pangs of hunger—all romanticizing to the contrary—seldom stimulate great art and never encourage the students, followers and imitators necessary for the formation of a style. Encouragement and support are essential to sustain any continuous artistic development. Most of the 'Bohemians' of the nineteenth century desired and sought approval and applause. Apparently Degas, the only one of the Impressionists who was indifferent to official success, was secure in his inherited wealth and social position. Even Baudelaire declared, when he was encouraged by the support of the revolutionary group during the revolution of 1848, that art should serve social ends. Only the victory of the counter-revolution caused him and his friends to return to 'art for art's sake.' Bohemianism in art was finally rescued, however, by that which was most the object of its scorn—commercialism, the businessman, in this case, the art dealer.

In other fields, modern commercial economics had stimulated experimentation and the continual development of new or improved products led to the development of the psycho-technics of advertising and sales methods in order to develop a market for new goods. Such methods finally made headway even in the arts. Art dealers began to encourage and even to support experiments in style by artists.

Thus, after a brief period of rather reluctant independence, art returned to its traditional role, however disguised, as a commercial product. The individualism which leads to such great diversity of styles is endorsed by the dynamics of the modern art market; a fact which is often obscured by the romantic haze which still surrounds the arts. The position of the dealer and the critic between the artist and the patron, however, has modified the dynamics of that relationship. Of the three ways mentioned in which art styles are influenced by patronage, only *selection* plays a major role in the 'fine arts' today, selection by art dealers and critics first, however, rather than directly by consumers. Works of art and artists are often selected therefore on the basis of their potentialities for promotional purposes rather than the satisfaction of deep-lying psychological needs of an important patron group.

The great and continued success of some artists such as Picasso, however,

suggests that their art does indeed satisfy the psychological needs of many people. The development of large segments of the population into consumers of 'fine art' through gallery visiting, books, films on art and other types of reproduction tends to break down the earlier compartmentalization into patron groups with more or less definite aesthetic needs.

The relative stylistic unity of historical periods before the nineteenth century resulted from the selection of satisfying art by ethnically, socially, politically, economically and, therefore, psychologically unified patron groups. The stylistic diversity of the modern period derives, largely, from the artist-dealer-patron relationship which has significantly reduced the direct influence of patrons on style.

VI. SUMMARY

This paper has suggested that Taine's categories be redefined. What he called *race* would include all the natural tendencies of artists as determined by physiological heritage and by social and artistic tradition. *Milieu* would be enlarged to include patron groups as they influence style by *attracting* artists to share their attitudes and dreams, by *stipulating* that works of art must contain specific traits, and by *selecting* the works of art which best satisfy them. Thus the 'transformer' which converts the cultural potentials of particular social, economic, political, religious or other systems into works of art of a particular kind is located in the relations existing between creative artists and contemporary patron groups while the yearnings, dreams, ideals and aesthetic needs of such groups are normally conditioned by their relations with economic systems and social conditions.

Style, therefore, is determined by the descent of traditions in art and their modification as they combine and adapt to outside conditions. The course of development is marked by changes in form which appear in individual works of art. Outside forces such as patronage act, necessarily, on individual artists, but their effects are apparent in the works of groups of artists or schools of art, and over successive ages, for traditions in the arts are transmitted from one generation to the next by the group, by schools for art studies, workshops, books on art, training programs, etc. The styles that evolve are manifested in groups of works linked together by exchange and transmission of significant stylistic factors.

Stylistic development occurs, therefore, through the artistically creative members of the community but the artistically nonproductive members (patron groups) decisively affect the survival of traditional styles and the large-scale development of new stylistic traits.

NOTES

[1] See Meyer Schapiro, 'Style,' in Kroeber (ed.), *Anthropology Today*, (Chicago, 1953), pp. 287–312. Schapiro gives an excellent summary of the problems concerning the concept of style in the arts and the main answers to them.

[2] Frederick Antal, *Florentine Painting and Its Social Background* (London, 1947). This is, I believe, the best treatment of the art of any one period from this point of view. Antal's 'Introduction' is especially enlightening, although even he says nothing specific about the ways in which patronage influences the production of particular kinds of art.

[3] Walter Abell, 'Toward a Unified Field of Aesthetics,' *Journal of Aesthetics and Art Criticism* (March, 1953), p. 201.

[4] Walter Abell, *The Collective Dream in Art* (Cambridge, Mass., 1957).

[5] Hippolyte Taine, 'On the Production of the Work of Art,' *Lectures on Art*, trans. by John Denand (New York, 1875), 1, Part II, 88*ff.*

[6] Taine, *La Fontaine and His Fables* (Paris, 1853), Joubert, pp. 342–344.

[7] Richard Wollheim, 'Sociological Explanation of the Arts: Some Distinctions,' *Proceedings of the Third International Congress on Aesthetics* (Turin, Italy, 1957).

[8] Antal, *op. cit.*, p. 4.

[9] Wollheim, *op. cit.*, p. 406.

[10] Thomas Munro, *Art and Progress* (mimeographed text), p. 194.

[11] It might be objected here that the art patronized by the king also changed in this direction. It must be remembered, however, that although the king had used the middle classes to reduce the power of the nobility, he was, in the long run, only the first among the nobles. He stood in the same position relative to the increasing wealth and power of the middle classes that they did. Their most basic beliefs, which were being challenged, were his. Their growing insecurity was shared by him as was their way of life and their tastes.

[12] Obviously the author does not believe that there is anything coincidental about such conflicts but rather that there is a direct causation. However, it does not lie within the scope of this paper to trace the history of each of these conflicts in detail. We must content ourselves for the present with pointing out the frequency of such 'coincidental' conflicts in two areas and with suggesting certain natural connections between the two which might logically explain how one affects the other. This is not intended to imply that this is the only cause of stylistic development, but that it is a very important one which has not been adequately considered heretofore.

[13] A. L. Kroeber, *Style and Civilization* (Ithaca, N.Y., Cornell University Press, 1957), p. 34.

NIKOLAUS PEVSNER

*French and Dutch Artists in the Seventeenth Century**

THE POLITICAL STRUCTURE into which Rembrandt was born was completely opposed to that which ruled Lebrun's life. An absolutist kingdom stands against a bourgeois republic, which means king, court, nobility and civil servants as patrons on the one hand and merchants and tradespeople on the other. Art which was in demand was likewise of opposite kind. The number of prospective customers in *France* was not very big, but most of them had considerable means at their command, derived mainly from ground-rent. It was regarded as a social obligation to spend lavishly for luxury and display, and the mercantilists proved that this was also economically sound. As moreover the aristocracy was brought up in a fenced orbit of conventions and under the rule of an accepted taste, there were plenty of commissions, but commissions to satisfy a precisely defined demand. An artist would not be much good to such a society, unless he could carry out large decorative jobs quickly and at the same time in such a way that their meaning and formal qualities would be accessible and palatable to the members of this society.

In *Holland* the artist could reckon on a much wider clientele in proportion to the size of the country. But the large number of consumers was counterbalanced by their less developed tradition in matters of art, their less trained judgment and taste and their generally smaller resources. For even a very wealthy merchant would not usually spend his hard-earned money so profusely as a ground-landlord living at Louis XIV's or Louis XV's court.

* Reprinted from *Academies of Art: Past and Present* (Cambridge: Cambridge University Press, 1940), pp. 132–139, by permission of Professor N. Pevsner.

This implies that the demand for art was wider in Holland than in France, but directed toward less costly individual products and not always products of particularly high cultural standard. Consequently the grand style could develop in Holland but to a very limited extent, and did develop only where commissions were placed by the Stadholder himself or the official representatives of powerful city councils.[1] As, furthermore, Calvinism had discredited the painting of altarpieces and all church decoration, the Dutch school found itself limited to small pictures for use in private houses.

It should not be necessary, but may in present-day conditions be advisable, to emphasize that by explaining this relation between social life and a specific religious creed and art, no causality is intended to be suggested. It is not the social system that is responsible for religion or for art; it is in this case chiefly the relatively constant factor of national character which brought about this bourgeois republic, this brand of Calvinism, and this style in art. Since, however, the problem under discussion in this book is not one of general *Geistesgeschichte* but one of professional history, the social and economic points of view have to be placed in the center of the picture. So now we must pass on from the opposed structures of the artist's clientele in France and in Holland to the social position of the artists themselves.

In *France* during the age of Louis XIV and Louis XV the artist was a social necessity for the governing class, as indispensable as the weaver in the royal tapestry workshops and the cabinet-maker in the Manufacture des Meubles de la Couronne, and in fact no less indispensable than in the Middle Ages. His patrons were only too willing to assist him if he conformed with their requirements. But the possibilities of assistance from the individual patron were by no means unlimited. Just as the aristocracy culminated in the narrower circle of the court, and the court in the king, so effective furtherance of art could only come from the king and from the court (including the highest range of civil servants). Recognizing the necessity of the artist thus became tantamount to binding him firmly into that system of organization which ruled with such hitherto unparalleled totality the State of Louis XIV. The method of doing this was the grant of the title of Peintres and Sculpteurs du Roi to suitable artists, with all the social consequences that a title of this kind had in a Baroque State. But in attaining this welcome honor, they had to give up their freedom, and not only externally, although they were just then trying to establish freedom from the guilds, but also internally, which means freedom of expression in art.

In this respect, the artist in *Holland* was much better off. He was virtually free, since the guild, provided that the annual tax was paid, did not interfere with his external life and nobody had the power or the conscious intention of

interfering with his style. So he painted what he liked and as he liked it. Conditions being as they were, it was out of the question for the painter to wait for the customer who would order a picture for his drawing room. Paintings were done in the artist's studio in ignorance of who would buy them and where they would go. Art dealing flourished, the link between producer and consumer was broken. There were two alternatives open to the painter in this situation. He could make up his mind to work for the market, or he could in the absence of personal patrons forget about the consumer entirely and regard his art as an unconditioned intercourse with his genius and his conscience. The first of these two attitudes is responsible for that typical quality of Dutch seventeenth-century painting, the formation of the specialist. If a painter were successful in peasant scenes, he would henceforth produce peasant scenes only. Were his landscapes with moonlight effects in demand, concentration upon these was the policy to be followed. For by this method alone could he secure a fairly steady market.

There was, however, another more dangerous aspect of the Dutch freedom. Where patrons order, the natural balance between production and consumption is guaranteed; competitive production for the open market remains in the dark as to the purchasing power on the other side and the willingness to buy. For the first time in the history of art one is faced with an oversupply of artists. As long as guilds controlled the entrance into the trade and the progress made by the individual member in it, nothing of the kind could happen. Now a proletariat of unsuccessful painters arose, painters *e.g.*, who for a monthly wage had to supply an art dealer with just so many original pictures or copies. And even artists of recognized reputation preferred to have a second job besides painting. Jan Steen and Aert van der Neer were innkeepers, van Goyen ventured upon the lucrative but risky trade in tulips, van de Cappelle owned a dyeing business, Philips Koninck bought a canal-shipping privilege, Hobbema a privilege on the excise on wine.[2] This system cannot be regarded as satisfactory. For otherwise would an artist as great as Hobbema have been prepared to give up painting almost entirely at the age of about thirty? There are only very few dated works known from the forty-nine years between his start on the other job and his death, and the supreme beauty of the late Avenue of Middelharnis rules out the explanation that he himself was afraid his powers were failing him.

The danger underlying this was increased by the taste of the art dealer's clientele. It has been said before that these Dutch merchants only rarely had a trained taste, although very often a real collecting passion. Otherwise art dealers and other traders dabbling in art could not have piled up such

surprising numbers of pictures. It is recorded that a certain painter and art dealer at Rotterdam left 200 pictures, and that the owner of a slop-shop when he died possessed 1,500 pictures. To satisfy the taste of such amateurs a painter had to adapt himself to their powers of comprehension. The more exacting an artist was, the less likely would it be that his works would meet with response in so amorphous a market. In Roman Catholic countries the artist who wanted to express deeper feeling would enshrine the best of his genius in altar pictures. That was barred in Holland, and if Rembrandt felt driven to express his philosophy in paintings from the Gospels, there was no steady demand for works of this kind, and he had to wait for the appreciative patron who would see such a picture and buy it. In France, where at all times the national genius prevails over the individual, this situation might have appeared tolerable, but in the Germanic country it was bound to end in tragedy. Rembrandt, the greatest genius that Holland ever produced, was its victim. As long as his art was comprehensible to the wealthy bourgeois of Amsterdam, he was admired. When he grew in spiritual intensity, when his speech became more and more the intimate meditation of a recluse, success deserted him.

You may consider this fortunate for the development of his art and welcome his tragic isolation, if you are a supporter of the Impressionists. In the conflict between the great artist and the bourgeois public, they always took sides with the artist, and most people today who have kept a live interest in art would be prepared to adopt their arguments. And yet it should not be forgotten that in the Middle Ages it seems as though, for whatever reason, the great men really were in charge of the great tasks. The masters of Chartres, and Reims and Naumburg, Giovanni Pisano, and Giotto and Duccio were not outcasts, nor cranks. And even at a later date the most uncompromising of the great geniuses of Italian painting were never without patrons, never without adequate work. This applies to Michelangelo as well as to Tintoretto and Caravaggio. So it is equally justifiable—and we should today perhaps say more justifiable—to regard Rembrandt's case as a warning of most immediate urgency. Leonardo and Michelangelo had destroyed the oneness of art as a craft and art as a profession. By this they had torn the artist out of the natural soil that had fed him until then. He remained uprooted, until the France of Louis XIV found new bonds to bring him back into the system of society. If the French system was to collapse, what would happen to the artist? What would be the consequence of the disappearance of all the educated and generous patrons of the *ancien régime*? Where would art go for support?

Holland answers these questions. Artists were by no means without work.

But while their numbers—not sifted out by the elaborate process of selection which the academies had worked out—grew out of all proportion, their success was no longer determined by the value of their art as recognized by a class of trained dilettanti, but depended on the verdict of a middle-class mass. Great genius was left to destitution and disdain.

These considerations, which for their contemporary importance have been allowed more space than would be immediately necessary, can now easily be applied to the field of education. The training of the artist in France and Holland was bound to pursue different aims and to proceed along different lines. The Académie Royale de Peinture et de Sculpture proves now to be the only instructional form congruous with the system of absolutism. By forcing all Peintres du Roi into the academy the king made sure that the prevailing style would be that of the artists whom he had chosen to represent his ideas. By granting a life-drawing monopoly to the academy, no young artist who aspired to the grand style at all could any longer hope to find adequate teaching outside. By thus bringing the young generation under the exclusive influence of the court artists, no other than the accepted style could be propagated. By letting the student pass through the hands of twelve different teachers in one year, it was even made impossible for any one personality within the academy to exert a preponderant influence. And by preventing any outsider from making headway, the breaking out of anti-academic talents was strongly discouraged and in fact reduced almost to nullity. An admirably compact and unassailable system, though one which could never have been developed nor successfully carried through but in a country whose national character was in accordance with it. This character enabled the French to create during the classic phase of their art such perfect entireties as Vaux and Versailles, works at first sight unimpeachably complete like a Gothic cathedral. There is, however, one fundamental difference between the thirteenth and the seventeenth century, between pre-Renaissance and post-Renaissance art, and this is most strikingly illustrated by the introduction of academies. What in the Middle Ages had been the result of natural growth now became the object of conscious reasoning and methodical endeavor.

As for Holland, a few words will be enough. The formation of academies was impossible as long as Dutch art flourished. Impossible, because it went against the nature of the country, and also because only tolerance gives your market sufficient variety. So there was no need to reform an educational system which although still medieval had in fact of late been much loosened. If a man was popular, as Rembrandt was for a time, he might have as many private pupils as he liked, in fact so many that it amounted to a private

academy³—did he lose his popularity, he was alone, without commissions or pupils.

If we now try to sum up what the social history of art created during the seventeenth century, it must be said that at its end three types of artists stood side by side. First, there was the master in the medieval sense, who supplied from his workshop both private customers and clerical or secular authorities. This was still the most usual type in Italy, in Flanders, in England and in Germany. Secondly, there was the academician, as he existed only in Paris. He also usually worked for individual clients or public bodies, with whom he had direct dealings. His social position was higher than that of most of his foreign colleagues, but he had become so much of a servant to the court that he was less free in his art than they. And thirdly there was the Dutch painter who enjoyed complete freedom, and worked in his studio for nobody in particular. The first of these three types was doomed when the Enlightenment and the French Revolution destroyed the guilds and the last remains of the medieval style of life; the other two, however, both created by the seventeenth century, represent the fundamental social polarity which determines the attitude of the artist up to the present day.

NOTES

[1] In connection with the natural relationship between official art and academic taste as here maintained, and in connection with the application of this rule to postwar developments in Europe, it may be worth pointing out that the most important research into this official, governmental style of painting in Holland all belongs to the few decades: H. Schneider, *Oud Holland*, Vol. XXXIII, 1915; *Jb. d. preuss. Kunstsamml*, Vol. XLVII, 1926; K. Bauch, *F. A. Backer* (Berlin, 1926); F. W. Hudig, *Frederik Hendrik en de Kunst van zijn tijd*, Inaugural Lecture, held in the University of Amsterdam in 1928.

[2] On the social conditions of art in Holland cf. H. Floerke, *Studien zur Niederlandischen Kunst- und Kulturge-schichte* (Munich and Leipzig, 1905); K. Martin, *Burlington Magazine*, Vols. VII, VIII, X, XI, 1905–07; and K. Martin, *Monatsh. f. Kunstwiss*, Vol. 1, Part II, 1908. I have also been fortunate in enjoying Dr. H. Gerson's assistance with regard to information on Dutch painting. In Floerke's book the case of J. Porcellis is quoted, who made an agreement with a cooper in 1615 according to which he had to supply for 15 fl. two pictures each week.

[3] Sandrart writes (ed. Peltzer, *loc. cit.* p. 203): 'his house at Amsterdam was crowded with almost innumerable young gentlemen who came for instruction and teaching.' Each of them paid 100 fl. a year. It can be

proved that life-drawing in common was part of the training. The pupils were separated from each other by partition walls (cf. Hofstede de Groot in *Feest-Bundel Dr. A. Bredius aangeboden* (1915) and in *Die Urkunden uber Rembrandt* [The Hague, 1906], No. 186). However, Sandrart was not prepared to accept this as academic education. In fact he blames Rembrandt violently for his hostility 'wider die unserer Profession hochst notigen Academien.'

DANIEL M. FOX

Artists in the Modern State: The Nineteenth-Century Background*

FOR OVER A century critics and scholars have dispensed and reinforced a common view of the social and economic attitudes of nineteenth-century artists. There were two kinds of artists, the story goes: an intolerant, jealous, businesslike academic aristocracy and a tumultuous artistic proletariat. Laymen are asked to sympathize with the isolation, alienation and uncertain economic status of the men in the second group. Nobody denies that mediocrities as well as most of the geniuses were part of this proletariat, but the usual conclusion is that 'the artists of genius answered [the public] only by intensifying their scornful rebuff.'[1]

This classification is a result of looking more carefully at works of art than at the duller details of how artists lived in order to do what was in them to do. Certainly men who worked in official and academic styles and avoided political or aesthetic controversy enjoyed more patronage than their more radical colleagues. But most artists were involved in a sort of Victorian Compromise—as much because they wanted to as because they had to. In the course of the nineteenth century, artists became businessmen-idealists. Bohemia had its fascinations, but most artists knew they produced a commodity that was hard to market, and that they engaged in activities demanding worldly abilities. They were often as conscious of supply and demand as middling farmers or manufacturers. But artists embraced a gospel that obscured their economic activities and justified verbal rejection of the world they wanted. It is not true that the public was completely insensitive to the

* Reprinted in revised form by permission of the author and publishers from *The Journal of Aesthetics and Art Criticism*, XXII, No. 2 (Winter, 1963), 135–140; 143–148.

best artists. Starvation seems to have been a rare occurrence. Malnutrition was more prevalent among factory hands than on the Left Bank.

The most important nineteenth-century innovation in the relation between artists and patrons was the administration of patronage by governments theoretically based on the consent of the governed. A belief in the necessity of public support for artists developed with the growth of the liberal nationalistic state. This new concept of the state as patron, rather than individual monarchs or aristocrats, led to many struggles and errors. The first efforts of the new patrons produced some fierce battles, disillusionment and what hindsight labels as stupidity. But the new patronage enabled thousands of artists in Western Europe to survive and paint the way they wanted to. The early struggles with government patronage were the prelude to the current patronage revolution in Western Europe and the United States. Each art presents different social, material and aesthetic problems. State patronage eventually affected all the arts. The present concern is to discuss some of the trends in the social history of painting from the end of the eighteenth to the closing decades of the nineteenth century.

At the end of the eighteenth century patronage came from the middle class as well as the aristocracy. Painting had a social function: as decoration, an index of sophistication and prestige, a luxury to be enjoyed aesthetically or materially and as an investment of potential financial value. Perhaps for the first time in the history of art men were painting more often in anticipation of a market than on commissions. By the end of the nineteenth century, government buildings, town halls, and public squares were full of paintings or statues. The artists who received these commissions were men who had captured the market by best anticipating the taste of the members of official committees.

I

When Castagnary, James Jarves, or William Morris divided artists into two classes, haves and have-nots, they were propagandizing. They took an extreme position in order to goad their readers into recognizing the difference between what they considered good and bad art. When David, Courbet, or Max Liebermann cursed discriminatory government patronage, it was a gesture combining egotism and a desire for reform with dislike of political and bureaucratic meddling. But when Sir Herbert Read and Arnold Hauser perpetuate myths declaimed in the heat of battle, some revision is necessary.

Read, a pessimistic intellectual descendant of Morris, Marx and Rousseau, looks backward and forward to a vague Golden Age of Art. He sees the basic problem of nineteenth-century artists as reconciling aesthetic sensations

and ideological motives with securing a livelihood in a world which had reduced all labor to a cash basis. He leaps from Rembrandt to the mid-nineteenth century and views the history of art since the Renaissance as 'full of instances of the tragic misunderstanding that has arisen between artists and their patrons.'[2] Entirely on the side of the painters, he describes the rise and fall of art styles in terms of Pareto's 'circulation of elites.'[3] To Read, the great art styles arise from a 'crude and virile art among the people' that is 'generally not recognized as art at the time of its creation.'[4]

His combination of the ideas of Pareto and Marx yields the conclusion that the greatest art is only possible under the distributive economics of a classless society in which workers own and control the means of production. The Middle Ages would have been a more marvelous period in art history, he claims, if artists had not been subjected to spiritual slavery. The modern artist, Read argues, suffers under economic slavery, except in totalitarian states where his spirit is coerced. However, he concludes, what an artist says is more important than how he is forced to say it.

This approach leads to some questionable statements about the social history of art in the nineteenth and twentieth centuries. Read declares that the artist 'became a parasite of the elite, exchanging flattery and amusement for means of subsistence.'[5] David, Courbet, Delacroix, Manet and Morris would have some difficulty recognizing themselves in this description. Read quotes Cézanne's opinion that 'the artist can only appeal to an extremely restricted number of people,' and adds that artists hoped they would influence an ever-expanding audience and become part of the culture of their time.[6]

This extension of Cézanne's remark is overintellectualized, reflecting men of words rather than wielders of paintbrushes. Read sees no difference between the effects of nineteenth-century patronage and earlier forms: artists dependent on oligarchic, aristocratic, or monarchic patronage are no 'happier' than those with middle-class or government patrons, he believes. Aside from the difficulty of defining 'happiness,' this opinion denies any significance to the increased interest in art among middle-class people in the nineteenth century. Most of the forty thousand people who visited the Paris Salon of 1863 every Sunday were not aristocrats—just 'caustic Parisians,' in Castagnary's words. Read declares that Daumier and Delacroix 'escaped into moralism and romanticism' as a result of the 'intolerable dilemma of the artist in a capitalistic epoch.'[7] This judgment is derived from his ideology. It is an attempt to see artists as more than human, disturbed by what disturbs Read and painting without very much relation to the perverse logic of style and technique.

Read has little hope for enlightened government patronage. He wants art to have a free, unhampered growth, and claims that 'the degradation of art during the last two centuries is in direct correspondence with the expansion of capitalism.'[8] The free and unhampered growth of capitalism excludes any possibility of a similar development in art. Thus, there can be no satisfactory government art patronage until economic and social life have been changed. However, he concludes his book *Art and Society* with the optimistic hope that the

> general release from fear and repression which is promised by the techniques of modern psychology no less than by the growing determination to win for humanity the benefits of modern methods of production . . . will recreate the conditions of a great art.[9]

It is difficult to assimilate this optimism with his other ideas. Read has damned middle-class patrons and government action, taken no notice of the increasingly undogmatic public patronage of Western Europe in the twentieth century and declared that the working classes are indifferent to great art because public art education cannot achieve anything until after the complete reform of society. Hands off the artists, he says—and then neglects to say how artists can improve their condition before the Revolution.

Arnold Hauser, despite his anti-middle-class bias, his tendency to exaggerate the isolation of Bohemia from the rest of society, and his conception of nineteenth-century patronage as a backwater, provides a fascinating introduction to an attempt to understand how artists lived and gained recognition in the nineteenth century. Unlike Read, he recognizes the importance of the French Revolution for the development of artists' belief in their freedom and even superiority. He emphasizes the fact that most artists were from middle-class backgrounds; they could not and would not discard all their acquired values. Hauser even censures several artists for 'adopting a moral bourgeois life for fear of seeming unreliable.'[10] He focuses on the romantic movement as 'a war of liberation not only against academies, churches, courts, patrons, amateurs, critics and masters, but against the very principle of tradition, authority, and rule.'[11]

Hauser describes the French Revolution as a liberating force for artists. But he views nineteenth-century patronage as a stabilization of 'the art machine,' a partial return to older patterns.[12] He argues that the art life of the French Second Empire 'resulted in easy and agreeable production destined for the comfortable and lazy-minded bourgeoisie,' that the passion of Courbet and his supporters was fundamentally political, and that it was a virtue to be a misunderstood artist.[13]

These ideas are the result of an attempt to explain why in the nineteenth century, unlike the sixteenth, the best artists were not the wealthiest and why there was so much 'bad taste' in the nineteenth century. Hauser, writing in 1951, was too immersed in the more distant past to see that nineteenth century developments provided the background for the expanding government patronage of contemporary Western Europe. Writing about the Renaissance in the first volume of his work, Hauser points out that most artists were average men trying to earn a living. 'The legend of the artist is complete,' he concludes.[14] Unfortunately, he did not apply his strong sense of social reality to the nineteenth century.

The mythology about nineteenth-century artists helped produce guilt feelings that make many present-day government cultural administrators zealous guardians of creative freedom. Perhaps a conviction of alienation spurred several artists to great achievement. But, although the best artists did not always get the best rewards, most of them received sufficient patronage to live, paint and exhibit. Most talented painters eventually convinced experts, dealers and government officials that they were not only aesthetically satisfying but also salable and worthy of support and encouragement from public funds.

The mythology, if it were true, would make the mixture of tradition and innovation in the present structure of European art patronage inexplicable. But the problem has never been examined from this point of view. Most of the writers on artists and society demand increased public interest and government patronage after having damned nineteenth-century patronage and public interest as bad for art.[15] The only way out of this dilemma is the difficult critical position that only the secondary sources know the real difference between good and bad art. Perhaps critics are a bit too charmed by the exuberant egotism and iconoclastic arrogance of the artist's pose. The only recent writer to sense that something of great importance for the place of art in society happened in the nineteenth century was the late Francis Henry Taylor. Introducing a book that was never completed, he wrote:

> No phase of our heritage of the past has undergone more radical changes in the past hundred years than have both the patronage of the contemporary artist and that accompanying sense of possession which from time immemorial has goaded the man of wealth into becoming a collector.[16]

II

The significance of the French Revolution for the social history of artists was largely the result of a historical accident: the fact that the most famous

artist of the period, Jacques Louis David, was also an able politician and administrator. David's success as an artist and a politician enabled French artists to realize that they could control their own affairs. For the first time, artists as a group were involved in politics and in the fight for freedom of expression. The repercussions of David's speech before the Assembly in 1790 are still being felt. David discussed the importance of the arts to the Revolution and the incompatibility of the Academy's policies with the new spirit of Reason and the Constitution. He called for the establishment of a self-governing Commune of the Arts.[17] This speech was the first public statement by an artist of the political and social utility of the arts under a government based on consent.

French artists were not particularly oppressed in the last half of the eighteenth century. Most talented painters could look forward to comfortable livings and exceptional men amassed middle-class fortunes. David himself had considerable patronage from the court, the aristocracy, wealthy collectors and dealers. But this patronage dried up rapidly at the beginning of the Revolution.

The first effect of the Revolution on artists was hardship, and a number of painters followed their patrons into exile. The rigid hierarchy and monopolistic privileges of the Academy had annoyed David for years. In France, and later in England, Russia, Germany and the United States, artists felt the pinch of economic and social dependence, saw the application of new political and social ideas to themselves, and then started worrying about the relationship of art to the people. There is no evidence that David's one-man art revolution was initially based on anything except an anti-academic animus and vague republican feelings. Anti-academicism was not new in 1790. It existed among the Dutch artists of the seventeenth century and the courtly painters of the French Rococo. But in the 1790's artists could connect their discontent to a set of political and social ideas that seemed to be working.

David and his colleagues moved quickly. On September 27, 1790, the Commune of the Arts was recognized by the Assembly. On August 21, the Assembly approved the opening of the Salon of 1791 to all French artists. For the first time the only legitimate exhibition was not an academic monopoly. David used his prominent position and powerful political connections to obtain subsidies for his fellow artists. A large sum was appropriated for 'Works of Encouragement'; the same title that had been used for the royal patronage list now served the Revolution. In December, 1791, a Jury of the Arts was established to judge competitions for public works and award commissions to artists on a merit basis. Academicians were a minority on the

Jury. David began a campaign for the construction of public works to provide glory for the Republic and patronage for artists.

By 1793 David had broken the Academy's power and developed the concept of the revolutionary artist to justify commissioning propaganda art projects. 'Each of us,' he said, 'is accountable to the fatherland for the talents which he has received from nature. . . . The arts ought to contribute powerfully to public instruction . . . the arts ought to help the progress of the human spirit.'[18]

The Commune of the Arts was the most powerful artists' pressure group in history. Under David's direction artists lobbied successfully for State patronage and artists' control of public exhibitions and competitions. Ideas and practices that would still be influential one hundred and forty years later in both the WPA Arts Projects and the *Reichskulturkammer* were fixed in artists' minds. In England in the 1830's, France in 1848 and 1871, Russia in 1917, Germany in 1918, Italy in the 1920's, politically inclined artists cited the precedents of the patronage revolution David had led.

The French Revolution had, for better and worse, firmly tied artists to the modern state. The individualism and freedom of expression that followed the defeat of the French Academy could not be driven from artists' minds, even by twentieth-century totalitarian dictatorships. The French revolutionaries' experiment with art patronage anticipated the dangers as well as the achievements of public patronage in the next century and a half. Questions were raised which have plagued artists, critics and public servants ever since.

In a sense, David's reforms drew the lines of battle. Who is competent to judge the merit of a work of art? Should the public patron focus on diffusion or quality? What do artists mean when they demand recognition? What exactly is creative freedom? These questions are still debated by artists, laymen and mediators between art and the public. A good example of the perpetual confusion about art in the modern state occurred at the opening of the Paris Salon of 1865 when the Minister of Fine Arts admonished artists to 'resist public taste.' The year before he had told them to 'trust the public.'[19]

<div align="center">III</div>

In 1890 a Swiss professor said that 'The destruction of the Academy was the great achievement in the world of art at the time of the French Revolution.'[20] As hindsight, this is a superb insight. But to French artists during the nineteenth century, the major gain was a sense of the possibilities of

freedom. Napoleon I established a new Academy which attempted to rule over art education and the Salons for the rest of the century.

But the actual effect of the Academy was not authoritarian. Artists had been given a taste of freedom. They knew how to fight for more. Certainly the favored few had the easiest admission and the best wall space at nineteenth-century Salons. But stylistic radicals could not be completely shut out from the only exhibition with any prestige. Their supporters—critics, wealthy amateurs with a taste for Bohemia, even politicians—made their presence felt. Delacroix's painting was shown for the first time at the Salon of 1824. From 1830 to 1848 there were sixteen Salons; Theodore Rousseau, Ary Sheffer, Diaz, Corot, Delacroix and Ingres appeared regularly. Courbet's work was rejected only a few times after 1847. After 1860, Manet, Vernet, Renoir, Libermann, Pissarro, Fantin-Latour, even Whistler had their works at several Salons.[21]

These artists were not satisfied with the administration of the Salon. They resented the jury of academicians and government officials and the fact that prizes and honors were usually awarded to academic favorites. In 1848 a group of artists presented a petition to the Provisional Government for a General Assembly of artists which would choose all government officials in the cultural bureaucracy. The Assembly elected Ingres president and Delacroix vice-president and persuaded the government to authorize a free Salon with a committee chosen by the artists to award honors and make selections for purchase by the State. This has been viewed as a great event, a product of the new political consciousness that necessarily fell to the forces of reaction the next year. But artists were an effective and articulate pressure group before 1848 and under the Second Empire.

In the last century and a half, there has been considerable debate about artists' competence to govern their patronage. The major arguments on the question were raised by the middle of the nineteenth century. David decided that artists are not necessarily the best judges of their colleagues' work. In November, 1793, he wrote:

> to leave the judgment of the productions of genius to artists alone would be to leave them in the rut of habit in which they crawled before the despotism they flattered. . . . Thus, he who is gifted with a fine sensibility, though without culture, and the philosopher, the poet and the scholar . . . are the judges most capable of representing the tastes and insights of the entire people.[22]

In England, criticism of the Royal Academy's favoritism led in 1798 to the House of Commons establishing a 'Committee of Taste,' composed of

amateurs, to judge competitions for monuments and for decorating public buildings. In 1840, David d'Angers wrote to the editor of an influential Paris magazine, 'I concede no jury of artists the right to admit or to refuse the work of their colleagues. . . . I recognize but one judge for the artists— the Public, which can pass sentence on cliques and coteries.'[23] Ingres, in a letter that seems to have been written in 1849, expressed a dualism that was part of most nineteenth-century artists' attitude toward the public and patrons:

> Exhibitions . . . must not be encouraged. . . . They ruin art, for it becomes a trade which the artist no longer respects. . . . We must open the doors of the exhibition to all. Humanity and art itself are interested in that solution of the problem. . . . Society has not the right to condemn the artist and his family to die of hunger because the productions of that artist are not to the taste of this or that person.[24]

And Delacroix, who, according to Sir Herbert Read, had rejected bourgeois society, wrote in his *Journal* in 1854, while serving on the Art Commission of the city of Paris,

> That is not to say that, if I had governmental power I would turn over questions of art . . . to commissions of artists. The commissions would be purely consultative and the able man who would preside over them would follow his own ideas entirely, after having listened to them [the artists]. When they are gathered at a meeting and are thinking of their profession alone, each one promptly goes back to his narrow point of view: when opposed by completely incompetent people, the sure and general advantages are clearly visible to their eyes and they will succeed in making them available to others.[25]

IV

Nineteenth-century artists and intellectuals were chronically dissatisfied. One of the manifestations among painters and critics was the conviction that patronage was much better in other countries. Thus, English commentators cited French examples, Germans used English and French innovations to club slow-moving government officials and, after 1870, even the French were impressed by a few English arts institutions.

Developments in English patronage in the first half of the nineteenth century had important consequences in the twentieth century. Too many writers share Edith Sitwell's opinion that 'The arts seemed to her [Victoria] just as friendly and no more dangerous than dear Dashy, and in the end the

whole nation felt that they might safely be patted and fed with sugar.'[26] The revolt against the Royal Academy, the parliamentary investigation of the condition of artists, and the application of political economy to the arts produced more than the Albert Memorial. These events and ideas help explain why Henry Moore statues are placed on the grounds of London County Council Housing Estates and why John Maynard Keynes became the first chairman of the government-supported British Arts Council.

Three books provide insights into what was happening to English artists. These writers foreshadow the changes in the condition of Western artists in the twentieth century. The books, by a cultural administrator, an artist and a critic, are the first attempts to discuss the artists' profession with only indirect reference to the often distorted subject of aesthetics.

In 1840, Edward Edwards, a staff member at the British Museum, published *The Administrative Economy of the Fine Arts in England*. Edwards attempted to connect art patronage with the Utilitarian agitation for state support and administration of education. Jeremy Bentham had discussed government support for the arts in *The Theory of Legislation*. He declared that the cost of art patronage could be met by attracting foreign visitors who would spend their money while enjoying art. But Bentham was in no hurry:

> It will be time to provide for actors, painters, and architects ... when individuals have been indemnified for the losses occasioned by war, crimes, and physical calamities, when the support of the indigent is provided for; till then all such expense would be an unjust preference granted to brilliant accessories over objects of necessity.[27]

Edwards, in 1840, may have thought the time had almost arrived. A Select Committee of the House of Commons had recently investigated the condition of art in England and concluded that

> The Arts have received little encouragement in this country. ... In many despotic countries ... more development has been given to genius. ... [We] frequently felt compelled to draw a comparison more favorable ... to our foreign rivals and especially to the French than could have been desired. ... [Academies], when they assume too exclusive and oligarchical a character ... damp the moral independence of all intellectual excellence. ... But the interposition of government should not extend to interference.[28]

Edwards was disturbed that the Government had taken no action on this report, and in an analysis of the evidence heard by the Committee, stated that 'the principle of nonintervention on the part of Government, however sound in commerce, has limits in respect to the Fine Arts ... carried beyond

which it becomes a serious evil.[29] He discussed various kinds of private and public patronage in England and on the Continent and commented on various schemes for organizing juries, exhibitions, public works commissions and academies. Finally, he suggested reforms in the procedure for commissioning works of art for public buildings. His suggestions have become public policy in England, Scandinavia, Holland and France in the twentieth-century—unfortunately, after a tortuous trial-and-error process.

In 1841, Sir Robert Peel, acting on a recommendation of the Select Committee of 1836, appointed Prince Albert as Chairman of a Commission to select artists to decorate the rebuilt Houses of Parliament. In 1845, John Pye, a respected landscape engraver, dedicated his book, *Patronage of British Art*, to

> Prince Albert and the other Commissioners of the Fine Arts who ... have afforded to genius and talents hitherto scarcely known the opportunity of winning the first place in an open competition and have enabled multitudes of Her Majesty's subjects to testify to the deep interest they take in the new direction thus given to the Fine Arts.[30]

Pye was overly optimistic, but his book is a significant document for a study of the attitudes and aspirations of artists in the nineteenth century. It is the only sustained polemic on the subject ever written by an artist. By the end of the century artists left these matters to critics and experts. Pye focused on ordinary painters, not transcendent figures. His book began with a discussion of historical facts that were forgotten in 1845. For example, he pointed out that until the mid-eighteenth century 'sign painting appears to have been the greatest resource of the British painter for employment.'[31] He described the first efforts of English painters to unite to provide opportunities for free exhibition and security for the aged and destitute of the profession. These efforts began in the 1760's and gathered momentum during the Napoleonic Wars, which 'suspended altogether that commerce by which British artists had been mainly enabled to live.'[32]

Pye blamed the Royal Academy for most of the troubles of British artists in the eighteenth and nineteenth centuries. He regarded the Academy as a monopoly in restraint of trade and, in words strikingly similar to those used by Castagnary twenty-five years later, claimed that the Academy's policies damaged 'the free exercise of the inalienable right of every British artist to control the revenue of exhibiting his own works.'[33]

But Pye was not an advocate of complete free enterprise: 'The influence of dealers is inimical to the advancement of modern art,' he wrote.[34] After a survey of David's policies during the French Revolution and an analysis of

the French Government's 1843 art budget, he called on the British Government to protect artists' 'moral right' to exhibit freely and to provide public commissions on the basis of ability, not favoritism.[35] Pye made a Malthusian prediction of what could happen to British artists if there were no reforms. Under existing conditions 'an increase in the number of artists could only tend ... to add to the general degradation of the many.'[36]

Pye did not oversimplify the problems of his fellow artists. In his closing remarks, he agreed with Henry Fuseli that 'accidental or partial honors cannot create genius, nor private profusion supply public neglect.'[37]

Pye demanded freedom and protection, a mixed cultural economy that would provide sufficient public and private support for artists and craftsmen to do an honest day's work. During the hearings before the Select Committee of the House of Commons in 1836, the Secretary of the Royal Academy was asked if the public had any control over the Academy's policies. 'I conceive not,' Mr. Howard replied, 'for we have never had any funds from the public.'[38] Apparently the public could not get what it did not pay for, and Prince Albert's 1851 plea to the Academy for 'an atmosphere of encouragement and appreciation' had very little moral suasion.[39] Something more was needed than either Edwards, Pye, Parliament, or Albert could offer.

John Ruskin attempted to put British artists into a new relationship with their patrons and the public in his 1857 lectures on *The Political Economy of Art*. The lectures are prophetic of the changes in European art patronage in the twentieth century. Ruskin began by formulating the problems of art in terms of political economy: How do we apply our labor to it? How can the results of artistic labor be preserved? How are the results best distributed? Ruskin's main concern was the discovery and employment of the 'man of genius.' He told his upper-middle-class audience that 'your born painter, if you don't make a painter of him, won't be a first-rate merchant or lawyer.'[40] Ruskin demanded art education for young people in every town and steady, secure employment for young artists: 'The best part of their early energy is lost in the battle for life,' he said.[41] He condemned the 'scrambling' of prize competitions and proposed 'adequate support and opportunity to display such power as they possess.'[42]

Ruskin also wanted to 'bring great art within reach of the multitude.'[43] He proposed to accomplish his goals by creating a national society to purchase paintings and present them to galleries, influencing private collectors to buy works by living artists, and increasing the number of commissions to decorate government and industrial buildings. Ruskin called for a 'worldwide effort' for the preservation of works of art that seems to modern eyes to combine features of UNESCO and American foundations.

The man who interpreted Turner and defended the Pre-Raphaelites tried
to give his comfortable audience an impression of the realities and problems
of artists' lives by talking to them in their own language—the jargon of
political economy. Ruskin's style was forced and his categories too rigid
because, like so many other nineteenth-century men of the arts, he was not
accustomed to switching from idealism and aesthetic discourse to public
discussion of economic realities.

Ruskin, like Castagnary, had considerable power as a mediator between
artists and the public. The mediators have been wrong on some occasions, by
our standards, but they were usually sincere. Collusion between reigning
experts and market-cornering dealers was a later development. The scholar
and museum director, Wilhelm von Bode, had a similar mediating function
in Prussia. German patronage was caught in a conflict between royal and
aristocratic practices and new forces: a middle-class public and liberal
political ideas.

Until the First World War, scholars and critics like von Bode and Ludwig
Justi and painters like Max Liebermann were fighting battles that had been
decided half a century or more earlier in France and England. Von Bode had
to develop confusing, often contradictory, policies to deal with the Kaiser,
private collectors and dealers, the bureaucracy, the needs of a public art
museum that was also a royal collection and the new forces in contemporary
art. Thus, he persuaded wealthy collectors to buy only old masters that would
eventually be willed to the Berlin Museum, defended the Secession painters
from reactionary critics, organized political pressure in the Prussian Landtag
to secure an appropriation for buying a valuable private collection, and used
his personal influence with the Kaiser to prevent the imposition of a tariff
on exported paintings. He attacked some art dealers as tyrants and accepted
retainers from others. He declared that most Berliners were insensitive to
art, but was as sensitive to newspaper criticism of his policies as art ad-
ministrators in England and France. Although von Bode usually voiced
'correct opinions' and moved in the best social circles, he ignored cries of
'Jew lover' and even infuriated the Kaiser by his vigorous defense of Max
Liebermann.[44]

V

Von Bode's career was a more unstable mixture of practical affairs and
aesthetic considerations than Ruskin's or Castagnary's. Other experts of his
generation could not hold the balance as well as he did. Berenson eventually
yielded completely to aesthetics, and the Duveens subjugated passion to

business. But the older pattern, the precarious balance, has emerged again in men like André Malraux and Sir Kenneth Clark.

A similar point can be made about artists. Delacroix and Courbet were more successful at balancing the economic and aesthetic sides of their careers than Gauguin or Van Gogh. But Henry Moore, Picasso and Jackson Pollock did not need to be outcasts. I will only suggest, and not argue fully at this time, that private art-collecting and the museum movement, which began to dominate the art world on both sides of the Atlantic in the last quarter of the nineteenth century, initially frustrated the trend toward increased government patronage of living artists. However, the First World War and the Great Depression forced wealthy collectors, museums and governments to join in picking up the thread of nineteenth-century public patronage development where it had broken during the 1870's.

The wildcatting character of the art market at the end of the nineteenth century forced mediators between living artists and the public to play the social game. Some collectors yielded and bought paintings by living artists. But the political struggles of the nineteenth century put a great deal of old art on the market, new historical techniques gave personality to dulled canvases and cracked statues, and the desire for cultural and social prestige led to their collection.

Collectors preferred modern technology to modern art. The great Berlin collector, Oskar Hainauer, was persuaded not to buy contemporary art by von Bode, and the House of Duveen did not deal extensively in work by living artists until well into the twentieth century. Wealthy American collectors took advantage of the lethargy and economic difficulties of European governments and bought many great works of art in these years. Many of the great aristocratic collections of Europe eventually became community property in American cities as a result of the gospel of wealth, the federal tax laws and renewed interest in the value of art for public education.

VI

Romain Rolland, discussing public support for the arts in 1903, declared that 'It is the role of the State to petrify all it touches, to transform a vibrant ideal into a bureaucratic ideal.'[45] In the same essay, Rolland described the patronage revolution of the 1790's and eventually concluded that well-managed public subsidies would be of benefit to the arts. Like other artists, he did not entirely reject support from public funds. This nineteenth-century pattern has persisted into the twentieth. Artists damn all government patronage when they do not receive the kind they want.

Perhaps artists are similar to the businessmen who call for free trade and removal of government controls combined with protective tariffs. Artists are even closer to those middle-class American farmers who, imbued with the myth of agrarian virtue, condemn government action and demand that the government legislate to provide the economic stability they desire.

But it would be sheer distortion to claim that painters are only interested in cash and creative freedom. They often talk of 'recognition,' a word meaning different things to different artists. But there are at least three common elements in every artist's definition of the word: understanding, sympathy and enough money to live decently.

Stylistic innovations and revolts against aesthetic conventions have been more frequent in the last century and a half than in any other period of art history. These innovations may be in part a reflection of the uncertainty of the new public and private patrons. When artists are not told what to paint, when they produce for a retail market, there are fewer restraints on the free exercise of imagination. Some innovations may have been a result of artists trying to capture new markets by being unique.

It is not accurate to argue that the content of twentieth-century art indicates that artists have completely rejected the external world. Artists have never ceased striving for recognition through exhibitions and sales. Uniqueness within limits set by fashion has been a necessity for ambitious artists in all periods. The constant attack on all but the latest conventions may be in part a product of nineteenth-century social changes which abolished intimate contact between artists and patrons. However, it is difficult to ascribe all stylistic changes to the relationship between artists and their market. Stylistic development can only be stimulated or hindered by external circumstances.[46]

Art has only recently become functional again—if 'function' is not defined in social terms. But artists have never been completely unfunctional. In the nineteenth century painters became, for better and worse, dependent on a broader public than ever before. They wanted freedom from stylistic, economic and social servitude. But they also wanted to influence the expanding apparatus of government patronage and the increasingly important international dealers' and collectors' market.

Their bombast and idealism, self-advertisement and aggressive loneliness were exaggerated—but also good salesmanship. Artists and art experts were aware of the strains in their compromise with the world of getting and spending. They criticized incompetent bureaucrats, monopolistic academies, corrupt dealers, and narrow-minded collectors more often than they attacked 'society' or the 'bourgeoisie.' William Morris complained about the influence

of the plutocracy on art, but William Morris and Company did a fair business until 1940. In the same way Sir Herbert Read, despite his ideology, accepted a five-thousand-dollar annual retainer from Mrs. Guggenheim. And a British artist, who considers himself a sincere socialist, recently remarked that 'One good thing about the Princess' marriage is that Tony Jones may provoke some enlightened patronage from the Royal Family.'[47]

There are distinct connections between David and the present cultural policies of André Malraux, between Prince Albert, Ruskin and the programs of the British Arts Council, between Wilhelm von Bode and the Standing Conference of Cultural Ministers in the German Federal Republic. The Salon des Refusés was a precursor of the liberal purchasing policy of the Paris Museum of Modern Art, and Ruskin's ideas about the need for organizing craftsmen and the social control of design have been influential in Scandinavia.

I have not found all the direct connections between nineteenth-century patronage and the developments in recent years. The continued patterns suggest that further research will indicate that the contemporary patronage revolution is related to developments in the first half of the nineteenth century. There are other connections too: the use of art as a political tool by the Nazis and Soviets, for example. But the nineteenth century seems to have been a period when artists achieved creative freedom while meeting the demands of a broadening and aesthetically insecure public. Artists struggled against government attempts to encourage an official style while diffusing patronage more widely. They won their fight for a liberal official arts policy, but after much frustration and many disappointments.

In the twentieth century, new standards of democratic government patronage have evolved, based on the conviction that if talent is discovered and trained and artists can place their work before an increasing number of people, the public institution has done its job. These standards are the result of the changed role of artists in the modern state as well as of new ideas about the utility of art. The role and the ideas have their roots in the late eighteenth and early nineteenth centuries. The future of artists' relations to their patrons is being built on nineteenth-century foundations.

NOTES

[1] N. Pevsner, *Academies of Art: Past and Present* (Cambridge, 1940), p. 241.
[2] H. Read, *Art and Society* (New York, 1937), p. 171.

[3] *Ibid.*, p. 144.
[4] *Ibid.*, p. 145.
[5] *Ibid.*, p. 165.
[6] *Ibid.*, p. 167.
[7] *Ibid.*, p. 182.
[8] *Ibid.*, p. 266.
[9] *Ibid.*, p. 275.
[10] A. Hauser, *Social History of Art* (London, 1951), p. 621.
[11] *Ibid.*, p. 643.
[12] *Ibid.*, p. 653.
[13] *Ibid.*, pp. 772, 775, 779.
[14] *Ibid.*, 301.
[15] *Ibid.*, p. 959; Pevsner, *op. cit.*, p. 295; H. M. Kallen, *Art and Freedom* (New York, 1942), Vol. II, *passim*.
[16] F. H. Taylor, *The Taste of Angels* (Boston, 1948), p. 591.
[17] D. L. Dowd, *Pageant-Master of the Republic* (Lincoln, Nebr., 1948), p. 32.
[18] *Ibid.*, p. 79.
[19] G. Boas (ed.), *Courbet and the Naturalistic Movement* (Baltimore, 1938), p. 66.
[20] K. Brun, *Jacques Louis David und die Französische Revolution* (Zurich, 1890), p. 11.
[21] M. DuSeigneur, *L'Art et les artistes au Salon de 1880* (Paris, 1880), Introduction, *passim*.
[22] R. Goldwater and M. Treves, *Artists on Art* (New York, 1947), p. 205.
[23] *Ibid.*, p. 223.
[24] *Ibid.*, p. 219.
[25] *Ibid.*, p. 234.
[26] M. S. Briggs, *Men of Taste* (London, 1947), p. 198.
[27] J. Bentham, *Theory of Legislation* (London, 1871), p. 136.
[28] E. Edwards, *The Administrative Economy of the Fine Arts in England* (London, 1840), pp. 10, 12, 13, 21.
[29] *Ibid.*, p. v.
[30] J. Pye, *Patronage of British Art* (London, 1845), p. 1.
[31] *Ibid.*, p. 26.
[32] *Ibid.*, p. 213.
[33] *Ibid.*, p. 134.
[34] *Ibid.*, p. 28.
[35] *Ibid.*, p. 293.
[36] *Ibid.*, p. 290.
[37] *Ibid.*, p. 295.
[38] *Ibid.*, p. 298.
[39] Briggs, *op. cit.*, p. 203.
[40] J. Ruskin, *The Political Economy of Art* (London, 1857), p. 31.
[41] *Ibid.*, p. 33.
[42] *Ibid.*, p. 34.
[43] *Ibid.*, p. 90.

[44] Wilhelm von Bode, *Mein Leben* (Berlin, 1930), *passim*.
[45] R. Rolland, *Le Theatre du peuple* (Paris, 1903), p. 3.
[46] Cf. A. L. Kroeber, *Style and Civilization* (Ithaca, N.Y., 1957), Chap. 2.
[47] A. MacNeish to the author, interview, Edinburgh, May, 1960.

HAROLD ROSENBERG

The Art Establishment*

THE AMERICAN ART establishment is in the process of construction. Much of it is still unfinished. Key posts are occupied by squatters. Permanent positions in it have not yet been assigned. One reason for its condition is that this Establishment is the newest among America's cultural-economic edifices; in its present form it dates no farther back than the five or six years since money began streaming into American art and art education, and trends in art prices (reaching $135,000 for a Wyeth, more than $100,000 for a Pollock, $60,000 for a de Kooning, $30,000 for a Johns) began to attract the attention of *Fortune*, *The Wall Street Journal* and *Barron's Weekly*. A deeper reason for its incompleteness is that the American Art Establishment lacks a solid foundation in public taste and values, and rocks back and forth on tides of fad.

Within the unfinished whole, there are a few older segments: The Museum of Modern Art, the Whitney Museum of American Art, the Solomon R. Guggenheim Museum; half-a-dozen galleries dating back to the Thirties and Forties; a handful of pre-1950 collectors; two or three writers of the same vintage. Even these, however, have little that is venerable about them; to hold their places thay have had to be in a state of constant refurbishing. The museums, continually undergoing momentous expansion in physical size and function, keep filling up with new people. The older galleries are jostled by hundreds of latecomers (the one with the biggest current names— the Marlborough-Gerson—opened late in 1963). Earlier collectors are ridden down by people rushing to anticipate the market. Perhaps the least-built-up area is in the constantly increasing space devoted to art in the daily and weekly press, in magazines and, most recently, in radio and

* Reprinted from *Esquire*, LXIII (January–June, 1965), 43, 46, 114, by permission of the author and the publisher.

TV. Art education of the public through the mass media offers the Establishment a virtually unlimited field for colonization. In sum, we are speaking of an Establishment that isn't established—and, even where it is, tends to develop cracks as it settles.

The outstanding characteristic of the American Art Establishment is its shakiness. This shows up most clearly in regard to creating reputations. Some people are convinced that a conspiracy is responsible for every big name and that no one ever achieves success except through wire-pulling. (The award to Robert Rauschenberg of the Venice Biennale Grand Prix in 1964 once again made the air thick with rumors.) Manipulated fame exists, of course, in the art world. But it is probably less than the rule it is elsewhere, not because the impulse to pull wires is lacking, but because pulling them does not necessarily cause any wheels to turn. Though people are made through the Establishment, the Establishment does not possess a reliable machinery for making people. One never knows who or what is going to succeed in putting an artist across. The same device or agency that works for painter A will fail to produce results for painter B. Some artists win their reputation through being consistently plugged by a dealer. Charles Egan, Sam Kootz, Betty Parsons brought such artists as de Kooning, Pollock, Hofmann, Gottlieb, Rothko, Guston, Kline, Newman, Motherwell, Tomlin to public attention long before the museums, the press and the majority of collectors were aware that anything was stirring in American art. Hans Hofmann, for instance, was sold at steadily rising prices from the forties on, yet it was not until 1963 that the Museum of Modern Art took individual notice of him. On the other hand, the museums often have a good deal to do with lifting an artist out of obscurity. Dorothy Miller's Museum of Modern Art '16 (or 14) Americans' Shows every few years have put younger talents on the map for dealers, reviewers and buyers. Lately, collectors and foundations have begun initiating recognition of individual artists through buying their works and making them available for public exhibition. Pop art was mainly promoted by two dealers—the Leo Castelli Gallery and the Green Gallery—and one collector—Robert C. Scull. The big break came when the Sidney Janis Gallery got on board in the fall of 1962. Then the Guggenheim and half a dozen out-of-town museums anxious not to miss the boat came tailing along. But all these forces—dealers, museums, collectors—have notoriously failed to affect responses of the art world in at least as many instances as they have succeeded. Dealers who have had sensational success with two or three artists have had to give up on five or six for whom they tried equally hard. Over the years, The Museum of Modern Art's 'Americans' have included a heavy percentage of busts. Collectors after striving to put over their favorites have ended by

hiding their work in the cellar. The sum of it is that no dealer, curator, buyer or critic can be depended upon to produce a reputation that is more than a momentary flurry, nor can any existing combination of these.

The result is widespread anxiety—the anxiety of individuals and groups concerning both their own status and that of the art which they exhibit, deal in, comment on, create. Like a newly installed revolutionary government, the Art Establishment is not fully convinced that it knows what it is doing, where it is going or if the things it is handling are real. It is affected by developments outside itself and over which it has no control—the condition of the stock market, the change in social moods and attitudes (for example, from revolt to conformity). Museum directors, dealers, critics, artists live with eyes and ears permanently cocked for trends. The general art public (gallery goers, art-book buyers, museum members) is subject to the same uneasy watchfulness; though having no material or status investment in how things turn out, it is more relaxed and ready to take things as they come.

Each appearance on the art scene of a new look or personality compels the Establishment person to take inventory of his resources and to decide whether it is to his advantage to embrace the novelty or to fight it. The museum director finds himself under pressure to show works featured as the newest thing in the picture weeklies; but if he goes along he risks critical attack should the press buildup collapse too soon. Similarly, the anxious dealer, collector, artist must weigh the advisability of a new move as against the likelihood that the style with which he is identified will continue to arouse interest. To take a wrong turn may prove mortal. On the other hand, to allow oneself to be bypassed by art history before one has become firmly embedded in that history is not only to be deprived of a place in the Establishment but to be condemned to intellectual extinction.

Thus the big question for the Establishment is: Has the time come to unload and take on something new? If so, whose judgment ought one to follow? One's own? That of the consensus? Some current Loud Noise? Especially outside of New York, the preferred solution is to accept *en bloc* whatever has gained prestige in the metropolis. To get on board early and to play the whole field—for example, Pop art, *plus* Abstract Expressionism, *plus* hard-edge—is the best insurance against being outsmarted by a sudden change of fashion. If these modes of art seem to represent irreconcilable premises concerning art and life, one can claim to have been guided by personal discrimination in choosing the particular examples.

Owing to its conditions of unremitting anxiety, the Art Establishment is easily swayed (as no established Establishment would be) by aggressively

stated opinions, attention-getting stunts (*e.g.*, Tinguely's self-destroying mechanized sculpture that fizzed out in the garden of The Museum of Modern Art), sheer brass (Warhol's imitation Brillo boxes). Praise by a critic or museum employee of an artist or a tendency is bound to fetch some support, providing the praise is all-out and without critical reservations. The claim that a work is historically significant is sufficient to clinch a sale, regardless of the poor condition or lack of attractiveness of the work itself, as is a confident forecast of capital gains. Periodic mentions in the press, expensive catalogs and reproductions, dealer-subsidized 'critical' biographies, large private and gallery parties influence an artist's standing despite everyone's awareness of how these things are arranged. A mediocre talent suddenly hailed as representing the ultimate phase in the evolution of world art will be accorded new respect not only by dealers, curators and reviewers but even by fellow artists.

One substance overlies all the elements of the Establishment, from museum personnel to dinner hostesses. That substance is talk. The Art Establishment subsists on words—much more, in fact, than it does on pictures. Talk there has more power than elsewhere because decisions are less sure and the consequences of acting on them more uncertain. In this sense, everyone in the art world has power, at least the power to pass the word along, mention names, repeat stock judgments, all of which produce an effect. The first qualification for entering the Art Establishment is to be familiar with its jargon and the people and things most often referred to. Getting in deeper depends on having a head start on the current gossip and an enlarged repertory of anecdotes about leading figures. The Establishment's lack of equilibrium puts a premium on name- and event-dropping.

To drop names effectively one must, of course, drop them in the right places. Good spots to unload gossip and renew one's supply are those exhibition openings, parties, bars and beaches where merely to be seen creates a presumption of belonging. In the preferred locations certain conversational tags can be depended on to distinguish Establishment people from the public-at-large. In the Hamptons a couple of years ago the standard 'in' question was 'Is Bill de Kooning in town?' Last summer it was changed to 'Has de Kooning finished his house?' 'In' questions that become that popular actually brand the questioner as 'out'. More ingenious Establishment candidates seek an esoteric switch. As I came up out of a wave off the Coast Guard Beach in East Hampton, a body floating by asked, 'Have the David Hares gone to Wyoming yet?'

Having the inside story on an event everyone has heard about is proof of weighty connections. Fringe personalities will go to almost any length

to be let in on a fresh scandal. One suspects that a significant percentage of Establishment love affairs originate in a lust for information. At the Cedar Bar or Chez Madison it is politic to modulate one's voice by a consciousness of poised eavesdroppers. One Sunday afternoon on the Barnes Landing Beach in Springs, Long Island, a group of artists and their wives was approached by a lady bather in dark glasses who was a total stranger to them. 'I am a friend of X and Y,' she introduced herself, giving as reference a couple of Establishment people. 'Please tell me what really happened at O's last night.' One of the women quickly filled her in. An artist, however, muttered audibly, 'A fine thing. Now gossip panhandlers!'

To enter more directly into the center of the Establishment, talk needs to be complemented by deeds, such as buying pictures, opening a gallery, winning the proper job or lover. (Giving parties, even elaborate ones, cannot be relied on, unless one is in possession of a nucleus of important guests and, above all, knows the people to keep out—the strongest Establishment personage can score a minus with a party too self-indulgent in respect to relatives, old friends or non- or sub-Establishment casuals.) A functioning relation to art or to artists (among the mysterious personages who loom large in the Establishment, through knowing everything that is going on, are tax consultants, lawyers, frame makers, hairdressers, psychiatrists, chairmen of museum 'friends' organizations, silent partners of galleries) confers an advantage over the mere ambitious onlooker. Thus the art world swarms with fake collectors and entrepreneurs, people who visit studios and, on the pretext of intending to buy pictures or arrange deals, induce artists to pull out and display every scrap of their work, with no further result than to supply the visitors with material for insiders' ta'k.

A deceptive aspect of the Art Establishment is that there is nothing to prevent anyone, whether serviceable or not, from getting right into the middle of things. Most Establishment events and hangouts are public or can be crashed easily. Even the homes and studios of top Establishmentarians are vulnerable to penetration by persons who feel, or pretend to feel, an interest in what the important figure is doing. Thus newcomers will often be found comfortably ensconced in coveted positions, while older members ask one another behind their hands, 'Who is this fellow (or dame) I keep running into lately ?' Some of the infiltrators persist in manifesting themselves in situation after situation: in time they become permanently affixed to the Establishment structure and are greeted as a matter of course, though no one knows their names or their business. Usually, however, outsiders who have made their way into the core of the Establishment discover in bewilderment and consternation that the center is no different from the outer

edge—in short, that there is no center, only individuals and institutions without a dominant authority or etiquette. With the effort to gain reflected glory thus proven wasted, the disappointed art (or artist) lover is likely to return to his normal habitat equipped to disseminate the intimate story of the art world, its doings, its heroes and its 'phonies' (favorite outsider epithet). The large turnover in Establishment hangers-on thus results in a significant contribution to public art education in America.

Artists dislike formal organization. The last really comprehensive association of artists in the United States was The Artists Union of the Thirties, active around the government art projects. The club, which was a lively factor in the rise of Abstract Expressionism in the Fifties, always kept a hazy area between members and nonmembers, and the repeated theme at the meetings of its 'voting members' was how to keep out strangers and who would fold the chairs and sweep up the cigarette butts. But though artists are touchy about rules and obligations, herd impulses are very strong in the art world. Cliques are constantly being formed, mostly based on convictions regarding what art ought to be and which style would prevail. Intellectual get-togethers are most numerous among the young and the unknown: later, the primary motive for assembling is overcoming boredom. Youth coteries subsist in varying degrees of potency around the Tenth Street galleries and sprinkled through the upper East Side. Their attitude toward the Establishment is uniformly hostile—whenever an occasion arises they attack it publicly as a means of gaining its notice. In these sallies, they are supported by perennial anti-Establishment Establishmentarians. Youth cliques, however, tend to dissolve quickly through the uneven success of their adherents.

Groupings based on sex were unknown in the Art Establishment until very recently. Though in the postwar years women became for the first time prominent on a large scale in American painting and sculpture, they insisted on being considered as artists, not as *women* artists. In contrast, a feature of the past four or five years has been the banding together of homo-sexual painters and their nonpainting auxiliaries in music, writing and museum work.

Another recently emerged power is the artist's widow. The widow is identified with the painter's person, but she is also an owner of his art properties—in the structure of the Establishment widows stand partway between artists and patron-collectors. Commonly, the widow controls the entirety of her dead husband's unsold production; this enables her to affect prices by the rate at which she releases his work on the market, to assist or sabotage retrospective exhibitions, to grant or withhold documents or rights

of reproduction needed by publishers and authors. (Mrs. Jackson Pollock, besides being a painter in her own right, is often credited with having almost singlehandedly forced up prices for contemporary American abstract art after the death of her husband.) She is also in a position to authenticate or reject unsigned paintings or drawings in the hands of others. Finally, she is the official source of the artist's life story, as well as of his private interpretation of that story. The result is that she is courted and her views heeded by dealers, collectors, curators, historians, publishers, to say nothing of lawyers and tax specialists. It is hard to think of anyone in the Establishment who exceeds the widow in the number of powers concentrated in the hands of a single person.

The widow's straddling of categories is duplicated by other Establishment people with multiple functions; the collector who acts as a dealer when the opportunity for a profit arises; the curator who doubles as a critic in magazine articles, speeches and catalog introductions; the critic (this is a new development) who, operating as combination art director and promoter, instructs a stable of painters on how to paint and praises their work in the art press and from the lecture platform.

A map of the Establishment would show it as extending outward from New York in dots and splashes across the country and around the globe. Exhibitions put together by metropolitan institutions are booked on a package basis by modern-art museums in Washington, Buffalo, Minneapolis, Chicago, San Francisco, Dallas, Los Angeles; smaller shows may dock at a dozen university galleries in as many states. Other exhibitions are set up, with or without State Department collaboration, to cover Latin America, Europe, Asia. Along with the shows go the educational (publicity) services of the originating institution: catalogs, reproductions, slides, essays defining the place of the work in art history, human-interest biographies, statements by the artist and, on occasion, visiting lecturers. New York recommendations pull down posts for painters as teachers and resident artists in universities throughout the United States and in countries on the Fulbright and foundation circuits. Out-of-town dealers strive to balance representation of local talent with offerings of New York names. Across the seas each summer stream dealers and museum advance agents to spread their favorites' fame and case the ground for new artists to take on, hot possibilities for shows and commission-splitting, allies in copping international prizes. In addition to its salesmen abroad, the Establishment has its advance men and resident agents, both Americans and foreigners, engaged in the dissemination of its products and reputations. In turn Europeans, Near Easterners, Australians, Asians keep scouting New York and points west on commercial assignments or

educational grants. Despite all this activity, however, the international distribution of American art is still largely undeveloped, owing chiefly to the reluctance of some leading New York dealers to share their cut with dealers overseas.

The power of the well-placed member of the Establishment to start an artist on tour around the country and the world, without necessarily a word of sense in support of his choice, constantly breeds in the art functionary the temptation to be the independent instigator of trends, styles and reputations, with the artist as his submissive instrument and grateful beneficiary. Even the art of the past seems susceptible to Establishment control through the practice of assembling works under tendentious labels.

The nonartist element of the Establishment has been swelling vastly in numbers, resources and self-adulation. Recruits come increasingly armed with academic degrees conferred by the mushrooming art-history departments of universities throughout the country. Yet the single most potent force in the art world is still, in the last analysis, the artist. One might say that in the trembling structure of the Establishment he is the sole semisolid substance. It is to him that the dealers and collectors, the curators and the art-department heads turn for recommendations. It is his judgment of his colleagues that reviewers listen in on before committing themselves in their columns. A painter with prestige among painters is bound to be discovered sooner or later by the independent tastes who determine when an artist deserves to be bought, hired, or chosen as one of the four or fourteen Americans currently entitled to museum fanfare. And beyond their effect on the public acceptance of work, the artists have the last word on that still more important aspect of art, its creation.

ROBERT ESCARPIT

The Act of Publication: Publication and Creation*

THE HISTORY OF the publication of the book and the history of the book are not to be confused. Printed or not, the book is only the most recent and most widespread of ways to reproduce a literary work for dissemination; but it is not the only way. The production of a play, for example, demonstrates that the act of publication can be implemented in a society that cannot read.[1] Today the movies, radio and television render audio-visual publications more effective than printed publications.

The semantic accordance of the word 'publish' with its Latin ancestor *publicare* gives us the idea of a 'release' at the disposal of an anonymous public. *Publicare simulacrum* implies the raising of a statue on a public square, the publishing of matrimonial bans, the making known to all persons, anonymous or not, a project which is private by its very nature. The oldest use of this word cited by Littré dates from the thirteenth century, and applied to furniture, signifies 'selling at a public auction.'

Let us retain this idea of the public auction of a work, this deliberate and almost brutal exposure of the secret of creation to the anonymous light of the public square. There is implied a kind of willful violence, an accepted profanation, all the more shocking to common sensitivity in that it brings financial considerations into play. To publish a work drawn from oneself for commercial reasons is a bit like prostituting oneself. *Publicare corpus*, says Plato.

But further, to publish a work is to complete it by abandoning it to others. In order to exist as an autonomous and free creation, a work must be

* Reprinted by permission of the author and the publisher from *Sociology of Literature*, by Robert Escarpit, 1960. Translated by Ernest Pick. Lake Erie College Press, 1965, Painesville, Ohio.

detached from its creator and follow alone its destiny among men. Such is the symbolism of the grand opening or of the *vernissage* of paintings in an art exhibit; by varnishing his work, the painter forbids himself further retouching. He abdicates his position as guardian of his work and declares it born in hanging it from the moulding for sale.

For it is indeed a birth. This act of violent creation is a delivery; a tearing asunder, at once a painful separation and the start of a new being, autonomous and free. Without undue exaggeration, we may compare the publisher's role to that of the obstetrician: he is not the source of life, nor does he carry it within himself, nor does he contribute of his flesh to its being, but without him the work, conceived and brought to the threshold of creation, could not come to exist.

This is nothing other than the essential aspect of the publisher's function. There are many others, and to complete the metaphor, our obstetrician must be a prenatal counselor, a judge of life or death for newborn babies (even an abortionist), a hygienist, a pedagogue, a tailor, a guide and . . . a dealer in slavery.

HISTORICAL DEVELOPMENT

The publisher is a recent phenomenon in the history of literary institutions, although for a long time means of copying the written word and distributing the work have existed. Often, an author did the copying and distributing himself. Reading in public was one of the favorite modes of *publication* in antiquity; even after the invention of the printing press, it was and still is one of the most convenient ways of trying out a work on a limited public. The most picturesque instance of distribution by an author is perhaps that of the *Yomiuri*, the father of Japanese newspapers: after having written them, the author ran them off and then sold them himself in the streets, shouting aloud main passages.

However, as far back as earliest antiquity, there were distribution specialists. At first, these were ambulatory storytellers who recounted traditional works and who still do in countries where hawking is common. Sometimes they read their own works. Here is an incontestable form of 'publication,' although a limited one.[2]

Nothing of consequence existed before the advent of the book; that is to say, the book in its earliest manuscript form. In Athens as early as the fifth century B.C. and in Rome during the classical era, scribes' workshops (*scriptoria*) could be found where entrepreneurs had manuscripts copied. The copies were then put on sale in real bookshops. There was thus already

a book industry and a book market. The largest circulation mentioned (references to this are rare) was never greater than a few hundred copies, but the idea of publishing was taking on form and substance. It is interesting to note that the Romans described publishing by the root of the verb *edere*, which means 'to put into the world,' 'to give birth to.' This sense of the word remained the same for Virgil and Ovid, but half a century later, Pliny cast a modern publisher's judgment when he spoke of *Libelli editione digni*.

As frequently happens, the idea preceded the technical means. The means in question were to lie undiscovered for fourteen centuries. With the printing press, the accent falls on publication—that is, on the availability of books to an anonymous public, rather than on the book itself. In this sense, it can be said that the publication of the Bible was one of the determining factors of the Reformation. Let us add that technical publishing was reinforced by linguistic publication, that is, the use of the vernacular.

The first printers were already publisher-obstetricians. Their choices were of a creative nature. Thus it was to Caxton that already antiquated writers such as Chaucer, Gower, Lydgate, Malory, etc., owe their resurrection to literary life, for had they been read only in manuscript form there would have been scant assurance of their being remembered by posterity.

The first printers were also businessmen, as their many 'utilitarian' but marketable books prove. Nevertheless, romances of chivalry, which were certain to sell to the aristocracy, were among the favorites to come from Caxton's press. His successor, Wynkyn de Worde, established a store for retail sales on Fleet Street, and this was one of the first bookstores in the modern sense of the word in England.

At the end of the fifteenth century there already existed large commercial enterprises like one owned by Anton Koburger, a printer from Nuremberg. He owned sixteen bookstores and had agents in the principal cities of Christendom. Aldo Manuzio of Venice is another example of a man who flourished in the book trade. In the sixteenth century, there was the dynasty of the Estiennes in France and, in Holland, the Plantins and the Elzevirs. We know the part played by the Netherlands until the eighteenth century as a center for the book market.[3] In most countries, printing corporations or guilds were formed and their activities were regulated strictly for reasons practical rather than economic.

The powerful printers, however, absorbed by the growing complexity of their industry, were quickly forced to abandon retail sales to specialists, to delegate to the latter the operation of all or part of their commercial functions. By the second half of the sixteenth century the word *libraire* in France was

no longer used to designate the functions of a copier, nor to refer to librarians (the English word, library, however, retains the original meaning). Around that time, the bookseller made his entry into English commercial life as the *Buchhandler* did in Germany.

The frontier was nevertheless not carefully delineated between the two professions, and licenses for Letters Patent in 1618 in France place printers and booksellers in a single group. Up to the end of the eighteenth century, it is difficult to assign either moral or financial responsibility to either or to decide which one would assume the risk of investing and answer for various claims that might be brought against a work. Traditionally, this thankless job fell on the shoulders of the printer, but as time went by the bookseller had to accept his share of it. In the beginning of the nineteenth century, Napoleonic legislation put an end to the debate by designating, to the profit of a third middleman, a responsible publisher for every publication—the equivalent of the mythical manager of French newspapers.

But at this date, the publisher had already been functioning for half a century: he was the manager who, relegating to the printer the technical side of the operation and to the bookseller the commercial side of it, coordinated manufacturing with sales specifications, dealt with the author and various subcontractors and, generally, set in order the isolated acts of publication. This action implemented the manager's general business policy. In other words, capitalistic exploitation was substituted for the exploitation of the artisan.

The substitution may be explained by the economic, political and cultural upsurge of the middle class. As we have already seen, literature ceased to be the privilege of men of letters at that time. The newly arrived middle class was demanding a literature to suit its own standards. The reading public became larger while a revolution took place in taste. Henceforth, realistic and sentimental novels, pre-romantic and romantic poems became works in large editions with tremendous circulation, the financing of which required the introduction of the powerful economic system that was succeeding so well in other areas of industrial and commercial activity.

The publication in 1740 of Richardson's *Pamela*, the prototype of the English novel, was an excellent example of capitalistic enterprise applied to the publishing industry. Richardson was President of the Corporation of Stationers, a sort of official printer for the British Government. Two of his colleagues in London, Rivington and Osborn, associated with him to publish a collection, destined for middle-class ladies, of model letters of the 'perfect secretary' type. Richardson, gifted as a writer, was to furnish the text himself. This was a perfect example of utilitarian publication. From

that text, by a series of transformations, Richardson's genius created *Pamela*, an epistolary novel, spawned by the nonliterary initiative of a group of book manufacturers and businessmen.

Among present publishing houses, a number have begun in such a way. For example, the house of John Murray accompanied the rise of British romanticism. Other publishing houses, such as Plon in France, developed from the printing press; but some, like Hachette, began as bookstores and grew into publishing houses. There still exist printer-publishers and bookseller-publishers.

During the first half of the twentieth century, the function of the publisher underwent a last transformation, particularly in France, which corresponds to the decline of capitalism and to the rise of the masses. Many publishers, dismayed by the costs of promotion and distribution, turned over this part of their business to specialized enterprises such as Hachette or Chaix. It is still difficult to evaluate the effect of this practice on the evolution of the publisher's function.

THE PUBLISHER'S FUNCTION

Reduced to their material operations, the publisher's functions can be summed up in three verbs: choose, manufacture and distribute. These three operations are linked together, each depending on the others while they condition one another; they form a cycle which constitutes the act of publication.

To each of these operations correspond respectively the three essential services of a publishing firm: those of the literary committee, the manufacturing office and the commercial department. The publisher coordinates their actions, gives them meaning and assumes responsibility for them. Even when the publisher remains anonymous and the policy of a house is fixed by an administrative council, there must be an individual—a director, a counselor or an administrator—to give the publishing act the personal and united character which is indispensable to it.

A publisher remains a publisher even should he delegate to specialists his diverse technical functions, such as the selection, manufacture and distribution of books. It is essential, however, that he be responsible for the moral and commercial aspects of the whole undertaking.

The unique problem of publishing is that of bringing an individual fact to the community, and each of the technical functions enumerated above corresponds to a relationship between the individual and the community.

Selection presupposes that the publisher—or his delegate—imagines a

possible public and chooses from the mass of writing which is submitted to him the works best suited for that public. This sort of conjecture has a two-fold and contradictory nature: on the one hand, it involves a judgment of fact as to what exactly the possible public desires, what it will buy; and on the other hand, a value judgment as to what *should be* the public's taste. It must take into account the aesthetic and moral systems of the human group in which the operation is performed. Two questions arise which are asked about all books, and to which the answers can be only a hypothetical compromise: Is the book salable? Is it good?

Caught between the authors' desires and the public's demands, whatever he imagines them to be, the modern publisher does not limit himself to the passive role of conciliator. He attempts to influence his authors in the interest of the public and the public in the interest of the author; in a word, he tries to induce a compatible writer-public relationship.

The ideal thing for a publisher is to find a writer who 'follows-up.' In fact, once the hazards and costs of launching him are undertaken and the effectiveness of the writer is established, he can be expected, without too much risk, to produce works similar to a first well-tried specimen. Having signed a long-term contract, the author then takes his place in the publisher's 'stable.' It is this stable which, assuming a collective policy, gives its tone and style to the publishing house. It is, in general, dominated by one person, the publisher himself (Julliard), or one of his advisors (Jean Paulham at Gallimard). With a team of readers (who are often writers for the house), the stable determines the selection and even influences the output of new writers who wish to become part of it.

The publisher further influences the public by instigating new patterns and habits. These habits may take the form of fashions, fads, even of a temporary infatuation with an author's personality, or they may have deeper origins and indicate predilections for certain thoughts, styles or types of literature. One of the oldest and most typical of such literary habits, consciously kept up if not entirely initiated by a publisher, was 'Byronism.'[4]

A particularly profitable formula is that of the specialized collection which boasts a unity of direction, presentation and interest. On the one hand, it permits the channeling of authors toward types of writing in which they have already proved themselves; on the other hand, it satisfies a well-defined, omnipresent, precise demand. Examples of this are the *Série Blême* published by Gallimard and Hachette's *Vies Quotidiennes*.

One can go even further and define one's public in the interest of controlling it to a greater degree and of establishing quasi-personal links between it and one's stable of authors. This is done usually for genres with

particularly well-marked traits such as the detective novel, the science-fiction
novel, the suspense novel, etc., by means of specialized magazines, book
clubs, or special-interest bulletins. As a result, a doctrine and an aesthetic
of any given genre are created, and the author-public community then
possesses the characteristic of every nascent collective consciousness:
orthodoxy.[5]

It must be remembered, therefore, that each selection presupposes a
theoretical public in the name of which and for whose benefit it is made, and
it also presupposes a sampling of writers which is supposed to reflect the
needs of that public. The whole literary game played by the publisher takes
place in the closed circle of these two groups which are, as we have seen,
defined in advance.

Manufacturing is part of the game as well. From the beginning of the
study, preliminary to actual manufacturing, the public must be kept con-
stantly in mind. Depending on whether the house is thinking in terms of
a handsome volume destined for a few hundred bibliophiles or a popular,
cheap book, everything changes: the paper, the format, the typography (the
choice of characters, the thickness of pages, etc.), the illustrations, the bind-
ing and, especially, the number of copies to be printed. From this moment
on, the publisher must calculate the profit he hopes to make from his work.
In fact, he must have calculated it back at the selection stage. Chosen because
of special qualities and for a special public, the book must have well-defined
and appropriate material characteristics.

The size of the edition is obviously the most important of these characteris-
tics. If the number of copies printed is insufficient, the manufacturing costs
(reading and preparation of the manuscript, composition, proofreading,
paging, typesetting) will be spread over an inadequate number of copies.
These costs are by far the heaviest in each venture and determine the sales
price, which, if too high, may put the work out of the reach of its eventual
public. If too many copies are printed, the supply will be immediately
swollen and a deficit caused by lack of sales will be inevitable, for the book
industry is one of the rare businesses in which the unsold manufactured
product has less value than the raw material.[6]

As for the other characteristics of the work, not only must the size of the
theoretical public be taken into account, but also its nature, its functional
needs and, in particular, its behavior patterns. The use of the illustrated
cover recently came to France from America. In the choice of a cover the
publisher must be aware of the diverse motivations which induce an eventual
client to purchase a book. In fact, if the drawing is well-chosen, it will
constitute a true lesson in literary criticism and translate graphically the

publisher's aesthetic and psychological analysis which guided his selection.[7]

Here we find the advantages of the 'collection' series whose presentation and optimum size of edition have been studied in advance once and for all.

For the publisher, manufacturing continues the selective process, as we can see. The judgment he has imposed on the book now takes form. He now transposes technically, through material decisions, that balance which from the beginning he has attempted to establish between the writers he proposes and the public which he supposes or creates.

The distribution of the work remains, that is, the sale itself, although gratuitous distribution of books does exist. Indeed, the sale of the book is almost indispensable to the completion of the literary fact. Byron remarked one day that to force a perfect stranger to take money out of his pocket (a gesture neither involuntary nor indifferent) to buy a book is the veritable consecration of the writer and a sign of his power.

In capitalistic countries, distribution is the most delicate part of the publishing act, everything converging toward it like a play moving toward its denouement. It determines success or failure. In a book's budget, distribution costs represent more than half of the sales price.[8]

The publisher finds himself confronted by a difficult problem: that of finding and truly reaching the theoretical public which he has supposed or cultivated from the beginning. For this purpose, he employs a certain number of advertising techniques.

The first and the most simple is the inclusion of the book in a bibliographical list, the kind that exists in most countries (for example the *Bibliographie de France*, a monthly publication of the *Cercle de la Librairie*). There booksellers and librarians will learn of the book's publication; personal contact with traveling salesmen, equipped with specimen copies, doubles the advertising value of this anonymous publicity. Commercial advertising of a normal kind (in newspapers, even posters or shopwindow displays) is directed at the public. This type of publicity is less common in France or England than in the United States. In the latter country, for example, the sales campaign is handled, *mutatis mutandis*, much the same way as that of any other commercial product.[9]

The inconvenience of ordinary advertising techniques is that they address the public at large and not the particular public at which the publisher aims. Of one thousand persons reached by publicity, there are perhaps about ten or twenty who may be expected to take an interest in the book, while the whole thousand may be interested in a brand of soap, or of liquor, or in a household article. For advertising to be profitable, it must be directed at those ten or twenty persons who might be influenced, however uncertainly,

by its sales pitch. Unfortunately, one can never be sure of the number of persons influenced, whether two or twenty, and furthermore their identity always varies with the kind of book offered. Thus we return to the *limited* and *personal* nature of the publishing act. And for this reason advertising which is directed at a certain group—especially in signed newspaper reviews—is preferable to mass advertising. Most effective may be the article by a literary editor or the column of a critic whose clientele of readers usually subscribes to his tastes. Publishers pay particular attention to press services; each volume, signed by the author, is accompanied by a review of the 'please-insert' type, and this review is a model feature article (laudatory, of course). Many minor periodicals are content to use it as is and to add a signature to it. Infinitely more interesting is the review of a publishing house critic in a newspaper having a clientele corresponding approximately to the publisher's theoretical public. All means of pressure are exerted to obtain such a review, for the most fecund of critics can scarcely produce more than two hundred reviews a year. It matters little that the review is unfavorable; as long as the book is talked about, even a bad review may be as profitable as a good one. Thus a literary 'catastrophe' may be worth a fortune.

Television, with its direct and personal appeal, has introduced extraordinarily efficacious criticism, and here the author himself confronts his public face to face. It has been ascertained that in the hours that follow the televised interview of an author, the sale of his book increases in what may reach considerable proportions.

To these diverse advertising techniques should be added those which consist of promoting a selection—for example, the choice of the best book of the month or the literary prize. One or two votes for a well-known prize is an advantage not neglected on the book's dustjacket.

Another procedure is more difficult to manage because of its ambivalent implications: the publication of a book in a newspaper or magazine either *in extenso*, in the form of excerpts, or in the form of a résumé. The very delicate problem consists of piquing the reader's interest without injuring the appeal of the work.[10]

The goal of all these techniques is to flush out the hypothetical, hidden public which is scattered among the population at large Naturally, it would be ideal to discover and contain that public and to keep it contained as a group once and for all. This is the rationale of book clubs, whose ultimate aim is to substitute the 'ready-made' for the 'custom-made.' Once found, catalogued, sometimes even bound by contract, the reader can no longer escape.

The same is true in dictatorships and, especially, in socialistic countries.

In the U.S.S.R., for example, the unsold book is relatively rare, for as competition does not exist a publisher has the means of adapting circulation to demand and demand to circulation.

In capitalistic countries, the publisher's situation is much more precarious. From the moment the book is put on sale, its fate is no longer in the publisher's hands. The sale of a book is regulated by special mechanisms in the book industry. The book behaves somewhat like those first teleguided rockets, most of which fell before taking their planned trajectory, while others went out of control completely and flew off erratically and unpredictably. In the same way, the majority of books published in France (60 to 70 per cent), fall out of the market before reaching a profitable volume of sales —and the publisher can do nothing about it. From time to time, a work crosses beyond the most optimistic, predictable boundaries and becomes a best seller. Sales curves vary in apparently undecipherable rhythms as soon as they break through a critical boundary (in general, in France, the '100,000 wall'). The publisher then can do nothing but blindly follow the first edition with others.

The reason for the publisher's lack of control is clear enough: it occurs when the work passes the limits of the hypothetical public for which it was conceived. It evolves then in unprospected and unsurveyed regions. The impossibility of foreseeing reactions at this moment illustrates the weakness of the system.

The act of publication is creative only in appearance. In reality, it takes place in a closed circuit within one social group. A work not adapted to this group fails; it is unlikely that it will find a more sympathetic public elsewhere—indeed, the very nature of the publisher's initial choice makes this inconceivable. We shall see that this 'second' public sometimes appears without forewarning due to a 'creative betrayal,' but it does not depend on the publisher.

Nor does the phenomenon of success depend on him either. It is as rare as it is unpredictable. Let us remember that of 100,000 works in France between 1945 and 1955, scarcely one out of a thousand broke through the '100,000 wall.' It can be seen that the publisher has no more positive influence on the destiny of his new-born work than the obstetrician with whom we have compared him. Nevertheless, his negative influence is considerable, for the beings he brings into the world enjoy only an artificial liberty strictly limited to the social circuit for which they have been delivered.

NOTES

[1] The theater poses special problems with which we cannot deal in this short study. We must hope to see a sociology of the theater. We have, however, taken examples from the theater when problems common to all forms of literature were analyzed.

[2] The limitation in question is due to the form of the distributed work, not to the area of distribution, which may be considerable and may be more extensive than that of a printed book. For while a book has need of a bookstore or library, a storyteller needs only a village square.

[3] 'Dutch bookstores make millions every year because the French were witty.' Voltaire, *Mélanges littéraires*.

[4] 'Byronism' is a fashion that was launched by the publication of the first two cantos of *Childe Harold;* its characteristics had been carefully adapted to the needs of the romantic public by the wishes of the publisher, John Murray. Afterward it was impossible for Byron to disengage himself from this legend. Murray urged him to write the same kind of literature and always arranged not to publish any of Byron's works that might shock the reading habits of his 'Haroldian' public.

[5] Two typical examples are to be found in France, *Fiction* and *Mystere* magazines, both published by the same company. In England, the venerable Hakluyt Society brings together those interested in adventure stories and encourages them to write.

[6] A work of literature is not profitable unless it sells between 5,000 and 6,000 copies; at least 2,000 copies must be sold for the publishing house to break even.

[7] The choice of title is essential to the sale of a book. As for the cover, it is much used for publicity purposes in France. It should principally reflect the title or directly reach one of the reader's motivations for reading. More intellectual but equally effective is the process which consists in analyzing the book on the dustjacket or on the back of the book. This is particularly aimed at browsers.

[8] In the *Monographie de l'édition* will be found complicated tables used to determine the retail sales price of a book. Briefly, the publishing cost after printing must be multiplied by a coefficient which varies from three to five.

[9] The *Encyclopaedia Britannica* indicates that publicity represents 10 per cent of the production cost in an American publishing house. Percentages are 6 per cent in England and 3 per cent in Germany.

[10] The *Notebooks of Major Thompson* was one example of successful pre-publication, helped by its publication at *irregular intervals* in *Le Figaro.*

DAN LACY

The Economics of Publishing, or
Adam Smith and Literature*

BETWEEN THE ARTIST and his audience stand the media of communication through which he must reach them: the opera companies, the theater managements, the broadcasting networks, the galleries, the publishing houses. To a degree, this has always been true. Throughout history an entrepreneur of some kind has assembled the artist's audience and given him the chance to be heard. Victorian authors as well as ours had to rely on publishers to disseminate their books; Mozart and Beethoven received the patronage of princes who were in a sense impresarios; Shakespeare wrote with both eyes on the needs and demands of the commercial theater of his day; and when Homer smote his lyre it was to satisfy a courtly market for flattering epics. But the media have grown so vast—armed with the technology of high-speed presses, television cameras and broadcasting towers, all organized into complex industries—that they now assume an almost wholly new role.

They can offer an artist audiences and financial rewards beyond any earlier imagining. The nineteenth-century publisher or theater manager could count in thousands the audiences he could find for a successful author or playwright. Today a novel—or a *Rise and Fall of the Third Reich*—that is fortunate enough to be a book-club choice and a successful paperback as well as a best seller may be read by millions. A television show may be seen by tens of millions. Indeed, it is said that more people witnessed a single televised performance of 'Hamlet' a few years ago than the sum of all the

* Reprinted by permission of the author and the publisher from *Daedalus*, XCII, No. 1 (Winter, 1963), 42–62.

audiences that had seen it enacted on all the stages of the world throughout the centuries since its opening night.

The financial rewards may be fitted to this scale of audience. Though only a few dozens or hundreds of unsalaried writers and composers may make enough from their work to live on, the occasional creator whose work meets the highest criteria of success in the mass media may gain great wealth in a single stroke. The author of a smash best-selling novel may possibly receive from royalties and from book-club, reprint and motion-picture rights a million dollars or more. The role of the media of communications *matters* now to a degree it never did before. One book finds an audience of 2,000— another, through televised adaptation as well as book sale, one of 30 million. Their suitability to the mass media is what determines the difference.

The role of the media matters also in another sense. The communications industries have become vast and largely autonomous enterprises, often imposing their own criteria upon the material they disseminate—criteria that may be unrelated either to the impulses of the creator or to the needs of the audience. The medium here tends to become the instrument of neither. Rather it may exist to serve its own ends, the principal one of which may be to return profits to an entrepreneur, primarily by attracting an appropriate audience for advertising. The medium thus may cease to be a mechanism existing in order to link a creator to an audience; rather the writer or composer may be hired to produce something to the medium's specifications that will aid it in assembling and 'conditioning' an audience for an advertisement. What the writer or composer is able to disseminate and what the audience may be able to see or hear may hence be determined not by their own desires or interests but by extraneous criteria imposed by the needs of the media.

These needs of the media in turn reflect the facts of their technology and their economic organization. Contrary to a general impression, they do not often reflect the personal idiosyncrasies of their owners. No publisher or record-company president or broadcasting-station owner can successfully or continuously impose his own tastes or views on the material disseminated through his medium in defiance of the requirement of the medium itself.

Particularly do the economics and technology of the media affect what is widely or massively available to the public. It is true that almost any writer with any trace of perceptible merit can get into print in some way, even if he has to have his book published at his own expense. And it is true that a determined inquirer can ultimately get to read or hear almost anything that has been printed or performed. But it is the media themselves that determine which authors or composers have access to the mass audience and, in turn,

what the cultural fare of the mass audience will be. It may hence be worth-while to look at one of the communications industries—in this case book publishing—in order to explore the relations between its economics and the actual communication between authors and readers in the United States.

We may begin by asking what a publisher does, what is the essential element in publishing. A publisher may hire authors to write books to his direction, and he may own a press on which to print them and bookstores in which to sell them. But in these activities he is being an author or a printer or a bookseller, not a publisher. The essence of publishing is pure entrepreneurship. The publisher contracts with an author for the right to issue his book; contracts with a printer and binder to have it manufactured; and then undertakes to promote it to the general or a special audience, to place it in the hands of wholesalers or bookstores where it will be sold, or to sell it by mail directly to schools or libraries or individuals. The publisher pays the costs and assumes the risks of issuing each book, and hence he occupies a highly speculative position. His role is somewhat analogous to that of a theater producer, or an independent film producer; but the invest-ment required in publishing any single book is far less than in producing any single film or play. His economic role is quite different from that of a manufacturer, whose activities are based on his owning a factory for the physical production of a commodity, or from that of a newspaper publisher or broadcaster, whose power to decide what is disseminated to the public is derived from his ownership of a large and expensive physical plant.

Important consequences flow from this specialized, entrepreneurial role of book publishing. In the first place, one can become a publisher with a very small capital investment—at least, as compared with the cost of entering any of the other communications industries. No investment in physical equipment is necessary beyond office furniture. If one wishes to publish so few books that shipping and storage space cannot be economically used, it is quite possible to contract for shipping and warehousing too, and many rather large publishers do. If the size of the business will not justify a full-time sales force, one can engage the services of 'commission men' who represent several publishers, or even arrange with a larger publisher to handle the entire sales and distribution operations. Similarly, a publisher too small to employ a full-time book designer or production department or a separate publicity staff can engage those services as well on an 'as-needed' basis.

The result is that almost anyone with a few thousand dollars who wants to 'publish' a book may do so, and anyone with a capital of $100,000 or even

less can establish a 'publishing house.' New ones in fact are started annually, and there are several hundred firms in the United States that can properly be called book publishers, not to mention the hundreds or perhaps even thousands of business firms, foundations, churches, schools, committees and citizen groups that issue books and pamphlets from time to time incidentally to their main activities. Hence, while there are only three major networks, two major press services, and in most cities only one newspaper publisher and not more than two or three television stations, there are hundreds of publishers to whom an author may turn. Each of these may expand or contract his output flexibly to respond to demand. If there is a demand none of them fills, new houses arise to meet it. Nor is publishing confined, as urban newspaper publishing or telecasting necessarily is, to men of great wealth with major investments to protect and hence with a bent toward the economic and political views of their class. All sorts of houses —commercial firms of widely ranging sizes, purely personal publishers, church and university presses, committees with a 'cause' and others with varying motivations—compete for attention.

There are, of course, small magazines, small newspapers and small radio stations. But the unique characteristic of small book publishers is that even the smallest has access, like the largest, to the entire national audience. Nothing published in the rural newspaper or the little magazine or broadcast by a small-town radio station can in that form reach beyond its local or previously defined special audience; but books published by very small publishers indeed may achieve very large sales. An outstanding example was the sale of more than 250,000 copies of *Arthritis and Common Sense*, published by the Witkower Press in Hartford, Connecticut. Such best-selling novelists as Frank Yerby, Frances Parkinson Keyes, Grace Metalious and James Baldwin are or have been published by houses that, though well established, are small in comparison with the giants of the industry.

Nor is a small publisher at an insuperably competitive disadvantage. There are undoubtedly economies in warehousing, shipping and sales force that accrue to the large publisher, as there may well be in overhead for the smaller publisher. But the competitive advantages of bigness that establish an almost irresistible trend to centralization and oligopoly in most manufacturing industries—the economies of mass production and mass advertising —are absent or are mitigated in publishing. Competition for efficiency in manufacture is between printers rather than between publishers, and the large publisher and the small publisher may well use the same printer and benefit from the same efficiency. Similarly, in publishing one advertises the book, not the publishing house, and budgets are geared to the size of the

edition, not the size of the publisher. Studebaker cannot possibly be advertised as Chevrolet is, but a book with an estimated sales potential of 20,000 copies is likely to have the same advertising allotment regardless of the size of the publisher.

In the number and variety of competing units, the ease with which they enter or leave the market place, and the flexibility with which each competitor can respond to changing demand, book publishing perhaps corresponds more closely than almost any other to the models of the classical economists who assumed perfect competition among atomized firms. It is Adam Smith's kind of industry.

Like the contractual relation with printers and binders, the publisher's contractual relation with authors providing for payments on a royalty basis has a major effect on the industry's communications function. In newspaper writing, in writing and composing for films and television, and in a great deal of magazine writing, the author or composer is an employee, hired on a salary or for a fixed fee to create a product to the specifications of the entrepreneur. In most book publishing, however, the author is not an employee but an independent partner of the publisher, sharing the publisher's risks and gains. He owns and controls his own work, which cannot be altered without his consent. And the dissemination of the author's work in the form in which he wants it is the object of the enterprise.

All the foregoing observations have been true of original publishing in free countries generally. What are the particular characteristics and dimensions of book publishing in the United States today? In the first place, it has grown very rapidly in recent years. Surveys done for the American Textbook Publishers Institute and the American Book Publishers Council, which between them embrace almost all book publishers of consequence in the United States, report an increase in the net sales of publishers from $501 million in 1952 to $1,240 million in 1961, an increase of about 15 per cent in nine years. Though the prices of any given form of book have increased over those years, the average price of all books has remained rather stable, because of the higher proportion of paperbacks and inexpensive children's books in the total output. The total number of individual books sold has hence increased in about the same proportion as the net sales in dollars. The American people and their institutions are buying, even on a per capita basis, about twice as many books as they were ten years ago.

As communications industries go, the book industry is now a big one, and it is probably growing faster than any of the others. Of this rather large complex, however, only a minor part is devoted to the original publishing of general books for the adult reader. The image of publishing as the

handmaiden of literature is only a very small part of the comprehensive picture. The two biggest sectors of industry are rather the publication of textbooks (elementary, high school and college) with total receipts in 1961 of $385 million, and the publication of encyclopedias, with the rather startlingly large volume of $345 million. Other categories are small by comparison.

Book clubs are the next largest with receipts of about $115 million, representing something over 75 million books. Then come children's books, with sales of $103 million representing 227 million books. Nearly 175 million of these books, bringing in about $35 million, are inexpensive children's books, the majority of them sold in supermarkets and similar outlets. Specialized and professional books (religious, law, medical, business, scientific and technical) are another big segment of the industry, with total sales of about $85 million. Paperback sales are about $97 million, representing about 305 million books. Of these, about 26 million books, selling at publishers' prices for $16 million, are the higher-priced 'trade' paperbacks, usually published by general publishers and sold primarily through magazine outlets. About 280 million books selling for $81 million are the usually less expensive paperbacks sold primarily (though by no means exclusively) through the same outlets as magazines. University presses represent about $12 million, and miscellaneous books not otherwise classified about $10 million of the total.

Of the whole complex of book-publishing enterprises in the United States, therefore, only about $87 million, or 7.5 per cent, represents hardcover, adult 'trade' publishing. This roughly defines the area of original publishing of general books for the adult—the novels, biographies, histories, popular works on science, politics and economics, the discussions of current issues, poetry and essays. This is what we think of traditionally as 'publishing,' yet it represents only about one-fifteenth of the book-publishing industry in the United States.

It is the economics of this small segment of the industry, however, that determines the character of the literature published in the United States, and it is worth examining in some detail. It will be useful to illustrate this by setting forth the specific economic pattern of the publishing of a single book. That pattern will not be exactly alike for any two books, varying as it will with price, size of edition and methods of sale; but perhaps a sort of composite can be presented. Let us imagine a novel, retailing at $5, of which about 6,500 copies have been printed. Let us suppose the publisher was lucky and sold about 6,000 of these, and that he was even luckier in that only about 1,000 of these were later returned by the bookstores as unsold. His

total income, assuming an average 40-per-cent discount, would have been $15,000. What would his costs have been? Production costs, including composition, paper, printing and binding, would probably have been about $6,000. Author's royalties would probably have come to $2,500, leaving a cost for the books themselves of $8,500, or a gross margin of $6,500.

Out of this a wide variety of expenses must be met. Editorial costs for work with the author and revising and copy-editing the manuscript, together with a pro-rata share of the costs of reading and rejecting the dozens of unpublishable manuscripts that must be gone through to find one that is suitable, would come to about $1,250—assuming an author who took little time in conference and produced a clean, easily handled manuscript. The book might have an advertising and promotion budget, including its share of overhead costs of the advertising and publicity department, of about $2,200—too little really to do any good, but too much in fact for the publisher to afford. Salesmen's commissions and other selling costs would come at least to another $750. An equal amount would be consumed in warehousing and shipping. Salaries of administrative personnel—bookkeepers, clerks, the comptroller, etc., employee benefits, rent, taxes and other general overhead, when pro-rated among all the titles published—would come to another $2,250.

The arithmetically minded reader will have noted that the expenses to be met out of the $6,500 gross margin have totaled $7,200, for a loss of $700. How does the publisher stay in business—especially when we consider that our hypothetical book was on the whole a very fortunate one? Its sales were modest, but it did sell, while many books sell only a thousand or two. Returns were only 20 per cent of net sales, when often they run twice as high on new novels. And the shrewd hypothetical publisher did not over-print, or splurge on a big advertising campaign for an unsalable book, or make any of the other mistakes that invite major loss.

He stays in business for several reasons. Frequently, even usually, he has a juvenile department or a textbook line, or a paperback series, or any one or more of other specialized divisions that are more dependable moneymakers and that carry part of the overhead of the trade department. And while he has many books that will lose a lot more, he hopes to have a few that are really major sellers and that can bring large profits. It need cost no more to select and edit a book that sells 100,000 copies than one that sells 5,000. Composition costs will become negligible, and printing and binding costs will be much less per copy because of the greater efficiency of longer printing runs. Royalties will run higher per copy, as most contracts provide that the royalty will increase from 10 per cent of the retail price to 15 per cent as sales increase. But all other per-copy prices will be markedly less,

and the profits to the publisher as well as the returns to the author will be substantial.

The third and often the most important factor enabling the publisher to stay in business is the income from subsidiary rights, especially from book clubs and from paperbound reprints. His contract with the author will always provide that the publisher controls the reprint of the book in these forms. The income is normally evenly shared with the author. The author may convey to the publisher or reserve for himself or his agent various other rights, such as dramatization, film, broadcast, serialization, or translation, and sometimes British Commonwealth rights for publications in English. If these rights are conveyed to the publisher, his share of the income from them is usually less than half and may be only 25 per cent or, in certain cases, even 10 per cent. When one reads of the sale of movie rights to a book for $100,000 or more, the transaction is almost always directly between the agent, acting for the author, and the film producer. The publisher is rarely involved in such bonanzas. Though confined generally to the more modest reprint rights—whether hardbound, paperbound, or book club—subsidiary rights income plays a major role in the economy of trade publishing.

On the average, it probably runs something over 8 per cent of the income from the sales of hardcover books. Our hypothetical book's share would hence have been $1,200 or a bit more for the publisher and an equal amount for the author, enough to provide a thin edge of profit (about $500) for the publisher and to increase the author's income from the book by half, from $2,500 to $3,700. But in practice the income from subsidiary rights is not distributed in this even manner. Most books are never reprinted at all and produce no subsidiary income, while a few books may hit a jackpot. The sale of rights to a major book club will produce from $60,000 to $100,000 to be shared with the author. A modestly successful—even an unsuccessful—reprint in a mass-market paperbound series will bring in from $3,000 to $5,000; guarantees of a minimum income of $100,000 are no longer great rarities for major books, with the actual earnings more often than not being much larger; and guarantees have gone as high as $400,000.

These windfalls of book-club and reprint payments come, of course, to the books that also achieve success in the trade. To those that have shall be given. The consequence is that the economics of trade publishing somewhat resembles that of a shrewd and informed bettor at the race tracks, whose loss of a number of small bets is offset by an occasional substantial win. Probably the great majority of new 'trade' books are published at a loss—which is usually not a great one unless the publisher has grossly overestimated its sales potentials and overinvested in printing or advertising. The continuation

of the whole flow of books is thus dependent on how frequent and how 'big' are the successes that by their income from large trade sales and large subsidiary rights serve to create a profit margin offsetting the more frequent small losses.

It would be logical to suppose that this dependence on 'best sellers' with substantial subsidiary-rights income would cause publishers to confine their offerings to works that had a good chance of achieving that kind of audience, and to refuse to publish the works that, whatever their merit, offered little hope of large sales. Possibly there is a marginal effect of this kind. Certainly the statistics that indicate that American publishers issue many fewer new titles every year than those of Japan, Great Britain, or Western Germany are often quoted to suggest such a limitation. But these statistics are largely illusory, being based on differing methods of defining 'books' and on the exclusion from the American figures of government publications. Probably the differences are minor and, where they exist, are in the area of highly specialized technical, scientific and professional publications. There does not appear to be any reason to believe that fiction or poetry or essays or histories, biographies and works on public affairs or science addressed to the layman, or any other 'trade' books of any conceivable merit fail of publication. On the contrary, an examination of any considerable part of the more than 2,000 new novels published every year suggests not only that all with any perceptible merit are published, but that hundreds appear without that justification.

How do we escape such a constriction in the number of books issued? Why do publishers continue to publish so vast a number of books when any consideration of the economics of their industry would suggest that it would be very much more profitable to publish many fewer titles with a high average edition sold of each? One reason is an engagingly persistent if unwary optimism on the part of publishers. When there are several dozen different trade publishers to whom a novel may be submitted, it is not difficult to find at least one whose hopeful eye may see possibilities not apparent to others. And who knows, the public favor can fall on odd choices; if it does not sell, the loss will not be very great; and just maybe . . .

A second reason is that if overhead costs are allocated pro rata among all titles published, as in our hypothetical case, most of them will be found to be unprofitable. Most publishers, however, will assume that they must in any case rent space, pay a management, support editorial, promotional and sales staffs and maintain warehousing and shipping facilities. If a new manuscript being considered promises to meet its direct costs and to contribute anything at all toward these general overhead items—even though that contribution

may be less than a pro-rata share—its publication may seem desirable. In economists' terms, publishers are likely to measure the returns from any new manuscript against the marginal or incremental cost of publishing it rather than against the total costs.

Finally, the competition among hundreds of publishers for publishable manuscripts is so great; the number of publishers (university presses, church publishers and the like) having some freedom from the necessity of pursuing profits is so large; and it is so relatively easy to establish new houses to issue worthy manuscripts that may fail of publication elsewhere, that any vacuum that may be left by the limiting practices of any single company or any number of companies is readily filled by others.

The economics of publishing hence permits the issuance of a most wide and varied range of writing, from comic books to the purest expressions of literature, from 25-cent infants' picture books to treatises on the most arcane area of physics, from political tracts to prayerbooks. Its economics also makes publishing exceptionally hospitable to all the winds of political and economic belief and to the unpopular new forms of literary expression. This is true in part for a reason already pointed out: that anyone may, at relatively little cost, gain access to the national market. A Communist-oriented book-publishing house is, for example, quite practical, while a Communist daily newspaper is impractical and a Communist broadcasting station would be impossible. But it is also true for a number of other reasons. The organization of the publishing industry makes each publisher a broker between a variety of authors and their audiences rather than his being the spokesman for a point of view, as is the publisher of a newspaper or magazine. A single publisher may well publish political figures of the right, the left and the center, hack writers of formula fiction as well as the most sensitive of poets, and sexy stories as well as manuals of chemical engineering. Hundreds of houses, each actively searching for every possible opportunity to make a dollar by bringing an author's product to an audience, even a small and specialized one, assure that no voice for which there is any listener is unheard. In the intense profit-seeking drive of a highly competitive, atomized industry there is a guarantee of the freedom of the press as effective as any in the Constitution.

Moreover, the economics of the industry permits a publisher to make money, or at least break even, if he can find an audience of, say, five thousand purchasers for a book over a two-year period. A general magazine, attempting a broad national circulation, could hardly make do with less than 100,000 people prepared to purchase every month at least; a nationally broadcast television program in prime time would have to assemble an audience of 5 million

or so every week. Hence books are able to cater to minority tastes and interests in a way impossible to those media whose economics compel them to seek a larger audience. Nor do books have to take into account the needs of their advertisers, as do magazines, newspapers and broadcasts. So long as it offers some chance of returning the modest cost of publishing, a book can be issued solely on its own merits without having to consider whether its purchasers make up an appropriate audience—in terms of size, interests, buying power and mood—for the advertisement of a commodity. In magazines, for example, the most inconsequential, hack-written pieces on boating, stamp-collecting, bee-keeping, or hi-fi receivers will be in active demand, because people interested in those subjects make up in each case a homogeneous market to which advertising can be profitably addressed and hence for whom numerous magazines can be published. But magazine outlets for a poem are limited, because people interested in poetry do not make up a homogeneous market, like people interested in stamp-collecting. From these pressures book publishing is happily free.

It is also remarkably free from the pressures of censorship. Economic pressure on a book publisher can have little effect. He is not exposed and vulnerable as a local newspaper or broadcasting station is. He cannot be boycotted, like a motion-picture theater. The censor's only means of pressure against the publisher himself is to refuse to buy the book, and the sort of controversy that accompanies such organized refusal is likely to stimulate so much interest as to sell far more copies of the book elsewhere. (I am referring here to trade publishing; textbook and encyclopedia publishers are necessarily somewhat more exposed to pressure.) Even if a publisher can be pressed into refusing to publish a book, there remain hundreds of others, many of whom will be prepared to consider it. The economic organization of book publishing thus equips it admirably for the issuance of writings of the widest possible variety, for the smallest and most specialized audiences, and with the greatest freedom from pressures of conformity or censorship.

When we turn to the actual distribution of these publications to the people, however, the situation is quite different; and for the great majority of titles distribution is limited, ineffective and costly. In part this weakness in distribution is a direct consequence of the strength of the industry in issuing materials. The very facts that about 15,000 new editions of the most diverse sorts appear annually, and that about 150,000 different titles are in print create the magnitude and difficulty of this task of making the whole range of American publishing available to more than 180 million people in thousands of cities, towns and villages across the country. If it were harder to get a book published, it would be easier to get it distributed.

The traditional pattern of book distribution is, of course, through bookstores. The publisher, through a sales force and through advance advertising in trade publications, tries to get bookstores to stock a book for sale. He then tries to call public attention to the book in three ways: by advertising to the public; by sending liberal numbers of free review copies to newspapers, magazines and technical journals; and by publicizing the book and its author as much as possible in all the media of communications. The bookseller in turn tries to promote books he considers salable by local advertising and direct mail (the cost of which may be shared by the publisher) and by such methods as window displays and word-of-mouth recommendations.

This method has severe limitations, both in scope and in cost. In the first place the number of bookstores in the United States is pitifully small. How many there are depends on what one calls a 'bookstore,' but there are perhaps 1,400 that stock a fairly wide representation of new hardbound books. Contrary to the general impression, the number of bookstores is increasing rather rapidly, but it remains completely inadequate to the effective national distribution of books. This is particularly true in small towns and rural areas. Indeed, save for a few university communities and resort areas, it would be rare to find a good bookstore in a city or town of less than 50,0000.

Even where there is a bookstore, and a good large one, it can rarely stock more than 3,000 to 4,000 titles, of which half or more may be standard older titles. This is likely to mean that even in a good bookstore there is only about one chance in ten that a new book will be in stock and perhaps one in a hundred that an older one will be. Still more discouraging is the fact that even when a bookstore exists, and even when it stocks a book on its shelves, it will be exposed to only a tiny fraction of the population. I would guess that hardly more than 1 per cent of the adult population are regular patrons of a bookstore.

The same kinds of limitation apply to advertising and promotion. The fact that each one of the thousands of titles every year must be separately advertised imposes almost insuperable obstacles in the way of effective national advertising. It is as though General Motors for each tenth Chevrolet had to change the name, design and characteristics of the car and launch a new national advertising campaign to sell the next ten cars. We have seen how pitifully small must be the advertising budget for the average single title, with the consequence that only for a very limited number of books is anything possible beyond one or two modest insertions in media with a relatively limited circulation, among a specially interested audience of book buyers. The advertising problem (except perhaps for encyclopedias and book clubs) is thus wholly different from that of the advertiser of a single brand

that remains on sale indefinitely. As compared with other industries, publishers spend an extraordinarily high proportion of their total revenue on advertising that has a regrettably small impact.

The same thing is true of reviews. Even *The New York Times*, which reviews many more books than any other journal addressed to the general public, covers only about 20 per cent of the annual output. Many books of major importance in specialized fields go entirely unnoticed in such general media, and it is by no means unknown for even National Book Award winners to go unreviewed in the major national journals.

The real problem is with the solid, meritorious book that is neither a best seller nor a major book-club choice and that is not reprinted in a mass-market paperbound edition. Thousands of such books are published annually and in their myriad diversity and range of content is the triumph of publishing. Yet, in consequence of all the difficulties described above, I suspect that for a typical book of this sort, one would find that in the overwhelming majority of counties in this country no copy had ever been seen in any bookstore or library, and that it had never been reviewed or even mentioned in any local newspaper or in any magazine or broadcast regularly read or seen. All the manifold intellectual and cultural resources offered in the vast annual flow of books passes unnoticed by the great majority of Americans and indeed unknown to them.

The fact that this method of distribution is ineffective does not make it inexpensive. Most of what a customer pays for a book in a bookstore goes not to get it written or printed or published, but rather to get it distributed to him. Trade books are usually sold to a bookseller at a discount that begins at 40 per cent for multiple-copy (and some single-copy) orders and may rise with the size of the order to 46 per cent or even 48 per cent, and they are usually sold under the condition that the bookseller may return them for full credit if he does not succeed in selling them. In other words, of the $5 a customer may pay for a novel, the bookseller may get $2, the printer about $1, the author about 75¢ and the publisher about $1.25. But of the $1.35 or $1.40 expenses the publisher must meet for this (see above), many are essentially distribution costs—sales, shipping, advertising and promotion—so that actually well over half the $5 goes for distribution. And yet it is needed. Except for fast-moving best sellers and some high-priced items, the bookseller's 40 per cent probably does not meet his actual costs.

To break through these limitations, publishers have resorted to three major devices: book clubs, paperbacks sold through magazine wholesalers and other mass-market channels and direct sales. Direct sales have been remarkably successful. These have taken two forms: house-to-house or

office-to-office selling and mail sales. The former is actually one of the oldest forms of book-selling in the United States, and it was commonplace in the nineteenth century for complete sets of major authors and other important works to be sold in that manner, often by subscription in advance of publication. Today, however, the need for high returns to salesmen permits this type of distribution only for expensive sets or specialized volumes like encyclopedias and medical and law books. More than one-fourth of the dollar volume of book sales goes through this channel, but it is irrelevant to the distribution of general books.

Mail sales have been more versatile. A conventional practice is to sell specialized, usually scholarly, books to potential buyers who can be readily identified and easily reached through specialized mailing lists or by relatively inexpensive advertising in learned or other specialized journals. Many university-press books are sold in this way. When the potential purchasers of a book cannot be narrowly defined as any specific professional group, the costs of selling by mail rise sharply. It is usually possible to meet these costs in selling to the general public only if the work is rather expensive (usually $10 or more) and if it offers something more to the buyer than the pleasure of reading it: for example, pride in a handsome and expensive possession like an art book or some aid to advancement. Neither method of direct sale is feasible for bringing most general books to the general public.

Book clubs and paperbounds were both adapted from the two principal magazine-distribution techniques. The book club distributes books to subscribers through the mail, like magazine subscriptions. The mass-market paperbound in fact uses for its distribution the very same national distributors, local wholesalers and individual newsstands used by magazines for their individual-copy circulation. Both these methods have been overwhelmingly successful in enlarging the audience for books and increasing the number distributed. Last year about 39 million hardbound adult 'trade' (that is, general) books were sold outside book-club channels, together with 26 million higher-priced 'trade' paperbounds sold primarily through bookstores. This contrasts with about 280 million paperbounds sold primarily through mass-market channels and nearly 80 million books distributed through book clubs. This means that of approximately 425 million general adult books sold in the United States last year, about 360 million went through book-club or mass-market channels. And only 39 million of the 65 million moving through traditional channels were hardbound. When it is further considered that a very considerable proportion of these 39 million copies was brought by libraries, it becomes evident that four general books out of five bought by or for individual American adults come to them through book-club or

mass-market channels. And many of the remaining fifth come as gifts rather than as purchases by the consumer himself.

These methods of sale have succeeded because they have surmounted the physical constraints of the bookstore and lessened the barriers of inertia. Rather than decide on a book and seek it out, one does nothing and the book club brings it. Paperbounds lie across one's daily path—on the newsstand, in the drugstore, in the grocery, at the cigar counter, in the bus terminal, at the railway station. They have also succeeded because they have sharply reduced the price of books, particularly in the case of the mass-market paperbound editions, which may sell for as little as one-eighth or even one-tenth the cost of an original hardbound edition. Indeed, the two go hand-in-hand: the ubiquitous display would be impractical for a book priced above the level of impulse buying; the price would be impossible except for mass distribution.

Why, then, not publish all or most books—and especially new books for the general audience—in paper bindings and with the same low prices achieve the same mass sale? A glance back to the analysis of the price structure of hardbound books should give the answer. Remember that of the price of a popular $5 book, from 50¢ to 75¢ goes to the author and only about $1 to the manufacturer and most of the rest to distribution costs. It is obvious that the sorts of savings achieved in mass-market paperbound editions must come primarily from the manner of distribution, not the manner of binding. Indeed, if books could be manufactured absolutely free, a $5 book would still be a $4 book unless other costs were reduced as well. Of course, the use of paper instead of board-and-cloth binding saves money; so do glueing in place of sewing and the use of smaller type and less expensive paper. So especially does printing 100,000 books at once on a high-speed rotary press. Only books that can sell that many copies fairly quickly can achieve that kind of savings. Royalties come down too. On the 50¢ edition they will be about 3¢, not the 75¢ of the popular $5 edition, and the author will normally get only half of that if it is a reprint. Editorial costs go way down, because most paperbounds are reprints that have already been edited, and the selection process is far less costly. So, of course, do administrative, shipping, warehousing and accounting costs per copy, when they are divided by the millions of copies flowing from the press.

But the principal savings must be found where the principal costs are found—in distribution. A mass-market paperbound must be sold with a cost for retailing of no more than 8¢ to 15¢ per copy and generally with only an infinitesimal cost for per-copy sales, advertising and promotion. This means that the books must essentially sell themselves. They must be books of the

sort that 100,000 or more people will buy on impulse if they see them displayed, either because the book or the author is well known or because the subject or theme commands interest. And there must be an opportunity for exposure, because books can be sold in this way only to the extent that they are displayed in high-traffic locations for buyers to see. It is also obvious that with so small a return to the retailer, he cannot ordinarily afford to maintain and check extensive stocks or to order for a customer individual titles he does not happen to have in stock at the moment. Except in some bookstores specializing in paperbounds, the customer is dependent on the more or less accidental content of the racks at any given outlet at any given time. The lower price of mass-market paperbounds is hence not due primarily to its binding, or even to the lower cost of manufacture in general, but to savings in editing, introducing and distributing it. These savings in turn are possible only for certain kinds of books, and only for a number of books not greater than can receive adequate exposure in available outlets. It has been possible through mass-market paperbounds to distribute billions of copies of thousands of titles to a much wider audience than could be reached by other means; but it is not possible to solve the problems of books in general merely by binding them in paper.

Many of the same observations apply to the higher-priced paperbacks usually published in much smaller editions (typically 5,000 to 20,000 copies) and distributed through conventional trade channels. The higher price not only permits a smaller edition; it also allows a much larger per-copy return to the bookseller. This in turn permits more selective stocking, personal assistance to customer and special ordering (usually with a small added service charge) of books not in stock. Many more titles can be accommodated in this pattern of distribution, and new series appear frequently; a recent sampling shows that slightly more than half of the 2,500 paperbacks issued in a three-month period were in this $1 to $3 range. These so-called 'trade' paperbacks are, however, like mass-market paperbacks, dependent in large measure upon impulse buying of copies on display. The number in print has now far outrun the capacity of the largest paperback bookstore even to stock, much less to display. In consequence, paperbacks are beginning to encounter some of the same distribution problems as hardbacks. As soon as the savings of the largely automatic distribution of a reasonably small number of titles, from among which the user has only a limited choice, begin to diminish, costs begin to rise. When it becomes necessary to finance a distribution mechanism that will allow a user to take realistic advantage of the fact that nearly 20,000 books are available in paperbacks, the price of paperbacks must go up. This is indeed happening and, though production

costs have also increased, higher distribution costs are perhaps the principal explanantion of the recent trend toward higher paperback prices. The more broadly the paperbound format is used for general publishing, the more nearly do its price structure and distribution problems approach those of hardbound publishing.

The consequence of these economic factors is that American publishing functions responsively, even brilliantly, in meeting national needs for the *issuance* of books; but it is able to *distribute* effectively only those for which the audience is either very large or else very specialized and clearly defined. It can do a very good job for the scientific, technical, scholarly, or professional book whose potential buyers are reached through specialized journals, or mailing lists And it can do a good job with the classics and very popular books for which the potential audience can justify large-scale advertising and stocking in bookstores and distribution by book-club or paperbound methods. It is the great body of books in between for which there is neither a mass audience nor an identifiable specialized audience with which, relatively speaking, we fail. And yet it is in making just such books available that book publishing can perform its most distinctive function, providing a communication service that can be given by no other medium.

Publishing and book distribution are in a period of very rapid change today. Some of these changes have been viewed with apprehension as further emphasizing a limited number of intensively sold, commercially profitable books to the derogation of the broader flow of literature. Among these changes are the merger of a number of publishing houses into larger aggregations, and the transformation of a number of others into publicly held corporations in which there is substantial outside investment presumably interested only in financial returns. The effect of the mergers on trade publishing has been generally overestimated. Most recent mergers have involved bringing together units from different areas of publishing, not competitive with each other, into a horizontally integrated company, or else have not involved trade publishing at all. Only two or three mergers of consequence have coalesced companies both of whose prior interests were primarily in trade publishing. And these have been offset in part by the rise of new companies.

Less easy to evaluate is the consequence of 'going public,' since publicly held corporations have previously been almost unknown in trade publishing; but it will almost certainly be small. Even if it should have an effect in curtailing or redirecting the trade publishing activities of any single house, it can hardly affect the output of American publishing generally. Dozens of substantial trade houses remain under personal or family ownership, new

houses are steadily being established, and any books refused as a result of new policies in one house can be quickly accepted by another. The greater size and strength of publishing houses may indeed have quite the opposite effect of providing new venture capital and enlarging the capacity to publish and distribute a widely diversified list.

Also feared has been the rise of discount-selling of books. Though this has been widespread only in some metropolitan areas (notably New York) and has been confined to limited numbers of best-selling titles, it has been viewed as the death-knell of general bookstores. Undoubtedly it has cost many bookstores some considerable numbers of sales of certain titles to which they could have normally looked for a major part of their profits. But the impact seems not to be as large as one might have feared. As we have noted, the number of bookstores is, in fact, growing rather rapidly on a national basis; and sales seem to be rising even in some of those quite near large discount houses. Other trends toward a broadening of the market for a wide variety of titles and a lessening of emphasis on a few 'best sellers' may help to offset this situation.

Much more important are the hopeful trends. One of the most important is the rapid growth of library service. This is not only important in itself, as bringing a wide diversity of books to people throughout the country, including small-town and rural areas, but also as providing the publisher with a market for many serious books addressed to a small but general audience, which it might not otherwise be possible to publish at all. This is not the place to discuss library development, but it is a very large and important factor in the economy of publishing as well as in the enrichment of education.

Also very hopeful are the educational developments that have led directly to a far wider and more varied demand for books at every level, from elementary school through college, and which in time should lead to a general elevation of the intellectual interests and book-buying habits of the American people. It has been a principal factor in the rapid growth of paperbound publishing and the broadening of its scope.

The larger and more varied the book market, the better it can be served. With each major increase in book-buying, more titles can progress to each level of book distribution. The doubling of per capita book purchases in the last decade for example, has already made it possible to keep in print in paperbacks not merely a few hundred mysteries, westerns and romances— as was the case at the beginning of the period—but nearly 20,000 titles covering every aspect of literature and scholarship. The same market growth has made it possible to expand book-club distribution from a few

dozen broadly popular general titles a year to the many hundreds that can now justify distribution through one of the nearly one hundred specialized book clubs. It has made possible the opening of the paperback and general book departments in the hundreds of college stores already mentioned. The proliferation of serious titles in such fields as science, public affairs and international relations is another consequence.

There is every reason to suppose that the market will continue to grow rapidly and will double again with the decade. Simple increase in the adult population will accomplish much of this. The postwar crop of babies which has accounted for our population boom has not yet affected the market for adult books, but it will have an enormous impact on that market within the decade. So will the explosion of college enrollments, which will add an additional 3,500,000 to 4,000,000 students within the decade. The effect of this will be immediate in the books that students buy for themselves and in those that are bought for new or enlarged college libraries. It will be even greater in its effect on the educational characteristics of the future population. We shall soon have twice as many well-to-do college-educated adults as we have now.

The effect of this vastly increased book market not only on the size but also on the character of book publishing and distribution will be great. Books that can be published at all now can then be published in editions two or three times as large, with accompanying economies in manufacture and distribution. Small bookstores can become larger, and towns with no book-stores will be able to afford them. Mass distribution can be achieved for many titles that can now have only limited sale. There is a vicious circle in much publishing now; small markets leading to small editions, high costs and inefficient distribution, ultimately restricting the market even further. The past decade has shown that for hundreds, even thousands of titles, a larger market can transform this into an upward spiral in which larger editions lead to lower costs and more and more efficient distribution which breaks through into even larger markets.

There is every reason to hope that over the next ten to twenty-five years an even more rapid increase in demand can effect such a transformation in the economics of publishing on a yet broader basis, embracing the whole of book publishing. If so, the consequence in enriching and diversifying the intellectual and cultural resources realistically available to Americans generally could be beneficent beyond measurement.

SUPPLEMENTARY READINGS

Frederick Antal, *Florentine Painting and Its Social Background*, London: Kegan Paul, 1948. A close study of the inter-relations of fourteenth- and early fifteenth-century Florentine painting with social, economic, and political conditions. Well illustrated and documented.

W. H. Bruford, *Germany in the Eighteenth Century: The Social Background of the Literary Revival*, Cambridge: Cambridge University Press, 1935, Part IV. Deals with the influence of political and social-structural changes on the character of German literature of this period. Includes useful information on writing and publishing as occupations.

Lewis A. Coser, *Man of Ideas*, New York: Free Press, 1965, Part I. A perceptive discussion of writing and publishing in eighteenth- and nineteenth-century England.

César Graña, *Bohemian* versus *Bourgeois*, New York: Basic Books, 1964. A scholarly study of the origins of discontent among French intellectuals and writers in the nineteenth century. Discusses changes in patronage and the appearance of a new reading public.

Daniel M. Fox, 'The New Arts Patronage in Europe and the United States,' *South Atlantic Quarterly*, Vol. 61 (1962), pp. 223–34. A comparison of contemporary American and Western European patterns of art patronage, including both governmental and foundation support.

Francis Haskell, *Patrons and Painters*, New York: Alfred Knopf, 1963. A carefully documented and illustrated study of art patronage in Italy in the seventeenth and eighteenth centuries; enlightening on the relations of art and society.

Edward L. Kamarck, ed., *Arts in Society*, Vol. 3, No. 4 (Summer, 1966): 'The University as a Cultural Leader.' This issue contains writings on: 'The Artist in Residence'; 'New University Art Centers' etc.

———, *Arts in Society*, Vol. 4, No. 2 (Summer, 1967): 'Censorship and the Arts.' More than half of this issue is devoted to articles, statements and interview material on censorship in the arts, representing the views of artists, psychiatrists, and social scientists.

Jean Lipman, ed., *Art in America*, Vol. 55 (March–April, 1967). This issue contains a number of useful accounts of contemporary patronage systems in different parts of the world; see especially Gene Baro, 'Patronage for Britain's Art'; Amy Goldin, 'Patronage under Communism'; Nan R. Peine, 'Patronage in Western Europe'; and Jay Jacobs, 'What the Federal Arts Program Really Means.'

Lillian B. Miller, *Patrons and Patriotism: the Encouragement of the Fine Arts in the United States, 1790–1860*, Chicago: University of Chicago Press, 1967. Stresses the influence of nationalism on the growth and development of painting and sculpture in the United States and deals informatively with efforts to encourage art through both public and private patronage.

Meyer Schapiro, 'On the Relation of Patron and Artist,' *American Journal of Sociology*, Vol. 70, No. 3 (November, 1964), pp. 363–69. Valuable for the

detailed information it provides on the nature of the artist-patron relation in the Middle Ages and the Renaissance.

Roger H. Smith, ed., *The American Reading Public*, New York: R. R. Bowker, 1963. In this collection of articles, see especially: Perry Knowlton, 'The Role of the Literary Agent'; Edward Shils, 'The Bookshop'; and Henri Peyre; 'What Is Wrong with American Book-Reviewing?'

Part IV
TASTEMAKERS AND PUBLICS

IV. TASTEMAKERS AND PUBLICS

Introduction

WHILE MOST SOCIETIES have established arrangements for reward-
ing artists and distributing their works, only advanced societies
have also evolved separate functionaries to cultivate public taste and
interest in the arts. In addition, for several centuries Western
societies have selected and preserved examples of the arts of various
periods in their museums and galleries, and many art museums have
extended their functions to include training the general public in
art appreciation. Furthermore, a class of persons known as 'critics'
has arisen, whose self-appointed task is education of the general
public in matters of artistic taste and discrimination.

Developing appreciation of literature has been the general purpose
of the critic since the eighteenth century, although his specific role
has changed in recent decades. Judith Kramer shows, for example,
that the literary critic of seventeenth- and eighteenth-century London
was maintained by the aristocracy, which regarded him as a 'man of
letters,' deserving of their respect and financial support. During this
period, critics wrote prefaces for books of essays and translated the
classics. Their role was limited to the preservation of learning and
taste for a restricted group of persons who were themselves men of
knowledge and culture.

During the eighteenth century a new reading public began to
develop, including merchants and shopkeepers, clerical workers and
women. These groups sought to better their lot through self-improve-
ment, and they eagerly read newspapers, periodicals and novels in

search of clues to proper conduct, acceptable taste, and the correct views on public affairs. Their demand for edifying reading matter coincided with the critics' wish to raise the level of literary taste and to serve as guides to behavior and manners. This confluence of interests led literary critics in the nineteenth century to write for periodicals as a means of shaping public taste.

In the twentieth century, in both England and the United States, the literary critic occupies an altered position in the art institution; he now writes for a select group of his literary peers, who may themselves be literary critics. He is not devoted to the advancement of literature in general or greatly concerned with raising the level of literary taste, and he has become ever more remote from the general educated public. Thus his role has become more specialized since the eighteenth century. The contemporary critic is supported chiefly by universities and foundations, and he regards his work as a specialized type of 'literature.'

The early role of the literary critic as mediator between the literary work and its public may have been assumed by a new agent—the professional reviewer. Both in the area of 'serious' literature and drama and in the popular arts, such as motion pictures and television, the reviewer now acts as interpreter and evaluator of literary and dramatic efforts for several segments of the public. His role varies with the type of publication for which he writes: 'mass' or 'class,' daily or weekly. Today's reviewer appears to combine the didactic functions of the eighteenth-century critic with some attempts at promotion and advertisement.

Lang's article explores the role of the contemporary newspaper and magazine reviewer-critic, which varies considerably from one art form to another. He found that reviewers of drama and books emphasized the artistic significance of works under scrutiny while reviewers of motion pictures and television productions paid relatively little attention to this criterion. Lang suggests that both traditional values and structured social relations affect the drama critic's role and the content of his reviews. The world of the legitimate theater is comparatively small, and the critic often appears to offer what is essentially a personal reaction to a play rather than an assessment of its significance for the public. In addition, the drama critic is assumed

to have some professional knowledge of the theater and to understand technical problems involved in staging plays; on the other hand, motion-picture and television reviewers are not expected to be familiar with the special techniques and production methods underlying these modern art forms, even though such knowledge might enhance their critical perceptions.

The critic acts as guide and interpreter in the visual arts as well as in literature. Artists are sometimes inclined to deny the influence of the critic on the artist's work or the public's reception of it. Painters and sculptors, for example, sometimes maintain that the quality and meaning of their work cannot be understood in words— which are the critic's medium—and so they are able to ignore his opinions. The influence of the critic's views on the artist's work is difficult to demonstrate objectively, but a good deal of impressionistic evidence suggests that some critics wield great power in the art world and that few artists are unaware of this fact.

Rosenberg and Fliegel document the artist's uneasy belief in the influence of art critics and the ambivalence of the Vanguard artists in New York City toward critics. Moreover, if the artist resents the power of critics to influence his career, he also feels the need for their professional understanding, support, and approval. From these contradictory attitudes the artist arrives at a deeply ambivalent view of critics, combining respect and dislike.

Actually, no reliable body of evidence exists on the effectiveness of the art critic as a tastemaker. It can be argued that if artists pay attention, albeit unwillingly, to what critics say, they will reflect the taste of critics in their work. However, critics may influence artists effectively without forming the taste of any art public. Therefore the question is still open whether and how critics affect public taste in literature and art.

Among the agencies that conventionally act as art tastemakers, some recognition must be given to museums. However, there is little empirical evidence concerning the influence of museums on the taste of any known population group. Museums differ in their philosophies of the preservation and exhibition of art and also in their stress on art education for the young. Some museums feel obliged to make their exhibits accessible to the largest number of persons

possible; others restrict their hours and make no effort to appeal to large numbers.

Against the lack of empirical knowledge about the effects of art museums on the formation and development of public taste, it is interesting to set the strongly held opinions of the Vanguard artists. They generally believed that museums place excessive demands on the assimilative powers of most people by concentrating too many kinds of art in too small an area. This leads to aesthetic confusion, weariness, and lack of comprehension on the part of the viewers.

In addition, artists claimed that museum officials stress the numbers of people visiting their collections as though there was a causal relation between exposure to works of art and comprehension, and they overemphasize the commercial aspects of exhibition, sales, and memberships. They object also to the frequent changes in exhibits, which make it difficult for viewers to become thoroughly familiar with the works of any one artist. In all, artists tend to evaluate museums in terms of how these institutions serve them rather than the public.

Between the artist or writer and his publics stands a figure that may influence taste indirectly even though his main purpose is business and commercial gain. This is the literary agent or art dealer. His chief purposes are to protect the artist from the need for direct contact with the public and to obtain the best possible financial rewards from the publisher or art buyer. His effect on public taste will be due largely to his success in introducing the work of the artists he represents to potential readers, viewers, buyers, and collectors, and to critics as well.

Rosenberg and Fliegel discovered that the Vanguard artists regarded dealers as necessary evils in a world that denies ready monetary rewards to artists. However, the dealer appears to be an institutionalized figure in the art-economic complex. The literary agent functions in a similar way in relation to the writer and the publisher, and can be useful to both. Ideally, he combines some knowledge of literature with a degree of sophistication about business, contracts, royalties and tax laws. His direct influence on taste is small, but the literary agent, like the art dealer, may contribute to public awareness of an unknown writer's talent by arranging for the publication of his work. His influence on tastemaking is incalculable, but not negligible.

The painter, sculptor or writer works not only to satisfy his need for personal expression but also to secure economic livelihood, recognition, and social esteem. These satisfactions can come only from publics that see and respond to his work. The Vanguard painters actually recognized four different publics, including friends, buyers and collectors, viewers, and critics. We have already noted that critics also function as a tastemaker group. Friends who are painters or who know a good deal about art are the most valuable and sympathetic public, but each artist realizes that this group cannot act as his buying public; he must come to terms with buyers and collectors.

The working artist both despises and needs this latter group even though it sometimes buys pictures with little or no awareness of their aesthetic merits and often 'as an investment' with the intention of storing them until the market is ready for their resale. Removal of his pictures from the public eye denies the painter the possibility of communicating with sympathetic viewers. Although this arouses his anger toward commercial buyers, the artist's need to sell his work cannot be denied and he develops strong ambivalence toward the public of buyers and collectors. Some artists appear to have developed a detached attitude toward both their work and buyers, possibly as a way of resolving their emotional conflicts. Artists are more tolerant of the foibles of the viewers though they often entertain doubts about this group's capacity to appreciate their work.

In terms of the institution of art, rather than the views of painters, the concept of 'art publics' takes on different meaning and significance. It is possible that a new public with demonstrated interest in several of the arts is emerging in America at present. This group, which is potentially vast and already numbers many millions, shares interest and participates consistently in activity related to one or more of the arts, either as 'consumers' who listen to orchestras and buy books and pictures or as professionals or amateurs who write, paint, act, or dance. Both of these types are termed 'culture consumers' by Toffler, who has charted and described this new art public. In so far as socioeconomic characteristics are concerned, the culture consumer and his family belong to the professional, business, technical or administrative classes; minority groups are underrepresented in terms of population. A certain life style—comfortable,

educated, alert to innovations in thought, behavior, dress, architecture
—characterizes the culture consumer. This new social being con-
stitutes the majority of the 'art public,' and his numbers and orienta-
tion toward art may have profound effects on its development in
Western civilization.

Steinberg employs a different and useful conception of the 'public'
to explain the negative reactions of many persons—artists included—
to much contemporary art. He argues that an art public consists, not of
specific people, but of all those who react to the work of a given
artist, whether with understanding, pleasure, shock, or anger.
Steinberg asserts that much contemporary art is overconcerned with
the annihilation of historical art values with respect to form, style
and materials without making clear the reasons for this attitude. As a
result of this negative posture, and the frequency of innovations, art
publics are given little time to assimilate recent developments before
new ones appear. In time, this endless procession of changes in art
styles becomes a self-justifying process, seeking change for its own
sake. This is the 'plight' of the public, according to Steinberg. If
many of Toffler's culture consumers fit Steinberg's conception of the
'art public,' then their 'plight' may well have serious consequences
for the future development of art.

JUDITH R. KRAMER

*The Social Role of the Literary Critic**

THE SOCIAL ROLE of the literary critic, defined here as mediator between artist and audience, and primarily interested in shaping literary judgments, has undergone a number of important changes since its emergence in the eighteenth century. These changes can be seen at a glance in the summary of the data presented in Tables I–V at the end of this chapter. The major developments in the critic's role during the past three centuries will be pointed out with reference to their broader implications for the critic and his status. It will be remembered that an analysis of the social role of the literary critic includes a consideration of the position or status of the critic, the rules or principles defining his expected behavior, his actual patterns of behavior and the orientation of his role toward others.

SOCIAL BACKGROUND OF THE CRITIC

A more thorough understanding of the emergence of the critic's role can be attained by a brief look at the social situation of the eighteenth century and its meaning for the critic. Certain social developments, whose beginnings can be traced to periods considerably earlier than the eighteenth century, were having their full effects at the time when the critic made his appearance in England.

The feudal-estate system had been shattered, and cities, as centers of commerce, were becoming increasingly prosperous and powerful. In these cities, new principles of social ascendancy were developing. Under the

* Reprinted from *The Social Role of the Literary Critic*, Master's thesis, University of Minnesota, 1954, pp. 162–184 (typed copy), by permission of the author.

estate system, honor had been associated with fixed-status groups, and the individual was accorded honor only by virtue of his membership in a family that belonged to one of the upper-status groups. In the cities, however, there was greater possible vertical mobility and the achievement of the individual became primary in gaining fame. The individual was beginning to be located on the basis of his own personal achievement apart from his prior institutional context, which, in turn, created a demand for education.

The merchant class calculated rank by wealth, not status. What is more important for purposes of this analysis, the merchant class possessed the skills of reading and writing. These urban merchants tended to be Protestant, and therefore extremely pious and sober men. The use of their leisure was part of their total effort to assure themselves of salvation and therefore could not be wasted in a frivolous manner. This engendered a religiously motivated need to improve their minds, which was one of the most important factors to help give rise to the development of the reading public in the eighteenth century.

This is not to say that the aristocracy simply faded out of the social picture along with their feudal estates. Many of the landed nobles had moved to the big cities and lived there off the rents they collected from their tenants. Even as late as the eighteenth century, these aristocrats figured importantly as a status group with a distinctive style of life. Whatever else this style of life was, the important fact is that it was defined and recognized as desirable by the other members of society. The noble didn't have to strive for individualized fame; he had honor by virtue of his family membership, which was accordingly very important to him. His religion, Anglicanism, was close to Catholicism in its ritualistic quality. Those aristocrats who were sufficiently educated to read and write, read not for business or religious purposes, but for pleasure in their leisure time. The leading members of the nobility patronized the arts, and knowledge of literature was a basis for status among them.[1]

Exactly what has this to do with the eighteenth-century critic? Table I shows that after Dryden, the critic was from the urban upper-middle and middle-middle classes (if not from London, then from one of the other socially and intellectually important towns), and tended to be Protestant (Pope was the only one who was not Protestant by birth). His father was either a professional man (usually clergyman) or a relatively prosperous tradesman, and the critic himself usually had a university education. This means that the eighteenth-century critic was from a class whose members possessed reading and writing skills anchored in business and were religiously and socially motivated to improve themselves. One desirable social improvement

was to have access to upper-class circles, and the critic's literary knowledge, when recognized, gained him such access. None of the eighteenth-century critics would have been welcomed in aristocratic drawing rooms on the basis of their birth alone; their literary achievements were their 'admittance ticket.' In so far as they brought the critic personal recognition and fame, these achievements were individualized, not familistic. The early critics applied their writing skills to literature, one of the status symbols of the upper class, which pursued literature for pleasure, and thereby gained admittance to that class. And after all, recognition and acceptance by the socially dominant group is attractive to the critic of any century.

Thus, the emerging critic's role was inextricably tied up with status factors, since his own literary work was still a status symbol of the old aristocracy. It is interesting to note that prestige was accorded by the upper class to the early critics as general men of letters, not as critics *per se*, since 'mere critics' were usually university scholars who had no prestige among the upper class.

By the nineteenth century, the production of literature had become more decidedly a middle-class activity in England, as can be seen from the social backgrounds of the critics in Table II. This was to be expected with the extraordinary increase in size and importance of the middle class, which had become the dominant class in the nineteenth century due to the effects of industrialization. The critic was a well-educated middle-class person striving for achievement. Again, his literary achievements bring recognition and acceptance by the upper class. Recall how pleased Hazlitt was to be known as a writer for the *Edinburgh Review*, an established arbiter of taste for the upper classes. It was a social, as well as a professional, feather in his cap. And Coleridge was a 'rage' among the 'best' people. However, this upper-class recognition no longer meant acceptance by the most socially powerful class. It was the middle class which was becoming increasingly influential in establishing a literary man's reputation. Critics of the latter part of the century, who wanted to be accepted and read by the middle class, had to be wary, for example, of their respectability both in their writings and in their personal lives. (Pater even went so far as to remove his original conclusion to the *Renaissance* since it was called 'shocking and immoral' by some.)

The early American critic of the nineteenth century was from the upper class, but his social background was like the English critic's. He came from a New England professional family (see Table III), he was well educated and moved in upper-class circles. His literary achievements reinforced his social prestige. Those critics who, like Aldrich, were not from the New England upper class, could gain access to it by their literary merit, if they

remained in the genteel tradition and wrote for the established and recognized periodicals. Trilling points out that the culture of nineteenth-century America had a place for literature, and, to a great extent, the value of literature at this time was assumed.[2] This meant that the upper educated classes accepted literary men and valued their accomplishments.

By the end of the century, industrialization had rendered the professional and commercial classes less powerful. The new American hero was the 'captain of industry,' who had amassed great wealth. Many of these industrialists, who now constituted an upper class based on wealth not status, were interested in the arts which could be 'conspicuously consumed' (e.g., painting and sculpture). However, they were not likely to value the literary man very highly. The critic of the late nineteenth century was from middle-class business families, and he either continued to move in such circles as a popularizer of literature, or he became 'Bohemian' and associated only with the literati.

Little information was available on the social backgrounds of the twentieth-century critics, other than the extent of their advanced education. Tables IV and V show that they practically all have Ph.D.'s and are members of the teaching profession. Logan Wilson remarks on how rarely academic men write autobiographical documents that are candid statements on themselves. Most commentaries written by and about academic men are usually technical commentaries on their work.[3] However, since the modern critics considered here are academic men, it can be assumed that they are not unlike the academic men of Wilson's study. This would mean that they are, by and large, from lower-middle-class business and farm families. Wilson further points out that 'graduate work is from the economic point of view a more accessible channel for vertical mobility than are most other types of professional training.'[4] Thus, a university career would indicate an improvement for the critic over his economic origins.

According to Wilson, this may mean that the academic man has acquired more intellectual than social graces. However, this is not likely to be true of the academic critics, particularly those new critics who are strongly advocating a reaffirmation of certain religious and aristocratic values. These critics tend to be sufficiently conservative, and even reactionary, in their general point of view to be accepted by other members of the upper middle class. Nevertheless, since literary activities no longer have the same prestige among the middle and upper classes as they did in the nineteenth century, critics are more likely to associate with others of the literary elite. However middle class the personal lives of the members of these literary coteries are, the members prefer to think that they are in the world, but not of it, and that

their status is not based on the same mundane principles as that of other groups. These literary in-groups, which are aware of the critic's achievements and accord him prestige, are inevitable in a social situation where members of the upper and middle classes have usually never heard of critics like Ransom and Tate, and therefore cannot grant them social honor. Lowell, on the other hand, was sufficiently well known in the nineteenth century to be appointed minister to Spain and England.

OCCUPATIONAL STATUS

Source of Income. English critics of the eighteenth century, no longer financially independent members of the upper class writing in their leisure time, were middle-class men who had to earn a living from their intellectual work. During the early part of the century, little of their livelihood was from their writings alone. They were usually dependent on some form of patronage in addition to the rather precarious income from the publication of their works. This patronage most often took the form of court appointments, which provided them with a relatively secure source of income. However, it was not until copyright laws made written work an income property and gave authors certain legal rights that writing could become an occupation. When the income from writing was secured by legal protection, the author was free from financial dependence upon the patron. This is when criticism begins to appear as an occupation. The critic could earn a living by writing without having to conform to the tastes of the aristocracy; he was relatively free to write what he pleased. By the end of the eighteenth century, an increasing number of critics were supporting themselves by their writings. They were often commissioned by booksellers and publishers to undertake particular pieces of work, and they wrote for the growing number of periodicals.

In the first half of the nineteenth century, both English and American critics typically worked as journalists for newspapers and periodicals. They also received fees for the annual series of lectures which most of them delivered in the public lyceums and later published as essays. These critics were adapting the form of their criticism to the available media of communication, *i.e.*, lecture halls and periodicals, and earning a living from it. The upper and middle classes were still supporting critics by attending their lectures and reading their essays in the periodicals, and the critic was able to be a 'free lance' intellectual. Whatever his responsibilities to his audience and their values, he at least had no obligations to a particular institution or to a ruling class. Toward the end of the nineteenth century, the critic began to

derive his income from an academic career, although in America, journalism was still the more typical source of income for the critic.

 · The established critics of the twentieth century in both England and America are virtually all faculty members of universities. (See Tables IV and V.) Their primary source of income is their academic salaries, although many of them are also editors of the critical quarterlies published at the universities. As a faculty member of a university, the critic is no longer a 'free lance' intellectual, but rather, a salaried employee of an academic bureaucracy.[5] This anchors him in a fixed position in the broader social system. In essence, this amounts to a new form of 'institutional' patronage. The few critics, like Blackmur, who have not the graduate degrees qualifying them for university positions may get appointments on the basis of their literary achievements alone (a situation not unlike the early court appointments).

The critic's financial security is bound up in an academic hierarchy in which he must 'produce' in order to receive promotions and maintain his status. The modern critic is in a competitive situation unknown to earlier critics. He conducts a few seminars, but his more important function is to continue with his own writing. His publications maintain his reputation and help to establish his university as a center of criticism.

Critics are indirectly 'patronized' by another institution, the foundations established by the big industrialists to promote the arts and sciences by providing them with some financial support. University departments and critical quarterlies have received grants from the foundations, and these, in turn, help to support the academic critic. Some of the critics have received fellowships directly from the foundations (e.g., the Guggenheim fellowships of Tate and Blackmur).

In essence, this means that critics are no longer supported by an aristocratic ruling class or by a general public. They are supported by specific institutions, i.e., universities and foundations, and this 'institutional patronage' has certain effects on the nature of their criticism to be discussed later in this chapter.

Location of Literary Activities. Since the cities had become centers of power and wealth, it is not unusual to find that London, as one of the dominant cities, was the scene of literary activities in eighteenth-century England. Since patrons, publishers and the new middle-class reading public could all be found in London, literary men went there to earn their livelihood. During the early part of the nineteenth century, London continued to be the city in which most of the critics lectured and wrote for periodicals. However, as other cities increased in importance due to industrialization, their wealth

and growing reading publics attracted publishers and writers. Lyceums were built in these cities, and critics lectured in them. They also wrote for periodicals whose circulations had spread to the provinces. By the end of the nineteenth century, the center of critical output began to shift to the two leading universities in England, Oxford and Cambridge, where it continues to be in the twentieth century. Cambridge, in particular, has an active group of critics and a quarterly review.

The early American critics of the nineteenth century wrote for periodicals published in the leading Eastern cities, particularly in New England. As in England, these were the cities which were commercially prominent, and which offered publishers publics that would buy books and periodicals. Academic critics of the latter part of the century tended to teach at Harvard, and journalist-critics to work in New York. In the twentieth century, however, critics can be found teaching at several of the leading universities throughout the country.

These universities, which have established critics on their staffs, attract many students of criticism. Students can serve their apprenticeship with the 'big men' with the hope that some of the critical prestige of the university will accrue to them and help them get positions later.[6] These universities become established centers of criticism by virtue of having leading critics as faculty members and a large number of student disciples, as well as critical quarterlies.

NATURE OF CRITICAL WORKS

Unfortunately, the necessarily narrow scope of this discussion does not permit a more than cursory examination of the works of the critics considered here. Some future observer will find a fruitful area of investigation in analyzing the substantive critical theories of different periods and relating them to the underlying sociological factors of the critic's role discussed in this study. However, a few broad statements can be made about the general form and nature of criticism during the past three centuries.

During the late seventeenth century and early eighteenth century, most English criticism appeared in the form of prefaces to creative works or translations of the classics. These prefaces tended to be either defenses of particular forms of creative writing (usually the literary form of the work to which the preface was affixed) or summaries of the ideas of the classical critical authorities. Later in the century, an increasing amount of criticism was to be found in the literary essays written for the growing number of periodicals. Since these essays were addressed to members of the middle class, who

still tended to regard literature as a frivolous pursuit of the aristocracy, the essays were concerned with defending the more serious functions of literature. Literature was justified on the grounds that it inculcated morality. More important than that, the essays also provided the rising members of the middle class with the established standards of good taste. Taste was a characteristic of the upper class that the rising middle class needed in order to be accepted socially, and critics like Addison and Johnson helped to supply the middle class with the proper literary opinions.

During the nineteenth century in both England and America, criticism continued to appear as the literary essays in periodicals. In addition to these, many of the book reviews were so broad in scope that they included discussions of the more general principles of literary criticism. The important new form that criticism took was the lecture (first to public audiences, then to university classes). These lectures were frequently published later as essays. The criticism of this century, although interested in defending the functions of literature, was not so much concerned with the improvement of taste. What disturbed the later nineteenth-century critics was that the middle class had become the dominant social class so rapidly that it never had had time to acquire the more fundamental things that are the foundations of good taste, *e.g.*, intelligence and aesthetic awareness. The critics set about developing these essentials in the middle class, hoping that good taste would be one of the results of their efforts.

In the twentieth century, there is a great increase in both the number of critical essays and the number of books devoted to criticism. Although the modern critic does little public lecturing, much of his critical work still takes the form of university lectures. Modern critical work reveals an unprecedented self-consciousness; a growing proportion of the essays deals with the functions of criticism and justifies their importance, rather than defending literature in general. This self-consciousness and ideology is characteristic of any discipline that is becoming specialized. A high degree of specialization of this sort also tends toward a stereotyping of certain ideas basic to the discipline. Thus, critical essays have become applications of given and indisputable principles to narrowly defined subjects. Nor have these essays been immune to what Logan Wilson calls the 'academic ideology (widely shared) that tends to measure the worth of a study by its precision rather than its importance.'[7] In emulating the sciences, modern critics strive for objectivity by intensively analyzing limited subjects, without venturing into broader areas of knowledge. Such studies are exact and formalistic, but not always of much literary significance. They stress problems of method and use of precise terminology.

JUDITH KRAMER: *The Social Role of the Literary Critic* 445

MEDIA OF COMMUNICATION AND THE NATURE OF THE
AUDIENCE FOR CRITICISM

The critical prefaces of the earlier English critics were appended to, and published with, some creative work. Few works of criticism were published separately. This criticism still had only a small audience drawn from the aristocratic upper class, whom the critic kept well supplied with the accepted literary opinions.

The crucial development for the critic in the eighteenth century was the growth of periodicals. The periodical provided the critic with a literary outlet and medium of communication that helped to stabilize his role. An increasing proportion of criticism appeared in periodicals during the eighteenth and nineteenth centuries. The important thing about the periodicals was the audience they put within the critic's reach. This audience was a middle-class one for whose edification and entertainment the periodicals were intended. During the eighteenth century, the critic was usually addressing upper-middle-class people who needed good taste and literary knowledge as part of the social graces required by their newly elevated economic positions.

The most important characteristic of the nineteenth century of relevance here was the differentiation taking place within the middle class. The 'general public' was beginning to become specialized into subpublics, and periodicals, accordingly, also became specialized, appealing only to certain segments of the audience. All types of periodicals developed, but the critic tended to continue to write for the established literary periodicals which were recognized arbiters of taste. These were addressed to the 'intelligent' public, which included professional and business people, and an increasing number of women, all of whom were interested in literary matters and read the accepted organs of literary opinion.

However, by the end of the century, William Dean Howells observed that the readers of the 'cultivated' American magazines were markedly losing interest in literary contributions. This marks the beginning of what Trilling calls the gulf between educated people and literature.[8] Society was becoming so specialized that general literary knowledge and abilities were considered irrelevant to any occupations but strictly literary ones. Either the critic had to become a 'popularizer' and 'vulgarizer' by writing for the popular magazines (as Americans like Huneker and Mencken did) or he had to resign himself to speaking more and more exclusively to a small number of literary people.

The little magazine was the organ for those critics of the early part of the

twentieth century who had chosen to address only the 'literary intelligentsia.' The critical quarterlies of the second quarter of the century are even more highly specialized, both in their content and their audience. The critics using the quarterlies sacrifice the range of their influence for recognition by their peers, since the quarterlies are not operative in shaping the judgments of any public except other literary experts. It is characteristic of specialized disciplines to have some journal which serves as a means for the expert to communicate his ideas to others in his field, and the critical quarterlies fulfill this function rather than any function in reference to a broader public.

ORIENTATION OF THE CRITIC'S ROLE

During the eighteenth and nineteenth centuries, the critic's role was oriented toward some part of the general reading public. He felt some responsibility to them to apply the prevailing standards (usually moral) to his judgment of literature. Critics were sufficiently few in number and the audience small enough and close enough to the critic so that the audience could exercise some control over the critic's standards. It could ultimately refuse to support him. On the other hand, the critic was able to move in literary circles whose members were among the most outstanding men of letters of the time, and he usually shared the general aesthetic outlook of the authors. His relationship with the authors was fairly direct and personal, and he was not so much interested in changing their aesthetic viewpoints as in improving their standards of writing. The critic believed the creative writer to possess a 'higher faculty' than the critic himself.

In the specialized society of the twentieth century, the critic is as distant from his audience as the artist previously was in the eighteenth century. He feels no responsibilities toward a public, either to express its standards or to shape its taste. If anything, he imposes his own standards on his public. Although most modern critics write poetry, they are not as closely related to the artist as were earlier critics, neither personally and socially, nor in the orientation of their role. This modern critic is not so concerned with improving writing as he is in unearthing the hidden meanings that even the author didn't know were in his work. The critic not only considers his own work equally as creative as the author's but he tends to derogate the author by his efforts to find meanings of which the author himself was not aware. He is addressing primarily other critics who possess an understanding of his terminology and methods of analysis.

THE CRITIC'S ACTIVITIES AND CONCEPTION OF HIS ROLE

The critic of the eighteenth and nineteenth centuries was actively involved in shaping the literary judgments of his public. Since he accomplished this in several different ways (*e.g.*, book reviewing, general essays, lectures), he had no clear self-image of his role. In general, he saw himself as a judge of literature, but he did not necessarily conceive of himself as a critic *per se.* He was often engaged in creative writing himself, and conceived of himself as a poet or man of letters. A few critics preferred to regard themselves as philosophers, others as general essayists. The 'mere critic' was confused both with the pedantic academic critic or with the hack reviewers, and since both of these were accorded so little prestige, few of the men considered here cared to be designated as such. At best, they considered themselves as intelligent readers addressing an audience of intelligent readers.

The critic of the twentieth century professes not to be concerned with shaping his readers' literary judgments. He wishes only to present the 'facts' of poetry arrived at by close, formal analysis. (It has already been pointed out how this 'objectivity' does not eliminate judgments being made for the reader.) Despite the fact that the modern critic claims not to be performing what is actually the primary function of the critic, and despite his limited influence, he has a very clear self-image of his role as critic. He conceives of himself first and foremost as a critic who is an expert in the analysis of literature. Although he writes poetry, he does not write book reviews for popular magazines, nor does he write literary essays dealing with relatively broad themes. In a word, his role and his activities within his role are now highly specialized.

CONCLUSION

It may be pointed out in conclusion that the literary critic as an occupational role can be studied in a manner similar to any other occupational role. Furthermore, the analysis here presented may prove to be a useful model in the sociological study of occupational roles other than that of literary critic. In any case, concepts and analytical tools have here been used which may be further developed and elaborated in their application to a sociology of occupational specialization and expertness.

TABLE I

The Social Background, Occupational Status, Nature of Critical Works and Literary Outlets
of Five English Critics of the Seventeenth and Eighteenth Centuries

Critic	Social Background				Occupational Status		Nature of Critical Works	Literary Outlets
	Place of Birth	Father's Occupation	Class Derivation	Education	Primary Source of Income	Location of Literary Activities		
John Dryden (1631–1700)	Northampton-shire	Small landowner	Upper middle	B.A., Cambridge	Patronage; court appts.; profits from plays; pub-lished work	London	Prefaces to plays and translations	Publication of preface
John Dennis (1637–1734)	London	Saddler	Middle	B.A., Cambridge	Patronage; court appts.; published work	London	Books of criticism	Publication of books of criticism
Joseph Addison (1672–1719)	Lichfield	Clergyman	Upper middle	B.A., M.A., Oxford	Patronage; gov't office; writing for periodicals	London	Literary essays	Periodicals
Alexander Pope (1688–1744)	London	Linen-draper	Middle	Privately tutored	Published works	Windsor Forest, London	Poems, essays	Publication of poems, essays
Samuel Johnson (1709–84)	Lichfield	Bookseller	Middle	1 year at Oxford	Comm. work; periodical writing; gov't pension	London	Literary essays, prefaces to poems	Periodicals; publication of prefaces

TABLE II

The Social Background, Occupational Status, Nature of Critical Works and Literary Outlets
of Four English Critics of the Nineteenth Century

Critic	Social Background				Occupational Status			Nature of Critical Works	Literary Outlets
	Place of Birth	Father's Occupation	Class Derivation	Education	Primary Source of Income	Location of Literary Activities			
Samuel Taylor Coleridge (1772–1834)	Devonshire	Vicar	Middle	2 years at Cambridge	Annuity; lectures; journalism	London; some provinces	Lectures; scattered crit., essays in longer bks.	Lecture halls; periodicals; newspapers	
William Hazlitt (1788–1830)	Kent	Unitarian minister	Middle	1 year theo. coll., studied art in Paris	Journalism lectures	London	Literary essays; lectures (later pub. as essays)	Periodicals; newspapers; lec. halls; pub. of essays	
Matthew Arnold (1822–88)	Laleham	Headmaster of Rugby; Oxford professor	Upper middle	B.A., Oxford	University professorship; gov't. position	Oxford	University lectures; lit. essays later col. into vol's	University; periodicals; pub. of essay collections	
Walter Pater (1829–94)	London	Physician	Middle	B.A., Oxford	University professorship	Oxford	University lectures; lit. essays later col. into vol's	University; periodicals; pub. of essay collections	

TABLE III

The Social Background, Occupational Status, Nature of Critical Works and Literary Outlets
of Four American Critics of the Nineteenth Century

Critic	Social Background				Occupational Status		Nature of Critical Works	Literary Outlets
	Place of Birth	Father's Occupation	Class Derivation	Education	Primary Source of Income	Location of Literary Activities		
Anon. critic-reviewer, 1st qtr. of century	Eastern cities, especially Boston	Professional man or merchant	Upper	B.A., Harvard	Law; ministry	Eastern cities	Reviews; literary essays	Periodicals
Ralph W. Emerson (1803–82)	Boston, Mass.	Unitarian clergyman	Upper middle	B.A., D.D., Harvard	Lectures	First in N. Eng. then N.Y.; midwest	Lectures, later pub. as essays	Lyceums; pub. of essay collections
James R. Lowell (1819–91)	Cambridge, Mass.	Minister	Upper	B.A., Harvard	Journ'sm; univ. professorship	Boston; Cambridge	Lit. essays; bk. rev's; Univ. lectures	Periodicals; university; pub. essays, collections
Thos. B. Aldrich (1836–1907)	Portsmouth, N.H.	Businessman	Middle	No college degree	Journ'sm; (editorship)	N.Y.; Boston	Editing; few lit. essays	Newspapers; periodicals
James G. Huneker (1860–1921)	Phil., Pa.	Businessman	Middle	Phil. Law Academy; stud. music Paris	Journalism	N.Y.	Lit. essays; dramatic, art, music, lit. reviews	Newspapers; magazines; pub. of essay collection

TABLE IV

The Social Background, Occupational Status, Nature of Critical Works and Literary Outlets
of Four English Critics of the Twentieth Century

Critic	Social Background				Occupational Status			Nature of Critical Works	Literary Outlets
	Place of Birth	Father's Occupation	Class Derivation	Education	Primary Source of Income	Location of Literary Activities			
T. S. Eliot (1888–1965)	St. Louis, Mo., Brit. sub. 1927	Businessman	Upper Middle	B.A., M.A., Harvard; grad. work at Oxford, Sorbonne LL.D. Edinburgh; Litt.D. Columbia	Published works; editorship of little mag; director, publishing firm	London		Literary essays	Critical little mags; pub. of essay collections
I. A. Richards (1893–)				B.A., M.A., Litt.D., Cambridge	University professorship	Cambridge, Eng.; Cambridge, Mass.		University lectures; books of criticism	Publication of books of criticism
F. R. Leavis (1895–)				B.A., Ph.D., Cambridge	University professorship; editorship of critical quarterly	Cambridge, Eng.		University lectures; literary essays	Critical quarterlies
William Empson (1906–)				B.A., graduate work at Cambridge	University professorship	Cambridge, Eng.; Far East; Sheffield		University lectures; bks. of criticism	Critical little mags; pub. of bks. of criticism

TABLE V

The Social Background, Occupational Status, Nature of Critical Works and Literary Outlets of Seven American Critics of the Twentieth Century

Critic	Social Background				Occupational Status		Nature of Critical Works	Literary Outlets
	Place of Birth	Father's Occupation	Class Derivation	Education	Primary Source of Income	Location of Literary Activities		
H. L. Mencken (1880–1954)	Baltimore, Md.	Businessman	Middle	Baltimore Polytech. Institute	Journ'sm; editorship	N.Y.; Baltimore	Literary essays; bk. rev's	Newspapers; pop. mag's; pub. of bks. of criticism
Ezra Pound (1885–)	Idaho			Ph.B. Hamilton Coll.; M.A., U. of Pennsylvania	Published works; editorship of crit. little mag.	Paris	Literary essays	Critical little mags.
Irving Babbitt (1865–1933)	Dayton, Ohio	Businessman	Middle	B.A., Harv., grad. work at Sorbonne	University professorship	Cambridge, Mass.	University lectures; bks. of criticism	Pub. of bks. of criticism
John Crowe Ransom (1888–)	Pulaski, Tenn.			B.A., Vanderbilt U.; grad. work at Oxford	University professorship; editorship of crit. quarterly	Nashville Tenn.; Kenyon, Ohio	Literary essays; bks. of criticism	Critical quarterlies; bks. of criticism

TABLE V—(*continued*)

The Social Background, Occupational Status, Nature of Critical Works and Literary Outlets of Seven American Critics of the Twentieth Century

Critic	Social Background			Occupational Status			Nature of Critical Works	Literary Outlets
	Place of Birth	Father's Occupation	Class Derivation	Education	Primary Source of Income	Location of Literary Activities		
Allen Tate (1899–)	Kentucky			B.A., Vanderbilt U.; Guggenheim fellowship	University professorship; editorship of critical quarterly	Texas; N. Carolina; Minnesota	Literary essays; bks. of criticism	Critical quarterlies; pub. of bks. of criticism
Yvor Winters (1900–1968)	Chicago, Ill.			B.A., M.A., U. of Colorado; Ph.D., Stan.	University professorship	California	Literary essays; bks. of criticism	Critical quarterlies; pub. of bks. of criticism
R. P. Blackmur (1904–1965)	Springfield, Mass.			No college degree; Guggenheim fellowship	Published works; University professorship	Princeton, N.J.	Literary essays	Critical quarterlies; pub. of essay collections

NOTES

¹ This discussion of the merchant class and the aristocracy was drawn from Don Martindale's lecture notes, 'Backgrounds of Modern Social Thought,' Spring, 1954.
² Lionel Trilling, 'The Function of the Little Magazine,' in *The Liberal Imagination* (New York: Doubleday, Anchor Books, 1953), p. 98.
³ Logan Wilson, *The Academic Man* (New York: Oxford University Press, 1942), p. 223.
⁴ *Ibid.*, pp. 19–20.
⁵ For a discussion of the 'bureaucratization of intellectuals,' see C. Wright Mills, *White Collar* (New York: Oxford University Press, 1951), Chaps. 6 and 7.
⁶ Wilson, *op. cit.*, p. 29.
⁷ *Ibid.*, p. 44.
⁸ Trilling, *op. cit.*, p. 95.

KURT LANG

*Mass, Class, and the Reviewer**

As REVIEWERS OR as the victims of reviewers many students of popular culture have rejoiced in Stephen Potter's broadsides on the art of review-manship. Yet little systematic evidence has been gathered to illuminate the roles of the reviewer whose criticism is regularly featured in the daily press and in weekly publications.[1]

How influential is the reviewer? The theater critic continues to be credited most often with the crucial role of kingmaker or executioner in the world of legitimate theater. On the whole, however, many observers are inclined to discount the reviewer's influence altogether. Because critical ratings and audience ratings fail to jibe, one comes to de-emphasize the impact which advertising and other mass-media promotion usually have on public selections. This minimization, in turn, expresses an approach which views the customer as being in the focal position within a network of mass and personal communication. Accordingly one studies how information and evaluations reach audiences. In terms of this frame of reference—most appropriate in assessing 'effects'—daily and weekly reviews become merely one among the many promotional pressures which converge upon the potential customer. And here it can be shown that a good part of the general informational flow actually reaches him not via the mass media but by word-of-mouth, *i.e.*, by the kind of informal diffusion of evaluation which is characteristic of every social circle.[2]

To what extent the reviewer plays a decisive role in the determination of smash hits and best sellers constitutes an interesting question. In the small study which serves as the basis for this article, we have, however, taken the

* Reprinted from *Social Problems*, VI, No. 1 (1958), 11–21, by permission of the author and the publisher. (Copyright The Society for the Study of Social Problems.)

reviewer and not the consumer as the focus of observation. From this view-point, it is the reviewer who occupies a 'central' position within the mass-entertainment world, standing between a potential or actual audience, on the one side, and the group of creators, managers and distributors engaged in marketing the popular arts, on the other. The main point is just how this intermediary position impinges on his role as a critic. The data collected constitute no more than a preliminary assessment of reviewmanship. They are designed to sketch some problem areas and do not permit the drawing of definitive conclusions.

The data. The writer undertook a systematic analysis of reviews over a six-week period in the fall of 1957. On the assumption that the role of the reviewer would differ not only according to (1) medium under review, but also according to (2) schedule of publication (daily or weekly), and (3) the audience to whom the publication is directed, reviews covered were those on television, books, movies and the legitimate theater printed in two New York City newspapers—one a *mass*-circulation publication, the other aimed at a much narrower *class* market. Of the two weekly magazines included, again, one was what we may broadly consider a *mass* magazine and the other a *class* publication. These designations are not intended as invidious terms. The two class publications were in a sense also mass offerings, except that they were aimed at a more specialized audience and at the higher educational levels. The mass publications, on the other hand, are not by definition low-brow and pulp publications. We simply selected a paper and a magazine enjoying very wide circulation, fully recognizing that the national magazine readership is what constitutes essentially a middlebrow mass market.

The number of reviews covered totals 462. Considered as reviews were only those write-ups which, in the eyes of the publication, merited a head-lined presentation. This definition eliminated a whole variety of book, drama, movie and TV 'notes,' which often are little more than announcements, trade gossip and news for an appropriate feature section. The mass daily did not discuss books; therefore book reviews from the Sunday supplement of another one were used.

Students in the writer's class on mass communications collected and coded the reviews. Each code sheet was checked against the review at least once either by the writer or by one of two volunteer helpers. The code covered three areas:

1. The reviewer's *over-all assessment* of the offering was rated along a five-point scale.[3]
2. For each review, we further checked whether the writer dealt with any

one or more of the following: (a) the *policy of the industry*; (b) *placement* of the offering in the context of the book world, theater, film, or television as signifying new styles, new talent, or experimentation—in short, its *cultural significance*; (c) *public import*, which entails some effort to evaluate (not merely interpret) the bearing of the content on contemporary social and political life; (d) estimating the *suitable audiences*; (e) estimation of its probable *public success*.

3. The allocation of space devoted exclusively to (a) description of *content* and manner of presentation, (b) background and history of the *production* and (c) *personal data* unrelated to the production concerning the writers, producers, or actors. Because of low reliability concerning specific paragraphs, figures on the third set of categories are based on reviews, not on the space measure.

On all categories used, coder agreement was above 90 per cent, often considerably above.

THE ROLE OF THE REVIEWER

Statistical and qualitative analysis of the reviews suggest that among the factors which must be considered in studying the role of the reviewer are his relations to the following: (1) the publication in which his reviews appear; (2) the medium with which he must concern himself; (3) industry pressures; (4) the image of the publication's audience (and the reviewer's image of his share of that audience); (5) professional self-conceptions of reviewers, *i.e.*, how they conform to the commonly accepted role of reviewer; and finally, certain structural transformations which have altered the relationship among critics, producers and their audiences. Through content analysis of the reviews, one may construct a preliminary definition of the reviewer's role.

The relationship to the publication. The reviewer's role is partially defined by his relation to the publication which employs him or solicits his review. By this we mean to indicate more than the usual reference to job-consciousness and security-mindedness. Each publication has a slant to which every contributor adapts himself. As might be expected, there were noticeable differences among the four publications with regard to style as well as length of the review. Also, there were characteristic aspects of the reviews which distinguished them from those in other journals and could be explained by the general tone of the publication.

The mass daily, to begin with, contained more subjective reactions and

also more general, over-all reactions which were not related to any specific content or element in the production. Thus these reviews can be thought of as generally more subjective but less inclined to 'explain' the sources of the reviewer's subjective reactions. They recommend rather than evaluate.

In the two class publications, reviewers are more prone to dwell on specific aspects of the performance and to let these, however obliquely, carry the general evaluation. The reader's ability to form his own over-all judgment is more likely to be taken for granted. A larger portion of each review consists of background information about the participating personalities, the history of the production and its relation to other similar ones.

How the publication's tone carries over into the reviews is exemplified best by the mass weekly. The flippant style of its reviews, which are unsigned as is the rest of its copy, duplicates the jargon which distinguishes the publication in its entirety. In format a 'critical,' analytical magazine, it has developed a formula for mass appeal on the line of 'We have no Gods except those we create.' It singles out items, not necessarily central, to epitomize any topic. This deceptive tone permeates its sections on the popular arts and largely accounts for the generally severe ratings of its reviews. Books, drama, and movies are on the average rated lowest by this publication, while its evaluation of TV closely approximates the mean of the other journals. How simple flippancy may damn a production is illustrated by the anonymous reviewer's branding a movie 'a pretty good example of Stiff Upper Lipmanship, Jolly Good Show Division.' After two sentences of rather lively description, the review concludes: 'As usual in this sort of thing the Germans are all neck, the British all cheek, and the audience all ears for the next jeer at poor old jerry.' This picture was well received by reviewers in other journals.

The relationship to the product. A review is not only a reflection of the image a publication creates of itself; some relation of the reviewer to the products of popular culture is also involved. The sheer availability of large amounts of material means that in taking note of an item, the reviewer (or editor) is already exercising some judgment concerning its significantce or suitability for the readership. In not being notified about all offerings, the reader in effect receives information (or even explicit advice) about how to allocate his time and money in order to satisfy personal inclinations.

In actuality, one medium more than another permits the reviewer leeway in exercising selective judgment. First, the variety of offerings in any medium is an importent determinant of how this function is exercised. Only a small percentage of the many general book titles can be reviewed in the

average publication. Among the 135 titles discussed in the four publications, only 13 were reviewed in three or more of them.[4] The average number of reviews per title was 1.5.

During the six-week period covered, there were significantly fewer plays than movie premieres, so that duplication might understandably be higher for the former. The reverse is the case. The observation of 2.3 reviews for the average drama and 2.9 for the average film suggests that the significance of many dramas is considered rather specialized in that they are not deemed worthy of general notice.

To offer a strictly comparable figure for television is not possible: a single program is often used to review and evaluate an entire series, and reviews of series may appear at different times. Yet duplication with respect to the series is extremely high: programs such as *Studio 1*, *Playhouse 90* or *Wide, Wide World* are subjected to discussion several times even in the same publication. On the other hand, the variety of programs available for viewing during a single week means the duplications in the strict sense are almost exclusively limited to the more spectacular programs thought to be of general significance.

Does the opportunity to select items affect the severity of criticism? An affirmative answer is indicated, if, wherever selection is possible, only the 'best' products are singled out for review. In the case of books, where reviews are least often duplicated, we did find the highest acclaim: 35 per cent of the books received the highest possible endorsement. In the case of drama, duplication was also low, and superlative ratings obtained in 27 per cent of the reviews, whereas movies, the medium most often discussed in more than one journal were also the ones reviewed most harshly. Forty-one per cent are noted unfavorably, and only 8 per cent got unqualified acclaim. Conversely, drama and book reviewers used the *least* favorable rating extremely sparingly (4 per cent of book reviews and 9 per cent of drama reviews), but use of this rating increases to 24 and 17 per cent, respectively, for movies and television. However, if selectivity were the major determinant of evaluation, weeklies which, because of space limitation, are able to give less coverage, should be more favorable than the daily newspapers. On the contrary, the weeklies are consistently more critical than the dailies, and the mass weekly, as well as the class weekly, is clearly more critical than its daily counterpart. These differences among publications remain even if only duplicate reviews are considered.

The observed rank order of critical acclaim—books, drama, movies in 1–2–3 order—is reproduced in every one of the four publications, independent of whether the publication was directed at the class or mass market. (Table I.)

Only the comparable rating of television productions varied according to the slant of the publications. Reviewers in the class journals rated video lowest, but in the two mass publications the praise bestowed on TV production is second only to books. This class-mass differential concerning TV raises the question of whether, in contrast to the other arts, the acceptance of programs by reviewers might reflect the failure of TV criticism so far to congeal into widely practiced conventions.

Table 1.*

Mean Ratings by Medium and Source

Publication	Books (N=196)	Theater (N=67)	Movies (N=90)	TV (N=109)	Total†	Mean Rank Order‡
Mass Daily	1.8	2.3	3.8	3.1	2.3	1.3
Mass Weekly	2.7	3.2	3.3	3.0	3.0	3.8
Class Daily	1.7	2.5	3.0	3.1	2.5	2.5
Class Weekly	2.3	2.4	3.1	3.4	2.5	3.0
Total	(2.1)	(2.6)	(3.2)	(2.9)		

* The number '1' designates the most favorable ratings; '5' the least favorable.
† Mean rating for entire publication (all four media).
‡ Based on degree of favorableness of the publication for each medium.

It was noted that TV reviews often do little more than articulate general attitudes concerning television, and radio in its heyday, while attracting mass enthusiasm, was met with similar reserve by the highbrow.[5] Apparently, class publications judge television by their own 'high' standards according to which it is grossly deficient. Mass publications utilize the standards of their readers who have already either seen the program under review or missed it irrevocably. The approach to the television product is '*Will* he, the reader, like it?' rather than '*Should* he like it?' The class journal, acting as a public conscience, seeks rather to influence people to reject what, by aesthetic standards, they should not like.

The pressures of publicity. Another factor deserving extensive study is the degree to which reviews are an extension of industry promotion. Notices of impending publications and announcement of production plans probably affect critical assessment in the reviews to an as yet undetermined degree. On the basis of the data, one can tentatively express doubt about a clear-cut relationship between rating and advertising. But the effect of industry publicity on the 'independence' of the reviewer is more complicated.

Essentially the question is: How much do the public relations activities of

the industry determine the selection of items? On the one hand, the reviewer is faced with the necessity of reporting events in the popular arts which at any moment are apt to attract wide attention, but the critic in him undoubtedly wants to bring to the readers' attention works of more permanent significance. This mixture of motives produces divergences between critical evaluation and editorial endorsement. It may also produce divergences between critical judgment and the decision to feature the review prominently. Especially in the weeklies, where the number of items reviewed is tailored to space, selection appears to hinge in good part on whether the item has received publicity. Consequently, while a selection by one of the major book clubs stands a greater chance of being reviewed, it does not necessarily receive greater approval.

That books are chosen for promotion through book clubs with some anticipation of their appeal does not exclude the possibility that reviewers contribute to the fulfillment of predicted appeal. They may do this not only by giving prominence to certain selections but by predicting wide appeal even for books about which they personally have little good to say. This possibility is suggested by three books, prominently featured in several of the publications, but which, nevertheless, received rather low evaluations. The prediction of wide sales was confirmed when all three subsequently made the best-seller list. The shock appeal of one author was duly noted in two reviews of his book. The third reviewer thought a season or two without a book by this author would only whet the public's literary appetite. Again—and this was not checked against a complete record of all releases and all openings—films at first-run theaters and Broadway plays (in contrast to those in smaller off-Broadway houses) appear (as judged by our sample) to have a better chance of being noted.

To gain more than routine notice for a newly launched enterprise, it seems almost necessary that the industry create an event of public significance. For example, in the case of a book by an unknown or virtually unknown author, all details of its production—the title, the make-up (including introductions by celebrities hailing the significance of the book), its very acceptance for publication—are in some measure conceived with an eye to promotional possibilities. Similarly, cinematic and dramatic productions must be launched as public events, but here the managers, since they are in a better position to choose their stars, create sensational publicity stunts, and determine the manner of release, are less dependent on favorable notice. Curiously enough, the television spectacular has had only very limited success in affecting or even upsetting entrenched viewing habits. But by dubbing this fare 'an event of unusual interest,' they have usually succeeded in drawing the

attention of critics. Since editors have their eyes set on what is judged to be timely and significant for the public, the TV reviewer can rarely afford to overlook a 'spectacular.' And, in this sense, the TV reviewer, like the book reviewer, combines the functions of publicist and critic. In their selection of programs, reviewers are influenced as much by the ability of the industry to promote a feeling of public significance as they are by aesthetic criteria.

The image of the audience. Of course, the extent to which the reviews in any publication emerge as an adjunct to the communications industry varies. It is affected by whether the image which the publication has of its own audience (and presumably the critic's image of his own share of that audience) coincides with or diverges from the one at which the industry offering is aimed. Here the difference between *class* and *mass* publication appears significant.

To begin with, the reviews contained few attempts to depict and define the type of audience for whom any offering might be intended or for whom it might be suited. This was as true for books and television programs, which might be expected to appeal to widely different groups in the population, as it was for drama and movies which reach what is perhaps a more 'homogeneous' audience. Where specific target audiences were mentioned, the most common referential categories are age-divisions,[6] with an occasional allusion to the connoisseur vs. layman. And there were hints (percentagewise very few) that a book would make an ideal Christmas present, etc.

Many publications do recommend or point editorially to offerings expected to interest their readers. These take the form of 'recommended' and 'special interest' lists or of editorial 'ratings.' Also lists of best sellers, box-office records, top audience ratings, etc., attract considerable attention.

How the image of the audience may affect reviewing policy comes out most clearly when we note that notwithstanding the amount of duplication between items selected for review, the reviewer for a *class* publication played a role different from his colleague writing for the *mass* journal. The mass reviewer, who often reviewed the whole bill at a movie theater (rather than a single film) focused on the star attraction. The class reviewer, too, gave prominence to the highly publicized feature but, at the same time, was more apt to note also out-of-the-way books, interesting Class B movies and documentaries, off-Broadway shows and limited-engagement runs, as well as small-audience and limited-appeal programs which were not in any way launched as spectaculars. In such instances, the cultural significance of the offering was stressed, and the tendency of 'class' reviewers to do so was markedly greater.

Reviewing as a profession. Helping to structure the role of the reviewer, then,

are certain relationships in which he participates—his position with respect to his publication, the product, industry promotion, his audience. Finally we must inquire about his professional definition of his function.

First, is the reviewer a newspaperman (or a journalist) who comes to specialize in reviews of the public or elite arts? Does he then think of himself as a newsman who is bound in his reviewing to seek out the newsworthy, to make use of public-relations handouts, to go after the inside story of how a book came to be written, or how a play came to be produced even if that story has no critical relevance? Or is he a specialist in communications or literature or a student of society who, though a writer, thinks of his first job as criticism?

Second, is there a general convention among critics concerning how critical one should be? We observed earlier the rank order of criticism. Can it be said, for example, that there is a tradition of just how hard one can be on the manuscripts which survive the screening-out process and make their way into the bindery? Do the same sort of conventions operate among theater critics and, in turn, movie reviewers? And may such conventions account in part for a rank order of acclaim independent of the reviewer's selectivity and of the audience for which he writes?

Third, such conventions are apt to reflect changes in the structural context of the popular arts, including the relationship between product and producer and the extent to which the critic thinks of himself as or is part of the industry which he is employed to evaluate. Criticism progressed in severity from books to theater, from theater to movies, and in the class magazines from movies to TV, as what once were private productions become more clearly corporate efforts. In this connection, a change in the structural context of the popular arts, the transmission from the older arts to what Seldes has recently called the public arts, becomes important.[7]

THE PUBLIC ARTS VS. THE ELITE ARTS

At least since the beginning of the nineteenth century the traditional critic has been concerned primarily with an evaluation of his private experience. His was a self-created task of go-between between the creator and his select audience, seeking to clarify the artist's message, estimating his craftsmanship, and interpreting the psychological milieu in which the message was framed. Even as art diffused from its elite circles to become 'mass culture,' the emphasis of the reviewer was still on his highly private experience, culturally meaningful for the 'happy few,' rather than on the public significance of the art form being examined.

Among the reviewers of the popular arts, the theater critic, more than the others, appears to have retained this traditional function. He describes his feelings and gives his estimate of how well the meanings meant to be conveyed were conveyed. For example:

> Watching and hearing it [the play], I had the odd and uneasy feeling that I was a reluctant psychiatrist listening to the confidence of strangers. Since I did not know or particularly care for these strangers, I was uncomfortable.

While opening night is not exactly private, the critic does discuss experience which comes only to the select—experience which his interested readers may share with him, but whose public significance in terms of everyday life is apt to be minor. He writes about the special world of the theater, in terms of which his experience is interpreted, and there is little apprehension of any broader social significance. Twenty-seven per cent of all drama reviews contained references to the item's cultural significance, compared with 6 per cent of movie reviews and 10 per cent of TV reviews. While the theater reviewer indulged in considerable discussion of his special world and its personalities, he largely ignored *the* public, *the* theater as a vital part of American life. Only 7 per cent of the reviews alluded to industry policy and 13 per cent to the public or political import of the play under dissection.

While books—the other of the older, traditional arts—were most often reviewed in terms of their current public import, allusions to a book's cultural-significance message were found as often here as in theater reviews. Still, the function of the book critic has metamorphosed with the changing times. He cannot assume that the book-reading public has the homogeneity of interests it once had. The reading public does not share a uniform conception of the importance of books, and this is due primarily to the variety of offerings. Nor can most of them be expected to have the time or inclination to live their lives within a world of books as does the full-time book reviewer.

As a consequence, the book reviewer cannot just report a personal reaction. Because he seems more impelled to document them, a much larger proportion of the total space is given over to mere outlining, even lengthy quotations, of the book contents. The book reviewer, like the drama critic, also fills in on the background and history of the title and its creator. But notification rather than assessment and evaluation appears to be the former's primary aim. His discussion usually fell upon the book and author whose views and actions have achieved some public notoriety or whose world appears 'timely.' Cultural significance is, however, duly noted.

In stark contrast to these two art forms, the reviewers of the public arts—

movies and television—pay little attention to the cultural and creative significance of an offering. (Perhaps there is little of it, but certainly enough has been written about the film as art to belie this suggestion!) But this content analysis does not at all support the charge that TV reviewers devote the bulk of their comments to personality gossip. Indeed, a smaller percentage of the TV reviews than of other reviews indulged in extensive trade gossip. It is in the older arts that the personal lives of the producers become relevant to their productions. Gossip, on the other hand, may be the function of movie and TV fan magazines rather than movie and TV reviews, where it is not related to the content of an offering. It is also a common feature of movie and television *sections* in newspapers (mostly publicity handouts).

The theater critic seems much more a part of a world he shares with the creative people of the theater than the reviewer of the other art forms. This may go a long way toward explaining why drama criticism in 'general interest' publications, even highly sophisticated drama criticism, is inclined to be favorable. The critic is impelled to give praise for effort and intent— even where he cannot approve the results. The book industry is a more impersonal business by comparison. Writers are more dispersed than in the highly centralized legitimate theater. And the relationship between reviewer and producer is more apt to revolve around a common interest in the subject matter of a book than in the trials and tribulations of production. Still, the interest in subject matter is apt to lead the reviewer who is often chosen because of this interest to put in a plug for the book. Hence book-reviewing lends itself so well for promotion.

The reviewers of the cinema and of TV are far removed from the industry, whose products are highly corporate creations. This is even more true of television than of the movies. Our analysis of reviews tends to confirm the charge that movie and TV reviewers show little awareness of the problems and techniques of production. Their reviews delve into the production background much less often than their counterparts who write about books and plays. Not always sharing a universe of discourse with the creators of broadcasting programs and films, the reviewers seem less apt to identify themselves with either the producers or creators. A movie ticket or a TV set constitutes sufficient qualification.

But there is a deeper sociological cause for this alienation of movie- and TV-reviewing from the production end. It is not only that many of these reviewers may come from the ranks of journalists. Moviegoing and tele-viewing are primarily habits. The reviewer of the public arts is in large measure the spokesman for his public vis-à-vis the industry. As such he is supposed to be 'independent.' For instance, when John Crosby appeared

as narrator for *The Seven Lively Arts*, suspicion concerning his role as TV critic was aired in reviews falling within the period covered by our analysis. No dual allegiances were to be permitted. Much of the time the TV critic speaks *for* his audience, and, to the extent that he does, he speaks *to* it proportionately less of the time. He is inclined to deal with the public consequences of TV programming, to assess likes, effects, and to verbalize demands which cannot find expression in box-office returns. Not every TV critic fills this role to the full. Penetrating analysis is often lacking, and the reviewer in the mass-circulation daily is all too prone to worship the standards which a TV-hungry public has come to accept. Judged by our analysis, the TV reviews in the mass publications do indeed set a relatively lower standard of criticism for themselves than do their peers in the class publications. In any case, the TV reviewers identify themselves, it seems, much more with the perspectives of their readerships. It should be interesting to inquire to what extent their remarks are addressed to the industry which they evaluate rather than to the readership which they have come to represent.

This redirection of attention to the industry and its policy follows to some degree from the fact that every viewer of a mass medium has his own special experience. Quite obviously, the television reviews are the only ones written *after* the prospective reader has presumably watched what is being reviewed. In a sense, each viewer is a part of the first-night audience. As part of such an elite, the viewer is his own expert. With the emergent tendency of the movie industry to release features directly to neighborhood houses, while giving extended runs in first-run houses with reserved seats at inflated prices, there may be a bifurcation in the movie audience and in movie-reviewing as well. The function of reviews of these first-run showings may usher in a new era of reviewing the film as an elite art, while the function of reviewing the whole range of offerings directly available to moviegoers takes on more of the characteristics of TV-reviewing.

SUMMARY AND IMPLICATIONS

On the basis of a content analysis of reviews, the writer has tried to outline some possible determinants of the role of the reviewer. The research is exploratory only; many problems are only touched upon. For instance, a more definite comparison of criticism contained in mass as compared to class publications had best seize upon a few works and examine in detail the range of elements singled out for review in *many* sources. Again, analysis of reviews of a work available in several forms, *e.g.*, book, legitimate drama and TV play (for example Marquand's *Point of No Return*), would allow for a

better evaluation of the content of the product (as opposed to medium and source) as a determinant of the reviewer's role.

Second, a more detailed picture of the place of reviews in the more general scheme of promotion would be desirable. The history of promoting a single product, the relationship of the release, advertising copy,[8] and content of the product to the content of the review could give us a better picture of how reviewing may be influenced by promotion.

Finally, the whole question of the creation of public interest constitutes a fascinating area of research. For, what, after all, is the impact on consumption patterns of such 'news services' as the publication in journals of best-seller lists, newsworthy TV shows, and the public institution of the *Hit Parade* on radio and TV? And how important is it that papers and magazines at intervals cite the 'big ten' in television ratings and make a horse race out of Sullivan vs. Allen? In the last instance, criticism is no longer free; nor can it possibly be effective. The reviewer reports only on offerings produced for a special market dominated by monopolistic interests.

NOTES

[1] Alan Dutscher, 'The Book Business in America,' in B. Rosenberg and D. M. White (eds.), *Mass Culture: The Popular Arts in America* (Glencoe, Ill.: The Free Press, 1957), pp. 126–140; C. A. Siepmann, 'Collection and Analysis of Prevailing Criticisms of Television Programming' (unpublished manuscript).

[2] Leo Handel, *Hollywood Looks at Its Audience* (Urbana, Ill.: University of Illinois Press, 1950), pp. 88–90; E. Katz and P. F. Lazarsfeld, *Personal Influence* (Glencoe, Ill.: The Free Press, 1955); Walter Kerr, *Pieces at Eight* (New York: Simon & Schuster, 1957).

[3] The points in the scale were defined as follows: 1—enthusiastic and unsparing praise; 2—generally favorable, or favorable on most aspects, but not superlatively; 3—strictly qualified praise or balance between praise and criticism; 4—generally unfavorable, or on most aspects, with only some qualifications; 5—completely unfavorable and critical; 0—a zero rating was used if the entire review was descriptive and it contained no evaluation.

[4] The fact that books, especially, are not always reviewed at precisely the time they are published and the influence of different deadlines suggest that actual duplication is somewhat higher than observed duplication within a specified time period. We tried to track down some duplicate reviews even though they fell outside of the period covered in the analysis.

[5] S. E. Frost, Jr., *Is American Radio Democratic?* (Chicago: University of Chicago Press, 1937).

[6] Occasionally with a definite list, *e.g.*, movies or shows intended for, or not suitable for, children.

[7] P. F. Lazarsfeld, 'The Role of Criticism in the Management of the Mass Media,' *Journalism Quarterly*, XXV (June, 1948), 115–126; Gilbert Seldes, *The Public Arts* (New York: Simon & Schuster, 1956).

[8] D. M. White *et al.*, 'Hollywood's Newspaper Advertising: Stereotype of a Nation's Taste,' in B. Rosenberg and D. M. White (eds.), *op. cit.*, pp. 443–450.

BERNARD ROSENBERG AND
NORRIS FLIEGEL

Dealers and Museums*

THE ARTIST USUALLY appreciates having a dealer who acts as a buffer between him and the buying public, who spares him the awkwardness of having to sell his things, which 'is almost like selling yourself somehow,' who performs a service which would be repugnant to the artist himself and deserves to be rewarded for it. He is a kind of broker, or better, he is like a publisher engaged in antagonistic cooperation with the artist. As such, he occupies a strategic place in the 'hierarchy or the bureaucracy of taste.' Thus:

> I think dealers are tastemakers in one very special sense. By being the first to exhibit your work they bring it to public attention. It's like a publisher publishes a book. What happens after that, whether it sells, whether it becomes a best-seller—that depends on public acceptance, which he does his best to foster.

Differences are also noted. If people very much like a book, there are hardly any so poor that they cannot buy it, but few of them can afford the paintings they like best, and not even Vincent Price wants petty bourgeois America to like his latest choices better than the work of accepted masters. The clientele of a Manhattan art dealer is as small and select as that of a Manhattan book publisher is large and indiscriminate; the nature of their transactions, so similar in one way, diverges as much as the targets they aim to hit.

The publisher and the dealer have in common that, economically, they

* Reprinted by permission of Quadrangle Books from *The Vanguard Artist: Portrait and Self-Portrait*, by Bernard Rosenberg and Norris Fliegel, pp. 229–231, 232–234, 238–250. Copyright 1965 by Bernard Rosenberg and Norris Fliegel.

are small potatoes—at a time when corporate giants stalk all business enter-
prise. The college-bred youngster of an earlier age, preferably one able to
live off inherited wealth, might well and sometimes did choose to settle down
as a publisher or a dealer. In that capacity, as a small businessman with good
family connections, treated indulgently by creditors, he could hope to
exercise his taste for literature or the fine arts. Big profits in a mass market
were out of the question; if we use almost any other sector of our economy
as the yardstick, they still are. Yet, by comparison with the recent past, book
and art profits seem huge, the market colossal, and its 'growth potential'
beyond measure. Mergers take place, there is even a modest flotation of
public stock, new and larger galleries open, Texas oil barons buy in, an
established English art house opens its lavish New York branch and raids
American dealers of their star attractions: all this looks much more like the
hurly-burly of big or greatly expanded business. For such business, the
dealer cannot be quite the type of man he was.

One artist knows an ex-publisher turned art dealer who fits the old mold
better than the new:

> This man was in Buffalo. Then he came to New York, gave up publishing,
> and got the idea of starting a gallery. He's quite remarkable, what with all
> the commercial pressures, because he retains a certain freshness. He feels
> as if he can manipulate and stimulate cultural activities, and that his
> gallery will be some sort of outlet for that. He's started publishing poets
> again, he's interested in the theater, he sponsors foreign films. Actually,
> it's all a little old-fashioned, and I don't know if it really works out—
> though with the acceleration of his income, his taste has improved: you
> can eat marvelous lobster down at his place.

Jibes aside, the artist has some fellow-feeling for a minority of dealers—
men of taste not totally dedicated to their own economic aggrandizement.
One painter recounts another unusual case:

> A dealer came here from California. I had a picture around that I had been
> trying to talk myself into liking for years. I mean, it's a little thing. I'd
> keep it up for a while, then take it down, and say to myself. 'You know,
> that's not bad.' Three days later, I'd say, 'It still stinks.' Well, he came on
> one of the days I didn't like it. I was embarrassed, but he kept raving
> about it. And he took it. So you see, dealers can have some standing. I
> mean, after all, without my Californian that painting would never have
> gone out into the world. After all, he's not entirely devoid of taste. . . .
> Maybe it is good. Anyway, the artist never really knows whether some-
> thing he's done is good . . . and maybe he shouldn't.

Among the many aspersions artists cast at dealers, there is an occasional tribute, like one to the dealer 'who has never suggested whether I change or not change,' who would not 'dare to advise me whether I was underproducing or overproducing' and would not dare 'out of self-respect.' This dealer is praised for showing work which she herself admires while refusing to show work offensive to her just because it might make money:

> My dealer has never even hinted at what she would like me to do or objected to anything that I have done. I expect that if I had gone off on a wild tangent, if I had suddenly begun to do something radically different, she might dislike it very much—not for the difference, but as a matter of taste. If so, she'd tell me she didn't want to show it, and I wouldn't want her to show it. This is the understanding I believe we have.

There is also reference to a Venezuelan art dealer who allegedly has a keen mind, responds to art and is therefore 'absolutely amazing,' and though very wealthy, does a lot for real art. In summary: 'You'd never believe he was a dealer!'

We do not find many instances of altruism in these data, but one account by an artist, who sells well, of how she came to switch galleries—after three of them in the chic midtown area put out feelers to her—does seem to afford a case in point:

> I was having lunch one day with my dealer, discussing galleries. I hadn't given much thought to the matter till she began talking about it. She said, 'Well, I don't have to tell you again that I think you're the greatest artist in this direction. I would hate to lose you, but if you go over to that gallery, you'll be the only artist there in this direction. You could be pushed individually.' She said, 'Here there are several others in this direction, and the untrained eye can't tell one from another. So when I'm showing the work, people will ask, "Which do you like better?" I have to say I like them all.' So, after we talked about it, I accepted an invitation from the S. gallery.

Such solicitude is so exceptional that no one else reports anything like it.

SOCIAL AND ECONOMIC NECESSITY OF THE DEALER

Mostly, as we have already suggested, the artist is thankful to his dealer simply for providing him with protection. 'I had a wealthy widow in here one day asking, "How much is this and this?" And I said, "Get the hell out! Out! Out! I don't care anything about you." ' By forfeiting 40 per cent of

his price to a dealer, the artist is spared 'those god-awful types trooping around' his studio, 'nagging and niggling about deals and all that.' He tells us that we have no idea how unpleasant it is to have to do business, 'to have every person who might or might not buy a sculpture come into the studio and spread out the deal.' We did not encounter a single artist who wants to be his own dealer. The gallery is a convenient place to show one's work, and those who run it are most useful for 'the dirty work they do.' The artist is happy to delegate a most important role to the dealer: that of financial and personal representative to the buying public. Partly it is a matter of conserving time and energy: 'If I had to be strongly concerned with selling my pictures, I wouldn't have time to make them—' and 'I'd be dividing myself into too many energy packages.' To sell oneself is unbecoming and inefficient:

> A good art dealer has the kind of personality that will work for his artist in a way that the artist can't work for himself. The average artist isn't able to call up critics, or museum people, or big collectors and say, 'You've got to come down and see my most recent thing. I think it's for you.' But a dealer who's on the ball will do just that.

The same sentiment is expressed in somewhat different terms:

> How can anyone talk about himself? I mean: 'Oh, those yellows are gorgeous! Look how it moves. I mean, Jesus, that picture is so moving.' A dealer doesn't always talk like that. He may not say, 'Those yellows are gorgeous,' but he has his pitch. How could it be the same as mine? I mean, maybe he thinks that picture stinks, but knows how to sell it. I couldn't care less.

The role difference is viewed as a character difference. No painter or sculptor likes to think of himself as temperamentally suited to salesmanship, least of all when it is required for the promotion of his own work. If, therefore, he wishes to deprecate another artist, nothing cuts deeper than to say, for instance, that so-and-so is 'really quite good at this sort of thing,' that he is 'terribly shrewd' or fundamentally 'a businessman.' To have the dealer's aptitudes is somehow to diminish oneself as an artist. Should you admit to having them in some slight degree, as an artist you recoil from their use: 'Actually, there's no reason why I couldn't send out postcards and say, "Come and see twenty new pictures in my enormous studio." But somehow that isn't what I want to do.' For doing it, the dealer and his gallery are a great convenience.

The impersonal character of this convenience troubles a few of our artists. A painter, well past middle age, observing the 'mechanized and rationalized'

relationship he now has with men of business not even personally known to him, remembers Paris in his youth: 'It was rather a small world. It was very concentrated. You would sit down with a specific group of five or six dealers, all well acquainted with you and your friends. That's all there was to it.' The number of people involved in art today is so great as to preclude intimacy; the quantity of interaction transforms its quality, and now and then produces some bewilderment:

> I think the whole thing is in such confusion. There are so many painters, so many dealers, so many galleries, so much in the marketplace that the real meaning of it has gone. It's all collapsed.

But for every artist who laments this dehumanization there are several who hail it. They feel relieved of the strain that is set up within and between any two people required to act warm and personal while engaged in cold cash transactions. These artists were glad to be shielded from the public; they were even happier to be shielded from their dealers: 'My dealer is a nice man. He's been very good to me. He does his job very well. And I never see him.' Is he pleased with this arrangement? 'I'm glad. Very glad. I'm so happy. I have no telephone or anything. It's the first time in my life that I've had it so good.' How so good?

> Look, I don't even know where my pictures are. Sometimes a couple drops in from God knows where and tells me my pictures are in the gallery, but it's just gossip. And then if something is sold, so I get a check. I tell you, it's a delightful situation. When one has such a dealer, one can reach this stage, the perfect condition for an artist to be in.

Nor is the dealer always so highly valued for his role as buffer:

> I think it works the other way around. The client in America is so conscious that he must have a prestige product that he needs the dealer to convince him that it's kosher. It's the dealer who convinces the client. He doesn't protect the artist so much from the client; his role is to give weight to what he sells—which means that a well-known dealer can sell many bad things that a poorer dealer can't. But protecting the artist; that's a minor factor. None of us likes to have clients coming in and rummaging around. . . . Some woman called up the other day. She asked to see small pictures and wanted to come over here. Well, I called the dealer, and he said he'd come over. He knew the woman, he knew her house. He'd pick the pictures out and take them over to my gallery, and show them to her there. So this is protecting me, and I like that. That's good. But then, that's

not a major problem at all. I mean, nobody, not even De Kooning, sells pictures so fast that his painting time will be taken away by a string of people outside his door. No, I think it's a very minor point.

No unqualified blessing is ever bestowed by artists on dealers. The most generous assessment is coupled with a touch of contempt, and most assessments are far from generous.

RESENTMENT OF DEALERS

But, 'even a bad dealer is better than none.' Narrowly defined, a good dealer goes about his business, which is money-grubbing, as unpretentiously as possible. He does his dirty work and keeps his distance.

Artists are undeniably testy on the subject of dealers. Why? What are their concrete grievances? Do they 'constantly have fights with dealers,' and are they 'always switching galleries,' as an esteemed painter heatedly contends? And if so, is it for the reason he advances, that no gallery really offers the artist what he wants? If not, our man wants to know, why do even very successful artists at the 'top galleries' keep looking for better ones?

Many artists feel that they are lifting the lid of corruption just a little to let us glimpse a hideous world they know too well. In their eyes many dealers are: irresponsible ('they don't handle the person correctly'); actually cruel ('they'll pick up artists and drop them'); filled with *réssentiment* ('unconsciously they hate artists. Lots of them are frustrated artists who can't stand productive people, and they take their revenge on us'); exploitative ('they take advantage of artists, but what's worse, they take advantage of ignoramuses who come to them for advice'); meretricious ('gimmicks are their stock-in-trade'). They are, above all, powerful agents of 'a sick system and a sick society which no artist by himself has the strength to lick.'

Dealers and clients, at their worst, reinforce one another:

The kind of audience we have here is based on nothing but prestige. These are people who want to buy pictures by big-name artists from a certain stable. And another kind buys because they think they are going to have a real little gold mine. Before very long a little Picasso will be discovered. He may be misshapen, the poor slob, but he will be found.

Patrons used to be churchmen and noblemen. They had nothing to do with intermediaries, 'secondary men,' agents, now called dealers, who do not proceed, for the most part, either from their own likes and dislikes, if any, or those of their artistically illiterate customers. Their common concern is with exploitable art—from which mutual benefits may be derived.

One reason for the great proliferation of galleries in New York (and in the hinterlands) is that they meet a new demand from people who have suddenly come into money and need to spend it for tax write-off purposes. A corps of financial experts advises them on how to invest in art and helps to generate demand. That the relationship is characterized by socio-cultural homogeneity becomes most apparent when we examine the supply side and discover that dealers may be motivated to set up in business for reasons indistinguishable from those which prompt their clients to buy:

> Mostly they're not hard-hearted businessmen but crazy businesswomen who run tax-loss galleries because their psychoanalysts said that they'd be happy doing it. And some of our major galleries are under those hands. Of course, a few commercial galleries are real hard business concerns, and they're the best, I think, for artists. But it's a very mixed-up field. It's full of people who aren't really art dealers. I would say nine out of ten galleries are phony. They have no commitment. They come and go like the wind. They're tax fronts. Now I would say this is a very unhealthy situation.

Worse than the villainous dealer, who merely cheats artists out of their money, is the manipulative dealer who, like too many curators, tries to dictate to artists about their work. Many say that the tentacles of control are put out by nearly every gallery in the city. Why? 'Because dealers feel their lives are at stake.' Money may gratify the artist, but to the dealer it is, and must be, everything. Dealers are accused of thinking that they can get good art by heaping financial rewards on the artist. 'Then, they feel . . . have the audacity to feel, that they can direct the artist, choose which pieces to show, advise him to keep producing more of the stuff that sells, to show off, to have too many shows.'

A young painter, already considered distinguished for his innovations, expresses delight that the critics have begun to murmur about him for being too varied. 'They can't follow me from one moment to the next. I think that's great.' At this early stage in his life as an artist, it strikes him that his gallery dealer leads a procession of critics and purchasers who emulate museum officials, all admonishing him: 'Whoa! Take it easy. No more changes. Consolidate your work. We've just gotten a big order from Such-and-Such Museum for a picture like such-and-such you did.' So we come full circle once again to the pressure and counterpressure, emanating mostly from museums but funneled very often through galleries and their personnel:

> So you're praised for something new and original. That means you get a painting to do, and you change the color or shift the elements around. But

it's the same picture. You just make variations on a single theme. That's your patent, and once you get it you're supposed to protect it. You have a vested interest.

Such quotations, and there are many, take us some distance toward the clarification of an apparent paradox: that artists, at one and the same time, complain of being pressured not to repeat themselves. The contradiction is resolved as they in turn are absolved of being mere malcontents, if the constraint toward newness is superficial—more a matter of appearance than reality, actually a disguise for doing the same old thing. Then indeed we have to do with coloristic and stylistic sleight of hand under cover of what one respondent calls 'aural jugglery.' And the artist's sense that he is being driven two ways to the same arid terminus becomes much more intelligible.

Are the dealers all that important? One answer is: 'For the moment, more than any other group, they control the art world. But they haven't always, and they won't always.' Another:

Today they are playing, I believe, an overimportant role. In other words, it's almost become as if they write the obituary and then sit around like pallbearers waiting for somebody to paint it for them. . . . Their advertising is so intense! I think, for instance, this whole business of Pop Art, and everything connected with it, was completely planned in the galleries. Even the name was dreamed up in advance. These few gallery people sat down and thought about it and brought in this comic strip and these particular elements, and promoted it and gave it a tremendous amount of publicity. . . . I think a lot of this happens on account of the constant shifting of attention from one gallery to another. A gallery comes on the scene with a certain importance, and in one year it can drop way down the ladder. So naturally, when that happens, the dealer tries to cook up something to get back up again.

Fads artificially induced to make money for gallery owners who wish to establish, sustain, or recoup their position do have detrimental effects—at least on good second-rate artists, if not on their betters. These are artists who before the fad 'were good in terms of what they were doing, men like so-and-so, who were doing their kind of work, which was never the best, but they were doing it very, very well.' What happened? 'Well, as soon as this new situation developed they weren't able to do what they had been doing half as effectively as before. It was true for every one of those painters.' 'Those painters' are not of the first magnitude, but they are mature and serious and not to be lightly dismissed. If even they can be injured by the

arbitrary rules of fad and fashion, how much more vulnerable are the young and the inexperienced. A lady painter in her thirties, also scandalized by the promotion of Pop art, angrily avers that 'If I were a young artist beginning now, looking at that stuff, I would say, "I don't want to do it. If that's what it is, I don't want to be an artist," and I'd go on to something else.' She emphasizes that art is now in an amorphous period of transition and, consequently, that artists are unsure of themselves. The masters will not be troubled by this openness, but those below and those still outside who may have the potential to move up and in could be deterred from doing so. At these levels the dealers' gimmickry is disastrous.

An anecdotal insight:

Well, I'll tell you, I've an Italian friend who works at the ABC Gallery, and she told me people come into the place, and in the course of working there she discovered this word 'crap.' She said, 'What does this word, crap, mean?' So we told her. She said, 'Everybody who comes in to see the show says, "This is crap and that is crap." ' But then, on the other hand, I asked her (she also works in an Italian gallery), 'When you get back to Italy, are you going to handle this crap?' and she shot back, 'Yes, I'm going to handle it!' So, it's something. It's a business. And they all say the same thing, so I guess it's true: if it's junk and somebody buys it, why not sell it? Like the thing is set up by these people who are so calloused about it, and certain artists will produce for this kind of thing because they get momentary success for it, they make some kind of money, they're fawned over for a few days. Certain people need that.

Certain people need that and will be attracted to it, but others are repelled, and if not yet launched in the fine arts they may be irretrievably lost. It is not inconceivable that some of the worst will be attracted and some of the best will not. In that case, worrisome inferences must be drawn by everyone concerned with discovering and fostering creativity.

Do the number and variety of galleries in New York City mitigate their harshness? No one in our group is impressed by the number and few admit the variety. The gross number of galleries in New York is a matter of dispute: some artists venture the round figure four hundred, but most scoff at the estimate. Characteristically, 'There may be that number, but I'd hardly call any of them *galleries*.' Or, 'When you cite that figure, it really means very little. They don't do anything for their artists, nor their artists for them.' And, qualitatively, 'I mean, when there were forty galleries they did much more than these four hundred.' A painter in his eighties, but still going strong, remembers that when he got started there were only two or three

galleries, 'quite undistinguished, you know, but they had nothing to do with contemporary art.' Presently, one or two more, notably Stieglitz's, came along, and they had off-shoots manned by 'people without any social background whatever,' who, by displaying current work, led to our own speculative and inflationary era.

Sculptors have a special problem:

> If you think there are so many galleries in New York, remember first of all that not all of them show sculpture. That eliminates a whole group. Then you take those that remain: if you have any objective vision about your own work and about the galleries, you don't just march into any one. There are some that don't handle Americans, some that don't handle contemporaries. Pretty soon you work down to a group of perhaps fifteen galleries in the whole city. So you look them over, and you decide that out of that group there may be five that can use a guy like you. For one reason or another, some of them may have too many sculptors already. . . . Now it's tougher for a sculptor, but I think no artist has more than five galleries that are really right for him, and—it's almost impossible to achieve, of course—but they should come to him. He shouldn't have to go to them.

Perhaps he shouldn't have to, but as things stand he does have to—and therein lies much of his trouble.

ART MUSEUMS

Artist after artist testifies to his skepticism about the value of contemporary museums. Their 'true' function, that of conserving good art by separating it from inferior work, has been sacrificed to business and amusement or, more accurately, to the amusement business. People go to museums in much the same spirit of passivity as they attend movies, providing themselves with a kind of respite from their grueling existence, 'to be distracted from—not confronted by—the human predicament':

> The museums have exhibitions that are constantly changing. They're like moving pictures. In fact, they are moving pictures. Just stand in one place in a museum—in September, October, November. You have a moving panorama of pictures presented to you.

The audience is increasingly weary, surfeited, 'overstimulated by new shows every month in museums,' its appetite for newness enlarged as steadily as that of a dipsomaniac for alcohol: 'You have one drink, two drinks, then you need more and more. Just so, the Museum of Modern Art has a show

where Tinguely burns down his sculpture. What do you mean, lastingness? What next? Will the Museum have to be burned down? Will the aesthetically sated man have to find his kicks in pyromania?'

Artists note a reciprocal relation between audiences bent on having new but superficial experience, and museums catering to their needs. Curators and directors of museums are alleged to have 'forced the hands of those who do these things, that is, the artists,' to have invoked and accepted the necessity of ceaseless change. Why? 'It's just a question of money. It attracts the public. Like, over a million people going to see the "Mona Lisa" from a distance, behind glass, for whole seconds before they move on, each of them paying one dollar. Every museum is in business.' Museum-goers in New York, given their great exposure, may require special titillation, but 'Even hidden places like the Cleveland Museum suddenly buy Klines and Yunkers—just to make it, to be modern, to pull in the crowds.'

THE IRRELEVANCY OF TASTE IN THE MUSEUM

One painter rails against the traditional museum, whose worst practices, combined with new defects, make the whole institution objectionable to him. It now does violence to art, the artist and the audience:

Take the Hirschorn collection at the Guggenheim. You get one or two paintings or sculptures by fifty to a hundred artists. That gives you maybe a sociological or cultural picture of our time, not an aesthetic picture. You can walk around the Hirschorn collection and tell what's been done in sculpture all over the world. This is not an aesthetic experience. It doesn't encourage penetration into the work of one or two artists. Nobody can tell from looking at one Michelangelo or one painting by Leonardo what his work is like.

Museum directors stand, not literally but figuratively, at their doors with a clock numbering the audience. They are naive enough to tell you that the last show brought in twenty thousand or forty thousand and created a great deal of interest in art. But they're just talking about some kind of entertainment.

Now I think the proper function of the museum is to show the work of one artist at a time—in its entirety—or at least it should cover a major portion of his work. There is no other way to discover the meanderings and the expeditions this artist has made in order to create a style, a visual image. Otherwise, with a skimpy sampling, all you get is a kind of disharmony. ... I think it was Paul Valery who said museums were an abomination. You know, you come in and there's this polished floor:

it's overheated and you have your coat, and you don't know what to do with it. And you're tired. It's too quiet or too noisy. Getting into the place is a problem. And then you enter a room and you see a landscape, and at the edge of your eye is a nude, and a battle scene. And so on. And Valery says it's like listening to ten orchestras playing at once. And it is. Every one of these works was made by the artist over a long period of time; he meant it to be contemplated and penetrated and examined by knowledgeable audiences. Our audiences are encouraged to look around, read the notices under each picture in order to get as much factual information as possible, and move on. It leads to a sense of disquiet, of jumpiness—which is not what art means or has meant or should mean.

This bill of particulars is fairly long. Artists who have found a new patron in the museum seem to be no fonder of it than of other patrons currently available to them. The museum's motives are also dubious: it is suspected not only of commercialism but of chauvinism. A board of directors in Texas or Oklahoma may sponsor living artists out of regional pride—to show New York, Illinois and California that there is nothing culturally backward about museums which were once content to receive classical works from artistic centers. They aspire to *be* artistic centers; patronage is a means to that end. When the outlying districts are infected by culture-vulturism, it may be said to have infected the whole country. And the whole country bids competitively against other countries which suffer from their own more ancient *amour propre*. 'Like Frenchmen, Americans feel that we must show the newest innovations of our boys, our team. In order to . . . I don't know . . . put it on record that we got there first, or something like that.'

* * *

The museums are indicted for lending themselves to the use of gimmicks; they are charged with having become the merchandisers, rather than the custodians, of art. If so, theirs is a heavy responsiblity. After all, museums decisively influence an artist's 'success'. A review in *The New Yorker*, a spread in *Time*, or a notice in *The New York Times* 'will bring crowds to your gallery,' but they come to see, not to buy. Let a museum pick you up, and 'You are immediately followed by a certain buying public which goes wherever the museum goes.' Therefore, the really significant tastemakers are the curators. We ask, 'How did this come about?' Answer:

I would ascribe their power to the fact that upper-middle class people, who make up most of the buying public, have forfeited their historic role as arbiters of taste. Through laziness, apathy, and ignorance, they have

given up the old role, handing it over to their own creations, to the museum. Do you follow me? They create a museum, and the museum does the dirty work for them. And then, if the museum certifies that something's all right, they go out and buy it. Those who support museums financially are also the biggest buyers of painting. If the Museum of Modern Art has a show, and you're in it, they say you're okay. The stamp is on you; otherwise, it isn't. That's why I say there's no truly enlightened public. We have an elite, but no free-wheeling public of any sufficient weight or dimension to consider our work seriously and then support it.

An artist who feels that 'his imagination is constantly on the block' typically criticizes the museum as such, the museum in New York and the museum in Dallas, the Museum of Modern Art and the Metropolitan Museum. Then he tends to shift his fire onto curators, subcurators and other officials who run the museum—or those who hire them, the irresponsible upper middle class dabbling in art works. Finally, while conceding that their revitalization has done some good, he pictures museums as inherently defective because 'their faults are the faults of our society.' By fostering new art every season, museums lend their sanction to that 'ugly contradiction in terms, "art for the moment."' Thus they share the general guilt, but disproportionately since 'the mere fact that they are museums gives them status in the community, tremendous respect and power.' How do they use these great assets? Not to make moral or aesthetic judgments, not to be like the academies of an earlier age which stubbornly upheld certain conservative standards. In our day young men need not rebel against the academicians by establishing galleries of their own. The museum as a sort of 'historical storage house' is stuffed with every manifestation of every trend on a very busy scene in perpetual ferment—which it wishes to reflect as comprehensively as possible. The museum's attitude is basically reportorial. It may set out more or less descriptively to capture the cultural ethos, to exhibit it as a full and fluid, rapidly rotating kaleidoscope:

> They just want to report the scene, but lots of people misinterpret what they are doing and say that they are promoting this and promoting that. I don't think they mean to promote. They simply want to show, well, everything. But you see, what happens is that buyers take advantage of their choices, and there you have a problem.

The contemporary museum is not an academy, but it is still widely assumed to have preserved many academic criteria. While the museum is palpably not limited to classical art, it is usually thought to be governed by some

principle of excellence. The message that museum selections are so much a matter of reportage has not yet been communicated to large segments of the art world. An ironic consequence of this situation is that buyers continue to act as if the reporters were nothing but arbiters. They collect on the basis of choices that were not meant to be normative, made by men, who, willy-nilly, became tastemakers. And the public, overwhelmed by an immense and increasing quantity of art, passively accepts as admirable those works bought under the influence of museums which only intended to tell people about 'our times.'

ALVIN TOFFLER

*The Culture Consumers**

'POETS DO NOT write for poets alone, but for men,' declared Wordsworth. But for what kind of men? Maoris? Edwardians? Hoboken stevedores? Throughout history artists have been influenced, consciously or unconsciously, by the character of the audience for their works. Not only the content, but the form of art works, reflect, at least in part, the cultural audience of their time. Certainly, the kind of flash that occurs between a work of art and its apprehender is conditioned by the character of the apprehender or 'consumer.' An audience of Papuans hearing Bach's *Goldberg Variations* for the first time clearly must experience something different from an audience consisting solely of Juilliard students. If we are concerned with the impact of the culture explosion on art and the artist—or, conversely, with the impact of art or artist on audience—we must ask ourselves a single central question: Who is the culture consumer? Who are these millions who, to the discomfiture of the elitists, are crowding our museums and concert halls and theaters nowadays?

Culture in America was never as tightly monopolized by a few as it was in countries having a feudal heritage. Yet the over-all audience for the fine arts has been so small, relative to the size of the population, as to have created a monopoly by default. Moreover, this tiny audience was hardly a representative cross-section of society as a whole. No scientific basis exists for analyzing the culture-consuming public of a generation or two ago. Nevertheless, three main components of the audience can be identified. There was, first, the Europe-oriented rich. Next there were the alienated intellectuals, often bitterly critical of what they viewed as a crassly materialistic society, followed

* Reprinted from Alvin Toffler, *The Culture Consumers*, St. Martin's Press, New York, 1964, pp. 24–41, by permission of the author and St. Martin's Press, Inc., Macmillen & Co. Ltd.

by artists and would-be artists, a small but important part of the total. The audience was also, if we can believe contemporaneous accounts, heavily female. The woman traditionally was responsible for bringing culture into the home. Finally, it was decidedly adult. The composition of the culture public shifted, of course, from time to time, place to place. But by and large the audience lacked any strong delegation from the great middle class of America, or from its masses of working people and farmers.

The recent growth of a mass audience for the arts has changed all this dramatically. Millions of Americans have been attracted to the arts, changing the composition of the audience profoundly. This change has been praised and damned as a 'democratization' of the arts. A major step toward democratization has, indeed, been taken. Yet we would be sorely deluded if we jumped to the conclusion that all Americans today are equal participants in the culture boom. The culture public today is still by no means a neat cross-section of the total population. It is far more representative than the arts audience of the past, but there are extremely large sectors of the American population that remain untouched by the new wave of interest in the arts. It is important, therefore, that we determine, as best we can, just how far the process of democratization has gone, and where, for all practical purposes, it stops. To do this we must begin to paint, as it were, a portrait of the culture consumer.

This is not easy. Consumer research has been able for years to tell us in mind-numbing detail what the average American automobile purchaser or soap user is like, what he earns, how many bathtubs, television sets, or educational degrees he has and where his warts are located. There has been no comparable body of data about the culture consumer. Nevertheless, in the past few years a number of pioneering attempts have been made to accumulate data on the arts audience. The market researchers themselves have begun to evince an interest in the culture consumer. By pulling together such fragmentary statistics as do exist, by attempting a few educated guesses and by calling upon the impressionistic evidence of well-placed observers, we can begin to trace the outlines of the portrait.

The first problem is definitional. There is no agreement as to what a truly cultured person is. There never has been. It is easier, however, to speak of a culture consumer. Let us arbitrarily say that, for our purposes, a culture consumer is a person who listens to classical music, or attends concerts, plays, operas, dance recitals or art films, or visits museums or galleries, or whose reading reflects an interest in the arts. Let us also include by definition all those who participate, as either professional or amateur, in what we loosely call artistic activity—*i.e.*, the painters (of both the Sunday and weekday

varieties), the actors, dancers, musicians, etc. Let us also include the millions of children who are 'consuming' art or music lessons at home or in school. It is obvious that this is a jaggedly crude definition. It is full of unanswered questions. But it is better than none at all. It permits us to begin.

The initial question in any discussion of the arts audience in America must be that of size. Just how large a mass of people is involved? What figures can we start with as a base upon which to build? We know, thanks to the market researchers, that in any average week about 3,500,000 individuals listen to classical music broadcasts over the stations of the Market One network alone. We have, for what it is worth, *Variety*'s estimate that attendance at amateur theatrical productions runs in the neighbourhood of 100 million per year. How often did each individual attend? Few amateur companies mount more than half a dozen productions a year, and even if we assume every individual attended all six in his or her community (an unlikely assumption) we would come up with a minimum figure of between 16 and 17 million individuals. Similarly, if we take the fact that American museums ticked off a total-attendance figure of between 200 million and 250 million in 1962, we can attempt the same kind of crude extrapolation. No one knows what the average frequency of attendance was, but if we assume, not too unreasonably, that the average museum attender did not attend more often than four times a year, we arrive at a total of at least 50 million individuals who set foot in a museum.

Let us arbitrarily reduce that number by half, inasmuch as many museums are devoted to subjects other than art. Let us take into account the estimate that 35.5 million Americans play musical instruments and the estimate that 40 million daub at a canvas now and then. Let us allow some factor for those who buy records or attend art films and who are not otherwise accounted for in the above enumeration. Performing similar statistical arabesques with other attendance figures, allowing wide margin for error, and checking them against income and education figures which, as we shall see, are important in any consideration of the arts audience, we arrive at a frankly unscientific, but nevertheless reasonable, conclusion that within the total 185 million population in the United States there is a subgroup of between 30 million and 45 million individuals who fit the rough definition given above.

This figure of 30 million to 45 million individuals will unquestionably bring a gasp of indignation from many. It sounds ludicrously high. It will seem less so, however, if we bear two points in mind. First, while we have spoken of these people as culture *consumers*, we must remember that much of the culture consumed is free of charge. Most museums, for example, charge no admission. Music and art lessons are available free in many communities,

not only to children but to adults as well. A good many concerts are open to the public at no cost, as are plays, dance recitals and similar events. Second, we must remember what this figure is not. It emphatically does not mean that there are that many 'cultured Americans.' Within this vast pool are some people for whom the arts are, indeed, a way of life. But the overwhelming majority, we may quite safely assume, are only casually interested in one or another of the arts. Still and all, if our rough guess is correct—even give or take several million—it provides a clue to the location of the arts in the geography of American life. It tells us that while cultural activity, broadly conceived, is not something in which a majority of Americans engage, it is nonetheless a part of the lives (albeit, perhaps, a small part) of a very substantial minority.

Simply in terms of mass, therefore, we are justified in speaking of a democratization as having occurred. This many people are no longer a cult. If these figures are at all correct, they mean that anywhere from one out of six to one out of four Americans is involved, in one way or another, with what we might call the culture industry. This is a degree of diffusion that few societies, past or present, can match.

Before we can move on, however, to determine to what degree these masses of people are representative of the total population, we need to know more about them. Fortunately, even with the very limited data available, we can begin to draw certain conclusions. For example, it is safe to say that since the end of World War II there has been a sharp increase in the proportion of men in the culture public. In prewar days father had to be coerced to attend a concert. Yet today a visit to the concert hall, or to a museum or theater, will reveal a more or less even division between men and women. A survey conducted in 1955 by the Minneapolis Symphony Orchestra already showed that 42 per cent of its audience was male. Among readers of *American Artist*, a magazine for amateur painters, 40 per cent are male. And a recent study of the audience of the Tyrone Guthrie Theatre in Minneapolis reflects about the same distribution: 55 per cent female, 45 per cent male. On Broadway, where theatergoing sometimes comes under the heading of business entertainment, the audience is predominantly male. A survey conducted by Thomas Gale Moore of the Carnegie Institute of Technology among the audiences of eight Broadway shows turned up a ratio of 63 per cent men to 37 per cent women. The old Maggie and Jiggs stereotype of the husband who is dragooned to the theater or concert hall by force is anachronistic. An American male is no longer regarded as a 'sissy' if he shows an interest in the arts. What this shift in numbers will mean eventually in terms of the psychological response of audiences, the kind of programming preferred, the tastes for

color, sound, or form, the appreciation or lack of appreciation for such qualities as subtlety—all these remain to be discovered. But it is clear that a striking change has occurred.

This shift toward increased male participation in the culture market has been accompanied, I think, by a drop in the average age of the culture consumer. Here the data is more fragmentary and decidedly impressionistic. But a surprising number of professional administrators in the arts, who have an opportunity to observe the audience firsthand, report being struck by the presence of youth in its midst. Alfred Barr, director of museum collections at the Museum of Modern Art, has remarked that when he was a young man, 'I didn't know any girl at Vassar and only one girl at Smith who would go to a gallery. And it's possible,' he adds wryly, 'that she went only because I wanted to.' Today, he says, 'it's a cheering and amusing experience going through the galleries with my daughter. She sees her friends and is saluted by them. They used to be teen-agers. Now they are in their twenties.'

Barr's personal impression is supported by that of Perry T. Rathbone, director of the Boston Museum of Fine Arts, who says his museum now draws more people in the twenty–forty bracket than it did in years past. In Richmond, Leslie Cheek, director of the Virginia Museum of Fine Arts, calls attention to the increasing number of 'young marrieds' on his membership list. He has suggested that after a young couple settle down and have their first child, they turn to the museum as a relatively inexpensive yet satisfying way to invest their leisure time.

Similarly, Harry Abrams, a leading publisher of art books, in appraising his market, concludes that the largest part of it lies with customers in the 25-to-45 age bracket, a group, he says, that is particularly alert to new trends.

In music, the Minneapolis Symphony Orchestra survey showed that 54 per cent of its attendance was thirty-five years or under, and when a reporter asked managers of a number of Boston-area opera groups to describe their audiences, they, too, emphazised the young set, people thirty and under. They commented about seeing a large number of students on dates. Even more striking is the estimate by Bryan Halliday of Janus Films, a leading distributor of art movies, that as much as 90 per cent of the audience for foreign art films is under forty.

One can hardly be dogmatic about the evidence, but it would seem that young people are more important in the arts audience today than at any time in memory. This should not surprise us. The median age of the American population as a whole is plummeting. It has been estimated that by 1966 fully 50 per cent of the total population of the country was under twenty-five

years of age. This, of course, is an astonishing fact by itself. Yet its implications for art are still to be explored. They will be immense. Ask any actor or musician whether or not he senses a difference when he performs for young people. The answer will be 'yes.' The increasing youthfulness of the culture consumer will affect programming deeply. For one thing, the younger the audience, the more receptive it is likely to be to all forms of innovation and experiment.

In terms of sex and age, therefore, it can be said that the culture public has become more truly representative of the total population than ever before. It is when we begin to examine the economic and educational characteristics of the arts audience that we see just how far the process of democratization has advanced, and how far from complete it is. Before World War II it was still possible to refer to the culture public as an elite audience. In most communities, especially the smaller ones, its core was the wealthy, old-stock, conservative upper stratum of the population. Today the locus has shifted definitely and irretrievably downward. But not all the way. What has happened is the rise of a new class to importance in the arts: the 'comfort class.'

In 1947 only 30 per cent of all American families and unrelated individuals had an income equivalent to $6,000 or more in 1962 dollars. By 1962, a brief fifteen years later, fully 48 per cent were in the $6,000 or more category, and one family in five had an income of more than $10,000 per year. This statistical fact has brought about dramatic changes in the structure of American society. It is not enough for our purposes to refer to the growth of the 'middle class' or to, as David Riesman puts it, the 'middle millions.' For 'middle' implies that part of the group earns more and part earns less than the median income of the nation. But the median income of the nation as late as 1962 was lower than $6,000. Thus the group referred to here was, by definition, above the national income norm. It could be termed the 'upper half' or, more traditionally, 'the upper middle.' Yet both of these terms are unsatisfactory because they focus purely on the economic characteristics of the group. The term 'comfort class' is more apt. It suggests something not merely about the group's economic condition, but about its psychological outlook.

There is a certain income point, different in each community but lying somewhere between $6,000 and $10,0000, beyond which a family need no longer concern itself solely about 'basics.' It becomes, as it were, comfort-oriented. It shifts its attention from quantity to quality. It begins to reach out for the minor luxuries. It begins to care about 'the better things of life'—meaning, very often, nonmaterial things. The comfort class is not the rich-rich. Neither is it the poor or middle-income group. It lies halfway between

middle and rich-rich. It is aggressive. It is moving up the scale. Its horizons are widening every day, both economically and psychologically. It is interested in comfort, in fulfillment, in nicety, not just necessity. The last decade and a half has seen an explosive growth in the number of families in this category, a tremendous spread of the new attitudes of this 'comfort˜class'. And it is from among these that the new culture public is drawn. The rich, of course, are still with us. They still own paintings and go to concerts. But numerically they form a relatively small part of the total audience. The culture consumer is, most often, a member of the comfort class.

What evidence supports this assertion? Let us begin with income. Between October, 1960, and October, 1961, *Playbill*, a publication distributed to Broadway theatergoers, conducted a survey of the audience at 368 different Broadway performances. It concluded that the median family income of those attending the theater was $10,032. During 1961, *Bravo*, a comparable publication that is distributed to the audiences at subscription concerts throughout the country, surveyed concertgoers in eighty-one cities. Median household income turned out to be $10,419.

The only other comprehensive data on the income of the culture consumer comes from readership studies made by magazines whose readers can be assumed to be culture consumers. *Theatre Arts*, for example, claims that its readers have a median income of $15,000. The *Saturday Review*, readers of which may be presumed to be interested in literature and music, claims a reader income figure of $13,090. *Show*, which calls itself 'The Magazine of the Arts,' reports a median of $13,049. For *Dance*, the leading magazine in its field, the figure lies between $9,000 and $10,000. And the readers of *American Artist* run up a median of $9,910.

Let us make appropriate discount for error or inflation; let us agree that these surveys represent soundings taken at different times, different places, under different circumstances, and with differing degrees of skill and scientific responsibility. Granted all this, the degree of concurrence is still remarkable.

In a country in which the national median income lies between $5,000 and $6,000 we find the lowest reported median for one of these cultural audiences to be about $9,000. Making all due allowances for error, we still find that the typical culture consumer is far above the national norm in income. Sociologists and economists tell us that the model of American society is no longer that of a pyramid with a broad base of low-income families, a small middle-income group and a tiny aristocracy but that of a diamond. If so, the culture consumer is clearly a part of that trapezoid that sits just above the center bulge.

Our culture consumer, it will be no surprise to learn, is also far better educated than the man in the street. He may not have completed college, but the odds are roughly four out of five that he has had at least some exposure to higher education or that the head of his household has. The *Bravo* concert-hall study and the Guthrie theater audience study both found that between 80 and 83 per cent of those in their audience had attended college or were members of families headed by a person who had been to college. Only *Playbill*'s Broadway audience differed somewhat. Its survey found that 66 per cent of the total had attended college. Once again, with the exception of the *Playbill* results, we have a remarkable concurrence. Even allowing for the *Playbill* figures, the weight of evidence is overwhelming.

This does not mean that there are not in our country some poorly educated Italian shoemakers who nourish a passion for grand opera or some denim-clad ditch-diggers with an appetite for abstract expressionism. What it does mean is that they form a small part of the total culture public. The culture consumer is, by American standards, a well-educated person. In fact, there is evidence that education is the single most important indicator of a person's cultural status, more important even than income. In short, an educated person without money is more likely to be a culture consumer than a rich person without an education. But these are the extremes. In most cases, education and income go hand in hand.

If we analyze the culture-consuming public by occupation we find further supporting evidence. Thus we discover that families in which the head of the household may be termed a professional or technical employee form a heavily disproportionate part of the culture public. In April, 1962, the U.S. Department of Labor found that, of all employed persons, only 12.8 per cent fell into the category it calls 'professional, technical and kindred workers.' Each of the arts audience studies uses a somewhat different category. But the high proportion of professional-technical people is noticeable throughout. In the Guthrie and Minneapolis Symphony Orchestra studies and in the *Bravo* survey the correlation is within a few percentage points. All three report that between 32 and 35 per cent of their attendance falls into the professional or technical classification.

The most interesting breakdown is provided by the *Bravo* study of concert-hall audiences which not only asked the occupation of the attender but of the head of the household. Thus students and housewives were asked to report the occupation of their family breadwinner. The survey found that 43.6 per cent of the total audience households were headed by professionals. It went on to show in what proportions:

Education
 (Professors, teachers, school administrators) 13.1%
Scientists
 (Engineers, chemists, architects, mathematicians, etc.) 10.8%
Medicine
 (Doctors, dentists, pharmacists, etc.) 7.3%
Lawyers, judges 2.1%
Accountants, auditors 1.9%
All other
 (Including clergymen, artists, librarians, nurses, editors, medical
 technicians, etc.) 8.4%

43.6%

If professionals and their families make up the single largest occupation block in the audience, they are followed by what might loosely be called businessmen or executives and their families. Some studies simply lump the business and professional categories together. Thus the *Playbill* study claims that 57.1 per cent of Broadway theatergoers are in families headed by someone in the business-executive-professional class.

It must be emphasized again that these studies are fragmentary at best and that they are, unfortunately, not directly compatible with one another. In consequence, the figures should not be taken literally. But they appear to indicate the relative orders of magnitude correctly, and they add up to the finding that the culture public is a selective, rather than representative slice of the U.S. population, with the professional-technical component playing a central role.

Ethnically, too, there is evidence that the culture audience is still far from being an accurate mirror of society. For example, although there are no statistical data that even attempt to analyze the racial or religious background of the arts public, conversations with gallery directors, orchestra managers and other arts administrators in many cities lead one to conclude that the culture public contains a higher than proportionate number of Jewish people. Jews, of course, have always been prominent as artists. (Count the number of Jews among the world's finest violinists, for example.) But, except perhaps for New York, where the Jewish population is very large, the Jewish community has probably not been disproportionately represented in the culture audience until recent years. The breakdown of anti-Semitism in society at large, and the general process of cultural democratization that we have been describing, along with the acceleration of assimilation among Jews, are all reflected

now, it would appear, in increasing culture consumption by American Jews.

The extension director of a university in California, in discussing the rising level of cultural activity in Los Angeles, cites the growth of the Jewish population there as a causative agent. A museum director in San Antonio says: 'The vast majority of collectors here are Jewish.' In Dallas the arts attract considerable support from the Jewish community. Detroit has witnessed a very perceptible change in the degree of Jewish involvement in community cultural life since the war. So enthusiastically have American Jews taken to the cultural explosion that some Jewish leaders have begun to complain that this interest in the arts is diverting their money and attention from more traditional pursuits.

Sam Freeman, an official of the National Jewish Welfare Board, has been quoted as saying that 'Jewish (community) activities tend to get overshadowed by the enormous appeal of creative activities in the general community.' And *The Reconstructionist*, a Jewish magazine, complains, perhaps melodramatically, that, 'whereas public concert and lecture halls report "standing room only" at many programs . . . Jewish (community centers), even the newest and most elaborate, are usually shrouded in darkness.'

There is still another discernible characteristic of the culture consumer that is worth noting; his relatively high mobility. The class we have been describing tends, in general, to travel more, to move more often, to progress up and down the social scale more rapidly than most Americans. Many of the young executives, professionals and technicians who with their families form the backbone of the culture public, are in fact modern-day migratory workers transplanted from community to community by their corporate employers. Many of them who come from larger cities suddenly find themselves living in small towns with limited or underdeveloped cultural resources. The newcomers, who not infrequently arrive en masse, promptly enroll in existing arts organizations, generate a good bit of cultural activity, and help form the audience. An excellent illustration of the process is to be found in Winston-Salem, North Carolina, where Western Electric opened a large new installation after World War II. The new plant brought with it a large body of professional, technical and white-collar employees. In 1960 a survey found that 17 per cent of all the names on the mailing lists of the city's primary arts organizations were those of Western Electric employees or their relatives.

If these observations are generally correct, then we may begin to sum up the distinguishing marks of the new culture audience: It is youthful. It is almost evenly divided between the sexes. It is financially comfortable. It

is well educated. It has a high proportion of professional, technical or executive families in it. There is a perceptible degree of Jewish participation in it. And it is relatively mobile.

This summary, by inference, also tells us who is not a part of the culture public. Thus, every survey so far conducted bears out the finding that blue-collar and service workers, for example, form only a minuscule part of the total. Despite the progress of democratization, the fact remains that the mass of American workers and farmers are not participants in the culture boom. The Minneapolis Symphony Orchestra study in 1955 showed that of the audience in attendance the night of the survey, a bare 2 per cent could be classified as workers. Seven years later the Guthrie study in the same city showed only 3.1 per cent in the category that included 'craftsman, foreman, laborer, farmer, etc., plus unemployed.' Clearly this is a generalization. The degree to which workers and their families are part of the audience varies with such factors as the price of admission, the complexity of the material presented, the amount of mass-media advertising or publicity surrounding the attraction, the social traditions of the community, the posture of the particular arts organization or institution toward the public and toward the lower-income groups specifically. It no doubt varies also from one art field to another. Nevertheless, there is little doubt that the worker and his family are badly underrepresented in the total culture public.

Similarly, as might be expected from these results, the number of Negroes in the culture audience is infinitesimal. The question of the racial composition of the culture public is complicated by the continued practice of segregation in a good many theaters, concert halls and other arts facilities. Actors' Equity, the theatrical union, has instructed its members to refuse engagements in segregated theaters. But the policy is by no means airtight, and there are many actors and actresses who do not belong to Equity. In music, when pianist Gary Graffman not long ago refused to perform in a segregated auditorium in Jackson, Mississippi, the German pianist Hans Richter-Haaser stepped forward to fill the engagement, commenting that 'as a foreigner' he saw no connection between music and the race issue. One wonders at a conception of music that excludes any consideration of who the audience is. Nevertheless, the fact remains that even where segregation policies do not bar Negroes, indeed, even where Negroes are actively welcomed, they form only a tiny part of the audience.

In Detroit, where a special effort was made to attract blue-collar workers and Negroes to a series of city-wide arts events, the results were dismal. In Waterloo, Iowa, where the community arts center is municipally supported and is located in the heart of the Negro district, hardly a handful of Negroes

make use of its activities. In some cities, of course, such as Winston-Salem, Negroes have their own amateur theater, art classes and the like. Many Negro colleges run active cultural programs and the appearance of Leontyne Price in a concert hall will attract a sizable Negro turnout. Nevertheless, the evidence is heavy that, percentagewise, the culture boom is still very much a white man's affair.

The culture consumer, as part of the rapidly growing comfort class, shares with others a particular style of life. A man who has made a considerable effort to study this style is a balding, voluble market researcher named Emanual Demby, president of Motivational Programmers, Inc. Demby works for many of the nation's large broadcasters, publishers and manufacturers. In the process he has compiled what he calls a research bank of data about the tastes and idiosyncrasies of precisely that population slice from which the culture public is so largely drawn. Hedging his remarks because of the looseness of the definition of the culture consumer, and because so many of the salient statistics are simply nonexistent, Demby nevertheless begins to fill in the portrait of the culture consumer with what must be regarded as speculative, though provocative, detail.

'If you looked into the home of your culture consumer,' he says, 'you would almost certainly find in it some kind of equipment for reproducing music—a record player or tape recorder. Between 70 and 95 per cent of your families would own them. Owning a phonograph or tape recorder obviously doesn't make a person a culture consumer. But almost all culture consumers own them. Far more of them proportionally than the public at large.' In contrast, Demby says, they probably own fewer television sets per hundred families than the general public.

Several years ago the Opinion Research Corp. of Princeton, New Jersey, made a provocative study of what it called *America's Tastemakers*. Its interest was not in aesthetic taste, but in the degree of acceptance of new products. In short, it wanted to know which individuals were most likely to be the first ones on their block to adopt a new consumer item, thus setting a pattern for their neighbors. It came to the conclusion that a high degree of mobility, as measured on seven different scales (in terms of geography, education, economics, social relations, kinship relations, occupation and intellect), coincided with a receptivity to new ideas or products. Demby uses somewhat different terms, but he agrees with the general drift of the tastemaker theory, and says, 'the culture consumer is likely to have a great many convenience appliances in his home long before, even years before, their use becomes general. You will find electric can openers, automatic slide projectors, electric dishwashers and garbage disposals far more often

in the home of the culture consumer than you will outside of this group.' This same willingness to take a chance can be observed in a higher readiness to use air travel. Of course, there is an important economic factor at work. Air travel is expensive. But, according to Demby, the families in the culture-consumer category are twice as likely to fly to their vacation site as the run-of-the-mill American family. They differ radically from the public, too, in what they would consider an ideal vacation. Most Americans, given their preference, would go to Hawaii for a holiday, Demby believes. The culture consumer, in contrast, lists Europe as his number-one choice.

Mobility suggests what might be called 'automobility.' Culture consumers, Demby is persuaded, buy more new cars than used cars, whereas the reverse is true of the public in general. And one out of five autos parked in the carports or garages of culture consumer families is likely to be of foreign make. They use these cars to get to their summer homes very often, because, if Demby is accurate, as many as one out of every four families in this group owns a second home. More than half also own at least a small portfolio of stocks, bonds, or mutual-fund shares.

In purchasing major household appliances, the culture consumer tends to buy the same name-brand items as most other Americans—G.E., Kenmore (Sears), Westinghouse, etc.—Demby asserts. But when it comes to food and drink he is likely to lean toward premium brands. Thus, Demby says, 'Canadian Club is probably his favorite blended whiskey; Smirnoff his vodka; and Old Grand-dad and Jack Daniels his choice among bourbons. His scotches are probably Cutty Sark and Ballantines.' Nor should it be assumed that the culture consumer is abstemious. Gallup has found that professionals, executives and white-collar groups, as a class, are relatively big drinkers. Culture consumers, as a class, also are, according to Demby. This goes for beer as well as distilled spirits. Those who still conceive of beer as a plebeian beverage may be surprised to learn that, at least according to Demby, beer is likely to be found in the refrigerators of more than half of all culture-consuming families. Their favorite brand, he says, is Budweiser.

Another characteristic of this group is its exposure to communications. The culture consumer, Demby says with some certainty, spends the better part of an hour with his daily newspaper, and a slightly longer time each day with a magazine. He listens to the radio, perhaps with only half an ear, for about an hour and a quarter. But if he owns an FM tuner the period spent listening to radio rises sharply. He may play his FM set for an hour and a half in the evening alone, plus another hour and a quarter divided between morning and afternoon. He is, through one medium or another, more

'tuned in' to the world around him than his non-culture-consuming counterpart.

Being 'tuned in' implies more than just passive receptivity. It implies active interaction with the world around them. This would appear to be a characteristic of the culture public—and especially of its hard core. Thus we may assume that readers of *Harper's* and *Atlantic* are, in general, also members of the arts audience. This finding is supported not merely by their choice of magazines both of which devote a considerable part of their editorial content to 'cultural' matters, but also by other known data about them, such as their high proclivity to purchase classical records, FM tuners, and other indicative goods. In 1962 these two magazines tried to find out, not how their readers differed from the general public—this they already knew; the pattern was clear, as described above: median income over $10,000; extremely high percentage of college graduates; and so forth—but to determine how their readers differed from other people in roughly similar economic circumstances. Thus they sent questionnaires to a selected group of readers and to their next-door neighbors. Would there be any pattern to differentiate readers of *Harper's* and *Atlantic* from their next-door neighbors? A number of distinguishing characteristics were uncovered. But one of the most interesting had to do precisely with the issue of 'activism.' The popular image of the reader or culture lover pictures a sedentary, home-centered person. Quite the opposite tended to be true. The readers of these two magazines, it turned out, were far more active in community, business and cultural affairs than their next-door neighbors were.

The pattern was consistent. Whether it was a country club or golf club, a Red Cross organization or YMCA, a business or professional organization, a lodge or service club, a political party or a cultural committee like a symphony association or an art-gallery group, the *Harper's-Atlantic* readers showed a higher percentage of memberships than their next-door neighbors. The only category in which the next-door neighbors were more active was 'Church or Religious Organizations' and here the difference was less than one percentage point.

Being more active, these people also tended toward community leadership. A higher percentage of those in the *Harper's-Atlantic* group were officers and directors of the above organizations than were their neighbors. This was true in every single category of organization but one: 'Country or Golf Club.'

They were active recreationally, too. Almost 30 per cent reported playing golf; a like number played tennis; a similar proportion participated in boating; and 18 per cent skied. In all these sports the *Harper's-Atlantic*

group outnumbered their neighbors. Only in hunting and bowling did the neighbors show a higher percentage of participation. The same pattern was repeated in the field of hobbies. Only in woodwork, outdoor cooking and photography did the neighbors show higher participation. There was a clear and consistent pattern, too, in civic participation. The subscriber group wrote more letters to elected officials and newspaper editors; they addressed more public meetings; they worked more in election campaigns.

It would be too facile, of course, to project these findings over the whole culture-consuming public. Although the magazine subscriber group showed more direct participation in cultural activities, the neighbor group also included culture consumers within it. But it may not be outlandish to assume that culture consumption and activism in general go hand in hand.

It is clear from the foregoing that the culture consumer is a new breed. He is a man in mid-passage. He is not part of the old, settled aristocracy, certain of its place in the world and confirmed in its interests, its judgments and its tastes (often quite bad, although we tend to remember only its examples of good taste). Nor is he part of the shrinking world of the blue-collar worker or the farmer. Yet neither is he the sadly limited, provincial middle-class man of the past. He is, for one thing, too educated. He is also too traveled. When it is not uprooting him and his family and moving it cross-country, his company is forever dispatching him to a convention in New York, a technical meeting in Boston, or a government hearing in Washington—even, if he is lucky, to a session with the branch manager in Brussels or Zurich or Rome. His wife has probably attended college and may well be taking adult-education courses in international relations or poetry or ceramics. In any event, she is no longer homebound. She has an automobile available to her and time for activities outside the house. She may well, for that matter, have a job, not from economic necessity but in many cases from choice. If not, she is probably active in one or more community or arts organizations. She has some ties with the outside world. Her husband is no longer Mr. Babbitt. And she is not Mrs. Babbitt.

This is not to romanticize the new comfort class or the culture-consuming sector of it. The culture consumers have their decided limitations. But it is altogether too easy to make fun of the ballet lessons they give their daughters or their efforts with easel or brush. Amateurs have always been an easy mark for the satirist, as have the *nouveaux riches*. It is also easy to shrug off their interest as mere status-climbing. It is much harder to analyze the true complexity of their motives. The rise of a mass public for the arts can, in its way, be compared with the rise of mass literacy in the eighteenth century in England. It must have amused the nobility to find their social

inferiors struggling with their ABC's. Yet mass literacy has been one of the really fundamental advances achieved by mankind in its long and gory history. The rise of interest in the arts by a mass public in the United States could, despite all the humor it provides to the caricaturist and the critical establishment, despite all the tinsel and tomfoolery it entails, herald something quite important in the social development of modern man.

BERNARD ROSENBERG AND
NORRIS FLIEGEL

The Artist and His Publics:
*The Ambiguity of Success**

CONFRONTING THE 'PUBLIC'

THE MATERIAL REWARDS of success eliminate certain practical hardships
but become added burdens in themselves because of the ambivalence
they arouse in the artist. The 'Public,' which is responsible for this success
or lack of it, in turn becomes the object of similarly mixed feelings. As we
have repeatedly noted, real artists are unanimous in declaring that they
paint out of inner necessity and not in response to external influences; but
they are also agreed that their painting, while not 'therapy or a hobby or a
commodity,' is at the same time intended for a wider purpose than simple
self-expression. They differ a bit in their definition of this purpose: whether,
for example, it is to reflect the times (which few believe), to anticipate the
future, or to disturb people's complacency, but there is a confluence of
opinion that 'paintings are painted to be seen.' Therefore, an audience or a
'public' is a necessity:

> If it's not being lived with, what's the point? In short, I guess artists want
> very much to be involved in other people. Painting is a calling, but I think
> there's a question of comradeship. You have found something, discovered
> something, and you want to say 'Hey—look at this' to people. They will
> share it with you. It's not simply someone superior who's conveying words.
> Naturally I like my paintings to be bought where as many people as

* Reprinted by permission of Quadrangle Books from *The Vanguard Artist: Portrait
and Self-Portrait*, by Bernard Rosenberg and Norris Fliegel, pp. 191–214. Copyright
1965 by Bernard Rosenberg and Norris Fliegel.

possible can see them. I think I even resent it a little bit when I have a painting that I like and somebody buys it and I have to think, 'Oh my God –is that painting going to be closed up in that place?' I think that the painter likes to feel that a painting, once it leaves his place, will get a chance to be seen.

I think that there is at least one truth about artistic life and that is that you do it in order for it to be seen. I mean, what is it all about if it isn't that? If it got stuck in vaults then I would be very disturbed, and so out of a bad reason, something marvelous might come. I could be bugged by the idea that there are ten paintings now that no one will ever see. I might think to myself, 'I've got to work twice as hard now.' It does matter to me; otherwise I would be inhuman. I have my ego, my life, and so does everyone else. But it doesn't matter to me in an extreme way inasmuch as I do these things because I have to do them. I am always surprised if somebody buys my pictures, even today. It's not pleasant what happens to some of them. Because I don't believe that pictures and music and poems—poems have to be read, books have to be read, pictures have to be seen—they're not things for storage. I guess I like to hang in good company and be looked at.

We should say, somewhat parenthetically, that this so-called public, or audience, while often referred to collectively, is not viewed as an undifferentiated whole. What Virgil Thomson describes for music obtains equally for art:

It is a false image of the truth, nevertheless, to group all the people who like listening to music into a composite character, a hydra-headed monster known as The Public. The Public doesn't exist save as a statistical concept.

But while *The Public* may not exist, *publics* do, and our artists view each with strangely differing feelings:

I think that there is nothing to do but recognize that there are very many publics. There is just no such thing as The Public. I think there never was, and I think that now, since there has been an enormous increase in population and an enormous increase in education, it is impossible to speak of a public. There is no such thing as there being a closed and absolute audience.

FRIENDS

It seems to us that painters and sculptors deal with four more or less distinct

publics that may be arbitrarily designated as: Friends, Buyers and Collectors, Viewers and Critics. Multiple-group membership accounts for some overlap among these four, but the artist still has a range of specific feelings about each category. Of these, Friends constitute the only segment more or less free of conflict. Artists wistfully but unequivocally agree that this would be their ideal audience—a body which with few exceptions would include mainly other artists. Such a group would be small, compact, responsive and emphatic with the artist's outlook and strivings. It would receive his work critically, but its responses would stem from a common orientation which excludes those personalized and extraneous considerations that color the comments and judgments of so many others. Artists are dismayed when 'The Public' at large willingly seizes upon everything and anything as 'art'; they are equally disturbed when serious work is rejected out of hand and without a hearing. The ideal audience of fellow-artist-friends would eliminate this situation. It would criticize with sympathy and understanding and provide stimulation for further growth, without encroaching upon the relationship of the artist to his work. However, no artist deludes himself with the possibility that such a group will become his effective audience. There are too many practical considerations involved:

I know damn well I have no control over who buys and so I just take it in silence. I'm aware at all times that while I get in touch with my public through my paintings, they've got nothing to do with me and I've got nothing to do with them. In order to make a living from your work, you can't sell your paintings to your friends or people who really seem to go for your work, because they know your work and you; people who are in sympathy with your way of life and who thus want to have your paintings. Like it is something that they can stand on—this is their symbol of the world. How many people do you have like that—that are intensely involved in a painting? And yet the artist would like this thing to be viewed as such.

Well of course it matters who gets my paintings. It matters very much. If I lowered my—if I was completely, if I was desirous of selling my paintings regardless and no matter, I could sell them all. But it matters very much to me who buys them. Very much, oh, very much. I think that it's of great significance when the buyer can have some pleasure, because that gives me pleasure. I would put it this way: since you are always putting this in a personal way, I don't think you can see my work without being disturbed by it in one way or another, and yet if you don't see it, it's another matter.

Of course it matters who buys it. I like people I like to buy my paintings. You are gratified if in rare instances there is someone who really loves the work and wants it for himself. But this, of course, will always be extremely rare. How many real friends does any artist have?

BUYERS AND COLLECTORS

To get their work before a sizable audience, artists feel they are forced into alien procedures; they must also accept the fact that much of their work will be acquired by aesthetically unappreciative buyers. They are elated when things go otherwise, but there is rarely any expectation that they will. Few can hold out for the 'perfect buyer.' The size of the purchasing audience often makes it difficult for the painter to know who his 'customer' is, let alone appraise what motivates him to buy. The pervasive feeling is that the patron of yesteryear and the collector of yesterday have been replaced by a new and difficult-to-define breed of art consumers—a group whose motivations are at best suspect. Painters seem to accommodate themselves to these realities without excessive rancor. Understandably, they deplore the fact that the buying group, which can in practical terms make them or break them as artists, is often guided by extraneous considerations. Yet only occasionally is a voice raised in unrestrained condemnation:

Well, personally, I think all those collectors are practically morons anyway. They have very low taste. People tell most of them what to do. Once in a while you get a collector who is foolish enough to buy something out of his own motivations, but they usually give that up after a while. They always fall back on 'expert' guidance and advice from other people. It helps them to ride on in comfort and not worry whether or not the guy is an artist. Maybe they like the decorative qualities of the painting. I don't know.

This man is expressing his personal frustrations, but they do not stem from material failure; like so many of his colleagues, he also has been a beneficiary of today's art boom.

Other respondents are more temperate in their reactions, although they leave little doubt as to their mixed feelings. Artists are not inclined to dramatize this dilemma, which turns on having the fate of their work, whose purpose is partly communicative in nature, determined by factors unrelated to its intended meaning or any other genuinely aesthetic consideration.

John Canaday, often an outspoken foe of modern art, describes the situation facing today's painter:

People now hang paintings on their wall with the idea that somehow something called culture will be exuded for absorption much in the way that they install an efficient humidifier in order to impregnate the air with beneficial moisture for breathing.

This concept of art by which the purchase of a picture becomes instant education is not entirely new. Pictures on the walls and books on the shelves, whether or not the pictures were seen or the books ever opened, supplied 'a cultured atmosphere' for our grandmothers' houses. The trouble today is that mass communication, mass color reproductions, mass museum programs, and mass cultural attacks in general when they propagandize for art will be most successful when the product being sold is flashiest. It is much easier to make a bad painting sound good than it is to explain why a good painting is good. When this misfortune is compounded by the misconception, peculiar to our century, that only the novel and 'original' painting is worthwhile, we finally reach the idea of the standard novelty—the mass product that people think of as something not mass-produced but special, the pseudo-esoteric item for general prestige consumption.[1]

With all of this, the contemporary artist successfully resists withdrawal into self-pity. He responds to, and focuses on, those few channels of genuine communication which remain open. Despite his contempt for most buyers and his frustration with prevailing conditions, he makes generally reasonable —and reasoned—observations. Each painter accommodates himself in his own nonulcer-producing way. He accepts the situation, knowing that to attempt to combat it head-on would be futile as well as debilitating. In making his modicum of peace with things as they are, the artist resolves much of his conflict; he relegates selling and exhibiting to a secondary position among his functions as an artist, and then passes them on to others. These maneuvers help him maintain objectivity in viewing himself:

It's mixed. I like selling a picture and it does make a difference. It would matter if somebody put them in a vault to wait for them to get more valuable. But really, the sale shouldn't matter. It's the painting of it and the idea you have at the time which is more valuable than the painting. After all, the painting is never exactly what it was meant to be anyway. It always turns out different in the execution. It's never what you've been really thinking.

It doesn't put you under special pressure when you have a limited audience. You don't paint before your audience and you don't paint for your public or your friends. You paint for yourself and this is the most

important factor. The rest completes it. What happens to the painting after it leaves you? Anything can happen to it.

Existing conditions force the contemporary artist to cultivate this attitude of apparent detachment from the subsequent fate of his work. Being essentially without a choice in these matters, he cannot allow himself to 'care' too much. Yet artists are too close to their feelings to maintain such distance consistently, without at least an occasional break. They may assert that it all matters very little, but the feeling often comes through that given a situation where meaningful choices could be found, they would indeed care a great deal:

It's immaterial to me who buys it. Naturally, if I had the choice I would have preferences, but it's not a serious matter because in most cases I don't know who buys them. It's just some anonymous person. I find out the name from my dealer, but this doesn't mean anything to me, that is, unless it's some person who is publicly known—maybe a big collector or some such person. I then have an idea of who the person is, but that's all. I usually don't know.

I think the old patron was lost around the eighteenth century, and after that you had no more patrons—just irresponsible purchasers of paintings. That is, if someone buys a painting, he is not a patron—he's just a customer. I've sold hundreds of paintings and I don't know where they are or who has them. They've disappeared. There are so many customers that you can't keep track or control of them.

Sure I have some interest in who buys it and where it ends up, but for purely pedestrian reasons. Once the thing is made up and I've settled in my mind what I think about it or what it's worth as a thing, then it's not too important. It goes out of the studio and I'm fairly indifferent. Of course I'm still interested though.

The important thing is that if a man buys your painting, it means he's putting up $500 or $1,000 or whatever it is; he's putting this up and this is a token of his faith. If he doesn't understand the painting and he puts up so much money, well, that's his tough luck—it's just too bad for him. I think there's a very real sort of relationship—even though I don't know the guy. He's anonymous but he's real. I can't see the situation as intolerable. I always thought it was awful and terrible, but I always thought it was tolerable.

I'm obviously on the side of the person who has some feeling for my work. I think for a composer's music to be locked up in a safe wouldn't be helping much, that is, if you believe a composer is good for mankind.

The same holds for the artist. When your paintings get into the wrong hands, then it's curtains down. But you can't let it get you.

Others are even less successful in detaching themselves from this aspect of their situation. They reveal more clearly the human suffering involved and how deeply they experience the consequences of the mass 'acceptance' which is their lot:

> I would like to feel that the people who are buying it would have concern for it or really feel for it, but I won't refuse to sell to people I don't particularly respect. There is conflict, however. You're really giving part of yourself away, and after they've gone you sort of have a lost feeling. But I guess I'd rather sell than keep it.
>
> I want to sell and I do, but it does matter who buys. If I feel that a man buys because he loves the work, it means something to me. On the other hand, if somebody goes out and pays his money and buys the work, that's it. I've been accused of trying to control the situation for my work, but I've never really tried to control it. What I've always wanted was some pleasure in the act of the sale, some human satisfaction—not just material satisfaction.
>
> Look. We don't paint masterpieces every day. It may take twenty pictures to arrive at one good picture. The other twenty pictures may be good, but they aren't it. We know the difference. I may have worked ten years to evolve the one picture that is 'it.' I feel a protective influence that I must exert on that picture. And I don't feel I'm robbing anyone by selling him the second best. I think it's good, but in a different sense than the particular one which contributes to helping your image survive. We have children. These are children, if you want, and there are certain children I want to protect. It seems to be a perfectly normal thing and I want the buyer to like the picture first of all.

Some painters heal this breach by selectively withholding certain deeply prized works from public sale. Others make gifts of their important works. Most refuse to make block sales. Beyond this, however, it is difficult to manage or dictate sales, or to control the fate of a painting after the commercial transaction has been completed.

> Now that I'm older I am concerned about where my paintings go. Certain pictures I prefer certain strata of collectors to have. I'm involved just enough with posterity that I want to know where my better pictures are going. Just for the sake of selling, I wouldn't really sell. I've refused to sell pictures, for example, in blocks, because I knew that they would go into a warehouse. I don't care particularly if a buyer gets my message. If

he doesn't get it now, he'll get it ten years from now, that is, if he has contact with it. My concern is the very cold fact that if he doesn't get the message, will he give the picture to a museum or will he stick it in a warehouse? That's the practical concern.

I'm pleased if somebody I think has a real eye and a good collection buys a picture of mine for the right reasons, but generally I don't care. There are certain pictures that I won't give up because they are key pictures. There aren't too many of those, however. It would disturb me quite a bit if all my pictures went into a vault for investment. But regardless, most of them are likely to be seen some of the time at least.

Sure it matters. For example, at a recent exhibition someone told me, 'Hey, I just sold three paintings.' And I thought 'Fine.' It was fine for him. A few days later I heard that one collector had bought them—a man who was evidently going everywhere and buying up things sight unseen—and was putting them in storage vaults. He was buying them practically unseen, although he did it on the word of his scouts. These things aren't bought blindfolded; somebody looks at them and he makes the judgment. The point is that my reaction to that kind of buying is very negative, and I think that others probably think the way I do. I just wouldn't sell that way. If the Museum of Modern Art had bought them then it would have been different.

Given these negative reactions, it is surprising when even an isolated respondent values the collector, and what prompts his positive remarks is not readily apparent, since he is situated so similarly to all others. Such views are far out of step with those of close colleagues.

I'm amazed at the number of buyers who seem to be so deeply involved in the feelings of what I'm doing. To become so involved and so responsive—it's somewhat new for me and so different from the forties.

I think that to some people maybe it is chic, but I think that with the people who are really involved—young collectors, for example—this is a passion. It's changed their lives. I've seen the people who have bought paintings and it's a different kind of collector. It used to be that Rockefeller or Barr at the Museum said, 'We ought to have one of those guys in there,' and so they'd buy something. In recent years a generation of self-made men, who have made a little money, have responded to works, have bought the works, and it's changed their lives. It's a different attitude toward the work than that of the original inherited-money collector who was involved in a do-good relationship and bought the painting to uplift. Today's collector is engaged in self-uplift; he can't live without it.

The only other positive note is struck by artists intimately associated with a specific collector. Their sweeping denunciations of collectors as a breed have already been recorded, but we must remind the reader that they are willing to impute creditable motives to individuals.

I sold a lot of paintings to A. R.; I sold about seventy paintings to him. But first of all, he knew me for years before he bought most of them. He bought a few things at first, and he hung them around his house. Some he donated to museums and other places. Some he saved and put away someplace. He buys a lot of other people's work, too. But with him, it isn't a blanket kind of approval. He thinks about those things before he does it.

I remember when D. F. K. bought a picture of X's for $8,000. Well, that really changed the whole scene. X was alive and painting and people were collecting him, but the painting could've been gotten for less. He really wanted to pay $8,000 for the painting to make the mark and he did it. I don't mean he wanted to pay $8,000 to make himself look grand. He wanted to give that picture that much importance.

Even the following broad group assessment (by a non-Jewish artist) must stand as highly personalized unless it can be supported by data not available to us:

The rich Anglo-Saxons aren't interested in buying paintings—at least not very much. They have to have a foundation. With the Jews it's a personal thing. That's been my experience—they take more of a personal interest in things—which is very good for everybody's morale. There's this guy who collects paintings and so does his wife. Suddenly the son comes down and is buying paintings. He's a friend of the artist and he thinks they're pretty terrific. It's a traditional thing with them. The more Anglo-Saxon types like B. Z.—well, it's pretty abstract for them. They do it like a good deed. You have to have a foundation, you have to have a big museum, and it all has to mean something for society. It isn't just like they liked the paintings. It's like they're obligated somehow to buy those paintings— like because they're the leaders of the country. My paintings sell mostly to people of Jewish stock. I know that's a fact.

Most typically then, the collector's relationship to art is regarded as shallow, as being no more than another example of conspicuous consumption or of crass financial speculation. He is considered an accumulator who lacks artistically acceptable motives:

Some guy came in the other day. First he went around and looked at the

other artists and followed them around. He demolished them one after the other. And then he came back and looked at my things. Since I was there personally he was a little more restrained. He was a buyer who handles large lots of paintings. He said that he couldn't like my things because I would have to have at least thirty similar things—they'd have to be done; he also told me I shouldn't be so insecure. Then later I realized the only reason the fellow came in was because he had money.

I think it's really everybody wanting in on culture. You see, there's more leisure time, there's more money, and there's more ennui; it seems as if suddenly you want to buy a picture rather than a Cadillac. Museums are filled with their daughters, who are given some kind of a life by doing Junior Council stuff.

I think that the consumption of art in America—and I use the word consumption advisedly—is not much different from the consumption of automobiles, refrigerators, jet planes to Europe, and so on. We are living in an affluent society—a society in which culture with a capital C, and in quotes, has become a symbol for those who can afford it. I think that the reasons most people buy art, are willing to pay high prices for it, is that they can afford to part with the money without straining. And the fact is that when the stock market dropped some time ago, sales dropped off. Most people only buy art as a luxury, not as a necessity.

Institutions buy art for what is known as prestige advertising—public relations. They have so much money it is difficult for them to put it into so-called direct advertising. They have to put it into something which then gives their product an aura of public works. I think this is the main motivating factor. Of course, there are other contributing factors; their wives come from Wellesley or Radcliffe, or they themselves have gone to Harvard or Yale. They've taken some superficial cultural-survey courses which give them the feeling that if they buy art they are also developing their cultural sensibilities. But they won't do without a mink coat or a car or all the things they consider necessities. They won't buy a second-hand car in order to buy art. You can't call this stuff cultural activity.

VIEWERS

Painter attitudes toward the third group, that is, the mass Viewing Audience, compared to those experienced vis-à-vis the collector, extend over a much wider spectrum. This becomes especially obvious when we study positive reactions. Some of our artists feel that while the viewing public has no real devotion to art, the level of its taste and appreciation is slowly rising. The

gallery- and museum-going boom, in conjunction with university and adult education, is regarded—but with many reservations—by a number of our respondents to be of at least some didactic value.

Well, I think that there's a fantastic interest. I mean if you just step up some Saturday to some of those galleries, there are some numbers of people that pour out of those galleries. It's phenomenal. There must be some kind of awareness of painting and all that. Yet I don't think that it's all so good. The people are interested in art and the artist is obliging them by coming down to meet them. There's nothing wrong with it. Sooner or later somebody's going to benefit from all of this. If you go around to the shows, if you like painting and all that—pretty soon you discover you don't like this one anymore, you liked that one in the past—you like this guy better—this person is not so good anymore, and pretty soon your level becomes . . . once you get the idea, you begin to have a higher and higher level of appreciation. You grow up to these things.

I guess I have contempt for the general public, but as I get older, I have less and less contempt, or rather, I will shut up more now instead of wasting my energy trying to convert what can't be changed. Taste may be better, but the general public does not have a heightened feeling. They are just better educated and so they know better what to look for. I mean, you probably get more about modern art at Radcliffe than you did fifty years ago, but I doubt if the passions of these girls or women are any deeper or heightened. The people have better taste, but no greater appreciation. I think that there are a greater number of people that are showing an interest in art, but not for the right reasons. There is just too much art. There's too much of everything. They cannot choose safely, as they are too insecure to feel safe in their choices. So they lean on the choices of the museums, or on the taste of a prominent critic, or the taste of a prominent collector, for instance, and this is a denial of vision and their own sensibility.

I have no real feelings about the public. I think it's wonderful that the attendance in museums and galleries is as high as it is. I think that it's wonderful that the public is as free to express itself about a painting as it is. Now I say this because there was a time when this was not so. It wasn't within one's particular range to assume that he knew about these things. He had a completely different attitude. You can walk up to a stranger today on 42nd Street and ask a stranger what he thinks of modern painting, and boy, he will tell you, and he's never even thought of it.

I think what I have noticed is an awareness in the public taste at any rate. I mean they mostly don't like what is going on, but they know what

is going on. This is also different than it was, whether I like it or not.

I think that the creative impulse is never going to be close to public understanding or insight at the given moment. I think there's a great gap there between what needs to be mined and what can be understood after. And there's always going to be a great gap between the conscience of the artist and his public appearance, his ideas, performance and the attitude he wants to present. The public isn't going to understand that so quickly. On the other hand, the public isn't so dumb or isn't as dumb as all that. They catch on pretty quick and they know what's good pretty much right away. But there is this gap between visual understanding and verbal understanding, and this is a major problem for the visual artist.

Notwithstanding this mild optimism, negative reactions still far outnumber the positive, and our respondents make any number of blunt damning statements as they discuss the Viewer:

Among ourselves we might say—no, I withdraw that. I would say that I publicly avow that the public is stupid. I make no bones about it.

The modern art audience is really a spineless and recumbent mass of people.

Most people don't understand what they're looking at, they don't understand what they are talking about, and they don't understand what they think they're interested in.

There's a falseness in this picturization of artists. First they're considered disingenuous and finally they are seen as very sophisticated. By that time you have a flock of people who also wish to enjoy this sophistication. But it's hard. It is still the stupid audience.

When I hear certain people talk about this abstract this or that, it's like they are talking about mink coats or something. There may be some acceptance deep down, but I still think they feel the same way now as they used to—they still think, 'My three-year-old could do it.'

When a man looks at a painting and says, 'My child can do it,' he is saying that the child is inferior to him; there's no question but that he can do it. That's the appreciation, if you like; he enjoys the idea that he can do it, too.

And even for those people who can't afford to buy it, the simple interest in having names of artists and styles on one's finger tips can become a social asset. I don't think it has anything to do with basic culture.

To be quite sincere, I am slightly contemptuous of the public. I think in a way an artist should produce for a smaller unit of people he respects.

But to be accepted by large audiences is fame and so that is something everybody wants, too.

I don't think it is valuable for people to think they are appreciating art when they are bored and think they are doing something good for their souls. I think they are sort of brainwashed into thinking they should like it and so they like it. I think that I prefer people to really enjoy themselves. I don't know. Maybe they do enjoy themselves. I don't know. I don't want to sound too snobbish about it, but I don't know what they really get out of it.

I think people are accepting a great deal more now because they're under enormous propaganda pressure and they are brainwashed.

If you follow history, you will find that the situation was always the same, except that this kind of audience is more blatant. It's more naked in its attitudes. I don't think that basically things were that much different when the Church and the nobility were the patrons. It's just that the diffuse public is primarily middle class, and to me, there's nothing more horrible than the middle class. That's the only change, really. The middle class is now in charge. That gives a pretty clear picture of my attitude, doesn't it?

Yet for all the severity of their comments, artists still convey an air of detached amusement or bemusement as they discuss the vices of the non-buyer. At odd moments an individual might decry the absence of a truly appreciative viewing audience:

Artists need more than just an audience; otherwise we'd be pleased with the hordes of viewers and buyers that confront us today. I think that the painter does suffer more than people in other fields. He has a much less literate audience. He doesn't have a painter's audience.

But most of this man's colleagues are more dispassionate. They do not take the viewing audience too seriously and consequently are less disappointed by it. They observe the teeming crowds at galleries and museums with a mixture of contempt and tolerance; they express disapproval and cling quixotically to a bit of hope for the future. Even the most disdainful artist does not treat the viewer with the total severity with which he unsparingly treats the collector.

This is because most artists feel relatively remote and distant from anonymous viewers. They may group the viewer with the collector while assessing the motivations behind their art 'interest':

They are docile conformists who can't resist the blandishments and

pressures of today's push toward attaining social standing by demonstrating an active interest in things cultural.

Beyond that, however, they make fewer demands on the viewer. They feel that meaningful art appreciation can not be achieved by a mass audience, so there is no reason to expect a properly responsive reaction from it. More importantly, however, artists see the actions of this mass audience as having little direct effect on their lives or the fate of their work.

This is the nub of the artist's quarrel with the collector. He may treat viewers with any number of feelings as he observes them 'playing at being interested in art.' But theirs is felt to be a world of fantasy, and when necessary their pretensions to knowledgeability can be exposed. For buyers the case is different. They make decisions about artists by dealing with their work in a direct, controlling and judgmental manner. They operate under the guise of connoisseurship; it implies a higher claim to appreciation and understanding. This causes the artist to demand a higher level of involvement with art from the collector, who, however, is seen as a man entangled with matters extraneous to the work. Therefore, while both the collector and the viewer are harshly criticized, the viewer's incapacity is judged as considerably less reprehensible than the collector's. The collector's actions impinge directly on the artist, confronting him with frustration, disappointment, or despair. An artist's contact with buyers may be minimal, but the latter's actions have tangible consequences for him and his work, especially where strong buyer demand develops for particular styles which the artist may be outgrowing, or where particular styles find little acceptance:

If you don't develop as a human being, you cannot improve your art. If your art stays the same, I don't believe you are a real artist. It must move. It must go. It must change. If it doesn't change, you are dead. If the market demands that you stay the same, or if you produce ten paintings for a certain client who wants the same thing, you are already denying your organic life as an artist, and this is the primary thing, to keep that organic life going.

Once a signature is recognized as the signature, they want more of the same. Experiments are not allowed at that time. A collector would be shocked if suddenly he couldn't recognize the handwriting anymore. He's invested thousands and thousands in that signature. But I've refused to sell at those times, and I needed the money, too—very badly. But I've refused to sell under those conditions because I think it is bad, and I think it works out badly for the artist in the long run.

CRITICS

The artist's relationship to his fourth public, the Critics, is even more complex and overshadows all others, both in its intensity and probable importance. Artists are involved in a serious tug-of-war with critics—a hip-and-thigh struggle which reflects the desire of each to be the ultimate arbiter of 'good art.' The artist may be tempted to shrug them off: 'The art world doesn't extend beyond other artists. There is no real place in it for the critic.' 'I do not think that the average artist—the kind I respect—respects the average critic. So therefore what the average critic has to say isn't going to affect the work of the artist.' Quiet reflection quickly modifies such reactions. The final, sober consensus is that critics are a weighty factor in the art world, that their responses are more influential in determining art futures than those of all other groups combined. This is an agreed-upon fact of artistic life, no matter how the individual artist delineates it. Whatever aspect of the art world comes up for consideration, the influence of the critic can be felt.

Artists note that a power hierarchy exists among critics, but there is no general agreement as to the relative position each holds. The art writers and reviewers of *Art News, Life, The New Yorker, The New York Times,* and *Time* are among those to whom positions of prime importance are most frequently assigned. Additionally, there are certain affiliated and unaffiliated individuals, such as Alfred Barr, John Canaday, Clement Greenberg, Thomas Hess, Harold Rosenberg and Meyer Schapiro. Each publication and each critic is viewed in a highly personalized manner, with no perfectly consistent pattern emerging (although *The New York Times* draws more than its share of brickbats). As a group, however, critics are resented because of their excessive 'tastemaking' powers. This is not simply a matter of economics, although artists generally recognize that the critic can and does influence art sales:

Each critic has got a lot of collectors in his grasp, and if he sounds the word, if he says somebody is good, really good—well, he certainly wouldn't have to worry financially for the next year.

Now he rhapsodizes over them. He hangs them in his dining room. Ten years ago he wouldn't even look at them. But that taste isn't his. There are exceptions, but if in all New York you can show me a half-dozen collectors who are really involved with painting and not following the choices of a few critics, well . . . they're cowed and intimidated and this isn't so hot.

I've been told the *New Yorker* reviews have a very important influence

on actual sales. As a matter of fact, one very important dealer has told me that the *New Yorker* is the most important force in influencing sales. The *New York Times* may be the most important in influencing opinion. But probably Alfred Barr is about it. If he buys, if he is enthusiastic about any young artist, then immediately other museums begin to follow, and you get on the museum circuit.

I personally think the patronage in this country is pretty bad. I think they make all the wrong choices. They are over-anxious to be led by their noses. They are not able to make up their own minds. They have taste-makers and opinion-makers. Like I read in the *Times* that Canaday said some good things about a gallery, and then the next Sunday he said that Monday the artist had gone to the gallery to pick up his mail and the gallery was closed, but people were already waiting outside, already wanting to go in and see the show. The show was sold out. Canaday had already prepared these people, in a sense.

Even more disturbing to the artist is the critic's ability to structure his public image: 'Certain critics, whether right or wrong in their judgment, are able to capture the hearts of people by fixing certain images into neat phrases. They transform the public mind and give it the channel in which to think.' Artists see this 'brainwashing' power as overwhelming, and even those who view critics with moderation are troubled by it:

I have no specific argument against the critics. It's just that they keep you boxed in, in relation to the wide world, under the guise of presenting you properly. They present you, and the world believes. The thing about the Pollock story is that he had no proper public image. They called him all kinds of names—the dripper and this and that. What does that mean? The average guy still figures this guy is a painter, but what the hell is he after that?

Painters and sculptors see 'reaching the public domain, not the domain of *Time* magazine,' as their main task, and the critic is experienced as a potent obstacle to that end—a personal obstacle whose objectivity is often doubted: 'Everyone has judgments about the reviewers in the *New York Times* or *Art News*. A lot of that stuff is whether people like *you* or if somebody wants to take up *with you*.' As the sheer bulk of art work increases, reaching an audience becomes more difficult, and resentment of the critic who 'legis-lates and decides what is worthy of the public' correspondingly increases. Artists feel that he has grown from being a critic to being an 'all-powerful judge who rates people howsoever he chooses. They know their opinions are

highly regarded; they then decide whether so and so is an artist. I don't think that that's what a critic should be.'

There are occasional attempts to discount the critic by suggesting that his views are really not his own:

I think that what has happened is that I and some of my colleagues have imposed our ideas of what art is on some of these authorities. We rammed it down their throats and thereby won an important victory over the authorities. We wanted to be accepted by them, but on our own terms. Now I think they understand a lot better. In fact, I think the whole problem is to keep ahead of them. They catch on very quickly.

One artist even suggests that the art world is now so large that critical authority carries little weight: 'If there's some kind of ability, it will be recognized by at least one segment of the art world in America. The art world in America is very large and diverse and nobody is so powerful that he can make or break somebody that has ability.' Others counter that: 'While I don't think they can break anybody, I think that neglect can cause you to wither, and I've known some very worthy artists that just didn't make it early enough.' Some despair:

Americans live under a dictatorship—brutal and bloodthirsty. Those people who buy, *even more those who influence the buyers*, are being brutal. They're not intellectuals and they're not sensitive, and they call the shots.

I think a very few people who have authority and power commit themselves, identify with something for either the right or the wrong reasons, and then they give the armies the nod to follow.

Critics have a lot of power because they are published, and one doesn't like to read an unfavorable opinion in a widely circulated journal. But if one were really rational about it, it would be as if your cleaning woman had said it. It shouldn't mean too much, because a lot of them are very dumb about it.

This last, almost contemptuous rejection of the critic, is different in quality from the rejection of the other segments of the 'public.' The sense of disappointment and underlying ambivalence is far clearer here; for the reality is—the artist needs the critic in a more profound sense than he needs the friend, the collector, or the viewing public, at least at certain stages of the evolution. As one of our better-known painters points out, the artist is 'self-appointed.' He has a belief in his work and considers himself an artist— which is sufficient to keep him working. But now and then he needs some confirmation of himself, at least in the process of developing. He may gain

it from his peers and teachers at the outset, but eventually he needs a response from the knowledgeable world; it is the art critic who, despite all reservations and disappointments, represents this knowledgeable 'world-at-large':

> I would put it this way—I'm putting myself back to that earliest period—if you had asked us what we would like, I think we would have said we would like to be accepted in the art world and be recognized as artists by people in positions of authority, for example, a critic or a museum director. There were questions as to whether we were artists or not, since an artist is self-appointed. You then have to be recognized as being an artist.
>
> I can only speak for myself. I want to be accepted by people who feel as I do and whose opinion I respect. They have to be willing to accept me as an artist, to recognize me as an artist. Probably a critic or a museum director. Some such authority. A person in the position of authority.

In view of this felt need, the artist finds it depressing that 'art criticism has become so remote and regimented. Critics are beginning to depend on their subcritics . . . you know, they have talent scouts who do the initial sorting . . . and you have the whole pecking order of questionables developing this way. Human equations are forgotten.'

The persistent need for a positive personal response is demonstrated by a very successful painter when he recalls that 'Two months ago I made a good painting. The day I finished that painting I called up W. Y. and I said, "Hey, I've just painted a painting." I called up on another pretext. I really wanted to announce that I had painted a *good* painting.' As an artist, he needs no reassurance; as a human being, beset by typical doubts and insecurities, he looks to a respected authority for some kind of confirmation.

No wonder then that the artist is ambivalent about the critic, who publicly does so much to define him and his work; since this definition is subjective, some uncertainty must always exist for the painter. He then must struggle to keep the person and the artist in himself separate. He acknowledges that critical comment can influence him as a person; he dare not let it affect him as an artist: 'In fact, this is the acid test for the painter. Can he be left unshaken by even the most knowledgeable criticism, regardless of its source? The critic may be able to tell us what we've done, but he can never tell us what to do. That would be our finish.' 'The proof of your ability is to survive and withstand any kind of shattering criticism and continue working. You can be vulnerable as a person, but not in your work.'

The artist thus recognizes his dependence on the art critic, even if for most it is only on this human level. Dependency fosters ambivalence, and

where the stakes are so high the pitch can sometimes be extreme. To know that your position may depend on someone's subjective and possibly fickle judgment is not easy to stomach, but this is the way it is:

> An artist's reputation is objectively established when the people who are in the art world, whose opinions are highly regarded, decide that so and so is an artist. Then they rate him in whatever way they choose. This is then the opinion which will be held by the whole culture.

The critic clearly represents the most important of all artist-public relationships, both from a practical point of view and in terms of meaning for the artist. On a very concrete level, critics are in a position of decisive influence in fixing the artist's position, particularly in relation to other publics —the collectors and the viewers. He serves as the interpreter and the judge of the artist and his works. Equally important to the painter, however, is that to him the critic is, like the dealer, a needed representative of the world-at-large. This role holds especially for the period when an artist still requires support and his peers no longer supply enough of it. The critic is then the most powerful segment of the artist's general public, significantly shaping the external realities of his life—against which his inner self can never be too fully protected.

NOTE

[1] John Canaday, *Embattled Critic* (New York: Farrar, Straus & Giroux, 1962), pp. 187–188.

LEO STEINBERG

Contemporary Art and the Plight of Its Public*

A FEW WORDS in defense of my topic, because some of my friends have doubted that it was worth talking about. One well-known abstract painter said to me, 'Oh, the public, we're always worrying about the public.' Another asked: 'What is this plight they're supposed to be in? After all, art doesn't have to be for everybody. Either people get it, and then they enjoy it; or else they don't get it, and then they don't need it. So what's the predicament?'

Well, I shall try to explain what I think it is, and before that, *whose* I think it is. In other words, I shall try to explain what I mean by 'the public.'

In 1906, Matisse exhibited a picture which he called *The Joy of Life* (now in the Barnes Foundation in Merion, Pennsylvania). It was, as we now know, one of the great breakthrough paintings of this century. The subject was an old-fashioned bacchanal—nude figures outdoors, stretched on the grass, dancing, making music or love, picking flowers and so on. It was his most ambitious undertaking—the largest painting he had yet produced; and it made people very angry. Angriest of all was Paul Signac, a leading modern painter, who was the vice-president of the Salon des Indépendants. He would have kept the picture out, and it was hung only because that year Matisse happened to be on the hanging committee, so that his painting did not have to pass a jury. But Signac wrote to a friend: 'Matisse seems to have gone to the dogs. Upon a canvas of two and a half meters, he has surrounded some strange characters with a line as thick as your thumb. Then he has

* Reprinted by permission of the author and the editor from *The New Art*, ed. by Gregory Battcock, E. P. Dutton & Co., New York, 1966, pp. 27–37 (text only).

covered the whole thing with a flat, well-defined tint, which, however pure, seems disgusting. It evokes the multicolored shop fronts of the merchants of paint, varnishes, and household goods.'

I cite this affair merely to suggest that Signac, a respected modern who had been in the *avante-garde* for years, was at that moment a member of Matisse's public, acting typically like a member of his public.

One year later, Matisse went to Picasso's studio to look at Picasso's latest painting, the *Demoiselles d'Avignon*, now in the Museum of Modern Art in New York. This, we now know, was another breakthrough for contemporary art; and this time it was Matisse who got angry. The picture, he said, was an outrage, an attempt to ridicule the whole modern movement. He swore that he would 'sink Picasso' and make him regret his hoax.

It seems to me that Matisse, at that moment, was acting, typically, like a member of Picasso's public.

Such incidents are not exceptional. They illustrate a general rule that whenever there appears an art that is truly new and original, the men who denounce it first and loudest are artists. Obviously, because they are the most engaged. No critic, no outraged bourgeois, can match an artist's passion in repudiation.

The men who kept Courbet and Manet and the Impressionists and the Post-Impressionists out of the salons were all painters. They were mostly academic painters. But it is not necessarily the academic painter who defends his own established manner against a novel way of making pictures or a threatened shift in taste. The leader of a revolutionary movement in art may get just as mad over a new departure, because there are few things so maddening as insubordination or betrayal in a revolutionary cause. And I think it was this sense of betrayal that made Matisse so angry in 1907 when he saw what he called 'Picasso's hoax.'

It serves no useful purpose to forget that Matisse's contribution to early Cubism—made at the height of his own creativity—was an attitude of absolute and arrogant incomprehension. In 1908, as juror for the *avante-garde* Salon d'Automne, he rejected Braque's new landscapes 'with little cubes'—just as, by 1912, the triumphant Cubists were to reject Duchamp's *Nude Descending a Stair*. Therefore, instead of repeating that only academic painters spurn the new, why not reverse the charge? Any man becomes academic by virtue of, or with respect to, what he rejects.

The academization of the *avant-garde* is in continuous process. It has been very noticeable in New York during the past few years. May we not then drop this useless, mythical distinction between—on one side—creative, forward-looking individuals whom we call artists, and—on the other side—

a sullen, anonymous, uncomprehending mass, whom we call the public?

In other words, my notion of the public is functional. The word 'public' for me does not designate any particular people; it refers to a role played by people, or to a role into which people are thrust or forced by a given experience. And only those who are beyond experience should be exempt from the charge of belonging to the public.

As to the 'plight'—here I mean simply the shock of discomfort, or the bewilderment or the anger or the boredom which some people always feel, and all people sometimes feel, when confronted with an unfamiliar new style. When I was younger, I was taught that this discomfort was of no importance, firstly because only philistines were said to experience it (which is a lie), and secondly because it was believed to be of short duration. This last point certainly appears to be true. No art seems to remain uncomfortable for very long. At any rate, no style of these last hundred years has long retained its early look of unacceptability. Which could lead one to suspect that the initial rejection of so many modern works was a mere historical accident.

In the early 1950's, certain spokesmen for what was then the *avante-garde*, tried to argue differently for Abstract Expressionism. They suggested that the raw violence and the immediate action which produced these pictures put them beyond the pale of art appreciation and rendered them inherently unacceptable. And as proof they pointed out, with a satisfied gnashing of teeth, that very few people bought these pictures. Today we know that this early reluctance to buy was but the normal time lag of ten years or less. By the late 1950's, the market for Abstract Expressionist art was amazingly active. There was nothing inherently unacceptable about these paintings after all. They just looked outrageous for a brief spell, while we of the reluctant public were coming around.

This rapid domestication of the outrageous is the most characteristic feature of our artistic life, and the time lag between shock received and thanks returned gets progressively shorter. At the present rate of taste adaptation, it takes about seven years for a young artist with a streak of wildness in him to turn from *enfant terrible* into elder statesman—not so much because he changes, but because the challenge he throws to the public is so quickly met.

So then the shock value of any violently new contemporary style is quickly exhausted. Before long, the new look looks familiar, then normal and handsome, finally authoritative. All is well, you may say. Our initial misjudgment has been corrected; if we, or our fathers, were wrong about Cubism a half-century ago, that's all changed now.

Yes, but one thing has not changed: the relation of any new art—while it is new—to its own moment; or, to put it the other way around: every moment during the past hundred years has had an outrageous art of its own, so that every generation, from Courbet down, has had a crack at the discomfort to be had from modern art. And in this sense it is quite wrong to say that the bewilderment people feel over a new style is of no great account since it doesn't last long. Indeed it does last; it has been with us for a century. And the thrill of pain caused by modern art is like an addiction—so much of a necessity to us, that societies like Soviet Russia, without any outrageous modern art of their own, seem to us to be only half alive. They do not suffer that perpetual anxiety, or periodic frustration, or unease, which is our normal condition, and which I call 'The Plight of the Public.'

I therefore conclude that this plight does matter because it is both chronic and endemic. That is to say, sooner or later it is everybody's predicament, whether artist or philistine, and therefore well worth taking seriously.

When a new, and apparently incomprehensible, work has appeared on the scene, we always hear of the perceptive critic who hailed it at once as a 'new reality,' or of the collector who recognized in it a great investment opportunity. Let me, on the other hand, put in a word for those who didn't get it.

Confronting a new work of art, they may feel excluded from something they thought they were part of—a sense of being thwarted, or deprived of something. And it is again a painter who put it best. When Georges Braque, in 1908, had his first view of the *Demoiselles d'Avignon*, he said: 'It is as though we were supposed to exchange our usual diet for one of tow and paraffin.' The important words here are 'our usual diet.' No use saying to a man, 'Look, if you don't like modern painting, why don't you leave it alone? Why do you worry about it?' There are people for whom an incomprehensible shift in art, something that really baffles or disturbs, is more like a drastic change—or better, a drastic reduction in the daily ration on which one has come to depend—as during a forced march, or while in prison. And so long as there are people who feel about art in this way, it is uninteresting to be told that there also exist certain snobs whose pretended feelings disguise a real indifference.

I know that there are people enough who are quite genuinely troubled over certain shifts as they occur in art. And this ought to give to what I call 'The Plight of the Public' a certain dignity. There is a sense of loss, of sudden exile, of something willfully denied—sometimes a feeling that one's accumulated culture or experience is hopelessly devalued, leaving one exposed to spiritual destitution. And this experience can hit an artist even harder than an amateur. This sense of loss or bewilderment is too often

described simply as a failure of aesthetic appreciation or an inability to perceive the positive values in a novel experience. Sooner or later, we say, the man—if he has it in him—will catch on, or catch up. But there is no dignity or positive content in his resistance to the new.

But suppose you describe this resistance as a difficulty in keeping up with another man's sacrifices or another man's pace of sacrifice. Let me try to explain what I mean by the 'sacrifice' in an original work of art. I think again of the *Joy of Life* by Matisse, the picture that so offended his fellow painters and critics. Matisse here disturbed certain habitual assumptions. For instance, one had always assumed that, faced with a figurative painting, one was entitled to look at the figures in it, that is, to focus on them one by one, as he wished. The painted figures offered enough seeming density to sustain the long gaze. Thus, from all his experience with art, a man felt entitled to some pleasurable reward if he focused on painted figures, especially if these figures were joyous, female, and nude. But in this picture, if one looks at the figures distinctly, there is a curious lack of reward. There is something withheld, for the figures lack coherence or structural articulation. Their outlines are traced without regard to the presence or the function of the bone within, and some of the figures are insulated by a heavy dark padding—those lines 'as thick as your thumb' that Signac complained about.

In the old days, one's first reaction would have been to exclaim—'This man can't draw.' But we have the painter's preliminary studies for the individual figures of this picture—a succession of splendid drawings—and these show Matisse to have been one of the most knowing draftsmen who ever lived. Yet, after so many preparatory sketches, he arrives, in the completed painting, at a kind of draftsmanship in which his skill seems deliberately mortified or sacrificed. The heavy outlines that accost these figured nymphs prevent any materialization of bulk or density. They seem to drain energy away from the core of the figure, making it radiate into the space about them. Or perhaps it is our vision that is shunted out, so that a figure is no sooner recognized than we are forced to let it go to follow an expanding, rhythmical system. It is somewhat like watching a stone drop into water; your eye follows the expanding circles, and it takes a deliberate, almost a perverse, effort of will to keep focusing on the point of first impact— perhaps because it is so unrewarding. And perhaps Matisse was trying to make his individual figures disappear for us, like that swallowed stone, so that we should be forced into recognizing a different system.

For the analogue in nature to this kind of drawing is not a scene or a stage on which solid forms are deployed; a truer analogue would be any circulatory system, as of a city or of the blood, where stoppage at any point implies a

pathological condition, like a blood clot or traffic jam. And I think Matisse must have felt that 'good drawing' in the traditional sense—that is, line and tone designating a solid form of specific character with concrete location in space—that such drawing would have tended to trap and arrest the eye, to stabilize it at a concentration of density, thereby drawing attention to the solids themselves; and this was not the kind of vision that Matisse wanted brought to his pictures.

It is lucky for us not to have been polled in 1906, because we should certainly not have been ready to discard visual habits which had been acquired in the contemplation of real masterpieces, and to toss them overboard, overnight, for one painting. Today this kind of analysis has become commonplace, because an enormous amount of this century's paintings derive from Matisse's example. The free-flowing color forms of Kandinsky and of Miró, and all of that painting since, which represents reality or experience as a condition of flux, owe their parentage or their freedom to the permissions claimed in this work.

But in 1906 this could not have been foreseen. And one almost suspects that part of the value of a painting like this comes to it in retrospect, as its potential is gradually actualized, sometimes in the action of others. But when Matisse painted this picture, Degas was still around, with ten more years of life in him. It was surely still possible to draw with bite and precision. No wonder that few were ready to join Matisse in the kind of sacrifice that seemed implied in his waving line. And the first to acclaim the picture was no fellow painter but an amateur with time on his hands: Leo Stein, the brother of Gertrude, who began, like everyone else, by disliking it, but returned to it again and again—and then, after some weeks, announced that it was a great painting, and proceeded to buy it. He had evidently become persuaded that the sacrifice here was worthwhile in view of a novel and positive experience that could not otherwise be had.

So far as I know, the first critic to speak of a new style in art in terms of sacrifice is Baudelaire. In his essay on Ingres he mentions a 'shrinkage of spiritual faculties' which Ingres imposes on himself in order to reach some cool, classic ideal—in the spirit, so he imagines, of Raphael. Baudelaire doesn't like Ingres; he feels that all imagination and movement are banished from his work. But, he says, 'I have sufficient insight into Ingres's character to hold that with him this is a heroic immolation, a sacrifice upon the altar of those faculties which he sincerely believes to be nobler and more important.' And then, by a remarkable leap, Baudelaire goes on to couple Ingres with Courbet, whom he also doesn't have much use for. He calls Courbet, 'a mighty workman, a man of fearsome, indomitable will, who has achieved

results which to some minds have already more charm than those of the great masters of the Raphaelesque tradition, owing, doubtless, to their positive solidity and their unabashed indelicacy.' But Baudelaire finds in Courbet the same peculiarity of mind as in Ingres, because he also massacred his faculties and silenced his imagination. 'But the difference is that the heroic sacrifice offered by M. Ingres, in honor of the idea and the tradition of Raphaelesque Beauty, is performed by M. Courbet on behalf of external, positive, and immediate nature. In their war against the imagination, they are obedient to different motives; but their two opposing varieties of fanaticism lead them to the same immolation.'

Baudelaire has rejected Courbet. Does this mean that his sensibility was unequal to that of the painter? Hardly, for Baudelaire's mind was, if anything, subtler, more sensitive, more adult than that of Courbet. Nor do I think that Baudelaire, as a literary man, can be accused of being typically insensitive to visual or plastic values. His rejection of Courbet simply means that, having his own ideals, he was not prepared to sacrifice the things that Courbet had discarded. Courbet himself, like any good artist, pursued only his own positive goals; the discarded values (for example, fantasy, 'ideal beauty') had long lost their positive virtue for him and thus were no loss. But they were still felt as a loss by Baudelaire, who perhaps imagined that fantasy and ideal beauty were yet unexhausted. And I think this is what it means, or may mean, when we say that a man, faced with a work of modern art, isn't 'with it.' It may simply mean that, having a strong attachment to certain values, he cannot serve an unfamiliar cult in which these same values are ridiculed.

And this, I think, is our plight most of the time. Contemporary art is constantly inviting us to applaud the destruction of values which we still cherish, while the positive cause, for the sake of which the sacrifices are made, is rarely made clear. So that the sacrifices appear as acts of demolition, or of dismantling, without any motive—just as Courbet's work appeared to Baudelaire to be simply a revolutionary gesture for its own sake.

SUPPLEMENTARY READINGS

Bernard Bowron, Leo Marx, and Arnold Rose, 'Literature and Covert Culture,' *American Quarterly*, Vol. 9 (Winter, 1957), pp. 377–86. Argues that literature often provides clues to contradictions within a culture that are institutionalized as 'covert' elements in the national pattern. Advises study of selected writers to disclose these obscure but important elements.

César Graña, 'The Private Lives of Public Museums,' *Trans-action*, Vol. 4, No. 5 (April, 1967), pp. 20–25. A perceptive account of the different ideologies expressed in art museums in the Western world; includes interesting speculations on the relations between museums and their publics.

Gerald Gross, ed., *Publishers on Publishing*, New York: R. R. Bowker, 1961. Interesting and often penetrating comments on publishing by leading American and English publishers. Note particularly the remarks by Michael Joseph on the functions of the literary agent (pp. 389–96).

L. Rust Hills, 'The Structure of the American Literary Establishment,' *Esquire*, Vol. 60 (July–December, 1963) pp. 41*ff.* A brief introduction, followed by an organized listing of the writers, editors, publishing houses, universities, literary agents, critics, and bookstores which Hills believed constituted the national literary establishment at the time of writing. Perceptive and amusing.

Richard Hoggart, *The Uses of Literacy*, London: Chatto and Windus, 1957, Part Two. An unusual analysis of the importance of 'popular culture' in the life of the working class of an English industrial city.

Vyautas Kavolis, 'Artistic Preferences of Urban Social Classes,' *Pacific Sociological Review*, Vol. 8, No. 1 (Spring, 1965), pp. 43–51. An attempt to relate preferences in art styles to social-class position in the contemporary United States. The author is aware of the methodological complexities of his problem and does not make excessive claims for the study. Stimulating.

Leo Lowenthal, *Literature, Popular Culture and Society*, Englewood Cliffs: Prentice-Hall, 1961. A valuable study of 'popular culture' and its interrelations with art and society. Includes both historical and contemporary material.

Russell Lynes, *The Tastemakers*, New York: Harper & Bros., 1949. A lucid historical account of the efforts of 'tastemakers' to develop an appreciation of the arts in the United States.

James E. Miller, Jr., and Paul D. Herring, eds., *The Arts and the Public*, Chicago: University of Chicago Press, 1967. An exploration of the relations between art and its publics in the United States, with special attention to the critic. See particularly the articles by Max Kozloff, 'Art Criticism Confidential,' and Harold Rosenberg, 'The Vanishing Spectator.'

Bernard S. Myers, *Problems of the Younger American Artist*, New York: City College Press, 1957. Reported a survey of some three hundred young American artists in New York City whose works had been recognized by art organizations. Informative on both the art world and the social careers of artists.

Gerald Reitlinger, *The Economics of Taste*, New York: Holt, Rinehart and Winston,

1961. This work in economics and art history traces the pattern of price changes and shifts in fashion which characterized chiefly the English market for paintings between 1760 and 1960.

Karl Erik Rosengren, *Sociological Aspects of the Literary System*, Stockholm: Natur Och Kultur, 1968. A comparative and quantitative study of mentions of writers in reviews of fiction in selected newspapers and magazines published in Sweden in the 1880's and from 1950 to 1965. Emphasis is placed on the formulation and solution of methodological problems, as well as on substantive findings. The research design is sophisticated, and the execution of the study is scholarly. A pioneer study of considerable value.

Walter Sutton, 'Contextualist Theory and Criticism as a Social Act,' *Journal of Aesthetics and Art Criticism*, Vol. 19 (Spring, 1961), pp. 317–25. A critique of that type of literary criticism which seeks to isolate the work of art from its historical and socio-cultural environment.

Bruce Watson, 'On the Nature of Art Publics,' *International Social Science Journal*, Vol. 20. No. 4 (1968), pp. 667–80. Attempts to provide a new typology of art publics which comprehends both attitudes toward art and a sense of shared community values. Some useful distinctions are made. Extensive bibliography.

Harrison C. White and Cynthia A. White, *Canvases and Careers*, New York: John Wiley & Sons, 1965. A study of social and economic forces which may have affected French painting in the nineteenth century. Includes interesting material on the governmental system of patronage, on critics, and on dealers.

Part V
METHODOLOGY

V. METHODOLOGY

Introduction

BECAUSE IT OVERLAPS so markedly with the humanities, the sociology of art exhibits a variety of modes of inquiry, ranging from the use of anecdotal material to the application of rigorous procedures from empirical research. These methods deserve careful analysis and comparison for their effectiveness, their principles of procedure, and their assumptions of reality—tasks that obviously cannot be undertaken here. Instead, we will indicate the variety of methods illustrated in this volume together with some methodological implications.

The selections that follow illustrate a majority of the methods in comman usage. Even a casual survey will show that the most prevalent is what may be called the 'social-historical' method. This category includes the purely descriptive type of social history, as in the selections by Gimpel and Harris in Part II, and the analytical type applied to historical trends of art in relation to society, which occupy the efforts of Bell, Leepa, Dewey and Poggioli in Part VI. Overlapping with this category is the functional analysis of occupational roles of critic and reviewers by Kramer and by Lang, respectively, in Part IV, and of the publishing business by Escarpit in Part III.

The minor categories include typologies or classifications, which appear in the work of Cowley and of Griff in Part II, and in the same section the studies of interactions within small groups by Rogers and by Forsyth and Kolenda. The latter study also uses data from

'participant observation,' which is related to the methods of ethnography exemplified in the selections by Fernandez and Graburn. Statistical methods are used only by Fischer, in Part I, which reflects the fact that these methods are infrequently applied to the fine arts as compared with the popular arts. Psychological approaches are illustrated only in Nash's use of the Rorschach test, along with interviews, and in Shahn's autobiographical reflections and introspective reconstructions in 'Biography of a Painting,' both selections appearing in Part II.

Other psychological tests and psychoanalytic methods are omitted because they usually exclude social and cultural aspects, but some common types in sociology are also not represented, notably content analysis and audience surveys. These are used frequently in the popular or mass arts but rarely in the fine arts. The widely known dramatistic method of Kenneth Burke is not included, for although it is a type of structural analysis, Burke develops it more as a theory than a method, as the selection by Duncan in Part VI indicates. Newer developments, such as Goffman's use of Burke in *The Presentation of Self in Everyday Life* (1959) and Garfinkel's *Studies in Ethnomethodology* (1967), are not yet exploited for problems in the fine arts.

Whatever method he uses, the scholar usually attempts to adapt it to the problem he is dealing with, but his choice may also reflect his training and his intellectual orientation. A humanist, for example, may prefer historical and descriptive or analytical methods, which may sometimes conceal some unstated assumptions about truth and reality. Or, like Ben Shahn, the scholar may be excellent at autobiography and introspection but dislike 'all statistics and most generalities.' Similarly, some social scientists regard methods of quantification and measurement as arbitrary fragmentation of the wholeness and uniqueness of experience, as represented in poetry and other arts. That is, they believe that the arts can be studied properly only by methods of *verstehen*, which take account of the subjective motives of behavior. The empirically minded, on the other hand, will tend to agree with Sanford Dornbusch, who recognizes the value of other types of intellectual effort but advances the view that data should be made reliable, that 'intersubjective reliability'

is a necessity, not an aspiration. In *The Arts in Society* (edited by Wilson, 1964), he insists that the researcher must attempt to reduce the overabundant variables prevalent in the arts and to build a base for the replication of his findings.

The selections presented in this section hardly provide a fair sample of the spectrum of methods exemplified in this entire book. Rather, they represent a few attempts to deal explicitly with sociological models and with ways of conducting research in the arts in particular. Texts on methods in the social sciences seldom show direct application to problems in the arts, and scholars concerned with the arts have demonstrated little interest in methods as such. The few studies that have appeared are concerned with literature more than the other arts. Consequently, the proportion of articles dealing with methods of analyzing literature is somewhat greater than an ideal choice would dictate, and inevitably, perhaps, this overemphasizes the sociology of knowledge, probably the most common framework for studies in the sociology of literature. Nevertheless, it is desirable for students to become aware of the importance of methods in the study of the arts, their advantages and limitations, as well as new opportunities, some of which are described in the selections that follow.

Alvin Toffler, in 'The Art of Measuring the Arts,' makes a plea for extensive accumulation of data on the arts and presents a set of categories that ought to be used, principally by the Census Bureau, so that the information can be nationwide, supplemented by sample surveys. The need for such data is acute. In *Symbols in Society* (1968) Hugh D. Duncan notes that 'those of us who have tried to make rigorous statements about the relationships between art and society are keenly aware of how little is known about the production, distribution and consumption of symbolic material in our society—or any society.' More daringly, Toffler formulates what he calls 'quality indicators,' fifteen factors which, combined, will, he thinks, ultimately be a measure of the quality of a civilization. Thus he attempts, head-on, to determine quality by quantitative measures.

George Huaco presents two highly simplified sociological models, one macroscopic, the other middle-level, which he uses for the historical analysis of film art but which are equally applicable to the fine arts. The second model illustrates visually five social structures,

or 'conditions,' that impinge on the literary work, which is Huaco's chief concern. For those who are more interested in interactional patterns, it is tempting to take his model and draw lines and arrows between author and patron, critic and audience, and between other structures, in order to represent the interactions of the total system as an ongoing institution. Nevertheless, Huaco's scheme makes explicit these different social variables that in some way contribute to the style and content of a literary work, and to historical changes.

Huaco's macroscopic model, as he says, is a modified form of Marxian conflict theory, from which the sociology of knowledge is derived. It is this orientation that Alexander Kern develops into a description of techniques for showing various social and cultural effects on literature, while avoiding the dogmatism of economic determinism. Although he is critical, he shows in five specific steps how Mannheim's ideas may be applied systematically to the analysis of forms and thought-styles in literature.

Howard Lee Nostrand's 'Literature in the Describing of a Literate Culture' also relies heavily on the work of social scientists, chiefly Murdock, Parsons, and Opler. Nostrand's concern is not the under-standing of literature and art in terms of their social contexts but, rather, the ways in which literature may provide indexes to the character of a culture. He proposes, therefore, six types of research, which he hopes will reveal the fundamental characteristics of a culture, including not only its outstanding achievements but also its customary patterns of behavior. He is thoroughly aware of the need to check literary data against other sources, such as the findings of the social sciences. Although he urges the researcher to use the broadest possible spectrum of variables to describe a culture, he relies heavily on Opler's analysis of cultural themes and suggests ways in which themes in literature may reveal the essential themes of culture.

Richard Wollheim cogently differentiates three types of sociological explanation: the causal, the expressive and the anecdotal. The elaborations in footnotes contain not only examples of these types but also highly critical analyses of the interpretations of Marxist historians such as Frederick Antal and Arnold Hauser. Wollheim emphasizes the need to take account of psychological factors, as links between social conditions and works of art. The article sharpens our

awareness of the unspoken assumptions of scholars who apply the methods and the framework of the sociology of knowledge.

Lucien Goldmann's genetic structural sociology rests squarely on Marxian dialectical materialism and follows the literary-critical tradition of Lukács. His concepts of 'mental structures' and 'collective consciousness' also recall Durkheim, and his conception of 'structure' shows some indebtedness to Lévi-Strauss. To state it in oversimplified terms, the genetic method consists in the process of dissecting the work in order to determine its complex structure and then discovering the group consciousness, a kind of *Weltanschauung*, which will explain this structure in its totality. The process is a familiar one for the sociology of knowledge, but it differs from many studies in this field in its exhaustive textual analysis and its rigorous demand for explanations of every aspect of the literary work. The article is impressive for its analytic power, as shown by the parallels and contrasts drawn between psychoanalysis and genetic structuralism, by the searching differentiation of this method from historical approaches and from 'formalistic' structuralism, and by the subtle distinctions between interpretation and explanation. Whether one agrees with the arguments or not, the exposition is wide-ranging and penetrating; it reveals a brilliant mind at work.

ALVIN TOFFLER

The Art of Measuring the Arts*

SINCE THE END of World War II, the United States has witnessed a startling rise in public participation in the arts. The creation of great new cultural centers in cities across the nation is only the most visible sign of this new public interest. Whether gauged by increasing attendance at museums and theaters, by sales of books, by the formation of arts councils (up from 125 in 1964 to approximately 300 in 1966), by the rise of FM radio stations specializing in classical music, or by the creation of the National Foundation on the Arts and Humanities, it is obvious that drastic changes are occurring in our nation's cultural life.

The 'culture explosion,' until recently a strictly American phenomenon, is, moreover, no longer limited to this country. The arts traditionally have been regarded as being more advanced in Europe than in the United States. Yet there is evidence of rapidly broadening public involvement in the arts in England, France, Sweden, Holland and other highly industrialized nations as well. So dramatic is this new international wave of interest that France's Minister of Cultural Affairs, André Malraux, in calling for the construction of ninety regional arts centers in his country, declared it to be the 'stupefying fact' of the last twenty years.[1] The international character of this phenomenon suggests that, far from being an accident of American history, a 'culture explosion' is a predictable part of the transition from an industrial to a postindustrial stage of society.

For anyone interested in the passage to postindustrialism, therefore, this fact, stupefying or not, is too important to ignore. No system of social accounting could possibly be complete without indicators of the cultural

* Reprinted by permission of Curtis Brown, Ltd. © 1967 by the American Academy of Political and Social Science.

life of the nation. Furthermore, such indicators must cast light on the quality of our cultural life as well as on its size and scope. Just as in the field of medical statistics we need to know not merely what health services are available, but also how good those services are, so, too, in the arts we need to devise objective, even—where possible—quantitative measures of cultural 'quality.'

This is, of course, a controversial position since the arts are commonly thought to be so subjective and relativistic as to be beyond objective measurement, particularly with respect to the issue of quality. The very idea of measuring the arts is abhorrent to many. Quality is popularly regarded not as an aggregate of quantified or quantifiable factors, but rather as a mysterious, metaphysical entity. Nonetheless, an effort not only should, but can, be made to deal with the issue of quality in objective terms. In the paper that follows, I shall sketch the rough requirements for a cultural data system and suggest ways in which the problem of 'quality indicators' might be broached. . . .

THE CULTURAL DATA SYSTEM

The system described below—while it goes far beyond anything now in existence—must be regarded as no more than a starting point.

Implicit in what I have said so far is a restrictive definition of the arts. I have used the terms 'culture' or 'the arts' more or less narrowly to refer to classical music, opera, dance, theater, the visual arts and our literary output. I shall continue to employ this narrow definition for the remainder of the paper, partly from reasons of convenience, partly because these are, indeed, the fields in which most needs to be done. But I wish to make it explicit that a cultural data system limited to these alone would be seriously deficient. Information on these subjects must be supplemented by statistical and other data about rock-and-roll, 'happenings,' jazz and a wide variety of other phenomena. It must be set in a context provided by compatible data about the output of radio and television, movies and mass magazines. Moreover, having brought such data together in a single place—an 'Arts Section' of the *Statistical Abstract of the United States*, for example—we need to integrate it with the relative wealth of information already available about education, science, research and communication.

We must begin by developing simple measures of the size of the culture industry: numbers of institutions or establishments, numbers of 'consumers' served, detailed data on the characteristics of these consumers, numbers of artists and the like. We need such information broken down by industry branch—that is, artistic discipline—and by geographical region. We need

economic data about the industry, including sales and sources of income. We need data about its output in terms of number of performances, productions and exhibitions, as well as seating or other physical capacity figures. Above all, we need to classify output in various ways, a subject to which I shall return shortly in the discussion of quality indicators.

We also need to distinguish as clearly as possible between professional and amateur work. (Establishing firm definitions of such terms will be an important and controversial first step in the process of implementing these proposals.) We need to know how the educational establishment feeds the culture industry, in the sense of training both consumers and artist-producers. Moreover, we need data on wages and level of employment in artistic and related occupations, as well as other sources of income that help artists to pay their bills.

This only begins to suggest some of the required information. I have made no effort to be exhaustive.

The tasks of collecting this data and integrating it with existing statistical data in other fields, must, in the end, fall to the Census Bureau. Only the Census Bureau has the skill, experience and other resources necessary for work on so large a scale. It is too late to introduce these data requirements into the 1970 decennial census, but it is not too early to start work on a special census of the arts for, say, 1972, when the main work connected with the decennial census will be completed. The work of the Census Bureau can be supplemented by that of competent social scientists, who can collect data in limited sectors of the field, as Baumol and Bowen have done in their recent work on the professional performing arts.[2] But a comprehensive and periodic census of the arts is a precondition for truly rational and imaginative steps to improve the quality of life in the United States.

It need hardly be pointed out that such data must be collected at regular intervals, so that trend lines can be established. Not all such data can come from institutional sources; much will have to be based on sample surveys of the relevant populations and other sources. Only a scattering of the required data is available in useful form today. We are, for example, much weaker in the performing arts than in the field of libraries or museums. We are weakest of all in the amateur sector that cuts all across the board. We are further along on education and employment than on consumption statistics. We are extremely weak on consumer characteristics and on output-classification. One of the first steps in creating a cultural data system must be to iron out these differences and to make the incoming data compatible from branch to branch of the industry. Then we face the sticky problem of finding the best ways to classify output. This is central to the development of 'quality

indicators.' It can, however, only be decided after we have determined what
is meant by 'quality indicators.'

THE MEASUREMENT OF QUALITY

How does one measure 'cultural quality'? This, then, is the next problem,
and it is not resolved by laying it at the door of the Census Bureau or any
other government agency. The task of defining quality and finding ways to
measure it is one in which many artists and social scientists must join, bring-
ing with them a variety of experimental approaches. This work calls for
the creation of a number of social-science centers devoted to the behavioral
analysis of the arts, and the pioneers in it should receive their primary
financial backing from imaginative and risk-oriented foundations and
universities.

How might such researchers proceed? The method suggested here is not
the only way. It is no more than a first attack on the problem. I am less con-
cerned that this method be adopted than that it demonstrate the feasibility
of what has been, until now, widely regarded as impossible.

It must be emphasized also that the desire to measure quality does not,
by any means, imply a dogmatic approach to the 'content' of quality. It
does not stem from a univalued aesthetic system. The method proposed
here does not assert that abstract painting is always either good or bad, or
that the Theater of the Absurd is necessarily awful. It certainly does not
imply that government should legitimate certain schools of art or officially
derogate others. That the system could conceivably be used for such purposes
is true—but only in the same sense that any technique can be used for evil
purposes. What the system *can* do is provide a common language for debate
over cultural issues so that proponents of different value systems can, at
least, agree on the facts. If it did nothing more, the system could effect a
bracing change, a healthy clearing of the cultural air.

If one turns to the writings of artists, critics and most philosophers on the
subject of artistic excellence or, more broadly, cultural 'quality,' one comes
away with a jumble of subjective assertions, conflicting speculations and
semantic tangles. There is no universally or even widely accepted definition
of the term 'quality' with respect to the arts. We must begin, therefore, by
constructing a provisional definition, bearing in mind that it should be, when
we are finished, a practical definition, one that will prove useful to social
policy-makers, either private or public.

In constructing such a definition, I shall start by assuming that quality
is not a single, irreducible entity, but a shifting combination of factors. What,

then, are these factors? We might begin the task of isolating them by trying to imagine a 'high-quality culture.'

Imagine a society whose cultural output was (1) copious, (2) richly varied, (3) technically outstanding and (4) marked by many works of excellence. Imagine further that a significant portion of this output represented (5) contemporary creative work, as distinguished from performances or reproductions of the finest works of the past. Assume that much of this output was also (6) of such high complexity that it required (7) a considerably sophisticated audience. Now imagine that a large and sophisticated audience did exist and, moreover, that it was (8) growing in size and that it was (9) highly committed to cultural activities. Imagine there to be (10) a vast amateur movement providing a training ground for both artists and audience. And assume further that the institutions of art, such as museums, theaters and arts centers were (11) geographically decentralized and increasing in number, size and the efficiency with which they disseminated the work of artists to the public. Suppose that artists in this society were (12) held in high esteem by the public and (13) well remunerated and that (14) among them were men of undoubted genius. Finally, imagine that the artistic products of this society were (15) consistently applauded in other countries around the globe.

Looking at such a society, might one not draw certain conclusions about its cultural life? Might one not be justified in referring to its high quality?

We might easily argue about the weight to be given to one or another of these factors in forming our judgment. We might wish to add or subtract a factor or two. Nevertheless, it seems to me that even the most unreasonable critics would regard such a society as having a thriving artistic life. Let us, therefore, label this, for our purposes, a 'high-quality culture.'

Quality Indicators. Next, let us look more closely at these factors. They are quite varied and comprehensive. Yet all have one thing in common: they are all, to one degree or another, *measurable* phenomena. Some can be measured with relative precision. Others permit of only rough approximations. Yet all can be reduced to quantitative statements. Taking these factors one at a time, let us see how.

1. We began by describing cultural output in our imaginary society as 'copious.' When we speak of cultural output we refer to the production of books and classical-music recordings, performances of plays and musicals, operas, ballets, concerts of orchestral or chamber music, art exhibitions and the like. These are discrete things or events, and are relatively simple to tot up. We can say, for example, that American theaters last year gave X thousand performances. The data requirements described above include

numerous measures of quantity of output on which to base a judgment as to whether or not output is 'copious.'

2. The next adjective used in describing the imaginary high-quality culture was 'richly varied.' It is here that the problem of output-classification rears its head. We need to devise classifications of the output of each branch of the culture industry that will reveal among other things, the degree of variety in that output. If we are referring to theater, for example, we shall want to go beyond the traditional breakdown into 'plays' and 'musicals'; we shall want to classify each unit of output, whether a performance or a production, into 'professional' or 'amateur.' We shall want to know how many performances, for example, were devoted to seventeenth-, eighteenth-, or nineteenth-century or contemporary drama; how many are tragedies, how many comedies; how many American in origin, how many English, French, or other. We might further subdivide into 'farce' or 'situation comedy,' into works of social or political commentary, fantasy and realism. The finer our system of output-classification, the better we shall be able to gauge variety.

With respect to the visual arts we need to classify output not merely according to whether an exhibition is 'special' or 'permanent' but according to the school of art represented, whether post-Raphaelite or Pop, Cubist, kinetic, or mixed. The same might be said of music. The problem of defining categories will not be simple, but it is by no means impossible. The fact that many works are borderline cases and that skilled judgment may be needed in assigning a work to one or another category or in establishing new categories does not rule out the possibility. The art of classification is already highly developed in museums. There is no reason why it cannot also be developed to the same level in the other arts.

To determine whether the nation's cultural output is diverse or not then becomes a relatively simple matter. It is not necessary to collect data on every single performance or work of art in the country. Rather, it is possible to construct a sampling procedure that would, at regular intervals, check the output of a cross-section of artistic institutions. This is already done in the field of music by the American Society of Composers, Authors, and Publishers, and Broadcast Music, Inc., both of which monitor and log the musical output of radio and television stations in order to enforce royalty payments to their members. The creation of a cross-sectional panel of arts institutions and a system for monitoring the output of both the amateur and professional sector is quite feasible technically. This done, it becomes possible to determine the degree to which cultural output can be regarded as 'richly varied.'

3. We next come to the phrase 'technically outstanding.' By this we mean that the work displays high competence in the purely technical sense. Are

the musicians playing the right notes? Are the pirouettes clean? Is the acting skilled? Is the novel filled with clichés and bad transitions? These are matters that can easily be judged by an artist's peers, and there are broad areas within which a panel of peers would be able to agree. The technical level of our cultural output could, thus, be submitted to carefully assembled panels for technical review. These panels might consist of artists and, perhaps, critics, who would be asked to judge a sampling of output and to render a judgment in quantitative terms. The model for this, too, already exists in the way pianists, for example, are scored in certain artistic competitions. Using such a system, or a modification of it, it becomes possible to measure technical proficiency in quite specific and statistically manipulable terms.

4. One of the characteristics of this imaginery society is that its cultural output includes many works of excellence. There are no rigid criteria of excellence, certainly none that meet with universal approval. Nonetheless, each year, of the thousands of new novels published, a few survive the critical discussion conducted by both reviewers and readers, and come to stand as works of excellence. The same is true of plays, works of sculpture, musical compositions and the like. History may later reverse the verdict, but for the time being, they take on a special significance.

Over a period of years, they come to be republished, or reproduced on the stage; they are quoted; they become a standard against which newer works are judged. There are many mechanisms by which the process is formalized —award programs, for example. But the decision as to whether a work is 'excellent' or not is, in the end, made by consensus.

This may be a thoroughly inadequate system for judging excellence, but it is the chief method upon which we now rely. Recognizing all its shortcomings we can nevertheless put it to work in a more systematic fashion in measuring the excellence of cultural output. It is thus possible systematically to monitor a representative sampling of reviews and critical essays, make content analyses of them for all references to individual works of art and derive from this a categorization of these works as 'bad,' 'good,' or 'excellent.'

Since in real life the process of consensus involves more than just professional critics, this categorization can be matched against several other factors. One might be the degree to which audience response concurred with that of the critics, a phenomenon at least roughly measurable in terms of attendance figures, copies of books purchased and similar statistics. (Popularity, while by no means a determining factor, would thus be given some weight.) Critics and consumers having been given their say, artists, too, must be consulted. Thus, one factor might be the frequency with which other artists cite a work as a creative source or influence.

It is even possible to strengthen the procedure by building in a base-line. This could be done by asking appropriate panels to rank-order a series of artists—say, Bach, Mozart, Brahms, Berlioz, Johann Strauss—in terms of over-all excellence. Having done this, the panels grading current musical output could be asked to relate the categorization derived from content analysis to the Bach-to-Strauss scale.

This naïve procedure can be made as sophisticated as we like. Thus, the term 'over-all excellence' implies a unidimensional conception of excellence. It is possible, however, to break this down into component dimensions. One might, for example, devise different lists of rank-ordered artists for such dimensions as 'originality' or 'structural complexity.' These would provide more refined standards against which to measure contemporary output, and might, in fact, be further subdivided.

From such analysis, it becomes possible to classify the individual works in a selected universe as 'excellent' or 'not excellent.' The ratio of excellent works to the total becomes a clue to the frequency with which excellence occurs in the society's total artistic output.

Admittedly, these are groping and highly imperfect methods for dealing with the subtle and difficult problem of excellence, but they represent at least one reasonably objective technique that permits us to take this factor into account in assessing a society's over-all cultural performance. No doubt, other ways can be found, too.

5. We next spoke of the society's output of contemporary creative work as distinct from presentations of the works of the past. A culture industry that did nothing but disseminate the great works of previous centuries and other nations, no matter how copious, varied, or proficient its output, could be accused of drawing too heavily on its reserves and foreign credit. We might legitimately expect any society with a 'quality' culture to be producing new creative works of its own. ('Creative' here is not used as a qualitative judgment, but in the purely descriptive sense in which it is commonly used to differentiate between the creative and performing arts.) If output is classified as suggested above, it becomes quite simple to develop contemporary-noncontemporary or native-foreign ratios. Some efforts along this line have already been made with respect to orchestral programming, and indicate what can be done elsewhere. The degree to which a society is producing and disseminating new creative work thus also becomes measurable.

6. We run into a more difficult problem when we speak of the complexity of the output and the need for sophisticated audiences. When we speak of complexity we refer to structural complication of the kind that differentiates *Cantata 140* from *Mary's Little Lamb* or the poems of Gerard Manley

Hopkins from those of Edgar Guest. Complexity in certain art forms is objectively determinable. Thus, for example, the complexity of music can probably be measured with mathematical precision by computer. In drama, literature, or the visual arts, it becomes far more difficult. The entire subject of complexity in art demands extended treatment not possible here. Yet at this point, too, a panel of competent critics, asked to rank various works in terms of complexity, could be expected to reach substantial agreement at least on works at both ends of the scale. Even a crude system of categorization would make it possible to measure higher or lower levels of complexity in the works being offered to the public.

7. Sophistication of audience can be defined in various ways, but the ability to derive pleasure from works of high structural complexity is at least one index. Thus, the development of complexity measures makes possible some assessment of audience sophistication, since it then becomes possible to measure size of audience for works at varying levels of difficulty.

8. In speaking of our imaginary society, we referred to a growing audience. Given the kind of attendance and consumption statistics suggested above, it becomes simple to determine whether the audience is growing or not, and even to do this by output-classification.

9. The degree of 'commitment' of the audience to artistic activity, whether as active amateurs or as spectators, can be measured, too. Commitment is a subjective matter, but it manifests itself in outward behavior. The decision, for example, to purchase a book or a pair of tickets to a chamber music recital is equally a decision *not* to purchase something else. It represents an allocation of consumer resources, a choice. It is not unfair to suggest that high expenditure, as a percentage of individual income, is a measure of high commitment. To the degree that this is true, we can measure commitment in economic terms. However, the allocation of money is only one indication of commitment. Another, and perhaps more important, indicator is the commitment of time. Taken together, high expenditure relative to income and high investment of time, suggest high commitment. Given appropriate data about culture consumers, we have ways to measure, at least crudely, degree of commitment.

10. The size of the amateur movement, and the degree to which it feeds artists and consumers to the professional sector, can be determined by fairly conventional census-type research and can be treated statistically.

11. The degree of decentralization and the number and size of institutions are similarly determinable by conventional means. The question of efficiency can be approached through comparative economic data. Efficiency obviously cannot be measured in quantitative terms alone. The expenditure of $200,000

to permit 200,000 people to see a bad play at a cost of $1.00 per head is not necessarily more efficient than $200,000 spent to permit 100,000 people to see a good play at a cost of $2.00 per head. In few fields are qualitative measures more critical. Yet, through an extension of the techniques described above, it becomes possible to classify institutions according to the quality range within which they customarily operate. It is possible, therefore, to measure economic inputs against output measured in terms of both quantity *and* quality. Moreover, it becomes possible to arrive at estimates of what, at least in economic terms, it ordinarily costs to achieve given levels of quality in each branch of cultural activity.

12. The degree to which artists are held in esteem by the public is measurable through well-developed techniques for the prestige-ranking of occupations.

13. The level of remuneration of artists is measurable in simple economic terms, and the implementation of the data-collection system suggested above provides the necessary data. In determining what is 'high' or 'low' remuneration, comparisons can be made with median income figures for the total society and with the artist-income to median-income ratios of other societies.

14. The problem of 'genius' is, like that of excellence, far more difficult. The appearance of genius is highly unpredictable. Yet there are ways to cope rationally even with this. Despite conflicting theories of art, despite great confusion over aesthetic values, it is possible here, too, to reach wide consensus. Thus, for example, there is today widespread agreement that Frank Lloyd Wright, Charles Chaplin, or Pablo Picasso deserve the label 'creative genius.' Various attempts have been made in other fields to arrive at objective measures of outstanding individual performance. Thus, scientists have been ranked by the number of publications attributed to them, by the frequency with which their papers are quoted and the like.[3] In the arts, it is possible to devise similar measures—a combination, perhaps, of frequency of citation as a source by other artists; awards won, for example, the Nobel Prize; and assessments made by peers and by the public. There is nothing, in principle, that prevents the formulation of a definition of genius based partly on consensus and partly on other objective and measurable data. Once this is done, it becomes theoretically possible to measure its presence or absence.

15. Finally, in describing our imaginary society, we referred to the applause which its artistic works attract in other countries. This, too, is an objectively measurable phenomenon. The State Department carefully screens the foreign press, radio and television. There is no reason why a

continuing index of foreign reaction to the arts of the United States could not be devised. In part, this might be based on content analysis of criticism published or broadcast abroad. When an American ballet troupe dances abroad, when an American art exhibit is shown or a novel translated, it is routinely subjected to criticism by both audience and reviewers. Foreign reactions to American art can be gauged by systematically analyzing this response. It can also be measured in terms of prizes or awards won by Americans at major international competitions such as the Venice Biennale, the Tschaikovsky Piano and Violin Festival, and similar events, not to speak of the Nobel Prize. In short, foreign responses to American art and artists is also measurable by fairly conventional techniques.

The Symbols of Quality. Bertram M. Gross writes in 'The State of the Nation':

> Some phenomena cannot be directly quantified. We cannot make direct measurements of human satisfactions or of the quantity of certain intangible services. But we can get quantitative measures by using what I call 'surrogates.' These are indirect indicators that serve as quantitative substitutes for, or representatives of, the phenomena we want to measure.[4]

This, in essence, is what I have proposed here for dealing with the issue of cultural quality.

If it is agreed that 'quality' is an aggregate of many factors, and if we can then define these factors in ways that permit measurement, we arrive at a way to measure the 'surrogates' or symbols of quality. The question of which factors should go into such a computation is one about which there might—and should—be lively debate. For the factors add up to a definition, and a definition, once widely accepted, takes on a compelling force of its own. I have tentatively defined 'cultural quality' as consisting of fifteen factors. But other factors might be employed instead, and quite a different definition arrived at.

Thus, we might wish to evaluate our cultural output along quite different parameters. We might wish to measure art publications circulated per thousand of the population, or the ratio of hours spent at 'live' performances as against those spent in the vicarious enjoyment of electronically transmitted art. We might want to compare hours spent in active participation in the arts as amateur actors, singers, painters and the like, with hours spent as spectators at professional events. We might wish to devise some over-all measure of what might be described as the 'artistically engaged' population as a percentage of the total population.

The fifteen factors I have suggested here as the surrogates of quality are thus only a few of the many that are possible. I do not offer them as a package. I have used them to illustrate an approach to the problems of measurement, rather than to 'sell' any particular definition of 'cultural quality.'

In fact, not only should there be sharp debate over which factors to be included, but also over the weight given to each factor. Some may wish to place special emphasis on the measures of excellence and genius; others, more socially minded than aesthetically concerned, might wish to weigh heavily such factors as size of audience. This method does not dictate the relative weights of the various factors, but merely provides a well-lighted arena for conflict.

Similarly, there is room for vigorous contention over the specification, with respect to each factor, of satisfactory levels of attainment. Thus, it is necessary to specify *how much* diversity adds up to 'richly varied,' or *how high* one sets the criteria for excellence or genius. The system proposed here, therefore, does not eliminate the need for value judgments to be made; instead, it clarifies the alternatives and takes the discussion of quality down from the lofty level of rhetorical abstraction to that of concrete reality. It becomes a practical tool for policymaking.

Unquestionably, each of these factors is no more than a partial and, no doubt, unreliable indicator of the quality of our cultural life. Yet it can safely be argued that the sum of these measures will be a truer index than any single indicator. I would contend that, even if one or another measure is insufficiently refined, the over-all picture that such a system could give us would be better, more accurate, and far more useful than anything we now have.

The system proposed here suffers from many shortcomings. It is easier, for example, to keep tabs on the output of continuing, established institutions than on the output of ephemeral or *ad hoc avant-garde* groupings. Yet such groups may, in the long run, turn out to be extremely important. It relies heavily, though not completely, on data reported by institutions. Yet it is important to find out what is happening in the interstices, so to speak, between institutions. There is a wide variety of informal artistic activities which, in sum, may be highly important and which this system is probably insufficiently discriminating to detect. The system does not, moreover, begin to answer such questions as why one person becomes a concert pianist while another, perhaps equally talented, settles for teaching. It does not probe deeply at all into audience motivation. One might list many other such inadequacies.

Nevertheless, a beginning needs to be made. A cultural data system pro-

viding the kind of information suggested above and incorporating quality indicators would, I believe, serve the purposes outlined earlier by providing insight into the processes of social change, by making it possible for decision-makers to weigh the cultural consequences of their behavior, by raising the level of political discussion about the arts and by improving the efficiency of management in the arts. Moreover, as the pieces of this system come into being, some created by government agencies, others by researchers in universities and elsewhere, one could go much further. Once we have had an opportunity to study the interplay of factors, it should also become possible to predict changes in one by changes in another. This means that we might learn exactly what conditions are necessary to raise or lower each variable. One may not be able to predict the appearance of genius or of some great creative stroke, but, using such a model, it may well become possible to predict the changes in one or another variable that would increase our society's output of cultural excellence. And in this may lie the final justification of the cultural-data-system idea.

Art is intimately tied to the society, more complexly now, perhaps, than at any time since the rise of industrial society. It is reasonable to study these ties, so that we may better serve whatever values we hold highest. A cultural data system is the basic tool for such a study. The system described here is a rickety, primitive version of the tools that we shall have in the future. But it is a start.

There are several practical steps to be taken to make this 'start' real. We need to pull together all the scattered and fragmentary data that now exist, and begin weaving them into an integrated fabric. The Census Bureau needs to begin, even now, preparing for a census of the arts by forming an advisory committee on cultural statistics. The National Foundation on the Arts and Humanities can play a catalytic role by bringing artists and social scientists together in conference—an unprecedented step that should prove stimulating to both groups. Funds, whether from the National Foundation or from the great private foundations, need to be provided for those, like a group at the University of Wisconsin, who are already eager to get on with the work. The National Foundation might also organize a committee on research standards and a clearinghouse for research findings, so that those engaged in the work can best take advantage of each other's discoveries.

But whatever steps are taken first, the important thing is to take them. For the sake of the arts, for the sake of society—and for the sake of those who prefer reason to rhetoric in our discussions of the arts—this system, or some modification of it, should be brought into being. Without it, no broader system of social accounting can claim to be complete.

NOTES

[1] *The New York Times*, December 11, 1966.
[2] William J. Baumol and William G. Bowen, *Performing Arts: The Economic Dilemma* (New York: Twentieth Century Fund, 1966).
[3] Derek J. de Solla Price, *Little Science, Big Science* (New York: Columbia University Press, 1963), Chap. 2.
[4] Bertram M. Gross, 'The State of the Nation,' in Raymond Bauer (ed.), *Social Indicators* (Cambridge, Mass.: M.I.T. Press, 1966), p. 267.

GEORGE A. HUACO

*The Sociological Model**

A SOCIOLOGY OF film art is an integral part of a sociology of art and literature; the latter, in turn, joins the sociological quest via the sociology of knowledge and the Marxian inheritance. These affiliations suggest the availability of certain models and the use of particular strategies. Specifically, we need one macroscopic model to analyze the major political, social and economic changes in the larger society and a middle-range model to analyze the historically specific matrix of the art, film, or literature in question. The formal link between these two models is the assumption that major political, social and economic changes in the larger society tend to affect art, literature, or film by being channeled or filtered through the social structures which constitute their social matrix.

My macroscopic model is essentially a modified version of the original conflict model of Marx, using categories borrowed from the work of Neil J. Smelser. The diagram illustrates this model.

Superstructure	Values, ideas, expressive symbols
	Norms (particularly legal and political)
Base	Mode of social organization (historically specific forms of class structure and institutions)
	Social resources (primarily economic, demographic, educational, technological)

* Reprinted by permission of the author from pp. 18–22 of *The Sociology of Film Art*. © 1965 by George A. Huaco, Basic Books, Inc., Publishers, New York.

The dynamic aspect of the model consists in the assumption that, in most historical societies (whether characterized by increasing or decreasing social resources), the major source of social change is a tension, or 'lack of fit,' between social resources and specific modes of social organization. Since film art is part of the category of expressive symbols, this model suggests that necessary conditions for the emergence and duration of film waves will be found among historically specific social resources, modes of social organization, political and legal norms and the artistic traditions of the society in question.

An initial observation is that each of the waves began shortly after a major war. Thus, German expressionism began after World War I; Soviet dynamic realism began after the 1917 Revolution and the Civil War; and the Italian neo-realist films began immediately after World War II:

War	Interval	Beginning of Wave
1914–18	1 year, 3 months	1920: *Caligari*
1917–21	4 years	1925: *Strike*
1939–45	No interval	1945: *Open City*

The connection between war and the three film waves seems to be that, in each case, the war provided some of the conditions necessary. As will be shown later, there seem to be at least four such conditions: (1) a cadre of directors, cameramen, editors, actors and other technicians; (2) the industrial plant required for film production; (3) a mode of organization of the film industry which is either in harmony with or at least permissive of the ideology of the wave; (4) a political climate which is either in harmony with or at least permissive of the ideology and style of the wave.

The third and fourth conditions differ qualitatively from the first two in that their role is primarily permissive. What I call the ideology of a film wave—the implications and suggestions inherent in the film plots—has to be established independently by a content analysis of film plots. Only after this is done is it possible to show that a given mode of organization of the film industry and a given climate of political and legal norms are favorable or unfavorable to the development of a film wave with a specific ideology.

The basic sociological hypothesis of this study is that all four conditions must be fully present before a wave of stylistically unified film art can begin. A corollary of this hypothesis is that the elimination of one or more of these conditions will be sufficient to produce the decline and destruction of a wave. It is also evident that these four structural conditions represent historically specific subcategories derived from the main categories of our

macroscopic model. This model, in turn, deals primarily with socio-economic and political changes in the larger society. To get closer to the film wave, we have to develop a middle-range model which will permit exploration of the immediate social matrix through which changes in the larger society affect film art.

This second model can best be understood as a derivation of a more complex model in the sociology of literature. In general, it can be said that literary phenomena are surrounded by five specific social structures, as shown in the diagram.

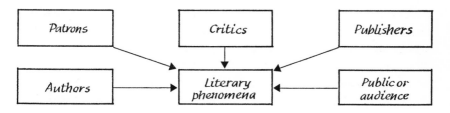

In the case of film art, the web of surrounding social structures seems to be more modest, because patrons and film producers are usually the same and because there is no consistent tradition of serious film criticism. On the other hand, a new social structure—of somewhat dubious sociological relevance—seems to emerge in the social context of film art: the actors. This structure is of dubious relevance because the history of film shows that, in periods of artistic efflorescence, film actors are completely subordinate to directors; the opposite is true of periods in which film becomes part of the mass culture. The rise of powerful and wealthy 'stars' and the development of a powerful and wealthy 'entertainment' film industry seem to be structurally linked.

Taking account of these observations, our middle-range model for the social structures which surround film art is as indicated in the diagram.

The sociological value of these models is quite high. The common social characteristics of the members of some of these surrounding social structures (such as film direutors and film audiences) can be explored with the aid of

biographical data or standard interview procedures. Other structures (such as the organization of the industry) can be explored for bureaucratic and institutional exigencies.

Unfortunately for any concrete study and in particular for any historical study, the unavailability of data can be counted on to ensure that the analysis will fall short of ideal possibilities. For the analysis of the social matrix of our three waves, we have some biographical data on a majority of the directors; we have reasonably good historical data on the organizational exigencies of film production; and we know nothing about the audiences.

In brief, this study will give a causal account of the rise and fall of three stylistically homogeneous waves of film art in terms of the presence or absence of four structural factors: a cadre of film technicians, the required industrial plant, a favorable mode of organization of the industry and a favorable political climate. The character of these factors will be established independently by the use of historical data. We will then examine the ideology implicit in the film plots of each wave and show for each period whether the organization of the film industry and the political climate were favorable to the development of a particular ideology. Next, we will explore the larger artistic-literary-dramatic cultural context for clues as to the genesis of the style of each wave. Finally, we will examine the social characteristics of each group of directors and link some of these social characteristics with specific ideological or artistic aspects of each film wave.

ALEXANDER KERN

The Sociology of Knowledge in the Study of Literature*

THE SOCIOLOGY OF knowledge—that branch of sociology which deals with the effects of social and cultural backgrounds upon the forms of thought and expression—offers a fruitful technique for the correlation of literature and society. This technique aims at being more systematic, more objective and more refined than previous attempts to use a knowledge of society in the interpretation of literary art.[1] Of course, the interpretation of literature as part of the cultural pattern is nothing new, but this particular discipline, besides furnishing a method for those in search of a technique, offers a breadth of grasp and a hold on objectivity which have not been achieved by those who have attacked the problem from a particular political or economic viewpoint.

If, as is often contended, the best histories are those written with a bias, it is at least in part because the author sees invidious relations between groups he dislikes and their written expression. Yet the man with a bias is liable to the defects of his virtue. First, he may fail to see the connections between the thought and position of his own group, and may claim a superior validity for the ideas of his own class, as has been the case with Marx and his followers. Second, he may make serious errors in the over-zealous application of his own preconceptions, as has Parrington on Thomas Hooker, or Babbitt on Wordsworth. Finally, such a scholar may isolate his one pet factor and claim that this factor is the cause of literature. But society is too complex for such a procedure.

* First published in *The Sewanee Review*, Vol. 50, No. 4, Autumn, 1942, © by The University of the South. Reprinted by permission of the author and *The Sewanee Review*.

More helpful is the widely accepted analogy of dynamic equilibria, as worked out by Willard Gibbs and applied to biology by L. J. Henderson and to society by Pareto. Gibbs found that in a closed system with a given number of variables the equations could be worked out so as to predict what effect the change of one variable would have upon the others. But in society, and especially in literature, the system is not closed, for we cannot follow the laboratory technique of excluding outside influences,[2] and even the number of variables is unknown. Thus the pursuit of one variable does not produce any causal connections, since an observable change in this factor may be merely an adjustment to a change in another. To the objection of Sorokin that the change of some factors not causally or functionally related to the rest will produce no or little change in the balance of the whole,[3] the answer may be made in passing that science takes this into account, since it is interested in the more significant changes and tries to allow for the results of the less important variables.

Accepting the concept of equilibria, the sociology of knowledge by its inclusiveness and refined technique, minimizes the defects of earlier attempts to link literature and society. It begins with the generally accepted assumption that thought is conditioned by society, and is unique only in carrying this assumption to its logical conclusion by pointing out that our own thought too is socially conditioned. On this postulate the whole elaborate structure of the sociology of knowledge is based. It claims that there is a large social content in the thought of any individual, and that many ideals and attitudes are absorbed in youth by even the greatest geniuses. This body of ideas is social in origin, and insofar as it was originally designed as a basis for group action, it is a rationalization of the group's interests. Thus the total ideology of the sociology of knowledge does not insinuate that the writer is trying to deceive, but seeks the relationships between certain thought forms and the cultural configurations in which they occur.

But the corollary that our own thought is suspect is what gives the sociology of knowledge its advantage in objectivity. Karl Mannheim goes so far as to point out that only in a time when social forces are in such conflict that we are all challenged to examine the usually unconscious basis of our own thought will the conception of total ideology arise. Indeed, he gets into deep water at this juncture by claiming that since society affects all thought, all knowledge is relative. He has of course been generally attacked for this untenable conclusion. The distinction between empirical and pragmatic truth made by the pragmatists, that between cognitive and non-cognitive knowledge made by the logical positivists, and that between a scientific proposition and an emotive statement made by the semanticists are

still valid.[4] That is, the truth of Einstein's general theory of relativity cannot be impugned by reference to the social factors which led him to formulate the problem, nor, as the Nazis claim, by the fact that he is a Jew.

But as Mannheim himself states, and all specialists claim, it is not necessary to accept his epistemology in order to apply his technique, which is the immediate subject of this paper. This process may be subdivided into a number of steps, not all of which need be applied to any one problem. First, select a period for study and pick the problem to be treated, setting up the leading concept and its opposite. Second, on the initial level of imputation analyze all the works involved, trace them to the central common idea, for example, trancendentalism, and produce a structural type which makes the *Weltanschauung* clear. Third, analyze the works and see to what extent they fit the construction. Blends and crossings of viewpoints within each work will be pointed out, and the actual history of the thought style will be charted. Fourth, on the level of sociological imputation, by going behind the *Weltanschauung*, seek to derive the structure and tendencies of thought style from the composition of the groups, classes, generations, occupations, sects, parties, regions, cliques, or schools which express themselves in that mode. Fifth, explain the direction of development of the body of thought 'through the structural situation and the changes it undergoes' and 'through the constantly varying problems raised by the changing structure.'

To make this general scheme meaningful it is necessary to explain each step in somewhat greater detail and to fill in some of the rather sketchily outlined steps of the process. Mannheim's formulation of the technique of the sociology of knowledge is designed to hold out the effects of prejudice as long as possible in the research process. A discussion of the constructed type will make this clear.

The first step in the construction of a type, a step which Mannheim does not himself distinguish from the second, is the selection of a concept and its opposite. It may at once be objected that this polarity is too simple, but by going from the general to the specific, later analyses produce all the necessary categories. Thus if one is dealing with transcendentalism, both Puritanism and Unitarianism would have to be adopted as contrasting thought forms and perhaps deism and materialism as well. More damning would be the contention that prejudice, which is to be so carefully excluded, operates at the very outset in the choice of the problem and the leading concepts. But this fact is of no methodological significance. One scholar will choose more fruitful subjects than another and will obtain more significant results, but the conclusions of both, if correctly obtained, will be equally true.

As for the second step, the construction of the type, this can be carried out with perfect objectivity. According to Professor Howard Becker,[5] this construct is not even an hypothesis, but rather an inductively derived heuristic fiction which is theoretically neither true nor false and to which given works will conform no more closely than they do to Professor René Wellek's similarly constructed period or movement.[6] Thus there should be no reason for falsely attributing good or bad characteristics to the type, though some scholars do indeed have this difficulty. In theory their approval or hatred of romanticism should not prevent them from constructing the type objectively or at least hiring someone else to do it. Once constructed, the type is useful in prediction. Given the type and a certain set of conditions there is at least a statistical likelihood, given the return of the conditions, that the results which held previously will follow. If, as has often been maintained from Aristotle to Bateson, history is interested in the uniqueness of the event, the sociology of knowledge, by trying to see whether configurations recur, shows the broader scope.

The third step of imputation, in which the works of a period are analyzed to see to what extent they actually fit the construction, to note the blends and crossings and to chart the actual course of an idea, is also designed to produce objective results. Certainly the cross-checking is more likely to be accurate than the technique of free, untested hypotheses, illustrated with carefully chosen examples, or of empathetic feeling into a period. By 'controlled observation,' that is, analysis and resynthesis, the course taken by a concept can be more accurately charted than by general impression.

However useful these three steps may be, it is the fourth, sociological imputation, which is the most distinctive and most significant. At the same time it demands the most thorough elaboration. In the first place Mannheim contends that not only the content, but the very structure of thought may be determined by the historico-social situation of the writer. A number of traits may be subject to this influence: (1) Words or concepts like *liberty* may have different meanings for different groups. (2) The absence of certain concepts may indicate the absence of social drives in that direction. Thus the idea of progress did not arise until the static society of the Middle Ages had been broken up. (3) Different groups have specially oriented categories. Conservatives are likely to be absolutists conceiving society as an organic, morphological whole; liberals are likely to be relativists and analytic rationalists. (4) Thought models are historico-socially oriented. Pragmatism can arise when the common-sense middle class becomes intellectually dominant and respectable. (5) The degree of concreteness and abstractedness of a theory may depend upon the social situation. Thus theoretical or moral

justifications may cloak materialistic interests. Or an attitude may not be worked out because the contradictions within it would become apparent, as may have been the case with Emerson's thought. (6) An ontology itself is socially conditioned.

Thus it is clear that the place and dignity which authors enjoy in society may influence the nature of their output. Even more important than the group into which an author is born is the group with which he affiliates. This is true because authors tend to become 'free' intellectuals, men who through insight and education are able to see through the traditions of their own group, and to ally themselves intellectually with any other sector of society. Certainly the shake-up of values produced by university experience is a widespread phenomenon. The artist, too, may break loose from his own group, may become a theorist, like Burke for a superior class, or like Marx for the masses. This new attachment will become more important than the author's origin. Or to put it another way, the type of public to which the author addresses himself will tend to shape his work. The levels of taste in society and the social preconceptions of the various layers will influence the aesthetic and moral aims of the writer who is appealing, consciously or not, to the group view. A study of patronage and emolument systems will cast some light on the unstated assumptions of the authors. Some exploring has already been done, but there are still many blank areas on the map.

The fifth and last step in the process, the development of a body of thought through the structural situation as related to the country as a whole and to the changes in time, involves several points. First the importance of a given group is not the same in all countries. In the nineteenth century, the position of the landed gentry was different in Germany and England, for example.[7] Consequently the position of the group must be worked out before its attitude can be clarified and explained. Next, the relationship between groups is not constant. Thus American history may be taken as the decline of the landed aristocracy, and ultimately of agrarian interests. Finally, even if the balance of interests remains relatively constant, the issues and the ideologies are continually changing. *States rights*, for example, which was once the agrarian doctrine, has now become the slogan of the business and financial interests which it was originally intended to forestall.

This outline of the Mannheim technique will strike many as immediately applicable to society, but there may be doubts whether it is applicable to literature, or if applicable, whether it has any real advantage over other types of approach. Admittedly the connections between the social base and the literary superstructure are complex, intricate and often concealed, while the relations upon the intellectual level are exceptionally strong. Nevertheless

the author is a member of society. Certainly the content of prose and poetry, the products of living authors, will be influenced by the author's place in that society. That this is true of the novel is sufficiently obvious, and specific relationships could be multiplied. The author's attitudes, too, are amenable to the same approach. He may be accepting the situation or he may be reacting against it by trying to produce reforms, or by turning aside, like the priest and the levite, to absorb himself in nature, self-contemplation, or art for art's sake.

Once it is seen that this is a valid discipline in the study of literature, it becomes evident that the system has many advantages. In the realm of objectivity, besides offering a controlled procedure, it enables the scholar to bring to light the unarticulated forces operating in the history of thought, and it enables him to expose his own view and to allow for it. In the realm of completeness it is particularly superior. Other social approaches have been applied in a partial and sporadic fashion, but the sociology of knowledge aims at a systematic approach. Furthermore this system includes many factors, since it does not seek to explain all things on the basis of only one cause, but rather emphasizes the interaction between thought and the social structure. It follows the history of an idea in the intellectual realm, but not there alone, and in the social realm, but not there alone; it is the interconnections which are traced. Thus Whitman is developed not solely from Emerson and not solely from society, but from both. In this way the technique avoids the difficulties of economic determinism. On the assumption that the class system will not explain all thought, the sociology of knowledge refines on the older concepts by adding smaller but clearly distinguishable subdivisions such as generations and regional groups, which are certainly distinct enough in American society. And it escapes the difficulties of economic determinism in another way. Without minimizing the importance of economic factors, it recognizes with the American pragmatists the influence of 'theoretical,' that is, intellectual factors in producing change, and thus it prevents the question-begging of the crude application of the economic cause.

Furthermore it is useful in many fields of research. It is perhaps most easily applied in biographical studies of individuals to explain why the men thought as they did. For example, the apparent inconsistencies in Dr. Holmes become explicable when he is looked upon as fitting one of the subtypes set up in Veblen's *Theory of the Leisure Class.*

The study of forms is also amenable to this approach. There can be little doubt, for example, that the present cult of poetry which can be understood only with a key is the result of the general attitude that the poet is a dreamer

who has nothing to say. Recognizing that the poet as seer is dead, the author intentionally contracts his audience and makes his work precious in order to build up his own dignity.[8] Literary scholars should also be encouraged by the success of art historians like Panofsky, Wind, Sorokin and Schapiro who have charted the changes of forms and imputed them to the philosophies and social situations of the artists. Professor Bateson's contention that poetic types depend upon language may be referred back to the social changes which produced the linguistic changes. I have begun work on the transcendentalists, endeavoring to explain on the basis of this technique why they habitually express themselves in essays, short poems and occasionally history, rather than in novels or long, dramatic poems. While my conclusions are not ready, it is already gratifying to discover how many fresh approaches are unearthed in the application of this methodology.

In the study of the history of ideas this technique is of major significance—perhaps of primary significance in the study of those transitional, unstable periods which accompany social change. In American literature, the rise and decline of movements like Puritanism, deism, transcendentalism, humanitarianism, realism, naturalism, imagism, the idea of progress, pre–World War I pessimism, Marxism, the renaissance of metaphysical poetry, the growth of critical schools, the changing role of the aristocracy and the cultural levels of the omnibus middle class—all these urgently need analysis from a social viewpoint.

The sociology of knowledge also aids intellectual history by indicating in what way literature can affect society. As has been pointed out, this system does not claim that all thought is socially determined. Thought patterns are part of the equilibrium of society, and change of thought can change the entire balance of the equilibrium. Mannheim says that the special realm of this study is the interconnections between thought and society. Certainly there are links on the intellectual plane and one man's thought may influence that of another as Plato's did that of Aristotle. The thought of an individual may also influence that of a group, even to the extent of producing social change. This was true of *Uncle Tom's Cabin* and of Montesquieu's doctrine of the separation of powers. Even exaggerated, simplified, or transformed ideas operate. Thus Jefferson was less democratic than his influence, Kant was not understood by the American transcendentalists, nor Hegel by many conscious proletarians. But lest it be thought that other influences are being ruled out, it is suggested that whether one's conception of romantic love is formed by Hemingway or Kathleen Norris depends upon one's own view of what seems suitable and true.

But after all, this methodology provides no panacea. It will not produce

laws of causation; it will not be able to explain the temperament of an author; it will not even explain why a work is great literature. That depends upon the author's ability to appeal to a relatively unchanging core of human emotion. Not being universal, this technique cannot because of its grounds claim that other methods are invalid. Whether the approach to literature is individual or social it holds to be a question of method, not principle. The results may not be isomorphic, but when they are not collaborative or corroborative, they are at least not in conflict. Consequently this approach does not exclude the genetic, nor the historical, nor the aesthetic approach, as Dr. Bergmann and Dr. Spence make clear, but recognizes each of them as valid so far as it goes.[9] Nor will it eliminate the bias of the scholar; it gives him a controlled technique and even a way of recognizing his prejudices, but he is still human and may need forgiveness. There may even be a danger of the technique's leading a scholar into fields which properly belong to sociology, but this consequence is not inevitable or necessary, since the aim is not to produce a sociology of literature, but to use a sociological technique already developed to interpret literature.

To define the limitations of the sociology of knowledge is also to mark off its areas of strength. One of its main values is that it offers a guide to the followers of those pioneers who first attacked literature from a particular social viewpoint. If this technique does not make these followers objective, its cross-checking may at least prevent them from committing egregious blunders. Furthermore it may open up new insights, not only for those who have used similar techniques before, but also for those who have not. The application of the complete methodology will demand an amazingly thorough examination of all aspects of the problem, some of them newly disclosed, and this is a most exciting feature. Because it emphasizes the links between thought and society, it transcends either purely intellectual or purely social considerations by including them both. But because it cannot explain literary greatness it does not rule out criticism. If the scholar has actually been able to prevent his bias from interfering with his thought while he has been assembling and organizing his material, he feels all the more the desire to act as judge from the position of his own taste and principles. As Professor Harry H. Clark says, it is the duty of the scholar to explain, interpret and evaluate.[10] But since we must understand what we judge, I suggest that the sociology of knowledge is of great value in performing the first two steps of this process.

NOTES

[1] Karl Mannheim, *Ideology and Utopia*, trans. by L. Wirth and E. Shils (New York, 1936). Chap. 5 and *passim* is the basic reference for this paper.
[2] E. Zilsel, 'Physics and the Problem of Historico-sociological Laws,' *Philosophy of Science*, VIII (October, 1941), 569.
[3] P. A. Sorokin, *Social and Cultural Dynamics* (New York, 1937), I, 14–22.
[4] Charles Morris, *Foundations of the Theory of Signs*, International Encyclopedia of Unified Science (Chicago, 1928), I, No. 2, 40–41; Robert K. Merton, 'Karl Mannheim and the Sociology of Knowledge,' *The Journal of Liberal Religion*, II (Winter, 1941), 134. Mannheim believes that objectivity can be achieved by synthesizing the vistas of several ideologies. While the practical value of such perspectives is tremendous, the question whether his epistemological generalizations are cogent still remains. Perhaps they show the effects of the philosophical atmosphere he breathed.
[5] H. E. Barnes and H. and F. B. Becker (eds.), *Contemporary Social Theory* (New York, 1940), Chap. 2, 'Constructive Typology.'
[6] 'Periods and Movements,' *English Institute Annual, 1940* (New York, 1941), pp. 90–91.
[7] E. Kohn-Bramstedt, *Aristocracy and the Middle Class in Germany* (London, 1937), p. 10.
[8] The problem is more complex than here suggested, not only because various types of obscurity must be isolated, but because obscurity itself must be explained partly by psychological factors, which are not the immediate subject of this paper. Mr. Kenneth Burke's brilliant analyses show how well the social and psychological approaches can be combined.
[9] G. Bergmann and K. W. Spence, 'Operationism and Theory in Psychology,' *Psychological Review*, XLVIII (January, 1941), 3.
[10] 'Intellectual History,' *English Institute Annual, 1940* (New York, 1941), p. 123.

HOWARD LEE NOSTRAND

*Literature in the Describing of a Literate Culture**

IF IT IS true that literary studies can give insight into a culture and society we should make the most of that possibility today, when such insight is so badly needed for the sake of better cross-cultural understanding and communication. Moreover, some of the light that literature can shed upon its environing society and underlying culture can extend our knowledge and appreciation of literature itself, by reason of the relationship between the literary work of art and its external context.

One dare not assume that the external context of literature will prove irrelevant to our understanding of it. A work of literature is organic not only in that it has an internal structure, but also—as Walter Sutton has lately been reminding us—in that it interacts with an environment before and after it is born.[1] There is enough truth in the 'cultural determinist' view of art so that one can be sure no Pirandello play will ever be found in Aeschylus' generation, nor a Brahms symphony in the time of Gregory the Great.

Milton Albrecht has shown three sorts of connection between literature and society. (They doubtless apply in varying degrees to all the arts, but to literature in particular.) Literature reflects accepted patterns of thought, feeling and action, including patterns of expression and the society's unconscious assumptions.[2] It innovates, giving expression to emerging themes that may not yet be definable in literal terms. And it is one instrument of social control, serving the purposes of maintaining or of changing the inherited patterns.[3] To know the accepted patterns, from all sources of

* Reproduced with the permission of the author and the editor from *The French Review*, XXXVII, 2, December, 1963.

evidence, and to see where literature is innovating so that it actually extends the growing edge of civilization, is to appreciate the nature and extent of a writer's originality. The influence of literature on society is, I admit, a realm of fact extraneous to literature itself; yet it is one which does contribute to the self-knowledge of a reader who wants to see his own response in perspective.

Some of the kinds of research to be proposed, moreover, look directly into literature and not beyond it. One of these will be the kind of research that I suggest the most hopefully of all. It studies literature to find the themes and norms active in it, including those expressed through its form. I admit an ulterior motive: it is to compare the themes and norms found in literature with those found in the culture's other expressive forms and in the society's institutions. Yet if any study of literature is defensible as an activity enhancing the intelligent enjoyment of it, the kind of 'theme' approach that will be suggested here is one of those that inquire the most directly into the art work's import and mode of existence.[4] It consequently minimizes the danger inherent in all *study* of the arts, the danger of analyzing to the exclusion of experiencing.

My sabbatical project of the past year, 'Groundwork for a Structural Description of French Culture,'[5] has broadened my perspective on the place of the thematic approach in a rounded effort to describe a nation's way of life. This approach now appears to me to be one of six that should be used in conjunction with one another, as interdependent means toward an eventual, structural description of a socio-cultural system—an ideal description which is still some years away, for our present factual knowledge and theoretical constructs are far from producing a coherent view of a people's way of life. . . .

COLLECTING HYPOTHESES

The first of the six approaches to a responsible understanding of a culture is to collect the plausible generalizations that have been made about it. If these allege that a belief or a custom is widespread, they are making a quantitative statement which can be established only by quantitative inquiry. Until the generalizations have been verified they remain in the status of hypotheses. Yet while they are in that status they can serve potently to stimulate imagination and inquiry, particularly when discrepant hypotheses about a people are juxtaposed and their areas of contradiction are explored.

Novelists, playwrights and poets, as well as the essayists and moralists,

are a rich source of provocative hypotheses, the more valuable because their originality sometimes ranges outside the systematic presuppositions that shape scientific observation. It makes no difference to the status of a hypothesis if it is expressed by a fictitious character, or indeed if it is discovered by the reader between the lines or in the structure of a work.

It is not new, of course, to collect authors' interpretations and judgments as Geoffroy Atkinson did in his exemplary organization of *Les Idées de Balzac*,[6] or as Geoffrey Gorer did in assembling his own quite Freudian hypotheses about the French family.[7] The fresh possibility lies in the comparing and interrelating of hypotheses arising from diverse premises. In the 'Groundwork' project, it has proved fruitful to collate hypotheses about the French in two arrangements, one according to themes of the culture and the other in a cross-cultural inventory.

Before we look at the remaining five approaches, I should raise a question that will be basic to all of them. Apart from furnishing hypotheses, what *evidence* can literature contribute toward describing a culture and society? Here we must distinguish between two great, mutually complementary aspects of a culture: the unusual achievements of a people and its usual patterns of behavior.

Great literature directly evidences some of the sublime heights to which a people is capable of rising on occasion. Literature in fact embodies much of the excellent in a culture, and gives it its most articulate concrete form. The excellence that has thus been achieved, however, is an abstraction. It has to be defined, and the question whether the same kinds of excellence appear in other activities of the people must be answered by examining its achievements in the other arts, in social behavior and so on.

The direct evidence literature gives of a people's usual patterns is more restricted. Wherever an author consciously interprets or even consciously reports behavior patterns, we face the disadvantages as well as the advantages of observing through his selective, organizing mind. His opinion, to be sure, is an authentic expression of one culture bearer, but just one. Only the patterns that *he* exemplifies without discussing them—such as unexamined assumptions, intellectual methods, sentiments, properties—can be taken as presumptive evidence of ascendent patterns or 'regularities' in a people's way of life. And this evidence must of course be put together with the pertinent evidence from other than literary sources.

A tantalizing research problem is to investigate how literary stereotypes differ from other accounts of the same social realities. The most direct ways of making the comparison may be the most economical. One of the dissertations growing out of the 'Groundwork' project, for example, will compare

the attitudes and interests of French adolescents at a given moment, (1) as described by social-science research and (2) as represented in a sampling of prose fiction and plays, some of whose authors belong to the adolescent age group. This sort of inquiry might be extended to compare different moments a decade or a generation apart; and to investigate further sources of information, such as the reflection of adolescents' interests and tastes in the periodicals written for them to enjoy.

FILLING INVENTORIES; BUILDING MODELS

These two approaches we may best bracket together for our present purpose, though they are very different and both essential.

A cross-cultural inventory is useful—and is also ultimately unsatisfactory —because it enumerates parts of a way of life without assuming structural and functional relations among them. It serves as a repository for storing information until our knowledge warrants trying out models that may describe the actual interplay within the organic whole. The inventory recommended is that of the Human Relations Area Files.[8] It is published in a helpful form with many cross-references, and its plan permits comparison with the 200 or more cultures that have been analyzed for the Files.

Any working model is a long way from becoming a verified description. We must be ready to discard the present schemes if the evidence goes against them. Nonetheless, I believe that the tentative model Talcott Parsons and others have been developing provides a more meaningful overview than does any of the inventories.

Professor Parsons distinguishes four levels of increasingly complex organization beginning with the most rudimentary, which appears at the bottom of the scale:

culture
society
the personality, conscious and assumed to have a will
the human organism, unconsciously adapting to its environment

The aspect of individual or collective life that constitutes each level is conceived as a system, distinguishable by its close internal relations, though it also interpenetrates with the other systems. Each system is analyzed into a set of subsystems. Of the top two levels, which most concern us here, Parsons writes: 'The social-system focus is on the conditions involved in the interaction of actual human individuals who constitute concrete collectivities with determinate membership. The cultural-system focus on the

other hand, is on "patterns" of meaning, *e.g.*, of values, of norms, of organized knowledge and beliefs, of expressive "form." "[9]

If we conceive a society not simply as persons but as the structure of their interaction, then 'culture' and 'society' are both abstractions drawn from the same field of data. Yet it seems useful to distinguish between them. There is some evidence that they may vary independently of each other in geographical extension, in degree of development, in stability, in longevity and in accessibility to all classes of a population. Hispanic culture extends over a score of nations that have separate socio-political structures. If we look below the human level, we find that the primates and the social insects have highly developed societies but only a rudimentary culture. A human society may remain stable while its culture changes (*e.g.*, its tastes, its ideology); in contrast, a group's culture may remain rigid while its young people move away, requiring radical social readjustment. Greek and Roman cultures persist as a live force after the societies are extinct, *i.e.*, after the ancient structures of social interaction have ceased to exist. Some of the goals in life that are shared by a whole population are not accessible to underprivileged groups through socially approved means—hence one cause of deviant behavior and delinquency.[10]

A special reason for making the distinction, even if it should prove to be only an analytical convenience, is that it can help us to recognize the full range of literature's relations with the rest of human activity. 'Literature and society' as a focus of scholarly interest has resulted in relatively good coverage of the social institutions. Similarly, 'literature and psychology' seems to have encompassed the main relations of literature to the patterns of individual personality. But at the cultural level we have neglected some important aspects of literature's external context by reason of our more atomistic focus, at that level, upon areas such as literature's relationship to religion, science, the history of ideas, the other arts, poetics and linguistics. Neglected areas important for understanding a people's culture, and its literature as a part of it, can be discovered by using as a check list several broad categories of cultural phenomena. Such a list follows, with notations on needed kinds of literary studies.

Values: the culture-wide purposes (ideals, aspirations),[11] with any distinctions required between professed principles and actual practices, and any differentiation for regions, socio-economic classes, political parties, ethnic or religious subcultures and age groups.

More studies are needed that define the aesthetic and moral values implicit in literary works of art. Here the purposes of appreciating literature and of

understanding a culture run closely parallel, for the values to be defined for the latter purpose are a key to the literary quality of a work. Artistic quality may not be relevant to the study of literature as a social document, but it does directly contribute toward describing the culture to which the literary work belongs.

The culture-wide values include a contingent of method-shaping values: purposes that shape such patterns of thought as a people's methods of seeking truth or agreement, of solving problems, of creating intellectual constructs. The method-shaping values are not the same from one culture to another. French university students, for example, will take satisfaction in a clear analysis of a problem represented as insoluble, while American students will feel uncomfortable unless the analysis points to a solution. The French satisfaction in clear definition—*voir clair, préciser*—apparently belongs to a very general orientation toward theorizing, in contrast with a more pragmatic emphasis of American culture on solving problems.

The method-shaping values have been little studied, and literature (including folk literature) gives a fine chance to observe evidence of them not only in the behavior of fictional characters but in the creative procedures taken for granted by the writers. The intellectual methods an author employs —in perceiving, stating, developing, inferring—are authentic evidence of patterns in a culture, and they also have a great deal to do with the nature and worth of what he has created.

Literature has not been neglected as a source of knowledge about the values classified as sentiments and tastes: the complex emotions that become regularized responses to type situations, and that determine the subtle flavor of life peculiar to a given milieu. Sentiments and tastes, however, are usually expressed consciously by an author, and then they lack value as direct evidence of a cultural regularity.

It would help greatly in describing a culture to know the tastes of readers; but one cannot infer from a book precisely what a group of readers finds in it. The internal study of literary works or art must be sharply distinguished from studies of the social impact of literature, which fall in the field of sociology. The problems of success and influence, which André Morize included in his *Problems and Methods of Literary History* (1922), are problems for sociological techniques of statistical analysis.[12] For example, the internal study of school classics can contribute little toward the knowledge we need of the adolescent age group in France. French adolescents doubtless owe something of what they are to the literature they read, both by choice and for school. Yet the question is what they get out of their reading, and this is a problem to be investigated through questionnaires and depth interviews. Internal

study of the literature that is read can hardly do more than show what is in the art works that the boys and girls do not respond to.

> *Assumptions about reality:* the key unproved suppositions about the nature of man and the world, which in conjunction with the value system form a culture's 'ground of meaning'—one of the subsystems at the cultural level of the Parsonian model.

Just as important as values and modes of thought, for the purposes of understanding a culture and its literature, are the underlying factual assumptions of a people, often called nowadays its 'existential premises.' Whether these prove to be dated and localized or universally human they are a vital part of a culture, and they have been too little studied. Literature is an ideal hunting ground for evidence of these key beliefs: they are precisely the sort of thing that authors nearly always assume rather than report.

> *Empirical beliefs:* the conclusions of the sciences and the humanities— Parsons' 'cognitive subsystem.'

Although essentially the same empirical knowledge is universal to all Western cultures, differences in the focus of interest can be considerable, and literature is a convenient source of presumptive evidence. In Peru, for example, where high-altitude living problems are a concern, much of the 'science' one finds in fiction and journalism consists of applied biology and physical anthropology, while in France or the United States the mathematical sciences generally receive more attention.

> *Language:* (Parsons assigns the syntax patterns of language to the cultural level, relating them to the culture's ground of meaning, while he places vocabulary items, at least those limited to a social institution, at the societal level.)

Studies of language and style in literature have produced valuable results, which can be built upon by comparing language patterns with other patterns in search of more general conclusions. Meanwhile, there is room for new experimental types of research on literary language, designed to probe a people's values, ground of meaning, social attitudes and so on.

Among the kinds of linguistic evidence are words and phrases whose complex meaning proves particularly hard to translate into another language. Clyde Kluckhohn has called attention to these invaluable clues to a culture, quoting a sentence written nearly three decades earlier by Carl Becker:

If we would discover the little backstairs door that for any age serves as

the secret entranceway to knowledge, we will do well to look for certain unobtrusive words with uncertain meanings that are permitted to slip off the tongue or the pen without fear and without research; words which, having from constant repetition lost their metaphorical significance, are unconsciously mistaken for objective realities. . . . In each age these magic words have their entrances and their exits.[13]

Paralanguage and kinesics: patterns of intonation and stress, gestures and body motions, etc.

Even in consciously describing one of these conventionalities, writers of fiction often give authentic reports of its form and meaning. Such details of a culture cannot be dismissed as a negligible source of insight. The scant attention devoted to them thus far has yielded some promising ideas.

Humor: its types, topics and proprieties.

The forms of joking and the range of its subject matter, clearly important for understanding a culture and some of its literature, are among the patterns of behavior that the subtlest author is likely to exemplify as faithfully as any other bearer of a culture. For humor must conform to an expected pattern or there is no 'point' to the joke; and the range of topics is determined by social control.

Art forms: Parsons' 'expressive symbolization' subsystem.

The arts of a people express its culture through their form as well as through their subject matter. Consequently the canons or norms that govern literary *genres*—their structure, tone, admissible materials, etc.—must be included in the describing of a culture. Here again the purpose of describing a culture parallels that of understanding literature itself. For the structure of a work and the other canons of form actualized in it carry a part of its artistic import. Furthermore, we grasp a single literary creation more fully if we know that it belongs to a type, such as the psychological novel or the lyric poem; and the fluid state of literary *genres* in our time requires us continually to define and redefine the types, on the basis of the same canons or norms that serve the purpose of cultural and of textual analysis.

Here we may end our list of main categories at the cultural level. It is clear that in several of these categories, the study of literature can make fresh contributions toward understanding a culture, while deepening our insight at the same time into literature itself.

Let me pass quickly over the similar check list of categories for the levels of society and personality. These levels fall outside our present topic, though all four levels, even the organismic, so interact that one can hardly overstress

their interdependence. The societal categories would be the familiar social institutions such as the familial, religious, educational, economic-occupational, political and judicial, intellectual-aesthetic and recreational. The categories of individual conduct may usefully include (among others) four different contexts of behavior and attitudes, all of which good fiction can help to illumine: the contexts of public communication, of the intimate group of friends, of verbalized but uncommunicated thoughts and of unverbalized but observable behavior.

ABSTRACTING MAIN THEMES

Of the six interdependent ways I am recommending to study a culture, this one is the most promising because it leads to central meanings which confer significance on diverse manifestations of the culture. In contrast, the models of cultural and social systems lead to much more limited sets of largely cause-and-effect or reciprocal-effect relations. Sorokin's distinction between the causal and the meaning-oriented methods of integration still stands, and it is the latter, the more intuitive search for unifying themes— basing itself where it can on quantitative comparisons and correlations— that leads to the discovery of 'consistent *styles*, typical *forms*, and significant *patterns*.'[14] A structural description of a culture must use both system-models and theme-configurations where they respectively apply.

The systematic 'themal' analysis of a culture developed by Morris E. Opler[15] starts with small 'theme expressions' observed in many details of a people's life and proceeds inductively to organize these according to the affinities among them, in pyramids of progressively fewer, more inclusive generalizations. The method avoids assuming that the peaks of the pyramids will duplicate previous stereotypes of 'national traits.' Each culture studied thus far appears to have only around a dozen irreducible themes at any moment. The tendency of themes to proliferate is checked by a counter-force toward simplification, perhaps because conflicts among values increase with the number of themes.

Literary study that abstracts and organizes theme expressions can serve the understanding of literature as well as of culture. There are, of course, the literal substantive themes like piety and motherhood, whose presence may have nothing to do with literary worth. But there are also intriguing substantive themes in the 'mythical state' which resist any literal statement. And there are procedural themes—the subtle modes of thought and their animating purposes—whose imprint upon the work of art becomes a part of its character and its excellence.

The 'themal' approach to literature must not be confused with a listing of motifs or topics. The search for the themes of a culture proceeds by synthesizing uncatalogued expressions into progressively larger configurations, first within literature and then beyond. The approach from a motif index proceeds by cataloguing discrete items under the headings of a cross-cultural inventory, whose additive arrangement leads neither to a structural model nor to a thematic synthesis.

A continuing study is being made, by several methods, of themes in the writings of five very different contemporary French authors: René Marill-Albérès, Yves Bonnefoy, Michel Butor, Pierre Daninos and Jean Bruller-Vercors. Each author is to write an essay defining the main themes of his life work, and later to comment on a list of purported themes of contemporary French culture. Students of his writings will abstract themes from theme expressions. And as a limited experiment, scientific 'content analysis' will be applied to some of the writings. It is expected that comparison of the conclusions reached by the different methods will show each of them to have advantages and blind spots. A philosophically minded scholar may, for example, bring to light more 'ground of meaning' assumptions than the author himself. Contributory studies are invited.

SYNTHESIZING HISTORICALLY; COMPARING CULTURES

These two approaches to a culture build on the more restricted ones already mentioned, as is evident; and they broaden the significance of the smaller-scale conclusions by embodying them in a more general understanding.

The historical and cross-cultural perspectives thus achieved can serve the understanding of literature. They add to its setting two great dimensions, each as epic-like in scale of grandeur as the aesthetic perspective achieved by applying the theoretic principles of internal exegesis and criticism.

The two more external perspectives can also serve our literary scholarship. In the presence of an active, interdisciplinary pursuit of historical synthesis and comparative study of cultures, the literary scholar can limit himself to questions answerable by his discipline's methods of inquiry, and yet can visualize the whole to which his contribution belongs. The parallel efforts of inquirers in other disciplines to define their working principles, moreover, enable him, when he does the same, to see precisely where it will be sound or unsound to integrate his conclusions into larger generalizations. To visualize our studies in this way as part of a multi-disciplinary enterprise constitutes a salutary criticism of much that we are now doing, particularly as we generalize and interpret the results of our investigations.

Studies of literature, in return, can illumine both the historical and the cross-cultural perspectives. Besides contributing to interdisciplinary syntheses, literary history can serve as an invaluable pioneer, finding likely possibilities of new syntheses both in the history of a culture and in the vast fields of the similarities and contrasts among ways of life. For literature is after all the most explicit record of the human spirit. The study of comparative literature is a mine of suggestive comparisons between cultures, as comparative government and comparative education are at the level of social institutions. No less suggestive are the literary works themselves which explore the conflict points and bases of compatibility between peoples as revealed in instances of contact.

Now that Westerners are coming to recognize the necessity of a perspective embracing the non-Western cultures, the pioneering capacity of literary studies is called upon for a further range of service to human understanding —as important, possibly, as is the cherishing enjoyment of literature itself. In my opinion, the two values need not conflict.

NOTES

[1] Walter Sutton, 'Contextualist Theory and Criticism as a Social Act,' *Journal of Aesthetics and Art Criticism*, XIX, No. 3 (Spring, 1961), 317–325 (especially p. 319).
[2] Milton C. Albrecht, 'The Relationship of Literature and Society,' *American Journal of Sociology*, LIX, No. 5 (March, 1954), 425–436.
[3] These three relationships seem to cover all the very diverse ways in which imaginative writers deal with social matters or otherwise relate to their culture. The diversity is striking, however, in such lists of studies as the two published jointly by General Topics VI of the Modern Language Association and the University of Miami Press: Thomas F. Marshall, George K. Smart and Louis J. Budd (eds.), *Literature and Society, 1950–1955: A Selective Bibliography*, University of Miami Publications in English and American Literature, No. 2 (Coral Gables, Fla.: University of Miami Press, 1956); Thomas F. Marshall and George K. Smart (eds.), *Literature and Society, 1956–1960; A Selective Bibliography*, University of Miami Publications in English and American Literature, No. 4 (Coral Gables, Fla.: University of Miami Press, 1962).
[4] I have elaborated this contention in an article on 'Literature, Area Study, and Hispanic Culture,' *Yearbook of Comparative and General Literature*, No. 10 (Bloomington: Indiana University Press, 1961), pp. 49–58. Also in *Hispania*, XLIV, No. 3 (September, 1961), 465–472. Cf. also Chap. 6, 'Theme: Statement and Idea,' in Cleanth Brooks and Robert Penn Warren, *Understanding Poetry*: 'The theme is as inevitable to poetry as

are words.' 3d ed. (New York: Holt, Rinehart and Winston, 1960), p. 340.
[5] 'Groundwork for a Structural Description of French Culture,' Project No. OE–2–14–031 of the Language Development Program, U.S. Office of Education, under Title VI of the National Defense Education Act of 1958.
[6] Geneva: Droz, 1949–50. Five small volumes.
[7] Unpublished. The most ingenious of these were utilized by Rhoda Métraux and Margaret Mead, *Themes in French Culture: A Preface to a Study of French Community*, Hoover Institute Studies, Series D, No. 1 (Stanford, Calif.: Stanford University Press, 1954).
[8] George P. Murdock, Clellan S. Ford, Alfred E. Hudson, Raymond Kennedy, Leo W. Simmons, and John W. M. Whiting, *Outline of Cultural Materials*, Behavior Science Outlines, Vol. I, 4th rev. ed. (New Haven, Conn.: Human Relations Area Files, Inc., 1961).
[9] Talcott Parsons, Edward Shils, Kaspar D. Naegele, and Jesse R. Pitts (eds.), *Theories of Society: Foundations of Modern Sociological Theory* (Glencoe, Ill.: The Free Press, 1961), I, 34.
[10] For the discrepancy between cultural values and institutional means, see pp. 99–100 of Richard Jessor, 'A Social Learning Approach to Culture and Behavior,' in Anthony F. C. Wallace (ed.), *Anthropology and Human Behavior* (Washington, D.C.: Anthropological Society of Washington, 1962), pp. 94–114.
[11] Parsons' motivational or consummatory subsystem. 'The Functional Differentiation of Cultural Systems,' *op. cit. supra*, II, 982–984.
[12] This point is well recognized by René Wellek and Austin Warren in their *Theory of Literature*, Chap. 9, 'Literature and Society' (New York: Harcourt, Brace & World, 1942; Harvest Book ed., 1956), p. 91. The entire chapter, with its notes and bibliography, is valuable background for the present discussion.
[13] Clyde Kluckhohn, *Anthropology and the Classics* (Providence, R.I.: Brown University Press, 1961), p. 44. From Carl Becker, *The Heavenly City of the Eighteenth Century Philosophers* (New Haven, Conn.: Yale University Press, 1932), p. 47.
[14] Pitirim A. Sorokin, *Social and Cultural Dynamics*, Vol. I, *Fluctuation of Forms of Art* (New York: American Book Company, 1937), Part 4, 'Logico-meaningful Integration and the Method of its Study.' See p. 23.
[15] See 'Themes as Dynamic Forces in Culture,' *American Journal of Sociology*, LI, No. 3 (November, 1945), 198–266; and 'The Themal Approach in Cultural Anthropology and Its Application to North Indian Data,' *Southwestern Journal of Anthropology*, XXIV (1968), 215–227.

RICHARD WOLLHEIM

*Sociological Explanation of the Arts: Some Distinctions**

I. TO GIVE AN *explanation* of an event A is to cite another event B which stands in a certain relation to A such that its existence makes the existence of A intelligible.

II. There are *prima facie* various different relations in which B might stand to A that have this consequence, *e.g.*, B might be the cause of A, or the motive for A, or a whole of which A is a part. Corresponding to each different relation there is a *different type of explanation*.

III. The explanation of A is *sociological* when B is a social factor, *e.g.*, an economic fact, or a fact about class structure.

It has been claimed by a number of writers that the mark of any truly scientific or progressive art history is the use of sociological explanation.[1] It follows, however, from the nature of explanation that there could be more than one type of sociological explanation: a fact of which its advocates seem scarcely aware.[2] In this paper I want to argue that not only could there be more than one type of sociological explanation, but in fact there is: further, that it is important to distinguish between the different types since each involves certain presuppositions peculiar to it. For one is not likely to get far either in giving or in assessing any particular explanation until one is clear what general type of explanation is involved.

1. The first and simplest type of social explanation of art is *causal*. On this view works of art are explained as being determined by, or as effects of, the

* Reprinted from *Proceedings of the Third International Congress on Aesthetics*,Venice, 1965, by permission of the author and of Professor Luigi Pareyson, Director of the Instituto di Estetica, University of Turin, Italy.

social conditions under which they are found. So for example Hauser seeks to explain the development of classicism in early Cinquecento painting as the effect of the struggle of the dominant elite to consolidate its social and economic position.[3]

The question arises of under what conditions we are entitled to claim that a given work of art is the effect of certain social conditions. More particularly, what justifies us in talking not just of the classicism of Raphael *and* a conservative society but of the classicism of Raphael *because of* a conservative society? Here, of course, we touch upon a central problem in the methodology of science, which cannot be discussed briefly: the analysis of causation. All I can do is to state quite baldly what seems to me to be incontrovertible: that is, that even if the empiricist analysis does not give us the whole answer, it certainly gives us part of the answer.[4] A necessary if not a sufficient condition for asserting a causal connection between an event B and an event A is the assertion of a regularity statement to the effect that whenever events of kind B take place, then events of kind A occur. From this it follows that any explanation of a particular work of art as the effect of certain social conditions presupposes a correlation between similar social conditions and similar works of art.

It would appear, then, that causal explanation in art history commits one to a certain program of art-historical inquiry. Without wishing to prejudge the results of such empirical research, I should like to observe:

a. It is noteworthy that despite the intensive study of the arts that has gone on in the last seventy or eighty years, no historian has produced any correlation between social conditions and art forms except on the most general, and therefore most trivial, level.[5]

b. It is arguable that even if such correlations were produced, explanation in terms of them would not be satisfying. For in relating works of art *directly* to social conditions, we should be omitting all reference to psychological factors and so, by implication, asserting these factors to be of no relevance to the understanding of art. But such a suggestion must be repugnant to all. Indeed it seems that particular sociological explanations are likely to be acceptable only to the degree to which interpolation of psychological factors between the social conditions and the works of art is easy and natural: that is to say, to the degree to which as explanations they cease to be sociological.[6]

My point about causal explanation might be put by saying that the causal relation is not a particular but a general relation. It holds, that is, not between particular things but between classes of things. Or if in conformity with ordinary usage we allow it to hold between particular things we must·

insist that it holds between them solely in virtue of their belonging to the class they do.

This point has been inadequately grasped by determinist historians of culture who often write as if a causal connection between a certain cultural product and its social environment could be not merely suggested, but conclusively established, by a close examination of these two phenomena in isolation: without, that is to say, any investigation of similar phenomena.[7] Such an approach is partly due to a metaphysical view of the causal nexus prevalent among determinist historians;[8] but partly it is that historians who are causal in their language are not always causal in their thought. Though they may talk of 'social determination,' what they have in mind is some other, noncausal type of sociological explanation.

2. Another type of sociological explanation of art is what might be called *expressive*. On this view (which is undoubtedly widespread) works of art are seen as expressing, as reflections of, the social conditions under which they are found. So, for instance, Antal writes: 'However much Giotto's art may be considered a great personal achievement, it must never be forgotten that it was at the same time the artistic expression of the widespread rule of the Florentine upper middle class at their ideological zenith.'[9]

The question now arises as to under what conditions we are entitled to claim that a given work of art is the expression, or reflection, of given social conditions. More particularly, what justifies us in talking not just of Giotto's painting *and* a prosperous upper-middle-class rule but of Giotto's painting *because of* a prosperous upper-middle-class rule? Now, the answer to this question differs I think from that given to the earlier question, in that here it seems possible to claim that we *observe* the connection, that we *see* that the art expresses its society or that we see the image of the society in its art. Accordingly we do not need knowledge of instances of similar art or, for that matter, knowledge of any other art at all. We see the society in its art as we see a man in his portrait, or his character in his handwriting: directly.

But, even if the expressive type of explanation, in contradistinction to the causal type, does not presuppose any general correlation between kinds of art and kinds of society, it is not without presuppositions of a general kind. For in order either to employ or to assess it, we need a general and consistent method of reading off social conditions from works of art so that every particular work tells us uniquely of one set of social conditions. Such a method most naturally takes the form of a general theory about the function of art in society, *e.g.*, that art depicts society, or that it idealizes society, or that it is a compensation for society.

In this connection, I should like to observe:

a. Whereas the correlations required by causal explanation are hard to find, theories of art are abundant. The trouble is indeed that there are so many plausible theories in circulation that, between them, they allow one to see any form of society in any given work of art.[10]

b. Whereas correlations between forms of art and social conditions deliberately ignore all psychological factors, theories of art pay a rather dubious lip-service to them. For to talk of the purpose of art half-suggests that one is talking of the purposes of artists: though it is noticeable that when theories of art are recast in their form, their plausibility diminishes.

3. The third type of social explanation of art is what might be called *anecdotal*. On this view there is no single relation sought for as holding works of art and social conditions: but in the case of each particular work of art a story is told which has as its first term some social or economic fact and as its last term the genesis of the particular work. As an example of this type of explanation, one might quote Meiss's effort to relate the style of religious painting current in Florence and Siena in the third quarter of the Trecento via a number of links to certain social and economic disasters that overtook the two cities in the 1340's and 1350's.[11]

Of this type of explanation it might be observed that

a. Unlike the two other types of explanation it involves no general presuppositions. For the connection that each incident in the anecdote has (or is supposed to have) with its predecessor and its successor satisfies merely the common-sense demand of congruity or relevance.

b. Unlike the two other types of explanation, this third type lays no claim either to exclusiveness or to finality. For, on a common-sense level, one account of a particular event does not necessarily enter into competition with other accounts of it. Claims to definitiveness emerge only when we claim to pierce the surface of things and find them 'underlying' or 'ultimate' explanations.

NOTES

[1] *E.g.*, A. von Martin, *Soziologie der Renaissance* (Stuttgart, 1932) translated as *Sociology of the Renaissance* (London, 1944), particularly author's preface to English translation; Frederik Antal, *Florentine Painting and its Social Background* (London, 1947); and 'Remarks on the method of Art History,' in *Burlington Magazine*, XCI (February–March, 1949), 49–52 and 73–75; Arnold Hauser, *The Social History of Art* (London, 1951),

2 vols. It is to be noted that Antal's claims on behalf of 'sociological interpretation' (as he calls it) are more extreme in *Florentine Painting* than in the Burlington articles. In the latter he suggests that the sociological method is only among several, though undoubtedly the most 'progressive.' In the former, however, he argues for its absolute superiority: Cf. 'The time will undoubtedly come when the purely factual basis, no less than the method of sociological interpretation, will be much more solidly established than it is to-day, and when each detail will take its proper place and be *correctly* interpreted,' *op. cit.*, p. 9 (my italics).

2 A glaring example of this is Antal's 'Remarks on the method of Art History.' Antal, who was really an advocate of sociological explanation in the strictest Marxist sense, nevertheless claimed as supporters of this new method critics and historians as diverse in approach as Gombrich, Herbert Read, Wind, George Thomson, Meyer Schapiro and Blunt. Equally significant in this context is Antal's misinterpretation of his own 'Observations on Girolamo da Carpi,' *Art Bulletin*, XXX (June, 1948), 81–103. For in this essay Antal accounts for Girolamo's stylistic evolution partly by appeal to 'influences' (in an 'old-fashioned' art-historical way) and partly by appeal to the terms of Girolamo's patronage and the nature of his various commissions. But in summarizing the essay Antal says that he has tried to show how the style of the period 'was ultimately based on the social changes.'

3 Hauser, *op. cit.*, pp. 345–348.

4 The best modern discussion of the problem of causation is to be found in G. H. F. von Wright, *The Logical Problem of Induction* (Helsinki, 1941).

5 *E.g.*, that nomadic tribes do not produce monumental works of art, R. Hinks, *Carolingian Art* (London, 1935), p. 209. On the poverty of the requisite correlations, see Meyer Schapiro 'Style,' in Kroeber (ed.), *Anthropology Today* (Chicago, 1953), pp. 310–311.

6 In other words, we are unlikely to accept an explanation of a work of art as the effect of certain social conditions unless we can see fairly straightforwardly how the social conditions might have induced a state of mind of which the work of art was a natural expression. This general view is borne out by consideration of particular cases. We can accept quite readily Plekhanov's explanation of Boucher's painting by reference to its alleged cause, the idleness and dissipation of the aristocracy, because we can understand how such an art might appeal to people in that position: see 'French Dramatic Literature and French Eighteenth-Century Painting from a Sociological Standpoint,' in G. V. Plekhanov, *Art and Social Life* (London, 1953), pp. 153–154. On the other hand, Hauser's explanation of the transition from the naturalistic style of Paleolithic art to the geometrical style of Neolithic art by reference to the transition from a hunting to a nomadic economy seems quite empty as an explanation because we do not see how this economic change could have been connected with a change in artistic style; that is to say, how the economic change could have led men to change or modify their style; see Hauser, *op. cit.*, pp. 35–43. An amusing commentary on this issue is provided by Hauser's attempt to explain the

rise of portraiture by reference to the development of commerce. Sensing the lack of explanatory value in this mere correlation, Hauser interpolates a psychological link in order to give it plausibility; he says that commercial life, by setting a premium on the ability to sum up a business partner, increases the interest in human psychology and this leads on to portraiture, *ibid.*, pp. 261–262. In this case the psychological interpretation is obviously strained, so we suspend judgment on Hauser's explanation irrespective of the truth of the correlation he cites. It is to be noted, however, that Hauser would resist this interpretation of his practice: for he explicitly rejects the value of psychological over sociological explanation; see his whole treatment of chivalric love, *ibid.*, pp. 219–221, particularly the following: 'But illuminating as is a psychological analysis of the equivocal nature of these emotions, the psychological facts are a product of historical circumstances which in turn require explanation and can only be explained sociologically. The psychological mechanism of this attachment to the wife of another, and of this intensification of emotion through the freedom with which it could be expressed, could never have been set in motion without the force of ancient religious and social taboos having first been weakened and the soil prepared for such an exuberant growth of erotic feelings by the rise of a new emancipated upper class. In this case, too, psychology, as so often, is only unclear, disguised, incompletely worked-out sociology.'

[7] *E.g.*, Plekhanov, having analyzed the social situation in France at the end of the eighteenth century, concludes: 'Having established the social causes which gave birth to the school of David, it is not difficult to explain its fall,' *op. cit.*, p. 158.

[8] For the Marxist view of causation, see particularly Lenin, *Materialism and Empirio-Criticism*, Chap. 3, Sec. 3.

[9] Antal, *op. cit.*, p. 165. Cf. 'Like the contemporary work of Giovanni da Milano in the Rinuccini chapel, these frescoes [*i.e.*, those in the Cappella Spagnuola] eminently reflect the transitional phase of upper middle class decline and the growing influence of the lower middle class, *ibid.*, p. 200. The interpretation of a society's culture as the 'reflection' or 'expression' of its economic basis is found in the great classics of Marxism, although undoubtedly official theory favors causal explanation; see, for example, Engel's interpretation of European religious history in the special introduction to the English translation of *Socialism Utopian and Scientific* (London, 1912), *e.g.*, 'His [*i.e.*, Calvin's] predestination doctrine was the religious expression of the fact that in the commercial world of competition success or failure does not depend upon a man's activity or cleverness, but upon circumstances uncontrollable by him.' Cf. Plekhanov's interpretation of Diderot's aesthetic as a 'reflection' of the revolutionary aspirations of the French Third Estate, *op. cit.*, p. 149.

Antal, though by profession a social determinist, employs a method which is a subtle and somewhat ambiguous variant of the expressive type of explanation. He characterizes it as follows: 'We can understand the origins and nature of co-existent styles only if we study the various sections

of society, reconstruct their philosophies and thence penetrate to their art,'
ibid., p. 4. In other words, the correct explanation of a work of art consists
of two steps: first showing that the work of art is intimately connected
with the literary, philosophical, religious, economic ideas of a certain
class, generally by means of certain thematic resemblances; and secondly,
showing that these ideas are somehow intrinsic to the class as such. The
first step is unexceptionable, although it has been forcefully argued that
Antal in carrying it out is often inaccurate or slipshod; see reviews of
Florentine Painting by Millard Meiss, *Art Bulletin*, XXXI (June, 1949),
143–150; and by Theodor E. Mommsen, *Journal of History of Ideas*, XI
(June, 1950), 369–379. But the second step of the explanation is open to
the difficulties inherent in any expressive type of explanation. Yet it is
clearly an essential step if the explanation is to be truly sociological. For to
relate works of art to ideas that happen to be held by a social class would
not be to give a sociological explanation; cf. the case where kinds of art are
correlated with blood groups, and division into blood groups happens for
no apparent reason to coincide with class divisions.

Antal clearly shows himself aware of the problem that confronts him
when he writes: 'Co-operation between the various branches of historical
science is still in a rudimentary stage; the number of books on the
psychology of the different social classes, particularly those which take the
historical development genuinely into account is very small,' *op. cit.*, pp.
8–9. But in the main text of the book he ignores these difficulties. So we
find him writing, for instance, of 'Arnolfo's "classic" style, springing from
an upper middle class mentality,' *op. cit.*, p. 128; or that 'The whole of
Daddi's composite style . . . corresponded exactly to the mentality of the
Florentine upper middle class of this generation,' *op. cit.*, p. 182. If Antal
means here by 'Florentine upper middle class mentality' merely the
mentality that the Florentine upper middle class happened to possess, his
explanation is not sociological; if, however, he means that which it
necessarily possessed, he has to explain by what right he thinks that it did
possess it necessarily.

Meiss in his review calls Antal's class concepts 'ideal concepts'—in that
they do not coincide with the actual contours of class groupings. This
doubtless is true. What is also true—and in some ways a more fundamental
point—is that they are what might be called 'classificatory' rather than
'referential' concepts.

10 Plekhanov provides a very good example of this kind of trivialization.
He held that the role of art in society can be explained in terms of one or
other of two principles: the principle of *imitation* (inherited from Tarde)
and the principle of *contradiction or antithesis*; see 'Letters without
Address' in Plekhanov, *op. cit.*, pp. 31–50. It is difficult to see how this
does not in practice amount to saying that works of art either copy social
conditions or do not copy them.

Other sociological historians are less explicit about their theories of art,
although one can usually glean what they are from the way particular
works are interpreted. The following passage from Antal, *Florentine*

Painting, seems to contain implicitly two theories: 'They [the Florentine upper middle class of the fourteenth century] liked to have their own religious ideals portrayed—for example, the pious friar (usually in the guise of a friar saint), charity (often in the form of a good work)—by which the justification of their own everyday life was elevated into the stable, religious sphere. Such representations helped to make their ideals convincing and binding for the other social classes as well,' *op. cit.*, p. 121. And another theory seems implied in this passage: 'The ideology of these illustrations [cassone panels of the early fifteenth century] is of the feudal-classic variety suited to this kind of patron and to this type of picture: they were commissioned from workshops, often employing artisan-like methods, by the wealthy, aristocratising, not over-progressive, yet to some extent cultured, middle class on the occasion of their marriages, and bore their coats-of-arms. Antiquity is here thought of as something at once archaic and distinguished, and appears in these cassoni as an especially elegant, aristocratic dream world,' *op. cit.*, p. 369.

[11] Millard Meiss, *Painting in Florence and Siena after the Black Death* (Princeton, 1951). On the distinction between the first and second types of sociological explanation and the third type, there are some suggestive remarks in E. Gombrich's review of Hauser, *Social History*, in *Art Bulletin*, XXXV (March, 1953), 79–84.

LUCIEN GOLDMANN

The Sociology of Literature: Status and Problems of Method*

THE GENETIC STRUCTURAL sociology of culture has given rise to a number of works which are characterized, in particular, by the fact that, in seeking to establish an operational method for the positive study of human facts—and, more especially, of cultural creation—their authors have been obliged to fall back on a type of philosophical reflection that might, in a somewhat general way, be described as dialectic.

The result is that this attitude may be presented either as an effort of positive research incorporating a mass of reflections of a philosophical character or as a philosophical attitude directed, in the first place, toward positive research and, in the end, constituting the methodological basis of a whole series of specific research activities.

Having, on more than one occasion, chosen the former of these methods of exposition, we shall endeavor to adopt the second. In doing so, however, it is important to stress from the very outset—but without much hope as to the effectiveness of this warning, for prejudices die hard—that the few remarks of a general and philosophical nature which follow are not prompted by any speculative intention and are put forward only insofar as they are essential to positive research.

The first general observation on which genetic structuralist thought is based is that all reflection on the human sciences is made not from without but from within society, that it is a part—varying in importance, of course,

* Reprinted from the *International Social Science Journal*, Vol. XIX, No. 4, 1967, by permission of the author and The United Nations Educational, Scientific and Cultural Organization.

according to circumstances—of the intellectual life of that society and, through it, of social life as a whole. Furthermore, to the selfsame extent to which thought is a part of social life, its very development transforms that social life itself more or less, according to its importance and effectiveness.

In the human sciences, the subject of thought is thus seen to form part, at least to some extent and with a certain number of mediations, of the object to which it is directed. On the other hand, this thought does not constitute an absolute beginning and it is, in a very large measure, shaped by the categories of the society which it studies, or of a society deriving therefrom. Thus the object studied is one of the constituent elements—and even one of the most important—of the structure of the thought of the research worker or workers.

Hegel summed all this up in a concise and brilliant formula—'the identity of the subject and object of thought.' We have merely attenuated the radical character of this formula—the result of Hegelian idealism, for which all reality is spirit—by substituting for it another, more in conformity with our dialectical materialist position according to which thought is an important aspect, but only an aspect, of reality: we speak of the partial identity of the subject and the object of research, that identity being valid, not for all knowledge, but only for the human sciences.

Whatever view is taken of the difference between the two formulas, however, they both affirm implicitly that the human sciences cannot have as objective a character as the natural sciences and that the intervention of values peculiar to certain social groups in the structure of theoretical thoughts is, at the present time, both general and inevitable in them.

This does not in any way, moreover, mean that these sciences cannot, in principle, attain a rigor similar to that of the sciences of nature; that rigor will merely be different and it will have to allow for the intervention of valorizations that cannot possibly be eliminated.

The second basic idea of any dialectic and genetic sociology is that human facts are the responses of an individual or collective subject, constituting an attempt to modify a given situation in a sense favorable to the aspirations of that subject. This implies that all behavior—and consequently every human fact—has a significant character, which is not always evident but which the research worker must, by his work, bring to light.

The same idea can be expressed in several different ways—by saying, for instance, that all human behavior (and, probably, even all animal behavior) tends to modify a situation felt by the subject to be a disequilibrium so as to establish an equilibrium or, again, that all human behavior (and, probably, all animal behavior) can be translated by the research worker in terms of

the existence of a practical problem and of an attempt to solve that problem.

Starting from these principles, the structuralist and genetic conception, the creator of which is unquestionably George Lukács, favors a radical transformation of the methods of the sociology of literature. All the earlier works—and most of the university works undertaken subsequently to the appearance of this conception—were concerned and still are concerned, in this discipline, with the content of literary works and the relationship between that content and the collective consciousness, that is to say, the ways in which men think and behave in daily life. This being the standpoint adopted, they naturally arrive at the result that the relationships between these two contents are all the more numerous, and literary sociology is all the more efficacious, according as the author of the writings studied has given proof of less creative imagination and has contented himself with relating his experiences while transposing them as little as possible. Furthermore, this type of study must, by its actual method, break up the unity of the work by directing its attention above all to whatever in the work is merely the reproduction of empirical reality and of daily life. In short, this sociology proves to be all the more fertile the more the works studied are mediocre. Moreover, what it seeks in these works is more documentary than literary in character.

It is not at all surprising, in these circumstances, that the great majority of those who are concerned with literature consider this kind of research as being, in the best of cases, only of very relative value and sometimes reject it altogether. Genetic structuralist sociology starts from premises that are not merely different but even quite opposite; we should like to mention here five of the most important of them:

1. The essential relationship between the life of society and literary creation is not concerned with the content of these two sectors of human reality, but only with the mental structures, with what might be called the categories which shape both the empirical consciousness of a certain social group and the imaginary universe created by the writer.

2. The experience of a single individual is much too brief and too limited to be able to create such a mental structure; this can only be the result of the conjoint activity of a large number of individuals who find themselves in a similar situation, that is to say, who constitute a privileged social group, these individuals having, for a lengthy period and in an intensive way, lived through a series of problems and having endeavored to find a significant solution for them. This means that mental structures or, to use a more

abstract term, significant categorial structures, are not individual phenomena, but social phenomena.

3. The relationship already mentioned between the structure of the consciousness of a social group and that of the universe of the work constitutes, in those cases which are most favorable for the research worker, an homology which is more or less rigorous but often also a simple significant relationship; it may therefore happen, in these circumstances—and it does indeed happen in most cases—that completely heterogeneous contents and even opposite contents, are structurally homologous, or else are found to be in a comprehensive relationship at the level of categorial structures. An imaginary universe, apparently completely removed from any specific experience—that of a fairy tale, for instance—may, in its structure, be strictly homologous with the experience of a particular social group or, at the very least, linked, in a significant manner, with that experience. There is therefore no longer any contradiction between, on the one hand, the existence of a close relationship between literary creation and social and historical reality and, on the other hand, the most powerful creative imagination.

4. From this point of view, the very peaks of literary creation may not only be studied quite as well as average works, but are even found to be particularly suitable for positive research. Moreover, the categorial structures with which this kind of literary sociology is concerned are precisely what gives the work its unity, that is to say, one of the two fundamental elements of its specifically aesthetic character and, in the case we are interested in, its truly literary quality.

5. The categorial structures, which govern the collective consciousness and which are transposed into the imaginary universe created by the artist, are neither conscious nor unconscious in the Freudian sense of the word, which presupposes a repression; they are nonconscious processes which, in certain respects, are akin to those which govern the functioning of the muscular or nervous structures and determine the particular character of our movements and our gestures. That is why, in most cases, the bringing to light of these structures and, implicitly, the comprehension of the work can be achieved neither by immanent literary study nor by study directed toward the conscious intentions of the writer or toward the psychology of the unconscious, but only by research of the structuralist and sociological type.

But these findings have important methodological consequences. They imply that, in the human sciences, all positive study must always begin with an effort to dissect the object studied, so that the object is seen as a complex

of significant reactions, the structure of which can account for most of the partial empirical aspects they present to the research worker.

In the case of the sociology of literature, this means that, in order to understand the work he is studying, the research worker must in the very first place seek to discover a structure which accounts for practically the whole of the text and must, for that purpose, observe one fundamental rule—which, unfortunately, the specialists of literature respect only very rarely—namely, that the research worker must account for the whole of the text and must add nothing to it. This means, too, that he must explain the genesis of that text by trying to show how and in what measure the building up of the structure which he has brought to light in the work has a functional character, that is to say, to what extent it constitutes an instance of significant behavior for an individual or collective subject in a given situation.

This way of posing the problem entails numerous consequences, which modify profoundly the traditional methods of study of social facts and, in particular, of literary facts. Let us mention a few of the more important of these, taking first the fact of not attaching special importance, in the comprehension of the work, to the conscious intentions of individuals and, in the case of literary works, to the conscious intentions of their authors.

Consciousness, indeed, is only a partial element of human behavior and, most frequently, has a content which is not adequate to the objective nature of that behavior. Contrary to the views of a certain number of philosophers, such as Descartes or Sartre, significance does not appear with consciousness and is not to be identified with it. A cat which is chasing a mouse behaves in a perfectly significant manner, without there being necessarily, or even probably, any consciousness, even of a rudimentary character;[1] of course, when man and, with him, symbolic function and thought appear in the biological scale, behavior becomes incomparably more complex; the sources of problems, conflicts and difficulties, and also the possibilities of resolving them, become more numerous and more involved, but there is nothing to indicate that consciousness often—or even occasionally—covers the whole of the objective significance of behavior. In the case of the writer, this same idea may be expressed in a much simpler fashion: it very frequently happens that his desire for aesthetic unity makes him write a work of which the overall structure, translated by the critic into conceptual language, constitutes a vision that is different from and even the opposite of his thought and his conviction and the intentions which prompted him when he composed the work.

That is why the sociologist of literature—and, in general, the critic—must treat the conscious intentions of the author as one indication among

many others, as a sort of reflection on the work, from which he gathers suggestions, in the same way as any other critical work, but on which he must form his judgment in the light of the text, without according it any favor.

Next we have the fact of not overestimating the importance of the individual in the explanation, which is above all the search for the subject, whether individual or collective, for which the mental structure which governs the work has a functional and significant character. The work has almost always, of course, an individual significant function for its author, but, most frequently, as we shall see, this individual function is not, or is only slightly, connected with the mental structure which governs the truly literary character of the work, and, in any case, it does not in any way create it. The fact of writing plays—and, more precisely, the plays he really wrote—doubtless had significance for the individual Racine, in the light of his youth passed in Port-Royal, his relations later with people of the theater and with the Court, his relations with the Jansenist group and its ideas and also many events in his life with which we are more or less familiar. But the existence of the tragic vision was already a constituent element of the situations forming the starting point from which Racine was led on to write his plays, whereas the building up of that vision, under the influence of the ideologists of the Jansenist group of Port-Royal and Saint-Cyran, was the functional and significant response of the *noblesse de robe* to a given historical situation. And it is with reference to that group and to its more or less developed ideology that the individual Racine had later to face a certain number of practical and moral problems which resulted ultimately in the creation of a work shaped by a tragic vision pursued to an extremely advanced degree of coherence. That is why it would be impossible to explain the genesis of that work and its significance merely by relating it to Racine's biography and psychology.

Thirdly, we have the fact that what are commonly called 'influences' have no explanatory value and, at the very most, constitute a factor and a problem which the research worker must explain. There are at every moment a considerable number of influences which may have their effect on a writer; what has to be explained is the reason why only a small number of them, or even only a single one, has really had any effect, and also why the works which have exerted this influence, were received with a certain number of distortions—and precisely with those particular distortions—in the mind of the person they influenced. But these are questions to which the answer must be sought in the work of the author studied and not, as is usually thought, in the work which is supposed to have influenced it.

In short, comprehension is a problem of the internal coherence of the text, which presupposes that the text, the whole of the text and nothing but the text, is taken literally and that, within it, one seeks an over-all significant structure. Explanation is a problem of seeking the individual or collective subject (in the case of a cultural work, we think, for the reasons we have given above,[2] that it is always a collective subject that is involved), in relation to which the mental structure which governs the work has a functional character and, for that very reason, a significant character. Let us add that, so far as the respective places of explanation and interpretation are concerned, two things which seem to us to be important have been brought to light by the works of structuralist sociology and by their confrontation with psychoanalytical works.

The first is the fact that the status of these two processes of research is not the same from two standpoints.

When libido is involved, it is impossible to separate interpretation from explanation, not only during, but also after, the period of research, whereas, at the end of that period, the separation can be effected in sociological analysis. There is no immanent interpretation of a dream or of the delirium of a madman,[3] probably for the simple reason that consciousness has not even any relative autonomy on the plane of the libido, that is to say on the plane of the behavior of an individual subject aiming directly at the possession of an object. Inversely, when the subject is transindividual, consciousness assumes much greater importance (there is no division of labor and, consequently, no action possible without conscious communication between the individuals who make up the subject) and tends to constitute a significant structure.

Genetic sociology and psychoanalysis have at least three elements in common, namely: (1) the assertion that all human behavior forms part of at least one significant structure; (2) the fact that to understand such behavior it must be incorporated in that structure—which the research worker must bring to light; (3) the assertion that structure is really comprehensible only if it is grasped at its genesis, individual or historical, as the case may be. In short, just like the sociology which we favor, psychoanalysis is a genetic structuralism.

Their opposite character resides, above all, in one point: psychoanalysis attempts to reduce all human behavior to one individual subject and to one form, whether manifest or sublimated, of desire for the object. Genetic sociology separates libidinal behavior, which is studied by psychoanalysis, from behavior of an historical character (of which all cultural creation forms part) which has a transindividual subject and which can be directed toward

the object only through the mediation of an aspiration after coherence. It follows that, even if all human behavior is incorporated both in libidinal structure and in an historical structure, it has not the same significance in the two cases, and the dissection of the object must not be identical either. Certain elements of art or of a literary composition—but not the work or the composition in their entirety—may be incorporated in a libidinal structure, and this will enable the psychoanalysts to understand them and to explain them by relating them to the individual's subconscious. The significances revealed will, however, in this case, have a status of the same order as that of any drawing or any written composition of any madman; furthermore, these same literary or artistic works, incorporated in an historical structure, will constitute relative structures which are practically coherent and unitary, possessing very great relative autonomy; this is one of the constituent elements of their truly literary or truly artistic value.

All human behavior and all human manifestations are, indeed, to a varying degree, mixtures of significances of both kinds. However, depending on whether the libidinal satisfaction predominates to the point of destroying the autonomous coherence almost completely, or whether, inversely, it is incorporated in the latter, while leaving it almost intact, we shall have before us either the product of a madman or a masterpiece (it being understood that most human manifestations lie somewhere between these two extremes).

The second is the fact that, despite the ample university discussions that have taken place, more particularly in the German universities, with regard to comprehension and explanation, these two processes of research are by no means opposed to one another and are not even different from one another.

On this point, we must, in the first place, eliminate all the romantic literature devoted to the sympathy, 'empathy' or identification necessary to understand a work. To us, comprehension seems to be a strictly intellectual process; it consists of the description as precisely as possible, of a significant structure. It is, of course, true that, as in the case of any intellectual process, it is favored by the immediate interest the research worker takes in his subject—that is to say, by the sympathy or antipathy or indifference which the object of research inspires in him; but, on the one hand, antipathy is a factor which is just as favorable to comprehension as is sympathy (Jansenism has never been better understood or better defined than by its persecutors when they formulated the famous 'Five Propositions,' which are a rigorous definition of the tragic vision) and, on the other hand, many other factors may be favorable or unfavorable to research, for instance, a good psychic

disposition, good health or, inversely, a state of depression or an attack of toothache; but all this has nothing to do with logic or epistemology.

It is necessary to go further, however. Comprehension and explanation are not two different intellectual processes, but one and the same process, related to different co-ordinates. We have said above that comprehension is the bringing to light of a significant structure immanent in the object studied (in the case with which we are concerned, in this or that literary work). Explanation is nothing other than the incorporation of this structure, as a constituent element, in an immediately embracing structure, which the research worker does not explore in any detailed manner but only insofar as such exploration is necessary in order to render intelligible the genesis of the work which he is studying. All that is necessary is to take the surrounding structure as an object of study and then what was explanation becomes comprehension and the explanatory research must be related to a new and even vaster structure.

Let us take an example. To understand *Les Pensées* of Pascal or the tragedies of Racine is to bring to light the tragic vision which constitutes the significant structure governing the whole of each of these works; but to understand the structure of extremist Jansenism is to explain the genesis of *Les Pensées* and of the tragedies of Racine. Similarly, to understand Jansenism is to explain the genesis of extremist Jansenism; to understand the history of the *noblesse de robe* in the seventeenth century is to explain the genesis of Jansenism; to understand class relations in French society of the seventeenth century is to explain the evolution of the *noblesse de robe*, etc.

It follows that all positive research in the human sciences must necessarily be conducted on two different levels—that of the object studied and that of the immediately surrounding structure, the difference between these levels of research residing above all in the degree to which the investigation is carried on each of these planes. The study of an object—a text, a social reality, etc.—cannot indeed be considered sufficient except when it has revealed a structure which accounts adequately for a considerable number of empirical facts, especially those which seem to present particular importance[4] so that it becomes, if not inconceivable, at least improbable, that another analysis could put forward another structure leading to the same or to better results.

The situation is different in regard to the surrounding structure. The research worker is concerned with this only in respect of its explanatory function in relation to the object of his study. It is, moreover, the possibility of bringing such a structure to light that will determine the choice of that particular one among the more or less considerable number of surrounding

structures which appear to be possible when the research is first embarked upon. The research worker will therefore halt his study when he has sufficiently revealed the relationship between the structure studied and the surrounding structure to account for the genesis of the former as a function of the latter. He can also, however, of course, carry his research much further; but, in that case, the object of the study changes at a certain moment and what was, for instance, a study on Pascal may become a study on Jansenism, or on the *noblesse de robe*, etc.

This being so, although it is true that in the practice of research, immanent interpretation and explanation through the surrounding structure are inseparable, and no progress can be made in either of these fields, except through a continual oscillation from one to the other, it is none the less important to make a rigorous distinction between interpretation and explanation in their nature and in the presentation of the results. Similarly, it is essential always to bear in mind not only the fact that the interpretation is always immanent in the texts studied (whereas the explanation is always external to them), but also the fact that everything which is placed in the relationship of the text with the facts which are external to it—whether it is a question of the social group, of the psychology of the author or of sunspots— has an explanatory character and must be judged from that standpoint.[5]

Now, though this principle seems easy to respect, deep-rooted prejudices cause it to be constantly transgressed in practice, and our contacts with specialists of literary studies have shown us how difficult it is to get them to adopt, with regard to the text they are studying, an attitude which, if not identical with, is at least similar to that of the physicist or the chemist who is recording the results of an experiment. To mention only a few examples taken haphazard, it was a specialist of literary history who explained to us one day that Hector cannot speak in *Andromaque* since he is dead, and that what occurs is therefore the illusion of a woman whom an extraordinary and quite hopeless situation has driven to the extreme limits of exasperation. Unfortunately there is nothing at all like that in Racine's text, from which we learn only, on two occasions, that Hector—the dead Hector—has spoken.

Again, another historian of literature explained to us that Dom Juan cannot be married every month because, even in the seventeenth century, that was in practice impossible, and that consequently it was necessary to take that affirmation in Molière's play in an ironical and figurative sense. It is hardly necessary to say that if this principle is accepted, it is very easy to make a text say anything one likes—even the exact opposite of what it explicitly states.[6]

What would be said of a physicist who denied the results of an experiment

592 PART FIVE: METHODOLOGY

and substituted for them others which pleased him better, for the sole
reason that the former appeared to him to be unlikely.

Again, in a discussion at the Royaumont symposium (1965), it was
extremely difficult to get the supporters of psychoanalytical interpretations
to admit the elementary fact that—whatever opinion one may hold of the
value of this kind of explanation, and even if it is given a preponderant value
—one cannot speak of the subconscious of Orestes or of a desire of Oedipus
to marry his mother, since Orestes and Oedipus are not living men but
texts and one has no right to add anything whatsoever to a text which makes
no mention of the subconscious or of incestuous desire.

The explanatory principle, even for any serious psychoanalytical explana-
tion, can reside only in the subconscious of Sophocles or Aeschylus, but never
in the subconscious of a literary character who exists only through what is
explicitly affirmed about him. In the field of explanation, it is to be noted
that literary specialists have a regrettable tendency to give pride of place to
psychological explanation, regardless of its efficacity and its results, simply
because it seems to them the most plausible, whereas quite obviously the
only truly scientific attitude consists in examining, in as impartial a manner
as possible, all the explanations that are put forward, even those which are
apparently the most absurd (that is why we mentioned sunspots just now,
although no one has seriously thought of finding an explanation in them),
making a choice solely and exclusively in accordance with the results to
which they lead and in accordance with the more or less considerable pro-
portion of the text which they make it possible to account for.

Starting from a text which for him represents a mass of empirical data
similar to those by which any other sociologist who undertakes a piece of
research is faced, the sociologist of literature must first tackle the problem
of ascertaining how far those data constitute a significant object, a structure
on which positive research can be carried out with fruitful results.

We may add that, when faced by this problem, the sociologist of literature
and art finds himself in a privileged situation as compared with research
workers operating in other fields, for it can be admitted that in most cases
the works which have survived the generation in which they were born
constitute just such a significant structure,[7] whereas it is by no means
probable that the analyses of the daily consciousness, or even current
sociological theories, coincide in those other fields with significant objects.
It is by no means certain for instance that objects of study such as 'scandal,'
'dictatorship,' 'culinary behavior,' etc., constitute such objects.

However that may be, the sociologist of literature must—like any other
sociologist—verify this fact and not admit straightaway that such and such

a work or such and such a group of works which he is studying constitutes a unitary structure.

In this respect, the process of investigation is the same throughout the whole field of the sciences of man. The research worker must secure a pattern, a model composed of a limited number of elements and relationships, starting from which he must be able to account for the great majority of the empirical data of which the object studied is thought to be composed.

It may be added that, having regard to the privileged situation of cultural creation as an object of study, the requirements of the sociologist of literature may be much greater than those of his fellow sociologists. It is by no means excessive to require a model to account for three-quarters or four-fifths of the text and there are already in existence a certain number of studies which appear to satisfy this requirement. We use the term 'appear' because, simply as a result of the insufficiency of material means, we have never been able to carry out a check of any work paragraph by paragraph, or speech by speech, although from the methodological standpoint, such a check obviously presents no difficulty.[8]

It is obvious that, most frequently in general sociology and very frequently in the sociology of literature, when research is concerned with several works, the research worker will be led to eliminate a whole series of empirical data which appeared at the outset to form part of the proposed object of study, and on the other hand, to add other data of which he had not thought in the first place.

We shall give just one example. When we started a sociological study on the works of Pascal, we were very quickly led to separate *Les Provinciales* from *Les Pensées* as corresponding to two different visions of the world, and therefore to two different epistemological models, with different sociological bases—centrist and semi-Cartesian Jansenism, the best-known representatives of which were Arnauld and Nicole, and extremist Jansenism, which was unknown up to that time and which we had to seek and find in the person of its chief theologian, Barcos, the abbé of Saint-Cyran, not far removed from whom were, among others, Singlin, Pascal's director, Lancelot, one of Racine's masters, and above all, Mother Angélique.[9] The bringing to light of the tragic structure which characterized the thoughts of Barcos and Pascal led us, moreover, to include in our research four of the chief plays of Racine, namely, *Andromaque, Britannicus, Bérénice* and *Phèdre*—a result which was all the more surprising because, up to that time, misled by superficial manifestations, the historians of literature who were trying to discover relationships between Port-Royal, and Racine's works sought them on the plane of content and directed their attention above all to the Christian plays

(*Esther* and *Athalie*) and not to the pagan plays, the structural categories of which nevertheless corresponded strictly to the structure of thought of the extremist Jansenist group.

Theoretically, the success of this first stage of the research and the validity of a model of coherence are shown, of course, by the fact that the model accounts for practically the whole of the text. In practice, there is however another criterion—of the nature not of law but of fact—which indicates with sufficient certainty that one is on the right path. This is the fact that certain details of the text, which had not in any way attracted the research worker's attention up to that point, suddenly appear to be both important and significant.

Let us once more give three examples in this connection.

At a time when verisimilitude constitutes a rule that is almost unanimously accepted, Racine, in *Andromaque*, makes a dead man speak. How can such an apparent incongruity be accounted for? It is sufficient to have found the pattern of the vision which governs the thought of extremist Jansenism to note that, for that thought, the silence of God and the fact that he is simply a spectator have as their corollary the fact that there exists no intramundane issue which makes it possible to safeguard fidelity to values, no possibility of living validly in the world, and that any attempt in this direction is blocked by unrealizable—and moreover in practice unknown—requirements of divinity (requirements which most frequently present themselves in a contradictory form). The profane transposition of this conception in Racine's plays results in the existence of two mute characters, or of two mute forces, which incarnate contradictory requirements: Hector, who demands the fidelity, and Astyanax, who demands the protection of Andromaque; Junie's love for Britannicus, which demands that she should protect him, and her purity which demands that she should accept no compromise with Néron; the Roman people and love, for Bérénice; later, the Sun and Venus, in Phèdre.

Although, however, the mutism of these forces or of these beings in the plays which incarnate absolute requirements is bound up with the absence of any intramundane solution, it is obvious that at the moment when Andromaque finds a solution by which it seems to her to be possible for her to marry Pyrrhus in order to protect Astyanax and to commit suicide before becoming his wife, in order to safeguard her fidelity, the mutism of Hector and Astyanax no longer corresponds to the structure of the play, and aesthetic requirements, stronger than any external rule, result in the extreme improbability of the dead man who speaks and indicates a possibility of overcoming the contradiction.

We take as our second example the famous scene of the appeal to magic in Goethe's *Faust*, in which Faust addresses himself to the Spirits of the Macrocosm and of the Earth, which correspond to the philosophies of Spinoza and Hegel. The reply of the second Spirit sums up the very essence of the play and, even more, of the first part of it—the opposition between, on the one hand, the philosophy of enlightenment, whose ideal was knowledge and comprehension, and, on the other hand, dialectical philosophy, centered on action. The reply of the Spirit of the Earth—'You resemble the Spirit you understand, and not me'—is not merely a refusal; it is also its justification. Faust is still at the level of 'understanding,' that is to say at the level of the Spirit of the Macrocosm, which is precisely what he wanted to outdistance. He will not be able to meet the Spirit of the Earth until the moment when he finds the true translation of the Gospel according to Saint John ('In the beginning was action') and when he accepts the pact with Mephistopheles.

Similarly, in Sartre's *La Nausée*, if the self-taught character—who also represents the Spirit of Enlightenment—reads the books in the library in the order of the catalogue, this is because the author has, consciously or unconsciously, aimed his satire at one of the most important features of the thought of enlightenment—the idea that knowledge can be conveyed with the help of dictionaries in which the subjects are arranged in alphabetical order (it is only necessary to think of Bayle's *Dictionnaire*, Voltaire's *Dictionnaire philosophique* and, above all, the *Encyclopédie*).

Once the research worker has advanced as far as possible in the search for the internal coherence of the work and its structural model, he must direct himself toward explanation.

Having reached this point, we must interpolate a digression concerning a subject which we have already touched upon. There is, indeed—as we have already said—a radical difference between the relationship of interpretation to explanation in the course of the research and the way in which that relationship presents itself at the end of the research. In the course of research, indeed, explanation and comprehension strengthen each other mutually, so that the research worker is led to revert continually from one to the other whereas, at the time when he halts his research, in order to present the results of it, he can, and indeed must, separate his interpretative hypotheses immanent to the work fairly sharply from his explanatory hypotheses which transcend it.

As it is our intention to stress the distinction between the two processes, we shall develop the present statement on the imaginary supposition of an interpretation that has been carried to an extremely advanced point by means

of immanent analysis and which is only subsequently directed toward explanation.

To look for an explanation means to look for a reality external to the work which presents a relationship to the structure of the work which is either one of concomitant variation (and this is extremely rare in the case of the sociology of literature) or, as is most frequently the case, a relationship of homology or a merely functional relationship, that is to say, a structure fulfilling a function (in the sense which these words bear in the sciences of life or the sciences of man).

It is impossible to say *a priori* which are the realities external to a work which are capable of fulfilling such an explanatory function with reference to its specifically literary features. It is, however, an actual fact that, up to the present time, insofar as historians of literature and the critics have concerned themselves with explanations, they have based themselves mainly on the individual psychology of the author and sometimes—less frequently and, above all, only fairly recently—on the structure of thought of certain social groups. It is therefore, for the moment, unnecessary to consider any other explanatory hypotheses, although one has certainly no right to eliminate them *a priori*.

Against the psychological explanations, however, several overwhelming objections present themselves as soon as one reflects on them a little more seriously. The first—and the least important—of these is that we have very little knowledge of the psychology of a writer whom we have not known and who, in most cases, has been dead for years. The majority of these so-called psychological explanations are therefore simply more or less intelligent and fanciful constructions of an imaginary psychology, built up, in most cases, on the basis of written evidence and in particular on that of the work itself. This is not merely going round in a circle but going round in a vicious circle, for the so-called explanatory psychology is nothing other than a paraphrase of the work it is supposed to explain.

Another argument—a much more serious one—which may be brought against psychological explanations is the fact that, so far as we are aware, they have never succeeded in accounting for any notable portion of the text, but merely for a few partial elements or a few extremely general features. Now, as we have already said, any explanation which accounts for only 50 to 60 per cent of the text offers no major scientific interest, since it is always possible to construct several others which explain an equal portion of the text, although naturally not the same portion. If results of this kind are accepted as satisfactory, it is possible at any moment to fabricate a mystic, Cartesian or Thomist Pascal, a Cornelian Racine, an existentialist Molière,

etc. The criterion for the choice between several interpretations then becomes the brilliance of mind or the intelligence of such and such a critic as compared with another—and this, of course, has nothing whatsoever to do with science.

Lastly, the third—and perhaps the most important—objection that can be brought against psychological explanations is the fact that although they undoubtedly do account for certain aspects and certain characteristic features of the work, these are always aspects and characteristic features which in the case of literature are not literary, in the case of a work of art are not aesthetic, in the case of a philosophical work are not philosophical, etc. Even the best and most successful psychoanalytical explanation of a work will never succeed in telling us in what respect that work differs from a piece of writing or a drawing by a madman, which psychoanalysis can explain to the same degree, and perhaps better, with the aid of similar processes.

This situation derives, we think, in the first place from the fact that although the work is the expression both of an individual structure and of a collective structure, it presents itself as an individual expression, especially as (1) the sublimated satisfaction of a desire for the possession of an object (see the Freudian analyses of Freudian inspiration); (2) the product of a certain number of individual psychic 'montages,' which can find expression in certain special features of the writing; (3) the more or less faithful or more or less distorted reproduction of a certain number of facts acquired or experiences lived through.

But in all this there is nothing that constitutes any literary, aesthetic or philosophical significance—in short, any cultural significance.

To remain in the realm of literature, the significance of a work does not lie in this or that story—the events related in the *Orestes* of Aeschylus, the *Electra* of Giraudoux and *Les Mouches* of Sartre are the same, yet these three works quite obviously have no essential element in common—nor does it lie in the psychology of this or that character, nor even in any stylistic peculiarity which recurs more or less frequently. The significance of the work, insofar as it is a literary work, is always of the same character, namely, a coherent universe within which the events occur and the psychology of the characters is situated and within the coherent expression of which the stylistic automatisms of the author are incorporated. Now, what distinguishes a work of art from the writing of a madman is precisely the fact that the latter speaks only of his desires and not of a universe with its laws and the problems which arise in it.

Conversely, it is true that the sociological explanations of the Lukácsian

school—however few as yet in number—do precisely pose the problem of the work as a unitary structure of the laws which govern its universe and of the link between that structured universe and the form in which it is expressed. It is also true that these analyses—when they are successful—account for a much greater portion of the text, frequently approaching the whole. It is true, lastly, that they not only bring out, in many cases, the importance and significance of elements that had completely escaped the critics by making it possible to establish links between those elements and the rest of the text, but they also bring to light important and hitherto unperceived relationships between the facts studied and many other phenomena of which neither the critics nor the historians had thought until then. Here again we shall content ourselves with a few examples.

It had always been known that, at the end of his life, Pascal had reverted to science and to the world, since he even organized a public competition on the problem of roulette, and also the first public conveyances (five-sou coaches). Yet no one had established any relationship between this individual behavior and the writing of *Les Pensées* and, in particular, the central fragment of that work relating to the *Pari*. It is only in our interpretation, when we connected the silence of God and the certainty of his existence, in Jansenist thought, with the special situation of the *noblesse de robe* in France, after the wars of religion, and with the impossibility of finding a satisfactory intramundane solution to the problems by which it was faced, that we became aware of the link between the most definitely extremist form of that thought, which carries uncertainty to the point of its most radical expression by extending it from the divine will to the very existence of the divinity, and the fact of situating the refusal of the world not in solitude, external to it, but within it by giving it an intramundane character.[10]

Similarly, once we had established a relationship between the genesis of Jansenism among the *gens de robe* and the change in monarchical policy and the birth of absolute monarchy, it became possible to show that the conversion of the Huguenot aristocracy to Catholicism was nothing other than the reverse of the same medal and constituted one and the same process.

One last example, which goes as far as the problem of literary form. It suffices to read Molière's *Dom Juan* to see that it has a different structure from the other great plays of the same author. Indeed, although Orgon, Alceste, Arnolphe and Harpagon are confronted by a whole world of interhuman relations, a society and, in the case of the first three of them, a character who expresses worldly good sense and the values which govern the universe of the play (Cléante, Philinte and Chrysale), there is nothing of that sort in *Dom Juan*. Sganarelle has only the servile wisdom of the people

which we find in nearly all the valets and servants of the other plays of Molière; so that the dialogues in *Dom Juan* are in reality only monologues in which different characters (Elvire, the Père, the Spectre), who are in no way related to one another, criticize Dom Juan's behavior and tell him that he will end up by provoking the divine wrath, without his defending himself in any way. Furthermore, the play contains one absolute impossibility, namely, the affirmation that Dom Juan gets married every month, which, quite obviously, was out of the question in the real life of the period. Now, the sociological explanation easily accounts for all these peculiarities. Molière's plays are written from the standpoint of the *noblesse de cour*, and the great character plays are neither abstract descriptions nor psychological analyses, but satires of real social groups, the picture of which is concentrated in a single psychological trait or special peculiarity of character; they are aimed at the bourgeois, who loves money and does not think that it is made above all to be spent, who wishes to exert his authority in the family, who wants to become a gentleman; the religious bigot and the member of the Compagnie du Saint-Sacrement, who interfere with the life of others and combat the libertine morality of the Court; the Jansenist—worthy of respect, of course, but too strict and refusing the slightest compromise.

Against all these social types, Molière can bring social reality, as he sees it, and his own moral attitude—libertine and epicurean—the liberty of woman, readiness to compromise, a sense of proportion in all things. In the case of *Dom Juan*, on the contrary, there is no question of a different social group, but of individuals who, within the very group depicted by the work of Molière, exaggerate and display no sense of proportion. That is why it is impossible to set in opposition to Dom Juan any moral attitude different from his own. All that can be said to him is that he is right to do what he does, but not to exaggerate or go as far as the absurd. Moreover, in the only sphere in which the moral attitude of the Court, at all events in theory, approves the fact of going to the extreme limit and does not find any exaggeration—that of courage and daring—Dom Juan becomes an entirely positive character. Apart from this, he is right to give alms to the beggar, but not to do so in a blaspheming manner; it is not absolutely necessary that he should pay his debts, but he must not make too much of a fool of Monsieur Dimanche (again, in this matter, Dom Juan's attitude is not really antipathetic). Finally, the chief subject of controversy in the matter of the moral attitude of the libertine being, of course, the problem of relations with women, Molière had to make it understood that Dom Juan is right to do what he does, but that, in this also, he goes beyond the limit. Now, apart from the fact, which is clearly indicated, that he goes too far in assaulting even peasant women

and in not keeping up his rank, this limit could not be defined with any degree of precision. Molière could not say that Dom Juan was wrong in seducing a woman every month, whereas he should be satisfied to seduce one every two or every six months; whence the solution which expresses exactly what had to be said—Dom Juan gets married—and there is nothing reprehensible about that; it is even a very good thing to do—but, unfortunately, he gets married every month; which is really going too far!

Having spoken especially, in this article, of the differences between the structuralist sociology of literature, on the one hand, and the traditional explanation offered by psychoanalysis or literary history, on the other hand, we should now like also to devote a few paragraphs to the supplementary difficulties by which genetic structuralism is separated from formalistic structuralism, on the one hand, and from empirical and nonsociological history, on the other hand.

For genetic structuralism, the whole range of human behavior (we employ this term in its widest possible sense, embracing also psychical behavior, thought, imagination, etc.) has a structural character. At the opposite extreme therefore from formalistic structuralism, which sees in structures the essential sector, but only a sector, of over-all human behavior, and which leaves aside what is too closely connected with a given historical situation or a precise stage of a biography, thus leading up to a sort of separation between the formal structures and the particular content of that behavior, genetic structuralism lays down as a principle the hypothesis that structural analysis must go much further in the sense of the historical and the individual and must one day, when it is much more advanced, constitute the very essence of the positive method in history.

But it is then that, finding himself faced by the historian, who attaches prime importance to the individual fact, in its immediate character, the sociologist who is a supporter of genetic structuralism encounters a difficulty which is the opposite of the one which separated him from the formalist for, notwithstanding the opposition which exists between them, the historian and the formalist both admit one essential point, namely, the incompatibility between structural analysis and concrete history.

Now, it is evident that immediate facts do not have a structural character. They are what in scientific parlance might be called a mixture of a considerable number of processes of structuration and destructuration, which no man of science could study as they are, in the form in which they are immediately given. It is a well-known fact that the noteworthy progress of the exact sciences is precisely due, *inter alia*, to the possibility of creating experimentally, in the laboratory, situations which replace the mixture, the

interplay of active factors constituted by the realities of daily life, by what might be called pure situations—for instance, the situation in which all the factors are made constant with the exception of one which can be made to vary and of which the action can be studied. In history, such a situation is, unfortunately, impossible to achieve; it is none the less true, however, that here, as in all other fields of research, what is immediately apparent does not coincide with the essence of phenomena (otherwise, as Marx once said, science would be useless), so that the chief methodological problem of the social and historical sciences is precisely that of working out the techniques by means of which it is possible to bring to light the principal elements the mixture and interplay of which constitute empirical reality. All the important concepts of historical research (Renaissance, Capitalism, Feudalism and also Jansenism, Christianity, Marxism, etc.) have a methodological status of this nature, and it is very easy to show that they have never coincided in any strict fashion with any particular empirical reality. It is none the less true that genetic structuralist methods have made it possible nowadays to establish concepts which are already very close to less comprehensive realities but which continue, of course, to retain a methodological status of the same nature. Although we cannot here dwell at length on the fundamental concept of the possible conscious,[11] let us at least say that, in its orientation toward the concrete, structuralist research can never go as far as the individual mixture and must stop short at the coherent structures which constitute the elements of it.

This is perhaps also the place to state that, as reality is never static, the very hypothesis that it is entirely constituted of processes of structuration implies the conclusion that each of these processes is, at the same time, a process of the destructuration of a certain number of earlier structures, at the expense of which it is in course of coming into being. The transition, in empirical reality, from the predominance of the former structures to the predominance of the new structure is precisely what dialectical thought designates as 'the transition from quantity to quality.'

It would therefore be more correct to say that, at any given moment, social and historical reality always presents itself as an extremely complex mixture, not of structures, but of processes of structuration and destructuration, the study of which will not have a scientific character until the day when the chief processes have been made clear with a sufficient degree of rigor.

Now, it is precisely on this point that the sociological study of the masterpieces of cultural creation acquires special value for general sociology. We have already emphasized that, in the whole range of social and historical

facts, the characteristic feature and the privilege of the great cultural creations reside in their extremely advanced structuration and in the weakness and fewness of heterogeneous elements incorporated in them. This means that these works are much more readily accessible to structuralist study than is the historical reality which gave birth to them and of which they form part. It means also that, when these cultural creations are brought into relationship with certain social and historical realities, they constitute valuable pointers in regard to the elements of which these realities are constituted.

This shows how very important it is to incorporate the study of them in the field of sociological research and in general sociology.[12]

Another problem which is of importance to research is that of verification. In dealing with it, we should like to mention a project which we have had in mind for some time but which we have so far not been able to carry out. It is a question of passing from individual and artisanal research to a form of research which is more methodical and, above all, is of a collective character. The idea was suggested to us by work for the analysis of literary texts on punched cards which, in most cases, is of an analytical character and starts from constituent elements in the hope of arriving at a general comprehensive study—which, to us, has always seemed to be problematical, to say the least.

The discussion has gone on for a long time; in modern times, it has continued since the days of Pascal and Descartes. It is the argument between dialectic and positivism. If the whole, the structure, the organism, the social group, the relative totality, are greater than the sum of the parts, it is illusory to think that it is possible to understand them by starting from the study of their constituent elements, whatever the technique employed in the research. Inversely, it is obvious that one cannot content oneself with the study of the whole either, since the whole exists only as the sum of the parts that make it up and of the relationships by which they are linked.

In fact, our research always took the form of a continual oscillation between the whole and the parts, by means of which the research worker attempted to build up a model, which he compared with the elements, and then reverted to the whole and made it precise, after which he came back once more to the elements and so on, until the time came when he considered both that the result was sufficiently substantial to be worth publishing and that any continuation of the same work on the same object called for an effort that would be disproportionate as compared with the additional results he might hope to obtain from it. It is in this sequence of research that we have thought it might be possible to introduce—not at the beginning, but at some intermediate stage—a process that would be more systematic and

above all collective. It has seemed to us, indeed, that when the research worker has built up a model which appears to him to present a certain degree of probability, he might, with the help of a team of collaborators, check it by comparing it with the whole of the work studied, paragraph by paragraph, in the case of a text in prose; line by line, in the case of a poem; speech by speech in the case of a play, by determining (1) to what extent each unit analyzed is incorporated in the over-all hypothesis, (2) the list of new elements and new relationships not provided for in the initial model, and (3) the frequency, within the work, of the elements and relationships provided for in this model.

Such a check should enable the research worker subsequently to (1) correct his outline, so as to account for the whole of the text, and (2) give his results a third dimension—that of the frequency, in the work in question, of different elements and relationships making up the over-all pattern.

Never having been able to carry out a piece of research of this kind on a sufficiently vast scale, we decided recently to undertake one, so to speak experimentally, as a sort of prototype, with our collaborators in Brussels, on Genêt's *Les Nègres*, a work concerning which we had already sketched out a fairly advanced hypothesis.[13] Progress is, of course, extremely slow and the study of a single text like *Les Nègres* will take more than an academic year. But the results of the analysis of the first ten pages were surprising, inasmuch as, over and above the mere verification, they have enabled us to take the first steps with our method in the field of form, in the narrowest sense of the word, whereas we had thought hitherto that that field was reserved for specialists whose absence from our working groups we had always greatly regretted.

Lastly, to conclude this discussion, we should like to mention a possibility of extending research, which we have not yet explored but which we have been contemplating for some time, by taking as a starting point Julia Kristeva's study on Bakhtin.[14]

Although we have not said so explicitly in the present article, it is obvious that, in the background of all our research, there is a precise concept of aesthetic value in general and of literary value in particular. This is the idea developed in German classical aesthetics, passing from Kant, through Hegel and Marx to the early works of Lukács, who defines this value as a tension overcome between, on the one hand, sensible multiplicity and richness and, on the other hand, the unity which organizes this multiplicity into a coherent whole. From this point of view, a literary work is seen to be all the more valuable and more important according as this tension is both stronger and more effectively overcome, that is to say, according as the sensible richness

and multiplicity of its universe are greater and as that universe is more rigorously organized, and constitutes a structural unity.

Having said this, it is no less obvious that, in almost all our work, as in that of all research workers who are inspired by the early writings of Lukács, the research centers round one single element of this tension—unity, which, in empirical reality, takes the form of a significant and coherent historical structure, the foundation of which is to be found in the behavior of certain privileged social groups. All the research of this school in the field of the sociology of literature had hitherto been directed, in the very first place, toward bringing to light coherent and unitary structures governing the all-embracing universe which, in our view, constitutes the significance of every important literary work. This is because, as we said earlier, it is only quite recently that this research has taken its very first steps in the direction of the structural link between the universe and the form which expresses it. In all this field of research, the other pole of tension—the multiplicity and richness—was admitted merely as one item of the data concerning which it could at most be said that, in the case of a literary work, it was made up of a multiplicity of individual and living beings who found themselves in particular situations, or else of individual images—making it possible to differentiate between literature and philosophy, which expresses the same visions of the world on the plane of general concepts. (There is no 'Death' in *Phèdre* and no 'Evil' in Goethe's *Faust*, but only Phèdre dying and the strictly individualized character of Mephistopheles. On the other hand, there are no individual characters either in Pascal or in Hegel, but only 'Evil' and 'Death.')

In pursuing our research in the sociology of literature, we have, however, always acted as if the existence of Phèdre or of Mephistopheles was a fact on which that science had no hold, and as if the more or less living, concrete and rich personality of those characters was a purely individual aspect of creation connected, in the first place, with the talent and psychology of the writer.

Bakhtin's ideas, as expounded by Kristeva, and the probably more radical form which she gives them when she develops her own conceptions,[15] seemed to us to open up a whole new and supplementary field for sociological investigation applied to literary creation.

Just as, in our concrete studies, we emphasized almost exclusively the vision of the world, the coherence and unity of the literary work, so Kristeva,[16] in her study program, rightly characterizing this dimension of the mental structure as being connected with doing, with collective action and—at the extreme limit—with dogmatism and repression, stresses above all

what is open to question, what is opposed to unity and what, in her view (and we think she is right on this point also), has a nonconformist and critical dimension. Now, it seems to us that all the aspects of literary work brought to light by Bakhtin and Kristeva correspond quite simply to the pole of richness and multiplicity in the classical conception of aesthetic value.

This means, in our view, that Kristeva adopts a unilateral position when she sees in cultural creation, in the first place, although not exclusively, the function of opposition and multiplicity (of 'dialogue' as opposed to 'monologue,' to use her terminology) but that what she has described nevertheless represents a real dimension of every truly important literary work. Moreover, by stressing the link which exists between the vision of the world, coherent conceptual thought and dogmatism, Kristeva has implicitly drawn attention to the sociological character not only of these elements, but also of what they refuse, deny and condemn.

By incorporating these reflections in the considerations that we have developed so far, we are led on to the idea that almost all great literary works have a function that is partially critical insofar as, by creating a rich and multiple universe of individual characters and particular situations—a universe that is organized by the coherence of a structure and of a vision of the world—they are led to incarnate also the positions which they condemn and, in order to make the characters which incarnate them concrete and living, to express all that can be humanly formulated in favor of their attitude and their behavior.

This means that these works, even if they express a particular vision of the world, are led, for literary and aesthetic reasons, to formulate also the limits of this vision and the human values that must be sacrificed in its defense.

It follows that, on the plane of literary analysis, it would, of course, be possible to go much further than we have done hitherto, by bringing to light all the antagonistic elements of the work which the structured vision must overcome and organize. Some of these elements are of an ontological nature, especially death, which constitutes an important difficulty for any vision of the world as an attempt aimed at giving a sense to life. Others are of a biological nature, especially eroticism, with all the problems of suppression studied by psychoanalysis. But there are also a certain number, by no means negligible, of elements of a social and historical nature. This is why sociology can, on this point, make an important contribution by showing why the writer, in a particular historical situation, chooses, among the great number of possible incarnations of antagonistic positions and attitudes which he condemns, precisely the few which he feels to be particularly important.

The vision of the tragedies of Racine condemns in radical fashion what we

have called *les fauves*, dominated by passion, and *les pantins*, who continually make mistakes about reality. But it is hardly necessary to recall to what point the reality and human value of Oreste, Hermione, Agrippine, or of Néron, Britannicus, Antiochus, Hippolyte or Thésée are incarnated in Racine's tragedy and to what a point Racine's text expresses in comprehensive fashion the aspirations and sufferings of these characters.

All this should be the object of detailed literary analyses. We consider it probable, however, that if passion and the struggle for political power find a much stronger and more powerful literary expression in Racine's works than virtue, which is passive and incapable of understanding reality, this difference of intensity in literary expression has its foundation in the social, psychical and intellectual realities of the society in which Racine lived and in the reality of the social forces to which the Jansenist group was opposed.

We have already indicated the reality of the social groups to which, in Molière, Harpagon, Georges Dandin, Tartuffe, Alceste and Dom Juan corresponded (the *bourgeoisie*, the Compagnie du Saint-Sacrement and the cabal of the bigots, the Jansenists, the aristocracy of the Court given to exaggeration) or, in Goethe's *Faust*, Wagner (the thought of enlightenment).

We halt our study at this point. It is obvious that this final part has, for the moment, only the value of a program, the realization of which will depend on the course taken by the future development of sociological research relating to cultural creation.

NOTES

[1] Descartes is thus obliged to reduce the cat to a machine, that is to say, to eliminate it as a specific reality, and Sartre leaves no place for it in *l'Être et le Néant*, which recognizes only the inert *En-soi* and the conscious *Pour-soi*.

[2] See Lucien Goldmann, *Le Dieu Caché* (Paris: Gallimard, 1956); *Sciences Humaines et Philosophie* (Paris: Gonthier, 1966); *Recherches Dialectiques* (Paris: Gallimard, 1959); *Le Sujet de la Création Culturelle* (communication to the second Colloque International de Sociologie de la Littérature, 1965).

[3] This, moreover, is why in France, where Freud's celebrated book *Traumdeutung* was published under the title *Explication des Rêves*, it was only after many years that certain psychoanalysts perceived that 'Deutung' means interpretation and not explanation. In actual fact, if, for a long time, this title did not give rise to any problems, this was above all because it was as valid as the original title. It is, in fact, impossible, in the Freudian analyses, to separate interpretation from explanation, as they both appeal to the unconscious.

[4] We have already said that in the case of literary texts the problem is simpler, for owing to the advanced structuration of the objects which are the subject of the research and the limited number of data (the whole text and nothing but the text), it is in most cases possible, if not in theory, at all events in practice, to replace this qualitative criterion by a quantitative criterion, namely a sufficiently large portion of the text.

[5] We stress this point because, in discussions with specialists in literature, we have very often found them claiming that they refuse explanation and content themselves with interpretation whereas, in reality, their ideas were quite as explicative as our own. What they were refusing was sociological explanation in favor of psychological explanation, which traditionally accepted, had become almost implicit.

In fact—and this is a particularly important principle—the interpretation of a work must comprise the whole of the text at the literal level and its validity is to be judged solely and exclusively in relation to the proportion of the part of the text which it succeeds in integrating. Explanation must account for the genesis of the same text, and its validity is to be judged solely and exclusively in accordance with the possibility of establishing at least a rigorous correlation—and as far as possible a significant and functional relationship—between, on the one hand, the development of a vision of the world and the genesis of a text originating from it, and, on the other hand, certain phenomena external to the latter.

The two prejudices which are the most widespread and the most dangerous for research consist, on the one hand, in thinking that a text must be 'sensible'—that is to say, acceptable to the thought of the critic—and, on the other hand, in demanding an explanation in conformity with the general ideas either of the critic himself or of the group to which he belongs and whose ideas he embodies. In both cases, what is demanded is that the facts should be in conformity with the research worker's own ideas, whereas what should be done is to seek out the difficulties and the surprising facts which apparently contradict accepted ideas.

[6] Similarly, in a fairly well-known dissertation on Pascal, the author quoting the latter's affirmation to the effect that 'things are true or false according to the point of view from which one looks at them,' added, as a good Cartesian, that Pascal had of course expressed himself badly and that what he meant was that things *appear* to be true or false according to the point of view from which one looks at them.

[7] This fact itself constitutes the epistemological and psycho-sociological condition of such survival.

[8] It may be added, in this connection, that in a first attempt, which we undertook in Brussels, and which was concerned with Jean Genêt's *Les Nègres*, it was possible, for the first pages, to account not only for the initial hypothesis regarding the structure of the universe of the work but also for a whole series of formal elements of the text.

[9] The major difficulty presented by most studies on Pascal arises, moreover, from the fact that the authors of the works in question, starting from a psychological explanation, whether explicit or implicit, did not even

imagine that Pascal could, in a few months, and perhaps even in a few weeks, have passed from one philosophical position to another, strictly opposite, which he was the first among the thinkers of Western Europe to formulate with extreme rigor. They admitted as being self-evident the existence of a kinship between *Les Provinciales* and *Les Pensées*.

Now, as the two texts did not—and do not—lend themselves to a unitary interpretation, they were obliged to invoke all sorts of reasons (stylistic exaggerations, texts written for libertines, texts expressing the thought of libertines and not Pascal's thought, etc.) to explain that Pascal meant to say—or at least thought—something quite different from what he had in fact written. We took the opposite course, starting by taking note of the rigorously coherent character of each of the two works and of the fact that they were almost entirely the opposite of each other, and only after that posing the question of how it was possible for any individual—however great a genius he might be—to pass so quickly from one position to another, quite different and even opposed, and it was this that led us to the discovery of Barcos and of extremist Jansenism, which suddenly threw a light on the whole problem.

In fact, while he was writing *Les Provinciales*, Pascal had to face an elaborate theological and moral school of thought, which enjoyed great prestige in Jansenist circles and which criticized him and rejected the views which he maintained. He had therefore, for a period of more than a year, to ponder the question whether it was he or his extremist critics who were right. The decision in favor of a change of position thus came to maturity slowly in him, and there is nothing surprising in the fact that a thinker of Pascal's stature after a prolonged period of meditation on a position which finally led to its adoption, should have been able subsequently to formulate it in a more radical and more coherent fashion than had been done by the chief theorists who had defended that position before he did.

[10] This return to the sciences, which was a strictly logical piece of behavior, of course shocked the other Jansenists who, being certain of the existence of God, did not admit the *Pari*; whence the childish legend of the fit of toothache which led to the discovery of roulette.

[11] See Lucien Goldmann, *Conscience Réelle et Conscience Possible* (communication to the fourth World Sociology Congress, 1959); and *Sciences Humaines et Philosophie* (Paris: Gonthier, 1966).

[12] Insofar as the great literary works are directed toward what is essential in the human reality of a period, the study of them may also furnish valuable indications regarding the psycho-sociological structure of events. It is thus that Molière might, it seems to us, have seized on and described an essential aspect of historical reality when, in the cabal of the bigots, he distinguishes the effort to group the *bourgeoisie* in the resistance to the recent social changes and the new morality to which they have given birth, more particularly at the Court, from the few rallying points of the great lords. For Tartuffe, Orgon's attempted seduction is essential. For Dom Juan, the decision to pretend hypocritically to be a good man and a bigot

is only one among many exaggerations and lies on the same plane as, for instance, his libertinage and his provocative and outrageous attitude in the scene with the beggar.

[13] See Lucien Goldmann, *Le Théâtre de Genêt: Essai d'Étude Sociologique* (Paris: Cahiers Renaud-Barrault, November, 1966).

[14] Published in *Critique*, No. 239. We should make it clear that we are not entirely in agreement with Kristeva's positions and that the considerations we have presented here have merely been developed after reading her study, without strictly coinciding with hers.

[15] To the division of literary works into monological and dialogical Kristeva adds the fact that even the literary works which Bakhtin describe as monological contain, if they are valid as literature, a dialogical an critical element.

[16] Not knowing Russian, and not having been able to read Bakhtin's works, it would be difficult for us to distinguish clearly between Bakhtin's own ideas and their development by Kristeva. For that reason we refer in the present article to the whole of the positions of Bakhtin and Kristeva while attributing them to the latter.

SUPPLEMENTARY READINGS

Bernard Berelson, *Content Analysis in Communications Research*, Glencoe: Free Press, 1952. Surveys various applications of content analysis, mostly to mass media. A chapter is devoted to qualitative content analysis, and another to content as reflection of 'deeper' phenomena.

Ronald M. Berndt, 'Some Methodological Considerations in the Study of Australian Aboriginal Art,' *Oceania*, Vol. 29 (1958–59), pp. 26–43.

Richard W. Budd, Robert K. Thorp, and Lewis Donohew, *Content Analysis of Communications*, New York: Macmillan, 1967. Continues the tradition of Berelson, Laswell, and others, dealing mainly with common problems in analysis of 'the message.'

Jozef B. Cohen, 'A Scale for the Measurement of Attitude Toward the Aesthetic Value,' *Journal of Psychology*, Vol. 12 (1941), pp. 75–79.

Sanford M. Dornbusch, 'Content and Method in the Study of the Higher Arts,' in Robert N. Wilson, ed., *The Arts in Society*, Englewood Cliffs: Prentice-Hall, 1964.

Hugh D. Duncan, *Symbols in Society*, New York: Oxford University Press, 1968. Besides axiomatic and theoretical propositions, the author formulates thirty-five methodological propositions on the structure and function of the symbolic act.

Barney G. Glaser and Anselm L. Strauss, *The Discovery of Grounded Theory: Strategies for Qualitative Research*, Chicago: Aldine, 1967.

Louis Gottschalk, Clyde Kluckhohn, and Robert Angell, *The Use of Personal Documents in History, Anthropology and Sociology*, Social Science Research Council Bulletin No. 53, 1945. For sociology, Angell surveys earlier work using personal documents, supplementing Blumer's critique of *The Polish Peasant* and overlapping Gordon Allport's account of the use of such documents in psychology (SSRC Bulletin No. 49, 1942).

Rollo Handy, *Methodology of the Behavioral Sciences: Problems and Controversies*, Springfield: Charles C. Thomas, 1964. Discusses the controversial aspects of scientific method in the behavioral sciences, maintaining that in large part they are attributable to 'ahistorical and noncontextual' views of science.

William T. Jones, *The Romantic Syndrome: Toward a New Method in Cultural Anthropology and History of Ideas*, The Hague: Nijhoff, 1961. Presents seven methodical 'axes of bias,' which represent preferences for basic values, expressed as opposing poles: order/disorder, inner/outer, and so on. Important for value analysis.

Abraham Kaplan, *The Conduct of Inquiry: Methodology for Behavioral Science*, San Francisco: Chandler, 1964. Points to the danger of identifying the scientific method with a preferred set of techniques, whereas the objectives of science may be achieved by a variety of procedures.

Babette Kass, 'Overlapping Magazine Reading: A New Method of Determining the Cultural Levels,' in Paul Lazarsfeld and Frank Stanton, eds., *Communications Research*, 1948–49, New York: Harper Bros., 1949, pp. 130–51. This method has high correlation with experts' ranking of cultural levels of magazines.

Joseph Wood Krutch, *Human Nature and the Human Condition*, New York: Random House, 1959. A clear statement of the author's attitude toward science and scientists.

Claude Lévi-Strauss, *Structural Anthropology*, Garden City: Doubleday, 1963; Anchor Books, 1967. A collection of papers outlining the author's theories on social structure and problems of method, which have greatly influenced scholars who have adopted the 'structural' approach to literary analysis.

Karl Mannheim, *Ideology and Utopia*, New York: Harcourt, Brace, 1936. The principal source for the sociology of knowledge dealt with by Alexander Kern.

Delbert C. Miller, *Handbook of Research Design and Social Measurement*, New York: David McKay, 1964.

Robert E. Mitchell, 'The Use of Content Analysis for Explanatory Studies,' *Public Opinion Quarterly*, Summer, 1967, pp. 230–41. Deals with methodological problems of content analysis for explanatory rather than descriptive purposes.

Charles E. Osgood, George J. Suci, and Percy H. Tannenbaum, *The Measurement of Meaning*, Urbana: University of Illinois Press, 1957. A progress report on the formulation and application of a general model, the 'semantic differential,' to the measurement of meaning.

Bernard S. Phillips, *Social Research: Strategy and Tactics*, New York: Macmillan, 1966. Shows how theory may be employed as a guide to the selection of research techniques.

Julian Simon, *Basic Research Methods in Social Science*, New York: Random House, 1968. Deals mainly with empirical methods.

Gideon Sjoberg and Roger Nett, *A Methodology for Social Research*, New York: Harper & Row, 1968. Research procedures placed in theoretical contexts, including the perspective of the sociology of knowledge.

Max Weber, *The Theory of Social and Economic Organization*, trans. by A. M. Henderson and Talcott Parsons, New York: Oxford University Press, 1947.

——, *The Methodology of the Social Sciences*, trans. and ed. by Edward A. Shils and Henry A. Finch, New York: Free Press, 1949. These two volumes contain Weber's principal contributions to methodology in the social sciences.

Ralph K. White, 'Value-Analysis: A Quantitative Method for Describing Qualitative Data,' *Journal of Social Psychology*, Vol. 19 (1944), pp. 351–58.

Robert N. Wilson, *Man Made Plain*, Cleveland: Howard Allen, 1958. The author's attitude toward the social sciences is expressed primarily in Chapter I, 'Literature, Society, and Personality.' In the Foreword, Henry A. Murray spells out his objections to prevailing methods in the social sciences.

Part VI
HISTORY AND THEORY

VI. HISTORY AND THEORY

Introduction

THE SOCIOLOGY of art is a field study encompassing a variety of viewpoints rather than a clearly defined subject matter or general theory. Represented in this volume are the viewpoints of social historians, art historians, and art critics as well as sociologists and anthropologists. These variations are a source of fascination to many scholars, some of whom have attempted to describe them. Thus Barnett, in the article below, sketches the historical development of sociological concern with art, discusses the present status of this work in the United States, and suggests some new orientations. Duncan, in the well-known collection edited by Becker and Boskoff on *Modern Sociological Theories in Contemporary Change* (1957), has surveyed the views of a number of European philosophers, historians and critics, as well as those of psychoanalysts, anthropologists and sociologists, but his principal concern is with theories of communication and symbolic experience. Walter Abell, in the selection that ends this volume, classifies six main critical traditions that attempt to explain art in its various aspects. Albrecht, in *The American Journal of Sociology* (March, 1954), differentiates several major conceptions of what literature reflects and examines some evidence that art functions as a means of social control and as a direct stimulus to deviant social behavior. More recently, Kavolis' *Artistic Expression— a Sociological Analysis* (1968) includes a host of 'gross generalizations,' abstracted from cross-cultural studies, from data on early civilizations, and from the results of investigations on social classes and on

major social institutions in Western civilization. Finally, the most monumental retrospect of Western art history, its theories, styles and trends, is the often-overlooked *Evolution in the Arts* (1963), by Thomas Munro.

All these surveys are valuable, encompassing many views and theories on art and its functions in society; all of them admit or imply the inconclusiveness of the theories and reveal the need for further empirical investigation as well as for theoretical reformulations.

These surveys also reveal a rather obvious yet culturally curious fact, that the center of scholarly interest in the fine arts is the *objet d'art*, the cultural artifact, and that this interest has been manifested mainly in three ways. One is historical, the effort to describe historical trends in the arts, to trace their growth, achievements, and changes over time. In this area Munro's *Evolution in the Arts* is indispensable.

The second approach is genetic, the attempt to discover how the forms of art come into being and to account for their qualities and styles. In methodological terms, art is the dependent variable, subject to numerous conditions: material and technical, psychological and social, ideological and philosophical. Walter Abell's six critical traditions are all genetic types, which he calls iconography, biographical criticism, historical determinism, aesthetic materialism, aesthetic teleology, and pure visibility. Although he includes the sociologically oriented concepts of literary historians such as Taine, he neglects important sociological theories, notably those of Sorokin and of Marx, which are described by Barnett, along with more recent contributions. Marxian theories are represented in this volume by Antal (Part II) and are extensively illustrated in Arnold Hauser's well-known *Social History of Art*. The sociological models of Huaco and of Goldmann, as indicated in the previous section, are derived from this theoretical framework, which constitutes a major genetic approach in the sociology of art.

The most comprehensive genetic theory, however, is developed by Walter Abell in *The Collective Dream in Art*. Noting the limitations of existing genetic theories, he conceives the possibility of interrelating them in a broad framework, which he calls 'psychohistorical.' The work of art he sees as the final product, the end of a chain of conditioning influences that begins with individual

psychology and passes into social psychology, through it into history with all its economic, technological and sociological concomitants, and beyond history to biological, geographical, and other foundations of history. He describes some of the mechanisms linking the principal factors, which combine to give rise to different content and art styles in Western civilization. Perhaps too sweeping to be entirely successful, his work is nevertheless an impressive attempt at theoretical synthesis, supported by the extensive knowledge of an art historian and demonstrating an analytic power of high order. The book must be read in its entirety to be properly appreciated.

The third approach differs from the genetic largely in emphasis. It assumes that various conditioning factors have influenced the work of art so that it becomes an index, a key to the nature of society and culture. The most obvious use of this approach is in archaeology, the field in which material artifacts become the basis of evidence and inference about a culture. Taking the same point of view, Toynbee claims that art styles more accurately establish the time span of a civilization, its growth and dissolution, than any other method of measurement. Indeed, historians have customarily used literature and the arts as evidence for the dress, manners, political events, ideas, *Weltanschauung* and many other aspects of a historical period. The extreme of this view is reached by Henry Commager, who states, in *The American Mind* (1950), that imaginative literature could faithfully replace the documentary record of the contemporary scene.

Sociologists have also adopted this approach. Its assumptions are implicit in the use of literary documents in the classic study *The Polish Peasant in Europe and America* (1918–20), by Thomas and Znaniecki. In the 1934 edition of *Social Disorganization*, Elliott and Merrill state that literature is probably 'the most significant index' of social disorganization. More recently, Howard Nostrand (see Part V) suggests that literature should be used as a means of determining the character of a national culture. In *Literature and the Image of Man* (1957), Leo Lowenthal searches creative literature for conceptions of man's relation to his society and time. Impressed by the resemblances of literary drama and interactional patterns in society, Hugh Duncan has adopted the dramatistic model of Kenneth Burke in *Language and Literature in Society* (1953), in part presented

in the selection included below. Besides proverbs and fables, literary dramas provide concepts for the analysis of society, the five key terms being act, scene, agent, agency and purpose. These concepts of dramatic structure become the basis for analysis of the sociodramas of public life.

In a later work, *Symbols in Society* (1968), Duncan pursues even further his concern with communication, the symbolic act, and its relation to society; yet he does not attempt to answer one of his own questions: 'How do we distinguish between drama as art and drama as social?' This question throws into doubt just what literature does in fact 'reflect' of society. Albert Guérard, the literary critic, believes that artistic literature is 'a dangerously distorting mirror,' and Bernard De Voto, in *The Literary Fallacy* (1944), has called attention to the danger of deducing the 'spirit of the age' from the art of that age—and then rediscovering the spirit in the art. Nostrand, as we have seen, is aware of this danger and insists that literary evidence must be checked against other sources. Not all sociologists have observed this precaution, and few have tried to answer Duncan's question, which is crucial for establishing the validity of this third approach to the work of art.

These three theoretical approaches to the *objet d'art* have absorbed most of the energies of scholars interested in studying the fine arts of the Western world. This degree of concentration is rather remarkable when one compares it to the predominant interest of scholars in the popular arts and mass comunications, which is centered on audience reaction, as illustrated in Klapper's *The Effects of Mass Communication* (1960). Comparable studies of audience reactions to the fine arts are relatively rare. Schücking's *The Sociology of Literary Taste* (1923) stands almost alone. The point becomes more conspicuous if one considers the treatment of 'art' by a tribe in New Ireland, Melanesia, as reported by E. R. Leach. The artists, who are professional specialists, are hired by rich patrons to construct their masterpieces and are paid lavishly for their services. The work may take six months or more to complete, after which it is exhibited at a festival held specially for the occasion. Then it is thrown away.

Whatever the reasons for these cultural differences, they call attention to areas that are much less explored than *objets d'art*. As is

implied in Leach's account, the function of the work for the festival was the tribe's primary concern, not the preservation of the object. Certainly the social functions of art in our society are not fully understood, in part, perhaps, because art has not been viewed as a total system in relation to other institutions in society. Art as an institution obviously involves many aspects waiting to be explored. Even Parsons, who has formulated probably the most fully developed theoretical system in sociology, admits that 'the field of expressive symbolism is, in a theoretical sense, one of the least developed parts of the theory of action.' The challenge is still there.

Similarly, there are neglected areas in studies of the popular or mass arts, which form a parallel and separate system, interrelated with the fine arts in ways probably peculiar to American society. Most of the articles in this section show awareness of both systems. Inevitably, some of them express their own value judgments about them. Both John Dewey and Sir Kenneth Clark, for example, favor a broadly based social art rather than the rarified fine arts. Clark defines a 'healthy and vital relationship between art and society' as one in which the majority feel that art is necessary to confirm their beliefs and to make the invisible world visible. Such is not the case today or in the recent past. Dewey more obviously deplores the separation of 'art-for-art's-sake' from everyday life. To the average person, he notes, jazz, the movies, and comic strips are the sources of vital art. Bensman and Gerver, on the other hand, strongly depreciate the qualities of the mass arts.

Most of the selections also show their authors' awareness of the historical development of the fine arts and their concern with the outstanding characteristics and the functions of the arts. Clark differentiates 'image art' from 'ornament.' The former, he believes, was created on behalf of an elite drawn from all social classes, an 'opiate of the few,' while the latter is an assertion of status. Bensman and Gerver, like Dewey, recognize the divorce of the fine arts from social life; they attribute to this separation the internal rationalization of the system, the elaboration of rules, and the dominant concern with technical problems. Poggioli explores the relationship of art to society in terms of the artist's alienation, psychological and social, economic and cultural, which leads to stylistic and aesthetic alienation. 'The

genuine art of bourgeois society,' he says, 'must be antibourgeois.'
Quentin Bell and Allen Leepa trace the independence of the fine arts
primarily through the romantic tradition of the nineteenth century.
Both are acutely aware of the recent revolt against romanticism and
of the development of the new movement that Leepa calls 'anti-art,'
which Bell sees as a new phase heralding the reintegration of the
artist into society. However, both Clark and Poggioli see the *avant-
garde* movements and the fine arts as a rarified system projected
indefinitely into the future.

Partly theoretical and historical, these articles assume, then, that
the fine arts exist as an independent realm in society, but they do not
consider the reasons for that separation. Only Dewey mentions some
possibilities, after observing that the divorce of the fine arts from
common life parallels that of religion. Museums and galleries, he
claims, exhibit not only the artistic greatness of the nation's past, but
also the booty gathered in the conquest of other nations. Thus he sees
a direct connection between the modern segregation of art and
nationalism and militarism. Another factor, he suggests, may be the
growth of capitalism, which produced a class of *nouveaux riches* who
became collector-capitalists of art. Whatever the soundness of his
observations, he is correct in thinking that nothing inherent in art
can account for its developing into a compartmental system. Only
'extraneous' conditions can explain it, but he leaves open the question
of how the aesthetic elements in everyday experience developed into
the refined satisfaction called 'aesthetic.' The search for the answers
goes on.

JAMES H. BARNETT

*The Sociology of Art**

INTELLECTUAL BACKGROUNDS OF THE SOCIOLOGY OF ART

THE INTELLECTUAL ROOTS of the sociology of art are to be found in the writings of a number of nineteenth-century Europeans. Accounts of the beginnings of the social interpretation of art invariably cite the writings of Madame de Staël, especially her *De la littérature considérée dans ses rapports avec les institutions sociales*.[1] Published in 1800, this volume discusses the relation of race and climate to literary styles, as well as the effects of women and religion on art.

Under the sway of the doctrine of progress and a belief in the stage theory of social development, Madame de Staël asserted that the literature of a society should be brought into harmony with its prevailing political beliefs. She believed that the rising republican spirit in French politics should be reflected in literature by introducing the figures of citizens and peasants into serious works, such as tragedies, rather than relegating them to comedies. In her view, literature should portray important changes in the social order, especially those which indicate movement toward the goals of liberty and justice. Her writings on this topic had wide influence during her life and for decades afterward.

The writings of Karl Marx as early as 1845 provide a more specific thesis concerning the relation of art and society.[2] Marx held that the system of production in existence at a given time determines both the content and the style of the arts of a society. On the basis of this type of analysis, plus his

* Reprinted by permission of the author and the publisher from Chapter 8 of *Sociology Today*, edited by Robert K. Merton, Leonard Broom, and Leonard S. Cottrell, Jr., © 1959 by Basic Books, Inc., Publishers, New York.

commitment to the doctrine of the inevitability of class conflict, Marx argued that even art preferences differ according to class position and outlook. Thus, for example, the English yeoman sang and danced to folk songs at a time when the aristocracy scorned this type of music in favor of the madrigal.[3]

Marx's portrayal of the distinction in class attitudes toward kinds of music is correct, but his explanation of its causes is satisfactory only to those who are committed to his over-all philosophy of society and of social change. Nevertheless, the Marxian analysis of the interrelations of art and society was of value because it specified the particular aspect of a society that might affect its art and insisted on a continuous, dynamic interchange among all the parts of that society. A host of scholars, representing a wide range of intellectual commitments to Marxist sociology, have adopted this point of view in studying art, and their views have been influential, if not conclusive.

Ernst Grosse, for example, carried the materialist interpretation of history over into his study of early art. In his book *The Beginnings of Art*, published in 1893, Grosse offered the thesis that art reflects the stage of economic organization of a society. On this point he wrote: 'the lifelike pictorial and sculptured representations of men and beasts, by which the hunting peoples are distinguished, present themselves to us very comprehensibly as aesthetic achievements of faculties which the struggle for existence necessarily develops to high perfection among hunting peoples in particular.'[4] Grosse also discussed the change in function of art from early times to modern civilizations. He advanced the thesis that among primitive men the most important social function of art was that of unification, while among civilized peoples it also serves to enrich and elevate the mind and the emotions. He brought to bear on this complex subject the methods of comparative ethnology in place of the extended philosophical discussion employed by Dubos, Herder and others.

As much cannot be said for the philosophy of art developed by Herbert Spencer, who applied his general evolutionary theory to account for the origin and persistence of aesthetic emotion. According to Spencer, human beings have the capacity to accumulate more energy than is necessary for survival.[5] In the course of evolutionary development, this extra energy became the basis for developing leisure-time activities which yield enjoyment, apart from use. Eventually these activities assumed the quality of beauty, which, as Kallen says, might be called 'dead use.'[6] As social adaptations became more efficient, the accumulation of unused energy available for expression in the arts increased. Thus, Spencer explained the origin of art in terms of the conditioning effects of a specific stage of social adaptation.

However, his thesis accounted only for the origin of art as a part of culture and did not enable scholars to explain differences in its form and content. It did, however, stimulate discussion of art from a naturalistic point of view.

A more influential precursor of contemporary sociology of art was Hippolyte Taine, whose *History of English Literature* first appeared in 1871. Taine advanced the thesis that 'A work of art is determined by an aggregate which is the general state of mind and surrounding circumstances.'[7] His detailed application and discussion of this proposition made it apparent that Taine attached special importance to the social medium or milieu which produces the 'state of mind' necessary for artistic creation.

Taine sought to account for this state of mind through the application of an analytical formula—'race-environment-time'—to different countries. The term 'race' comprehended sets of ideas about heredity, land and climate; 'environment' included social, economic and cultural factors; while 'time' focused attention on aspects of both stability and change in a civilization. When used with discrimination and erudition, Taine's formula was useful in highlighting the intellectual problems that had to be confronted by those who would explore the relations of art and society.

He was among the first critics to discuss the relations of the artist to his society and to his peers and the ways in which the public affects the creative output of the artist. Levin characterized Taine's influence on the social interpretation of literature as follows: 'Taine's *History* got rid, for once and all, of the uncritical notion that books dropped like meteorites from the sky. The social basis of art might thereafter be overlooked, but it could hardly be disputed.'[8]

Another French scholar of the nineteenth century, Jean-Marie Guyau, espoused the thesis, in his *Art from the Point of View of Sociology* (1887), that social integration is embodied in works of art. For Guyau, great art was necessarily social and the isolated artist who created for his private pleasure was decadent. According to Kallen, in Guyau's theory of art 'The artist's images, the sensations they stir, the recollections they call up, the emotions and judgements they awaken, are but symbols and communications of the collective life.'[9]

This theory of causation is in keeping with the dominant tradition of French sociology, which emphasizes the primacy of social solidarity, consensus and the collective conscience. However, Guyau's book offered few intellectual tools for studying the relations of art and society, although it did provide interesting analyses of the social ideas embodied in the work of Victor Hugo, Alfred de Vigny, Alfred de Musset and other prominent French writers. Nevertheless, Guyau's writings on the relation of art to its

social environment sustained the interest of French scholars in this intriguing topic.

From the foregoing, it is apparent that during the nineteenth century a number of influential figures were struggling with the question of how art and society were related.[10] Their answers were varied, but none denied that art, society and culture were inextricably tied together, although the nature of the connections was obscure. Most of these discussions were philosophical and polemical, although Taine and Grosse, at least, made careful attempts at objective investigation. These writers posed the general question and provided several plausible hypotheses, but they left the issues unresolved. It remained for scholars of the twentieth century to attack the problem from fresh perspectives and with new methods.

CONTEMPORARY AMERICAN STUDIES

During the twentieth century, sociological interest in the relations of art and society has persisted, and scholars in Europe and the United States have undertaken both theoretical discussions and specific research in this field. The work of European scholars—for example, Max Weber's essay *The Rational and Social Foundations of Music*, Charles Lalo's *L'Art et la vie sociale*, Ernst Kohn-Bramstedt's *Aristocracy and the Middle Classes in Germany* and Levin Schücking's *The Sociology of Literary Taste*—exhibits their traditional inclination to confront issues from an historical point of view. Of these publications, only the book by Lalo, a student of aesthetics, offers a framework for developing a comprehensive sociology of art. Lalo examined art in relation to its social milieu with special attention to religious, familial and political institutions, discussed the differences between popular art and the art of elite groups, and analyzed the social role of the artist. Unfortunately, his treatment is discursive and provided little in the way of methods or models for research. Nevertheless, Lalo's work is exceptional in this field and is all the more remarkable in that it was written by a person who was not a professional sociologist.[11]

A detailed assessment of the work of continental scholars in the sociology of art cannot be undertaken here because of limitations of space, the inaccessibility of certain publications and the difficulty of interpreting work published in at least four different languages.[12] In view of these difficulties, this discussion will focus on a number of studies by American sociologists who were directly interested in developing new methods of investigation in the sociology of art.

The most ambitious and extensive work in this field, Sorokin's *Social and*

Cultural Dynamics, Volume I, *Fluctuations of Forms of Art*,[13] combines the viewpoint of the sociologist, the art historian and the philosopher of history. Sorokin has studied art in its manifold historical forms as a way of testing a general theory of social and cultural change. In other volumes of this massive work, he explores evidences of change in religion, law, science and ethics in an attempt to discern patterns which can be considered laws or principles of what he terms the socio-cultural process. He examines art for clues to the general processes of cultural integration and change rather than to learn how it is related to the social order in a causal-functional manner. It is clear that the role of the philosopher of history has dominated Sorokin's approach to art in this book.

From his examination of a wide range of art-history materials dealing with literature, music, painting, sculpture and architecture, Sorokin concludes that there are no linear or cyclical curves of development that will accurately characterize the long-run alterations in the content and style of the arts, even within a single civilization. Instead, Sorokin believes that he has discovered abundant evidence that the several arts fluctuate in time between two polar conceptual types—the ideational and the sensate. The former type denotes art that embodies religious, other-worldly qualities and the latter the secular, sensual ones. Utilizing these constructed types, he explains changes of style in painting, subjects and the like as part of a vast swing of the cultural-historical pendulum rather than by reference to more immediate conditions that might operate as causes in a given society at a particular time. Sorokin has worked with an extended canvas of twenty-five centuries of art history. Specialists have agreed with many of his chartings of change in some of the arts and have expressed reservations concerning this conclusion in the others, especially in architecture.

So far as the sociology of art is concerned, Sorokin's work appears to provide a body of useful historical information on the arts which may provide hypotheses for the sociologist, who must then plan research on limited, specific problems bearing on the hypothesis. Moreover, Sorokin's detailed data on such items as shifts in the proportion of social classes and of the sexes found in European portraiture by centuries calls attention to a problem that merits more intensive study. For example, the sociologist who is attempting to understand the impact of social and cultural forces on the content of portraiture will need to limit his area of research as to time and place and to investigate the existing class structure, the art public interested in portrait painting, the social position of the painter and the dominant schools of painting. The fact that portraits of women bring higher prices than studies of men by the same painter suggests a relevant problem for sociologists to

investigate; this would entail intensive study of a small segment of one area of art charted by Sorokin.

In keeping with the empirical emphasis of American social science, sociologists have made their most distinctive achievements in the development and application of research methods to problems that are limited in scope. A few of the more important studies of this type warrant mention. Mueller's work on *The American Symphony Orchestra*[14] is an excellent illustration of an approach to a distinct type of art organization in which the interaction of aesthetic factors with the social and cultural environment is studied historically and also analyzed in terms of contemporary social functions. Mueller has demonstrated the impact of social factors on the major orchestras of the United States as manifested in their changing repertoires, their varying patterns of relations with unions, management and boards of directors, and their accommodation to the folkways of their audiences. His study showed that social factors, the personalities of conductors and variations in seating plans for the sections of the orchestra affected the aesthetic character of orchestral performances as well as did the technical virtuosity of the conductors and musicians.

Mueller's study is illuminating not only for what it reveals about the social evolution of the symphony orchestra but even more for what it contributes to our understanding of the formation of musical taste. In this work, he has come to grips, in terms of specific research materials, with one facet of the larger question of how society conditions art. More studies of this type might enable sociologists to remove this issue from the realm of speculation to that of evidence and proof.

Another departure from the traditional type of study in the sociology of art was made by Wilson in his doctoral thesis, *The American Poet: A Role Investigation*.[15] On the basis of interviews and the results of projective tests, Wilson analyzed twenty-four successful American poets in an attempt to explore the nature and dimensions of the poet's role as a creative artist and as a member of contemporary American society. He concluded that the role of the poet is not institutionalized in American society and that the poet suffers from neglect rather than from hostility in the contemporary social order. One of Wilson's more interesting findings was that what he termed the technical-vocational segment of the poet's role dominated all other aspects of his behavior. As the author phrases it: 'When the poet acts as a societal member, much of his role has been performed by the pervasive nature of his occupation.' Through example, this study suggests a procedure for studying creative artists in other fields and also provides a useful conceptual framework for organizing and interpreting findings.

A similar attempt to explore the social and psychological world of another kind of creative artist is found in Nash's doctoral thesis on *The American Composer* and in a later article dealing with the socialization of the American composer.[16] Nash's study is based on data concerning personality and social-background factors acquired by administering Rorschach tests and by interviewing twenty-three prominent American composers of serious music. It also includes an interpretation of the composer against the backdrop of contemporary American society and analyzes his social position, rewards, satisfactions and frustrations.

Nash found that his group of contemporary American composers were dissatisfied with their social role, that they resented the necessity of toadying to managers, conductors, instrumentalists and others in order to achieve performance of their musical works. Nash's descriptive materials on the role situation of the composer, and especially on his adjustment to this situation by developing role versatility, are of considerable value to sociologists, for they offer proof of the effective social conditioning of the work of art at its source—*i.e.*, in the creator.

Although most research in the sociology of art has been concerned with either literature or music, a recent study by Kolaja and Wilson[17] utilizes materials from painting and poetry. This provides a rough test situation in which to investigate the response of different art forms to the same sets of social influences. The authors examine the possibility that different art media of a given society will exhibit certain common cultural characteristics at a particular time. The investigators independently analyzed a sizable sample of paintings and poems created by American artists during the same year, paying special attention to the portrayals of social relationships in both media. They concluded that both the painters and the poets in their samples perceived 'the individual' as greatly isolated and as lacking relationships with other persons. The considerable difference between their perception of the typical contemporary person and similar portrayals in popular art suggests that the painters and poets who create 'serious' art are members of an art subculture and represent a restricted group. Regardless of the substantive correctness of this interpretation, the study has great promise as an innovation in methodology that may enable scholars to identify and perhaps to assess the temporal congruence of meaning among the several arts.

Several studies have been made of the relations of art and society that involve the use of quantitative techniques. These deal with literature and are promising in terms of methods and interesting in their substantive findings. Inglis, for example, has attempted to ascertain the temporal priority of social

as against literary influences by analyzing the pattern of economic and occupational attributes of the heroines of popular fiction. She studied several hundred items of fiction that appeared in a leading 'mass' magazine over a thirty-five–year period, comparing the pattern revealed in these sources with changes in the same attributes of American women of similar age as set forth in census data. She concludes: 'The fictional trend [of attributes] lags about a decade behind the actual trend.'[18] This study supports the thesis that literature, at least of the 'mass' type, reflects societal changes rather than causes them by inducing readers to imitate characters in fiction.

In an investigation of 'Majority and Minority Americans,' Berelson and Salter analyzed approximately two hundred short stories published in eight 'mass media' magazines in two years and found that fictional portrayals of minority-group members were consistently less favorable than portrayals of 'majority' Americans—*i.e.*, those who are white, Protestant, English-speaking and of Anglo-Saxon ancestry.[19] These findings are set forth in quantitative terms which dramatize the differences in the literary depictions of the majority and minority Americans. Although the substantive findings of this study are significant, the authors have failed to prove their contention that adverse representations of minority groups in American 'mass media' fiction reinforce existing stereotypes and thus mold social attitudes. We do not yet know how individuals respond to fiction, how they assimilate its norms, attitudes and values into their own minds and emotions. It may be that fiction has considerable influence as an agency of social control, but this view is, at present, a hypothesis rather than an established fact. A different method will have to be devised to deal satisfactorily with this problem.

In an interesting paper, Albrecht has reported on the results of an attempt to test the hypothesis that literature reflects cultural values—specifically the values of the family.[20] A configuration of family values was devised from a series of studies in family sociology to serve as a basis of comparison for values discovered in fictional materials. A group of 153 short stories, selected from magazines that were classified on the basis of certain technical criteria as representing different cultural levels, was studied for themes expressing adherence to or rejection of the values set forth in the configuration. Albrecht worked out the percentages of adherence to or rejection of the configuration of family values appearing in the short stories and discovered distinct patterns according to cultural levels. He concluded that his general hypothesis was confirmed but that the *frequency* of themes appearing in the stories was not satisfactory evidence of the prevalence of common values. This study exhibits considerable ingenuity in research design and demonstrates that research can deal with intangibles such as values if qualitative

units are defined carefully and if both logic and statistics are employed with full realization of their potentialities and their limitations.

A recent and most stimulating contribution to the sociological study of literature is Lowenthal's *Literature and the Image of Man*.[21] This book presents a sociological analysis and interpretation of selected novels and dramas written by European authors between 1600 and 1900, including works by several prominent Spanish and French writers, one play by Shakespeare, two novels by Goethe, several plays of Ibsen and the novels of Hamsun. Lowenthal's main thesis is that creative writers, through their selection—often unconscious—of plots, characterizations, depiction of milieus and emphasis on values, convincingly portray man's relation to his society and times. Thus creative literature provides one kind of documentation for the study of social structure and cultural change. However, Lowenthal goes beyond this point to espouse the view that creative writers are highly sensitive to *incipient changes* in man's relation to his society and often reflect this awareness in their work. Thus, scrutiny of their writings may be of special importance to students of social change.

This thesis is attractive, and Lowenthal's sociological approach to literature is stimulating and provocative. It applies imagination to significant sociological problems and is concerned with the unique and value-relevant rather than with the repetitive and measurable aspects of this art form. The sociology of literature can benefit considerably from Lowenthal's type of study. It should be noted, however, that he has neglected or ignored such matters as negative cases, representativeness of sample and validation of literary by nonliterary materials.

REORIENTATION

Today, the sociologist needs a different approach to the problem of the relationship of art and society. Until quite recently, studies in this field by sociologists have been directed almost entirely at works of art in literature, music, the visual arts and, occasionally, the drama and the dance as well. It is high time for sociologists to abandon this exclusive concentration on works of art and emulate scholars in other disciplines by extending their area of interest to embrace the artists and the art public as well.[22] This could be done by conceiving of art as a process in which the artist, the work of art and the art public are interacting elements. Thus, from the standpoint of sociology, the artist is born into a society possessing a particular culture. He is socialized by his society in ways that affect his personality and, in particular, his attitudes toward and entrance into the art world via formal

training, apprenticeship, or his individual efforts. Once the individual artist is committed to art as a career, he works in his chosen medium, employing the corpus of art techniques, traditions, values and materials provided by his society. These things are socially 'given'; the artist must utilize them or devise new media with which to express his artistic insights, values and emotions.

If he is to make a living as an artist, the work of art he creates, whether in literature, music, or the visual arts, must not only express his convictions in aesthetic form but also elicit a favorable response from some public. To do this, it must attract the attention of a potentially interested public. This necessitates contact with a body of institutionalized machinery in the form of art galleries, publication houses and boards of directors of symphony orchestras, because these agencies are able to determine which works of art shall be made accessible to the art publics. The response of the publics, and even of the critics, who seek to act as 'taste leaders' in large measure determines the immediate fate of a work of art and may cause the artist to decide to paint, write, or compose in a different manner. For example, there is some evidence to indicate that young American painters pursue the abstract style of painting not from artistic preference but because many galleries will exhibit or buy only this type of work.[23] To recapitulate, the initial recruitment of the individual artist, his training, his career as a creative artist, his artistic creations or performances and the public response to them —all can be seen as aspects or elements in the *art process*.

The sociologist should direct his efforts at a systematic inquiry into the various aspects of this process, perhaps concentrating on the social relations, social structures, norms and roles which characterize the vocation of the artist. It should be acknowledged that this type of approach is more appropriate to the study of the art process in contemporary Western society than in preliterate societies, in which art occupies a different place in a communal culture and in which the role of the artist-craftsman has a different profile. However, comparative studies of artists, works of art and art publics in different societies, both advanced and preliterate, would illuminate this problem.[24]

A related approach would entail partitioning the total area of art into the several recognized arts and studying each one separately. This procedure would enable the sociologist to take into account not only the fact that the various arts possess distinct technical 'cultures' but also the possibility that the social situations of the creative artist in music, literature and the visual arts may be markedly different in the same society at a particular time. The several arts do not necessarily receive public recognition and support

to an equal degree at any given time, and thus the tenor of the *art process* in one art may contrast sharply with that in another. For example, the famous New York 'Armory Show' of 1913 gained public attention for modern painting and the favor of a small but powerful art elite some years before modern music received like recognition in the United States.[25] The question of parallel developments in the arts should be investigated, not taken for granted as settled.

In studying the arts, the sociologist confronts one difficult problem that can be solved only with the sympathetic collaboration of the art historian and critic. This is the problem of identifying the works of 'serious' art that are worthy of study and of determining their place in the historical development of the particular art form. Without assistance from those who have technical knowledge of the arts, the sociologist will usually be unable to discriminate between matters of style, imagery, subject matter and the like that reflect important social and cultural influences and those that express merely the dominant aesthetic conventions of an art at a specific time. Artists imitate leaders in their fields as well as create their own versions of what they find significant in the world of experience, and only those who are familiar with aesthetic development in a particular art can distinguish between imitative and creative art.

A practical difficulty for the sociologist of art is the occasional unwillingness of artists to tolerate 'objective' scrutiny of themselves and of their work. Nash discovered this in his study of composers, and similar difficulties can be anticipated by those who undertake sociological studies of artists in other fields.

Finally, the sociologist undertaking the study of the arts must confront the question of what kinds of creative activity can be included in the 'arts': which arts are marginal, and which belong to some other aspect of the total cultural tradition? The writer believes it well to adopt a provisional attitude on this question and to avoid commitment to a rigid system of classification. The fine arts—music, literature, painting, sculpture and architecture—are the traditional core of pure art in the Western world and might well constitute the central focus of study for the sociologist. However, it is advisable to recognize that the modern dance and the 'serious' theater can also lay claim to being pure arts, as demonstrated by their development of aesthetic forms through which the artist seeks to embody and communicate the significance of experience. The applied arts, such as ceramics and textile design, appear to lack this intent to communicate; instead, they emphasize the importance of aesthetically satisfying designs, planes and surfaces. The capacity of these arts to symbolize more complex and abstract ideas and

emotions through aesthetic forms appears limited in comparison with the potentialities of the traditional fine arts. However, the applied arts may provide a fertile area for research in terms of indicating the functions of art publics in the over-all art process. Investigation of the publics which buy furniture of Italian, Scandinavian, or 'transitional modern' design, for example, might shed light on both the techniques of social climbing and the transitory character of public taste.

The mass media of communication present another problem for the sociologist in that the magazine story, radio play, television play and motion picture sometimes seek to reach beyond the function of entertainment and attempt to symbolize experience and to express ideas and emotions that are not mere documentary reflections of daily life. For the most part, the mass media of entertainment strive chiefly to please, amuse and instruct in terms of familiar events and conventional patterns of belief and behavior, but occasionally they criticize, evaluate and offer new interpretations of the 'human condition.' In such cases, they may take on the character of art. Unquestionably the mass media are of enormous importance to contemporary society as agencies of social communication and, on occasion, as genuinely creative forms. In addition, as Munro has pointed out,[26] great changes in technique and materials are occurring in many of the marginal arts; it would be unwise to restrict the label of art to only a few activities.

For the present, sociologists of art need to undertake a great many frankly exploratory and descriptive studies in order to ascertain the over-all dimensions of this field. Only then will it be possible to formulate and test hypotheses that will yield generalizations applicable to all or to certain types of arts. And only after this stage in turn has been reached will it be possible to extract from our knowledge of the artist, the work of art and the art public conclusions that will contribute to scientific knowledge of society and culture.

NOTES

[1] Madame de Staël, *De la littérature considérée dans ses rapports avec les institutions sociales* (Paris, 1800).

[2] Karl Marx and Frederick Engels, *Literature and Art* (International, 1947), Chap. 1.

[3] Louis Harap, *Social Roots of the Arts* (International, 1949), p. 83.

[4] Ernst Grosse, *The Beginnings of Art* (New York: Appleton, 1914), p. 311.

[5] Herbert Spencer, *The Principles of Psychology* (New York: Appleton, 1882), II, 629f.

[6] Horace Kallen, *Art and Freedom* (New York: Duell, Sloan and Pearce, 1942), II, 568.

[7] Hippolyte Taine, *History of English Literature* (New York: Henry Holt, 1886), I, 30.

[8] Harry Levin, 'Literature as an Institution,' in Mark Shorer *et al.* (eds.), *Criticism—The Foundations of Modern Literary Judgment* (New York: Harcourt, Brace, 1948), p. 546.

[9] Kallen, *op. cit.*, p. 601.

[10] For a discussion of this problem as it was approached by a number of other nineteenth-century thinkers, see H. A. Needham, *Le Développement de l'Esthétique Sociologique en France et en Angleterre au XIXe Siècle* (Paris, 1926).

[11] For a more recent formulation of his views on this topic, see Charles Lalo, 'Méthodes et objects de l'esthetique sociologique,' *Revue Internationale de Philosophie*, III (1949), 5–42 (Brussels).

[12] For example, H. Sauermann. 'Soziologie der Kunst,' in Karl Dunkmann (ed.), *Lehrbuch der Soziologie und Sozialphilosophie* (Berlin, 1931), pp. 308–333; M. Mierendorff and H. Tost, 'Grundlagen einer Kunstsoziologie,' in *Kölner Zeitschrift für Soziologie*, I (1953–54), 1–15; E. Souriau, 'L'Art et la vie sociale,' in *Cahiers Internationaux de Sociologie*, V (1948), 66–96; Lucio Mendieta y Nunez, 'Sociologia del Arte,' in *Revista Mexicana de Sociologia*, XIX (1957), 67–84; V. Loos, *Samhället och Bildkonsten* (Stockholm, 1948).

[13] Pitirim Sorokin, *Social and Cultural Dynamics*, Vol. I, *Fluctuations of Forms of Art* (American Book, 1937).

[14] John H. Mueller, *The American Symphony Orchestra: A Social History of Musical Taste* (Bloomington, Ind.: Indiana University Press, 1951).

[15] Robert N. Wilson, *The American Poet: A Role Investigation* (Ph.D. dissertation, Harvard University, 1952), p. 176.

[16] Dennison J. Nash, *The American Composer* (Ph.D. dissertation, University of Pennsylvania, 1954); and 'The Socialization of an Artist: The American Composer,' *Social Forces*, XXXV (1957), 307–313.

[17] Jiri Kolaja and Robert N. Wilson, 'The Themes of Social Isolation in American Painting and Poetry,' *Aesthetics and Art Criticism*, XIII, No. 1 (1954), 37–45.

[18] Ruth Inglis, 'An Objective Approach to the Relationships Between Fiction and Society,' *American Sociological Review*, III, No. 4 (1938), 630.

[19] Bernard Berelson and Patricia Salter, 'Majority and Minority Americans,' *Public Opinion Quarterly*, X (1946), 168–190.

[20] Milton Albrecht, 'Does Literature Reflect Common Values?' *American Sociological Review*, XXI, No. 6 (1956), 722–729.

[21] Leo Lowenthal, *Literature and the Image of Man* (Boston: Beacon Press, 1957).

[22] See R. Wellek and A. Warren, *Theory of Literature* (New York: Harcourt, Brace, 1955), Chap. 9.

[23] Bernard S. Myers, *Problems of the Younger American Artist* (New York: City College Press, 1957), Chap. 2.

[24] See George Mills, 'Art: An Introduction to Qualitative Anthropology,' *Aesthetics and Art Criticism*, XVI (1957), 1–17.
[25] See John I. H. Baur, *Revolution and Tradition in Modern American Art* (Cambridge, Mass.: Harvard University Press, 1951), pp. 5–6.
[22] Thomas Munro, *The Arts and Their Interrelations* (New York: Liberal Arts Press, 1949).

KENNETH CLARK

*Art and Society**

'ART' IS AN extensive word. In this essay I limit it to the branch of art that I know best, the visual arts: and I take this term to cover everything made in response to the feeling that certain events or objects of contemplation, seen or imagined, are so important that they must be recorded; and that certain objects of use are so important that they must be enriched. These two aspects of visual art I refer to as image and ornament. They used to be called 'fine art' and 'applied art,' and in the nineteenth century were severely distinguished from one another. Today we tend to minimize this distinction. We believe that the form-creating instinct can express itself in both ornament and image: all ornament, however abstract, suggests some visual experience; all images, however factual, reveal some sense of design. Both are forms of order. And both are sacramental. 'What is this sacrament?' as the catechism says. 'The outward and visible sign of an inward and spiritual grace.' Both image and ornament are revelations of a state of mind and social temper.

Having accepted this basic unity, however, these two branches of visual art show very great differences, especially in their relationship to society, and I shall consider them separately. I think it true to say that all image art of any value has been made by, or on behalf of, a small minority: not necessarily a governing class in a political sense, but a governing class in an intellectual and spiritual sense. Since I shall often refer to this minority, I must decide what to call it. Plato's 'governors' is too narrow a term, Rousseau's *volonté générale* is too wide and too mysterious. For the sake of brevity I have referred to it as an *elite*; although in fact it is not elected, and may be drawn from any class of society.

Images are not made for fun. In fact it is almost true to say that all image art of value illustrates or confirms a system of belief held by an elite, and very often is employed consciously as a means of maintaining that system. Obvious examples are the theocratic art of Egypt, the Parthenon with its Olympian embodiment of Greek philosophy, the stained glass of Chartres and Bourges illustrating not only Christian legend but the whole superstructure of patristic theology, the temples of Angkor and Borobudur, the Basilica of Assisi and its Buddhist equivalent Ajanta, the Stanze of Raphael and so forth, down to David's picture of the Oath of the Haratii. The list could be expanded till in the end it would include most of the greatest visible feats of human imagination and all of those which are in any way related to society and do not depend solely on the genius of an individual artist. It seems that an image achieves the concentration, clarity and rhythmic energy which make it memorable only when it illustrates or confirms what a minority believes to be an important truth.

The images provided for the majority by the elite may be more, or less, popular. Franciscan art in the thirteenth century and Baroque art in the seventeenth century were two attempts to create a new repertoire of images which should be more popular than that which preceded it. Both consciously exploited emotionalism. But the artists who gave the finest expression of those styles—let us say, Cimabue and Bernini—were working for a small group of patrons, and were deeply receptive to their ideas. Bernini's Saint Theresa became a popular image; it revealed to the majority a hidden need. But it was Bernini's own invention and in its origin it owed nothing to popular demands. Even the images which we first believe to have a popular origin—for example, those charming woodcuts known as *images d'Epinal*—are for the most part naïve and imperfect memories of images already invented for the elite by such an artist as Philippe de Champagne. The only exceptions I can think of are those anecdotal strips which simply tell a story, often with the help of balloons of text. Such were the illustrations of late antique manuscripts, the painting of popular artists like Pacino di Bonaguida, the *Biblia Pauperum* and its derivatives, and a number of Japanese scrolls, like the comic animals attributed to Toba Sojo. These, I believe, are the only forms of autochthonous popular image art before the nineteenth century, and I mention them now because they reveal a fundamental characteristic of all popular art: that it is concerned with narration.

At first sight ornament would seem to be a more popular form of expression than image. Ornament has the character of a language—nineteenth-century writers used, quite properly, to speak of the grammar of ornament—and insofar as it is a living language it is accepted almost unconsciously by

the majority. However, there is this difference, that whereas language seems to have evolved unconsciously from mass needs, a system of ornament has seldom been invented by 'the people.' In fact I can think of only one exception: the pottery of the Mexican Indians, which is outstandingly beautiful and does seem to be a genuine popular creation. In Europe good folk ornament turns out almost always to be a cruder rendering of a minority style; and I think the same is true of China, India, Persia and the whole Muslim culture. I would even extend this to the most vital and expressive of all ornament styles—that produced by the so-called folk-wandering peoples. I believe that the finest Scythian ornaments were by a great artist working for a chief, and that most of what has been discovered in Scandinavia or Scotland is a half-understood imitation of these artistocratic adornments.

In ornament the ulterior motive is less strong than in the image. It does not openly recommend a system. But no one maintains that it exists solely to please the eye and lacks ulterior motive altogether. It is an assertion of status—whether in a cope or crown or crosier or *portail royal* or precious reliquary. This fact, which has been worked out in detail by Marxist historians, is taken by them as a condemnation of art; and, as everyone knows, Veblen coined for it the expression 'conspicuous waste.' This expression is apt, but I do not find it at all damaging. All art is waste in a material sense; and the idea that things should be made more precious-looking in accordance with the status of the user seems to me entirely fitting. I think that a bishop should have finer vestments than a deacon and that the portal of a cathedral should be more richly ornamented than the door of a warehouse. I would go further and say that ornament is inseparable from hierarchy. It is not only the result, but the cause of status. The carving on the corner capitals of the Doge's Palace and the central window of the Palazzo Farnese confer a kind of kingship on those points of the buildings. In a democratic building, where all windows are equal, no ornament is permissible; although I understand that the higher executives may have more windows.

THE FIRST AND SECOND LAWS

So I would deduce from history this first law (in the Ruskinian sense) of the relationship of art and society: that visual art, whether it takes the form of image or ornament, is made by a minority for a minority, and would add this rider, that the image-making part is usually controlled in the interests of a system, and that the ornamental part is usually the index of status.

Created by a minority: yes, but accepted by the majority unquestionably,

eagerly and with a sense of participation. The degree of physical participation in the great popular works of art is hard to assess. We know that in the building of the Gothic cathedrals—Chartres is the most familiar example—whole villages moved to be nearer the work, and men were prepared to learn subsidiary crafts in order to help the professional masons. We can assume that the same was true of Borobudur or Ellora, although the economic status of the workers may have been different. A parallel in modern life would be the building of a great liner in Clydebank, where the whole life of the town depends on the work. But, apart from this active participation, one has only to read the accounts of how, in the great ages of artistic creation, works of art were brought into existence—the long and serious thought which preceded the commission, the public anxiety about its progress, the joy when it was at last accomplished and the procession in which it was carried to its destination, to the sound of bells and singing of a *Te Deum*—one has only to come upon such documents, common enough in the Middle Ages and Renaissance, and applicable, surely, to Olympia and the Acropolis of Athens, to recognize that the society of those times needed art, believed without question in the value of art and participated imaginatively in its making. So this would be my second law: that a healthy and vital relationship between art and society exists when the majority feel that art is absolutely necessary to them, to confirm their beliefs, to inform them about matters of lasting importance and to make the invisible visible.

Now, in saying that this is the *healthiest* relationship between art and society, I must not be understood as saying that these are the *only* circumstances under which good works of art can be produced. Even before 1870 great pictures were painted by individuals who had no relationship with society at all and whose work was distasteful or incomprehensible to the majority. Rembrandt and Turner, in their later phases, are obvious examples. In the history of art, as in all history, nothing poses a more delicate problem of interpretation than the relationship between individual genius and the general will. But even if we believe, as I am inclined to do, that inspiration is more likely to illuminate an individual than a mass and that all the memorable forms of art were originally invented by individuals of genius, we must agree that at certain periods these individuals are isolated, at others they enlist behind them a whole army of assent and participation.

Nor is this direct relationship of need and unquestioning belief certain to produce good art. Artistic faculties are somewhat unequally—we may think unfairly—distributed among the peoples of the globe: and although the relationship may be sound, not all needs have the same validity. However, I am sufficiently a Ruskinian to believe that when a society, over a long

period, produces an art which is lacking in vitality and imaginative power, but which nevertheless seems to be accepted by the majority, there is something wrong with that society.

This brings me back to the part of my opening definition, where I said that art was a sacrament; and I must now consider how an inward and spiritual grace can be given outward and visible form. The answer is, through symbols. A symbol is a sort of analogy in the physical sphere for some spiritual or intellectual experience. Usually it is the concentration of several related experiences so complex that they cannot be expressed in any rational form, and so intense that a physical symbol suggests itself unconsciously. We know from the saints of every religion that the most poignant spiritual experiences demand expression by physical analogies, and, in spite of Pascal and Spinoza, we may infer that spiritual experiences which remain abstract are not usually very intense. Symbols may start as a result of private revelations, but their value in art depends on the degree to which they can be felt and accepted by others. In fact nearly all intensely felt symbols have some universal quality, which makes them comprehensible even when their maker believes them to be peculiar to himself. But it is also true that the sacramental character of art is far more easily achieved when the principal objects of belief have already been given a symbolic form which is generally recognized and accepted: in other words, when there is an established mythology and iconography.

WHY AN EMPTY CHAIR WILL NOT DO

In this question of art and society the importance of an accepted iconography cannot be overstated. Without it the network of beliefs and customs which holds a society together may never take shape as art. If an iconography contains a number of sufficiently powerful symbols, it can positively alter a philosophic system. The points of dogma for which no satisfactory image can be created tend to be dropped from popular religious exposition, and episodes which have scarcely occupied the attention of theologians tend to grow in importance if they produce a compelling image. I would go so far as to say that the failure to discover a satisfactory symbol for the Holy Ghost has seriously impaired our concept of the Trinity.

Let me give an example of iconographic triumph and disaster from one painter in one place: Titian in Venice. In the *Frari* his sublime image of the Assumption of the Virgin is so corporeally convincing that it provided a point of departure for Baroque painting, and this image was to float in the background of Catholic imagination down to our own day. In the *Salute*

is Titian's painting of Pentecost, a work over which he took great pains, but without success. It was the final blow to a subject which had never found an impressive iconographical form, and which in spite of its theological importance, gradually faded from the consciousness of popular Catholicism. Let me take another example from Buddhism. It had been categorically laid down that the Buddha must not be portrayed, and in the earliest scenes of his life, such as those on the stupa at Sanchi, the central point of each episode is left a blank—an empty chair or a deserted boat. This insult to the image-making faculty was not to be borne, and a representation of the Buddha was finally accepted. But where did it come from? From the imitation, in the fringes of the Buddhist world, of some Praxitelian Apollo. Thus the most extreme example of spirituality was embodied by the most concrete expression of physical beauty. Conversely, dogma may triumph over the popular love of imagery in a theocratic society, and produce an iconography, like that of later Buddhism, with its 10,000 Buddhas, which deprives images of all artistic quality.

Lest it should be thought that this question of iconography does not apply to modern life, let me add that it is not confined to dogmatic religion. For example, the iconography of the Romantic movement from 1790 to 1830 was almost as compulsive as if it had been laid down by the Council of Trent. The tiger in Blake, Stubbs, Géricault, Delacroix, Barye and a dozen lesser artists; the cloud in Wordsworth and Byron, Shelley, Turner and Constable; the shipwreck in Byron, Turner, Goya, Géricault, Delacroix and Victor Hugo—these are symbols of Romanticism, used and accepted unconsciously because they expressed the new worship of nature and power, and a new sense of destiny. I think it would be a mistake to call this state of mind a religion. That word should be reserved for beliefs which are based on a book of holy writ and involve certain formal observances. But at least we can say that the belief in nature, which expressed itself in the landscape painting of the nineteenth century and has remained the most productive source of popular art to this day, is a nonmaterial belief. It is something which cannot be justified by reason alone and seems to lift the life of the senses onto a higher plane.

This suggests another 'law' in the relationship of art and society: that it is valuable only when the spiritual life is strong enough to insist on some sort of expression through symbols. No great social arts can be based on material values or physical sensations alone.

This 'law' leads me to consider the problem of luxury art. Now, it would be dishonest for me to take a puritanical or Veblenist view of luxury art. Moreover, there is a point—Watteau's *Enseigne de Gersaint* is an example

—at which the sensuous quality of luxury art is so fine that it offers a spiritual experience. We are playing with words and concepts which, as we breathe on them, come alive and flutter from our hands. Still, the fact remains that, in the long run, luxury art implies the reverse of what I have called a healthy relationship between art and society and so has a deadening effect. The most obvious example is the art of eighteenth-century France, where, however, the arrogant elaboration demanded by powerful patrons is sometimes sweetened, and given lasting value, by a reasonable belief in the *douceur de vivre*. But the predominance of luxury art in the eighteenth century is a short and harmless episode compared to that long slumber of the creative imagination which lasted from the end of the second century B.C. to the third century A.D. For almost five hundred years not a single new form of any value was invented except perhaps, in architecture. Works from the preceding centuries were reproduced interminably—made smoother and sweeter for private collectors, bigger and coarser for the public.

What can we say of the relations of this art to the society which produced and accepted it? That no one believed in its symbols; that no one looked to it for confirmation or enlightenment. In short that no one wanted it, except as a conventional form of display. The Romans did not want art and they did not make it; but they collected it.

The problem of luxury art is complicated by the fact that the periods in which it predominates are usually periods when the art of the past is collected and esteemed. This was obviously the case in Hellenized Rome and in eighteenth-century England: conversely the idea of collecting and displaying works of an earlier period was hardly known in those cultures where the need for art was strong and widely diffused. One must distinguish, of course, between the fruitful use by artists of earlier works, which took place in thirteenth-century Rheims no less than in fifteenth-century Florence, and the competitive accumulation of collectors. The feeling for the art of the past in Donatello or Ghiberti is entirely different from that of the eighteenth-century connoisseurs—at once more passionate and more practical. 'How can I use these admirable inventions to give my own message?' 'How can I surpass them in truth or expressive power?' These are the questions aroused by the work of the past in the great ages of art. In periods of luxury art, on the other hand, works of the past are collected at worst for reasons of prestige and at best in order to establish a standard of taste. The concept of good taste is the virtuous profession of luxury art. But one cannot imagine it existing in the twelfth century, or even in the Renaissance; and without going into the complex question of what the words can mean, I am inclined to doubt if a

completely healthy relationship between art and society is possible while the concept of good taste exists.

WHAT COUNTS IS THE COUNT

Such, then, are the deductions that I would make from studying the history of art; and I have ventured, in the nineteenth-century manner, to call them laws. It is arguable that this word should never be applied to the historical process: we see too little. But at least we can say that these are strong probabilities which should be our first criteria when we come to examine the relations of art to society at the present day. In doing so I may be allowed one assumption: that fundamentally human beings have not changed. The picture of human nature which we derive from the Book of Kings or the Fourth Dynasty Egyptian portrait heads in Cairo and Boston is much the same as what we know today, and I think we may safely assume that it will take more than television and the internal-combustion engine to change us. In fact, I would suppose that we have more in common with the Middle Ages than our fathers had, because to us universal destruction is an actual possibility, whereas to our fathers it was only a pious fiction. However, if human nature has not changed, human society has; and changed as the result of a basic shift of mental outlook.

This change can be described in one word: materialism. The word has taken on a pejorative sense, but materialism has been the source of achievements which have added immeasurably to the well-being and happiness of mankind. Whether as the dialectical materialism of the East or the liberal materialism of the West, it has given to masses of men a new standard of living, a new sense of status and a new hope. These benefits have been achieved because materialism has been the philosophical basis of two outstanding human activities, one in the moral and one in the intellectual sphere: humanitarianism and science. These are the integrating forces of our culture, and they are as powerful, and as all-pervasive, as was Christianity in the Middle Ages.

Now, how does this underlying philosophy of materialism relate to art? One cannot help being aware of one very serious obstacle. Materialism and all its children are dedicated to measurement. Bentham's philosophy was based on the greatest good for the greatest *number*. Democracy depends on counting the *number* of votes. All social studies are based on statistics. Science, although it claims to have outgrown that phase, reached its present position by an unprecedented accuracy of measurement.

In its century of triumph, measurement has even become an article of

faith. The potential of faith in the human mind is probably fairly constant, but it attaches itself to different ideas or manifestations at different periods. The bones of the saints, the Rights of Man, psychoanalysis—all these have been the means of precipitating a quantity of faith which is always in solution. People probably believe as much nonsense today as they did in the Middle Ages; but we demand of our precipitant that it *look* as if it could be proved—that it appear to be measurable. People might have believed in art during the last fifty years if its effects could have been stated in an immense table of figures or a very complicated graph; of course they would not have checked the figures or understood the graph, but the existence of these symbols of measurement would have sustained their faith.

But we cannot measure the amount of satisfaction which we derive from a song. We cannot even measure the relative greatness of artists, and attempts to do so by giving marks, popular in the eighteenth century, produced ridiculous results: Giulio Romano always came out top of the poll, which as we all know, by some unanalyzable form of knowledge, is incorrect. The more honest philosophers of materialism have recognized that art cannot be measured in material terms. Bentham invented the unforgettable comparison between pushpin and poetry, coming down on the side of pushpin because more people wanted it. Poetry he defined as 'misrepresentation,' which is the liberal counterpart to Veblen's 'conspicuous waste.' The philosophers of dialectical materialism have accepted art only insofar as its magical properties have conceded the right to enjoy and even to produce art among the rights of minorities. Art is the opiate of the few.

How are the philosophic assumptions of materialism reflected in the actual status of art in modern society? It is incontrovertible that 'fine art,' as the term is usually understood, is the preserve of a very small minority. We must not be bamboozled by the claim that more people listen to 'good' music or visit the picture galleries; nor even by the fact that a few of us have tricked the unsuspecting viewer into looking at old pictures on television. Similar claims could be made for the nineteenth century—for example, during the Manchester Art Treasures Exhibition in 1857, special trains ran from all over England, and whole factories closed down in order that the workers could enjoy the experience of art; and yet the next fifty years saw the consolidation of a Philistinism unequaled since the Roman Republic.

Anyone who has been concerned with those 'arts' which really depend on the support of a majority—the cinema, television, or wholesale furnishing—knows that the minority which is interested in art is so small as to be irrelevant in any serious calculation. In England, the majority is not merely apathetic, but hostile to art. A recent example was the film of *The Horse's*

Mouth, which the exhibitors would not show (in spite of brilliant acting and hilarious comedy) simply because the leading character was an artist. If only, they said, he had been a schoolmaster or a doctor! This is perfectly understandable. The existence of these freakish members of society whose usefulness cannot be demonstrated, but who often seem to be enjoying themselves and sometimes even to be making money, is an affront to the ordinary hard-working man. It is fair to say that in spite of this feeling, artists are treated tolerantly in democratic countries.

We should be grateful for this tolerance, but does it not fall far short of my second condition for a healthy relationship between art and society: that the majority feel art to be absolutely necessary to them; that they are not merely consumers, but participants; and that they receive works of art as the expression of their own deepest feelings?

Before answering this question, I must look back at my original definition of the word 'art.' Do the majority still feel that material things must be made more precious? Do they still feel that certain images are so important that they must be preserved? In a sense the answer is yes. The majority still want ornament on their clothes, their furnishing fabrics, their wallpapers and many objects of daily use. More than this, they still mind very much how things look, independent of their utility. Whether it be dress or automobile design, they are still in the grip of style. They and the designers are swept along by a blind destiny, a mysterious force which they cannot analyze, but of which they are acutely conscious when they look back at the fashions of twenty years ago.

A NECESSARY PURGE

But no one pretends that, in the last fifty years, the use of ornament has revealed a satisfactory relationship between art and society. Ruskin and William Morris supposed that this was due to the intervention of the machine. But this theory turns out to be applicable only to the Gothic style. In almost every other style the machine is an extended tool that can be used with confidence; and for that matter a great deal of the ornament of the past, from the Viking goldsmith work of Sutton Hoo to the inlaid panels of the Taj Mahal, is entirely devoid of manual sensibility and might just as well have been made by a machine.

From a technical point of view, the premises on which ornamental art is produced have not greatly changed. When we examine it in the light of my other laws, however, the change is considerable. With a single exception, the ornament favored by the majority is no longer made for an elite; and it

no longer has any underlying sense of symbolic meaning. In one branch of art—in architecture—it has almost ceased to exist; and although we have now grown used to buildings without ornament, the historian must record that this is a unique event in the history of art, and one which would certainly have shocked those famous architects of the past who gave so much thought to the character of their ornament, and counted upon it at all points of focus and transition. The great refusal of modern architecture was perhaps a necessary purge and had certain health-giving consequences. But often it is simply an impoverishment, an excuse for meanness and a triumph for the spirit that denies. That it is not the expression of a popular will we learn when we look down the blank face of a modern building into the shop windows at its base; and this leads me to the exception I mentioned just now: it is women's dress. There, it seems to me, the compulsion is so strong that a healthy relationship between art and society is never lost. I am not suggesting that all fashions are equally good—of course, there are moments of failing invention and false direction. But they always right themselves because there is an indestructible *volonté générale*—an interaction between the elite and the masses, a sense of status and an unconscious feeling for symbolism.

If the position of ornament in modern society is uneasy and incomplete, the position of image art has suffered a far more drastic change, owing to the invention of the camera. The public hunger for memorable and credible images has in no way declined, but it is satisfied every day by illustrated papers; and the love of landscape which, as I said, was one of the chief spiritual conquests of the nineteenth century, is fed by colored postcards. I am not denying that there is an element of art in press photography; I will also admit that I derive a pleasure from colored postcards which must, I suppose, be called aesthetic. I prefer a good colored postcard to a bad landscape painting. But in both these projections of the image, much of what we believe gives art its value is necessarily omitted. There is selection, but no order, and no extension of the imaginative faculty.

To realize how destructive has been the effect of the camera on image art, consider the art of portraiture. The desire to hand down one's likeness to posterity produced one of the chief social arts of the post-medieval world. It did so because the portrait painters of the time had behind them an immense weight of *volonté générale*. The sitters participated because they knew that their desire to perpetuate their likenesses could not be achieved in any other way. Now, no one supposes that a photograph, however skillful, is comparable with a Goya as a work of art, or even as a likeness. But the fact that photography exists, and can tell us far more accurately than a mediocre painting what people looked like, has knocked away the foundation upon

which portraiture rested. There is no longer a feeling of participation in the sitters. The portrait painter no longer feels that he is really needed, any more than ornament is needed on a building; and so he, too, has become an anachronism.

The portrait is typical of the decline of confidence in art which is felt unconsciously by the mass of people as a result of the camera. There is, however, one form of popular imagery which is not entirely dependent on photography, and that is the poster. Here, a number of my conditions for a healthy relationship between art and society obtain. Posters are made on behalf of a minority and aim at supporting some belief; they appeal to a majority, and millions of people derive from them what they take to be information about matters which they believe to be important. Moreover, posters achieve their effects through the use of symbols, and it is a curious fact that the ordinary man will accept in posters a symbolic treatment, a freedom from realism, which he would not accept in a picture framed in a gallery, simply because a poster does not exist for its own sake, but is concerned with something he needs. All this is true, and yet we know that in spite of many effective and memorable posters, advertising has not produced an art comparable to the windows of Chartres Cathedral; and never can. The reason is, of course, that it lacks what I have called the sacramental element in art. I said earlier that the nearest equivalent in modern life to the building of a medieval cathedral was the construction of a giant liner. But the liner is built for the convenience of passengers and the benefit of shareholders. The cathedral was built to the glory of God. One might add that advertising art is concerned with lies, of a relatively harmless and acceptable kind; but one must remember that the great art of the past was also concerned with lies, often of a much more dangerous kind. The difference is not one of truth, but of the different realms to which these two forms of art belong—the realm of matter and the realm of spirit.

CAPTURE YOUR BIRD ALIVE

I need not press any further the point that the philosophy of materialism is hostile to art. But what about its two noble kinsmen, humanitarianism and science? Although they are to a great extent committed to measurement, they are not wholly materialistic. They recognize values which we may call moral, intellectual and even aesthetic. They are the integrating beliefs of the last 150 years. How are they connected with art?

The more enlightened supporters of humanitarianism have often bewailed the fact that art seems to have flourished in societies which were quite the

reverse of humane. Yet we feel instinctively that this is natural; that kindness, mildness, decency are not as likely to produce art as violence, passion and ruthlessness. One of the most ancient and persistent images in art is the lion devouring a horse or deer; and it must puzzle the humanitarian mind that this bloodthirsty episode came to be accepted as a suitable decoration for pagan sarcophagi; then entered Christian iconography as a symbol of the spiritual life; and finally became the dominating motif of the only great religious painter of the nineteenth century, Delacroix. The answer is given in Blake's *Marriage of Heaven and Hell*, and I will not be so foolish as to elaborate it. But I may quote the words of a great living painter: 'It isn't enough to have the eyes of a gazelle; you also need the claws of a cat in order to capture your bird alive and play with it before you eat it and so join its life to yours.' To put it less picturesquely, art depends on a condition of spiritual energy, which must devour and transform all that is passive and phlegmatic in life, and no amount of good will can take the place of this creative hunger.

I am not saying that violence and brutality *beget* art, or that there is not still far too much violence and brutality left in the world. The bright new towns in our welfare state are an achievement of which humanity may be proud. But do not let us suppose that this peaceful, humdrum, hell-free, de-Christianized life has been achieved without loss. And apart from the unlikeliness of art being forged at such a low temperature, the doctrine of equality and the drift toward equality, on which such a society depends, run counter to one of my first laws. We have many reliable indications of what Mr. and Mrs. Honest Everyman really want. We don't need surveys and questionnaires—only a glance at suburban or provincial furniture stores and television advertisements. There we see the art of a prosperous democracy—the art that is easily unwrapped—the art of least resistance. This would not matter much, were it not that Gresham's law—that bad money drives out good—is equally true of spiritual currency; and we are all surrounded by far more bad art than we are aware of. I observed during the war, when the amount of conspicuous waste was cut down in the interest of economy, and objects of daily use, like teacups, were made without even a curve, let alone a pattern, that the appetite for real works of art was much keener and more discriminating than it was before.

With science the position is rather different. It is not so much a soil in which art will not grow as it is a rival crop. The development of physical science in the last hundred years has been one of the most colossal efforts the human intellect has ever made. Now, I think it is arguable that human beings can produce, in a given epoch, only a certain amount of creative power, and

that this is directed to different ends at different times; and I believe that the dazzling achievements of science during the last seventy years have deflected many of those skills and endowments which go to the making of a work of art. To begin with, there is the sheer energy. In every molding of a Florentine palace we are conscious of an immense intellectual energy, and it is the absence of this energy in the nineteenth-century copies of Renaissance buildings which makes them seem so dead. To find a form with the same vitality as the window moldings of the Palazzo Strozzi, I must wait till I get back into an airplane, and look at the relation of the engine to the wing. That form is alive, not (as used to be said) because it is functional—many functional shapes are entirely uninteresting—but because it is animated by the breath of modern science.

WARM BLOOD IN SCIENCE

The deflections from art to science are the more serious because these are not, as used to be supposed, two contrary activities, but draw on many of the same capacities of the human mind. In the last resort each depends on the imagination. Artist and scientist alike are trying to give concrete form to dimly apprehended ideas. Both, in the words of Aristotle's famous definition of poetry, are hoping 'to see similars in dissimilars.' 'All science,' says Dr. Bronowski, 'is the search for unity in hidden likenesses, and the starting point is an image, because then the unity is before our mind's eye.' He gives the example of how Copernicus' notion of the solar system was inspired by the old astrological image of man with the signs of the Zodiac distributed about his body, and notices how Copernicus uses warm-blooded expressions to describe the chilly operations of outer space. 'The earth conceives from the sun' or 'The sun rules a family of stars.' Our scientists are no longer as anthropomorphic as that; but they still depend on humanly comprehensible images, and the valid symbols of our time, invented to embody some scientific truth, have taken root in the popular imagination. Do those red and blue balls connected by rods really resemble a type of atomic structure? I am too ignorant to say, but I accept the symbol just as an early Christian accepted the Fish or the Lamb, and I find it echoed or even (it would seem) anticipated in the work of modern artists like Kandinsky and Miró.

Finally there is the question of popular interest and approval. The position of science in the modern world illustrates clearly what I meant by a vital relationship with society. Science is front-page news; every child has a scientific toy; small boys dream of space ships; big boys know how to make a radio set. What does a compulsory visit to an art museum mean compared to this—

an opportunity to fool around and hide behind the showcases? And, at the other end of the scale, the research scientist has universities competing for his favors with millions of dollars' worth of plant and equipment, while principalities and powers wait breathless for his conclusions. So he goes to work, as Titian once did, confident that he will succeed, because he knows that everybody needs him.

ELITE OR PRIESTHOOD?

Such are the conclusions which force themselves upon me when I examine, in the light of history, the present relations of art and society. Those who care for art and feel a sense of loyalty to their own times may feel it their duty to refute these conclusions, but I think they will find it difficult to do so without straining the evidence. Does this mean that a broadly based social art is unlikely to appear for a long time? I am inclined to think so. This is not as catastrophic as it sounds. At least 90 per cent of our fellow countrymen get on very well without art, and I don't quite know why we should bother about them or try to persuade them to take an interest. No one tries to persuade me to take an interest in racing. And yet some instinct I can neither define nor defend makes me believe that people without art are incomplete and that posterity will have a poor opinion of them; and so I peer anxiously into the dark scene I have described. This is what I find.

The fact that art is not only tolerated, but actually supported by government and municipal funds, although it is hardly worth a single vote and practically no politician has the faintest belief or interest in it, shows that it has retained some of its magic power. The unbelieving majority still recognize that the believing minority, in picture galleries and concert halls, achieve a state of mind of peculiar value. There are very few people who have never had an aesthetic experience, either from the sound of a band or the sight of a sunset or the action of a horse. The words 'beauty' and 'beautiful' often pass the lips of those who have never looked at a work of art—oftener, perhaps, than they pass the lips of museum curators—and some meaning must be attached to them.

I believe that the majority of people really long to experience that moment of pure, disinterested, nonmaterial satisfaction which causes them to ejaculate the word 'beautiful,' and, since this experience can be obtained more reliably through works of art than through any other means, I believe that those of us who try to make works of art more accessible are not wasting our time. But how little we know of what we are doing. I am not even sure that museum art and its modern derivatives, however extended and skillfully

contrived, will ever bring about a healthy relationship between art and society. It is too deeply rooted in cultural values which only a small minority can acquire.

Here we reach the crux of the problem: the nature of the elite. It was my first conclusion that art cannot exist without one, my second that the elite must inspire confidence in the majority. During the last hundred years values in art have been established by a minority so small and so cut off from the sources of life, that it cannot be called an elite in my sense of the word. Let us call it a priesthood, and add that in preserving its mysteries from the profanation of all-conquering materialism, it has made them rather too mysterious. There is something admirable in all forms of bigotry, but I do not believe that we can return to a healthy relationship between art and society over so narrow a bridge. On the contrary, I believe that our hope lies in an expanding elite, an elite drawn from every class, and with varying degrees of education, but united in a belief that nonmaterial values can be discovered in visible things.

Is it fatuous to interpret the large sale of books on art and the relative success of certain television programs as a sign that such an elite is forming? But even if these are genuine snowdrops, and not paper flowers stuck in the woods by hopeful highbrows, many obstacles will remain. There is a lack of an iconography. There is the glut of false art which blunts our appetites. There is even the danger that true art may be degraded through the media of mass communications. But I believe that all these obstacles can be overcome if only the *need* for art, which lies dormant and unperceived in the spirit of every man, yet is manifested by him unconsciously every day, can be united with the *will* to art which must remain the endowment, and the responsibility, of the happy few.

JOHN DEWEY

*The Live Creature**

BY ONE OF the ironic perversities that often attend the course of affairs, the existence of the works of art upon which formation of an aesthetic theory depends has become an obstruction to theory about them. For one reason, these works are products that exist externally and physically. In common conception, the work of art is often identified with the building, book, painting, or statue in its existence apart from human experience. Since the actual work of art is what the product does with and in experience, the result is not favorable to understanding. In addition, the very perfection of some of these products, the prestige they possess because of a long history of unquestioned admiration, creates conventions that get in the way of fresh insight. When an art product once attains classic status, it somehow becomes isolated from the human conditions under which it was brought into being and from the human consequences it engenders in actual life experience.

When artistic objects are separated from both conditions of origin and operation in experience, a wall is built around them that renders almost opaque their general significance, with which aesthetic theory deals. Art is remitted to a separate realm, where it is cut off from that association with the materials and aims of every other form of human effort, undergoing and achievement. A primary task is thus imposed upon one who undertakes to write upon the philosophy of the fine arts. This task is to restore continuity between the refined and intensified forms of experience that are works of art and the everyday events, doings and sufferings that are universally recognized to constitute experience. Mountain peaks do not float unsupported; they do not even just rest upon the earth. They *are* the earth in one of its

* Reprinted by permission of G. P. Putnam's Sons from *Art as Experience* by John Dewey. Copyright 1934 by John Dewey; renewed 1962 by Mrs. Roberta Dewey.

manifest operations. It is the business of those who are concerned with the theory of the earth, geographers and geologists, to make this fact evident in its various implications. The theorist who would deal philosophically with fine art has a like task to accomplish.

If one is willing to grant this position, even if only by way of temporary experiment, he will see that there follows a conclusion at first sight surprising. In order to understand the meaning of artistic products, we have to forget them for a time, to turn aside from them and have recourse to the ordinary forces and conditions of experience that we do not usually regard as aesthetic. We must arrive at the theory of art by means of a detour. For theory is concerned with understanding, insight, not without exclamations of admiration, and stimulation of that emotional outburst often called appreciation. It is quite possible to enjoy flowers in their colored form and delicate fragrance without knowing anything about plants theoretically. But if one sets out to *understand* the flowering of plants, he is committed to finding out something about the interactions of soil, air, water and sunlight that condition the growth of plants.

By common consent, the Parthenon is a great work of art. Yet it has aesthetic standing only as the work becomes an experience for a human being. And, if one is to go beyond personal enjoyment into the formation of a theory about that large republic of art of which the building is one member, one has to be willing at some point in his reflections to turn from it to the bustling, arguing, acutely sensitive Athenian citizens, with civic sense identified with a civic religion, of whose experience the temple was an expression, and who built it not as a work of art but as a civic commemoration. The turning to them is as human beings who had needs that were a demand for the building and that were carried to fulfillment in it; it is not an examination such as might be carried on by a sociologist in search for material relevant to his purpose. The one who sets out to theorize about the aesthetic experience embodied in the Parthenon must realize in thought what the people into whose lives it entered had in common, as creators and as those who were satisfied with it, with people in our own homes and on our own streets.

In order to *understand* the aesthetic in its ultimate and approved forms, one must begin with it in the raw; in the events and scenes that hold the attentive eye and ear of man, arousing his interest and affording him enjoyment as he looks and listens: the sights that hold the crowd—the fire engine rushing by; the machines excavating enormous holes in the earth; the human fly climbing the steeple-side; the men perched high in air on girders, throwing and catching red-hot bolts. The sources of art in human experience will be learned by him who sees how the tense grace of the ball-player infects

the onlooking crowd; who notes the delight of the housewife in tending her plants, and the intent interest of her good man in tending the patch of green in front of the house; the zest of the spectator in poking the wood burning on the hearth and in watching the darting flames and crumbling coals. These people, if questioned as to the reason for their actions, would doubtless return reasonable answers. The man who poked the sticks of burning wood would say he did it to make the fire burn better; but he is none the less fascinated by the colorful drama of change enacted before his eyes and imaginatively partakes in it. He does not remain a cold spectator. What Coleridge said of the reader of poetry is true in its way of all who are happily absorbed in their activities of mind and body: 'The reader should be carried forward, not merely or chiefly by the mechanical impulse of curiosity, not by a restless desire to arrive at the final solution, but by the pleasurable activity of the journey itself.'

The intelligent mechanic engaged in his job, interested in doing well and finding satisfaction in his handiwork, caring for his materials and tools with genuine affection, is artistically engaged. The difference between such a worker and the inept and careless bungler is as great in the shop as it is in the studio. Oftentimes the product may not appeal to the aesthetic sense of those who use the product. The fault, however, is oftentimes not so much with the worker as with the conditions of the market for which his product is designed. Were conditions and opportunities different, things as significant to the eye as those produced by earlier craftsmen would be made.

So extensive and subtly pervasive are the ideas that set art upon a remote pedestal, that many a person would be repelled rather than pleased if told that he enjoyed his casual recreations, in part at least, because of their aesthetic quality. The arts which today have most vitality for the average person are things he does not take to be arts: for instance, the movie, jazz, the comic strip and, too frequently, newspaper accounts of love nests, murders and exploits of bandits. For, when what he knows as art is relegated to the museum and gallery, the unconquerable impulse toward experiences enjoyable in themselves finds such outlet as the daily environment provides. Many a person who protests against the museum conception of art, still shares the fallacy from which that conception springs. For the popular notion comes from a separation of art from the objects and scenes of ordinary experience that many theorists and critics pride themselves upon holding and even elaborating. The times when select and distinguished objects are closely connected with the products of usual vocations are the times when appreciation of the former is most rife and most keen. When, because of their remoteness, the objects acknowledged by the cultivated to be works of fine art seem

anemic to the mass of people, aesthetic hunger is likely to seek the cheap and the vulgar.

The factors that have glorified fine art by setting it upon a far-off pedestal did not arise within the realm of art nor is their influence confined to the arts. For many persons an aura of mingled awe and unreality encompasses the 'spiritual' and the 'ideal' while 'matter' has become by contrast a term of depreciation, something to be explained away or apologized for. The forces at work are those that have removed religion as well as fine art from the scope of the common or community life. The forces have historically produced so many of the dislocations and divisions of modern life and thought that art could not escape their influence. We do not have to travel to the ends of the earth nor return many millennia in time to find peoples for whom everything that intensifies the sense of immediate living is an object of intense admiration. Bodily scarification, waving feathers, gaudy robes, shining ornaments of gold and silver, of emerald and jade, formed the contents of aesthetic arts, and, presumably, without the vulgarity of class exhibitionism that attends their analogues today. Domestic utensils, furnishings of tent and house, rugs, mats, jars, pots, bows, spears, were wrought with such delighted care that today we hunt them out and give them places of honor in our art museums. Yet in their own time and place, such things were enhancements of the processes of everyday life. Instead of being elevated to a niche apart, they belonged to display of prowess, the manifestation of group and clan membership, worship of gods, feasting and fasting, fighting, hunting, and all the rhythmic crises that punctuate the stream of living.

Dancing and pantomime, the sources of the art of the theater, flourished as part of religious rites and celebrations. Musical art abounded in the fingering of the stretched string, the beating of the taut skin, the blowing with reeds. Even in the caves, human habitations were adorned with colored pictures that kept alive to the senses experiences with the animals that were so closely bound with the lives of humans. Structures that housed their gods and the instrumentalities that facilitated commerce with the higher powers were wrought with especial fineness. But the arts of the drama, music, painting and architecture thus exemplified had no peculiar connection with theaters, galleries, museums. They were part of the significant life of an organized community.

The collective life that was manifested in war, worship and the forum knew no division between, on the one hand, what was characteristic of these places and operations and, on the other, the arts that brought color, grace and dignity into them. Painting and sculpture were organically one with architecture, as that was one with the social purpose that buildings served.

Music and song were intimate parts of the rites and ceremonies in which the meaning of group life was consummated. Drama was a vital re-enactment of the legends and history of group life. Not even in Athens can such arts be torn loose from this setting in direct experience and yet retain their significant character. Athletic sports, as well as drama, celebrated and enforced traditions of race and group, instructing the people, commemorating glories and strengthening their civic pride.

Under such conditions, it is not surprising that the Athenian Greeks, when they came to reflect upon art, formed the idea that it is an act of reproduction, or imitation. There are many objections to this conception. But the vogue of the theory is testimony to the close connection of the fine arts with daily life; the idea would not have occurred to any one had art been remote from the interests of life. For the doctrine did not signify that art was a literal copying of objects, but that it reflected the emotions and ideas that are associated with the chief institutions of social life. Plato felt this connection so strongly that it led him to his idea of the necessity of censorship of poets, dramatists and musicians. Perhaps he exaggerated when he said that a change from the Doric to the Lydian mode in music would be the sure precursor of civic degeneration. But no contemporary would have doubted that music was an integral part of the ethos and the institutions of the community. The idea of 'art for art's sake' would not have been even understood.

There must then be historic reasons for the rise of the compartmental conception of fine art. Our present museums and galleries to which works of fine art are removed and stored illustrate some of the causes that have operated to segregate art instead of finding it an attendant of temple, forum and other forms of associated life. An instructive history of modern art could be written in terms of the formation of the distinctively modern institutions of museum and exhibition gallery. I may point to a few outstanding facts. Most European museums are, among other things, memorials of the rise of nationalism and imperialism. Every capital must have its own museum of painting, sculpture, etc., devoted in part to exhibiting the greatness of its artistic past, and, in other part, to exhibiting the loot gathered by its monarchs in conquest of other nations; for instance, the accumulations of the spoils of Napoleon that are in the Louvre. They testify to the connection between the modern segregation of art and nationalism and militarism. Doubtless this connection has served at times a useful purpose, as in the case of Japan, who, when she was in the process of westernization, saved much of her art treasures by nationalizing the temples that contained them.

The growth of capitalism has been a powerful influence in the development of the museum as the proper home for works of art, and in the promotion of the idea that they are apart from the common life. The *nouveaux riches*, who are an important by-product of the capitalist system, have felt especially bound to surround themselves with works of fine art which, being rare, are also costly. Generally speaking, the typical collector is the typical capitalist. For evidence of good standing in the realm of higher culture, he amasses paintings, statuary and artistic *bijoux*, as his stocks and bonds certify to his standing in the economic world.

Not merely individuals, but communities and nations, put their cultural good taste in evidence by building opera houses, galleries and museums. These show that a community is not wholly absorbed in material wealth, because it is willing to spend its gains in patronage of art. It erects these buildings and collects their contents as it now builds a cathedral. These things reflect and establish superior cultural status, while their segregation from the common life reflects the fact that they are not part of a native and spontaneous culture. They are a kind of counterpart of a holier-than-thou attitude, exhibited not toward persons as such but toward the interests and occupations that absorb most of the community's time and energy.

Modern industry and commerce have an international scope. The contents of galleries and museums testify to the growth of economic cosmopolitanism. The mobility of trade and of populations, due to the economic system, has weakened or destroyed the connection between works of art and the *genius loci* of which they were once the natural expression. As works of art have lost their indigenous status, they have acquired a new one—that of being specimens of fine art and nothing else. Moreover, works of art are now produced, like other articles, for sale in the market. Economic patronage by wealthy and powerful individuals has at many times played a part in the encouragement of artistic production. Probably many a savage tribe had its Maecenas. But now even that much of intimate social connection is lost in the impersonality of a world market. Objects that were in the past valid and significant because of their place in the life of a community now function in isolation from the conditions of their origin. By that fact they are also set apart from common experience, and serve as insignia of taste and certificates of special culture.

Because of changes in industrial conditions the artist has been pushed to one side from the mainstreams of active interest. Industry has been mechanized and an artist cannot work mechanically for mass production. He is less integrated than formerly in the normal flow of social services. A peculiar aesthetic 'individualism' results. Artists find it incumbent upon them to

betake themselves to their work as an isolated means of 'self-expression.' In order not to cater to the trend of economic forces, they often feel obliged to exaggerate their separateness to the point of eccentricity. Consequently artistic products take on to a still greater degree the air of something independent and esoteric.

Put the action of all such forces together, and the conditions that create the gulf which exists generally between producer and consumer in modern society operate to create also a chasm between ordinary and aesthetic experience. Finally we have, as the record of this chasm, accepted as if it were normal, the philosophies of art that locate it in a region inhabited by no other creature, and that emphasize beyond all reason the merely contemplative character of the aesthetic. Confusion of values enters in to accentuate the separation. Adventitious matters, like the pleasure of collecting, of exhibiting, of ownership and display, simulate aesthetic values. Criticism is affected. There is much applause for the wonders of appreciation and the glories of the transcendent beauty of art indulged in without much regard to capacity for aesthetic perception in the concrete.

My purpose, however, is not to engage in an economic interpretation of the history of the arts, much less to argue that economic conditions are either invariably or directly relevant to perception and enjoyment, or even to interpretation of individual works of art. It is to indicate that *theories* which isolate art and its appreciation by placing them in a realm of their own, disconnected from other modes of experiencing, are not inherent in the subject matter but arise because of specifiable extraneous conditions. Embedded as they are in institutions and in habits of life, these conditions operate effectively because they work so unconsciously. Then the theorist assumes they are embedded in the nature of things. Nevertheless, the influence of these conditions is not confined to theory. As I have already indicated, it deeply affects the practice of living, driving away aesthetic perceptions that are necessary ingredients of happiness, or reducing them to the level of compensating transient pleasurable excitations.

Even to readers who are adversely inclined to what has been said, the implications of the statements that have been made may be useful in defining the nature of the problem: that of recovering the continuity of aesthetic experience with normal processes of living. The understanding of art and of its role in civilization is not furthered by setting out with eulogies of it nor by occupying ourselves exclusively at the outset with great works of art recognized as such. The comprehension which theory essays will be arrived at by a detour; by going back to experience of the common or mill run of things to discover the aesthetic quality such experience possesses.

Theory can start with and from acknowledged works of art only when the aesthetic is already compartmentalized, or only when works of art are set in a niche apart instead of being celebrations, recognized as such, of the things of ordinary experience. Even a crude experience, if authentically an experience, is more fit to give a clue to the intrinsic nature of aesthetic experience than is an object already set apart from any other mode of experience. Following this clue we can discover how the work of art develops and accentuates what is characteristically valuable in things of everyday enjoyment. The art product will then be seen to issue from the latter, when the full meaning of ordinary experience is expressed, as dyes come out of coal tar products when they receive special treatment.

Many theories about art already exist. If there is justification for proposing yet another philosophy of the aesthetic, it must be found in a new mode of approach. Combinations and permutations among existing theories can easily be brought forth by those so inclined. But, to my mind, the trouble with existing theories is that they start from a ready-made compartmentalization, or from a conception of art that 'spiritualizes' it out of connection with the objects of concrete experience. The alternative, however, to such spiritualization is not a degrading and philistinish materialization of works of fine art, but a conception that discloses the way in which these works idealize qualities found in common experience. Were works of art placed in a directly human context in popular esteem, they would have a much wider appeal than they can have when pigeon-hole theories of art win general acceptance.

A conception of fine art that sets out from its connection with discovered qualities of ordinary experience will be able to indicate the factors and forces that favor the normal development of common human activities into matters of artistic value. It will also be able to point out those conditions that arrest its normal growth. Writers on aesthetic theory often raise the question of whether aesthetic philosophy can aid in cultivation of aesthetic appreciation. The question is a branch of the general theory of criticism, which, it seems to me, fails to accomplish its full office if it does not indicate what to look for and what to find in concrete aesthetic objects. But, in any case, it is safe to say that a philosophy of art is sterilized unless it makes us aware of the function of art in relation to other modes of experience, and unless it indicates why this function is so inadequately realized, and unless it suggests the conditions under which the office would be successfully performed.

The comparison of the emergence of works of art out of ordinary experiences to the refining of raw materials into valuable products may seem to some unworthy, if not an actual attempt to reduce works of art to the status

of articles manufactured for commercial purposes. The point, however, is that no amount of ecstatic eulogy of finished works can of itself assist the understanding or the generation of such works. Flowers can be enjoyed without knowing about the interactions of soil, air, moisture and seeds of which they are the result. But they cannot be *understood* without taking just these interactions into account—and theory is a matter of understanding Theory is concerned with discovering the nature of the production of works of art and of their enjoyment in perception. How is it that the everyday making of things grows into that form of making which is genuinely artistic? How is it that our everyday enjoyment of scenes and situations develops into the peculiar satisfaction that attends the experience which is emphatically aesthetic? These are the questions theory must answer. The answers cannot be found, unless we are willing to find the germs and roots in matters of experience that we do not currently regard as aesthetic. Having discovered these active seeds, we may follow the course of their growth into the highest forms of finished and refined art.

It is a commonplace that we cannot direct, save accidentally, the growth and flowering of plants, however lovely and enjoyed, without understanding their causal conditions. It should be just as commonplace that aesthetic understanding—as distinct from sheer personal enjoyment—must start with the soil, air and light out of which things aesthetically admirable arise. And these conditions are the conditions and factors that make an ordinary experience complete. The more we recognize this fact, the more we shall find ourselves faced with a problem rather than with a final solution. If artistic and aesthetic quality is implicit in every normal experience, how shall we explain how and why it so generally fails to become explicit? Why is it that to multitudes art seems to be an importation into experience from a foreign country and the aesthetic to be a synonym for something artificial?

JOSEPH BENSMAN AND ISRAEL GERVER

Art and the Mass Society*

THE WITHDRAWAL OF artists from concern with social meaning during recent decades stems from two general sources: the *internal* rationalization of art, as found in technical and aesthetic systems; and the *external* orientation of art, as indicated in the changing social position of the artist. In this paper both will be treated in detail.

The internal rationalization of art as an aesthetic system refers to art as *pure art*, art as a form. As a medium apart from other media, art develops rules, logics and an internal economy of its own. The development of all modern art in the last two centuries is the history of explication, expansion and development of 'inner logics' both for the field and for schools of art. Over a long period of time the aesthetic premises of the arts have become more rationalized, self-conscious and self-consistent. Consequently artistic fulfillment consists of expressing and exhausting the possibilities inherent in a set of aesthetic assumptions.

Among and within schools there are rivalries between the partisans of divergent aesthetic assumptions and techniques. Such factions do not remain static. When the limits of the traditional philosophy are reached, new assumptions are posited and new techniques and modes of creativity are permitted.

The consequences of this process are

1. The major problems of art become primarily technical, and the artist

* A revised and expanded version of a paper presented at the American Sociological Society annual meeting in September, 1954, at Urbana, Illinois. Reprinted from *Social Problems*, Summer, 1958, pp. 4–10, by permission of the authors and The Society for the Study of Social Problems.

becomes primarily concerned with problems of techniques.[1] As a consequence, the artist is constrained to focus his attention on methodological problems. The meaning of social experience becomes secondary and in some cases is almost excluded from the scope of art.

2. As the rationalization of each artistic medium develops, its techniques, methods, conventions, rules, language and logic become more elaborate and precise. The position of artist then requires a thorough, intensive, and prolonged professional training, indoctrination and practice. At the same time the appreciation of the artistic product increasingly requires a knowledge of those highly sophisticated criteria upon which the work is based. Since a knowledge of such criteria can only be based upon specialized and intensive training, art becomes more and more inaccessible and incomprehensible to those who have not acquired the aesthetic standards of appreciation. The work of art is alienated from the taste of the lay public, and artistic interpreters (critics, educators, publicists, managers, dealers) become important in determining the channels by which works of art are exposed to and accepted by an untrained public.

3. The development of self-conscious schools of art is not monolithic. The artistic and aesthetic foundations of a school are the results of usage, acceptance by producers of commonly agreed upon aesthetic propositions. Even though artists belong to numerous and competing schools, art is still peculiarly a means of personal expression. Specific artists of any one school will emphasize different tenets of a school. Given this situation, the general public is confronted with an overwhelming plenitude of artistic traditions which are presented side by side.

The relationship of artistic product to the social position of the artist has been studied and documented in the last century. One major type of analysis has been in the Marxist tradition.[2] It has emphasized the relationship of the artist to the means of production, to the class structure and to markets. In general, the major thesis of Marxist analysis is that artistic production 'reflects' the system of economic and industrial production. The Marxist argument stresses the problems of the market for works of art. Taste is defined as a reflection of changes in the composition and character of the supporting strata for artists, the purchasers of artistic production who compose the market.

Marxists attempt to demonstrate a parallel between the class position of the artist and themes, symbols, avoidances and biases in his artistic production. This leads generally to a circumvention of aesthetic considerations. Moreover, overemphasis on external criteria of artistic productions results less in

generalizations about art, and more in generalizations about society.[3] These limitations do not completely invalidate external analysis, so long as it is not used as a simple-minded approach. The same stricture applies to internal analysis.

In modern times there have been many shifts in the relationship of art to society. The Renaissance entailed greater secularization. This occurred along with the rise of new classes with secular tastes, new financial resources for art purchases. The major change in the market relations of the Renaissance artist was primarily from religious to secular patronage.[4]

While the artist had lower social status, the relationship of the artist to his consumer was a close one. The artist participated in and knew the life of his patrons. There was common universe of taste between artist and consumer generated by shared social existence and the special character of the patrons.

The rise of a large middle class in the eighteenth and nineteenth centuries resulted in a mass market for art. For example, portraiture was transformed into a middle-class art, but more significant than the class nature of such art is its mass character. With mass audiences whose obligation was the purchase of a ticket, or a book, rather than employment of the artist, art reached monumental proportions. The full symphony orchestra became the characteristic expression of music and it performed for large audiences in architecturally appropriate halls.[5]

Nineteenth-century artists captured large audiences by adopting mass themes which expressed national, political and social aspirations.

Within mass audiences, scientific technology increased the scope within which the artist operated, and the artist was increasingly removed from his audience. Indeed today the musician may make a reputation on phonograph records before he makes a live debut. Major concert performers such as Artur Rubinstein and Joseph Szigetti were introduced to the musical audience in this country via the phonograph recording. In the past decade the long-playing record has accelerated this procedure of promoting performers and composers (both dead and alive) by records rather than by risking expensive live performances. Similarly in painting, the reproduction of pictures has led to a mass audience, but the painter's relationship to the audience has been depersonalized.

The very impersonality of the market place removed the artist from the art consumer. As art consumption adjusted to the purchase price of tickets, books, etc., the type and character of artistic consumer was further differentiated, making it more difficult for the artist to absorb and share the clients' world. Since appreciation of art is associated with the price of a ticket, the intellectual requirements for art consumption are reduced.

The newer art consumers of differentiated background with feebler critical criteria have replaced the stable patron groups of previous eras; correspondingly, the canons of art have become less stable. The artist, not confronting a particular patron, can choose his public from a plurality of possible consumers. He is not bound to fulfill the artistic demands of a specific consumer, nor does he necessarily face a public whose standards are either firm or highly developed.

When the artist appeals to a mass audience, he encounters certain economic gatekeepers: the impresarios, promoters, critics, etc., whose often erroneous stereotypes of the public may become demands upon the artist.[6]

In modern society, where artists have engaged in social commentary, they have more often than not rejected dominant social values. Serious art has generally been hostile or indifferent to industrialism and the middle-class way of life. This rejection has not necessarily been programmatic, utopian, or revolutionary, but rather critical of the philistinism and shoddiness of materialistic society.

Serious arts may reject the world by avoiding it—in portraying a world in which formal aesthetic concerns are dominant (Impressionism, Cubism, symbolism, abstract art, etc.)—or reject the world by portraying its most unseemly side (neo-Gothicism, surrealism, naturalism, etc.). The very term 'naturalism' has less frequently meant portrayal of the world as it is and more frequently refers to the ugliness of the world—the world as unnatural.

Since the artist is not directly concerned with a mass audience, the absence of direct pressures based on personal contacts with a patron frees the artist from all external demands and forces him to develop his own perspectives. The internal standards most directly relevant to the artist *qua* artist are those of technique.

From this there emerges another set of consequences. Art is essentially *exploratory*. Each product is an extension of the past and a feat of *virtuosity*. Mere reproduction of past work is avoided. *Novelty* in virtuosity becomes an end in itself. Freedom from the patron and the particular public, the production for an impersonal market, tends to isolate the producer from the consumer socially and economically. The artist's life patterns are separated from the rest of society, and aesthetic concerns intensify this separation.

It is perhaps ironical that the development of the mass middle-class audience enables the artist to reject middle-class standards in asserting his independence. At times, such assertions of independence surpass the aesthetic reasons for independence, for example the phenomena of Bohemianism, in which the 'artistic attitude' transcends artistic production. As art becomes

increasingly concerned with its own dynamics, the freedom of art to pursue artistic ends places serious art at tension with the society.

The serious arts, as described above, exhibit two major interrelated tendencies. Serious, self-conscious artists become primarily concerned with the creation, development, expansion, exploration and criticism of their central techniques and methods. As a result of this attitude, the artists either avoid the world in artistic self-preoccupation, or they reject the world because it ignores and rejects their central core of values. Thus, the artist forsakes the attempt at intellectual leadership where his art would be an instrument to define or influence the society.

This pattern is not true of the mass arts. In the mass arts, the concern with techniques is almost as great as in the serious arts, but the mass arts attempt to express themes and messages characteristic of either everyday life or more precisely what its consumers need or want to believe about everyday life. The mass arts may communicate inaccurately with major distortions but they do communicate!

Since the mass arts involve the use of vast and expensive communication networks, the mass arts are based on heavy capital outlays and fixed expenses. Even when unit costs are low, they can only be profitable when they have a high sales volume. This is especially true of the *free* mass arts, radio, TV and to a large extent the press; for, in these sponsored arts, circulation, surveys of readership and Nielsen ratings are a substitute for sales volume.

Given this apparatus, the mass artists can only be viewed as technicians who are elements of vast and intricate administrative organizations geared to satisfying existing demands. They are assisted by market researchers, whether formally defined as such or not, by promoters, publicity men, agents, financial and other analysts, impresarios, critics and agency representatives.[7] The content of the artist's work is supplied to him by others, and he must execute the design within the limits of mass formulae. The genius in this field is the artist who is his own market researcher, that is, one who can predict when the largest market will be available for a given technical feat, be it the tough detective of Hammett *et al.* or the plastic models of religious figures which decorate automobile windshields as mass contemporary iconography.

While the mass artist is as involved in problems of technique as is the serious artist, there are differences. As noted earlier, the technical preoccupations of serious artists result from attempts to solve technical and aesthetic problems.

The mass artist can rarely define his own problems, because they are

predefined for him by the keepers of the public taste. The solutions are necessarily simple, since they cannot go beyond public knowledge. This also holds for the means of presentation. The mass artist cannot go radically beyond established techniques, because this would violate the canons of established tastes. Instead he must rely on the serious arts to establish and develop new techniques. When these become acceptable to sufficiently large audiences, they can be adopted by the mass artists.

The economics of the mass market determine the content of art and its form. Under the compulsion of the mass approach, the businessman of the arts must attempt to find stereotypes of publics which will support mer-chandisable products. This is not an easy task. It has been assumed by many analysts of mass mentality that 'mass' means lack of differentiation, and that mass society consists of a vast number of undifferentiated people. This idea reflects an inaccurate derivation of the character of the audience from the standardized products that they consume. Actually, the mass society is a conglomeration of different groups—classes, occupations, perspectives, traditions and geographical and cultural backgrounds.

The mass arts have to find 'meaningful' themes which evoke the experiences of these diverse groups. The cultural level of the mass arts is irrelevant. What is important is an audience large enough to justify a competitive return on an investment. In a society which has a sizable population, there may be big enough 'middle-brow' and even 'high-brow' audiences to justify the costs of the relatively less expensive mass arts, such as the symphony and opera. When the specialized publics are sufficiently large, it is possible to make money with specialized mass productions addressed to different groups.

As the anticipated potential audiences increase in size, a number of limitations and restrictions are placed on producers. These have been analyzed elsewhere and will only be restated here.[8]

1. The larger the anticipated audience, the greater is the care that the *thematic treatment should not alienate any interest group of the potential audience*. This means that controversial subjects must be ignored, unless the resolution of the conflict is neutral. Such themes should be stated so that no pressure group is likely to attack the work and thereby influence large numbers of potential consumers to boycott the product.

2. Concurrently, characters must be created so that diverse groups can identify them. These symbols of identification are sterotyped abstractions. 'Realism' consists of adding external details to the 'abstraction' rather than developing the themes and figures from their internal necessity; for example,

the use of folk-song flavor in movie background music in order to present a convincing rural background.

3. The mass media are constantly vulnerable to intimidation by legal censors and the would-be censors of pressure groups. The controllers of the mass arts must continually estimate and respond to the weights and influences of conflicting pressure and interest groups. The final product is almost always a compromise, an adjustment to these different estimates. It is this form of audience calculus, rather than the internal dynamics of the art form, the creative theme, or the internal logic of the characters and events portrayed, which largely determines the mass product.

4. Since the mass arts are the creation of semi-permanent institutions and associations, the merits of any particular *art product* are viewed by its owners as less important than the maintenance of the institution. Thus, good will, good public relations, respectability, a favorable public esteem are necessary. Artistic producers are always viewed both as technicians and as upholders of public, private and political morality. Failure to measure up to these may result in catastrophe, even when no technical failure is present.

5. Because of the above factors, the mass arts are conservative. They rarely risk capital in presentations which are beyond the ascertained taste, experience, knowledge and illusions of the audience. This is true of political as well as artistic areas. When large numbers of the members of society go in a new political direction, it becomes feasible for the mass media to move in that direction. The dynamics of such changes lie outside of the sphere of the arts; but, because of this tendency to conform, the mass arts can be used as a device for estimating the underlying state of public opinion.[9] While the principle governing the mass arts is one of conformity to established norms, when marked changes occur, the prescient mass artist (if he guesses correctly) can give public expression to a trend.

The rise of science fiction especially during the post–World War II years provides an example. The number of pulp magazines more than quadrupled, and the market spread to the slick magazines, which started to publish science fiction. With the public faced with the power of science in the form of atomic bombs, guided missiles, rocketry, space satellites, etc., the mass market for literature involving futuristic possibilities of science was inevitable. Along with the popularity of science fiction there has also developed a distaste for dealing with the harsher potentialities of science for this world.

We have until now emphasized the limitations of the mass arts. They cannot come to grips with reality in such a way as to alienate large segments of their

calculated audience. Since in a complex society almost all 'problems' are controversial (except where a predetermined solution is prevalent and respectable), the mass arts manifestly avoid these conflicts.

However, the avoidance of all problems *per se* would result in the economic collapse of art as an industry. The initial economic assumptions of the mass arts include their ability to stimulate interest. They must provide some points of relevance to the consumer. The mass arts, while they explicitly avoid the manifest problems of social experience, actually disguise it and mirror the psychological life of their intended audience.

Thus, the mass arts provide scope for identification. The identification symbol may either provide for wish fulfillment or for the release of aggressions and hostilities which the consumer cannot express. Hence, on the one hand, the identifying symbols tend to be wealthy, glamorous, exciting and to have sexual access to desirable partners, at the same time the protagonists are threatened by outside forces, cannot control their environment and give expression to types of brutal, violent and antisocial behavior which are not possible in the ordinary life of the consumer. Mass-art production is similar to the world of dreams and phantasy as described by psychoanalysis. All of the elements of reality are present in disguised form. Psychologically the mass arts are different from individual projections in that in modern society the projective mechanisms are alienated from their users. Modern man does not even manufacture his own illusions. Instead they are manufactured for him by an elite corps of scientific mass producers which provides him with comfortable illusions. The primary act of mass-art consumers is the act of identification, and modern scientific mass psychological techniques make such identification easy.[10]

Whether this tendency is desirable or not is beyond the scope of this essay. One can argue that such mass illusion and deception makes it difficult for the consumer to come to grips with reality and hence understand his social world and deal intelligently with his problems.

It is also possible to argue that the mass arts tend to permit the gradual release and displacement of tensions which might otherwise be intolerable; that direct facing of reality where individuals do not possess the ability or the power to deal with it might lead to radical reconstructions of the society in directions which are not necessarily desirable.

These speculations aside, the dominant fact remains that the world presented by the mass arts to the consumer is a world which manifestly does not exist. The symbolic apparatus of modern society does not adequately describe or clarify his way of life. In the public-relations sphere, the consumer's experiences are interpreted in order to permit his manipulation. In the world

of serious art his experiences are avoided. In the mass arts his experiences are transvalued so that the consumer can respond in terms of controlled processes of reaction which lead only to relatively crude and synthetic emotions. Thus in all spheres of symbolic communication, the consumer has to try to penetrate a confusion which is impenetrable, and at best he can only occasionally glimpse the underlying reality behind the arts either in their serious or mass forms.

NOTES

[1] See René Leibowitz, *Schoenberg and His School* (New York: Philosophical *Library*, 1949), pp. xiii–xiv, 259–284.

[2] Georg Lukács, *Studies in European Realism* (London: Holloway, 1950); George Plekhanov, *Art and Society* (New York: Critics Group Series, 1937), No. 3.

[3] For example, Lukács describes Balzac as an analyst of 'the true nature of the capitalist world' (*op. cit.*, Chaps. 1–3). He also asserts: 'Balzac depicted the original accumulation of capital in the ideological sphere' (*op. cit.*, p. 63).

[4] See Jacob Burckhardt, *The Civilization of the Renaissance in Italy* (London: Phaidon Press, 1945); Arnold Hauser, *Social History of Art*, (New York: Alfred A. Knopf, 1951), Vol. I.

[5] Cecil Smith, *Worlds of Music* (New York: Lippincott, 1952).

[6] *Ibid.*

[7] *Ibid.*

[8] See Clyde and Florence Kluckhohn, 'American Culture: Generalized Orientations,' in Lyman Bryson, Louis Finkelstein and R. M. McIver (eds.), *Conflicts of Power in Modern Culture* (New York: Harper Brothers, 1947), pp. 106–128; Robert K. Merton, *Mass Persuasion* (New York: Harper Brothers, 1946); George Orwell, 'The Ethics of the Detective Story,' *Politics*, Vol. I (November, 1944).

[9] Cf. Leo Lowenthal, 'Biographies in Popular Magazines,' in Paul F. Lazarsfeld and Frank Stanton (eds.), *Radio Research* (New York: Harper Brothers, 1943), pp. 507–520.

[10] Nathan Leites and Martha Wolfenstein, *The Movies* (Glencoe, Ill.: The Free Press, 1950).

RENATO POGGIOLI

*The Artist in the Modern World**

ART AND SOCIETY

IN A DEMOCRATIC society, as Baudelaire wrote in discussing Poe, the tyranny of public opinion prevails morally as well as culturally, but since this is a tyranny incapable of exercising authority or of establishing absolute conformity, such a society ends by tolerating—within a limited area—manifestations of eccentricity and nonconformity affected by individuals and groups operating in a direction opposed to the norms of society. Even in the field of culture, democratic society is forced to admit—in addition to conventional and official art—what is called *art d'exception*. In the very act of transgressing the norms of society by proclaiming itself to be antidemocratic and antibourgeois, *avant-garde* art does not realize that it pays involuntary homage to democratic middle-class society. It is not aware that it is expressing the evolutionary and progressive principle of this social order even as it abandons itself to the opposing illusions of inversion and revolution.

The *avant-garde* artist, like the Romantic artist, often accuses modern society of killing him, and Antonin Artaud, in his knowledgeable biography of Van Gogh, does not hesitate to describe the Dutch painter as 'a suicide of society.' It is interesting to note that these words echo Vigny's where, in a letter on Chatterton, he described that poet as a 'suicide of society.' Such an accusation would make no sense, however, if it did not presuppose that the historical and psychological type of the *avant-garde* artist—a phenomenon typical of our social system—would be inconceivable except in a

* Reprinted from *The Graduate Journal*, Winter, 1964, pp. 98–117, © by The Board of Regents of the University of Texas, by permission of *The Graduate Journal* and Mrs. Renata Poggioli, Literary Executor.

society and culture like our present one. Even if one admits that this social order condemns him to die, a different social order would simply have made it impossible for the *avant-garde* artist to be born. Perhaps the relationship between the artist and contemporary society was best expressed by Mallarmé, when, in an interview with newspapermen which permitted him to borrow a political image, he declared that in a period and culture like ours the artist finds himself 'on strike against society.' A strike cannot take place except where there are labor relations which give rise to conflicts of interest.

The complex series of links between *avant-garde* art and the society to which it belongs willy-nilly will also be considered from the specific and distinct perspective of cultural reality. In terms of historical necessity, the relationship cannot help being a positive one: it is the relation of parent to child. On a deeper level, however, and in the less comprehensive sphere which is that of culture in the narrower sense of the word, this same relationship can also become consciously, deliberately and freely negative. In this sense, *avant-garde* art assumes the functions and aspects of a cultural opposition to its own society and especially to the conventional, official culture.

In this connection, we may recall that this formula was first used by the critic von Sydow to define the special characteristic of European Decadence. It can also be applied, with even greater validity, to modern art as a general phenomenon, without any qualifications or exceptions. The concept of a negative culture cannot mean the absolute negation of the prevailing culture, which would be a contradiction in terms, except in a metaphorical sense. It means rather the radical negation of a general culture by a specific one. In other words, Decadence and *avant-garde* art appear only when a conflict arises between two parallel cultures in a given historical situation and in a given society. The wider and more inclusive culture can sometimes—although not always—ignore the exclusive and particular culture, but the latter has no alternative but to assume a hostile attitude toward the former.

Avant-garde art, as a minority culture, must attack and deny the majority culture to which it is opposed, *i.e.*, the mass culture which has recently appeared in the modern world because of the growth of mass communication, information and education. Mass culture has reached the highest point of its development in American society, the most typically liberal-democratic, middle-class-capitalistic and technical-industrial of all modern societies.

At least in theory, the *avant-garde* artist means to react not so much against society itself as against the civilization created by society. To him the mass culture looms as a pseudo-culture, against whose specious values he directs his revolt. Faithful to a qualitative system of values, the modern artist,

faced with the quantitative values of modern society, feels both left out and rebellious. This state of mind has practical social consequences, but above all it arouses in the modern artist a particular anguish: a consciousness that artists of other times and civilizations never felt so rejected or isolated, even if they were infinitely less free. From this feeling of isolation emerge dreams of revolution or reaction, of past or future *Utopias*, and other equally impossible visions of new orders to come or old ones revived.

This social and psychological condition, characteristic of the cultural anarchy of our times, has been called *alienation*. It will be our task in the coming pages to diagnose and outline its principal features. Reversing the usual process for the moment, let us look at the prognosis, which is easily summed up in saying that the disease is chronic and destined to continue. In fact, it can only end with the death of the patient, that is, with the disappearance of the *avant-garde* type of artist from the historical and cultural scene, which in turn could only take place if there were to be a radical change in the social and political system. One of the reasons we presumed to deny the validity of certain statements by artists and contemporary critics predicting the imminent disappearance of the *avant-garde* movement—statements based on its alleged decline—was that we have not yet reached the point of believing in the imminent or fated decline of the society and civilization in which we live. To make a hypothetical and somewhat negative equation, we would say that *avant-garde* art is condemned to perish if our civilization is condemned to perish, that is, if the world we know is destined to decline in a future different social order, where mass culture would be the only possible and recognized one. If an undifferentiated series of totalitarian societies were to be established, which would not permit the survival of a single intellectual minority, they would be unable to conceive, let alone recognize, the value—or even the existence—of the exceptional and individual. If, on the other hand, a change of this sort is neither imminent nor fated, *avant-garde* art is destined or condemned to last, blessed in its freedom and cursed in its alienation.

PSYCHOLOGICAL AND SOCIAL ALIENATION

The state of alienation will first be considered from the viewpoint of psychological alienation. Even Marx, who first used the term, borrowing it from Hegel and from the lexicon of law (although he found the causes of what he called *Entfremdung* in progressive social degeneration, in the irreparable crises of a society incapable either of renewing itself or of dying), nevertheless traced its features in terms of individual psychology with some ethical and

religious implications. He described the course of social degeneration as a process of demoralization. In short, he defined it as the feeling of futility and isolation which the individual experiences when he realizes that he is completely estranged from a society which has lost awareness of the human condition and of its own historical mission. It was above all in a psychological sense that the concept of alienation was later stretched or made narrower. At its broadest it has been applied to the situation of modern man in general, and to the plight of the modern artist in particular.

Even at the start of an analysis of the psychological phenomenon of alienation, we can see that it is not merely a painful state of mind, but a pain capable of being felt as a positive reality, as a source of enthusiasm and exaltation. In fact, there have been many Romantic artists, and other eager pioneers of successive artistic generations, who have regarded this state of mind as a source of pride, and therefore as a pretext to hurl a defiant, gigantic or Promethean challenge to the world of man, of history and of God.

Forced to live in the desert of his abandonment or on the mountaintops of his own solitude, the artist comes to find the consolation of heroic destiny in what Baudelaire has called his 'curse.' In Nietzsche's terms the artist thus thinks he can sublimate his fatal and prophetic illness in the almost super-human creative activity which the German philosopher presupposed to be the condition of all spiritual and mental health. The artist thus hopes to fulfill himself and his own work by following the path of sin and transgression. He hopes to taste the fruit of knowledge by means of disobedience and rebellion. The artist then becomes, in Rimbaud's words, *le grand malade, le grand criminel, le grand maudit, et le suprême savant*!

Such euphoria was short-lived, however, and was found to be only a morbid illusion. Later, the state of alienation came to be considered a pathetic and tragic, rather than a heroic and Dionysian, experience. Because of this feeling, the artist was driven to turn the weapons of his antagonism and nihilism against himself, instead, as formerly, against society and the external world.

Baudelaire already approached this attitude in his myth of *L'Héautonti-morouménos*, 'the self-tormentor.' Sometimes the artist ends by considering the state of alienation as a disgrace or as a moral ghetto. When he tries to react against such a fate he finds no other escape than self-caricature or self-mockery. Aware that bourgeois society looks at him only as a charlatan, the artist deliberately and ostentatiously assumes the role of comic actor. From this stems the myth of the artist as *pagliaccio* and mountebank. Between the alternating extremes of self-criticism and self-pity, the artist comes to see himself sometimes as a comic victim and sometimes as a tragic victim,

although the latter seems to predominate. In recent years, in the milieux of *avant-garde* artists and critics, under the influence of psychological and anthropological theory, the artist has consequently been conceived as a sort of *agnus dei*, or sacrificial lamb, or innocent creature on whom society turns its own sense of error and sin. The artist is sacrificed so that the blood thus spilled will redeem the sins of the whole tribe. In this way the poet or artist, having fallen from the position of the elect to that of the rejected (one has only to think of the themes of exile on earth, of curses, of disappointment in the well-known works of Nerval, Baudelaire and Mallarmé), assumes, in turn, the new roles of saint and martyr. He may even assert that he has a quasi-religious vocation rather than emphasize the satanic impulse of revolt, evoked by Baudelaire in his dictum 'the man of letters is the enemy of the world.'

Sometimes the state of alienation is conceived not only in ethical and psychical terms, in the 'science of the mind,' to use Toynbee's phrase, but also in purely pathological terms. We have already mentioned the exaltation of illness and of the accursed condition by Baudelaire and Nietzsche, but now the exaltation gives way to submission and piety, precisely because these states are no longer treated as metaphysical realities—in the mystical and figurative sense—but as objective, physical phenomena, as illnesses in the literal sense of the word.

This approach has established a fatal identity between *art* and *neurosis*, as an obvious consequence of the theories of Freud and psychoanalysis. It has, in fact, equated the concept of alienation with the occupational illness of the artist and the writer. Edmund Wilson, for instance, in his collection of essays called *The Wound and the Bow*, revives the myth of Philoctetes, abandoned with the shame of his wound on the island of Lemnos, with no other support than that of his own bow, to suggest that the vocation of the artist is linked to an innate pathological tendency, to a rift between body and mind and to evil in the body, no less than in the mind. Sometimes that most terrible illness, which corrodes the brain and the intelligence, insanity, is considered to be almost an occupational hazard of the artist, just because the state of alienation, with the fatal dualism which accompanies it, might contribute to the development of that split in the mind of the patient which is called schizophrenia. In this connection, it is perhaps worth noting that many psychoanalysts who have studied the alienation of the artist are naturally inclined to interpret the concept in a sense analogous to the psychiatric sense of the term.

The historical origin of the term 'alienation'—the significant fact that it was coined and first applied by Marx—as well as the internal logic of the

concept, which presupposes the existence of a larger body to which the individual must first belong before he can be alienated, suffice in themselves to show that the psychological definition of 'alienation' is inseparable from the sociological definition. We have already said something about what we may call the *social alienation* of the modern artist elsewhere, speaking of the unpopularity of *avant-garde* art and its relation to politics. We shall return to this problem from a different point of view. Here it is sufficient to repeat again what we said about the relation of the *avant-garde* to its public, that is, to deny again that this public is identical with the cultural and social group that is known as the *intelligentsia*, and to deny that the state of alienation can justifiably be considered in purely classical terms. For other reasons, however, this does not prevent us from examining the state of alienation in the particular perspective of the economic conditions of modern art, and the relations between the artist and society which are affected by work. There is no doubt that an important aspect of the social alienation of the artist takes the form of *economic alienation*.

ECONOMIC AND CULTURAL ALIENATION

It might be maintained that the development of the alienated state of mind, like the appearance of *avant-gardisme*, is a phenomenon, if not wholly determined, at least partly conditioned by the economic situation of the artist and the writer, notably by the practical, ideological and psychic effects of sudden economic changes in relatively recent times. In other words, the modern artist or writer has not yet succeeded in reconciling himself wholly to the fact that capitalist, bourgeois society tends to treat him on the one hand as a parasite and consumer and on the other hand as a worker or producer, rather than as a creator. The society which gives him the opportunity to earn his living directly by the public sale of his own work and by selling his time and labor, has subjected him to the dangers of alternating economic independence and dependence. By putting him on the level with the industrial worker, society has subjected the artist to the hazards of unemployment and overproduction, thus creating what the English critic Christopher Caudwell described as 'the false position of the poet as a producer for the market.' Courtier or artisan, the writer or artist of other times could count on the relative security offered him by the protection of a sponsor or the responsibility of a patron. Reduced to the status of an industrial worker, the modern artist is deprived of any guarantee that the fruits of his labor— under the market law of supply and demand—can fill certain needs which, if not urgent, are at least fairly extensive and regular.

Given the fact that bourgeois society, with its cult of respectability and its tendency to distinguish clearly between intellectual work and manual labor, prefers to consider the fruit of artistic and literary endeavor as a service rather than as a product, the modern artist or writer is naturally led to assume the attitude that he is a free professional, but in most cases he lacks the fixed clientele that the doctor, the lawyer and the engineer can count on. Bourgeois society and government are naturally (and fortunately, we think) not inclined to regularize and set norms for the artist's work as a necessary, although unproductive, social service, as they do for the clergyman, the judge and the teacher. Thus when a tendency of this sort appears to any considerable or lasting degree, it is recognized as a symbol of radical change in the social structure. In totalitarian or nonliberal societies, or in exceptional circumstances such as temporary dictatorship during a major war, there occurs the fairly recent phenomenon of bureaucratization of intellectuals, writers and artists.

For different but equally important reasons, it is interesting to observe the rare examples of contemporary patronage of the arts, which cannot help operating in a bourgeois way. While the patrons of the past operated with individual initiative even if they had access to public funds, in our day even private patrons tend to operate in a public and civic sense.

Despite the dangers and difficulties of the situation, the modern artist and writer have opened the door to financial success to a point simply unthinkable in earlier times or societies. It is certainly not pure coincidence that our era, in which—to take an example from the field of literature—the important book is one written for a selected public, in a small edition for a limited number of collectors and literary persons, should also be the era of best sellers, which are sometimes sold by the million. In other words, the age of modern art and *littérature d'exception* is also the era of commercial literature and industrial art.

This gives rise to the frequent and usually sincere refusal, on the part of the real artist in our day, to give in to the lure of material success. Furthermore, even if he allows himself to be tempted, the artist can only put his trust in chance or luck because the public he wishes to reach is not reducible to a definite entity or to a series of classifiable groups—thanks to its great numbers, the complexity of its needs and the variations in its structure. Nothing is more significant than the American tendency to classify the public in the three categories of 'high-brow,' 'middle-brow' and 'low-brow.' It is still true, however, that neither the critic and the sociologist, who operate with hindsight and judgment *a posteriori*, nor, even less, the writer and the artist, who must act intuitively and *a priori*, are in a position to determine

even approximately the structure and the particular standards of taste of any of these categories at a given moment.

We repeat that the modern artist and writer tends to reject the temptation of material success and if it is an undefined public to which they address themselves, it is necessarily limited in number, socially incoherent and perpetually subject to capricious changes of fashion. It must, perforce, be the group known by the ridiculous and mocking epithet 'high-brow.' This tendency might seem to be a quasi-traditional and classical return to the judgment of an intelligent, elite public, appealed to by a creative aristocracy, but this would be only a surface judgment. This public has no clearly defined existence as a social group or distinct entity. The very concept of 'high-brow' presupposes the co-existing groups of 'middle-brow' and 'low-brow'; the boundaries are often blurred or distinguished only by degree. What is more important in this alleged return to an older pattern is a very new phenomenon directly determined—by way of an extreme unyielding reaction—by the historical attitude which prevailed in the immediate past and which operated in the opposite way.

As a psychological phenomenon *avant-garde* art—at least in its most recent and extreme forms—may seem to have arisen as a reaction provoked by the failure to establish a different and contrary type of social order. In the hundred years from the last quarter of the eighteenth century to the last quarter of the nineteenth century, many writers, and to a lesser degree some artists, conceived the ambitious notion of transforming the pen or the brush, the fiddler's bow or the conductor's baton, into a marshal's baton. In other words, they hoped to acquire with their own tools intellectual power, moral prestige and social authority comparable to conquests which were being made with the scepter, the miter and the sword. The same degree of commercial success was not sought except as a symbol of the triumph, a laurel won with the victory.

This was the dream of Balzac, who chose as his mission, 'to complete with the pen what Napoleon had begun with the sword.' The dream was shared, with greater or less intensity, by the greatest artists and writers of the period, from Voltaire and Rousseau to Dostoievski and Tolstoy. This ambition was often conceived in terms of religious preaching and moral conversion rather than as an armed conquest of new realms of the mind. No one represented this dream or embodied this ambition with greater audacity and magnificence than Balzac himself. He did not succeed, however, in gaining the power he sought; even less did he gain the economic authority of that power. For this very reason Pedro Salinas describes this dream—'the power of the writer'—and the failure of this ambition, by a phrase which is also the title

of one of Balzac's famous novels, *Lost Illusions*. By a highly significant co-incidence, the role of historic symbol, identical to Salinas', had already been attributed to the same novel of Balzac's by a very different critic, the Marxist Georg Lukács. Lukács, in fact, considered Balzac's masterpiece to be the first conscious revelation on the part of any modern artist that he had fallen permanently to the level of a pure and simple 'producer for the market,' in Caudwell's phrase. Lukács' opinion is that in *Les Illusions Perdues* Balzac focuses the story not only on Lucien de Rubempré but also on the trans-formation of literary production into merchandise.

Although the modern artist may be conscious that those illusions are forever lost, he has not yet succeeded in ignoring or in forgetting completely the very dream in which he is no longer able to believe. This psychological ambivalence, caused by disappointment and nostalgia, justifies the artist's paradoxical lament, which is both antihistorical and illogical, about the scarcity—or the outright lack—of a contemporary public for his work. In fact, this lament was voiced in a period when for the first time that public potentially coincided with the majority of the population. It was voiced by the type of artist who, by definition, addressed himself to a restricted or specific public, which is differentiated from an unlimited, general public by means of a deliberate act of opposition. This lament makes sense only insofar as the contemporary artist—despite his disdain and affectation—continues to nurse an unspoken yearning for happier and safer times when the creator could count on an attentive, faithful and unified public, however small it might be, to which he was linked by a set of identical presuppositions and by the same artistic and aesthetic values. One might say that the modern artist, who worships genius, does not at all resign himself, at least in his inner mind, to the permanent loss of the advantages inherent in cultural environments which are dominated by the principle of genius rather than by that of taste.

In the optimistic atmosphere of early Romanticism, Wordsworth, while recognizing the difficulty of the situation, accepted it as an inevitable and natural circumstance when he stated that 'every poet must create the taste by which he is to be enjoyed.' In post-Romantic culture, however, this parti-cularly arduous task of the modern genius becomes an enormous undertak-ing, futile and also impossible. The pathos of this vain and titanic effort, symbolized by many modern artists in the myths of Tantalus and Sisyphus, leads the poet of our time to choose as the supreme theme of art the tragic, problematic nature of his own work, the labor of poetry itself. A culture which is dominated by such a dichotomy between culture and taste, rather than co-ordinating them or subordinating one to the other, is destined at first not

to be able to count on the existence of an elite capable of accepting, appreciating and judging works of art, because it is not only the artist but also the elite which finds itself perpetually in the state T. S. Eliot suggestively describes as 'disassociation of sensibility.' In any case, the artist must continually search for this elite without the certainty of finding it either at the beginning or at the end of his career. He may spend all his life aimlessly plodding on in his desolate no-man's land. This futile pilgrimage makes him consider the act of creating itself as a game of chance, a toss of the dice on the table of fate, as Mallarmé did. Whereas the classic artist, who looked only to the remote past and the distant future, succeeded in finding himself in harmony with his own contemporaries, the modern artist, so conscious of the task assigned to him by the *Zeitgeist* itself, ends by considering even a work in progress as a sort of posthumous work. Mallarmé himself showed awareness of this particular situation when he declared, in a little-known interview, 'for me, the case of the poet in this society which does not allow him to live, is the case of a man who isolates himself to carve his own tomb.'

Such considerations, which bring into paradoxical relief what we might call the contemporary artist's feeling of *historical alienation*, lead us to the purely sociological interpretation of the concept of alienation. A cultural sociology of our times can only be constructed on the hypothesis of a pluralism of intellectual levels, which are distinct and contradictory. This pluralism blocks crystallization or formalization. What occurs is really the opposite of the clearly hierarchical stratification of medieval society, or of primitive, archaic civilizations. The cultural and social situation of our time is in a state of continual flux, a never-ending process of agitation and metamorphosis.

From the political point of view, this situation produces a phenomenon opposite to what Pareto called 'the circulation of the elites,' which really means circulation within the elites. Instead, what happens is a continual rise and fall from one elite to another, and between elite and non-elite. For this very reason, the artist and the intellectual are naturally led to form their own group and to assume a distinct position, detached from the traditional culture of the society to which they belong, at least by origin. It is a continuous process of disintegration, because society and various social groups react in their turn in an equally strong, but contrary direction. It can be said that this relationship of reciprocal destruction is, on the surface at least, the only real link which connects *avant-garde* art to its own social environment. This reduction of the relations between art and society to a purely negative function, which from the artist's point of view is alienation both in name and in form, is a new historical fact of incalculable importance and

profound significance. When critics and observers praise or blame *avant-garde* art for its refusal not only to serve but even to express contemporary society, they fail to realize that *avant-garde* art is not only the direct expression of a negative cultural relationship, but also the indirect expression of the human and social condition which has created this schism in the structure of the culture.

Sometimes the negative nature of this relation takes the form of reciprocal inertia, creating the illusion that a given aesthetic experience occurred virtually without any contact with its setting. In this case, social alienation takes the form of isolation from history and isolation in time. To describe manifestations of this kind, or, rather, to locate them on the map which represents the battlefield of modern culture, Caudwell, a Marxist, coined the idea of the 'poetic pocket,' using an image from the art of the past, seeing them in those aesthetic expressions which seem to unfold by a purely internal logic for which it would be impossible to find analogous or parallel lines of development in contemporary social and political life. There are even more examples in modern art, in our opinion, especially in the movement of aestheticism, and in the groups which are partially distinct from the movement as a whole and become what are called 'sects.' Caudwell knows better than we do that no human activity, even the freest, can function in a void, in a condition of absolute ignorance of its own historical context. For this reason, the term 'poetic pocket' describes a situation which is more apparent than real. If it is applied with discrimination to the theme of our study, however, the term is useful and suggestive, just because it puts into clear relief—to the point of absurdity—the state of opposition in which *avant-garde* art has found itself when faced with present social reality.

It is really the fanatical supporters of the absolute value of aesthetic isolation who are most disposed to accuse society of failing in its alleged duty to give practical aid and moral support to the activities of *l'art d'exception*. Forgetting that such activity is often characterized by social inertia, they do not seem to realize that society cannot respond to this inertia except by a similar inactivity. Need we repeat that *avant-garde* art is short-sighted in accusing, from its own isolation, the only type of society in which this isolation has become both necessary and possible? *Avant-garde* art has no right to protest that it is not treated like a wild flower when it is a hothouse flower. Like the metaphor of the poetic pocket, this image of the hothouse flower may perhaps serve to emphasize a truth already mentioned, that is, that the alienation of modern art from its society, and vice versa, not only manifests itself in psychological and sociological, economic and practical forms, but also in cultural and aesthetic forms. And although we have not

heretofore had occasion to examine purely formal values, alienation in cultural and aesthetic forms is the most significant and striking of all. Turning now to the formal aspects of the question, let us consider the more intimate aesthetic criterion of style from the viewpoint of *stylistic alienation*.

STYLISTIC AND AESTHETIC ALIENATION

Malraux observed that the origins of modern art coincided with the repudiation of bourgeois culture on the part of the artist. In contemporary aesthetic ideology, he observed, 'it is not the proletariat or the aristocracy which is the object of antagonism, but the artist.' The antagonism between the bourgeois mind and the artistic mind, which, like all antagonisms, implies an interdependent relationship between the two forces, became the theme *par excellence* of Thomas Mann's work in which the antagonism is reduced from a social controversy, a public and external conflict, to a private question, a psychic crisis. If at times the drama falls to the level of comedy, describing the artist as bourgeois and ironically invoking the ambivalence created by that situation, at other times it borders on tragedy, when the writer describes the bourgeois as artist, representing him as the victim of an alter-ego in his innermost self, and as the creator of work which is the artistic nemesis of bourgeois culture. If, on the sociological plane, the problem of the relations between the artistic mind and the bourgeois mind ends, in spite of everything, in a synthesis, on the historical plane the problem remains unresolved and in a state of antithesis. In the latter perspective, that of culture, which underlines the separation as well as the reciprocal nature of the two opposites, it must of course be asserted as an absolute principle that the real art of bourgeois society must be antibourgeois. It is more important to note that such a principle operates not only in the realm of content but also in that of form. Modern art, therefore, opposes the stylistic theory and practice which dominate the society and civilization it belongs to. Its chief function is to react against bourgeois taste. We say taste, rather than style, because, to quote Malraux again, 'there are styles of the bourgeois era but there is not a single bourgeois style.' What matters here, therefore, is not so much the denial of the existence of a bourgeois style as the affirmation—a paradox only in appearance—of the coexistence of many styles within the culture of the middle class. The postulate that interests us is, then, that a pluralism of styles is one of the defining characteristics of the contemporary artistic situation, or, if you will, of bourgois culture.

It is really by way of reaction against the pluralism of bourgeois taste that *avant-garde* art takes the path of stylistic dissent. According to Malraux,

the modern artist ventured into the field of deformation and abstractionism with the intention of escaping from that 'imaginary museum' or 'museum without walls' in which he had found himself enclosed since the invention, perfection and diffusion of photographic reproduction which has made even the most archaic and esoteric artistic creations of all schools, all styles, all times and all countries accessible and familiar to the most inexperienced artist and to the most provincial and remote public. *L'art d'exception*, in this case painting, might thus appear as an act of protest against the cosmopolitanism and universalism of contemporary taste. These, incidentally, are the most obvious, external characteristics of a phenomenon as ambiguous and complex as contemporary aesthetic pluralism. If the preservation of such pluralism is also the fruit of negative factors, such as eclectic tolerance or skeptical indifference, its initial appearance was made possible by a series of conflicts and crises. The first of these conflicts was, naturally, that which divides once for all the art and culture of the *avant-garde* from popular art and culture in the traditional sense. One becomes conscious of the separation provoked by such a conflict only after the failure of romantic 'populism,' or exaltation of 'the people.' The separation itself, seen as an unbridgeable chasm, came later when scientific sociology established rather too neat a distinction between culture in the humanist sense and culture in the anthropological sense. Since then purely ethnic cultures have almost completely disappeared from Western civilization, and this disappearance is only one of many nemeses in a democratic, technological and industrial civilization like ours. Many artists of our time, those, so to speak, less extremely and typically futuristic, have realized that the very nature of our civilization leads to loss or annihilation of the values represented by more deeply rooted traditions, which are less self-conscious and more spontaneous. They have imagined that they could alter the process by postulating unattainable restorations or expecting impossible solutions.

The first of these illusions deceived a man of the Right, T. S. Eliot, who dreamed of a new medievalism in the future, with a hierarchical society and a stratified culture. The other illusion was cherished by a man of the Left, Herbert Read, who recommended the reconstitution of a popular culture and a craftsman's art in the setting of a progressive society. Unfortunately, modern society, through specialization and technology, has broken all ties between craftsmanship and artistic endeavor and has destroyed every form of folklore and ethnic culture, transforming the very concept of the people, which today is synonymous with the very different concept of the masses. Thus Read's program, like Eliot's nostalgia, is easily recognized for what it is, a retrospective *Utopia*. In reality, there has been only one modern poet who

has penetrated the sources of national folklore, the Spaniard García Lorca, who belonged to a society which was still static and crystallized. Despite the similarity of the situation, the modern Irish poets, from Yeats on, were not in a position to achieve equally successful results, because they were constrained to use English—the language of a modern culture—as their instrument.

In the figurative arts, the ethnic element operates at present only on the lower level of applied arts and decoration. Modern painting and sculpture, as shown by abstractionism, immediately produce a rigid, mechanical effect, rather than the effect of the ingenious *arabesques* of popular art. Despite its modernism, recent art has allowed itself to be more easily seduced by esoteric and archaic styles, preferring to follow the pattern of archaeology rather than the example of ethnology. An intermingling of popular and modern styles is very rare, because the art of our time—just because it flourishes in a state of stylistic pluralism—tends to take on the pure form of any style, unless, as in the special case of Decadence, it hates eclectic styles and syncretic forms. The same principle applies to the great 'chameleon-like' artists of our time, such as Picasso and Stravinsky, who, in passing with facility from one stylistic phase to another, finally attain a unique style which pervades every one of their works.

The more important conflict is not between *avant-garde* art and ethnical culture but between *avant-garde* art and mass culture. This latter, which is absolutely different from culture in the anthropological sense, is nevertheless called in English 'popular' art and culture. This does not mean popular in the Romantic sense—culture or art created by the people—but popular in the empirical and practical sense of art and culture produced *for* the masses. From this point of view such 'popular' art is the most genuine aspect assumed by bourgeois cultures in countries of great technical and industrial potentiality. In such countries, furthermore, the very concept of 'the people' today has no other function than to distinguish the group of manual laborers from the vast class called *petite bourgeoisie*, which also includes farmers, artisans and others. It seems almost inevitable that in this society, which has seen the assimilation of the proletariat by the bourgeoisie, there arises immediately also the proletarianization of culture. The second of these phenomena does not appear by itself; it appears exclusively in capitalist society. The mass culture which dominates in Communist Russia is imposed from above, it is not the natural result of public consensus, according to the law of supply and demand, but an artificial political production, following the authoritarian formula of the 'social mandate.' In other words, what has taken place in Russia is not so much a proletarianization as a 'bureaucratization' of culture, which has made the artist a functionary rather than a

producer. The immediate effect of this special change is that it has destroyed *avant-garde* art and produced a state of alienation. Meanwhile, from our particular point of view, this new fact suffices to prove that Trotsky was right when, toward the end of the first phase of the Communist experiment, he denied that a proletarian art or culture could—or should—continue to exist under the domination of the 'dictatorship of the proletariat.'

The only genuine form of proletarian art and culture is that which is prefabricated at the lowest intellectual level of the bourgeoisie itself. As to literature, this phenomenon has already been noted by Christopher Caudwell, in one of the most suggestive pages of his *Illusion and Reality*. 'The authentic proletarian literature of every day consists of the thrillers, the love stories, the cowboy stories, the popular movies, jazz and the yellow press.' Essentially, it is this culture of the mass and proletarian art (the only types of popular art and culture possible in a society like ours) that *avant-garde* art opposes, an opposition supporting the fact, already noted, that the task of *avant-gardisme* is to fight against articulate public opinion, against tradition and academic culture, against the bourgeois *intelligentsia*.

The tragic and unique predicament of *avant-garde* art lies in its necessity to fight on two fronts, that is, to fight against two types of artistic or pseudo-artistic production which are in a state of opposition and mutual negation. Edmund Wilson has given these two types the paradocixally contrasting names, 'classics' and 'commercials.' Bourgeois culture is certainly incapable of discriminating between the value of the first and the worthlessness of the second, just as the bourgeois critic is incapable of setting up criteria of taste which would distinguish between the various levels of the contemporary public. *Avant-gardisme* instinctively opposes them both, however. It fulfills a function no less genuine and primary than its protest against the culture of the dominating class when it opposes its minor by-products in the art and culture of the masses (in Caudwell's sense of the word).

This double reaction, against bourgeois taste and against proletarian taste, can definitively explain the statements—contradictory only in appearance— that the psychology of the *avant-garde* is dominated by an aristocratic or antiproletarian tendency and by an anarchical or antibourgeois tendency. On the sociological level as well as on the aesthetic level, there is no conflict between the two tendencies. The parallel oppositions to bourgeois taste and to proletarian taste converge in the single opposition to the criterion they hold in common, that which unites them. This can be identified as a common cult of the *cliché*. Thus reappears on a higher level the relationship already established between *avant-gardisme* and the banal, a relation of inter-dependence, precisely because it is determined by a reciprocal resistance of

equal strength on both sides. As we have already said, banality is only the modern form of ugliness. If the criterion of beauty is as indefinable as it is unique, the category of ugliness—even if considered as a series of historical variants—is, on the other hand, infinite and thus susceptible of innumerable definitions. This proves again, to the point of absurdity, the complex and irreducible aesthetic pluralism of our time.

The recognition of pluralism, very important in the sociology of taste, loses all meaning or value on the level of artistic creativity, where it has only a negative function, if any. An epoch which has many styles has none. This truth holds also in the case where multiplicity is reducible to a simpler dualistic relation. Bypassing for a moment the basic antithesis of modern art—between *avant-garde* style and all opposing styles—and limiting ourselves to a partial and provisional antithesis, it is easy to recognize that where no bourgeois style exists, no proletarian style can exist. In other words, proletariat and bourgeoisie, in relation to mass culture, take their styles where they find them, that is, from cultures and societies different from their own. In short, the absence of a style of its own is a phenomenon not confined to capitalism or socialism, but is characteristic of all democratic societies, in the liberal sense or otherwise, of all quantitative, technical and industrial civilizations.

Just because it is deprived of a style of its own, a civilization of this type prefers an eclectic style, in which technical ability in the aesthetic sense is combined with technical ability in the practical sense. Such a style is formed by means of a synthesis, or rather a syncretization of traditional forms, academic and realistic, regulated by the wholly modern taste for photography and stereotype. The artist of our time, just because he can easily imitate all techniques, ancient or modern, scientific or artistic, since he has at hand the means to realize perfectly the effects of *trompe l'oeil*, refuses to accept as his own a style which becomes a purely mechanical product, and is thus the negation of style in the real sense of the word. This refusal becomes an act or gesture impossible for the artist who operates in a technical civilization or in a mass culture when it is at the same time a totalitarian society. The point is, again, proved by the case of Soviet Russia, where the formula of 'socialist realism' is not only an ideological dogma which determines the content of art but also a stylistic canon, so that in the graphic arts as well as in literature, the point is reached where any divergence from official style is regarded not only as an aesthetic heresy but also as a political deviation, and is condemned specifically as 'formalism.' The refusal to follow a prescribed style or mass taste sanctioned by public consensus, whether active or passive, remains both positive and necessary within a really bourgeois

society which is obliged to admit the existence of minorities and exceptional individuals. Naturally, this tolerance is only a negative reality and as such provokes in turn the intolerance of the artist. Jean-Paul Sartre went so far as to say that, thanks to the unification of the public (he might more accurately have said the confusion), a phenomenon resulting from the diffusion of mass culture from the lowest social levels to the highest, the modern writer has no alternative but to assume a position of absolute intransigence, undifferentiated antagonism, to the often numerous and always indistinct mass of his own readers. The quotation is worth including, for it closes with a just recognition of the historical uniqueness of this negative relationship: 'To tell the truth, the drastic blurring of levels in the public since 1848 has caused the author initially to write against all readers . . . this fundamental conflict between the writer and the public is an unprecedented phenomenon in this history of literature.' The affirmation of the existence of such discord and the attempt to define its essence appears in almost the same words in Georg Lukács' preface to his book *Studies in European Realism*, in which the Hungarian critic traces the origins of the phenomenon to the French Revolution and Romanticism, once more situating the turning point in Balzac's work. 'From the French Revolution on, social evolution has proceeded in one direction, which makes for an inevitable conflict between the aspirations of men of letters and their contemporary public. In this entire period the writer could achieve greatness only insofar as he reacted against the everyday currents. Since Balzac, the resistance of everyday life to the basic trends of literature and art has grown constantly stronger.' Sartre's judgment, confirmed by Lukács, leads us to conclude that in the course of the last century, and perhaps for more than a century and a half, the state of alienation has changed from an exceptional condition to the regular norm for the modern artist and writer.

In this condition we find one more reaffirmation that the principle of bourgeois art is to be antibourgeois. It is again to Sartre that we turn for the expression of this general truth from the particular perspective of the artist: 'the bourgeois writer and the accursed writer work on the same level.' This means that the bourgeois writer or artist is in a constant state of social protest; it does not mean that he becomes a real revolutionary in the political sense. Similarly, even when the artist is driven to embrace—sometimes for purely aesthetic motives—a reactionary ideal, he is not necessarily transformed into a conservative. It should not be forgotten that his social protest manifests itself mainly on the level of form and thus alienation from society becomes also *alienation from tradition*. In contrast to the classical artist, who could draw on tradition as a stable and recurrent series of public expressions,

the modern artist works in chaos and in darkness and is overcome by the
feeling of impending upheaval in language and style.

Avant-garde art seems destined, therefore, to oscillate forever between
opposing poles of alienation, psychological and social, economic and his-
torical, aesthetic and stylistic. There is no doubt that all forms of alienation
lead ultimately to ethical alienation, and it is certainly to the latter that
Sartre refers in the passage quoted above. This alienation expressed itself,
even before the advent of Existentialism, in the art and literature of revolt
that has been so conspicuous in culture and thought from Romanticism
onward, and which in the case of *avant-gardisme* in the narrow sense, shows
itself with the greatest intensity in German Expressionism. The investi-
gation of this revolt would carry us too far and go beyond the limits of the
present study, whose task is to examine *avant-gardisme* and alienation as
historical norms and as intellectual expressions. Here we would say only that
even when it refuses to yield to the siren-song of aestheticism and renounces
the temptation of self-worship, *avant-gardisme* is nonetheless condemned to a
liberty which is slavery, and to serve too often the negative and destructive
principle of art for art's sake.

QUENTIN BELL

Conformity and Nonconformity in the Fine Arts*

THE ARTIST IS, in popular mythology, a nonconformist. He is thought to diverge from the group and to be, in every way, eccentric. His art will, very likely, be incomprehensible save perhaps to the members of a small coterie. He is less fixed in his habits and in his habitat than is the business-man or the manual worker. In short, he is a Bohemian.

The popular conception of the artist is, of course, inexact; there are a great many painters and sculptors who, in their social habits, are almost indistinguishable from their fellow men, and a great mass of painting and sculpture is always in perfect conformity with current tastes and current conventions. Most art is, perforce, socially acceptable and socially comprehensible.

Nevertheless, the popular conception does correspond to a reality. The social status of the painter has, since the Renaissance, been much more fluid than that of the members of most other professions. His work calls for the public expression of his most intimate feelings—a sale, so to speak, of his dirty linen—and this certainly imposes emotional strains that are severe in proportion to the intimacy of the artist's confessions. Moreover, for the past hundred and fifty years the fine arts have been in a state of permanent revolution, and that revolution, which has been an insurrection of indivi-dualists, has had the effect of making painting more and more a means of intimate public exposure and hence of public incomprehension. Those

* Reprinted with permission of the author and The Macmillan Company from *Culture and Social Character*, edited by S. M. Lipset and Leo Lowenthal. © 1961 by The Free Press of Glencoe, Inc.

works that we now think most valuable in the output of the nineteenth century were produced by a small minority of rebels acting in defiance of public opinion, including the opinion of the vast majority of their colleagues. To some extent this aesthetic nonconformity has been associated with social nonconformity, so that the use of the word 'bourgeois' as a term of abuse belongs as much to the terminology of Romantic art as it does to that of Marxism.

There are therefore sufficient grounds for the habitual judgment of the man in the street who believes that the behavior of artists is strange and unpredictable. At the same time, this view of the artist is a comparatively new one in the history of art, and there is no reason to suppose that it existed, or had any foundation in reality, before the Renaissance, or at all events before the time of Giotto.

Within the guild system the status of the painter was as clearly defined as that of the goldsmith, the fuller, or the harness maker, with whom, indeed, his guild contracted corporate alliances. The idea of genius, or rather of the man of genius, which is so firmly embodied in our modern conception of the artist, was not provided for by guild regulations, and the 'masterpiece,' which we now think of as the exceptional work of an exceptional performer, was no more than the craftsmanlike production that every individual presented to his guild when he was received as master. The art of painting was a trade clearly placed among the lower, or mechanical, arts, and this position was perfectly well understood by all parties.

In this tradition-directed social context the innovator or revolutionary did not enter into the scheme of things, and the idea of individual pre-eminence was itself extremely limited. One painter might be better than another painter, just as one cobbler might be better than another cobbler; but that was about all. We recognize this fact in our methods of criticism, where the terms 'Maya,' or 'Hispano-Mauresque,' which represent the works of many individual artists, are used with just as much precision as the names Corot or Manet. We take it for granted that the aesthetic homogeneity of an entire community at one stage of development is roughly equivalent to that of a single individual at another.

One has only to think of the fantastic diversity of talent and of style in the painting of the past hundred years, as compared with the uniform achievements of many generations of Chinese potters in the earlier dynasties, to see how radical the change has been. It is no exaggeration to say that there is less variation in style and aesthetic quality in a hundred years of medieval sculpture than Picasso alone has shown in his lifetime.

It should be noted that in those minor arts in which there has been no social

fragmentation, such as peasant pottery, pewter work, weaving and the like, homogeneity of character and achievement has persisted long after the fine arts have become diversified into the very good and the very bad, so that it is impossible to describe the aesthetic quality of a painting by saying, simply, that it is 'Dutch seventeenth century,' whereas the term 'Delft' conveys a reasonably exact account of a whole class of objects.

Until we come to a fairly recent period, the evidence concerning the social behavior of artists is not extensive; but it would appear that the changing pattern of behavior of the artist is closely linked with the aesthetic fragmentation to which I have referred. The process that I have called 'fragmentation' arises when a certain number of artists, breaking with tradition, present the public with new techniques and new ideas. Good workmanship then becomes of less importance than talent. The painter ceases to be a pure craftsman; he becomes a pictorial poet and demands a status such as that enjoyed by the liberal artist. Already we find this claim made for painters by Petrarch in the fourteenth century, but I think that it was not until the middle of the fifteenth century that society was ready to listen to it. The treatise of the fifteenth-century architect and humanist Alberti, with its insistence upon the mathematical nature of the art, upon humanism, and upon the historical and poetical functions of the painter, marks the change. But it was the painters themselves who made it inevitable. The artists of the High Renaissance were in fact so eminent, there were among them so many great men, that it became necessary to find a new social apparatus that might contain them, rather in the same way that it became necessary to find a new social apparatus for the engineer and the industrialist of the nineteenth century. In the one case, as in the other, the process of social readjustment created difficulties. 'I have never been a painter or a sculptor,' said Michelangelo, 'in the sense of having kept a shop.' The wife of a freshly knighted grocer could not have been more haughty.

The social aspirations of the post-Renaissance artist eventually found expression, first in Rome, and then in Paris, with the establishment of academies of art. The academy was a professional association imitated from those that had been created by the philosophers and the literati. It was established in opposition to the guild; it gave the artist a professional hierarchy and provided an education in taste that could supplement, and eventually replace, the purely manual training of the workshop.

Libertas restituat artes may seem, to modern painters, to have been a strange motto for the Academy of Louis XIV, but in fact the Academy did liberate the painter from the restrictive practices and the plebeian associations of the Guild of St. Luke; it enabled him freely to seek his fortune as a

graphic poet or a pictorial philosopher and, with the example of Raphael and Sir Peter Paul Rubens before him, to live and to paint like a gentleman.

The style of the academies was, or was intended to be, free from the frantic distortions of mannerism, from the striking verisimilitude of the followers of Caravaggio, from the gaudy colors of Venice or, in fact, from any of those artifices whereby a painter might gain the favor of the crowd. It was an art for the highly educated, its program being aptly expressed in five words: 'nobility,' 'decorum,' 'regularity,' 'chastity' and 'restraint.' It forms a coherent part of the age of Racine, which was also the age of Poussin, and of that 'regime of status' which flourished in the seventeenth century, decayed in the eighteenth century and perished in 1789.

But already, contemporaneous with the French Royal Academy, we find, in the free society of Holland, painters who escaped not only from the bondage of the guilds but also from the conventions of the academies, and it is here, in the work of Rembrandt, that we may perceive the first tremendous insurrection of the human spirit that was to burst out again so violently in the nineteenth century. In his later work Rembrandt owes allegiance to no one; he is a 'self-directed painter' bound only by his own conscience as an artist.

The guilds were destroyed both by the emergence of a professional association that was socially more attractive than a trade corporation and, in Holland, by the development of free enterprise. The training of apprentices in the workshop outlived the guild and continued until, for economic reasons, it became unnecessary. But, at an early stage, the teacher-pupil relationship was modified.

Before the Renaissance, the main task of the pupil was to learn to imitate his employer until the work of the apprentice became indistinguishable from that of the master. Therefore, for so long as the articles of apprentice-ship lasted, the master could sell the pupil's work as his own. As the art of painting developed, the work of the pupil might, as he achieved mastery, diverge a little, be a little more 'modern' than that of his employer. But the distinction between the two would in general be slight and their common character would be strongly imprinted by the community to which they both belonged.

In the sixteenth century the local and paternal relationship was increasingly replaced by international and ideological 'schools.' We find Italianizing northerners; schools, such as the 'Roman School,' which were not strictly local; and those of the mannerists and naturalists, which were schools of thought. This was not a wholly new development in the history of art; ideas have always traveled. But the tendency of the smaller centers to

accept foreign influences and to become provincial instead of being regional was greatly strengthened and accelerated.

As this process developed, the role of the teacher diminished. Painters found their masters, not in real life, but in museums; and the school, despite some persistent local affiliations, became an ideological phenomenon.

By the time this stage had been reached, that is, by the nineteenth century, the academies had long ceased to be of use to the progressive artist. Like the guilds, which by then were to some extent idealized in the minds of painters, they had outlived their purpose. Now it was the academies that were seen as the enemies of individual expression. Originality was now the grand desideratum. The academies claimed the right to teach, to assess and to regulate the affairs of the fine arts, and this was felt to be an intolerable infringement of the rights of the individual.

The painting of the nineteenth century has frequently been classified under a number of headings: Romanticism, Realism, Impressionism, Neo-Impressionism, and so on; but these schools, or movements, as we might more truly call them, correspond only in a very rough and ready way to the actual work of the painters, and there were a great many eccentric figures, some of them by no means undistinguished, who, in reality, defy classification. The main currents of artistic feeling are definable; but the only common quality of the great artists of that period was an intense belief in the right of the painter to express himself as he saw fit. They were attacked by and opposed to 'official art,' and they were all *Indépendants*.

The idea of genius, of native abilities finding expression without the assistance of teaching or the help of 'rules of art,' was one that had already perturbed Sir Joshua Reynolds when he founded the Royal Academy. In the late nineteenth century the emergence of the 'autodidact' in the person of the 'Douanier' Rousseau, a Sunday painter who by academic standards was quite untaught and quite inept, together with a new child-centered doctrine of art education and a new belief in the supreme value of 'self-expression,' completed the process.

Deprived of all rules, the artist had now to regulate his conduct entirely by his personal conception of what was right or wrong in art. Nor could he do this by looking to the example of those masters who had followed the 'grand style'; certainly he looked at the museums, perhaps more than ever before, but he could no longer find in them a coherent development, a true apostolic succession from the Greeks to the High Renaissance and from the High Renaissance to the great academicians.

In truth, that academic path which avoided the Venetians, the Flemish and the Dutch had always been too narrow for comfort; but with the

growing taste for Gothic and primitive art, for Romanesque and Byzantine, for Pre-Columbian, peasant and child art, the artist was left with no path of any kind; the world was all before him. In aesthetic theory it became necessary to search for some common denominator, for 'significant form' and 'plastic values,' which, in fact, left the painter to the dictates of his own artistic conscience, to what Cézanne called '*sa petite sensation*.'

Thus the twentieth-century painter or sculptor finds that he may express himself freely with no outward censor to thwart him, while the inward censor has but one question to put to him: 'Are you being honest with yourself?' It is a terrible question to answer.

This freedom from aesthetic restraints was purchased at a heavy price. The typical life history of the independent painter of the nineteenth century is one of conflict maintained against the indifference or the hostility of the public; insults and ridicule had to be faced, and unless he could depend upon extraneous financial support, the painter was likely to starve. As his mode of expression became more comprehensible to the general public and became, as one may say, part of the pictorial language of the century, the rebel might establish himself with a small clientele; but for many there was never any public recognition.

The reasons for this solid opposition are comparatively clear. A number of revolutionaries affronted public opinion by adopting an attitude explicitly or implicitly critical of the social system of their day; but their greatest fault was that they were too frank concerning their own feelings in an age that valued social dissimulation. An outburst of violent emotion expressed in an unfamiliar idiom cannot but appear brutal, offensive and obscene. It is hard for us today to understand the outcry against painters, such as Manet or Renoir, because we have grown too accustomed to their manner of address to be affronted. But if we compare the work of these painters with those of their prosperous rivals, the men who gave the public what it wanted, we shall, I think, understand why the *Indépendants* seemed insufferably sincere. They were telling the truth about what they saw; they were guilty of making personal remarks.

One effect of this revulsion of feeling on the part of the great public was to divorce the most interesting painters of the period from those patrons who, in the past, had made abundant use of works of art for instruction, propaganda and conspicuous consumption; in particular, divorce them from the churches.

The great religious bodies had probably made comfortable patrons because they had not, until very recently, felt it necessary to demand sincerity from the artist; in a medieval or in a savage society they could take

his work for granted. The tradition-directed artist did not have to worry about 'feeling'; he was given his assignment—his Buddha or his Virgin— and knew perfectly well, down to the last gesture and the last fold of drapery, what he had to do. The religious form was accepted by both parties.

This ecclesiastical framework continued to function and to provide an adequate container for the artist long after he had ceased to take it for granted that the chief part of his work would be religious, and long after he had developed sufficient spiritual autonomy to acquire a quite personal notion of sacred art. In the fifteenth century the Church seems to have found no difficulty in accepting sacred art that was completely frivolous and worldly in treatment, and, in the High Renaissance, paganism established a comfortable *modus vivendi* with Christianity. It was not until after the Counter-Reformation that the Inquisition raised some objections to Veronese's translation of the New Testament into the proud and flaunting opulence of Venice, and this was but a first unemphatic protest.

How completely the social situation has changed may be judged from the fact that from about 1860 to 1945, a period in which many great artists flourished and in which many of them were intensely religious, there is hardly one instance of a great master being asked to decorate a church. For the first time in history a great aesthetic movement has developed without at any point making contact with organized religion. There have indeed been numerous religious painters, but their works have not been used to advertise faith; they have painted easel pictures to be sold by dealers to private individuals.

The reason for this estrangement between the Church and the artists is, I think, clear; the churches are social institutions and the artists, living in an age of permanent revolution, have employed an idiom that is not socially acceptable.

Within recent years a fairly widespread and determined effort has been made to bring experimental art into the service of the churches; but these efforts have encountered very strong resistance from both the laity and the hierarchy. Opposition of this kind is very understandable. To the ordinary churchgoer the decencies and proprieties of worship are a matter of the first importance: a man smoking or a woman preaching in church are as repugnant as heresy, and the works of modern artists, however religious, are shocking in proportion to their sincerity.

The traditional patrons of the arts, the aristocracy, the monarchy and the great municipal bodies, were also alienated from that which was most interesting in the art of their time. The baroque glorification of contemporary history or, for that matter, the rococo decoration of the life of the leisure

class required a certain measure of social adjustment by the artist, which could not be achieved by the individualist painters of the nineteenth century. The court painter was working for a public, and the independent was painting for himself; whereas the former was socially integrated to a point at which he could achieve his ends without loss of sincerity, the latter was not. The work of the courtier painters of the nineteenth century betrays, it seems to me, an uneasy consciousness of the artist's predicament; the painter was forced to assume an attitude he did not altogether feel.

The nineteenth-century rebels, when they sold at all, sold to the middle classes, but even here their clientele was very restricted. To some extent this may be attributed to the fact that members of this class were culturally dependent on their 'social superiors.' It is interesting, in this connection, to note that the American industrialists were more ready to purchase works by the Impressionists than were the more tradition-directed magnates of Europe.

But there are certain qualities in the visual arts that are valued by the customers of almost every age and class: expense, workmanship, technical efficiency (which may sometimes take the form of verisimilitude). These essentially economic demands have produced a number of seemingly contradictory impulses, which must be examined.

We have seen that, in the social context in which the artist simply did that which was expected of him, ideological considerations hardly occurred either to the producer or to the customer; that which the patron (and the guild) demanded was hard work. The labor expended upon a work of art is, in an aesthetic sense, wasted because it is socially required that the artifact (which is after all a thing for show or an instrument of conspicuous consumption) should manifestly have been expensive to make. Among very primitive people this 'honorific waste' of labor can take very naïve forms: the piling of stone upon stone to build a pyramid or a megalithic structure in honor of a monarch or a deity. Something of the same mode of displaying power may still be seen in advanced cultures that exhibit their power by the construction of colossi such as the Empire State Building or the Palace of the Soviets.

But the subtler notion of embodying labor power in skill, as in the fabulous intricacies of late Gothic architecture, must be almost equally ancient, and the unsophisticated observer may still express his admiration for a piece of lace or finely carved wood by exclaiming at the amount of work that has been 'put into it.'

In representational painting as we know it in the West, the usual assessment of skill has been based upon the artist's ability to achieve verisimilitude, and the works that earn the praise of the majority are those which, being

highly finished in every detail, are immediately convincing as representation.

Legends, such as the story of Zeuxis and the grapes, show how important the public has felt this to be. There can be little doubt that, in the consumer-producer relationship, the demand and the supply of skill have—until very recently, at all events—been the chief consideration. It was the main business of the artist to supply the patron with a polite artifact.

The word 'polite' is, in this connection, of great convenience because it suggests a highly finished surface and also a socially acceptable manner. Works of this kind have been valued in every culture of which we have any record, and it would not be hard to discover examples of this tendency in the products of schools that are, in every other respect, perfectly opposed. Among these examples are some of the greatest masterpieces of painting and sculpture. In the twentieth century we value politeness less than we used to. We see in it a form of dissimulation particularly reprehensible in an artist. But considering the work of past ages it must be allowed that when the artist was sufficiently at ease in his social environment, he could be both polite and sincere.

It is once more in the Renaissance that we find the first manifestations of the now common notion that a rude, imperfect and unfinished work might be as valuable as a correct and impeccable performance. It was then that the drawing, which for the medieval artist was no more than a means to an end—a mapping out of the main forms in the picture—became valuable for its own sake, and was presented to friends and collected by amateurs.

The drawing or sketch is frequently a more intimate thing than the finished work of art; it is, as it were, the *extempore* conversation of art, less elegant but more personal than the balanced periods of a carefully prepared address. In the later works of Titian and in the paintings of Tintoretto the sketch makes its appearance in the finished painting, and from that time forward the charm of a loose, personal handling of pigment becomes a major feature of European painting.

This cavalier disregard of finish—as that term would have been understood by the van Eycks or by Ingres—characterizes nearly all the important painting of the past hundred years, and with it goes a disregard for verisimilitude, or at least for the kind of verisimilitude that is associated with the mirror-image. The Impressionists, observing light and attempting to record its effects with scientific accuracy, were not untrue to nature; but they were completely at variance with contemporary standards of craftsmanship and, until the public had become accustomed to their mode of vision, their mingling of red and blue in grass, their splashes of green and violet upon the human face, seemed a grotesque travesty. But it was not, I think, the

apparent untruth of their statements that shocked the public so much as the brutality, the impolite, uncraftsmanlike directness of their manner.

The middle-class culture that had produced the startlingly personal contribution of Rembrandt also produced one of the most impersonal art forms that have ever been created: the Dutch still life. Here we have the kind of art that, despite some attempts at emblematic significance, and despite its astonishing potentialities in the hands of genius, is capable of being a mere exhibition of manual dexterity: the painting of lifelike flies upon lifelike grapes, the placing of a highlight within a wine glass, the restatement of every tiny detail upon a patterned curtain.

The Victorian middle classes seem to have had the same taste for exact workmanship, for painting that has the quality of highly polished furniture combined, in their case, with sentimental piety. It is interesting, in this connection, to note how quickly the great British public came to terms with the Pre-Raphaelites. The Pre-Raphaelites began by giving offense; they were original, sincere and, in a sense, revolutionary. But their belief in scrupulous exactitude, in the virtues of labor and unremitting attention to detail, were too perfectly in accord with the middle-class ethos to be rejected. Ruskin himself, for all his sincere admiration of Turner and Tintoretto, could not resist the temptation to apply the gospel of hard work to art criticism. In the Whistler-Ruskin trial this conception of art as honest toil—as opposed to art as a careless outpouring of the spirit—emerges with the greatest clarity. The solid, almost unanimous opposition of the middle classes to Impressionism was based upon the view that it was the business of the painter to produce a recognizable and edifying image of nature in an honest and workmanlike fashion, and this conception of the painter's duty seems hardly to have been modified until the second quarter of the present century. I am speaking here of the opinions of the man in the street.

Nevertheless, the Impressionists did represent one of the main social tendencies of the age, although it was a tendency that for long remained hidden. It was the age of the machine (one of its machines being the camera), and in that age the valuation of craftsmanship as a means of securing social prestige underwent a drastic transformation.

In the eighteenth century the apparatus of conspicuous consumption was based quite simply on the amount of skill and wealth that a rich man could display; his carpets, tapestries, porcelain, statuary and pictures were all polite artifacts, the products of academies or expensive workshops. If he looked to the past or to foreign lands his choice still lay with cultures or periods that could supply polite objects, the product of much labor, such as was to be found in the porcelain of the Manchus or the architecture of the

late Middle Ages. The home of the peasant, on the other hand, contained rude work; naïve, painted images that we might value today, but that would have looked grotesquely out of place in an eighteenth-century gentleman's home.

With the advent of the machine, a change began. The factories could now turn out products of very high finish which were, nevertheless, comparatively cheap. The homes of the poor were now decorated with steel engravings, electrotypes, photography and mass-produced bone china. High finish had been cheapened, and the rich—as though in self-defense—manifested a quite new enthusiasm for handmade things, for peasant pottery, weaving, or basketwork and, in their cultural appreciation, for medieval, archaic, or primitive art. From a social point of view, technical perfection lost its value for display purposes when the machine could attain that perfection at minimal cost.

Thus, although the indifference of the independent artists toward the attainment of a smooth surface quality was sure to arouse strong opposition their methods were in harmony with a tendency that, ultimately, was bound to prevail.

The history of art in the nineteenth century is one of a growing disassociation between the general public and a small but formidable minority of artists. The self-directed painter found himself invariably and increasingly in conflict with society. But it is necessary to qualify this view—in the first place, by pointing out that the general public can learn to tolerate a new idiom; and, in the second place, by admitting that the majority of artists, those who design our advertisements, our furnishings and the pictures that hang in 'salons' and academies *do* live by pleasing the public, although in my opinion, their susceptibility to the existing situation is made manifest by the patent insincerity of their works. They may claim to be tradition-directed artists, but in fact they are self-directed artists who are untrue to themselves, the only tradition-directed artists now living being members of very poor, backward, or savage communities.

But, when all allowances have been made, the pattern is still recognizable, revealing an ever increasing emphasis upon individual, as opposed to communal, expression. History shows us first an almost complete identification of artist and his public, then the emergence of talented individuals within the accepted artistic formulas of the age, then the man of genius, who might be more or less misunderstood by the general public, and finally the completely intransigent declaration of personal independence, the rejection of all rules and all controls and the nonconforming artist opposed to all but a very few enlightened members of the public.

Such was, and such to a large extent still is, the social situation of the artist in the stage of inner-direction. Is it possible that a new phase is now beginning and that we are witnessing a reintegration of the artist into society?

There are reasons for thinking that something of the kind is happening. But what follows is in the highest degree speculative and is certainly not offered in a spirit of dogmatic assertion.

1. From the sociological point of view, the most striking change that has occurred in the history of the fine arts during the first half of the twentieth century is the transformation of the typical life history of the nonconforming artist. Before 1910 there was no independent artist, save Monet, who had ever come near to achieving the financial success of the 'academic' salon painters. And even in that year painters such as Derain, Matisse, Picasso, Bracque and Vlaminck were far from affluent. By 1930 all these painters and many others of the same rebel band were selling at big prices, and the boom is still on. The independent artist no longer dies in a garret, he dies in a suite of rooms surrounded by doctors, secretaries and journalists. He achieves not only wealth, but also fame in his own lifetime.

An unsophisticated public still supports a large number of conforming painters (in the old sense of the word) who can produce acceptable works, especially portraits, and make a good living; advertising agents and industrialists do likewise. But the position of these artists is rather similar to that of the writers and illustrators of the comics; they have a vast clientele, but they remain, to a large extent, anonymous. The great names in contemporary art are Matisse and Picasso, Bracque and Henry Moore, and although not everyone may like them, eveyone has heard of them. Among a thousand Americans to whom these names are familiar, is there one who could supply the name of the actual President of the Royal or any other academy? There may be, in fact there obviously are, thousands of unknown 'nonconforming' painters, but it is not their nonconformity that stands between them and fame.

Obviously this change implies a change of public temper. In fact there is today a kind of rival establishment that plays a part not unlike that of the old academies, and which is, to a large extent, international. Prizes and awards are given, exhibitions are held with a generous use of funds by bodies that, clearly, are more afraid of being old-fashioned than of anything else.

The museums of modern art, the glossier magazines, the designers of sets for stage or films, the interior decorators of new business premises, even some of the churches, all those who make it their business to be in the swim, now offer patronage to the 'rebels,' and not merely to those rebels who with

age have become established, but also to the young and relatively unknown.

Broadly speaking, we may say that there are today two main roads to fortune for a young artist. He may learn to please that still large and naïve public that demands a flattering handmade photograph disguised as an old master, or he may squirt his canvas with creosote, scour, scratch, blast and excoriate it, until it hangs in fashionable tatters upon the walls of one of our principal art galleries. The former method may still command a steadier sale than the latter, and it calls for less salesmanship; but the latter is the true highway to glory and to wealth. The painters who run to neither excess may think themselves lucky if they can keep body and soul together, because whatever their talents they are very unlikely to achieve worldly success.

2. I have suggested that one of the reasons why independent art in the nineteenth century was felt to be offensive was that it was too personal to be endured. Perhaps we may ascribe the acceptability of much contemporary work to a reverse tendency. The *Fauves*—the 'wild beasts'—who came to maturity before 1914 adopted an extremely offensive style; but their successors have, in different ways, reduced the personal element in their art to a bare minimum. This is not an easy thing to achieve in graphic art. The faithful reproduction of an old master by a modern copyist can rarely be mistaken for an original, and experts can, with a surprisingly high degree of unanimity, attribute a slight sketch to a period, a school, or in many cases an individual. The quality of the artist's vision is made evident in some incomprehensible but clearly recognizable manner, in every stroke that he makes. But this applies only to a line drawn freehand. A line drawn with a ruler, whether it be drawn by Sir John Millais or by Giotto, is, or at least can be made, completely impersonal.

There are abstract works consisting simply of geometrical forms and flat areas of color, or of evenly tinted wood or plastic, which could be copied with a high degree of accuracy by a student who had never seen the original but had been furnished with a series of measurements. This, of course, does not mean that the artist has eliminated the personal quality from his work, but only that he has placed himself in the same position as the architect, surrendering that power of intimate communication that is peculiar to the pictorial arts.

Within recent years, however, painters have adopted techniques that have the effect, if not the intention, of abolishing that quality of design (I use the word both in the sense of pattern and of intention) that is still preserved in abstract art. The painting can now be reduced to an accident. Throw a bucket of liquid paint at your canvas and you rid yourself, at one blow, of the personal quality that results from the manipulation of brush or pencil, and

also of the sense of directed effort that appears when any attempt is made at arrangement. It would seem to be possible, with a little ingenuity, to remove the personal quality altogether from action painting by the use of machinery. These endeavors reach the ultimate Nirvana of impersonality in the work of those Parisians who content themselves with the exhibition of a rectangle of plain, tinted wallpaper within a frame.

The idea of the artist as an individualist is still too strongly held by the artists themselves for them to be able to contemplate complete immolation. Each man entertains the modest hope that his accidents may be better than those of his neighbor. The actress whose part demands that she shall appear before the public disheveled and dilapidated contrives a sweet disorder in her dress and a becoming confusion in her hair. So too the action painter sees to it that his accident shall not be lacking in charm, and in fact much of the work of these artists is extremely decorative. Nevertheless it does appear to me that there is a clear tendency toward impersonality of style; the means adopted, whether they involve the use of the ruler or of the watering can, must, of necessity, tend toward uniformity of style and achievement.

3. The great flowering of independent art in France during the nineteenth century was unique in that, unlike any other great artistic movement, it was accompanied by no corresponding development in architecture and the applied arts. It was, as one may say, socially isolated. To some extent this was made inevitable by the revolutionary character of the various movements; but it is also true that Impressionism, both the Impressionism of Monet and that of Degas, consisted in the observation of life and had practically nothing in common with decorative art. The painter surveyed the world impartially, not looking for those things that were deemed beautiful, but for those that could be restated in terms of reflected light. A girl dressed for a ball, a railway station, a row of suburban houses or a dish of onions would all serve his purpose equally well. It was left to Morris and his disciples, to the apostles of *art nouveau* and later to Roger Fry in England and Gropius in Germany, to attempt a reconciliation of modern art and modern life.

In a sense these efforts have been successful, and the twentieth century has its own style. 'Contemporary' wallpaper, furniture, fabrics and interior decoration derive clearly from contemporary painting, although frequently as the result of vulgarization in the worst sense of the word. At the same time architecture and engineering have exerted a notable influence upon the arts of painting and sculpture. Both abstract painting and action painting have a congruous relationship with what may be called 'functional architecture,'

the former as an extension, almost a parody, of the structures of the machine age, the latter as a decorative foil to the regular unbroken surfaces of the modern building, giving relief to the eye, but at the same time harmonizing by reason of its similarly impersonal character.

Thus, the nonconforming painter (if the term can still legitimately be used), unlike his predecessors of the last century, fits well enough into the style of the age.

Thus, it would appear that the artists of today may be returning to a position in which they can be fully integrated in society. They are swimming with the current; they give the public what it wants and are rewarded accordingly. To an ever increasing extent they are ready to submerge their personalities in the common artistic personality of the age. Their art is no longer a protest; it has become part of a general assent.

In all this the artists may seem to be returning to the position of the medieval painter or the craftsman of primitive society. But their conformity is of a new kind: they remain, in a sense, revolutionary, because they explicitly reject tradition and have little or nothing to do with the past. Their revolutions are quasi-unanimous movements, however, and they change direction in the manner of a shoal of fish, a flight of starlings, or the designers of women's clothes. Their nonconformity is essentially conformist and provides less and less scope for the lonely eccentric or the pre-eminent leader.

If this tendency continues we may perhaps see a progressive disappearance of the man of genius and an ever growing conformity in manners, morals and ideas until the artist is indistinguishable from the rest of the community.

In this essay I have attempted to avoid the terminology of *The Lonely Crowd*, but it seems to me that the process of evolution that I have attempted to describe falls nicely enough into the phases of tradition-direction, inner-direction and now, as it would seem, other-direction. It would also be possible, I think, to point to the existence of 'autonomous' artists; but whether these have any chance of survival in the world as we know it remains to be seen.

ALLEN LEEPA

*Anti-Art and Criticism**

ART FORMS BASED on the major ideas, feelings and events of a cultural period emerge, live, fight for survival. They may help broaden the humanistic basis of society, as in the Renaissance, revolutionize the concepts of pictorial space, as in the work of Cézanne, or attack the very culture that harbors them, as in some of the art forms today. One of the major characteristics of Pop art, for instance, is its sardonic reaction to the banality that surrounds us, though the bitterness is expressed by parody rather than by such traditional means as a critical subject matter or a violence of form. The means employed are depersonalized, the artist eliminating his own feelings in paintings of repetitious images and comic-book cartoons. Objects are no longer imbued with traditional animistic or romantic associations. Why? The theories advanced, in what follows, are that the meaning of art, no less than the meaning of man, is under attack; that inherited contradictions in Romanticism enter into Existential directions today; and that traditional definitions and meanings in art must be re-examined and a new criticism developed.

Despite the apparent novelty and obvious impersonality of some contemporary art forms, the vitality of these new movements persists. They are manifestations of twentieth-century thinking in a world under pressure, when processes of social growth all over the globe are being telescoped with incredible urgency, at a time when the possibility of nuclear annihilation is as close as a push button. The gray flannel suit and the organization man are being mocked, defrocked, criticized, declared absurd—by a means

* Reprinted from *The New Art*, edited by Gregory Battcock, E. P. Dutton & Company, Inc., New York, N.Y., 1966, by permission of the author, editor and publisher. The article will be incorporated in Professor Leepa's forthcoming book *Problems in Contemporary Painting*.

that is often as absurd (a carefully designed and disguised absurdity) as the thing ridiculed. However, as with all new directions in art, time alone must be the final judge as to which forms will survive as the fittest spokesmen of our epoch—as the most precise, catholic and profound expression of our unprecedented age.

The definitions of 'art' and of 'criticism' vary widely. It is important therefore to define these terms. This is particularly necessary today when various contemporary movements all but reverse accepted art meanings.

One definition of art is that it is the expression of emotional meanings in the organized patterns of a medium. It is a definition that emphasizes emotion rather than idea. While one does not exist without the other— thought is accompanied by a physical, visceral reaction—some contemporary artists disdain such a definition as being suitable for Abstract Expressionism and the Romantic tradition but inadequate for today.

Art is a form of knowledge. Knowledge is usually interpreted to mean intellectual understanding by verbal or rational means—information, learning, scholarship. Yet there is emotional understanding which, while not independent of intellectual responses, does not primarily depend on them. A work of art communicates itself through both idea and feeling, not idea alone. Since the human act of cognition is thought to depend on man's ability to use a written and spoken language, *i.e.*, to employ and store verbal symbols, all forms of knowledge can, presumably, be traced back to verbal skills. But the act of cognition does not preclude its use in forms of knowledge that are not primarily verbal, as in the case of art. The pragmatic test, of course, is that a visual work of art cannot be translated into words. The assumption that it can, as when someone asks that a painting be explained to him, attests to Western man's over-reliance on rational thoughts as the primary, if not the only, way to understand the world. In art, the primary instrument of knowing is the experience itself, for which only the work itself is the vehicle of communication without the intermediary of words.

Art is a metaphorical statement that is defined by those meanings and human equivalents which man feels most directly, truthfully and comprehensively represent him at any particular time. It is particularly necessary to approach art this way if we are to understand something of what is happening at the present time.

What is criticism? It is the employment of discrimination in the judgment of something. As such, it is an elemental factor in experience. We judge ourselves, others and knowledge itself. To judge is to employ standards. A thing is right or wrong, good or bad, valid or invalid according to the criteria employed. One of the major problems faced by art criticism, it would seem,

is the establishment of such standards. But can standards be determined? What is being judged? What are the criteria used? The problems these questions raise are more easily asked than answered.

Art is the communication of human experience and is, therefore, subjective: what the artist expresses cannot be evaluated objectively. The spectator's, or critic's, experience of the work is also subjective. In short, both the work of art and its criticism make for a continuous, reciprocally dependent vicious circle in which one is defined by the other.

At first glance, it would seem possible to employ in art a procedure similar to that used in philosophy—to define premises so that consequences can be drawn from them. The artist begins his work employing various premises and assumptions, states a point of view and aims at goals. But this method does not work in art as it does in philosophy because the experiencing of art is both emotional and intellectual and not, like philosophy, primarily intellectual. Subjective criticism can be, and is, easily abused: 'educated' opinions proffered by persons with an ability to write or with previous literary experience—though in a totally unrelated field—are accepted as art criticism.

There is another way of approaching the problem of criticism, and that is to view it as a means of describing, identifying and analyzing those characteristics that uniquely mark a particular work of art. This is attempted in as precise and as objective a way as possible without immediately applying subjective judgments and with a minimum reference to *a priori* standards. It is impossible, of course, not to use any standards whatever, since there is some point of reference, some philosophic or psychological overtone to all perceptions. The emphasis in this form of criticism, however, is on the internal *Gestalt* of a work and not on its relationship to standardized aesthetic systems of values. The functions of the critic, then, are to observe, describe and reveal—as accurately and objectively as possible—what the artist is trying to say and to show how he does or does not succeed in accomplishing his goals.

While the critic's ability to be objective is dependent on his knowledge and training as an art historian, art philosopher, aesthetician, artist, he does not function exclusively as any of these. The primary role of the critic is concerned with the work of art itself. Otherwise, the work becomes weakened or lost if the critic functions as a prisoner of fixed viewpoints. In other words, if art is viewed as the expression of a static set of ideas, experiences, aesthetic values, or even humanistic positions, the critic will impose on the works that he sees, the concepts, principles and attitudes inherent in the system of appraisal he is employing. This type of approach—the belief in an absolute set of fundamentals applicable to all arts, of all times—has led to innumerable

aesthetic miscalculations. Often, partial truths have been taken for the whole truth. Roger Fry, for example, so strictly insisted on significant form as the basis of art that, instead of form being viewed as part of the total creative statement it became *the* criterion.

The problem that the serious critic faces is how to *identify* a work of art—its particular content, unique structure and special meaning. His dilemma is how to recognize that element of uniqueness in a work of art that requires subjective reaction while not allowing himself to be unduly prejudiced by such reactions. Likes and dislikes of the critic are less important than what the work itself communicates. While the ability to perceive various kinds of content in a work of art is not always predicated on the emotional preferences of the critic, too often such preferences preclude a sympathetic analysis of the work. A more serious shortcoming is an inability to react in kind to various qualities in the work, such as the sensitive integration of form and content or the expression of a feeling-content through form alone, because of a lack of perceptual awareness. Equally inept is a critic who fails to see an art movement in terms of, and against the background of, the forces that give birth to it. Since there is no completely objective way to view a work of art, the critic must seek to be as catholic and as profound as he can. He must attempt to be as aware as possible of the experiential factors on which he bases his personal reactions in order to see more objectively the work in its own singleness of purpose. While the artist recognizes these changes by revealing them creatively, the critic acknowledges them descriptively and analytically.

Significant creative work is new. The great art is contemporary art. As such, it is 'subversive'—shaking up traditional criteria of art and criticism. It challenges both past and present as it discovers the new. This challenge confronts the critic today no less than it did in the past. What changes are taking place? What are the characteristics of the new directions? How significant are they?

To understand the present, it is helpful to know its roots in the past. One of the principal characteristics of various contemporary *avant-garde* movements is their break with the tradition of Romanticism. The Romantic ideal has been one of the dominating factors in art. At its core is emotional expression and personal interpretation. This is as true of Abstract Expressionism as of Fauvism or Impressionism. The emphasis in the Romantic movement is on the personal vision of the artist, his sentiments, his viewpoint, his reactions, his dreams and his ideals. To find the basis of the Romanticism we know today, we must go back to the last century.

The nineteenth-century Romantic created his own world, out of his

feelings, beliefs, ideas and ideals. He rebelled against the idea, exemplified in the philosophic world of Descartes and the mechanical world of Newton, that personal experience and personality were secondary, and counted for little, that only the mind really mattered and could, in cold calculation, analyze and understand all there was to know about the world and human experience. Why should the past—Plato, for instance—be looked to for answers to the problems of contemporary life or for a definition of man's role in the universe? Why should other authorities—the Church, for example —have exclusive monopoly on final answers in matters so personal that the individual could hardly come to grips with them, their complexities and implications. Man began to look to himself rather than to external authority.

But the vitality of the Romantic, heroic as it was, bordered on the irresponsible. Complete personal independence led to nihilism. While Romanticism insisted on the importance of the individual, it also argued for the political liberty of all. Freedom was an inherent right of every human being. The Romantic, who initially insisted on the inner freedom and importance of the individual, embraced the concepts of universal freedom for everyone. This created a dilemma. A person could not be completely free without infringing on the rights of others. Romanticism therefore lost something of its initial vitality, and freedom became institutionalized. The idealized self, the rallying cry for the Romantic rebellion, changed. What was first the personal protest of the Romantic became a part of the social protest of the masses, and soon dominated the nineteenth century—in government, trade, economics and politics. The ideal of the rugged individualist, who operated primarily for himself under a laissez-faire philosophy, gave way to that government control for the benefit of all.

Romanticism supported concepts, created dilemmas and influenced ideas that are part of the fabric of our thinking today. Ideas of individual freedom versus mass liberty, id versus superego, laissez-faire versus federal control, obligation to self versus responsibility to others are very much a part of our lives today. In art, similar dilemmas are evident. There are problems concerning the relationship between the expressional act and various kinds of control; between external limitations (object, media, technique) and internal ones (idea, feeling, method); between Expressionist directions and Neoclassic aims; between the theories and allegiances of hard-edge painting and those of soft-edge Expressionism; and most recently, between anti-Romantic Pop and new Realist artists and the form-conscious Abstract Expressionists.

A movement in rebellion is dedicated at the same time to its own goals and ideals—the line of demarcation between rebellion and dedication is not

always easy to discern. An act of rebellion against an idea external to itself must also be an act of rebellion against something within the person. The self of the Romantic, in other words, is in rebellion, and as a result, the Romantic movement in art is characterized by a struggle for the hidden within the self, a search for the intangible and mysterious in nature, the unattainable in experience. The deepest within the self is to be sought, but it cannot be released without a fierce personal struggle and intensive search.

When Romanticism gradually lost its momentum, the aesthetic pendulum swung to an opposite pole, to existentialism. Existentialism, one of the most vital philosophies of the twentieth century and particularly of the postwar world, holds that man's position on earth is absurd—he is unable to understand the reason for his existence. Rather than continuing to look to Romantic, imaginary, subjective interpretations of the world, the existentialists prefer to face existence phenomenologically. The existentialist's position is obviously in strenuous opposition to the Romantic's. Existentialism challenges many of the most cherished values, assumptions, theories and beliefs of the nineteenth and twentieth centuries.

Art is caught up in this shift in man's evaluation of himself and his role in the world. Some of the new movements no longer take seriously the idea that art is the embodiment of a subjective, intangible, imaginary world, one that must somehow be re-experienced by the spectator. Instead, he is free to experience his own world in relation to the picture—if this is what is most meaningful to him. A work of art is an extra- or super-phenomenal object unto itself, to be examined without prior conceptual commitments, without thinking of it as a surreptitious representation of something else other than an image in a painting. A house drawn on canvas, for instance, has a different existential existence than an actual house and should not, therefore, be compared to it. The house on the canvas forms a new *Gestalt* in relation to the medium and material of which it is a part and in relationship to the spectator who views it. It is to be experienced in terms of its own unique situation, its own set of relationships, with no prior, generalized, imaginary transference of any kind expected or assumed. This is quite different from the Romantic's expectation that, the spectator identify with the artist's vision and attempt to possess the same kind of reality that he experienced when he played off his personality against the world. What has happened in the newer art directions is anti-art when viewed against the traditional sacrosanct meanings and definitions of art.

The anti-art movements today are based on the idea that experience

changes to abstractions and existence to constructions in logic, when idea, unadulterated by sentiment, is given its fullest recognition. Individual personality ceases to be of primary importance since it is based on Romantic associations. In the new art, or anti-art, reason functions in the service of the will, first to attempt to go beyond logic, and then to go beyond individual personality in order to escape from the contradictions of Romantic freedom.

The absurdity of man's position in the world has become the guiding idea of many contemporary artists. The most meaningful act that can be performed, they insist, is to emphasize the meaninglessness of life. In the antinovels of Beckett, a typical hero finds that nothing is more real than nothing—he withdraws and dies without realizing any conclusions. Robbe-Grillet states about his novels, 'A new form always seems to be more or less an absence of any form at all, since it is unconsciously judged by reference to consecrated forms.'

The anti-art position of the painter and sculptor parallels that of artists in other fields. The following is a typical composite of their positions:

> I do not want to project myself into my work; to identify myself in my painting is to mistake me for it. . . . I cannot perceive the universe in the same black-and-white way that the Abstractionists did. Black-and-white ideas mean clichés to me. I was nourished on them as a child. They meant commercials, falsity, duplicity, slickness, Madison Avenue. Now, all of this must be reversed. White becomes black. . . . Heros are nauseating. They are cardboard mannikins. The world is not exclusively composed of stereotype good persons and bad persons. There are other paths to explore. . . . A new image can be created, one that does not differentiate what is and what is not, what exists and what does not. This can be created powerfully by means of the very contradictions that produce them. Why should right and wrong, existence and nonexistence, be the proper categories and only alternatives? Concepts, feelings, theories, ideologies, goals can mislead; they have no bearing on my work. The work exists as art solely within itself.

Anti-art can be viewed as a crisis in Romanticism, with existentialism as one of the dominating influences. Anti-art thinking has focused on the idea that art, when romantically employed, is simply the duplication of the experiences of everyday life. Art, then, is subordinate to such experiences. It ceases to exist in its own right. In watching a drama, the audience reacts by identifying its own experiences with those of the characters and the situations presented in the play. But we already know about such experiences and situations from non-art sources. Why use art this way?

Art, the anti-Romantic believes, must have a more significant function to serve. What is needed, he feels, is a new approach, one that is no less than a complete redefinition of art itself. If it is to cease to be a handmaiden to everyday emotional experiences, art must first be considered as an idea, a concept, a symbol apart from such experiences. In other words, it must somehow be viewed first as a thing apart from the duplication of feelings or the expression of personality. These already exist within their own contexts: they have a life of their own. But what of the life of a work of art? What is its context, its unique context? Is it simply to communicate the experiences already occurring in the human being, to copy or duplicate them, so that the spectator, when viewing a work of art, relives the sensation of sorrow, happiness, exhilaration, piety and pity that he already experiences daily? Instead, are there perceptions that relate to a *Gestalt* unique to the idea of a work of art itself? It is within this framework of thinking that new art concepts and forms are developing.

We can think back to movements in the past that appear similar to some that are occurring today, to Dadaism, for instance. But where Dada was primarily an act of rebellion, and a Romantic one at that, Pop art is primarily parody. It is anti-Romantic, anti-emotional, anti-intellectual and anti-art.

Another way to view the effort to break from the Romantic tradition is to remember that Romanticism refers primarily to a state of experience within the individual rather than to his relationship to a work of art. When he fantasizes about emotionalized ideals, personal dreams and far-away places, he is engaged in imaginative experiences. As such, his is a behavioral activity, not an artistic one. To rebel against society, to fight against tyrannical aspects of science, to argue against fixed and arbitrary standards for human behavior —these are not the same types of activity as that which deals with problems of art. Concern with them or their employment in art does not, according to the anti-Romantic, clarify, develop, encourage, or reassert the integral, independent nature of art.

Existentialism states that it is impossible to establish the necessary truth of any knowledge acquired by experience. Man's sensory investigations do not yield the necessary information that would make it possible to come to certain or necessary conclusions about the nature of life—its ultimate purpose, structure, or meaning. We can, for instance, touch something and not know that it is made up of millions of electrons in movement. Science does not reveal the ultimate truth about an object. Neither do instruments or techniques. All that man can be sure of is that certain consequences will follow from particular concepts, once he has defined them. The concepts,

however, are limited by the theory on which they are based. Theories are
not absolutes. The attitude that man exists in a state of total ignorance can
lead to a position of complete skepticism: man is unable to know anything
about the world which is absolutely necessary or true.

Existential problems become uppermost when authenticity rather than
Romantic freedom becomes the critical issue at stake. At the core of the
Romantic effort is the aim to transcend all—media, techniques, methods—
to reveal through personal sensibility, the authoritative act, the 'agony' of
creation, the unattainable and unrevealable. He pushes for that which can-
not be stated. The effort of the nineteenth century was to make the world an
implicit part of consciousness; but once this position became untenable,
changes developed—social as well as philosophic—that brought the existen-
tialism of Kierkegaard, Sartre and Camus to the fore and the I-thou concept
of Buber into prominence. Buber felt, for instance, that the individual 'I'
discovers authentic being only through responses—agreeing or disagreeing—
to the 'thou' of others. The crisis of modern man, according to Buber, is his
'loss of community . . . individualism sees man only in relation to himself,
but collectivism does not see man at all, it only sees society.'

For man to have authenticity, he must have the capacity for dissatisfaction
and self-criticism. Otherwise, self-satisfaction, smugness and appetites
circumscribe and bind him. Culture means the capacity to criticize—
criticism based on analysis and evaluation. Democracy offers the opportunity
for creative self-development but is not its guarantee. Democratic man is
without culture until he attemps to live authentically.

The existentialist denies the classic idea of tragedy, and resorts to parody;
contemporary man can be dealt with only derisively, since his position in the
world is nonsensical, not simply tragic. Parody is more desperate than
tragedy, for it ridicules hope as well as despair: the heart of comedy is
incongruity. Today, the scientist, existential philosopher and artist all agree
that the universe is no longer understandable:

We are now approaching a bound beyond which we are forever stopped
from pushing our inquiries, not by the construction of the world, but by
the construction of ourselves. The world fades out and eludes us because
it becomes meaningless. We cannot even express this in the way we would
like. We cannot say that there exists a world beyond any knowledge
possible to us because of the nature of knowledge. The very concept of
existence becomes meaningless. It is literally true that the only way of
reacting to this is to shut up. We are confronted with something truly
ineffable. We have reached the limit of the vision of the great pioneers of

science, the vision, namely, that we live in a sympathetic world, in that it is comprehensible by our minds.[1]

The parody of the human situation in art is purposely demonstrated by such obvious devices as reproducing advertising art of the kind that dominates and standardizes thought in America. Satirization of aesthetic intellectualism is expressed by the stretching of pants on a canvas, with pockets bulging, to ridicule the theory of the picture plane. The myth of freedom and individualism in America is stressed by repeating *ad infinitum* on a canvas surface the same photographic image. Are these anti-art manifestations truly works of art? The contemporary artist replies by asking another question, 'Was painting of the past art?' The artist does not attempt to define art. He feels that as he defines himself, his art defines itself.

To be alive, art must create. To do so is to explore fearlessly and profoundly the meaning of existence. This exploration is not scientific or simply analytical. But why exploration? Art, as we said, is a form of knowledge and as such can help man understand the world—as can all forms of knowledge. Anything of importance to man is significant in the degree that it touches on his meanings. By expanding his understanding and experiences, he provides new insights, and life renews itself. Art offers this possibility to an extraordinary degree since it can employ more of man's faculties in an integrated and concentrated way than perhaps any other instrument of knowing that he employs. The fact that the knowledge offered by art is experienced at the same moment that it reveals its meaning gives it the distinction of being at one and the same time a living counterpart of life and also an activator of it.

Art criticism can also function as an activator of experience. While it does so by revealing insight about a field other than itself—it discusses art and not the art of criticism—it nevertheless can play an important role. By discussing the content of what the artist does within the context of how he does it, the critic can help clarify how, why, and what the artist is saying about the times in which man lives. Man is helped to see himself. But criticism that does not help to reveal the meanings the artist is creating fails in its responsibilities.

The critic constructively contributes to aesthetic meanings when he speaks of the inner structure of a work or the relationship of its parts, and of the way they interact with each other to construct and create that particular work. The intentions of the artist must be examined in terms of the way in which they are fulfilled in his work. The nature of the particular work will then be discussed in terms of its uniqueness and the universals to which they relate.

The most significant directions in criticism are those that help reveal the content of art as it comments on and reveals the present condition of man.

NOTE

[1] P. W. Bridgman, 'Philosophical Implications of Physics,' in American Academy of Arts and Science *Bulletin*, Vol. III, No. 5 (February, 1950).

HUGH D. DUNCAN

*Literature as Equipment for Action: Burke's Dramatistic Conception**

WHERE FREUD USES the dream and the witticism and Malinowski the spell, Burke uses the proverb as an illustration of the sociological function of verbal symbolism. 'Proverbs are designed for consolation or vengeance, for admonition or exhortation, for foretelling. . . . Or they name typical, recurrent situations.'[1] That is, people find a certain social relationship recurring so frequently that they must have a way of naming it to begin dealing with it at all.

The Eskimos have special names for many different kinds of snow (fifteen, if I remember rightly) because variations in the quality of snow greatly affect their living. Hence, they must 'size up' snow more accurately than we do. And the same is true of social phenomena. Social structures give rise to 'type' situations, subtle subdivisions of the relationships involved in competitive and cooperative acts. Many proverbs seek to chart, in more or less homey and picturesque ways, these 'type' situations. I submit that such naming is done, not for the sheer glory of the thing, but because of its bearing upon human welfare. A different name for snow implies a different kind of hunt. Some names for snow imply that one should not hunt at all. And similarly, the names for typical, recurrent social situations are not developed out of 'disinterested curiosity,' but because the names imply a command (what to expect, what to look out for).[2]

The proverb is a community attitude for dealing with a situation: 'In so far

* Reprinted from *Language and Literature in Society*, The Bedminster Press, 1961. (Originally published by the Chicago University Press, 1953.) Copyright 1953 The Bedminster Press. Reprinted by permission.

as situations are typical and recurrent in a given social structure, people develop names for them and strategies for handling them.' This characteristic of the proverb is, in Burke's scheme, true of even the most sophisticated works of art: 'For surely, the most highly alembicated and sophisticated work of art, arising in complex civilizations, could be considered as designed to organize and command the army of one's thoughts and images, and to so organize them that one "imposes on the enemy the time and place and conditions for fighting preferred by oneself".'[3] This is very noticeable in the use of slang. Here the proverb does not represent a traditional fixation of attitudes but the attempt of a people who are up against a new set of recurrent situations, situations (as in America) typical of their business, their politics, their criminal organizations and their sports. Either there were no words for these in standard English,[4] people did not know them, or they failed to conform to established verbal proprieties. Such slang is the beginning of the proverbial, a kind of folk criticism.

A sociology of literature must codify the various strategies which artists have developed for naming situations. The first class would be the timeless classics (such as Aesop's *Fables*) which apply to contemporary human relations just as fully as they did in ancient Greece. A given human relationship may be at one time named in terms of foxes and lions, if there are foxes and lions about; or it may today be named in terms of salesmanship, advertising, or the tactics of politicians. But, however various the particulars of expression may be, it is impossible to understand human action without reference to those universal names for recurring situations:

> What would such sociological categories be like? They would consider works of art, I think, as strategies for selecting enemies and allies, for socializing losses, for warding off evil eye, for purification, propriation, and desanctification, consolation and vengeance, admonition or exhortation, implicit commands or instructions of one sort or another. Art forms like 'tragedy' or 'comedy' or 'satire' would be treated as *equipments* for *living*, that size up situations in various ways and in keeping with correspondingly various attitudes. The typical ingredients of such forms would be sought. Their relation to typical situations would be stressed. Their comparative values would be considered, with the intention of formulating a 'strategy of strategies,' the 'over-all' strategy obtained by inspection of the lot.[5]

While it is true that existential factors giving rise to a code of moral and aesthetic values are social (the 'substructure' that supports the ideological 'superstructure'), the objective materials[6] utilized by an individual writer

are largely the moral and aesthetic values themselves. Social conditions require stress on certain values, and these values form objective material with which the artist works in constructing symbols. Thus, in American business enterprise, the aggressive type of salesman possesses high social value. Our popular artists enhance their appeal by idealizing a character who is the 'live-wire' type. Men enact roles;[7] they change roles. They participate. They undergo changes of identity. Human motivation must be understood in terms of how people communicate with one another as they accept and reject identifications in the complex of modern society, where identification takes place among competing and conflicting symbol systems. To some degree, conflicts are resolved in the symbolic realm. Persons highly skilled in moral and imaginative perception acquire great enterprise and resourcefulness in purely symbolic solutions of conflict by their ability to manipulate the means by which our attitudes are formed. In one sense these manipulations are like prayer, if by 'prayer' we understand the coaching of attitudes of the audience or the self. Once we study the various strategies that men use to solve their conflicts on this level of symbolic action (conceived of as implicit commands to audience and self), we gain greater understanding of the resistance encountered when we shift allegiance to reigning symbols of authority.[8]

Many metaphors for social action are possible. For operational purposes it is enough to state clearly which metaphor (man as machine, animal, etc.) is to be used; collect and order data in terms of this; and state a conclusion which can be validated through reference to the data. But a *theory* of action requires more than this. It requires, above all, that we show what elements in human action are included, what left out. It may be impossible for one discipline to deal with each element. We should not expect an anatomist to say much about the emotions; yet, unless the anatomist conceives of his analysis of the human body in terms of a general theory of the physiology of man, and this, in turn, as a specialized branch of a theory of man acting in his human capacities, there is little he can say about man as man (however much he may say about him as animal). Once we make man part of a nature determined by physical laws alone, there is nothing we can say (as students of a physical nature) about man's search for truth, goodness and beauty. The excesses of naturalism must therefore be avoided as much as those of supernaturalism.

When we must judge human motivation (as in law, ethics, etc.), we ask (to paraphrase Aristotle)[9] who is involved in the act we are considering, what he is doing, by what means, where, or under what conditions and, finally, for what purpose. This is not to say that every system of explanation for

motives considers each of these elements or gives them equal weight, but as Burke contends, theories of action useful for explaining the structure of the act in terms of function of action in society must take such terms into consideration. Burke is not alone in this contention, any more than he is in his dramatistic point of view. Durkheim used dramatic constructs in his analysis of ritual as a paradigm for social action in general.[10] Radcliffe-Brown tells us that for the Andaman Islander 'the world is merely a stage on which the social drama is perpetually enacted.'[11] Freud also selects a great ritual drama, the *Oedipus Rex* of Sophocles, and uses it as a prototype for describing the development of sexual roles as these are determined by their development within the family. George Herbert Mead's general analysis of the act, when concerned with action and not simply with perception or knowledge, considers it in terms of play and the game.[12] Huizinga proposes that we consider play as the characteristic human act.[13] Even economists and social scientists trained within the traditions of positivism conceive of action in terms of roles, orientation, or rules. Thus, Frank H. Knight, speaking as an economist, holds that, of the 'motives attached to production as an activity rather than to the product, the most obvious is its appeal as a competitive game.'[14] Talcott Parsons insists that, unless a theory of action includes 'the subjective point of view, *i.e.*, that of the actor,' it cannot be used in constructing a theory of social action.[15]

Burke proposes that we accept the ritual drama as a 'pure' form of human action, but, unlike both Freud and Durkheim, he insists that we give full weight to the dialectical aspects of action. It is the resolution of many voices, representing various interests, which is characteristic of completed acts in our society. Unlike Freud, Burke stresses the proportion between various elements in the act (such as cognition, evaluation, or as organized systems: knowledge, love and authority) rather than an essence of the act (such as sex, religion, or economics alone). A proportional type of analysis makes use of symbolic operations in dreams but considers other elements. These are the hortatory or persuasive functions of symbols in the production of co-operative and nonco-operative attitudes (often in the same act, as in war propaganda, where we are urged to love one another, yet to hate an enemy) and the way in which symbols are used to 'name' or chart experience (as in the proverb or law), so that we can act effectively.

An art work cannot be regarded simply as a dream, because it is also a *communication*, a choice of verbal gesture for the inducement of corresponding attitudes on the part of the one addressed. Considering a symbolic work from this point of view, 'we begin with the incantatory elements in art, the ways of leading in or leading on the hypothetical audience to which the

[symbolic work] as a medium is addressed (though this hypothetical audience be nothing more concrete, as regards social relations, than a critical aspect of the poet's own personality).'[16] To develop this point, Burke uses Mead's construction of the 'I' and the 'Me.' 'Roughly, I should say that the slightest presence of revision is *per se* indication of a poet's feeling that his work is addressed (if only, as Mead might say, that address of an "I" to its "Me").'[17] Burke holds that, once we consider the symbolic work as a communication to an audience, we cannot analyze it without making use of theories of rhetoric (which he conceives of as the study of efficient verbal means for affecting a given audience). This is the basis for the kind of analysis he undertakes in the second volume of his three-volume work on motives. The importance of Burke's analysis of rhetoric (and his review of theories of rhetoric) lies in his analysis of how the speaker makes his appeals. He does not assume that, once we have said something about the sex, age, class, education, occupation, or other conditions of an audience, we have said anything about how these factors affect symbols as such.

There is no scheme of symbolic analysis which does not assume (implicitly or explicitly) that the symbolic work is addressed to another. Even Freud's dream has a censor which is addressed by the dreamer. The ways in which this address takes place—the rhetoric of dreams, so to speak—is defined by Freud as a series of sexual puns.[18] But, since language is the product of a culture, we must know the culture in which the pun is being made, in order to know the specific content of the experience. Even the Freudian analyst must know the 'history of civilization, mythology, the psychology of religion, and literature'; for, 'unless [the analyst] is well oriented in these fields, the analyst will be unable to bring understanding to bear upon much of his material.'[19] The conditions within which the rhetoric of dreams must function are determined in part by the superego, which includes 'not merely the personalities of the parents themselves, but also the racial, national, and family traditions handed on through them as well as the demands of the immediate social milieu which they represent.'[20] This suggests, then, that, even on the level of dream analysis, what we know of language as a cultural instrument will determine to a large degree what we know about the dream.[21]

In his analysis of wit, Freud is more concerned than elsewhere with the structure of communicative functions. Wit must be intelligible to at least three people—the person making the witticism, the object of it, and a third, who acts as audience. Wit is always an appeal from the speaker to this audience, and, if we are to understand the function of wit, we must understand the expectations and values of the audience as well as the motivations

of the speaker or writer. The speaker must express his wit in terms under-
standable to the audience, for, without the collaboration of the audience, the
speaker cannot get rid of his lust (if the witticism is sexual) or his hostility
(if the witticism is over status). The hearer must be in psychic harmony with
the first person, he must possess the same inner inhibitions which the wit-
work has overcome in the first person. As Freud stresses, 'Every witticism
thus demands its own public, and to laugh over the same witticism is proof
of absolute psychic agreement.'[22] Hence analysis of what wit is doing for the
speaker will also be analysis of what it is doing for the audience.

Burke proposes two other ingredients in symbolic appeal, aside from the
Freudian dream-wish. These he calls 'prayer' and 'chart.' In religious
practice, prayer is effective to the degree that it has a public function. Prayer
is the expression of a wish (like the dream), but it is an inducement, an appeal,
an invitation to hearer and reader alike to make himself over in the image of
the selected prayer. Prayer, then, is the ideal type of linguistic incantation.
It is a way of leading on audiences, which may range from one's own super-
ego to what the literary artist knows as a general reading public. But prayer,[23]
unlike the dream, becomes more powerful as it becomes more public, and it
becomes more public as it is based in a supernatural world of faith which
offers suppliants ways of dealing with the great human experiences of birth,
suffering and death. When verbal symbols are used in prayer, they mean
what they do to the suppliant because of what he assumes they mean to the
larger community of suppliants. As a religion develops, it creates a cos-
mogony, which may be depicted in tales of religious heroes, culture heroes,
or sagas of gods and demigods. This cosmology becomes more binding as
it becomes more widely accepted, and, as a deep sense of communion with
fellow worshipers develops, symbols expressing this become highly com-
municative. The same is true of the opposite of prayer, the curse, where
wide acceptance of the values expressed in the oath make it so fearful to
those against whom it is directed.

If prayer is a petition, magic is a command, an exhortation directed toward
the attainment of practical aims. Just as prayer finds its counterpart in oath,
indictment and invective, so, too, there is the spell and the counterspell,
white and black magic. It is difficult, of course, to separate magical decrees
from prayerful petition, even in primary situations. There will be many
borderline cases, and, finally, in modern competitive society, where we have
many group identifications, each group will seek to 'bless' its own members
at the same time that it damns its opponents. This double character of all
symbolic usage must be taken into account.[24] Proverbial symbols, unlike the
dream, magic, or prayer, are a realistic 'sizing-up' of a social situation. Some

experience becomes significant enough for the writer and his public to need a name for it. As these names become typical through repetition within a group, they become proverbial. Without such ways of pointing at certain elements common to both audience and speaker, there can be no communication at all. But in this naming process the artist seeks to affect human action, for, as we use such names, we evoke attitudes in others, and hence in ourselves. The name may be plaintive, vindictive, sorrowful, consoling, or joyful, an act of commemoration, a curse, a mourning, or a sympathetic gesture.

In his use of 'chart' as a construct for one mode of symbolic expression, Burke is in substantial agreement with Malinowski, who holds that symbolism must be understood in terms of a very pragmatic function,[25] namely, that of establishing desired relations between objects, verbal gestures, series of actions and attitudes in such a way that individuals derive satisfaction from the symbolic (as well as the motor) phases of the act. But Burke is concerned with how to demonstrate these functions in the literature of a complex, modern society.

Burke's technique of symbolic analysis consists of codifying the 'associational clusters' in the work of a writer or speaker. The basic unit for such analysis is the image, not the word, sentence, paragraph, or other lexical units as such. He contends that the work of every writer contains a set of implicit equations which are manifest in certain kinds of acts, images, personalities and situations which express the writer's notions of heroism, villainy, consolation, despair, etc. The interrelationships among these clusters of imagery will lead to an understanding of the writer's motives. There is no need to supply motives, since 'the interrelationships themselves *are* his motives. For they are his *situation*; and *situation* is but another word for motives.'[26] These clusters of images and the interrelationships among them are both private and public. When we analyze Coleridge's work, we can cite both kinds of cluster. We find

... ingredients in the figure of the albatross slain in *The Ancient Mariner* that are peculiar to Coleridge (*i.e.*, the figure is doing something for Coleridge that it is not doing for anyone else); yet the introduction of the albatross, as victim of a crime to motivate the sense of guilt in the poem, was suggested by Wordsworth. And, as Lowes has shown amply, *The Ancient Mariner* also drew upon legends as public as those of the Wandering Jew and the fratricide of Cain.'[27]

We must specify the image or images which we consider to be representative of the symbolic work—key images which we classify in terms of frequency, intensity, relational linkages, or other categories.[28]

As a further aid in the analysis of imagery, Burke distinguished among three levels of symbolic action: biological, personal (intimate, familiar, familistic) and abstract (group identification). Biological or kinaesthetic imagery is found in images of gripping, repelling, eating, excreting, sleeping, waking, through sensory imagery in which natural objects or events are treated as replicas of corresponding mental states. Thus the images of even a realistic novel may symbolize some over-all quality of experience, such as growth, decay, drought, fixity, ice, desiccation, stability, etc. Familistic images are those which show relationships to father, mother, doctor, nurse, friends, etc. Abstract images are those which indicate the groups in a given society with which the writer enrolls himself, as with the proletarian writers who indicate their group identifications in society by the choice of the workingman as hero.

Selecting representative images, classifying associational clusters and charting their interrelationships constitute essentially a structural approach. When we seek to analyze the dynamic function of imagery (as it affects role-taking), we must watch for changes in role, for abandonments of the old self in symbolic deaths, rebirths, suicide, parricide, or prolicide. All forms of indictment, vituperation, vindictiveness against a villain, like depictions of the kill (such as sacrifice, suicide, etc.), are clues to symbolic transformation. The representative symbolic role of the villain as scapegoat, the vessel of unwanted evil, the sacrificial figure upon whom the burden of evil is ritualistically loaded, is a master key to transformations in symbolic role.

There are various degrees of symbolic rebirth. A total rebirth would require a change of substance, for no rebirth is complete until the old self has been destroyed and a new self created. The higher the social value of the group into which the new self enters, the greater the value of the rebirth to the self. The villain (or whatever form the symbolic scapegoat takes) is a 'suppurating' device, a way of bringing evil to a head. In the symbolic productions of complex societies, it is no longer enough to create symbolic rituals of purification and consequent means of expiation out of animals or things. They must be endowed with social co-ordinates. For the expiation to be thorough, the character delegated to the role of sacrifice must be worthy (equal in value, social rank, or whatever the co-ordinates of action call for) of sacrifice. The villain must be almost as strong and powerful as the hero for great purification to come from triumph over him.

NOTES

[1] Kenneth Burke, *The Philosophy of Literary Form: Studies in Symbolic Action* (Baton Rouge, La.: Louisiana State University Press, 1941), p. 293.

[2] *Ibid.*, pp. 293–294.

[3] *Ibid.*, p. 298.

[4] Mencken's *American Language* offers many splendid discussions (with examples) of this point. For the sociologist interested in American culture as well as language, this work is indispensable.

[5] Burke, *op. cit.*, p. 304.

[6] See Dilthey's 'objective mind' as discussed in Section II of Part III ('Plan der Fortsetzung zum Aufbau der geschichtlichen Welt in den Geisteswissenschaften') of his *Der Aufbau der geschichtlichen Welt in den Geisteswissenschaften*, Vol. VII of the collected works. H. A. Hodges' work in English on Dilthey, *Wilhelm Dilthey: An Introduction* (New York: Oxford University Press, 1944), contains a treatment of this conception as well as a brief translation of some of Dilthey's work (see pp. 118–120). For specific references to 'objective mind' consult the Index.

[7] Burke's 'dramatism' has much in common with Cooley's 'dramatic insight' (see Cooley's 'The Roots of Social Knowledge,' *American Journal of Sociology*, XXXII, No. 1 [July, 1926], 59–79) and Mead's 'vocal gesture' in role-taking. Simmel's 'interaction' is what Burke would call a dramatistic interaction (see Simmel's 'The Sociology of Sociability' as translated by Everett C. Hughes in *American Journal of Sociology*, LV, No. 3 [November, 1949], 254–261). Simmel, of course, was interested in the *forms* which various kinds of symbolic interaction assumed. Burke is interested, too, in the forms of symbolic action, but, for him, the process of interaction must be considered as symbolic. His dramatism is important to social scientists not simply because he uses the form of the drama as his 'ideal-type' for all types of action where symbols are involved but because he shows how such a construct can be used for analyzing the symbolic aspects of action in terms of symbols.

[8] Burke holds that there is a strong moral imperative for such types of analysis, since 'it should offer a *ground in common* between propagandizer and propagandized, whereby the maximum amount of readjustment could be accomplished through the "parliamentary" [discourse, discussion]. That is: it should avoid the coaching of *unnecessary* factional dispute by considering modes of response applicable to *all* men and it could confine differences solely to those areas where differences *are* necessary. Such procedure is especially to be desired in the propagandist, since humaneness is the soundest implement of persuasion. For it contributes towards the general humanization of policies, even should bad policies prevail' (Burke, 'Twelve Propositions on the Relation between Economics and Psychology,' *op. cit.*, p. 313); Burke's italics.

[9] See *Nicomachean Ethics* iii. IIIa.

[10] See Book III, 'The Principal Ritual Attitudes' and 'Conclusion' in E. Durkheim, *The Elementary Forms of the Religious Life*, trans. from the French by J. W. Swain (Glencoe, Ill.: The Free Press, 1947).

11 See A. R. Radcliffe-Brown, *The Andaman Islanders* (Glencoe, Ill.: The Free Press, 1948), p. 390. Where Durkheim selects religious rites, Radcliffe-Brown selects the dance ('It is in the dance that the community expresses most completely its own unity') (p. 279). There is a discussion of the dance as the representative tribal act in Chapter 5, 'The Interpretation of Andamanese Customs and Beliefs: Ceremonial.'

12 It should be remembered that Mead has been edited and interpreted by scholars who are not interested in theories of social action but in theories of knowledge. When we turn to Mead's own writings (not edited lecture notes), we find a dramatistic conception of action. True, he talks about on-going conversation, vocal gesture, play and the game, and not the drama as such. Yet his whole conception of sociation is that of role-taking, and 'role' is essentially a dramatic term (see 'The Genesis of the Self and Social Control,' *The Philosophy of the Present* [Chicago and London: Open Court, 1932], Chapter 5, as well as *Mind, Self, and Society* [Chicago: University of Chicago Press, 1934], *Movements of Thought in the Nineteenth Century* [Chicago: University of Chicago Press, 1936] and *The Philosophy of the Act* [Chicago: University of Chicago Press, 1938].

13 See J. Huizinga, *Homo ludens: A Study of the Play-Element in Culture* (London: Routledge & Kegan Paul, 1949), esp. Chapter 1 on the 'Nature and Significance of Play as a Cultural Phenomenon.'

14 F. H. Knight, *The Ethics of Competition and Other Essays* (London: George Allen & Unwin, 1936), p. 60.

15 Parsons states: 'an "act" involves logically the following: (1) it implies an agent, an "actor." (2) For puposes of definition the act must have an "end," a future state of affairs toward which the process of action is oriented. (3) It must be initiated in a "situation" of which the trends of development differ in one or more important respects from the state of affairs to which the action is oriented, the end. This situation is in turn analyzable into two elements: those over which the actor has no control, that is, which he cannot alter, or prevent from being altered, in conformity with this end, and those over which he has such control. The former may be termed the "conditions" of action, the latter the "means." (4) Finally, there is inherent in the conception of this unit, in its analytical uses, a certain mode of relationship between these elements. That is, in the choice of alternative means to an end, in so far as the situation allows alternatives, there is a "normative orientation of action"' (Talcott Parsons, *The Structure of Social Action* [New York: Harper & Brothers, 1937], p. 44). There are notes to this section which are not quoted here.

16 Kenneth Burke, *op. cit.*, p. 281.

17 *Ibid.*, p. 282.

18 Although, as we have stated before, Freud does not fully carry out his theory of language as sexual punning in his concrete analysis of cases, where he stresses the pudencies of status along with those of sex. In these cases 'inhibition' is at once a sexual and a status term.

19 S. Freud, *The Question of Lay Analysis* (New York: W. W. Norton, 1950), p. 118.

[20] S. Freud, *An Outline of Psychoanalysis* (New York: W. W. Norton, 1949), p. 17.

[21] See Freud's essay on 'The Antithetical Sense of Primal Words' in the fourth volume of *The Collected Papers of Sigmund Freud*, 5 vols. (London: Institute of Psycho-Analysis, Hogarth Press).

[22] *Wit and Its Relation to the Unconscious*, in *The Basic Writings of Sigmund Freud*, trans. and ed. by A. A. Brill (New York: Modern Library, 1938), p. 737. Throughout his analysis of wit, Freud speaks of both sex and hostility (in status contexts) as well as hostility in sex.

[23] On this distinction between magic and religious invocation see Malinowski's essay 'Magic, Science, and Religion' in *Magic, Science, and Religion and other Essays* (Glencoe, Ill.: The Free Press, 1948), pp. 67–71.

[24] For discussion of this point and Burke's three modes of symbolic action see Burke, *op. cit.*, p. 283.

[25] Malinowski says: 'We have now seen that what we have defined as charter, that is the traditionally established values, programs, and principles of organized behavior, correspond once more, fully and directly, to our concept of drive, insofar as this is culturally reinterpreted' (*A Scientific Theory of Culture* [Chapel Hill, N.C., University of North Carolina Press, 1944], p. 144).

[26] On this conception of situation as motive see Kenneth Burke, *Permanence and Change: An Anatomy of Purpose* (New York: New Republic Books, 1935), pp. 30–54, especially the section 'Motives Are Shorthand Terms for Situations.'

[27] Burke, *op. cit.*, pp. 22–23.

[28] On pp. 33–34 of *The Philosophy of Literary Form*, Burke illustrates his technique for finding out which images represent what and to what degree they are key images.

WALTER ABELL

Toward a Unified Field in Critical Studies*

THE APPROACH TO universality and definitiveness achieved by the historical side of our historico-critical development has by no means characterized its critical side. Here our knowledge is still in a formative and fermentive state. Any effort to grasp the field as a whole confronts us with a bewildering intricacy of schools and counterschools, of oppositions and conflicts, of multiple problems rather than unifying solutions.

An iconographer like Mâle will tell us that medieval art is a 'closed world' to us unless we learn to decipher the obscure 'hieroglyphics of its subject-matter.'[1] Exactly opposite assertions come to us from critics imbued with the concept of 'pure visibility.' They insist that subject matter is 'irrelevant' to artistic significance and that we should concentrate our attention on the 'plastic form' inherent in visual creations as such. One recurrent point of view urges that to understand art and artist we must, in Taine's words, 'comprehend the general social and intellectual condition of the time to which they belong. Herein is to be found the final explanation; herein resides the primitive cause determining all that follows it.'[2] We have had earlier occasion to quote Lionello Venturi as a spokesman of the opposite view that 'the consideration of art as a document in the life of peoples' is to be classed among the 'deviations from the criticism of art' and that 'the only reality of art is the personality of the artist, as it is manifested in his works of art.'[3]

Other conflicting points of view could be indicated. The reader desiring

* Reprinted by permission of the publisher from Walter Abell, *The Collective Dream in Art*, Cambridge, Mass.: Harvard University Press, © 1957 by the President and Fellows of Harvard College.

a comprehensive survey of the intricacies of recent critical thought can turn to the later chapters in such summaries as Bernard Bosanquet's *History of Aesthetic* (1892), Lionello Venturi's *History of Art Criticism* (1936) and Gilbert and Kuhn's *A History of Aesthetics* (1939).

It is doubtful whether the ferment of ideas just suggested can be reduced to any single systematic framework which would be satisfactory to everybody. After considerable effort to obtain perspective on the field as a whole, however, the author has concluded that it can fairly well be charted under six headings: six approaches or points of view, six directions of attention and emphasis, each of which may be said to constitute a tradition within the totality of recent efforts to interpret art. These six main critical traditions, together with some outstanding representatives of each of them, are as follows:

1. *Iconography.* Emphasis is on subject matter and its natural or literary sources as a basis for understanding art. Active during the Middle Ages in a preoccupation with sacred texts, the iconographic approach expanded during the Renaissance to include the direct imitation of nature among the objectives of art and keys to its subject matter. It has since reverted mainly to concern with literary sources, especially the forgotten ones associated with past forms of art. Characteristic recent contributions to this tradition have been made by Emile Mâle, Erwin Panofsky and Edgar Wind.

2. *Biographical Criticism.* Emphasis is on the creative personality as the chief basis for understanding art. Exponents of this point of view have been chiefly concerned with the lives and works of individual artists. The tradition extends from the Renaissance, when Vasari and others wrote their 'Lives,' to the present day. Under the influence of psychoanalysis, its sphere of inquiry has been extended in the twentieth century to include the unconscious depths of the creative personality—an extension illustrated by Freud's *Leonardo Da Vinci.*

3. *Historical Determinism.* Emphasis is on civilization and environment as the conditioning sources of art forms. This point of view was presented by John Winckelmann in the eighteenth century, by Hippolyte Taine in the nineteenth. E. Viollet-le-Duc, Henry Adams and others have thought in more restricted ranges of historical reference. A marginal, ethically centered variation of the tradition occurs in the work of Ruskin, Tolstoy and others who stress the moral effect which art should have on society, as distinguished from the historical effect which society has upon art.

4. *Aesthetic Materialism.* Emphasis is on material, technique and function as the chief factors determining art forms. This approach is most frequently

applied to architecture and the useful crafts, but it has been proposed for all the arts. Lessing advanced the thesis in his *Laocoon* (1766). A century later Gottfried Semper formulated it into a system in *Der Stil in den Technischen und Tektonischen Kunsten* (Style in the Crafts and Structural Arts: 1863). Viollet-le-Duc employed this point of view as well as the preceding one. One of the earlier statements of it by an American was Charles Herbert Moore's *Gothic Architecture* (1899).

5. *Aesthetic Teleology*. Art forms are explained as the outcome of a psychological 'will to art' associated with epochs or races. This was enunciated at the beginning of the twentieth century by Alois Riegl as an incidental critical aspect of a historical work—*Spätromische Kunstindustrie* (Late Roman Industrial Arts). The approach was adopted as the basis for a 'psychology of style' by Wilhelm Worringer, in his *Abstraction and Empathy* and *Form Problems of Gothic*.

6. *Pure Visibility*. Works of art are explained in terms of the formal significance resulting from the organization of lines, colors and other plastic elements. The method is employed as a means of descriptive classification by Heinrich Wölfflin in his *Principles of Art History*. It is called the chief basis of aesthetic values by many recent critics—among others, Roger Fry, Clive Bell and Albert C. Barnes.

In the foregoing outline we have listed the six approaches chronologically, following the approximate order of their historical emergence in works which still play an active part in our critical literature. One of the earliest concepts of creative motivation is the medieval one of divine inspiration, which corresponds with the religious emphasis in medieval life and art; one of the latest of such concepts is that of pure visibility, which corresponds with recent abstraction. Between these temporal extremes we can find other correspondences, such as that among the individualism of the Renaissance, its artistic expression in such forms as portraiture and its critical expression in emphasizing individual genius as the source of what is artistically important.

From our point of view it is not surprising that theories about art should reveal evolutionary directions corresponding to those followed by art itself. Not only are the theorists dependent upon the work of the artists; the artists are influenced by an intellectual climate which includes the work of the theorists, and both, in the measure of their creative capacity, are responding to common cultural directives.

Dialectically, the six traditions have tended to group themselves into three pairs of thesis and antithesis. Iconographic interpretations have been opposed by formal ones; individualistic, by social ones; mechanistic, by teleological

ones. In the heat of debate, which is usually intensified by the clash of personalities, it has frequently seemed to the champions of each point of view that the difference between their position and that of their opponents was one of truth as opposed to error. Reflective wisdom suggests that any point of view maintained by a number of serious thinkers over a period of time has *something* to recommend it; that each of the six traditions, therefore, may be accepted as embodying *a* truth or *an aspect* of truth; and that, if *the* truth can be reached at all, it presumably lies in the direction of a synthesis capable of resolving the oppositions among the various traditions into a larger unity.

If we turn our attention to possible bases for such a unity, organic relations among the six traditions begin to suggest themselves. In the first place, as indicated by the diagram shown below, they would seem to fall into two groups: one concerned with the inherent attributes of art, the other with forces which motivate the creation of art. In the first group are the traditions devoted primarily to the subject matter, the form, the material, the technique and the physical functions of works at art. In the second group are those devoted to creative motivation as ascribed, respectively, to the individual artist, to races and to historical states of civilization.

AN ORGANIC CLASSIFICATION OF RECENT CRITICAL TRADITIONS

Intrinsic attributes of art	Iconography and other studies in subject matter
	Pure visibility emphasizing form
	Aesthetic materialism emphasizing material, technique and function
Motivation of art	Biographical studies emphasizing personality of the artist
	Aesthetic teleology emphasizing will to art resident in races
	Historical determinism emphasizing influence of civilization and environment

The three approaches gathered in our first group, though they have occasioned more than one internecine feud, are in no sense incompatible. Each deals with, and illuminates, certain aspects of the work of art. In studying a fully integrated work of art like a Gothic cathedral, where all aspects are merged, we might follow each approach in turn to our enlightenment. Through the iconographic approach we could penetrate the mysterious world of religious imagery presented by the sculpture and stained glass of the building itself and by the painting of its altarpieces and other accessories. The visibility approach would quicken our perceptions of design, focusing our attention upon the proportions of mass and space, the rhythmic flow of lines, the harmonies of color, the repetition and endless variation of motifs such as that presented by the pointed arch. The material approach would show us the dependence of the whole fabric upon the physical properties of stone and glass, upon the physical forces of weight and thrust, and the marvelous adaptation of pier, arch, and buttress to their functions as members of the structural organism. From this same material approach we could also, if we wished (thinking back to Lessing), learn some of the reasons why the same religious subject receives different formations in the portals, the windows and the altarpieces—differences due in part to the respective natures of carved stone, of stained glass and of painted surfaces.

It is obvious that each of these approaches contributes something to the observer's understanding of, and responsiveness to, the work of art, and it is obvious, therefore, that each has its value for the study of art. The limitations that may be ascribed to them are those not of insignificance or error but of partiality. If and when any of them has revealed such limitations, it has done so either in regarding itself as a self-sufficient basis for the interpretation of art or in opposing other approaches. Truth for each would seem to lie in recognizing itself as a competent aspect of a larger whole and in maintaining positive relationships toward other approaches in the interests of that larger whole. Such an attitude would promote integration on two levels. It would liberate the three approaches of our first group from their respective limitations and their mutual conflicts, harmonizing them within the balanced totality of the group, and it would open the way for recognition of organic connections between the first group as a whole and the factors comprising our second group.

The author's earlier work *Representation and Form* was an effort in the first of these directions. Its point of departure was the recent opposition between the pure-visibility tradition and that which has ascribed significance to subject matter. Its outcome was the proposal of a basis of synthesis within which, from the aesthetic point of view, the two could be integrated.

This was a step toward a unitary conception of the work of art, but the unity which it conceived was one of surface factors, or what we are here calling the 'intrinsic attributes' of art objects. It did not extend the inquiry to the forces of motivation or inspiration upon which both the formal and the representational characteristics of works of art are ultimately dependent. Hence, it might be compared to a study of the manifest imagery of dreams that did not raise the question of what latent motivation had inspired the manifest imagery. Its depth limitation in this respect is shared by all studies that confine their fields of reference to the factors dealt with by the traditions of our first group. This brings us to the second and wider basis of integration suggested above: the relationship between the traditions listed in our first and our second groups, which is, in principle, the relationship between resulting effects and their motivating causes.

Iconographical, formal and functional studies, when pursued in isolation, have not concerned themselves directly with questions of creative motivation, but each approach has tended to assume motives reflecting its own preoccupations. Iconography has attached so much importance to 'influences' that it might seem to imply that the historic works of art were created for the purpose of being influenced—an idea so preposterous that no one seriously entertains it. More reasonable, as a motive related to iconography, would be the assumption that the creative purpose lay in representing the subject matter of the work studied. Functionalism, for its part, has tacitly assumed that the aim of art was to achieve fitness to material and structural demands; formalism, that its aim was to achieve finely organized perceptual relationships.

In each case we may accept the statement as involving a partial motivation —the immediate motivation for a component aspect of the total work. But reflection should make clear that in no case alone, nor in all together, do these statements involve an adequate motivation for art as a whole. If we say in so many words that the purpose of building the Gothic cathedrals was to allow architects to pose and solve problems of thrust and counterthrust, the proposition joins the ranks of the preposterous. The assertion that the purpose was to represent subject matter for its own sake is hardly less so. The subjects were considered important for their power to express something external to themselves—religion—and, if we extend our frame of reference to include religion, then, we have left our first group of concerns, strictly speaking, and connected the subject matter intrinsic to the first group with one of the forces of civilization included in the second.

The remaining alternative—that the artist creates in order to achieve aesthetic form—corresponds so well with the conscious aspect of his own

creative experience, and also with our enjoyment of formal beauty, that we might seem justified in accepting it as an ultimate motivation. That it can hardly be so, however, is suggested by various considerations. In the case of artistic undertakings as vast as those of the cathedrals, the pleasures of perceiving harmony and proportion would hardly seem a sufficient incentive to inspire whole communities to spend immense sums of wealth and effort over generations of time. And, even in the case of small, individually executed works such as easel paintings, for which aesthetic form may seem a sufficient justification, the student of depth psychology can hardly accept the conscious formal experience as independent of presumed unconscious motives.

Subject, form and structure, it appears, are means to more inclusive and elusive ends, not ends in themselves. They are agencies for fulfilling motivation, not types of motivation. The realization of this fact has led various thinkers to proceed upon the assumptions, or to formulate the theories comprising our second group of traditions: those ascribing the motivation of art to the impulse and capacity of the individual artist, to a racial will to art and to the historical energies of a state of civilization. Before scanning these traditions, we might note that the Middle Ages had previously proposed a motivation for art which has faded out of more recent thought but which, like all things past, is no doubt destined to reappear in modified and perhaps more analytical form in the future.

There was in medieval consciousness no realization that art had a history, no sense of it as a reflection of human cultures, no emphasis upon individuals as its creators. Like the rest of the universe it was explained and justified as a revelation of the glory of God. A monk, Theophilus, wrote a treatise on art in the twelfth century. He discusses techniques and formal concerns, but presents them as recipes serving a purpose, not as purposes in themselves. The purpose was to manifest divinity through the adornment of places of worship. In accomplishing that purpose, Theophilus tells the artist, 'you have in some way exposed to the eyes of the faithful the Paradise of God. . . . You have succeeded in letting the Creator be praised in creation and in showing God to be admirable in his work.'[4]

The Renaissance, still unaware of historical and cultural determinism, but highly aware of a new individualistic detachment from the body social, proposed the first of our extant ideas of motive: the genius of the individual artist. At the time of its Renaissance inception, this individualistic motivation was 'still trailing clouds of glory.' As we read one of its early literary embodiments, Vasari's *Lives*, we are continually made aware of genius as the special gift of God. Giotto accomplishes his artistic revolution 'by the favour of Heaven.' Leonardo's superiority is such as 'manifestly to prove that he has

been specially endowed by the hand of God himself, and has not obtained his pre-eminence by human teaching, or the power of man.'[5] Vasari seems but to paraphrase himself in ascribing the genius of Raphael, Michelangelo and other great artists to the same divine source. There was in this conception a recognition that genius, though embodied in individuals, is not individually self-contained or self-explanatory, but the external source here ascribed to it was not destined to remain convincing for subsequent Western thought. The greatness of the great man was gradually detached from religious affiliations and was explained in terms of superior intellectual and aesthetic endowment or, with the advent of psychoanalysis, in terms of impulse generated by the individual unconscious.

Biographical criticism had special value for the development of the philosophy of art in that it was an instrument of correlation and synthesis. Instead of confining attention exclusively to objects of art, it called for observation of the relations between certain objects of art and a human being. In thus recognizing a tie between art and life, it introduced a correlative approach which, if pursued to its logical conclusion, was bound eventually to lead beyond the individual. Although the purely biographical approach was long considered, and by biographers is sometimes still accepted, as a sufficient basis for the discussion of an artist's work, it contains ingredients for its own dissolution into larger circles of human experience.

The individual, as we have more than once had occasion to observe, does not exist alone but in society. The study of his life and art inevitably leads to some degree of consideration for the given society in general and for the particular members of it with whom the individual was most closely associated. Leonardo da Vinci may, in Vasari's eyes, have derived his genius from God and have owed nothing 'to the power of man,' but he did not study with God; he studied with Verrochio. Accordingly, having explained the divine source of the artist's genius on the first page of his *Life* of Leonardo, Vasari arrives on the second page at the youthful aspirant's apprenticeship to the older master, and by page three is relating Leonardo to social enterprises full of the techno-economic concerns of the epoch such as 'the formation of a canal from Pisa to Florence.'[6]

Thus, while the theoretical assumption as to the motivating source of art might remain centered in the psychology of the individual, the practice of biographical criticism inevitably demanded a larger frame of reference. Recognition of this fact led many writers subsequent to the Renaissance to entitle their works, not the 'Life,' but the 'Life and Times,' of the given artist. Through the 'times,' the way was open for a consideration of historical and social factors in their relationship to art.

In the biographical tradition, historical factors remained a background against which the individual stood out in vigorous highlight. By the eighteenth century another tradition was arising to reverse the emphasis. Synchronizing with the emergence of Western historical consciousness, aware for the first time of such inclusive entities as the whole rise and fall of Greek civilization, this tradition gave its chief thought to the saga of societies, the epic march of civilizations. Seen in such panoramic perspective the individual shrank to the role of a participant, albeit perhaps a leading participant, in the historical destiny of his epoch, and even his epoch receded into place as one of the phases of a cycle of civilization. This point of view in general we are calling historical determinism (the biographical one might be called personal determinism). Actually historical and social factors are so numerous and complex that they permit of many intellectual analyses, with the result that the tradition concerned with them is a complex of several different formulations or subtraditions.

The two most important of these in the literature of art are listed last in the diagram on page 727. They are historical determinism proper and what, for purposes of distinction, may be called racial determinism. We have noted in an earlier and more general context that a third variant, economic determinism, can be considered as a restricted form of historical determinism. Historical determinism proper received its first major exposition in *The History of Ancient Art* by John Winckelmann (1764). Winckelmann ascribed the progress and superiority of art among the Greeks 'partly to the influence of climate, partly to their constitution and government, and the habits of thinking which originated therefrom, and, in equal degree also, to respect for the artist, and the use and application of art.'[7] 'Being consecrated to the gods, and devoted only to the holiest and best purposes of the land,' the artist's 'work was made to conform to the lofty ideas of the whole nation.' All these conditioning factors—geographical, political, religious and others— are elaborated in Winckelmann's discussion.

What the eighteenth century thus conceived with reference to its absorption in Classical antiquity, the nineteenth applied to its new enthusiasm for the Western Middle Ages. Writers like Viollet-le-Duc and, later and within narrower limits, Henry Adams studied medieval art in relation to its historical background. Supported by an intervening century of growth in both historical and critical consciousness, Viollet-le-Duc related Gothic art to a remarkably extensive and remarkably solid frame of reference. His exposition of the functional aspects of Gothic architecture, such as the evolution of its structural organism, remains basic today, and his conception of the conditioning forces to which architectural structure must adapt itself

extends from 'the nature of the materials' to 'the climate' and 'the historical conditions of an epoch.'[8] His discussion of the historical background of Gothic art refers to the new expansive force of Western life after the eleventh century, the emergence of the free cities, and many of the other historical circumstances adduced in our chapter on Gothic history.

Winckelmann and Viollet-le-Duc had both related their concepts of historical determinism to the study of one selected type of art: in the first case, primarily Greek art, with marginal references to other ancient national styles; in the second case, French medieval art. The first writer to separate historical determinism from a single context and propose it as a theory having the validity of a general principle, applicable to all historical contexts, appears to have been Hippolyte Taine (1828–93). Relating his observations to the art of Greece, of medieval Europe, of Renaissance Italy and of the seventeenth-century Low Countries, with references to other areas and periods, and also in the light of extensive studies in English, Spanish and other literatures, Taine proposed a motivation sequence in four principal terms. These terms, elaborated in their author's *Philosophy of Art*,[9] are as follows: (1) A 'general situation' involving such realities as a 'state of wealth or poverty, a particular form of society, a certain species of religious faith,' gives rise to (2) 'corresponding needs, aptitudes, and sentiments.' This reigning mentality finds its most complete embodiment in (3) a 'representative man'—the youthful Greek athlete, the medieval monk—who becomes the culture hero of the period and the primary subject of its art. The artists then strive to express the character of this representative man in (4) 'sounds, forms, colors, or language giving this character sensuous form, or which comport with the tendencies and faculties comprising it.'

It will be observed that the first, second and fourth terms of the above sequence—general situation, resulting sentiments and their artistic expressions—closely parallel the psycho-historical sequence of historical circumstance, psychic state and cultural expressions. Taine's theory, much more solid and penetrating in his development than it may sound in our summary, is probably the most complete formulation of the principle of historical determinism to be found in the literature specifically devoted to art.

The last of our six main critical traditions, which we have referred to as 'racial determinism', emerged somewhat obliquely from the aesthetic teleology of Riegl. The latter had enunciated a 'will to art'—*Kunstwollen*—as the basic factor in the motivation of works of art. The principle was important not only because it related art to obscure psychological impulse, but because it provided a corrective to the widespread tendency to judge one form of art in terms of another. Riegl was himself chiefly occupied with the decorative

arts of the declining Roman world; arts which, in relation to the High Classical standards of preceding periods, had frequently been condemned as decadent. Riegl maintained that these arts owed their nature, not to negative inability to fulfill the artistic aims of previous periods, but to a positive fulfillment of the intent, the artistic will, of their own period. Every period, he said, has its own will impulse or 'will' as a motivation for its art. Consequently, that art can be judged only by the degree to which it fulfills its own will. To judge it by comparison with other types of art that owed their nature to other intentions is to misjudge and to fail to understand it.[10]

The will to art as Riegl conceives it has much in common with the second term in Taine's motivating sequence: the 'needs, aptitudes, and sentiments' corresponding to a particular historical situation. Riegl himself leaves the nature of the artistic will vague and its source largely undetermined. As Gilbert and Kuhn have put it, 'Riegl's "will to art" leaves us in doubt as to whether we have to do with a psychological hypothesis or a rudimentary metaphysics.'[11] Riegl's most direct successor, Wilhelm Worringer, ostensibly decided for the psychological alternative by making the 'will' concept the basis of a 'psychology of style.' In Worringer's general statements of theory, both psychological and historical determinants are given due consideration. The changes in the will to art as it passes from period to period are recognized as standing in orderly relationship to 'the variations that take place in the constitution of the mind and soul of mankind,' and these variations in turn are governed by the 'fundamental process of the whole historical evolution of mankind: the checkered, fateful process of man's adjustment to the outer world.'[12]

In practice, Worringer abandons both psychology and history. He makes no use of the findings of scientific psychology of any school, and little if any reference to the political, economic, or other circumstances of historical epochs. His 'psychical categories' turn out, in Spenglerian fashion, to be 'timeless racial phenomena' associated with the supposedly unchanging natures of primitive man, of Classical man, of Oriental man and of Gothic man. We are thus left with race as the ultimate determinant of art in Worringer's system. Teutonic racial stock becomes 'the *conditio sine qua non* of the Gothic.'[13] Its artistic expression is not limited to Gothic proper of the high Middle Ages 'but through the centuries manifests itself continually in ever new disguises' as a 'latent Gothic.' This 'latent Gothic' characterizes all Western European art from the bronze age to the present day.

Such a theory provides no means of explaining the differences which Western European or other art undergoes in its passage through successive phases of its history, but it does call attention to a certain continuing element

which, in Worringer's terms, is conceived as the result of racial determinism. The precarious equilibrium of the concept of race is amusingly illustrated by the fact that, to the German Worringer, Teutonic stock is the indispensable racial source of Gothic art, whereas the Frenchman Viollet-le-Duc attributes Gothic achievements to the genius of the Gallo-Roman peoples occupying the basins of the Seine, the Loire and the Somme.[14]

In summary, our second group of traditions may be said to indicate the personality of the individual artist, the genius of the race to which he belongs, and the historical and environmental conditions which that race is experiencing as three alternative bases for the motivation of art. Here again the three proposals are in no sense incompatible with each other. An individual artist emerges from some racial stock, and the stock to which he belongs undergoes the conditioning circumstances of historical evolution. Each of these levels of life and experience might well be expected to play some part in the motivation of art.

We have now briefly reviewed all six of the traditions in terms of which I have been attempting to analyze our inheritance of critical thought within the field of art. Although these traditions have by no means existed in ideal harmony with each other, we can see from the foregoing discussion that they are capable of ideal interrelationships. They mutually complete, rather than contradict, each other. The traditions of historical and racial determinism emphasize the ultimate sources of collective human experience. The biographical tradition emphasizes the individual artist who emerges from this collective background and becomes an organ of expression for it. The traditions of subject, form and function emphasize characteristic instrumentalities employed by the artist, or submitted to by him, in fashioning specific works of art. Thus grouped, our six traditions may be conceived as component aspects of an organic totality, providing together our most comprehensive perspective on the interpretation of art. It is no doubt because each contributes knowledge and insight essential to the completeness of the totality that all have survived as living critical traditions.

But if each tradition envisages some aspect of the artistic totality, and if all are capable of organic interconnections, we should also observe that the several traditions differ greatly in their relative inclusiveness. The iconographical, formal and functional ones, when pursued within the limits of their own disciplines, are relatively narrow, each confining itself to one component aspect of works of art. The biographical tradition provides a beginning of synthesis by bringing all the aspects of the work of an artist into relationship with his creative personality. The racial tradition offers a broader synthesis, for theoretically at least, it can consider all the factors just

indicated plus their relationship to the race to which the artist belongs. The historical tradition reaches a maximum synthesis, including all the foregoing factors as seen in relationship to the environment and the historical condition of the race or society involved.

NOTES

¹ See Emile Mâle, *Religious Art in France, XIII Century*, trans. by Dora Nussey (New York: E. P. Dutton, 1913), pp. vii–viii.
² Hippolyte Taine, *Lectures on Art, First Series*, trans. by J. Durand (New York: Henry Holt, 1875), p. 30.
³ Lionello Venturi, *History of Art Criticism*, trans. with notes by C. Marriott (New York: E. P. Dutton, 1936) pp. 309, 310.
⁴ *Ibid.*, p. 70.
⁵ Giorgio Vasari, *Lives of Seventy of the Most Eminent Painters, Sculptors and Architects*, ed. and annotated by E. H. and E. W. Blashfield and A. A. Hopkins (New York: Charles Scribner's Sons, 1926), I, 48; II, 370.
⁶ *Ibid.*, II, 372.
⁷ John Winckelmann, *The History of Ancient Art*, trans. by G. H. Lodge, (Boston: Osgood, 1872), II, 4, 21.
⁸ Eugène Viollet-le-Duc, *Dictionnaire raisonné de l'architecture française du XIe au XVIe siecle* (Paris: Morel, 1882), I, 116.
⁹ Included in Taine, *op. cit.*, pp. 157–161.
¹⁰ Alois Riegl, *Spätromische Kunstindustrie* (Vienna, Oster: Staatstruckerei, 1927), pp. 8–11.
¹¹ Katharine E. Gilbert and Helmut Kuhn, *A History of Aesthetics* (Bloomington, Ind.: Indiana University Press, 1953), p. 547.
¹² Wilhelm Worringer, *Form Problems of Gothic* (New York: Steckert, 1920), pp. 25–26.
¹³ *Ibid.*, pp. 45, 146.
¹⁴ Viollet-le-Duc, *op. cit.*, I, 144–145.

SUPPLEMENTARY READINGS

Walter Abell, *The Collective Dream in Art*, Cambridge: Harvard University Press, 1957; Schocken Books, 1966.

Milton C. Albrecht, 'The Relationship of Literature and Society,' *American Journal of Sociology*, Vol. 59 (March, 1954), pp. 425-36.

Pierre Aubery, 'Pour une interprétation sociologique de la littérature,' *French Review*, Vol. 37 (December, 1963), pp. 169-75. Claims that literature should go beyond aesthetic functions for literate audiences and critics and serve as an agency of social reform.

Arthur J. Brodbeck, 'Placing Aesthetic Developments in Social Context: A Program of Value Analysis,' *Journal of Social Issues*, Vol. 20 (January, 1964), pp. 8-25.

Kenneth Burke, *A Grammar of Motives*, and *A Rhetoric of Motives*, New York: Prentice-Hall, 1952. A detailed working out of the author's dramatistic model for analysis of society.

Christopher Caudwell, *Illusion and Reality*, New York: International Publishers, 1947. A survey of poetry from the Marxist viewpoint.

Joel E. Cohen, 'Information Theory and Music,' *Behavioral Science*, Vol. 7 (April, 1962), pp. 137-63.

Henry Commager, *The American Mind*, New Haven: Yale University Press, 1950.

Bernard De Voto, *The Literary Fallacy*, Boston: Little, Brown, 1944.

Hugh D. Duncan, 'Sociology of Art, Literature and Music: Social Contents of Symbolic Experience,' in Howard Becker and Alvin Boskoff, eds., *Modern Sociological Theory in Contemporary Change*, New York: Dryden Press, 1957, pp. 483-99.

Peter K. Etzkorn, 'Georg Simmel and the Sociology of Music,' *Social Forces*, Vol. 43 (October, 1964), pp. 101-7.

Herbert Gamberg, 'The Modern Literary Ethos: A Sociological Interpretation,' *Social Forces*, Vol. 27 (October, 1958), pp. 7-14. An analysis of the views of several critics and their interpretation of literary trends.

Albert Guérard, *Literature and Society*, Boston: Lothrop, Lee & Shepard, 1935.

Louis Harap, *Social Roots of the Arts*, New York: International Publishers, 1949. A restatement of Marxist principles as applied to art in its various aspects.

Arnold Hauser, *The Philosophy of Art History*, New York: Alfred A. Knopf, 1959. Hauser expounds on the philosophical presuppositions of his conception of art history and his conviction that the sociological method is indispensable in the history of art.

Richard Hoggart, 'Literature and Society,' *American Scholar*, Vol. 35 (Spring, 1966), pp. 277-89. A defense of good literature not merely as 'document' but as re-creation of 'the experiential wholeness of life,' and a plea to apply literary critical analysis to the popular arts and other forms of mass communication.

Vytautas Kavolis, *Artistic Expression: A Sociological Analysis*, Ithaca: Cornell University Press, 1968.

Joseph T. Klapper, *The Effects of Mass Communication*, Glencoe: Free Press, 1960.

E. R. Leach, 'Aesthetics,' Chapter III in *The Institutions of Primitive Society*, Glencoe, Ill.: Free Press, 1961. Shows ways in which Western man's concepts of art and aesthetics are applied to primitive art.

Max Lerner and Edwin Mims, Jr., 'Literature,' in *Encyclopedia of the Social Sciences*, New York: Macmillan, 1933. A perceptive and valuable survey.

Leo Lowenthal, *Literature and the Image of Man*, Boston: Beacon Press, 1957.

Karl Marx and Frederick Engels, *Literature and Art*, New York: International Publishers, 1947. Selections from their writings that recognize that the highest achievements in literature and art do not bear a direct relationship to the development of the economy.

Radhakamal Mukerjee, *The Social Function of Art*, New York: Philosophical Library, 1954. Art is represented as a social and community enterprise that unifies society, confirms its traditions, and contributes to its stability.

Thomas Munro, *Evolution in the Arts and Other Theories of Culture History*, Cleveland Museum of Art, 1963.

José Ortega y Gasset, *The Dehumanization of Art*, Garden City: Doubleday Anchor Books, 1956, pp. 4–50. A classic statement on the new, dehumanized art, which 'divides the public into the two classes of those who understand it and those who do not.'

Talcott Parsons, *The Social System*, New York: Free Press, 1951, Chap. 9. Describes the role of the artist, whom Parsons sees as serving a subcultural group with distinct standards, comparable to those of a 'sect,' and whose belief system differs from society's general ideology.

Talcott Parsons, Edward Shils, Kaspar Naegele and Jesse R. Pitts, *Theories of Society*, New York: Free Press, 1965, 4 vols. Volume IV includes a section on symbolism, with an introduction by Parsons, which recognizes the patterning of 'meanings' of objects but admits inadequacies in incorporating symbolic forms into the theory of action.

Morse Peckham, *Man's Rage for Chaos: Biology, Behavior and the Arts*, New York: Chilton, 1965. A behavioristic approach to the arts, which assumes that the function of art in society is to disrupt traditional patterns and values.

Renato Poggioli, *The Theory of the Avant-Garde*, Cambridge: Harvard University Press, 1968.

Herbert Read, *Art and Society*, New York: Pantheon, 1945. Schocken Books, 1966. Assumes that art represents an 'autonomous activity' but is interrelated with many aspects and types of society; describes these relationships to primitive peoples, to religion and to Western society.

Albert Salomon, 'Sociology and the Literary Artist, 'in Stanley Romaine Hopper, ed., *Spiritual Problems in Contemporary Literature*, New York: Harper Torchbook, 1957, pp. 15–24. Argues that literature deals with the whole man whereas sociology is limited to the social man.

Levin L. Schücking, *The Sociology of Literary Taste*, trans. by Brian Battershaw, Chicago: University of Chicago Press, 1966. Deals with literary taste, trends and the various conditions that influence and sustain it.

Alyhons Silbermann, *The Sociology of Music*, trans. by Corbet Stewart, London: Routledge & Kegan Paul, 1963. The sociological approach includes consideration

of the social determinants of musical experience and the structure, functions and behavior of socio-musical groups.

Adolph S. Tomars, *Introduction to the Sociology of Art*, Mexico City: published by the author, 1940. One of the first systematic attempts to examine the relationship of art to social groups. Using the concepts formulated by MacIver, Tomars describes the social contexts and character of communal art, class art and associational art.

Arnold J. Toynbee, *A Study of History*, London: Oxford University Press, 4 vols., 1934–39. Dismissing Spengler's organic concept of culture, Toynbee accepts the idea of dominant tendencies or bent, which is manifested in art, along with its reflection of the duration of a culture.

NOTES ON CONTRIBUTORS

Walter Abell (1897–1956) was Professor of Art at Michigan State University and author of *The Collective Dream in Art* (1957) and *Representation and Form* (1936; reissued, 1966).

Milton C. Albrecht is Professor of Sociology at the State University of New York at Buffalo; author of articles on education, psychology, and the sociology of art; and editor of *Studies in Sociology* (1967).

Frederick Antal (1887–1954) was an art historian of international reputation who became a leading specialist in Mannerist painting. He was a pioneer exponent of the sociological interpretation of art and had a strong influence on the methods of research currently being applied in this field.

James H. Barnett is Professor of Sociology at the University of Connecticut and author of *Divorce and the American Divorce Novel* (1939; reissued 1968) and *The American Christmas* (1954).

Quentin Bell, painter, sculptor, critic, and lecturer, is currently Professor of History and Theory of Art, Sussex University, England. His publications include *Ruskin* (1963), *School of Design* (1963), and *Victorian Artists* (1967).

Joseph Bensman is Associate Professor of Sociology at the City College of the City University of New York and co-author (with Israel Gerver) of *Art and Mass Society* (1958).

Sir Kenneth Clark is an art historian, former director of the National Gallery in London, Slade Professor of Fine Arts at Oxford, and Chairman of the Independent Television Authority of Great Britain. His books include *Moments of Vision* (1954), *The Nude* (1955), and *A Failure of Nerve* (1967).

Malcolm Cowley is a critic, poet, and literary historian. Among his books are *Blue Juanita* (1929), *Exile's Return* (1951), *The Faulkner-Cowley File* (1966), and *Think Back on Us* (1967). He describes *The Literary Situation* (1954), from which the selection in this volume is taken, as a 'social history of literature in our time.'

John Dewey (1859–1952), noted educator and philosopher, was Professor of Philosophy at Columbia University for nearly fifty years. His contributions to social science include, among others, *Human Nature and Conduct* (1922), *Art as Experience* (1934), and *Theory of Inquiry* (1938).

Hugh D. Duncan is Professor of Sociology and English, Southern Illinois University, and author of *Language and Literature in Society* (1953), *Communication and the Social Order* (1962), and *Symbols in Society* (1968).

Marvin Elkoff is a free-lance writer and advertising consultant. He has contributed articles to *Esquire*, *Holiday*, and numerous other magazines.

Sondra Forsyth Enos has performed with many prominent ballet and modern dance companies, has taught ballet, and has done choreography for stage and television.

Robert Escarpit is Professor of Comparative Literature at the University of Bordeaux, Director of the Institute of Literature and Mass Culture, and author of *The Book Revolution* (1965) and biographies of Byron, Kipling, and Hemingway.

James Fernandez is Professor of Anthropology at Dartmouth College. He has done field work in southern Equatorial and West Africa and in northern Spain. His main interest is in the problem of logico-aesthetic integration.

John L. Fischer is Professor of Anthropology at Tulane University.

Norris Fliegel is Associate Professor of Educational Psychology at Hunter College and a practicing psychotherapist.

Daniel M. Fox is Assistant Professor of History and research fellow, Institute of Politics, Harvard University. He is the auther of *Engines of Culture* (1963) and *The Discovery of Abundance* (1967).

Israel Gerver is with the Office of Juvenile Delinquency, U.S. Department of Health, Education, and Welfare, in Washington, D.C., and co-author (with Joseph Bensman) of *Art and Mass Society* (1958).

Jean Gimpel is the author of *Contre l'art et les artistes*, recently published in France. He is the son of the well-known art collector and dealer René Gimpel.

Lucien Goldmann is director of studies at the École Pratique des Hautes Études, Paris, and director of the Center for the Sociology of Literature of the Free University of Brussels. Among his works are *The Hidden God* (1964) and *Pour une sociologie du roman* (1964).

Nelson H. H. Graburn is Assistant Professor of Anthropology at the University of California, Berkeley. He has done field research among the Eskimos of eastern Canada and the Indians of northern Quebec. Among his interests is the comparative study of contemporary arts.

Mason Griff is Professor and Chairman of the Department of Sociology, South-eastern Massachusetts University. His scholarly interests are in the sociology of the arts and aesthetics and in mass society and culture. He is a contributor to *Diogenes*.

Neil Harris is Associate Professor of History at The University of Chicago and editor of *The History of the United States* (1969).

Edward B. Henning is Curator of Contemporary Art at the Cleveland Museum of Art.

George A. Huaco is Associate Professor of Sociology, the State University of New York at Buffalo, and author of *The Sociology of Film Art* (1965).

Alexander Kern is Professor of American Literature and Civilization, University of Iowa, and author of numerous articles in American cultural history.

Pauline Kolenda is Professor of Anthropology at the University of Houston. Her major interests are in the culture of India and in heirarchy, rank, and social organization in various societies.

Judith R. Kramer is Assistant Professor of Sociology at Brooklyn College.

Alfred L. Kroeber (1876–1960) was Professor of Anthropology at Columbia University and the University of California, Berkeley. Founder and President of the American Anthropological Association (1917), he was a recipient of the Huxley Medal, the Viking Medal, and the medal of the Royal Anthropological Institute. He wrote books on Peru, the Zuñi Indians, the Indians of California, and the people of the Philippines, as well as *Configurations of Culture Growth* (1944) and *Style and Civilizations* (1957).

Dan Lacy is a publishing-company executive and author of *Books and the Future* (1956) and *Freedom and Communications* (1961).

Kurt Lang, a specialist in the study of mass communications, is Professor of Sociology at the State University of New York at Stony Brook.

Allen Leepa is Associate Professor of Art, Department of Graduate Painting, Michigan State University. A Fulbright scholar at the Sorbonne, he has lectured at the Brooklyn and Metropolitan museums. He is the author of *The Challenge of Modern Art* (1961) and of a forthcoming volume on problems in contemporary painting.

Alan Lomax, Professor of Anthropology at Columbia University, is a folklorist. He has edited the nineteen-volume *World Library of Folk and Primitive Music* (1951–57); his research on cantometrics has resulted in several articles, as well as *Folk Song Style and Culture* (1968).

F. van der Meer is Professor of Art History, University of Nijmegan, the Netherlands. He is the author of the *Atlas of the Early Christian World* (1960), *Augustine the Bishop* (1962), and *Early Christian Art* (1967).

Dennison Nash is Professor of Sociology and Anthropology, University of Connecticut. He has long been interested in the sociology of music, religion, culture, and personality. He has recently completed *A Community in Limbo: An Anthropological Study of an American Community Abroad*.

Howard Lee Nostrand is Professor of Romance Languages and Literatures, University of Washington, Seattle. A former president of the American Association of Teachers of French, he has also received honors from the Peruvian and French governments. He is a co-author of *Research on Language Teaching* (1962).

Nikolaus Pevsner is Professor of the History of Art, Birbeck College, University of London, and author of *High Victorian Design* (1951) and *The Englishness of English Art* (1956).

Renato Poggioli (1907–63), born in Florence, Italy, became a U.S. citizen and served for many years as Curt Hugo Reisinger Professor of Slavic and Comparative Literature at Harvard University. His last publication, now translated as *The Theory of the Avant-Garde* (1968), was preceded by *The Poets of Russia, 1890–1930* (1960), and *The Phoenix and the Spider* (1957) essays on Russian writers.

Sir Herbert Read (1893–1968), British poet, critic, and philosopher, was renowned throughout Europe and America. Among his many works are *Art and Society* (1936), *Forms of Things Unknown* (1960), and *Art and Alienation* (1967).

Maria Rogers, one of the founders of the Committee on Autonomous Groups, has spent many years in the field of adult education. She pioneered in making parents' organizations standard media for parent education.

Bernard Rosenberg is Associate Professor of Sociology, City College of New York, and co-editor (with David Manning White) of *Mass Culture* (1957).

Harold Rosenberg is the author of *The Tradition of the New* (1959) and other works of art criticism.

Ben Shahn (1898–1969) was a painter whose works are exhibited in many museums. He was Charles Eliot Norton Professor at Harvard University, 1956–57.

Leo Steinberg is Professor of Art History at Hunter College and author of numerous articles on art criticism.

Anselm Strauss is Professor of Sociology, University of California, San Francisco Medical Center. His most recent books are *The Discovery of Grounded Theory* and *Awareness of Dying*.

Alvin Toffler, former associate editor of *Fortune*, is a professional writer. He is the author of *The Culture Consumers* (1964) and more than one hundred published articles.

Ian Watt, formerly a fellow of St. John's College, England, is currently Professor of English at Stanford University. His *The Rise of the Novel* (1957) has been widely acclaimed.

Richard Wollheim is Professor of Philosophy of Mind and Logic, University of London. He is the author of, among other works, *Socialism and Culture* (1961) and *Art and Its Objects* (1968).

INDEX